National Register of
Psychotherapists 2000

National Register of Psychotherapists

2000

United Kingdom Council for Psychotherapy

ROUTLEDGE
Taylor & Francis Group

UKCP

UNITED KINGDOM COUNCIL FOR PSYCHOTHERAPY

First published 2000
by Routledge, part of the Taylor & Francis Group
11 New Fetter Lane, London EC4P 4EE

© 2000 United Kingdom Council for Psychotherapy

Typeset by Facing Pages, Southwick

Printed and bound in Great Britain by
Hobbs the Printers, Southampton

British Library Cataloguing in Publication Data
A catalogue record for this book is available from the British Library

Library of Congress Cataloguing in Publication Data
A catalogue record for this book has been requested
ISBN 0-415-23015-2
ISSN 1461-0175

Table of Contents

Foreword

It is now 29 years since the Foster Report proposed that psychotherapy should become a regulated registrable profession. The lengthy and difficult task of bringing together all the major differing modalities of psychotherapy practised in the United Kingdom into one organisation was finally completed with the formal establishment in 1993 of the UKCP, and the launch of the first official National Register of Psychotherapists.

The UKCP's prime objective is that of protection of the public. It has had charitable status from its inception. It has now developed, by reason of its growth, into an Incorporated Charitable Company. This requires that the UKCP shall be open and accountable both to the Charity Commissioners and to Companies House in the way that it is run.

The UKCP also demands accountability of its Member Organisations, of its eight Sections which represent the different modalities of psychotherapy, and of its registered practitioners themselves. No organisation may become part of the UKCP unless it conforms to substantial criteria, and no individual may be registered unless they are ethically accountable to the Member Organisation. Thus the UKCP's 78 Member Organisations which cover over 4,800 psychotherapists are expected to adhere to and apply guidelines for standards of training and ethical practice that are intended to protect the vast numbers of the public who use these services. Any registered psychotherapist who is found guilty of serious misconduct, or otherwise acts in contravention of the Member Organisation's own Code of Ethics, is at risk of penalty, or in the final instance of being struck off the Register. This degree of accountability is reflected in the National Register of qualified psychotherapists.

The UKCP was established with the goal of creating a broadly based profession of psychotherapy that would be as well regulated as are other traditional professions. This is still its goal. Until statutory registration is a reality, and no longer an ideal towards which we are working, the UKCP is committed to ensuring that as high standards of self regulation as possible are adopted by UKCP Member Organisations and their practitioners, in the public interest.

The UKCP is now nationally well known and respected. Its Register of qualified psychotherapists can be located in main libraries, medical centres, and other public health institutions throughout the country. The UKCP itself, and the Register in particular, enables the public to know about the different kinds of psychotherapy available in the United Kingdom, where to contact the relevant organisations, and helps members of the public to find an appropriately qualified psychotherapist for the particular modality being sought.

The UKCP is active not only in this country but also plays a leading part in helping to forge the boundaries of the profession throughout western and eastern European countries through the European Association of Psychotherapy and beyond. There is now a World Council of Psychotherapy. In both of these overseas arenas the UKCP carries influence and prestige for that which it has already achieved in Great Britain. Its Register of British UKCP registered psychotherapists is, in part, the public expression of that effort and achievement.

Helen Tarsh
Chair of Registration Board

Using the Register

The *National Register of Psychotherapists* is designed to make it easy to find and contact a psychotherapist in your area. The names, addresses and telephone numbers of registered psychotherapists are listed alphabetically within geographical areas. Each entry includes a brief description of the type of psychotherapy offered and a code denoting the organisation(s) to which the psychotherapist belongs. A list of these codes and the organisations they relate to appears on page xviii. The register also lists practitioners under the organisation(s) to which they belong.

Each of the eight sections of UKCP has a **Flag Statement** outlining its purpose and distinguishing it from the other sections. The **Flag Statements** and a list of organisations belonging to each section appear on pages xv–xviii.

*One asterisk by the name of a psychotherapist indicates that this psychotherapist has been granted the label of psychoanalyst by the Registration Board. The use of this label is currently under discussion within UKCP.

**Two asterisks beside the Organisation Code of members of the Confederation of Analytical Psychologists indicates that these psychotherapists belong to either the Society of Analytical Psychology (SAP) or the British Association of Psychotherapists (BAP) or both. The BAP and the SAP were founding Member Organisations of the UKCP. Since 1999 they are no longer members.

Users of the Register may inquire of the UKCP office as to whether a named practitioner is currently listed on the UKCP data base. We hope that you will find this register easy to use and that you will write with your comments to:

United Kingdom Council for Psychotherapy
167–169 Great Portland Street
London WIN 5FB
Tel: 020 7436 3002
Fax: 020 7436 3013
Email: UKCP@psychotherapy.org.uk
http://www.psychotherapy.org.uk

The information contained in the Register was accurate at the time of going to print. Additions and deletions to the Register are published biannually in the UKCP newsletter, *The Psychotherapist*. The UKCP database of the *National Register of Psychotherapists* is continually updated.

Governing Board

Ann Casement	Chair
Alan Thomson	Vice Chair
Christine Lister-Ford	Honorary Secretary
Fiona Palmer Barnes	Chair, Ethics Committee
Ken Evans	Training Standards Officer
Jenny Corrigall	Professional Development Officer
Helen Tarsh	Chair, Registration Board
Heward Wilkinson	Elected Member
Adam Saltiel	Elected Member
Charlotte Sills	Elected Member
Michael Crowe	Royal College of Psychiatrists
Margaret Hunter	Psychoanalytically-based Therapy with Children Section
Del Loewenthal	Universities Psychotherapy Association
Jennie McNamara	Humanistic and Integrative Psychotherapy Section
Sylvia Cohen	Psychoanalytic and Psychodynamic Section
Lesley Parkinson	British Psychological Society
Nancy Graham	Family, Couple, Sexual and Systemic Therapy Section
David Campbell	Tavistock Clinic
Lucy Burtt	Experiential Constructivist Therapies Section
Ross McDonald	Hypno-psychotherapy Section
Diane Hirst	Analytical Psychology Section
Chris Williams	Behavioural and Cognitive Psychotherapy Section

Registration Board

Helen Tarsh	Chair
Peter Haworth	Vice Chair Humanistic and Integrative Psychotherapy Section
Judy Ryde	Honorary Secretary Humanistic and Integrative Psychotherapy Section
Paul Birley	Hypno-psychotherapy Section
Nicky Buckley	Psychoanalytic and Psychodynamic Section
John Burnham	Family, Couple, Sexual and Systemic Therapy Section
Catherine Crowther	Analytical Psychology Section
Dr. Sarah Davenport	Royal College of Psychiatrists
Alexandra Fanning	Psychoanalytic and Psychodynamic Section
Mike Harding	Experiential Constructivist Therapies Section
Peter Haworth	Humanistic and Integrative Psychotherapy Section
Lucy King	Psychoanlytic and Psychodynamic Section
Francis Lillie	Behavioural and Cognitive Psychotherapy Section
Nicky Model	Psychoanalytically-based Therapy with Children Section
Nick Pamphlett	Humanistic and Integrative Psychotherapy Section
Lesley Parkinson	British Psychological Society
Kevin Power	Universities Psychotherapy Association

Ethical Guidelines
of the United Kingdom Council for Psychotherapy

1. INTRODUCTION

1.1 The purpose of a Code of Ethics is to define general principles and to establish standards of professional conduct for psychotherapists in their work and to inform and protect those members of the public who seek their services. Each organisation will include and elaborate upon the following principles in its Code of Ethics.

1.2 All psychotherapists are expected to approach their work with the aim of alleviating suffering and promoting the well-being of their clients. Psychotherapists should endeavour to use their abilities and skills to their client's best advantage without prejudice and with due recognition of the value and dignity of every human being.

1.3 **All psychotherapists on the UKCP Register are required to adhere to the Codes of Ethics and Practice of their own organisations which will be consistent with the following statements and which will have been approved by the appropriate UKCP Section.**

2. CODES OF ETHICS

Each Member Organisation of UKCP must have published a Code of Ethics approved by the appropriate UKCP Section and appropriate for the practitioners of that particular organisation and their clients. The Code of Ethics will include and elaborate upon the following ten points to which attention is drawn here. All psychotherapists on the UKCP Register are required to adhere to the Codes of Ethics of their own organisations.

2.1 **Qualifications**: Psychotherapists are required to disclose their qualifications when requested and not claim, or imply, qualifications that they do not have.

2.2 **Terms, Conditions and Methods of Practice**: Psychotherapists are required to disclose on request their terms, conditions and, where appropriate, methods of practice at the outset of psychotherapy.

2.3 **Confidentiality**: Psychotherapists are required to preserve confidentiality and to disclose, if requested, the limits of confidentiality and circumstances under which it might be broken to specific third parties.

2.4 **Professional Relationship**: Psychotherapists should consider the client's best interest when making appropriate contact with the client's GP, relevant psychiatric services, or other relevant professionals with the client's knowledge. Psychotherapists should be aware of their own limitations.

2.5 **Relationship with Clients**: Psychotherapists are required to maintain appropriate boundaries with their clients. They must take care not to exploit their clients, current or past, in any way, financially, sexually, or emotionally.

2.6 **Research**: Psychotherapists are required to clarify with clients the nature, purpose and conditions of any research in which the clients are to be involved and to ensure that informed and verifiable consent is given before commencement.

2.7 **Publication**: Psychotherapists are required to safeguard the welfare and anonymity of clients when any form of publication of clinical material is being considered and to obtain their consent whenever possible.

2.8 **Practitioner Competence**: Psychotherapists are required to maintain their ability to perform competently and to take necessary steps to do so.

2.9 **Indemnity Insurance**: Psychotherapists are required to ensure that their professional work is adequately covered by appropriate indemnity insurance.

2.10 **Detrimental Behaviour**:

(i) Psychotherapists are required to refrain from any behaviour that may be detrimental to the profession, to colleagues or to trainees.

(ii) Psychotherapists are required to take appropriate action in accordance with Clause 5.7 with regard to the behaviour of a colleague which may be detrimental to the profession, to colleagues or to trainees.

3. ADVERTISING

Member organisations of UKCP and individual psychotherapists are required to restrict promotion of their work to a description of the type of psychotherapy they provide. Psychotherapists are required to distinguish carefully between self-descriptions, as in a list, and advertising seeking enquiries.

4. CODE OF PRACTICE

Each Member Organisation of UKCP will have published a Code of Practice approved by the appropriate UKCP

Section and appropriate for the practitioners of that particular organisation and their clients. The purpose of Codes of Practice is to clarify and expand upon the general principles established in the Code of Ethics of the organisation and the practical application of those principles. All psychotherapists on the UKCP Register will be required to adhere to the Codes of Practice of their own organisations.

5. COMPLAINTS PROCEDURE

Each Member Organisation of UKCP must have published a Complaints Procedure, including information about the acceptability or otherwise of a complaint made by a third party against a practitioner, approved by the appropriate UKCP Section and appropriate for the practitioners of that particular organisation and their clients. The purpose of a Complaints Procedure is to ensure that practitioners and their clients have clear information about the procedure and processes involved in dealing with complaints. All psychotherapists on the UKCP Register are required to adhere to the Complaints Procedure of their own organisation.

5.1 **Making a complaint**: A client wishing to complain shall be advised to contact the Member Organisation.

5.2 **Receiving a complaint**: A Member Organisation receiving a complaint against one of its psycho-therapists shall ensure that the therapist is informed immediately and that both complainant and therapist are aware of the Complaints Procedure.

5.3 **Appeals**

(i) After the completion of the Complaints Procedure within an organisation, provision must be made for an appeal, stating time limits, grounds and procedures.

(ii) After the completion of all procedures in an organisation, an appeal may be made to the Central Final Appeals Committee of UKCP.

5.4 **Reports to UKCP Section**: Where a complaint is upheld the Section shall be informed by the organisation.

5.5 **Reports to the UKCP Registration Board**. Member Organisations are required to report to the UKCP Registration Board the names of members who have been suspended or expelled.

5.6 **Complaints upheld and convictions**: Psychotherapists are required to inform their Member Organisations if any complaint is upheld against them in another Member Organisation, if they are convicted of any notifiable criminal offence or if successful civil proceedings are brought against them in relation to their work as psychotherapists.

5.7 **Conduct of colleagues**: Psychotherapists concerned that a colleague's conduct may be unprofessional should initiate the Complaints Procedure of the relevant Member Organisation.

5.8 The resignation of a member of an organisation shall not be allowed to impede the process of any investigation as long as the alleged offence took place during the person's membership.

6. SANCTIONS

Psychotherapists who are suspended by, or expelled from, a Member Organisation are automatically deleted from the UKCP Register.

7. MONITORING COMPLAINTS

7.1 Member Organisations shall report to the Registration Board annually concerning the number of complaints received, the nature of the complaints and their disposition.

7.2 The Registration Board shall report annually to the Governing Body on the adequacy of Member Organisations' disciplinary procedures.

Sections and Flag Statements

I. ANALYTICAL PSYCHOLOGY SECTION

This stems from the work of C G Jung. The central idea is that what we do and feel, how we think of ourselves and other people, depend on forces and processes we are not aware of — the 'unconscious'. These may be part of our common human nature or particular to the individual.

The analytical psychologist (also known as a Jungian analyst) tries to understand these unconscious elements in what the patient says and the dreams they report. Particular attention is given to how the patient regards the analyst and vice versa. It can be beneficial for a patient to understand how this 'transference' mirrors the early family situation, enabling them to take conscious control. Jungian analysts believe that we are all highly capable of healing ourselves and taking charge of our lives.

Analytical psychologists treat people suffering from emotional disorders or problems with relationships, but can also help 'normal' people who are discontented with themselves or have lost a sense of direction in their lives. So it is not necessary to be 'ill' to benefit from Jungian analysis, since self-discovery and the exploration of the inner world are valuable in themselves.

Analytical psychology also has much to say about society and culture, showing how unconscious processes affect the groups and institutions we belong to.

ORGANISATIONS
Association of Jungian Analysts
The Independent Group of Analytical Psychologists
Confederation of Analytical Psychologists

2. BEHAVIOURAL AND COGNITIVE PSYCHOTHERAPY SECTION

The Behavioural and Cognitive Psychotherapies are used to treat a wide range of emotional disorders, using a problem-solving approach. There is a large body of research evidence which demonstrates the effectiveness of these psychotherapies in treating problems such as: depression, panic attacks, agoraphobia, obsessive-compulsive disorder, post-traumatic stress disorder, eating disorders, chronic pain, irritable bowel syndrome.

Therapists and client work as a team to identify problems and examine these in terms of the relationship between thoughts, feelings, behaviour and the individual's environment.

The main focus in treatment is on the here and now (as opposed to the past) and how current problems interfere with the client's daily life. The aim of therapy is to help the client understand their problems and develop practical ways of dealing with them. There is an emphasis on self-help and the therapist will ask the client to deliberately practise applying their new knowledge and skills to their problems in between therapy sessions.

Typically treatment consists of 12–13 weekly sessions of an hour. This may be in health centres, specialist departments or hospital out-patient clinics. The behavioural cognitive psychotherapies are widely available in the NHS, as well as the private sector. Many healthcare professionals are trained in these therapies, including clinical psychologists, psychiatric nurses and social workers.

ORGANISATION
British Association for Behavioural and Cognitive Psychotherapies

3. EXPERIENTIAL CONSTRUCTIVIST THERAPIES SECTION

These therapies are based on the assumption that our world is not just given to us to complete, but that we construct our individual picture of it from our own personal experiences. Then, what we do, what we believe, what we feel, is largely dictated by this picture, or model. For a person badly treated, the world may be seen as cruel or unreliable, whereas, for one well treated, it may appear a good place. We are constantly modifying our models in the light of experience.

The first task in therapy is to help the client clarify the models they use, consciously or not, to represent the world to themselves. They will need to explore and try out different ways of constructing their model and living within it, with no suggestion that any particular model is the 'correct' one. Changes may come in a small way in different behaviour or more extensively in revision of values, beliefs and identity.

These therapies often have a specific focus and expect to effect positive change in the short term, as well as dealing with the underlying issues which may require longer term therapy. The setting may be one-to-one or in a group. A wide range of methods is used, imaginatively tailored to the individual, who is involved at every stage. The process, depending on mutual respect between therapist and client, is designed to enable the client to take better charge of their life.

ORGANISATIONS
Association for Neuro-Linguistic Programming
Centre for Personal Construct Psychology
Society for Existential Analysis

4. FAMILY, COUPLE, SEXUAL AND SYSTEMIC THERAPY SECTION

The members within this group of organisations share an assumption that individuals' problems cannot adequately be understood without considering the relevance of the

families and groups which form each individual's past and present wider context. Information about this wider system may be elicited within therapy sessions with individuals, couples or family groups. Some systemic psychotherapists also consult to organisational and business systems.

Therapy aims to identify and explore the patterns of beliefs and behaviours in roles and relationships (including sexual relationships) which seem to have become set over time, and to enable people to decide where change would be desirable and to facilitate the process of establishing new and more fulfilling patterns. Systemic psychotherapists, whilst often actively intervening in client systems, strive to maintain a non-blaming and neutral position, respecting differences of culture, race, gender, sexual orientation etc. Therapists may work in teams using live consulation, or as sole practitioners using retrospective consultation in order to draw upon other perspectives to their practice. Therapy is often relatively short-term.

ORGANISATIONS

Association for Family Therapy
British Association for Sexual and Relationship Therapy
The Family Institute, Cardiff
Institute of Family Therapy
Kensington Consultation Centre

5. HUMANISTIC AND INTEGRATIVE PSYCHOTHERAPY SECTION

This Section includes different psychotherapies which approach the individual as a whole person including body, feelings, mind and spirit. Members welcome interdisciplinary dialogue and an exploration of different psychological processes with particular emphasis on integration within the Section. Organisations in this Section practice approaches compatible with the following:

Humanistic Psychotherapy is an approach which tries to do justice to the whole person including body, mind and spirit. It represents a broad range of therapeutic methods. Each method recognises the self-healing capacities of the client and believes that the greatest expert on the client is the client. The humanistic psychotherapist works towards an authentic meeting of equals in the therapy relationship.

Existential Psychotherapy aims at enabling clients to find constructive ways of coming to terms with the challenges of everyday living. The focus is on clients' concrete individual experience of anxiety and distress leading to an exploration of their personal beliefs and value system, in order to clarify and understand these in relation to the specific physical, psychological and socio-cultural context. The experience and influence of the past, present and future are given equal emphasis. The questioning of assumptions and facing up to the possibilities and limitations of living is an important part of this interactive, dynamic and direct approach.

Transpersonal/Psychospiritual Psychotherapy can be defined by its orientation which includes the spiritual dimension rather than the content of therapy. It views the human psyche as having a central core Self or Soul as the centre of identity as well as a personal ego. Psychotherapists draw on a wide range of therapeutic methods towards the uncovering of past psychological material within a context of the individual's potential based on spiritual insight and experience. Within this perspective there is both a movement of the personal centre to the Self and a movement of the Self to manifest its nature through and in the personal centre. Thus therapy includes both repair and individuation.

Integrative Psychotherapy can be distinguished from eclecticism by its determination to show there are significant connections between different therapies, which may be unrecognised by their exclusive proponents. While remaining respectful to each approach, integrative psychotherapy draws from many sources in the belief that no one approach has all the truth. The therapeutic relationship is the vehicle for experience, growth and change. It aims to hold together the dual forces of disintegration and integration, as presented by the psychologically distressed and disabled. The integrative therapeutic experience leads towards a greater toleration of life's experiences and an increase of creativity and service.

ORGANISATIONS

Association of Accredited Psychospiritual
 Psychotherapists
Association of Cognitive Analytic Therapists
Association of Humanistic Psychology Practitioners
Bath Centre for Psychotherapy and Counselling
British Psychodrama Association
Centre for Counselling and Psychotherapy Education
Centre for Transpersonal Psychology
Chiron Centre for Body Psychotherapy
The Gerda Boyesen Centre
The Gestalt Centre, London
The Institute of Psychosynthesis
Gestalt Psychotherapy Training Institute
Institute for Arts in Therapy and Education
Institute of Transactional Analysis
Karuna Institute
London Association of Primal Psychotherapists
Metanoia Institute
The Minster Centre
Northern Guild for Psychotherapy
North Staffs. Association for Psychotherapy
Psychosynthesis and Education Trust
Regent's College School of Psychotherapy
Re.Vision
The Sherwood Psychotherapy Training Institute
Spectrum

6. HYPNO-PSYCHOTHERAPY SECTION

Hypno-psychotherapy is the branch of psychotherapy which uses hypnosis. It rests on an extensive body of work and publications over the last three hundred years, leading to that of Milton Erickson and those influenced by him. It understands that we have a learned model of the world which can restrict the way we feel, what we understand, our attitudes and behaviour. Hypnosis is a state of relaxation

which people enter voluntarily, during which there occurs an altered state of conscious awareness. The therapist can intervene to draw the individual's attention to new possibilities, to alternative patterns of thought, emotion and behaviour. The methods and strategies used in therapy are designed to make use of the resources and capabilities that reside within all people, and do not require an individual to fit into a standardised pattern. Hypnotherapy may be valuable for anyone seeking to resolve specific problems, or for personal developments.

ORGANISATIONS
>British Autogenic Society
>Centre Training School of Hypnotherapy and Psychotherapy
>The National College of Hypnosis and Psychotherapy
>The National Register of Hypnotherapists and Psychotherapists
>National School of Hypnosis and Psychotherapy

7. PSYCHOANALYTIC AND PSYCHODYNAMIC SECTION

These therapies are based on psychoanalytic theory and practice. They may take place one-to-one or in a group. They may be of long or short duration. The central principle is that much distress has been caused by events in early life which we are no longer aware of. The therapy offers a reliable setting for the patient to explore free associations, memories, phantasies, feelings and dreams, to do with past and present. Particular attention is given to the interaction with the therapist, through which the patient may relive situations from their early life, the 'transference'. In these ways, the patient may achieve a new and better resolution of longstanding conflicts.

ORGANISATIONS
>Arbours Association
>Association for Group and Individual Psychotherapy
>British Association of Psychoanalytic and Psychodynamic Psychotherapy Supervisors
>The Association of Independent Psychotherapists
>Cambridge Society for Psychotherapy
>Centre for Attachment-Based Psychoanalytic Psychotherapy
>Centre for Freudian Analysis and Research
>Centre for Psychoanalytical Psychotherapy
>The Forum for Independent Psychotherapists
>The Guild of Psychotherapists
>The Guildford Centre for Psychotherapy
>The Hallam Institute of Psychotherapy
>Foundation for Psychotherapy and Counselling
>Institute of Group Analysis
>Institute of Psychotherapy and Social Studies
>Liverpool Psychotherapy Diploma Organisation (University of Liverpool)
>London Centre for Psychotherapy
>Nafisiyat
>Northern Association for Analytical Psychotherapy
>North West Institute of Dynamic Psychotherapy
>Philadelphia Association

>Severnside Institute for Psychotherapy
>The Site for Contemporary Psychoanalysis
>South Trent Training in Dynamic Psychotherapy
>Vaughan Association of Psychodynamic Psychotherapists
>West Midlands Institute of Psychotherapy
>Westminster Pastoral Foundation
>The Women's Therapy Centre
>Yorkshire Association for Psychodynamic Psychotherapy

8. PSYCHOANALYTICALLY-BASED THERAPY WITH CHILDREN SECTION

Therapists in this Section work with children who have problems beyond the resources of parent or school. Psychoanalytic theory is used to understand what the children have to say, consciously or unconsciously, in conversation, play, drawings and educational tasks. The aim is to restore the child to the stage of development appropriate to their age. This is done by observing the child within a reliable setting and interpreting their behaviour, including how they relate to the therapist and how they use materials supplied. As children depend on adults and the environment they provide, the work often includes contact with parents and families and treatment of them.

ORGANISATIONS
>Association of Child Psychotherapists
>Forum for the Advancement of Educational Therapy and Therapeutic Teaching

INSTITUTIONAL MEMBERS

A category of full membership of UKCP open to those psychotherapy organisations whose large size and complexity make it inappropriate for their membership to be confined to any individual Section. Institutional members have two seats on the Governing Board.

ORGANISATIONS
>Tavistock Clinic
>Universities Psychotherapy Association

SPECIAL MEMBERS

Two organisations of unique importance to the profession of psychotherapy and encompassing other related disciplines, have retained this special category of full membership. Each has a seat on the Governing Board. (This is not an open category of membership and cannot be applied for.)

ORGANISATIONS
>British Psychological Society
>Royal College of Psychiatrists

FRIENDS OF THE COUNCIL

A non-voting category for organisations closely associated with UKCP but not seeking full membership.

ORGANISATION
>British Association for Counselling

Organisation Codes

Code	Organisation
AAPP	Association of Accredited Psychospiritual Psychotherapists
AIP	Association of Independent Psychotherapists
ARBS	Arbours Association
ACAT	Association of Cognitive Analytic Therapists
ACP	Association of Child Psychotherapists
AFT	Association for Family Therapy and Systemic Practice in the UK
AGIP	Association for Group and Individual Psychotherapy
AHPP	Association of Humanistic Psychology Practitioners
AJA	Association of Jungian Analysts
ANLP	Association for Neuro-Linguistic Programming
BABCP	British Association for Behavioural and Cognitive Psychotherapy
BAC	British Association for Counselling
BAPPPS	British Association for Psychoanalytic and Psychodynamic Psychotherapy Supervision
BAS	British Autogenic Society
BASMT	British Association for Sexual and Marital Therapy
BCPC	Bath Centre for Psychotherapy and Counselling
BPA	British Psychodrama Association
BPS	British Psychological Society
BTC	The Gerda Boyesen Centre
CAP	The Confederation of Analytical Psychologists
CAPP	Centre for Attachment-Based Psychoanalytical Psychotherapy
CCBP	Chiron Centre for Body Psychotherapy
CCPE	Centre for Counselling & Psychotherapy Education
CFAR	Centre for Freudian Analysis and Research
CPCP	Centre for Personal Construct Psychology
CPP	Centre for Psychoanalytical Studies
CSP	Cambridge Society for Psychotherapy
CSPK	Centre for the Study of Psychotherapy (University of Kent)
CTP	Centre for Transpersonal Psychology
CTS	Centre Training School for Hypnotherapy and Psychotherapy
FAETT	Forum for Advancement of Educational Therapy & Therapeutic Teaching
FIC	The Family Institute, Cardiff
FIP	Forum for Independent Psychotherapists
FPC	Foundation for Psychotherapy and Counselling
GCL	The Gestalt Centre, London
GCSP	Guildford Centre and Society for Psychotherapy
GPTI	Gestalt Psychotherapy Training Institute
GUILD	Guild of Psychotherapists
HIP	Hallam Institute of Psychotherapy
IATE	Institute for Arts in Therapy and Education

Code	Organisation
IFT	Institute of Family Therapy
IGA	Institute of Group Analysis
IGAP	The Independent Group of Analytical Psychologists
IPC(WPF)	Institute of Psychotherapy and Counselling (WPF)
IPS	Institute of Psychosynthesis
IPSS	Institute of Psychotherapy and Social Studies
ITA	Institute of Transactional Analysis
KCC	Kensington Consultation Centre
KI	Karuna Institute
LAPP	London Association of Primal Psychotherapists
LCP	London Centre for Psychotherapy
LPDO	Liverpool Psychotherapy Diploma Organisation (University of Liverpool)
MC	Minster Centre
MET	The Metanoia Institute
NAAP	Northern Association for Analytical Psychotherapy
NAFSI	NAFSIYAT
NCHP	National College of Hypnotherapists and Psychotherapists
NGP	Northern Guild for Psychotherapy
NRHP	The National Register of Hypnotherapists and Psychotherapists
NSAP	North Staffs. Association for Psychotherapy
NSHAP	National School of Hypnosis and Psychotherapy
NWIDP	North West Institute for Dynamic Psychotherapy
PA	Philadelphia Association
PET	Psychosynthesis & Education Trust
RCSPC	Regent's College School of Psychotherapy and Counselling
RCPsych	Royal College of Psychiatrists
RE.V	Re.Vision
SEA	Society for Existential Analysis
SITE	The Site for Contemporary Psychoanalysis
SIP	Severenside Institute for Psychotherapy
SPEC	Spectrum
SPTI	The Sherwood Psychotherapy Training Institute
STTDP	South Trent Training in Dynamic Psychotherapy
TAVI	Tavistock Clinic
TMSI	Tavistock Marital Studies Institute
UPA	Universities Psychotherapy Association
VAPP	Vaughan Association of Psychodynamic Psychotherapists
WMIP	West Midlands Institute of Psychotherapy
WPF	Westminster Pastoral Foundation
WTC	The Women's Therapy Centre
YAPP	Yorkshire Association for Psychodynamic Psychotherapy

Geographical Listings

AVON

ARIS, Sarajane
Transpersonal Psychotherapist
10 Greendale Road, Redland
Bristol BS6 7LJ
01225 731632
CTP

ASH, Robert
Psychoanalytic Psychotherapist
Top Flat, 54 Cotham Road, Cotham
Bristol BS6 6DW
01275 341314/0117 942 7079
SIP

AYLARD, Paul
Psychodynamic Psychotherapist
Heath House Priory Hospital
Heath House Lane
Off Bell Hill
Bristol BS16 1EQ
0117 952 5255
YAPP

BARNES, Hugh
Family Therapist
Child & Adolescent Service
Bristol Royal Hosp. Sick Children
St. Michael's Hill, Bristol BS2 8BJ
0117 9285457/0117 9285413
AFT

BARRETT, Julie
Humanistic and Integrative
Psychotherapist
Lower Brook Cottage, Woollard
Pensford
Bristol BS39 4HU
01761 490 149
BCPC

BARROWS, Paul
Child Psychotherapist
Knowle Clinic Child & Adolescent
Service
Broadfield Road, Knowle
Bristol BS4 2UH
0117 9144330
ACP

BARWELL, Peter
Psychoanalytic Psychotherapist
51 Woodstock Road. Redland
Bristol BS6 7EW
0117 9247 580
GUILD

BAZELEY-WHITE, Diana
Family Therapist
Dept Child & Family Psychiatry
Buckingham Gardens, Downends
Bristol BS16 5TW
0117 9576025
AFT

BEBBER, Gillian
Psychoanalytic Psychotherapist
22 Church Street, Bathford
Bath BA1 7TU
01225 858490
SIP

BOOTH, Philip
Body Psychotherapist, Integrative
Psychotherapist
6 Clare Road, Cotham, Bristol BS6 5TB
0117 987 0142
CCBP

BOX, Sally
Psychoanalytic Psychotherapist
22 Clifton Wood Road
Clifton, Bristol BS8 4TW
0117 926 2902
SIP

BROWN, Ray
Psychoanalytic Psychotherapist
15 Nottingham Road
Bishopston, Bristol BS7 9DH
0117 942 6105
SIP

BROWN, Robin Gordon
Psychoanalytic Psychotherapist
14 Ambra Vale West
Clifton Wood, Bristol BS8 4RD
0117 926 2886
SIP

CAMPBELL, Janet
Transpersonal Psychotherapist
50 Banner Road, Montpelier
Bristol BS6 5LZ
0117 955 2395
CTP

CAMPS, Thomas
Psychoanalytic Psychotherapist
8 Duchess Road, Bristol BS8 2LA
020 7974 1388
WMIP

CARDER, Misha
Hypno-Psychotherapist
76 Lower Oldfield Park
Bath BA2 3HP
01225 313531
NSHAP

CATTON, Derek Anthony
Humanistic and Integrative
Psychotherapist
25 Oldfield Road, Bath BA2 3NF
01225 462 157
BCPC

CHALK, Caroline
Psychosynthesis Psychotherapist
White Hart Cottage
Freshford Lane, Freshford
Bath BA3 6DR
01225 722533
AAPP

CHALKLEY, A.J.
Cognitive Psychotherapist
Clinical Psychology Department
Bath Mental Healthcare Trust
Bath NHS House, Combe Park
Bath BA1 3QE
01225 731711/01225 731732
BABCP

CHESHIRE, Jane
Psychodynamic Psychotherapist
74 Wells Road
Bath BA2 3AR
01225 482283
WMIP

CLACEY, Robert
Psychoanalytic Psychotherapist
51 Devonshire Buildings
Bath BA2 4SU
01225 313742
SIP

CLYNE, Rachel
Psychosynthesis Psychotherapist
2 Mendip View, Highbury Street
Coleford
Somerset BA3 5NT
01373 813 349
AAPP

COLLENS, Louise
Psychoanalytic Psychotherapist
120 Chesterfield Road, St. Andrews
Bristol BS6 5DU
0117 924 7118
SIP

COLLIS, Whiz
Humanistic Psychotherapist
74 York Road, Montpelier
Bristol BS6 5QF
0117 955 9600
AHPP

COTTMAN, Barbara
Psychoanalytic Psychotherapist
Church Cottage, Corston
Bath BA2 GAY
01225 874237
SIP

CRISPIN, Jean
Humanistic and Integrative
Psychotherapist
22 Westerleigh Road, Pucklechurch
Bristol BS17 3RD
0117 9373191
BCPC

CUBIE, Paul
Systemic Psychotherapist
8 Wrenbert Road, Staple Hill
South Gloucester BS16 5JQ
0117 965 6025
AFT

CUTLER, Jane
Psychosynthesis Psychotherapist
66 Dunkerry Road, Windmill Hill
Bristol BS3 4LA
0117 9632 505
AAPP

DAVIES, Sheila
Psychoanalytic Psychotherapist
35 Bath Hill, Keynsham
Bristol BS18 1HJ
0117 986 1020
SIP

DEWEY, George
Humanistic and Integrative
Psychotherapist
21 Nutgrove Avenue
Victoria Park
Bristol BS3 4QE
0117 966 1100
BCPC

DOUGLAS, Dana
Psychosynthesis Psychotherapist
Wellspring, Faukland
Somerset BA3 5UX
01373 834 338
AAPP

DRESSER, Iain
Psychoanalytic Psychotherapist
3 The Paragon, Clifton
Bristol BS8 4LA
0117 973 3731
SIP

DUNCAN, Fraser
Hypno-Psychotherapist
1 Stanley Crescent, Filton
Bristol BS34 7NH
0117 377 7695
NSHAP

ELMAN, Anthony
Humanistic and Integrative
Psychotherapist
143 North Road
Bristol BS6 5AH
0117 9247668
BCPC

ESSEX, Susanne
Family Therapist
Dept Child & Family Psychiatry
Southmead Hospital
Monks Park Road
Bristol BS10 5NB
0117 959 5800/0117 953 5396
AFT

FEILDEN, Tish
Integrative Psychotherapist
Sheephouse Farm,
Warleigh, Bathford
Bath BA1 8EE
01225 858301
BCPC

FORTUNE, Rosalind
Cognitive Behavioural Psychotherapist
CABOT CMHT
12 Grove Road, Redland
Bristol BS6 6UJ
0117 940 5389/0117 973 5142
BABCP

GABRIEL, Jill
Humanistic and Integrative
Psychotherapist
Langridge House, Langridge
Bath BA1 9BX
01225 318834
SPEC

GARDNER, Fiona
Psychoanalytic Psychotherapist
Suite 3,4/5 Bridge Street
Bath BA2 4AP
01225 463054
SIP

GARDNER, Peter
Integrative Psychotherapist
Harpers Batch, Winford
Bristol BS40 8AF
01275 472598
RCSPC

GASKELL, Christine
Family Therapist
28 Claremont Avenue
Bristol BS7 8JE
0117 9240808
AFT

GELL, Eva
Psychoanalytic Psychotherapist
116 Redland Road
Bristol BS6 6QT
0117 909 5730
SIP

GILL, Douglas
Psychoanalytic Psychotherapist
75 Sefton Park Road, St Andrews
Bristol BS7 9AN
0117 942 6604/020 7916 5429
PA

GOSLING, Pat*
Psychoanalytic Psychotherapist
White Hart Cottage
38 High Street, Rode
Somerset BA3 6PA
01373 830901
GUILD

GRAHAM, Margaret
Humanistic and Integrative
Psychotherapist
18 The Tyning, Widcombe
Bath BA2 6AL
01225 425181
BCPC

GRANT, Nuala
Sexual and Relationship Psychotherapist
24 Shelley Road, Beechen Cliff
Bath BA2 4RJ
01225 312232
BASRT

GREEN, Sylvia
Psychoanalytic Psychotherapist
29 Calton Gardens
Bath BA2 4QG
01225 421746/01225 482326
SIP

GREENAN, Maria
Cognitive Behavioural Psychotherapist
The Old Smithy, Bath Road
Oakhill
Bath BA3 5AF
01749 841334
BABCP

GREGORY, Judith
Gestalt Psychotherapist
'Fernlea', Yate Road, Iron Acton
Bristol BS17 1XY
01454 228418/0117 985 9210
GPTI

GRESTY, Julia
Core Process Psychotherapist
71 Mendip Road, Bedminster
Bristol BS3 4BP
0117 9637 285
AAPP

GUEST, Nicola
Child Psychotherapist
The Bridge Foundation
12 Sydenham Road
Bristol BS6 5SH
0117 942510
ACP

HADWIN, Peter
Integrative Psychotherapist
27 Cloverdale Drive
Longwell Green
Bristol BS30 9XZ
0402 941189/017908 3557
MET

HAHN, Herbert
Psychoanalytic Psychotherapist
Suite 4, The Old Chapel
Fairview Drive
Bristol BS6 6PW
0117 942 5078
SIP

HAMBLIN, David
Humanistic and Integrative
Psychotherapist, Psychosynthesis
Psychotherapist
11 Kensington Gardens
Bath BA1 6LH
01225 317 272
AAPP

HANLEY, Marie
Psychoanalytic Psychotherapist
3 Exeter Buildings, Redland
Bristol BS6 6TH
0117 946 6910
SIP

HARRIS, Clare
Psychoanalytic Psychotherapist
24a Upper Cheltenham Place
Montpelier
Bristol BS6 5HR
0117 9555619
SIP

HART, Kate
Cognitive Behavioural Psychotherapist
149 Heron Gardens, Portishead
North Somerset BS20 7BN
0402 804932/01275 818419
BABCP

HARWOOD, Matthew
Analytical Psychologist-Jungian Analyst
1 Battlefields House, Lansdown
Bath BA1 9DD
0117 932 9204
IGAP

HASKAYNE, Amanda
Integrative Psychotherapist
10 Bluebell Road, Trinity Fields
Weston-Super-Mare
North Somerset BS22 9QJ
01934 513021
RCSPC

HASTINGS, Jon
Humanistic and Integrative
Psychotherapist
29 Cobourg Road, Montpelier
Bristol BS6 5HT
0117 935 0915
BCPC

HASTINGS, Kim
Humanistic and Integrative
Psychotherapist
42A Upper Cheltenham Place
Montpelier
Bristol BS6 5HR
0117 954 0649
BCPC

HAWDON, Sheila
Psychoanalytic Psychotherapist
Ashlands
Belmont Road, Combe Down
Bath BA2 5JR
01225 840420
SIP

HAWKINS, Peter
Humanistic and Integrative
Psychotherapist
285 Bloomfield Road
Bath BA2 2NU
01225 836191
BCPC

HAYWOOD, Carol
Transpersonal Psychotherapist
24 Royal York Crescent
Bristol BS8 4JX
0117 9743 717
CTP

HIGGINS, Judith
Gestalt Psychotherapist
5 Fairfield Road, Montpelier
Bristol BS6 5JN
0117 985 0391
GPTI

HORWOOD, Tone
Psychoanalytic Psychotherapist
41 St Luke's Crescent, Totterdown
Bristol BS3 4RZ
0117 972 1077
IPSS

HUGHES, Hatty
Attachment-based Psychoanalytic
Psychotherapist
11 Orchard Street
Bristol BS1 5EH
0117 954 1843
CAPP

HUTCHINSON, Gary
Integrative Psychosynthesis
Psychotherapist
33 Apsley Road
Bath BA1 3LP
01225 421735
RE.V

JAMES, Glenys
Psychoanalytic Psychotherapist
Flat 1, 20 The Belmont, Lansdown
Bath BA1 5DZ
01225 463324/01380 871818
SIP

JAMES, Pat
Psychoanalytic Psychotherapist
2 The Dymboro, Midsomer Norton
Bath BA3 2QU
01761 415538
WMIP

JEFFRIES, Rosie
Integrative Psychotherapist
129 Mina Road, St. Werburgh's
Bristol BS2 9YF
0117 9763818/0117 9551471
MET

JEZARD-CLARK, Pam
Cognitive Behavioural Psychotherapist
Petherton, 3 Petherton Road
Hengrove
Bristol BS14 2BP
01275 834048
BABCP

JOHNSON, Patricia Anne
Integrative Psychotherapist
9b Alpha Road, Southville
Bristol BS3 1DH
0117 9631610
MC

JONES, Rhiannon Marie
Cognitive Behavioural Psychotherapist
55 Waverley Road, Redland
Bristol BS6 6ET
0117 974 2002
BABCP

KEVLIN, Kunderke
Psychosynthesis Psychotherapist
12 Avon Vale, Stoke Bishop
Bristol BS9 1TB
0117 968 7748
AAPP

KUHN, Sue
Cognitive Analytic Therapist
13 Belgrave Crescent
Bath BA1 5JU
01225 465846
ACAT

LANDMAN, Angus
Psychosynthesis Psychotherapist
Hilltop, Little Solsbury
Northend
Bath BA1 7JQ
0976 719 597/01225 852 242
AAPP

LAPWORTH, Phil
Integrative Psychotherapist, Transactional
Analysis Psychotherapist
Lilac Cottage, 65 Murhill
Limpley Stoke
Bath BA3 6HQ
01225 722348
ITA

LEIGHTON, Tim
Cognitive Analytic Therapist
35 Belvedere
Bath BA1 5HR
01225 335818
ACAT

LIST, Renee
Gestalt Psychotherapist
74 Eastlyn Road, Bedminster Down
Bristol BS13 7HY
0117 953 5049
GPTI

MACKEWN, Jennifer
Integrative Psychotherapist
Southstoke House, Packhorse Lane
Southstoke
Bath BA2 7DJ
01225 836 090
MET

MANSI, Susan
Core Process Psychotherapist
16 Green Bank Road, Southville
Bristol BS3 1RH
0117 9660973
AAPP

MARKHAM, Angela
Family Therapist
3 The Paragon, Clifton
Bristol BS8
0117 923 9038/0117 923 9038
AFT

MARLOWE, Martin
Cognitive Analytic Therapist
Bath North CMHT
Bath NHS House, Newbridge Hill
Bath BA1 3QE
01225 731642
ACAT

MATTHEWS, Shane
Family Therapist
Psychology Department
Gloucester House
Southmead Hospital
Bristol BS18 5NB
0117 9595808
FIC

MCGOWAN, Fran
Humanistic and Integrative
Psychotherapist
1 Abermarle Terrace, Joy Hill
Hotwells
Bristol BS8 4NA
BCPC

MCKEOWN, Andy
Integrative Psychotherapist
Fairleigh House, Leigh Street
Leigh upon Mendip
Somerset BA3 5QQ
01373 812237/020 8202 1023
MET

MCLOUGHLIN, Brendan
Psychoanalytic Psychotherapist
The Open House Centre
Manvers Street
Bath BA1 1JW
01225 481297
FPC

MCNAMARA, Barbara
Psychoanalytic Psychotherapist
31 Sommerville Road, St. Andrews
Bristol BS7 9AD
0117 944 4206
SIP

MILLS, Christopher
Humanistic and Integrative
Psychotherapist
6B Hanover Street
Bath BA1 6PP
01225 445237
BCPC

MILTON, Thelma
Humanistic and Integrative
Psychotherapist
26 Salisbury Road, Redland
Bristol BS6 7AP
0117 9427 518
BCPC

MITCHESON BROWN, Muriel
Psychoanalytic Psychotherapist
16 Woodstock Road, Redland
Bristol BS6 7EJ
0117 924 1676
SIP

MUNRO, Carole
Hypno-Psychotherapist
S'Algar
7 Park Road, Congresbury
Bristol 5HJ
01934 628845/01934 834169
NRHP

NAYDLER, Nick
Humanistic and Integrative
Psychotherapist
4 Seddon Road, St. Werburghs
Bristol BS2 9YA
0117 9550752
BCPC

NORMAN, Harry
NLP Psychotherapist
29 Wesley Place, Clifton
Bristol BS8 4YD
0117 968 2417
ANLP

NYE, Georgiana
Psychosynthesis Psychotherapist
45 Canynge Road
Clifton
Bristol BS8 3LH
0117 973 3769
AAPP

PADGETT, Louise
Core Process Psychotherapist
6 Fenton Road, Bishopston
Bristol BS7 8ND
0117 9426 332
AAPP

PATTERSON, Linda
Psychoanalytic Psychotherapist
10 Brookleaze Buildings, Larkhall
Bath BA1 6RA
01225 463054/01225 311163
SIP

PIECZORA, Marek
Systemic Psychotherapist
11 Montague Flats
Eugene Street, St James
Bristol BS2 8EU
0117 926 6333
FIC

PIRANI, Alix
Individual and Group Humanistic
Psychotherapist
3 Avondale Court, Goodeve Road
Bristol BS9 1NU
0117 968 5141
BCPC

POPE, Sian
NLP Psychotherapist
2 Stubs Cottages
Bristol Road
Wraxall BS48 3HJ
01275 856537
ANLP

PREECE, Rob
Transpersonal Psychotherapist
56 Dunkery Road, Windmill Hill
Bristol BS3 4LA
01647 432363/0117 924 0832
CTP

PULLEN, Caroline J
Sexual and Relationship Psychotherapist
16 Heywood Road
Pill, Nr Somerset BS20 0ED
01275 374170
BASRT

PULLIN, Andrew
Group Analyst
Bath Practice for Group Analysis
1 Frome Road, Beckington
Near Bath BA3 6TD
01373 831 389
IGA

PURKISS, Jane
Humanistic and Integrative
Psychotherapist
93 Stackpool Road, Southville
Bristol BS3 1NX
0117 966 2957
BCPC

RICHARDS, Christopher
Psychoanalytic Psychotherapist
4 St. Ronan's Avenue, Redland
Bristol BS6 6EP
0117 909 3474 (t/f)
SIP

RICHARDSON, Gillian
Sexual and Relationship Psychotherapist
Maycroft Cottage
Highbury Villas, Kingsdown
Bristol BS2 8BY
0117 925 0115
BASRT

ROWE, Jill
Psychoanalytic Psychotherapist
8 Somerset Street, Kingsdown
Bristol BS2 8NB
0117 942 1016
SIP

RYALL, Sue
Integrative Psychosynthesis
Psychotherapist
13 Camden Terrace
Clifton
Bristol BS8 4PU
0117 925 0041
RE.V

RYDE, Judy
Humanistic and Integrative
Psychotherapist
285 Bloomfield Road
Bath BA2 2NU
01225 833657
BCPC

SAWERS, Martin
Humanistic and Integrative
Psychotherapist
24 Ambrose Road
Clifton Wood
Bristol BS8 4RJ
01735 673765/0117 909 8196
BCPC

SAYERS, Jacqui
Family Psychotherapist
36 Devonshire Buildings
Bath BA2 4SU
01225 825075
FIC

SCHREIBER-KOUNINE, Christa
Cognitive Behavioural Psychotherapist
2 Upper Camden Place
Bath BA1 5HX
0117 928 6551/4/07970 952599
BABCP

SELBY, Anne
Humanistic and Integrative
Psychotherapist
Prospect House
4 Prospect Place
Beechen Cliff
Bath BA2 4QP
01225 428826
BCPC

SHEARD, Tim
Cognitive Analytic Therapist
Heath House, Priory Hospital
Heath House Lane, off Bell Hill
Bristol BS16 1EQ
0117 952 5255
ACAT

SHEEHAN, Nuala
Family Psychotherapist
6 Thomas Street, Bath BA1 5NW
01225 334957
IFT

SIMMONS, Alison
Psychodrama Psychotherapist
Lower Hounsley Farm
Pool Lane, Ridgehill, Nr. Winford
Bristol BS40 8BP
01275 472264
BPA

SLATTERY, David
Humanistic and Integrative
Psychotherapist
37 Stafford Road, St. Werburghs
Bristol BS2 9UR
0117 985 9210/0145 383 2215
BCPC

SMITH, Donna
Family Therapist
The Old Rectory, Bradford Road
Rode, Nr. Bath BA3 6PR
01373 830710
AFT

SMITH, Gill
Integrative Psychotherapist
Centre for Whole Health
12 Victoria Place, Bristol BS3 3PB
01225 334624
MC

SMITH, Hilary Frances
Humanistic and Integrative
Psychotherapist
16 Sydenham Lane, Cotham
Bristol BS6 6SQ
BCPC

SPROSTON, Suzanne
Psychoanalytic Psychotherapist
7 Hampton Park, Redland
Bristol BS6 6LG
0117 909 4366
SIP

STALLARD, Paul
Cognitive Behavioural Psychotherapist
Dept. Child & Family Psychiatry
Royal United Hospital, Coombe Park
Bath BA1 3NG
01225 825075
BABCP

STEVENS, Yvonne J
Cognitive Analytic Therapist
The Carthouse, Crossways Farm
Heath House, Wedmore
Somerset BS28 4UG
01934 713693
ACAT

STONES, Christine
Psychoanalytic Psychotherapist
31 Barley Croft, Westbury-on-Trym
Bristol BS9 3TG
0117 9682397
SIP

STRATFORD, Jacqueline Anne
Family Therapist
8 Owen Grove, Henleaze
Bristol BS9 4EF
0117 962 8627
AFT

SUTTON-SMITH, Deirdre
Group Analyst, Psychoanalytic
Psychotherapist
12 Sydenham Road, Bristol BS6 5SH
0117 944 1005/01453 872 786
IGA

TRAVIS, Mary
Analytical Psychologist-Jungian Analyst
73 Alma Road, Clifton
Bristol BS8 2DW
0117 9730403
AJA

TUTE, Iris
Psychoanalytic Psychotherapist
46 Eastfield, Bristol BS9 4BE
0117 962 1460/0117 962 4631
SIP

VALENTINE, Christine
Humanistic and Integrative
Psychotherapist
42 Millmead Road, Oldfield Park
Bath BA2 3JP
01225 337372
BCPC

VINE, Francis
NLP Psychotherapist
11 Argyle Place, Cliftonwood
Bristol BS8 4RH
0117 927 3205
ANLP

WALKER, George
Family Therapist
Gloucester House
Southmead Hospital
Westbury on Trym
Bristol BS10 5NB
0117 9595807
AFT

WARNER, Kerri
Transactional Analysis Psychotherapist
4 Laburnum Road, Hanham
Bristol BS15 3DU
0117 9090784
ITA

WEBB, Deborah
Biodynamic Psychotherapist
17 Rockcliffe Road
Bath BA2 6QN
01225 461361
BTC

WELLS, Martin
Transactional Analysis Psychotherapist
11 Clare Road, Cotham
Bristol BS6 5TB
0117 9656061
ext 4641/0117 9247457
ITA

WHEWAY, John Kirti
Humanistic and Integrative
Psychotherapist
5 Fairfield Road, Montpelier
Bristol BS6 5JN
0117 985 0391
BCPC

WHITE, Jan
Family Therapist
University of Bristol
School for Policy Studies
8 Woodland Road
Bristol BS8 1EZ
0117 9546724/0117 9546737
AFT

WHITFIELD, Erica
Core Process Psychotherapist
Old Mill Cottage, 42 Northend
Bath BA1 7ES
01225 858 791/01225 477 000
AAPP

WILLIAMS, Chris
Analytical Psychologist-Jungian Analyst
8 Stuart Place
Bath BA2 3RQ
01225 463054/01225 427705
AJA

WILLS, Frank
Cognitive Psychotherapist
7 St. Matthews Road, Cotham
Bristol BS6 5TS
0117 924 3574
BABCP

WILSON, Alexandra
Psychoanalytic Psychotherapist
Flat 7, Abbey House, Abbey Green
Bath BA1 1NR
01225 464874/01225 336591
SIP

WITT, John
Humanistic and Integrative
Psychotherapist
2 Fircliff Park, Portishead
Bristol BS20 7HQ
01275 818580/020 8347 8735
SPEC

YARIV, Gail
Psychoanalytic Psychotherapist
121 York Road, Montpelier
Bristol BS6 5QG
0117 955 1827
FPC

BEDFORDSHIRE

BEIJNE, Sabina
Cognitive Behavioural Psychotherapist
Harrold Medical Practice
Peach's Close, Harrold
Bedford MK43 7DX
01234 720225/020 8682 6249
BABCP

BROWN, Mavis
Systemic Psychotherapist
Child & Family Consultation Clinic
Union Street Child Health Clinic
Union Street
Bedford MK40 2SH
KCC

CLACKSON, Suzanne
Psychoanalytic Psychotherapist
21 Bradgate Road, Bedford MK40 3DE
01234 356996
GUILD

CLARE, Louise
Psychoanalytic Psychotherapist
11 Warden Abbey
Bedford MK41 0SW
01234 267405
GUILD

CODD, Anne Marie
Psychoanalytic Psychotherapist
The Old School House, High Street
Lidlington MK43 0RN
01525 406300
AGIP

COX, Keith Fredrick
Family Therapist
5 Britannia Avenue, Limbury
Luton LU3 1XD
01582 652290
AFT

DUTTON, Andrew
Psychoanalytic Psychotherapist
Flat 4, Priory Terrace
Roise Street
Bedford MK40 1JE
01234 267903
GUILD

FRANKE, Christine
Psychoanalytic Psychotherapist
14 Old Station Court, Blunham
Bedford MK44 3PN
01234 346077/01767 640863
AGIP

GILKES, Pauline
Hypno-Psychotherapist
1 Mill Cottage, 101 Mill Road
Sharnbrook, Bedford MK44 1NP
01234 781533
NRHP

HANNAH, Chris
Systemic Psychotherapist
39 Summer Street, Slip End
Luton LU1 4BL
01582 422578
KCC

HANNAH, Clare
Systemic Psychotherapist
39 Summer Street, Slip End
Luton LU1 4BL
01582 422578
KCC

HEATH, Christine
Child Psychotherapist
95 High Street, Langford
Beds SG18 9RY
01582 708140/01462 700 021
ACP

HICKMAN, Sue
Systemic Psychotherapist
11 Colchester Way
Bedford MK41 8BG
KCC

JAMESON, Anne
Transpersonal Psychotherapist
Dunstable, Bedfordshire
01525 229172
CCPE

KATZ, Janice
Psychoanalytic Psychotherapist
29 King Street, Luton LU1
01582 492206/01582 482220
FIP

KING, Madeleine
Systemic Psychotherapist
41 Leighton Road, Toddington
Dunstable LU5 6AL
01525 872298
KCC

KRAUSE, Inga-Britt
Family Therapist
4 The Coach House
Bromham Hall, Bromham
Bedford MK43 8HH
020 7624 8605/01234 823880
AFT

MCALLISTER, Christopher
Cognitive Behavioural Psychotherapist
255 New Bedford Road
Luton LU3 1LW
01582 876800
BABCP

MCGUINNESS, Maureen
Psychosynthesis Psychotherapist
38 Woodgreen Road, Luton LU2 8BU
01582 455681
AAPP

MCKAY, Barbara
Systemic Psychotherapist
Quince Cottage
54 Wood End Road, Wood End
Kempston MK43 9BD
KCC

MOORE, Rosemary*
Psychoanalytic Psychotherapist
147 Dudley Street, Bedford MK40 3SY
01234 344736
GUILD

MORRIS, Peter A.
Cognitive Behavioural Psychotherapist
Beacon House, 5 Regent Street
Dunstable LU6 1LR
01582 478850
BABCP

PARAMOUR, Annabelle
Psychoanalytic Psychotherapist
68 The Grove, Bedford MK40 3JN
01234 345553
CSP

PEART, Mary
Psychosynthesis Psychotherapist
3 School House Mews
High Street
Silsoe MK45 4DY
01525 862139
AAPP

ROGERS, Anne
Psychoanalytic Psychotherapist
32a Church End, Renhold MK41 0LU
01234 771595
AGIP

SWEET, Patricia
Systemic Psychotherapist
16 Arbroath Road, Sundon Park
Luton LU3 3LA
01582 708370
KCC

TRODDEN, Ian
Cognitive Behavioural Psychotherapist
Clin Psychol & Psychotherapy Srvcs
10(A) Goldington Road
Bedford Hospital, North Wing
Bedford MK40 3NF
0234/0234
BABCP

TRUSTAM, Gillian
Psychoanalytic Psychotherapist
86 High Street, Oakley
Beds MK43 7RH
01234 822985
AGIP

WARBURTON, Kitty
Integrative Psychotherapist
18 The Warren, Clapham MK41 6DW
01234 271938/01234 793362
RCSPC

BERKSHIRE

DAMS, Janet
Attachment-based Psychoanalytic
Psychotherapist
24 Stone Street, Reading RG30 1HU
01189 676500
CAPP

AUFFLICK, Julia
Systemic Psychotherapist
26 Grove Close, Old Windsor
Berkshire SL4 2LY
KCC

BURCH, Jean Gillanders
Sexual and Relationship Psychotherapist
The Peppers, Mustard Lane
Sonning RG4 6GH
BASRT

BURNET-SMITH, Tamara
Autogenic Psychotherapist, Humanistic
Psychotherapist
71 Westfield Road, Caversham
Reading RG4 8HL
01189 479957
BAS

CLAPHAM, Miles
Psychoanalytic Psychotherapist
Huntercombe Manor Hospital
Huntercombe Lane, South Taplow
Maidenhead SL6 0PQ
PA

COLLINS, Jane
Sexual and Relationship Psychotherapist
Magnolia House Surgery
Sunningdale, Ascot SL5 0QJ
01344 637800
BASRT

COOPER, Janette
Family Therapist
5 Buckhurst Way, Earley
Reading RG6 7RL
0118 962 6095/0118 966 1543
AFT

COXWELL-WHITE, Jenny
Integrative Psychotherapist
113 New Road, North Ascot SL5 8PZ
01344 884142
CCBP

CUFF, Jenny
Autogenic Psychotherapist
153 Northcourt Avenue
Reading RG2 7HG
0118 986 6987
BAS

DONALD, Philippa
Transpersonal Psychotherapist
23 Bulmershe Road
Reading RG1 5RH
0118 961 3996
CCPE

EATON, John
Hypno-Psychotherapist, NLP
Psychotherapist
Waterloo House, 158 London Road
Newbury RG14 2AX
0403 571363/01635 44444
NSHAP

ENGLAND, David
Psychosynthesis Psychotherapist
48 Trenchard Road, Holyport
Maidenhead SL6 2LR
01628 639313
AAPP

FAGAN, Anthony F.
Transpersonal Psychotherapist
7 Bath Road, Thatcham, Newbury
Berks. RG18 4AG
01635 864416
CCPE

HAIGH, Rex
Group Analyst
Winterbourne Therapeutic Community
53-55 Argylle Road, Reading RG7 3UE
0118 956 1250
IGA

HARRIS, Sue
Integrative Arts Psychotherapist
30 St Leonards Road
Windsor SL4 3BU
01753 858 239
IATE

HENLEY, Mavis G
Group Analytic Psychotherapist
15 Primrose Lane, Winnersh
Wokingham RG41 5UR
0118 9894222
UPA

HUGHES, Patrick
Group Analyst
12 Instow Road, Earley
Reading RG6 2QJ
0118 987 3049
IGA

JOHNSON-SMITH, Camilla
Group Analytic Psychotherapist
Rainbow's End
Cock Lane
Southend Bradfield
Nr. Reading RG7 6HN
0973 110029/0118 974 4650
LCP

KANAKAM, Jonathan
Hypno-Psychotherapist
50 Farnham Road
Slough SL1 3TA
01753 552976
NSHAP

KLEIN, Wendy
Systemic Psychotherapist
12 St. James Close, Pangbourne
Reading RG8 7AP
01734 842856
AFT

KNOWLES, Jane
Group Analyst
7 Albert Road, Caversham
Reading RG4 7AN
01734 561250/01734 478872
IGA

KOWALSKI, Reinhard
Core Process Psychotherapist
11 Bramley Close
Maidenhead SL6 3HQ
01628 681 719
AAPP

MALONEY, Chris
Psychoanalytic Psychotherapist
Dept of Mental Health
Heatherwood Hospital
Ascot SL5 8AA
01344 877472
UPA

MCGREGOR, Tony
Hypno-Psychotherapist
127 Kingsley Close, Shaw
Newbury RG14 2EB
01635 34231
NRHP

MELTON, Jane
Cognitive Analytic Therapist
46 Clifton Road
Wokingham RG41 1NB
0118 977 1409
ACAT

MONCUR, Pamela
Sexual and Relationship Psychotherapist
Boulters Lodge, Boulters Lane
Maidenhead SL6 8TJ
01628 634892
BASRT

MURRAY, Jane
Integrative Psychotherapist
5 Chieveley Mews, London Road
Sunningdale SL5 0UD
01344 626366
MET

O'BRIEN, Kirsty M G
Cognitive Psychotherapist
Penrhyn, Ball Hill
Newbury RG20 0NY
01635 253539
BABCP

PARR, John
Transactional Analysis Psychotherapist
Norcot House, 131 Norcot Road
Tilehurst,
Reading RG30 6BS
01189 454477/01189 453388
ITA

PECKITT, R.G.
Cognitive Behavioural Psychotherapist
Broodmore Special Hospital
Crowthorne
Berkshire RG4 7EG
01344 773 111
BABCP

POOL, Nicky
Transpersonal Psychotherapist
Purton House, Purton Lane
Farnham Royal
Bucks. SL2 3LY
01753 646625
CTP

RICHARDS, Janet
Psychoanalytic Psychotherapist
35 Bulmershe Road
Reading RG1 5RH
0118 9269545
GUILD

SCOVELL, Janet
Integrative Psychotherapist
25 The Grove
Reading RG1 4RB
0118 956 1976
MC

SELBY, Gina
Personal Construct Psychotherapist
Ships Cottage
Ashford Hill
Newbury RG19 8BD
01189 810033/01189 811793/817247
CPCP

SHORT, Patricia
Systemic Psychotherapist
Broadmoor Hospital
Psychology Department
Crowthorne
Berkshire RG45 7EG
KCC

VINCENT, Christopher
Psychoanalytic Psychotherapist,
Psychoanalytic Marital Psychotherapist
Wellington Cottage, 18 Victoria Street
Slough SL1 1PR
020 7435 7111/01753 774558
TMSI

VON BÜHLER, José
Sexual and Relationship Psychotherapist
The Cardinal Clinic
Bishop's Lodge, Oakley Green
Windsor SL4 5UL
0973 442146
BASRT

WAGSTAFF, Susan
Family Therapist
Berkshire Adolescent Unit
71 Barkham Road
Wokingham Hospital
Wokingham RG41 2RE
0118 949 5019/0118 949 5026
AFT

WARD, Hilary
Transpersonal Psychotherapist
Blair Villa, Wokefield Row
Mortimer RG7 3AL
CCPE

WHITE, Ruth
Transpersonal Psychotherapist
Dragon Den
3 Manor Farm Mews
Manor Farm Lane, Tidmarsh
Nr. Reading, RG8 8EY
0118 984 5480
CTP

WILLIS, Lynne
Family Therapist
Huntercombe Manor Hospital
Huntercombe Lane South
Taplow
Maidenhead SL6 0PQ
01628 667881/01628 666989
AFT

WRIGHT, Shelagh
Family Therapist
The Last Drop, Sheephouse Road
Maidenhead SL6 8HJ
01628 628069
AFT

BUCKINGHAMSHIRE

ADAMS, Ghislaine
Hypno-Psychotherapist
41 London Road, Stony Stratford
Milton Keynes MK11 1JQ
01908 566362
NSHAP

ALDER, Helena
Integrative Psychotherapist
Woodside Corner, 11 Baring Crescent
Beaconsfield HP9 2NG
01494 673557
MC

ALDER, Roger
Integrative Psychotherapist
Woodside Corner
11 Baring Crescent
Beaconsfield HP9 2NG
01494 673557
MC

ANTAO, Ivor
Group Analyst
45 Grenville Green
Aylesbury HP21 8HB
01296 393363/01296 27197
IGA

AXSON, Barbara Astrid
Educational Therapist
"Westways" Milton Avenue
Gerrards Cross SL9 8QW
01753 886928 (t/f)
FAETT

BAILEY, Lorna M.
Group Analyst, Psychodynamic
Psychotherapist
17 Faraday Drive
Milton Keynes MK5 7DD
01908 669741
UPA

BOLLINGHAUS, Elaine
Psychoanalytic Marital Psychotherapist
'Loudhams', Burtons Lane
Little Chalfont HP8 4BS
01494 765947
TMSI

BROWNE, Val
Psychoanalytic Psychotherapist
19 Hampden Hill
Beaconsfield HP9 1BP
01494 678023
FPC

BURNS, Elizabeth
Family Therapist
11 Green End Street, Astow Clinton
Aylesbury HP22 5JE
01296 630048
IFT

BUTCHER, Barbara
Hypno-Psychotherapist
35 Lowfield Way
Hazlemere HP15 7RR
01494 814306
NSHAP

DALE, Anne M.
Hypno-Psychotherapist
Little Grove, Grove Lane
Chesham HP5 3QQ
01494 776066/01494 778610
NSHAP

DE GROOT, Marianne
Sexual and Relationship Psychotherapist
Antlers
52 Longfield Drive
Amersham HP6 5HE
01494 727321
BASRT

FOX, Delia-Ann
Integrative Psychotherapist
24 Barley Way, Marlow SL7 2UG
01628 487 433
RCSPC

GOLDING, Pauline
Hypno-Psychotherapist
Kingsgate Therapy Centre
32 The Rowans
Gerrards Cross SL9 8SE
07957 706652/01753 883062
NRHP

GORDON, John Fredrick
Psychoanalytic Psychotherapist
Medical Officer & Psychotherapist
HM Prison Grendon
Grendon Underwood
Aylesbury HP18 0TL
PA

GRINONNEAU, Peter
Hypno-Psychotherapist
271 Whalley Drive, Bletchley
Milton Keynes MK3 6PL
01908 375694
NRHP

HARDMAN, Jacquie
Psychoanalytic Psychotherapist
Oak House, Botley Road
Chesham HP5 1XG
01494 783 402
FPC

HARRISON, Susan
Sexual and Relationship Psychotherapist
Briar Patch, Little London Green
Oakley
Aylesbury HP18 9QL
01844 238313
BASRT

HELEY, Mary
Integrative Psychotherapist
The Old Lamb, Potter Row
South Heath,
Great Missenden HP16 9LT
01494 862860
MET

HENDERSON, Mary
Integrative Psychotherapist
5 Lawrence Grove
Prestwood
Great Missenden HP16 0SN
01494 865252
RCSPC

HILL, Finella
Systemic Psychotherapist
10 Bowerdean Road
High Wycombe HP13 6AX
01494 471739
IFT

JACKSON, Jo
Systemic Psychotherapist
Acorn Cottage, Bigmore Lane
Cadmore End HP14 3UR
01494 882692
KCC

JOHNSTON, Candace
Sexual and Relationship Psychotherapist
Newport Pagnell Medical Centre
Queens Avenue,
Newport Pagnell MK46 8QT
01908 611767
BASRT

JORDAN, Elizabeth
Humanistic Psychotherapist
67 Garratts Way
High Wycombe HP13 5YT
01494 451 643
AHPP

KEMPS, Charmaine
Family Therapist
Dept of Child & Adolescent Psy.
Eaglestone Health Centre
Milton Keynes MK6 5AZ
01908 607501
AFT

LEON, Barbara D.
Psychoanalytic Psychotherapist
10 Darlington Close
Amersham-on-the-Hill HP6 5AD
01494 729903
FPC

LEVITSKY, Patricia D.
Integrative Psychotherapist
Sportsman's Cottage
Beacon Hill, Penn HP10 8NJ
01494 812219
GPTI

LORENZ, Bernice
Autogenic Psychotherapist
The Spinney, Hagpielane
Coleshill, Amersham HP7 0LS
01494 722 618/01494 723 642
BAS

MARATOS, Jason
Group Analyst
Briarwood Cottage
4 Mitchell Walk
Amersham HP6 6NN
01494 728203
IGA

MASON, Letizia
Transpersonal Psychotherapist
96 New Road, Marlow SL7 3NW
CCPE

MCGRATH, Patrick
Group Analyst
71 Eaton Avenue, Bletchley
Milton Keynes MK2 2HN
01908 372 868
IGA

MCNAB, Sue
Family Therapist
Dell House, Wash Hill
Wooburn Green HP10 0JA
01628 526275
AFT

MEAD, Jannie
Cognitive Analytic Therapist
Campbell Centre
Milton Keynes CMHT
Milton Keynes MK6 5NG
01908 243134
ACAT

NEWSON, Mary
Psychosynthesis Psychotherapist
The Dower Cottage
5 Little Shardeloes
Amersham HP7 0EF
01494 727 141
AAPP

PALMER, Lisa Elaine
Cognitive Behavioural Psychotherapist
Psychotherapy Dept
Tindal Centre, Bierton Road
Aylesbury HP20 1HU
01296 393363 ext 364
BABCP

PANCHKOWRY, Marion
Group Analyst
Bramble Cottage
Dunton.
Nr. Buckingham MK18 3LW
07771 632325/01296 504365
IGA

PARKER, Michael
Group Analyst
Wing Therapist, HMP Grendon
Grendon Underwood
Aylesbury HP18 0TL
IGA

PHILPS, Janet
Child Psychotherapist
Department of Child & Adolescent
Psychiatry
Eaglestone Health Centre
Standing Way, Eaglestone
Milton Keynes MK6 5NG
01908 607501/01234 881365
ACP

POLLARD, Cynthia
Cognitive Analytic Therapist
Mill End, Mill Lane
Gerrards Cross SL9 8AZ
01753 885164
ACAT

RAND, Judith Ann
Psychosynthesis Psychotherapist
310 Berkhamsted Road
Chesham HP5 3EZ
0370 233 258
AAPP

REAY, Ruth
Family Therapist
Greensleeves, Thorns Lane
Whiteleaf HP27 0LT
01844 275052
AFT

REDDY, Michael
Transactional Analysis Psychotherapist
90 Church Road
Woburn Sands MK17 8TR
01908 584944
ITA

REIDY, Rachel
Cognitive Analytic Therapist
Woodbine Cottage
81 Totteridge Lane
High Wycombe HP13 7QA
01494 526006/01494 527597
ACAT

ROBERTS, Alison
Systemic Psychotherapist
Dormers, Buckland Village
Nr Aylesbury HP22 5HY
01296 630256
KCC

ROSSETER, Bill
Psychoanalytic Psychotherapist
14 Lower Way
Great Brickhill
Milton Keynes MK17 9AG
01525 261493
FPC

ROY, Jane
Sexual and Relationship Psychotherapist
10 Faraday Drive
Shenley Lodge
Milton Keynes MK5 7DA
0411 917002/01908 674118
BASRT

STEINER, Monika Celebi
Psychoanalytic Psychotherapist
13 Lansdown Road
Chalfont St. Peter SL9 9SP
01753 882112
IPSS

YATES, Helen
Integrative Psychotherapist
The Rectory
Water Stratford Road, Finmere
Buckingham MK18
01280 848 112/01280 847184
MET

WORTH, Piers
NLP Psychotherapist
4 Hollow Rise
High Wycombe HP13 5NU
01494 464297
ANLP

YOUNG, Diana
Transpersonal Psychotherapist
Damien House, 23 High Street
Great Missenden HP16 9AA
01494 866 440
CCPE

CAMBRIDGESHIRE

ALISTER, Ian
Analytical Psychologist-Jungian Analyst
56 Hertford Street
Cambridge CB4 3AQ
01223 575146
CAP

ARRIENS, Pamela
Psychoanalytic Psychotherapist
3 Middlemoor Road, Whittlesford
Cambridge CB2 4PB
01223 832877
CSP

ATKINSON, Pamela
Integrative Psychotherapist
63 Stanley Road
Cambridge CB5 8LF
01223 321245
SPTI

BACON, Roger*
Psychoanalytic Psychotherapist
Cambridge Psychotherapy Practice
26 Newnham Road
Cambridge CB3 9EY
01223 369894/01223 560262
GUILD

BELL, Lydia J.
Cognitive Behavioural Psychotherapist
The Pheonix Centre
Adolescent Eating Disorder
Ida Darwin, Fulbourn
Cambridge CB1 5EE
01223 884314
BABCP

BERMINGHAM, Donald
Cognitive Analytic Therapist
South Building, Primrose Lane
Huntingdon PE18
ACAT

BLYTH, Doug
Integrative Psychotherapist
2 High Street
Waterbeach CB5 9HN
01223 568808/01223 441179
RCSPC

BRIANT, Michael
Psychoanalytic Psychotherapist
Kingfisher Cottage
1 Church Rate Walk
Cambridge CB3 9HJ
01223 332865/01223 464611
GUILD

BRIANT, Steve
Psychoanalytic Psychotherapist
57 Victoria Road
Cambridge CB4 3BW
01223 327165
CSP

BROSAN, Lee
Cognitive Psychotherapist
Dept of Cognitive Behavioural Therapy
Box 190
Addenbrooke's Hospital
Cambridge CB2 2QQ
01223 217960
BABCP

BROWN, Ulla
Psychoanalytic Psychotherapist
9 Stretton Avenue
Cambridge CB4 3ES
01223 327117
CSP

BUCKLEY, Jane
Analytical Psychologist-Jungian Analyst
92 Granchester Meadows
Cambridge CB3 9JN
01223 352182
CAP

BYFORD, Sally
Biodynamic Psychotherapist
The Little Orchard
Long Lane, Linton CB1 6NS
01223 321436
BTC

CAMERON, Angela
Integrative Psychotherapist
18 Clare Street, Cambridge CB4 3BY
01223 361043
RCSPC

CAMPBELL NYE, Aileen
Analytical Psychologist-Jungian Analyst
6 Granham's Road, Great Shelford
Cambridge CB2 5LQ
01223 844218
IGAP

CARR, Samantha
Systemic Psychotherapist
27 Meadow Way
Great Paxton, St Neots
Cambridgeshire PE19 4RR
01480 474552 (t/f)
KCC

CHURCHILL-MOSS, Duncan
Cognitive Behavioural Psychotherapist
18 Hinton Road, Fulbourne
Cambridge CB1 5DZ
01223 723020/01223 514861
BABCP

COCKETT, Ann
Psychoanalytic Psychotherapist
"Watermeadows"
Kings Mill Lane, Great Shelford
Cambridge CB2 5EJ
01223 843265
CSP

CONROY, Jennifer J.
Cognitive Behavioural Psychotherapist
22 Green End, Fen Ditton
Cambridge CB5 8SX
01223 292124/01223 217939
BABCP

CORRIGALL, Jenny
Psychoanalytic Psychotherapist
10 Willow Walk
Cambridge CB1 1LA
01223 361703
CSP

DASGUPTA, Carol
Psychoanalytic Psychotherapist
1 Dean Drive, Holbrook Road
Cambridge CB1 4SW
01223 212179
CSP

DAUDY, Isabelle
Psychoanalytic Psychotherapist
Long Thatch
74 High Street, Great Abington
Cambridge CB1 6AE
01223 890866
IPSS

DAVIES, Alison
Psychoanalytic Psychotherapist
27 Priory Road
Cambridge CB5 8HT
01223 357221/01223 510171
SITE

DAVIES, Judy
Psychoanalytic Psychotherapist
87 Alpha Road
Cambridge CB3 9JZ
01223 515526
CSP

DELL, Jacqueline
Humanistic Psychotherapist
White Lodge, 1 Comberton Road
Harlton
Cambs. CB3 7EU
01223 262281
AHPP

DENMAN, Chess
Cognitive Analytic Therapist
Department of Psychotherapy
Box 190
Addenbrookes Hospital
Cambridge CB3
01223 217958
ACAT

DIGGLE, Sedwell
Analytical Psychologist-Jungian Analyst
92 Canterbury Street
Cambridge CB4 3QE
01223 351310
CAP

DOKTOR, Ditty
Group Analytic Psychotherapist
2 Whitwell Farm Cottage
Coton CB3 7PW
01954 210 132
FPC

DYSON, Margaret
Integrative Psychotherapist
4 Kimberley Road
Cambridge CB4 1HH
01223 367311
MC

FARRELL, Margaret*
Psychoanalytic Psychotherapist
The Old Stores, 5 High Street
Grantchester
Cambridge CB3 9NF
01223 369894
GUILD

FITZGERALD-KLEIN, Marianne
Transpersonal Psychotherapist
17 Cambridge Road, Madingley
Cambridge CB3 8AH
01954 211 350(t/f)
CCPE

FLANAGAN, Diana
Psychodynamic Psychotherapist
16 Crawthorne Road
Peterborough PE1 4AB
VAPP

FLETCHER, Karyn
Transpersonal Psychotherapist
18 Coulson Way, Alconbury
Cambridgeshire PE17 5WU
01480 896290
CTP

FRESHWATER, Dawn
Integrative Psychosynthesis
Psychotherapist
4 Websters Close, Glinton
Peterborough PE6 7LQ
01733 253 761
RE.V

GAGNERE, Maryline
Biodynamic Psychotherapist
6 Chalky Road
Great Abington CB1 6HT
01223 893675
BTC

GARDINER, Vicki
Analytical Psychologist-Jungian Analyst
35 Walcot Walk, Netherton
Peterborough PE3 9QF
01733 266213
CAP

GENTRY, Valerie
Psychoanalytic Psychotherapist
30 Hinton Avenue,
Cambridge CB1 4AS
01223 212821
CSP

GOODRICK, Jean
Psychoanalytic Psychotherapist
Choice
7c Station Road
Cambridge CB4 4NO
01223 573073
CSP

GORDON, Leila
Psychoanalytic Psychotherapist
37 Herbert Street
Cambridge CB4 1AQ
01223 367912
CSP

GREAVES, Sarah*
Psychoanalytic Psychotherapist
33 Eltisley Avenue, Newnham
Cambridge CB3 9JQ
01223 354526
GUILD

GREENLAND, Sue
Group Analyst
Myrtleberry Cottage
27a Pierce Lane, Fulbourn
Cambridge CB1 5DJ
01223 880287
IGA

GUEST, Hazel
Humanistic Psychotherapist,
Transpersonal Psychotherapist
44 Beaufort Place, Thompson's Lane
Cambridge CB5 8AG
01223 369148
CTP

GUILD, Liz
Psychoanalytic Psychotherapist
198 Sturton Street
Cambridge CB1 2QF
01223 339166/01223 311042
SITE

HALL, David
Psychoanalytic Psychotherapist
47 Cavendish Avenue
Cambridge CB1 4UR
01223 249 732
GUILD

HARDY, Liz
Psychoanalytic Psychotherapist
90 Tenison Road
Cambridge CB1 2DW
01223 367850
PA

HARGRAVES, Annie
Psychoanalytic Psychotherapist
192, Perevel Road
Cambridge CB5 8RL
020 7902900/01223 413343
CSP

HARRISON, Gillian
Family Therapist, Systemic
Psychotherapist
21 Millington Road
Cambridge CB3 9HW
01223 357778/01480 415300
IFT

HARTLEY, Althea
Systemic Psychotherapist
Family Consultation Service
Cedars Family Unit
16 Aldermans Drive
Peterborough PE3 6AR
KCC

HARVEY, Paul
Personal Construct Psychotherapist
21 Gurney Way, Cambridge CB4 2ED
01223 301 387/07071 880870
CPCP

HAYNES, Eric
Hypno-Psychotherapist
33A Bridewell Road
Cherry Hinton
Cambridge CB1 4EN
01223 214281
NSHAP

HIESTAND, Rene
Cognitive Behavioural Psychotherapist
36 High Street, March
Cambridge PE15 9JR
01354 661903
BABCP

HOLLAND, Louise
Child Psychotherapist
21 Richmond Road
Cambridge CB4 3PP
01223 353029
ACP

HUTCHISON, Eric
Analytical Psychologist-Jungian Analyst
77 Long Road, Cambridge CB2 2HE
01223 840381
CAP

JONES, Dan
Group Analyst
59 Cavendish Avenue
Cambridge CB1 4UR
01223 246 257
IGA

KILGOUR, Mimi
NLP Psychotherapist
332 Eastfield Road
Peterborough PE1 4RA
01733 312900
ANLP

KING, Lucy
Psychoanalytic Psychotherapist
7 Water Street, Chesterton
Cambridge CB4 1NZ
01223 367742
PA

KLUG, Liebe
Psychoanalytic Psychotherapist
70 Cavendish Avenue
Cambridge CB1 4UT
01223 248959
CSP

LEGGATT, Jenny
Analytical Psychotherapist
158 Gwydir Street
Cambridge CB1 2LW
01223 369977
AGIP

LEW, Clara
Psychoanalytic Psychotherapist
20 Owlstone Road
Cambridge CB3 9JH
CSP

LEWINGTON, Paul
Systemic Psychotherapist
Brookside Family Consultation Clinic
Douglas House
18d Trumpington Road
Cambridge CB2 2AH
01223 746001
IFT

LINTOTT, Bill
Group Analyst
7 Haverhill Road
Stapleford
Cambridge CB2 5BX
01223 369894/01223 842008
IGA

MARTIN, Angela
Sexual and Relationship Psychotherapist
Woodfield
53 Church Street, Warmington
Peterborough PE8 6TE
BASRT

MCDOUALL, Veronica
Psychoanalytic Psychotherapist
71 Bridge Street
Cambridge CB2 1UR
01223 313515/01223 576648
FPC

MILLER, Michael*
Psychoanalytic Psychotherapist
Cambridge Psychotherapy Practice
26 Newnham Road, Newnham
Cambridge CB3 9EX
01223 369894/01223 845030
GUILD

MINAAR, Doris
Psychoanalytic Psychotherapist
4 Millington Road
Cambridge CB3 9HP
01223 357895
CSP

MORGAN, Sian*
Psychoanalytic Psychotherapist
The Cambridge Psychotherapy Practice
26 Newnham Road
Cambridge CB3 9EY
01223 369894/01638 741390
GUILD

MURDIN, Lesley
Psychoanalytic Psychotherapist
32 Belvoir Road
Cambridge CB4 1JJ
01223 312848/07970 08975
FPC

MURPHY, Derry
Personal Construct Psychotherapist
18 Mallets Road, Cherry Hinton
Cambridge CB1 4HA
07930 361736/01223 245 210
CPCP

PAIN, Jean
Hypno-Psychotherapist, NLP
Psychotherapist
7 Way Lane, Waterbeach
Cambs. CB5 9NQ
01223 860 356
ANLP

PARKINSON, Dorn
Psychoanalytic Psychotherapist
Archway House, Town Street
Upwell
Wisbech PE14 9AD
01945 773941
CSP

PEGLAR, Graham
Psychodynamic Psychotherapist
26 Malta Road
Cambridge CB1 3PZ
01223 411514
VAPP

PEPPER, Marie
Psychoanalytic Psychotherapist
1 Barrow Road
Cambridge CB2 2AP
01223 352800
CSP

POLLARD, James
Attachment-based Psychoanalytic
Psychotherapist
60 Montague Road
Cambridge CB4 1BX
01223 314398
CAPP

QUILTER, Sally
Integrative Psychotherapist
8 Hurst Park Avenue
Cambridge CB4 2AE
SPTI

RAISBECK, Linde
Humanistic and Integrative
Psychotherapist
10 Leys Avenue
Cambridge CB4 2AW
01223 352811
AHPP

RANDALL, Rosemary
Psychoanalytic Psychotherapist
113 Gwydir Street
Cambridge CB1 2LG
01223 313539
CSP

REYNOLDS, Alun
Humanistic Psychotherapist
12 Orchard Avenue
Cambridge CB4 2AH
01223 571393/01223 416166
AHPP

ROBINSON, Carole
Psychoanalytic Psychotherapist
University of Cambridge Counselling
Service
14 Trumpington Street
Cambridge CB2 1QA
01223 332865
CSP

SCOTT, Glenys
Psychoanalytic Psychotherapist
Hill Farm
128 Green End
Comberton
Cambs. CB3 7DY
01223 332865/01223 262925
GUILD

SEARLE, Yvonne
Psychodrama Psychotherapist 199
Huntingdon Road
Cambridge CB3 0DL
BPA

SERPELL, Vivienne
Sexual and Relationship Psychotherapist
Scotts
High Street, Whittlesford
Cambridge CB2 4LT
01223 833218
BASRT

SIMPSON, Michael J A
Analytical Psychologist-Jungian Analyst
2 Cotton's Field, Dry Drayton
Cambridge CB3 8DG
01954 780558
CAP

SINCLAIR, Alison
Psychoanalytic Psychotherapist
99 Windsor Road
Cambridge CB4 3JL
01223 565985/01223 369894
GUILD

SINCLAIR, Fiona
Contemporary Psychologist,
Psychoanalytic Psychotherapist
9 Emmanuel Road
Cambridge CB1 1JW
01223 364 834
FIP

SMITH, Gillian
Psychoanalytic Psychotherapist
5 Alpha Terrace
Trumpington
Cambridge CB2 2HS
01223 842073
CSP

STRATTON-WOODWARD, Sally
Integrative Psychotherapist
15 East Street
Bluntisham
Huntingdon PE17 3LS
01487 841659
SPTI

STYLES, Heather
Gestalt Psychotherapist
109 Vinery Road
Cambridge CB1 3DW
01223 414595
GCL

TAUSSIG, Hanna
Psychoanalytic Psychotherapist
296 Hills Road
Cambridge CB2 2QG
01223 246643
GUILD

TODD, Gillian
Cognitive Psychotherapist
6 Hauxton Road, Trumpington
Cambridge CB2 2LT
01223 217957/01223 841151
BABCP

TOWNSEND, Heather
Psychoanalytic Psychotherapist
12 Gwydir Road
Cambridge CB1 2LL
01223 510 434
SITE

TREGEAR, Barbara
Psychodrama Psychotherapist
79 Gough Way
Cambridge CB3 9LN
01223 365963/01223 357221
BPA

VOIKHANSKAYA, Marina*
Psychoanalytic Psychotherapist
20 Garden Walk
Cambridge CB4 3EN
01223 67747
GUILD

WARWICK, Heather
Sexual and Relationship Psychotherapist
CAMBRIDGESHIRE
01223 245380
BASRT

WATERSTON, John
Humanistic Psychotherapist
22 Waverley Park, Orchard Road
Great Shelford, Cambridge CB2 5BA
01223 843894
AHPP

WEAVER, Carol
Integrative Psychotherapist
Nene Cottage, 10 Fotheringhay
Peterborough PE8 5HZ
01832 226329
RCSPC

WESTLAND, Gill
Body Psychotherapist, Humanistic Psychotherapist, Integrative Psychotherapist
8 Wetenhall Road
Cambridge CB1 3AG
01223 214658
AHPP

WHITTLE, Lorna
Psychoanalytic Psychotherapist
28 Missleton Court
Cambridge CB1 4BL
01223 213969
ARBS

WILDE, Deborah
Psychoanalytic Psychotherapist
45 Riverside, Cambridge CB5 8HN
01223 562519
CSP

WOOLLISCROFT, Jenny
Gestalt Psychotherapist, Humanistic Psychotherapist
80 Andrew Road, Eynesbury
St. Neots
Huntingdon PE19 2QL
01480 470804
AHPP

WRIGHT, Elizabeth*
Lacanian Analyst, Psychoanalytic Psychotherapist
3 Boathouse Court, Trafalgar Road
Cambridge CB4 1DU
01223 350256
CFAR

CHANNEL ISLANDS

BOWEN, Barry
Family Therapist
Hautbois, Route des Genets
St Brelade, Jersey JE3 8DB
AFT

CRASKE, Sarah
Family Therapist
Rose Cottage, Oberlands Road
St Martins, Guernsey GY4 6SW
01481 34442
IFT

DYER, Ian P.
Cognitive Behavioural Psychotherapist
Queens House
St Saviours Hospital
La Route de la Hougue Bie
St Saviour, Jersey JE2 7UW
01534 857992/01534 623223
BABCP

FARMER, Christopher
Psychodrama Psychotherapist
La Couture, Belval Road, Vale
Guernsey GY3 5LW
01484 725241 x327/01481 45334
BPA

LUCAS, Rosemarie
Cognitive Behavioural Psychotherapist
Villa Angia, Les Ruisseaux
St. Brelade, Jersey JE3 8DD
01534 43326
BABCP

SINGLETON, Kryrin
Transpersonal Psychotherapist
La Neurve Charterie
Frie au Four, St Saviour's
Guernsey GY7 9TG
01481 67187
CCPE

CHESHIRE

ACKROYD, Rosemary
Sexual and Relationship Psychotherapist
57 Clement Road, Marple Bridge
Stockport SK6 5AG
0161 427 1568
BASRT

ALDERTON, Chris
Cognitive Behavioural Psychotherapist
70 Tarvin Road, Littleton
Chester CH3 7DF
01244 335417
BABCP

ARNOLD, Sue
Psychosynthesis Psychotherapist
Willow Cottage
Tallarn Green, Nr. Malpas
Cheshire SY14 7LJ
01948 770 697
AAPP

BERMAN, Paul
Group Analyst
The Moorings, Mereside Road
Knutsford
Cheshire WA16 6QR
01565 830874
IGA

BIBBEY, Judy
Psychoanalytic Psychotherapist
Psychology Services Department
Stepping Hill Hospital
Stockport SK2 7JE
0161 419678/0774 7782245
UPA

BIGGINS, Toby
Family Therapist
79 Welsh Row
Nantwich
Cheshire CW5 5ET
01270 629617
AFT

BIRD, John
Psychoanalytic Psychotherapist
17 Macclesfield Road
Wilmslow SK9 2AA
01625 523292
NWIDP

BLAMPIED, Annette N
Psychoanalytic Psychotherapist
30 Wharf Terrace
Madeley Heath
Nr Crewe CW3 9LP
01782 751509
UPA

BORONAT, Dascha
Group Analyst
5 Victoria Avenue
Cheadle Hulme SK8 5DJ
0161 488 4504
IGA

BRERETON, June
Transactional Analysis Psychotherapist
"Pendene", 116 Stocks Lane
Stalybridge SK15 2TQ
0161 303 7925
ITA

BUTCHER, Josie
Family Psychotherapist
3 Lomax Road, Willaston
Nantwich CW5 6RN
01270 663733
BASRT

CLARKE, Elaine
Psychoanalytic Psychotherapist
8 Windmill Lane
Preston-on-the-Hill
Warrington WA4 4AZ
01928 713811
LPDO

COLLINS, Gloria
Psychoanalytic Psychotherapist
Halton Psychotherapy and Family
Services
Thorn Road Clinic, Thorn Road
Runcorn WA7 5HQ
01928 575073
LPDO

COOPER, Graham
Psychoanalytic Psychotherapist
Denton House, Denton Drive
Northwich CW9 7LU
01606 353800
LPDO

CROCKER, Allen John
Family Therapist
36 Kingsley Road
Frodsham WA6 6SH
01928 739768
AFT

DATES, Stephanie
Transactional Analysis Psychotherapist
Swallowfield, Slade Lane
Mobberley WA16 7QN
01565 873059
ITA

FERNANDEZ, Nigel R.
Cognitive Behavioural Psychotherapist
Dept. of Clinical Psychology
Stepping Hill Hospital
Poplar Grove
Stockport SK2 7JE
0161 419 4678/0161 230 7473
BABCP

FITTON, Freda
Gestalt Psychotherapist
15 The Beeches
Upton CH2 1PE
01244 348843
GPTI

GARVEY, Rachel
Cognitive Behavioural Psychotherapist
Behavioural-Cognitive Psychotherapy
Room 33 Ingersley Building
Macclesfield Dist Gen Hospital
Victoria Road SK10 3BL
01625 663415
BABCP

GELDEARD, Bryan W.J.
Psychoanalytic Psychotherapist
Psychology Department, Halton General
Hospital, East Lane
Runcorn WA7 2DA
01928 714567 ext 3175
LPDO

GLYNN, Julie
Psychoanalytic Psychotherapist
Garven Place Clinic
Sankey Street
Warrington WA4 6PY
01925 574519
LPDO

GONSALKORALE, Wendy
Hypno-Psychotherapist
Westward, Brooklands Crescent
Sale M33 3NB
0161 976 1268
CTIS

GREEN, Barbara A.
Psychoanalytic Psychotherapist
Stockport Psychology Services
Stepping Hill Hospital
Poplar Grove
Stockport SK2 7JE
LPDO

GREENFIELD, Terence Aubrey
Cognitive Behavioural Psychotherapist,
Hypno-Psychotherapist
First Floor, 157 Ashley Road
Hale
Altrincham WA14 3UW
0161 928 3898/0161 929 0361
BABCP

HAWORTH CHESTER, Ann
Psychoanalytic Psychotherapist
Gifford Mount, East Downs Road
Bowden, Nr. Altrincham WA14 2LG
0161 928 7101
LPDO

HOBBES, Robin
Transactional Analysis Psychotherapist
6 Clarence Road, Hale
Altrincham WA15 8SG
0161 928 9997
ITA

HOLYOAK, Patricia
Cognitive Behavioural Psychotherapist
8 Wicker Lane, Guilden Sutton
Chester CH3 7EL
01244 300513
BABCP

HUNT, Patricia A
Psychoanalytic Psychotherapist, Sexual
and Relationship Psychotherapist
Rose Cottage, Foxwist Green
Whitegate, nr. Northwich CW8 2BJ
01606 882170
NWIDP

ISAAC, Toni-Lee
Hypno-Psychotherapist
3 Victoria Drive, Sale Moor M33 3HZ
0161 973 6357
CTIS

JONES, Janet D.
Cognitive Behavioural Psychotherapist
Directorate of Clinical Psychology
West Cheshire (NHS) Trust
Liverpool Road
Chester CH2 1UL
01244 364046
BABCP

KAY, Malcolm
Psychodrama Psychotherapist
Halton Psychotherapy & Family Service
Thorn Road Clinic
Runcorn WA7 7HQ
01928 575073/0161 788 0490
BPA

KILGOUR, Joyce
Family Therapist, Systemic
Psychotherapist
Cheadle Royal Healthcare
100 Wilmslow Road
Cheadle SK8 3DG
0161 495 4902/0161 428 2457
AFT

KIRK, Kate
Psychodrama Psychotherapist
222a Chester Road, Helsby
Frodsham WA6 0AW
01928 722918/01606 852347
BPA

LAWRENCE, Elizabeth
Sexual and Relationship Psychotherapist
Hillcroft
Park Lane, Little Bollington
Altrincham WA14 4TH
0161 928 1342
BASRT

LEDWARD, Judi
Integrative Psychotherapist
6 Clarence Road, Hale
Altrincham WA15 8SG
0161 928 9997
NGP

LEE, Denis
Family Psychotherapist
CAMHS F Block
Macclesfield DGH,East Cheshire
NHS Trust,Victoria Road
Macclesfield SK10 3BL
01625 663770/01625 663772
AFT

LEWIS, Ken
Cognitive Behavioural Psychotherapist
7 Brown Heath Road
Waverton CH3 7PP
01244 336774/01244 392732
BABCP

LILLEY, Diana
Group Analyst
Thorn Lea House
32 Grappenhall Lane, Stockton Heath
Warrington WA4 2AG
01925 268322
IGA

LITTLEWOOD, Ann
Psychodynamic Psychotherapist
The Weald, 69 Oldfield Road
Altrincham WA14 4BH
0161 928 2792
HIP

LOVELL, Karina
Cognitive Behavioural Psychotherapist
Psychological Services Department
Stepping Hill Hospital, Poplar Grove
Stockport SK2 7JE
0161 419 4678
BABCP

LUCAS, Carol
Transactional Analysis Psychotherapist
17 Prince's Road, Heaton Mersey
Stockport SK4 3NQ
0161 443 1628
ITA

MAHON, David
Hypno-Psychotherapist
7 Grammar School Road
Warrington WA4 1JN
01925 635662
NRHP

MCBURNIE, Dolores
Psychosynthesis Psychotherapist
Moor House, Dig Lane
Frodsham WA6 6VN
01928 731 406
AAPP

MCCORMICK, Helen
Psychoanalytic Psychotherapist
13 Lyceum Way, Coppenhall
Crewe CW1 3YF
01270 256397
WMIP

MCINTEE, Jeannie
Psychoanalytic Psychotherapist
Chester Therapy Centre
20 Walpole Street
Chester CH1 4HE
01244 390121
LPDO

MCKAY, Molly
Cognitive Behavioural Psychotherapist
Dept. of Psychological Therapies
Warrington Community Health Care
Garven Place Clinic
Sankey St., Warrington WA1 1RH
01925 653295/01925 655221 x3838
BABCP

MCLOUGHLIN, Una
Group Analyst
Altrincham Priory Hospital
Rappax Road, Hale
Altrincham WA15 0NX
0161 904 0050
IGA

NEILL, Denis E.
Family Therapist
17 Sunnybank, Holly Road South
Wilmslow SK9 1ND
01625 539707
AFT

NEVIN, Jaqui
Psychoanalytic Psychotherapist
c/o Denton House
Denton Drive, Northwich CW9 7TU
01606 353800
LPDO

OATES, Stephanie
Transactional Analysis Psychotherapist
Swallowfield, Slade Lane
Mobberley WA16 7QN
01565 873059
ITA

O'CARROLL, Pierce J.
Cognitive Behavioural Psychotherapist
University College Chester
Parkgate Road, Chester CH1 4BJ
01244 364046/0151 231 4233
BABCP

PANTALL, Marlis
Integrative Psychotherapist
7 Balmoral Avenue
Cheadle Hulme, Cheadle SK8 5EG
0161 4855274
NSAP

POLLET, Sheena
Psychoanalytic Psychotherapist
Thorn Road Clinic
Thorn Road, Runcorn WA7 5SH
01928 575073
LPDO

POLLITT, Mo
Cognitive Behavioural Psychotherapist
Lane End, 1 Lache Lane
Chester CH4 7LP
01244 681130
BABCP

PRINCE, Tania
Hypno-Psychotherapist
20 Cumberland Street
Macclesfield SK10 1DD
01625 879113/01625 520016
NRHP

READING, Clive
Cognitive Behavioural Psychotherapist
Dept of Clinical Psychology
Stepping Hill Hospital
Stockport SK2 7JE
0161 419 5755
BABCP

REDGRAVE, Kenneth
Hypno-Psychotherapist
11 Parker Avenue
Hartford, Northwich CW8 3AH
01606 74874
CTIS

RIDGWAY, Jane
Cognitive Behavioural Psychotherapist
Department of Psychology
Stepping Hill Hospital
Poplar Grove
Stockport SK2 7JE
0410 415711/0161 419 5766
BABCP

SEXTON, Janette G.
Psychoanalytic Psychotherapist
West Cheshire N.H.S. Trust
West Cheshire Hospital
Liverpool Road
Chester
01244 364893
LPDO

THOBURN, Marjorie
Sexual and Relationship Psychotherapist
Whitegables, Vicarage Hill, Helsby
Nr Warrington WA6 9AD
01928 722304
BASRT

THOMAS, Sandra V.M.
Psychodynamic Psychotherapist
Brookfield House
193-195 Wellington Road
South Stockport SK2 6NG
0161 429 6100/0161 419 9001
HIP

TUNWELL, Ann
Sexual and Relationship Psychotherapist
Waulkmill Cottage
Ingersley Vale, Bollington
Macclesfield SK10 5BP
01625 576821
BASRT

WESTERN, Simon
Family Therapist
Field House, Shed Lane
Chester CH3 5NG
01244 342703
AFT

WETHERILL, Julie
Group Analyst
51 Bancroft Road
Widnes WA8 3LR
mobile: 0402 925 796/
0151 422 0563
IGA

WHITTAM, Enid
Integrative Psychotherapist
1 Dorfold Way
Upton-on-Chester
Chester CH2 1QS
01244 380737
NSAP

WILDE, Verina
Cognitive Behavioural Psychotherapist
Psychology Department
District General Hospital
Victoria Road
Macclesfield SK10 3BL
01625 501150/01625 663547
BABCP

WILSON, Mary
Cognitive Behavioural Psychotherapist
3 Back Jodrell Street, New Mills
Stockport SK12 3HL
01663 745219/0850 297276
BABCP

CLEVELAND

ANDREWS, Carol
Integrative Psychotherapist, Transactional
Analysis Psychotherapist
100a The Grove, Marton, Middlesbrough
Cleveland TS1 8AN
01642 312 676
NGP

CATESBY, Cynthia
Integrative Psychotherapist
Badgers Green, West End
Sedgefield, Co Durham TS21 2BS
01740 620440
SPTI

FIRTH, Sue
Psychoanalytic Psychotherapist
34, The Holme, Gt Broughton
Middlesbrough TS9 7HF
01642 712736
NAAP

HAVEMAN, Jolien
Cognitive Psychotherapist
Centre for Health & Medical Research
School of Health, University of Teesside,
Borough Road, Cleveland TS1 3BA
01642 384124
BABCP

HELLIER, Mary B.
Psychoanalytic Psychotherapist
Woodlands Road Clinic
Middlesbrough TS1 3BL
01642 247311
NAAP

HOMER, Marjorie
Integrative Psychotherapist, Transactional
Analysis Psychotherapist
2 Hebron Road, Middlesbrough TS5 6RD
01642 814270
NGP

LISTER-FORD, Christine
Integrative Psychotherapist
The Northern Guild for Psychotherapy
77 Acklam Road
Thornaby-on-Tees TS17 7BD
01642 649004/0191 209 8383
NGP

MCNAMARA, Jennifer
Integrative Psychotherapist, Transactional
Analysis Psychotherapist
The Northern Guild for Psychotherapy
77 Acklam Road
Thornaby-on-Tees TS17 7BD
01642 649004/0191 2098383
NGP

MIDGLEY, David
Transactional Analysis Psychotherapist
13 Barker Road, Linthorpe
Middlesbrough TS5 5EW
01642 821254
ITA

PEARSON, Beryl
Integrative Psychotherapist
The Giardini, Roxby Lane
Staithes, Saltburn-by-the-Sea TS13 5DZ
01947 840572/01484 460786
SPTI

RICHARDSON, Sue
Attachment-based Psychoanalytic
Psychotherapist
22 Queens Road
Middlesbrough TS5 6EE
01642 817658
CAPP

STRANG, Susi
NLP Psychotherapist
Sun Dial House
29 High Street, Skelton
Saltburn by the Sea TS12 2EF
01287 654175
ANLP

SZARY, Gerard
NLP Psychotherapist
98 Oxbridge Lane
Stockton on Tees TS18 4HW
01642 678 653
ANLP

THACKER, Rose
Integrative Psychotherapist, Transactional
Analysis Psychotherapist
13 Ruskin Avenue
Saltburn TS12 1QB
01287 622947
NGP

WICKS, Carole Ann
Integrative Psychotherapist
28 Cornfield road
Middlesbrough TS5 5QL
01642 815271
NGP

WILLIAMS, Steve
Cognitive Psychotherapist
The Spinney, Hutton Village
Guisborough TS14 8EP
01287 637416
BABCP

CORNWALL

ALLEN, Cheryl
Core Process Psychotherapist
23 Holmbush Road
St.Austell PL25 3LF
01726 69486
AAPP

COGAN, Margaret
Cognitive Behavioural Psychotherapist
Dept. of Clinical Psychology
Banham House
St.Lawrences Hospital
Bodmin PL31 2QT
01208 251 460
BABCP

COOMBS, Suzanne*
Psychoanalytic Psychotherapist
"Garth"
Steeple Lane
Trelyon Downs TR26 2AP
01736 7950
GUILD

CRAMER, William
Psychodrama Psychotherapist
Trevillick Cottage, Trevillick
Tintagel PL34 0DN
01840 770691
BPA

FOWLES, Anne
Transpersonal Psychotherapist
Rainbow's End, 22 York Street
Penzance TR18 2PW
01736 363114
CTP

FRANSELLA, Fay
Personal Construct Psychotherapist
The Sail Loft, Mulberry Quay
Market Strand
Falmouth TR11 3HD
01326 314 871
CPCP

FRENCH, Jean
Transactional Analysis Psychotherapist
The 12 Steps, Trenance
Mawgan Porth
Nr. Newquay TR8 4BX
01637 860435
ITA

GIMBLETT, Jeanne
Cognitive Behavioural Psychotherapist
Highland Cottage, St. Breward
Bodmin PL30 4NU
01208 850597
BABCP

GREEN, Marion
Gestalt Psychotherapist
2 Gibbons Field, Mullion
Helston TR13 3EA
01326 240734
SPTI

GRIFFITHS, Thelma
Transpersonal Psychotherapist
Boswedden House
St Just TR19 7NJ
01736 788733
CCPE

GRIGG, Roz
Core Process Psychotherapist
10 North Hill Park
St. Austell PL25 4BJ
01726 61675
AAPP

HAYWARD, Mark
Family Therapist
Little Clicker, Hornington Tops
Liskeard PL14 3QA
01503 240822
AFT

HODD, Amanda
Family Therapist
Child & Family Centre
Treliske Hospital
Truro TR1 3LQ
01872 354350/01872 354379
AFT

HUDSON, Peter
Family Therapist
Child & Family Centre
Treliske Hospital
Truro
01872 354350
AFT

KING, Michael
Family Therapist
8 Amble Road, Callington PL17 7QE
01579 335226
AFT

LUCE, Peter James
Hypno-Psychotherapist
269 New Road, SaltasH PL12 6HQ
01752 844 777
NRHP

MANNING, Helen
Gestalt Psychotherapist
Bounds Cottage
Cargreen
Saltash PL12 6PA
01752 840603
GPTI

MAY, Jo
Core Process Psychotherapist
Rosemerryn, Lamorna, Penzance
Cornwall
01736 810 530
AAPP

MIDDLETON, Richard
Family Therapist
8 Lescudjack Road
Penzance TR18 3AD
01736 362196
AFT

MORRIS, David
Cognitive Behavioural Psychotherapist
The Old Parsonage
58 Church Street, Mevagissey
St Austell PL26 6SR
07771 983159/01726 844818(t/f)
BABCP

PAYNE, John
Psychoanalytic Psychotherapist
Greenscombe House
Luckett
Callington PL17 8LF
01579 370149
GUILD

REES, Susan
Child Psychotherapist
An Skyber, Trevithal
Near Paul
Penzance TR19 6UQ
01736 731973
ACP

RETALLICK, Malcolm
Gestalt Psychotherapist
48 Molesworth Street
Wadebridge PL27 7DP
01208 812048
MET

SEVER, Michael
Hypno-Psychotherapist
'Veritas'
25 Polwithen Drive
Carbis Bay
St. Ives TR26 2SP
01736 798399
NRHP

SIMPSON, Kevin J.
Psychoanalytic Psychotherapist
Outlook (South)
2 Broad Park, St Keyne
Liskeard PL14 4RH
01579 342203
LPDO

SPRENT, Sue
Group Analytic Psychotherapist
Beagletodn, Towednack
St Ives TR26 3AY
01736 794 304
LCP

TREWHELLA, John
Hypno-Psychotherapist
Castle Gayer, Leys Lane
Marazion TR17 0AQ
01736 711548
NRHP

WILSON, Gillian
Child Psychotherapist
Child & Family Centre
Treliske Hospital
Truro TR1 3LQ
01872 354350
ACP

COUNTY DURHAM

ALLINSON, Mary A.
Cognitive Behavioural Psychotherapist
Teesdale Community Health Services
Victoria Road
Barnard Castle DL12 8HT
01325 461686/01833 637795
BABCP

BIRCHMORE, Terry
Group Analyst
Child & Family Centre
Health Centre, Newcastle Road
Chester le Street DH3 3UR
IGA

CLARKE, Stephen Lawrence
Cognitive Psychotherapist
The Derwent Clinics
Bede House, Shotley Bridge Hospital
Consett DH8 0NB
01207 214660/01207 586049
BABCP

COOPER, Margaret H
Psychoanalytic Psychotherapist
2 Manor Close
Shincliffe Village DH1 2NS
0191 386 5818
NAAP

DRAPER, Pim
Cognitive Behavioural Psychotherapist
Department of Psychology
Darlington Memorial Hospital
Hollyhurst Road
Darlington DL3 6HX
01325 746578
BABCP

GILBERT, Barbara
Psychoanalytic Psychotherapist
68 Gurney Valley
Bishop Auckland DL14 8RW
01388 604418
NAAP

JOHNSON, Janette
Integrative Psychotherapist, Transactional
Analysis Psychotherapist
3 Bluecoat Buildings, Claypath
Durham DH1 1RF
0191 384 4942
NGP

LEMON, Marcia
Psychosynthesis Psychotherapist
47 Hawthorn Terrace
Durham DH1 4EL
0191 384 5526/0191 477 1011
AAPP

LOISEAU, Kate
Integrative Psychotherapist
Cholet Cottage, Killerby
Darlington DL2 2UQ
01325 374606
SPTI

LOUDON, Julia
Sexual and Relationship Psychotherapist
The Sex Therapy and Counselling
Service
The Marion Centre, Memorial Hospital
Darlington DL3 6HX
01325 743578
BASRT

MILES, Carolyn
Psychoanalytic Psychotherapist
University Health Services
42 Old Elvet, Durham DH1 3JF
0191 374 2000
NAAP

PROUDLEY, Helen
Sexual and Relationship Psychotherapist
Sex Therapy and Counselling Service
Marion Centre, Memorial Hospital,
Hollhurst Road
Darlington 01325 743578
BASRT

STANBURY, Christine
Psychoanalytic Psychotherapist
Derwent Clinic
Shotley Bridge Consett
Durham DH8 0NB
01207 583 4671
NAAP

TOMKINSON, John S
Psychoanalytic Psychotherapist
County Hospital, North Road
Durham DH1 5RD
0191 333 3477/0191 333 3400
UPA

WATSON, Pauline
Psychoanalytic Psychotherapist
Shotley Bridge Hospital
Shotley Bridge, Consett
01207 503 456
NAAP

CUMBRIA

APPLEGARTH, Janet
Psychoanalytic Psychotherapist
2 Tallows Whins, Lazonby
Penrith CA10 1AR
01768 898390
LPDO

BAYNES, Monica
Psychoanalytic Psychotherapist
5 Stainbank Green, Brigsteer Road
Kendal LA9 5RP
01539 740605
LPDO

BURGESS, Alison
Family Therapist
Child & Fam.Con. Unit
Workington Infirmary
Infirmary Road
Workington CA14 2UN
01946 523053/01900 6022440
AFT

COOK, Jane
Integrative Psychotherapist
Castle Gate Barn, Castle Carrock
Near Carlisle CA4 9LT
01228 70646
MC

COX, Mary
Transactional Analysis Psychotherapist
Cambrai House, Calderbridge
Seascale CA20 1DH
01946 841239
ITA

EGERTON, Judy
Psychoanalytic Psychotherapist
Psychotherapy Services
Beech Lodge, Garlands Hospital
Carlisle CA1 3SU
01228 602392
LPDO

FORSYTH, Angus
Cognitive Behavioural Psychotherapist
104 Greenacres
Wetheral, Carlisle CA4 8LD
01228 561786
BABCP

HEATH, John
Transactional Analysis Psychotherapist
122 Highgate, Kendal LA9 4HE
01539 723356
ITA

HOUSE, Wyn
Sexual and Relationship Psychotherapist
Ravenscroft, Lake Road
Windermere LA23 2EQ
015394 42665
BASRT

KELLY, Gillian
Body Psychotherapist, Gestalt
Psychotherapist
Dillygarth, Loughrigg
Ambleside LA22 9HF
01539 433903
CCBP

KENNY, Peter
Psychoanalytic Psychotherapist
26 Spital Park
Kendal LA9 6HG
01539 720572
WMIP

LOBEL, Sandra
Sexual and Relationship Psychotherapist
Low Lodge
Rockland Road
Grange Over Sands LA11 7HR
015395 35140/0161 434 9804
BASRT

LONGFORD, Joan
Psychoanalytic Psychotherapist
Department of Psychotherapy
Beech Lodge, Garlans Hospital
Carlisle
01228 602000
NAAP

MACDONALD, Alasdair
Family Therapist
Garlands Hospital
Carlisle CA1 5SX
01228 602468
AFT

MCQUILLIN, Jane
Transactional Analysis Psychotherapist
31 Prince's Street
Ulverston LA12 7NQ
01229 588404
ITA

TOD, Ian
Psychoanalytic Psychotherapist
The Brough Medical Centre
Brough
Nr. Kirby Stephen CA17 4AY
NAAP

WHITLEY, Liz
Transactional Analysis Psychotherapist
24 Wordsworth Street
Penrith CA11 7QY
01768 899941
ITA

WILSON, Maureen
Psychoanalytic Psychotherapist
Banna Cottage
Hutton Park, New Hutton
Kendal LA8 0AY
01539 737766
AGIP

DERBYSHIRE

ADLER, Eve
Sexual and Relationship Psychotherapist
Acorn House, 1 Church Lane
Morley DE7 6DE
01332 833898
BASRT

ANDERSON, Naomi
Gestalt Psychotherapist
The White Lodge, The Hayes
Swanwick DE55 1AT
01773 608950
SPTI

DANIELS, Frank
NLP Psychotherapist
103 Hands Road
Heanor DE75 7HB
01773 532195
ANLP

DENNESS, Brian
Psychoanalytic Psychotherapist
Department of Psychotherapy (NHS)
Temple House
Mill Hill Lane
Derby DE23 6SA
01332 364512
STTDP

EVANS, Gail
Sexual and Relationship Psychotherapist
Chesterfield 01246 208099
BASRT

FITZGERALD, Patricia
Integrative Psychotherapist
61 Hollywood Avenue
Littleover
Derby DE23 6JD
SPTI

GILSON, Jean
Gestalt Psychotherapist
138 Derby Road
Swanwick DE55 1AD
01773 607926
SPTI

GREVILLE, Coral
Gestalt Psychotherapist
The Willow, Main Street
Ellastone, Nr Ashbourne,
Derby DE6 2GZ
01335 324593
SPTI

JACK, Bridget
Family Therapist
Oaklands
103 Duffield Road
Derby DE22 1AE
01332 365221/01332 205989
AFT

JOHNSON, Michael
NLP Psychotherapist
5 Glenthorne Close
Chesterfield S40 3AR
01246 273002
ANLP

JONES, Sue
Systemic Psychotherapist
9 Hob Hill, Meadows, Hague Street
Glossop SK13 8LW
FIC

JORDAN, Karen
Gestalt Psychotherapist
2 Forge Steps, Makenes
Millford
Derby DE56
SPTI

LEAKEY, Peter
NLP Psychotherapist
Clinical Psychology Department
Walton Hospital
82 Whitecoates Lane
Chesterfield S40 3HW
01246 552871
ANLP

MANSALL, Cordelia
Integrative Psychotherapist
30 Toadmoor Lane
Ambergate DE55 2GN
01773 8539168
RCSPC

MUSCHAMP, Maureen
Transpersonal Psychotherapist
Hillcroft, 37 Summer Lane
Wirksworth
Derby DE4 4EB
01629 823146
CTP

OVERS, Nicola
Personal Construct Psychotherapist
The Cottage
Longnor Nr Buxton SK17 0LA
01298 83806/01827 308 820
CPCP

PARKINSON, Jillian
Transactional Analysis Psychotherapist
19 Chapel Street
Measham DE12 7JD
01530 272772
ITA

PROCTER, Sue
Cognitive Psychotherapist
Shirley Centre
16A South Street
Derby DE1 1DS
01332 292160/01332 571765
BABCP

ROBINSON, Gary
Systemic Psychotherapist
2 Foxcroft, Sunny Bank
Tibshelf DE55 5QR
01332 365221
FIC

SCHRÖDER, Thomas
Psychoanalytic Psychotherapist
Derby Dept. of Psychotherapy (NHS)
Temple House, Mill Hill Lane
Derby DE23 6SA
01332 364 512
STTDP

SERIEYS, Nicholas Michael
Cognitive Behavioural Psychotherapist
14 Balmoral Close, Littleover
Derby DE23 6DY
0973 520550
BABCP

SHAW, Robert
Integrative Psychotherapist
41 St. John Street
Ashbourne
Derby DE6 1GP
01335 300440
SPTI

SMITH, David
Psychoanalytic Psychotherapist
Derby Dept. of Psychotherapy (NHS)
Temple House, Mill Hill Lane
Derby DE23 6SA
01332 364512
STTDP

SMITH, Janet M.
Psychoanalytic Psychotherapist
Dept. of Psychotherapy
Temple House, Mill Hill Lane
Derby DE23 6SA
01332 364512
NWIDP

TAYLOR, Jon
Cognitive Behavioural Psychotherapist
55 Church Street
Littleover
Derby DE23 6GF
01332 272434/01283 505330
BABCP

THOMPSON, Jeanette
Family Therapist
Stubbins House
Stubbins Lane, Chinley
High Peak SK23 6ED
AFT

WALSH, Belinda
Cognitive Behavioural Psychotherapist
Clinical Psychology Department
Walton Hospital, Whitecotes Lane
Chesterfield S40 3HN
01246 552871
BABCP

WEEKS, Mark
Systemic Psychotherapist
28 Haddon Street
Normanton
Derby DE23 6NP
FIC

WOOD, Sally
Family Therapist
Oaklands, 103 Duffield Road
Derby DE22 1AE
01332 365221/01332 205989
AFT

DEVON

ADEY, John
Integrative Psychotherapist
Woodlands, Christow
Exeter EX6 7PJ
01647 252684/01392 403446
RCSPC

ANJALI, Yon
Core Process Psychotherapist
53 Penys Road, Totnes TQ9 5TL
01803 862 543
AAPP

BALDREY, Sarah
Cognitive Behavioural Psychotherapist
Medical Administration
Level 7, Maternity Unit
Derriford Hospital
Plymouth PL6 8DH
01752 763716
BABCP

BENNUN, Ian
Family Therapist
Hengrave House, Torbay Hospital
Torquay TQ2 7AA
01803 654572/01803 615 767
AFT

BENOR, Ruth
Autogenic Psychotherapist
19 Fore Street
Bishopsteinton TQ14 9QR
01626 7879649
BAS

BOOTH, Nick
Family Therapist
Department of Psychology
Church Lane, Heavitree
Exeter EX2 5SH
01392 403170
AFT

BOSTON, Mary
Child Psychotherapist
Marina, Golf Links Road
Westward Ho
Bideford EX39 1HH
01237 470424
ACP

BROUGH, Julie
Family Therapist
44 South Street
Torrington EX38 8AB
01805 622223
AFT

BUCKLAND, Richard
Child Psychotherapist
Plymouth Child & Family Consultation
Service
Erme House
Mount Gould Hospital
Plymouth PL4 7QD
01752 272360
ACP

BURLAND, Roger
Cognitive Behavioural Psychotherapist
Middle Yarnacott, Swimbridge,
Barnstaple EX32 0QY
0441 010071/01271 830373
BABCP

CALLAWAY, Hazel
Attachment-based Psychoanalytic
Psychotherapist
8 Victoria Avenue, Millbridge
Plymouth PL1 5NH
01752 509535
CAPP

CAMPBELL, Margaret
Core Process Psychotherapist
1 Kiln Cottages, Broadhempston
Totnes TQ9 6BT
01803 813144
AAPP

CAMPBELL-BEATTIE, John
Hypno-Psychotherapist
Rosemary Hill, 64A Underlane
Plymstock
Plymouth PL9 9JZ
01752 484265
NRHP

CARNEGIE, Deborah
Core Process Psychotherapist
1 Rose Cottages, Maudlin Road
Totnes TQ9 5TG
01803 800913
AAPP

CLAYTON, Valerie
Core Process Psychotherapist
Beaumont, Bridgetown
Totnes TQ9 5BE
01803 866 294
AAPP

CLEVELY, Sarah
Transactional Analysis Psychotherapist
10 Bartholomew Terrace
Exeter EX4 3BW
01392 432 952
MET

COX, Miranda
Core Process Psychotherapist
3 St Helens, Heywood Road
Bideford EX39 3PQ
AAPP

DALE, Francis
Child Psychotherapist
Rockmead, Lustleigh
Newton Abbot TQ13 9TH
01647 277237
ACP

DAVID, Ann
Integrative Psychotherapist, Transactional
Analysis Psychotherapist, Maryknowle
Malborough
Kingsbridge TQ7 3DB
01548 842159 (t/f)
ITA

DAVID, Julian
Analytical Psychologist-Jungian Analyst,
Luscombe Farm
Buckkfast Leigh TQ11 0LP
01364 642373
IGAP

DAWSON, Jenny
Gestalt Psychotherapist
36 Raleigh Road
Exmouth EX8 2SB
01395 269076
GPTI

DEAS, Francis
Core Process Psychotherapist
Highgate House, Hennock
Nr Bovey Tracy,
Newton Abbot TQ13 6PZ
01626 833 654
AAPP

DYEHOUSE, Pat
Psychoanalytic Psychotherapist
Hazel Tor Barn, Lower Soar
Soar Mill Cove, Malborough, Kingsbridge
TQ7 3DS
01548 561450
ARBS

DYMOND, Christina
Core Process Psychotherapist
Maybelle Cottage, Sandford
Crediton EX17 4LR
01363 775138
AAPP

ETHERINGTON, Mary Elizabeth
Transactional Analysis Psychotherapist
4 Oak Drive, Oak Park
Cullompton EX15 1NW
01884 33812
ITA

FERRIS, Mary
Core Process Psychotherapist
27 Lawn Vista
Sidmouth EX10 9BY
01395 577588
AAPP

FISH, Sue
Gestalt Psychotherapist, Integrative
Psychotherapist
"Maryknowle", Malborough
Nr. Kingsbridge TQ7 3DB
01243 573475
GPTI

GARDNER, Sarah
Core Process Psychotherapist
14 Edgerton Park Road
Exeter EX4 6DD
01392 423010
AAPP

GERLACH, Lynne
Integrative Psychotherapist
Collywell, Brownston
Nr.Ivybridge PL21 0SQ
01548 821 192
MET

GOLZ, Angelika
Humanistic Psychotherapist
Flat 1, 19 Bridgetown
Totnes TQ9 5BA
01803 867413
AHPP

HACKETT, Jenny
Integrative Psychotherapist
Hillcross, Stockland
Honiton EX14 9DA
01404 881565
BCPC

HENSHAW, Judith
Transactional Analysis Psychotherapist
"Ollivers", Halsfordwood Lane
Nadderwater
Nr. Exeter EX4 2LD
01392 811416
ITA

HERBERT, JME
Family Therapist
1 Riverview Bridge Road
Kingswear TQ6 0DZ
01803 752 430
AFT

HEWSON, Julie Ann
Transactional Analysis Psychotherapist
Iron Mill, Oakford
Tiverton EX16 9EN
01398 351379
ITA

HOARE, Ian
Humanistic and Integrative
Psychotherapist
36 Raleigh Road
Exmouth EX8 2SB
01395 269076
BCPC

HODGES, Barbara
Psychodrama Psychotherapist
Seymour House, 62 Lipson Road
Plymouth PL4 8RH
01752 79000/01752 661730
BPA

HOLMES, Jeremy
Psychoanalytic Psychotherapist
The Old Rectory, Stoke Rivers
Barnstaple EX32 7LB
01271 322666/01598 710291
SIP

HORTON, Annie
Transactional Analysis Psychotherapist
28 Halyards, Ferry Road
Topsham
Exeter EX3 0JU
01392 876518
ITA

JENKINS, Dinah
Cognitive Behavioural Psychotherapist
Occupational Health &Safety Unit
Derriford Hospital
Plymouth PL6 8DH
01503 262067/01752 763586
BABC

JENSEN, Greta
Psychosynthesis Psychotherapist
Star House, Pleases Passage
High Street
Totnes TQ9 5QN
01803 865 954
AAPP

JONES, Nicole
Psychoanalytic Psychotherapist
57 Thornton Hill
Exeter EX4 4NR
01803 558257/01392 254408
SIP

KALISCH, David
Core Process Psychotherapist,
Humanistic Psychotherapist
"Warrencroft"
56 East Budleigh Road
Budleigh Salterton EX9 6EJ
01395 446307
AAPP

KARP, Marcia
Psychodrama Psychotherapist
Holwell International Centre for
Psychodrama, North Walk
Lyton EX35 6HJ
0011 (0) 1598 753754
BPA

KIRBY, Alan
Humanistic Psychotherapist
Little Pomeroy, Somerset Place
Bridgetown
Totnes TQ9 5AX
01803 866922
AHPP

LABWORTH, Yig
Core Process Psychotherapist,
Humanistic and Integrative
Psychotherapist
Chalice House, 11 Howell Road
Exeter EX4 4LG
01392 427370
AAPP

LANGLEY, Dorothy
Psychodrama Psychotherapist
Hanningfields, Warborough Hill
Kenton
Exeter EX6 8LR
01626 890433
BPA

LEWIS, Philip J.
NLP Psychotherapist
33 Northfield Road
Okehampton EX20 1BB
01837 54061
ANLP

LINNELL, Maxine
Core Process Psychotherapist
6 Pengilly Way, Hartland
Nr. Bideford EX39 6HR
01237 441691
AAPP

LLEWELLYN, Alice
NLP Psychotherapist
Bay Villa, Plymouth Road
Totnes TQ9 5PQ
01803 866706
ANLP

LOXTERKAMP, Lorne
Child Psychotherapist
Family Consultancy
Health Centre, Vicarage Street
Barnstaple EX32 7BT
01271 371761/01271 814901
ACP

MALLARDO, Renee
Hypno-Psychotherapist
Old Forge Cottage
39 Ringmore Road
Shaldon TQ14 0AG
01626 873881
NRHP

MALONEY, Sean
Core Process Psychotherapist
1 Orchard Terrace, Tuckenham
Totnes TQ9 7EJ
01803 732 264
AAPP

MCGOURAN, Gill
Transpersonal Psychotherapist
South West Counselling Centre
45 New Street, The Barbican
Plymouth PL1 2ND
01752 250621
CTP

MERRIOTT, Peter
Transpersonal Psychotherapist
58 Church Road
Wembury PL9 0JG
01752 862224
CTP

MILLS, Judith
NLP Psychotherapist
Higher Thatch, Ebford Lane, Ebford
Exeter EX3 0QX
01392 873984
ANLP

MOORE, Jill
Sexual and Relationship Psychotherapist
3 Marlow Close, Shiphay
Torquay TQ2 6DQ
01803 409940
BASRT

MUNSEY, Jon
Psychodrama Psychotherapist
11 Auction Way, Woolfardisworthy
Nr Bideford EX39 8TT
01237 47237/01237 431 706
BPA

NICHOLSON, Elizabeth
Psychoanalytic Psychotherapist
White Oaks
18 St. Brannocks Park Road
Ilfracombe EX34 8HX
01271 864003
GUILD

NIGHTINGALE, Eileen
Psychosynthesis Psychotherapist
Blackmore House, May Terrace
Sidmouth EX10 8EN
01395 513923
AAPP

NOACK, Miké
Individual and Group Humanistic
Psychotherapist
The Maisonette, 50A Fore Street
Totnes TQ9 5RP
01803 862805
AHPP

NORTH, Joanna
Core Process Psychotherapist
5 Culm Valley Way, Uffculme
Cullompton EX15 3XZ
01884 841774
AAPP

OLDFIELD, Nina
Integrative Psychotherapist
3 Bolberry Court, Malborough
Kingsbridge TQ7 3DY
07050 043081/01548 561013 (t/f)
RCSPC

OPENSHAW, Sally
Sexual and Relationship Psychotherapist
North Down House
North Down Road
Bideford EX39 3LT
01237 476757
BASRT

O'REILLY, Paul
Family Therapist
Dept. of Clinical and Community
Psychology, Church Lane
Heavitree
Exeter EX2 5SH
01392 403186/01392 403189
AFT

PEHRSSON-TATHAM, Lena
Psychoanalytic Psychotherapist
Maynards, Cornworthy
Totnes TQ9 7HB
01803 864466/01803 732733
SIP

ROBERTSON, Zuleika*
Psychoanalytic Psychotherapist
6 Prospect Park
off Old Tiverton Road
St. James
Exeter EX4 6NA
013924 30162
GUILD

RODDICK, Mary
Family Therapist
Coombe Farm, Christow
Exeter EX6 7NR
01647 252553
AFT

ROTAS, Joanna
Core Process Psychotherapist
3 Western Villas, Collins Road
Totnes TQ9 5PW
01803 864990
AAPP

SARRA, Nicholas
Group Analyst
Nibbscott, Washfield
Tiverton EX16 9QY
01884 256 349
IGA

SCHNEIDER, Caroline
Family Therapist
Dept. of Child and Adolescent Mental
Health, Erme House
Mount Gould Hospital
Mount Gould Rd.
Plymouth
01752 272316
AFT

SCOTT HAYWARD, Anna
NLP Psychotherapist
16 Brunswick Terrace
Torquay TQ1 4AE
01803 323885
ANLP

SEYMOUR CLARK, Vivienne
Psychoanalytic Psychotherapist
25 Brooklands, Bridgetown
Totnes TQ9 5AR
01803 864976
CSP

SHELDON, Brian
Cognitive Behavioural Psychotherapist
Centre for Evidence Based Soc Serv
Amory Building
University of Exeter
Exeter EX4 4RJ
01392 263323/01392 263229
BABCP

SIERODA, Helen
Psychosynthesis Psychotherapist
Eaglehurst, Mill Street
Chagford TQ13 8AR
01647 432202
AAPP

SILLS, Franklyn
Core Process Psychotherapist
Natsworthy Manor
Widecombe-in-the-Moor
Newton Abbot TQ13 7TR
01647 221 457
AAPP

SILLS, Maura
Core Process Psychotherapist
Natsworthy Manor
Widecombe-in-the-Moor
Newton Abbot TQ13 7TR
01647 221 457
AAPP

SKEET, Maggie
Gestalt Psychotherapist
6 Matford Mews, Matford
Exeter EX2 8XP
01392 218783
GPTI

SPRAGUE, Ken
Psychodrama Psychotherapist
Hoelwell Centre, North Walk
Lynton EX35 6HJ
0044 0 1598 753754
BPA

SPURGEON, Richard
Psychosynthesis Psychotherapist
Star House, Please's Passage
High Street
Totnes TQ9 5QN
01803 864 509
AAPP

STATHERS, John
Core Process Psychotherapist
Henacre House, Rack Park Road
Kingsbridge TQ7 1DQ
01548 857 567
AAPP

STEWART, Lindsey
Humanistic Psychotherapist
Burnside, Avonwick
South Brent TQ10 9EZ
01364 73201
AHPP

STUNDEN, Patricia
Core Process Psychotherapist
18 Corner Brake, Woolwell
Plymouth PL6 7QP
01752 702931
AAPP

SWALLOW, Joan
Integrative Psychotherapist, Transpersonal
Psychotherapist
Bridge House, Culmstock
Collumpton EX15 3JJ
01884 840513
CTP

SWALLOW, Reynold
Transpersonal Psychotherapist
Bridge House, Culmstock
Collumpton EX15 3JJ
01884 840513
CTP

SWINFIELD, Ray
Core Process Psychotherapist
Flat 8, 58 High Street
Totnes TQ9 5SQ
01803 865458
AAPP

TATHAM, Peter
Analytical Psychologist-Jungian Analyst,
Psychoanalytic Psychotherapist
Maynards, Cornworthy
Totnes TQ9 7HB
01803 732733
IGAP

TAYLOR, Crispin
Family Therapist
Iddesleigh House Clinic
Heavitree Road
Exeter EX1 2NE
01392 276348
AFT

TAYLOR, Helen
Personal Construct Psychotherapist
56 Camperdown Terrace
Exmouth EX8 1EQ
01395 267615
CPCP

TAYLOR, Susan
Core Process Psychotherapist
Kingston Cottage
Kingston, Dittisham
Dartmouth TQ6 0JB
01803 722 459
AAPP

THOMAS, Alyss
Core Process Psychotherapist
The Practice, One the Plains
Totnes TQ9 5DR
01803 862 300/01803 732 751
AAPP

TILLEY, Alison
Gestalt Psychotherapist
1 Railway Cotts, Lapford
Nr Crediton EX17 6QU
01363 83057
SPTI

TOWERS, Cathy
Integrative Psychosynthesis
Psychotherapist
Flat 3, Greenacre, Isca Road
Exmouth EX8 2EZ
01395 278 437
RE.V

TRELFA, Joanne
Core Process Psychotherapist
1 Bolberry Down, Bolberry
Malborough
Kingsbridge TQ7 3OM
01548 561835
AAPP

URRY, Amy
Family Therapist
70 Queen Elizabeth Drive
Crediton
Exeter EX17 2EJ
01392 403170
AFT

VERNON, Olabisi
Transactional Analysis Psychotherapist
Taylors, Chittlehamholt
Umberleigh EX37 9NT
01769 540609
ITA

WARD, Barbara
Psychosynthesis Psychotherapist
3 Wheelwright Court
Walkhampton
Yelverton PL20 6LA
01822 855 619
AAPP

WARIN, Judy
Cognitive Analytic Therapist
Psychotherapy Department
Wonford House Hospital
Dryden Road
Exeter EX2 5AF
01392 403422
ACAT

WATSON, Gay
Core Process Psychotherapist
Coombery, Tuckenhay
Totnes TQ9 7EP
01803 732 272
AAPP

WEBBER, Wendy
Core Process Psychotherapist
Cutteridge Farm, Whitestone
Exeter EX4 2HE
01392 811 838
AAPP

WEIR, Felicity
Child Psychotherapist
The Day Unit
Torquay Child & Family Con.Service
187 Newton Road
Torquay TQ2 7AJ
01803 655692/01626 873228
ACP

WHEADON, Sylvia
Psychodrama Psychotherapist
Littlecroft, 16 Clampitt Road
Ipplepen
Newton Abbot TQ12 5TE
BPA

WHELAN, P W A
Sexual and Relationship Psychotherapist
Olde Court Coach House
Higher Lincombe Road
Torquay TQ1 2EX
01803 212483
BASRT

WILLOW, Angela
Core Process Psychotherapist
1 Orchard Terrace, Tuckenhay
Totnes TQ9 7EJ
01803 732264
AAPP

WILSON, Jancis
Core Process Psychotherapist
Church Close
Throwleigh EX20 2HX
01647 231 264
AAPP

WOODING, Sandra
Psychodrama Psychotherapist
Lower Cator Farmhouse
Lower Cator
Widecombe-in-the-Moor
TQ13 7TX
01364 621239
BPA

WRIGHT, Maureen
Psychodrama Psychotherapist
Thornlea, Town Lane
Woodbury
Nr. Exeter EX4 1NB
01395 232373/01395 232001
BPA

DORSET

BENNETT, Gerald A.
Cognitive Behavioural Psychotherapist
Community Drug Team
Park Lodge, Gloucester Road
Bournemouth BH7 6JF
01202 397003
BABCP

BLUNDEN, Jane
Cognitive Analytic Therapist
Branicsome Clinic
Layton Road, Parkstone
Poole BH12 3BJ
0956 976955/01202 735300
ACAT

BOTTERILL, Willie
Personal Construct Psychotherapist
Northleigh House, Northleigh Lane
Colehill, Wimbourne BH21 2PH
020 7530 4238
CPCP

BRADLEY, Linda
Integrative Psychotherapist
28 High Park Road
Broadstone BH18 9DE
07775 665702/01202 303757
RCSPC

BRAY, Stephen
NLP Psychotherapist
Roughwood, Letton Park
Blandford Forum DT11 7EG
01258 458889
ANLP

CADBURY, Stephanie
Sexual and Relationship Psychotherapist
Dorset Healthcare Trust, Psychology Dept
18 Tower Road, Boscombe
Bournemouth BH1 4LB
BASRT

CLARKE, Susan Elizabeth
Cognitive Analytic Therapist, Cognitive Psychotherapist
Intensive Psychol Theraparies Service
Branksome Clinic
Layton Road, Parkstone
Poole BH12 2BJ
01202 735300
BABCP

DENNIS, Stephen
Transactional Analysis Psychotherapist
4 Whitehall
Maiden Newton DT2
ITA

FINCH, Auberon
Core Process Psychotherapist
6 Bakers Paddock, Broadmayne
Dorchester DT2 8HD
01305 761100 x 8843/01305 854501
AAPP

GESSERT, Astrid*
Lacanian Analyst
Consulting Rooms, Winterbourne Hospital
Herringston Road
Dorchester DT1 2DR
01305 263252/01297 560397
CFAR

HARRIS, Neil
Gestalt Psychotherapist
Roundhay, Chapel Lane
Bransgore BH23 8BN
01425 673395
GPTI

JELFS, Martin
Humanistic and Integrative Psychotherapist
65 North Street
Wareham BH20 4AD
0973 504121/01929 556563
AHPP

LACY-SMITH, Jo
Humanistic and Integrative Psychotherapist
2 Ackerman Road
Dorchester DT1 1NZ
01305 266721
BCPC

LILLITOS, Aleathea G.
Child Psychotherapist
Dorset
01300 348 197
ACP

LIPSITH, Josie
Sexual and Relationship Psychotherapist
4 Martello Road
Branksome Park
Poole BH13 7DH
01202 709155
BASRT

LOGUE, Nancy
Sexual and Relationship Psychotherapist
Halves House, 132 East Street
Corfe Castle BH20 5EH
01929 481163
BASRT

LONG, Jennifer
Cognitive Behavioural Psychotherapist
Dept. of Psychological Therapies
16-18 Tower Road, Boscombe
Bournemouth BH1 4LB
01202 304634
BABCP

MARCH-SMITH, Rosie
Humanistic and Integrative Psychotherapist
Ellerslie
Cattistock
Dorchester DT2 0JL
01300 321355
AHPP

MARSHALL, Cherrith A.
Systemic Psychotherapist
Maple Young Peoples Service
Dorest Healthcare Trust
Shaftesbury Road
Poole, BH15 2NT
01202 667130
FIC

MOWLAN, Madeleine
Core Process Psychotherapist
6 Fleet Lane, Chickerell
Weymouth DT3 4DF
01305 854501/01305 772268
AAPP

NEWBERY, Christopher
Humanistic and Integrative
Psychotherapist
12 St. George's Avenue
Weymouth DT4 7TU
01305 786172
AHPP

NOTTINGHAM, Sue
Systemic Psychotherapist
Coach House, North Street
Bere Regis
Wareham BH20 7LA
01929 472645
KCC

OSTLER, Dorothy
Systemic Psychotherapist
Shelley Clinic
Boscombe Community Hospital
BH1 4JQ
01202 443011
FIC

PALMER, Dorothy
Sexual and Relationship Psychotherapist
Cobbler's Cottage
High Street
Burwash
East SussexHOW IS THIS DORSET
BH23 2AE
01435 883617
BASRT

PHILLIPS, Laurie
Psychoanalytic Psychotherapist
11 Viking Way
Mudeford,
Christchurch BH23 4AQ
01425 276417/01425 276278
AGIP

RAYMOND, Caroline
Hypno-Psychotherapist
Tower Hill Cottage
Tower Hill
Iwerne Minster DT11 8NH
01747 811071
NRHP

ROBINSON, Martin
Analytical Psychologist-Jungian Analyst,
Psychoanalytic Psychotherapist
White Hill Farmhouse
Stoke Wake
Nr. Blandford Forum DT11 0HF
020 8459 5442/01258 817301
AJA

ROSE, Stuart
Cognitive Behavioural Psychotherapist
Highfield, Lee Lane
Bridport DT6 4AJ
020 85759677/01308 458600
BABCP

RUBIE, Val
Attachment-based Psychoanalytic
Psychotherapist
5 Partway Lane, Hazelbury Bryan
Sturminster Newton DT10 2DP
CAPP

SEPPING, Paul
Group Analyst
Child Development Centre
Poole Hospital, Longfleet Road
Poole BH15 2JB
IGA

SONES, Joanne
Child Psychotherapist
West Dorset Childrens' Centre
Damers Road
Dorchester DT1 2LB
01305 254712
ACP

SONES, Michael
Child Psychotherapist
Child, Adolescent & Family Mental Health
Service
Poole General Hospital
Longfleet Road
Poole BH15 2JB
01202 442741
ACP

TOMLINSON, Andy
Hypno-Psychotherapist
71 Wareham Road
Corfe Mullen
Wimborne BH21 3JX
01202 659883
NSHAP

TRACY, Colin
Humanistic and Integrative
Psychotherapist
2 Ackerman Road
Dorchester DT1 1NZ
01305 266721
BCPC

VENKI, Malathi
Cognitive Behavioural Psychotherapist
11 William Road, Queens Park
Bournemouth BH7 7BB
01202 246719
BABCP

WALLACE-SMITH, Nigel
Sexual and Relationship Psychotherapist
Canford Cottage
27 Pottery Road
Poole BH14 8RA
01202 738052
BASRT

WATERFIELD, Julia
Integrative Arts Psychotherapist
1 Old Bakery Cottages
Charlton Marshall
Blandford Forum DT11 9NH
01258 480691
IATE

WEBSTER, Sarah Craven
Humanistic and Integrative
Psychotherapist
Bagley Cottage
Stoke Abbott
Beaminster DT8 3JN
01308 867114
SPEC

WILDASH, Sheila
Psychoanalytic Psychotherapist
10 Fairway Drive, Northmoor Park
Wareham BH20 4SG
01929 553097
AGIP

WILTSHIRE, Gill
Cognitive Behavioural Psychotherapist
61 Lowther Road
Bournemouth BH8 8NW
01202 398233
BABCP

WITHERS, Jacqueline M.J.
Cognitive Behavioural Psychotherapist
Addiction Service & Psychology
Department
16-18 Tower Road
Boscombe
Bournemouth BH1 4LB
01202 443200
BABCP

WOTTON, Annette
Psychoanalytic Psychotherapist
Bure Homage Lodge
Bure Lane
Christchurch BH23 4DP
01425 272 204
AGIP

ESSEX

ANDERSON, Janet
Child Psychotherapist
North Essex Child & Family Consultation
Service
Whitehills Road
Loughton IG10 1TS
01279 692300
ACP

ARUNDELL, Jane
Group Analytic Psychotherapist
49 Alfred Road
Brentwood CM14 4BT
01245 345345/01277 224618
FPC

BAYLEY, Sydney
Core Process Psychotherapist
44 Ernest Road, Wivenhoe
Colchester CO7 9LQ
01206 822 406
AAPP

BEIGHTON, Chris
Sexual and Relationship Psychotherapist
86 Greenhills
Harlow CM20 3SZ
01279 450285
BASRT

BINGHAM, Jane
Psychoanalytic Psychotherapist
20 Marine Close
Leigh-On-Sea SS9 2RD
01245 252414/01702 5588969
FPC

BRANKIN, Irene
Psychosynthesis Psychotherapist
14 Lynton Road
Hadleigh SS7 2QQ
01702 555420
AAPP

BRIGGS, Andrew
Child Psychotherapist
North Essex Child & Fam.Consult.Serv
Stanwell House, Stanwell Street
Colchester CO2 7DL
01206 287321/01206 560934
ACP

BRIGGS, Margarete
Psychoanalytic Psychotherapist
11 Home Close
Harlow CM20 3PD
01279 423093
CSP

BRITTEN, Stewart
Child Psychotherapist, Jungian Child
Analyst
The Rows, Layer de la Haye
Colchester CO2 0EU
01206 738299
ACP

BURTON, Jean
Family Therapist
St James House, Perry Road
Harlow CM18 7NP
01279 432626
AFT

CAMERON, Katherine
Psychoanalytic Psychotherapist
57 Castle Street
Saffron Waldon CB10 1BD
01799 527449
IPSS

CHAPMAN, Maureen R
Psychoanalytic Psychotherapist
The Rectory
Theydon Mount
Epping CM16 7PW
01992 578723
FPC

CLEMENTS, Sue
Family Therapist
The Acorns
220 Stamford Road
Dagenham RM9 4EL
020 8270 6572
AFT

CLEMENTS-JEWERY, Sue
Sexual and Relationship Psychotherapist
Bodey House
Stock Road
Stock CM4 9DH
01277 840668
BASRT

CLOWES, Brenda
Sexual and Relationship Psychotherapist
176 Princes Road
Buckhurst Hill IG9 5DJ
020 8505 8328
BASRT

COHN, Nancy
Child Psychotherapist, Psychoanalytic
Psychotherapist
Child & Family Consultation Service
62 Maidstone Road
Grays RM17 6NF
01375 816900/01245 516030
GUILD

COLLINS, Lynda
Systemic Psychotherapist
26 Guys Farm Road
South Woodham Ferrers
Chelmsford CM3 5NE
01245 320733
IFT

COUSSENS, Kay
Integrative Psychotherapist
42 Glenwood Drive, Gidea Park
Romford RM2 5AS
01708 755384
MC

CROUCH, Carol
Existential Psychotherapist
Woodside, 61 Russell Road
Buckhurst Hill IG9 5QF
020 8504 0059
RCSPC

D'AGUILAR, Yvonne
Systemic Psychotherapist
2 Link Way
Hornchurch RM11 3RW
KCC

DAVISON, Susan
Psychoanalytic Psychotherapist
55 Constantine Road
Colchester CO3 3DX
01206 512958
GUILD

DEEBLE, Elizabeth A.
Cognitive Behavioural Psychotherapist
Psychology Dept.
Goodmayes Hospital
Barley Lane
Goodmayes IG3 8XJ
020 8970 8434
BABCP

DEFRIES, Jeanne Margaret
Systemic Psychotherapist
Orchard Cottage, Shellow Road
Willlingale
Ongar CM5 0SS
01277 896233
KCC

EDEN, Sharon
Psychosynthesis Psychotherapist
128 Meads Lane
Seven Kings
Ilford IG3 8PE
020 8590 3850
AAPP

ELDER, Meldene
Systemic Psychotherapist
17 Cavenham Gardens
Hornchurch RM11 2AU
KCC

ELLIS, Sian
Psychoanalytic Psychotherapist
171 Theydon Grove
Epping CM16 4QA
020 7272 7013/01992 574018
AGIP

ERICH, Vicki
Sexual and Relationship Psychotherapist
236 Hamlet Court Road
Westcliffe-on-Sea SS0 7DE
01702 307493
BASRT

FOX, Almuth-Maria
Integrative Psychotherapist
101 Hadleigh Road
Leigh-on-Sea SS9 2LY
01277 840668/01702 472634
RCSPC

GALE, Derek
Humanistic Psychotherapist
The Gale Centre
Stable Cottage, Whitakers Way
Loughton IG10 1SQ
020 8508 9346
AHPP

GOODCHILD, Margaret
Child Psychotherapist
Maldon Child & Family Consultation
Service
Harkenwell
St. Peters Hospital
Spital Road,
Maldon CM9 8EG
01621 722900
ACP

GRAINGER, Eve
Child Psychotherapist
Barking & Dagenham Child & Family
Consult. Service
31 Woodward Road
Dagenham RM9 4SJ
020 8270 6427/8/020 8348 5457
ACP

GRAVELLE, John
Integrative Psychotherapist
8 Gordon Road
Chelmsford CM2 9LL
01245 491795
MC

GREATREX, Julian
Psychosynthesis Psychotherapist
15 Grange Avenue
Woodford Green IG8 9JT
020 8504 0191
AAPP

GREAVES, Thomas
Core Process Psychotherapist
4 Tylers Close
Loughton IG10 3BD
020 8502 1708
AAPP

GREENWOOD, Angela
Educational Therapist
34 Sea View Road
Leigh on Sea SS9 1AT
01702473540
FAETT

HACKER HUGHES, Jamie G.H.
Cognitive Behavioural Psychotherapist
7 Rainsford Avenue
Chelmsford CM1 2PJ
0966 370201
BABCP

HARVEY, Linda Mary
Cognitive Analytic Therapist
Norbrook, Eastwick
Nr. Harlow CM20 2QX
01279 410 435
ACAT

HEERAN, Rita
Psychoanalytic Psychotherapist
39b Selbourne Road
Ilford IG1 3AH
020 8514 0022
CPP

HENDRY, Devam
Psychosynthesis Psychotherapist
14 Home Close
Harlow CM20 3PD
01279 414470
AAPP

HOLLINGWORTH, Amanda
Sexual and Relationship Psychotherapist
Old Fairfields, Hatfield Peverel
Chelmsford CM3 2NT
01245 381480
BASRT

HORMASJI, Faridoon
Hypno-Psychotherapist
2A Cross Road
Romford RM7 8AT
020 7637 3377/01708 764740
NRHP

HOWARD, Trevor
Systemic Psychotherapist
10 Southsea Avenue
Leigh on Sea SS9 2AX
01702 474351
KCC

HOWTONE, Christina
Hypno-Psychotherapist
139 Sevenoaks Close
Harold Hill RM3 7EF
01708 373175
NSHAP

HUDSON, Rachel
Psychoanalytic Psychotherapist
30 Gordon Road
Ilford IG1 1SP
020 8553 3089
FPC

HURST, Margaret
Child Psychotherapist
North Essex Child & Family Consultation
Service
Rannoch Lodge
146 Broomfield Road
Chelmsford CM1 1RN
01245 544869
ACP

JACOBS, Linda
Family Therapist
101 Farmleigh Avenue
Clacton on Sea CO15 4UL
0410 186 263/020 7733 9617
IFT

JACOBSON, Rosemary
Integrative Psychotherapist
Dept. of Clinical Psychology
Mental Health Unit
Princess Alexandra Hospital
Harlow CM20 1QX
020 8444 8009/01279 827276
RCSPC

JOHNSTONE, Janice Mary
Hypno-Psychotherapist
40 Saffron Court
Saffron Walden CB11 4HB
01799 500540
NRHP

JONES, Amanda
Systemic Psychotherapist
King George Hospital
Paediatric Department
Barley Lane, Goodmayes
Ilford IG3 8YB
020 8846 1340/020 8970 8098
KCC

JULIEN, Michael
Integrative Psychotherapist
497 Aldborough Road North
Newbury Park
Ilford IG2 7SY
020 8599 0625
RCSPC

KENDRICK, Margaret
Hypno-Psychotherapist
3 Seaview Parade
Maylandsea CM3 6EL
01621 742745
NSHAP

KWEI, Caryl Lesley
Cognitive Behavioural Psychotherapist
6 Brentwood Place
Sawyers Hall Lane
Brentwood CM15 9DN
01227 226834
BABCP

KWEI, Daniel
Gestalt Psychotherapist
6 Brentwood Place
Sawyers Hall Lane
Brentwood CM15 9DN
01277 226834
GPTI

LAU, Annie
Family Psychotherapist
Child Guidance Clinic
Loxford Hall
Loxford Lane
Ilford IG1 2PL
020 7478 7211
IFT

LEWIS, Jo-Ann
Psychoanalytic Psychotherapist
6 Fairview Gardens
Woodford Green IG8 1BJ
020 8559 1318
AGIP

LLOYD, Roger
Group Analytic Psychotherapist
494 Heathway
Dagenham RM10 7SH
020 8984 9887
FPC

LOMOND, Lynne Marsha
Transactional Analysis Psychotherapist
97 Ladyshot
Harlow CM20 3EW
01279 413716(t/f)
ITA

MANNING, Anthony John
Family Therapist
12 The Drive
Loughton IG10 1HB
020 8478 3101/020 8281 7093
AFT

MATHEWS, Trevor J.
Cognitive Behavioural Psychotherapist
11 Arundel Mews
Billericay CM12 0FW
01277 631554/01245 351441
BABCP

MILLAR, David
Child Psychotherapist
North Essex Child & Family Consultation Service
Stanwell House, Stanwell Street
Colchester CO2 7DL
01206 287321/01206 768211
ACP

MORO, Julie Ann
Family Therapist
Lionmede
216 Springfield Road
Chelmsford CM2 6BN
01245 353 789/01277 636 242
AFT

NEENAN, Michael
Cognitive Behavioural Psychotherapist
36 Shearers Way
Boreham CM3 3AE
01245 468262
BABCP

NUTTAL, Clive
Integrative Psychotherapist
52 Chigwell Rise
Chigwell IG7 6AG
020 8500 7250
RCSPC

PARMLEY, Alison
Gestalt Psychotherapist
8 Orchard Close, Great Baddow
Chelmsford CM2 9SL
01245 600159
GPTI

PENN, Joyce
Hypno-Psychotherapist
213 York Road
Southend-on-Sea SS1 2RU
01702 462191
NRHP

PLOWMAN, Polly
Integrative Psychosynthesis Psychotherapist
71 South Street
Manningtree CO11 1DT
01206 393104
RE.V

PLUMMER, Glenys
Psychoanalytic Psychotherapist
"Conifers" Ravenstock Lane
Little Walden
Saffron Walden CB10 1XG
01799 522116
CSP

RAICAR, Maeja Alexandra
Attachment-based Psychoanalytic Psychotherapist
8 Feering Road
Billericay CM11 2DR
01268 770990
CAPP

REYNOLDS, Dorothy
Systemic Psychotherapist
6 Ruskin Dene, Lake Avenue
Billericay CM12 0AN
01277 653259
IFT

RICE, Paul
Behavioural Psychotherapist
Blackwater House
81 Riverside Way, Kelvedon
Colchester CO5 9LX
01376 571515/01277 223581
BABCP

RIX, Sandy
Sexual and Relationship Psychotherapist
Coopers, Coopers Hill
Ongar CM5 9EG
07050 162912/01277 362912
BASRT

RUGELEY, Brenda
Humanistic Psychotherapist
39 Woodland Way, Marden Ash
Ongar CM5 9EP
01277 363307
AHPP

SABAYINDA, Michael
Integrative Psychotherapist
287 Prittlewell Chase
Westcliffe-on-Sea
Southend SS0 0PL
01702 393680
RCSPC

SALMON, Cindy
Transpersonal Psychotherapist
Friars Cottages, 68 Castle Road
Colchester CO1 1UN
01206 573721
CTP

SCHREIBER, Kaye
Systemic Psychotherapist
8 Kenneth Road
Thundersley
01268 366 800
KCC

SCOTT, Michael
Group Analyst
20 Thornwood
Colchester CO4 5LR
01206 854965
IGA

SHOOTER, Lesley
Psychoanalytic Psychotherapist
38 Links Avenue, Gidea Park
Romford RM2 6ND
01708 760286
AIP

SHRIMPTON, David W
Psychodynamic Psychotherapist
Oakleigh, Church Road
Wickham St Paul CO9 2PN
01787 269594
WMIP

SMITH, Richard
Transpersonal Psychotherapist
15 Squirrel's Field
Myland Gate, Mill Road
Colchester 01206 844 032
CCPE

STABLEFORD, Joyce
Hypno-Psychotherapist
18 Alma Close
Benfleet SS7 2EG
01702 557 649
CTIS

STACEY-ONG, Lesley
Systemic Psychotherapist
9 The Copse, Bannister Green
Felsted nr Dunmow CM6 3NP
020 8984 1234/01371 821428
KCC

STEEL, Patricia
Hypno-Psychotherapist
Apple Bee, 56 Burnway
Emerson Park
Hornchurch RM11 3SG
01708 472573
NRHP

SUCHER, Ingerborg
Psychoanalytic Psychotherapist
The Priest's House, 2 Walden Road
Littlebury,
nr Saffron Walden CB11 4TA
01799 526437
IPSS

TAPANG, Peter
Family Therapist
23 Joydon Drive, Chadwell Heath
Romford RM6 4ST
020 8887 0606/
020 8220 7757/0956 947288
IFT

TEMPEST, Jeanette
Psychosynthesis Psychotherapist
21 St. Andrews Road
Shoeburyness SS3 9JA
01702 294 754
AAPP

TENG, Christina
Systemic Psychotherapist
33 Furrowfelde, Kingswood
Basildon SS16 5HA
01268 533769
KCC

THOMPSON, Joan
NLP Psychotherapist
31 Priory Crescent
Prittlewell
Southend-on-Sea SS2 6JY
01702 613828
ANLP

TROSH, Joanna
Cognitive Behavioural Psychotherapist
Behavioural Psychotherapy Dept.
Chelmsford and Essex Centre
New London Road
Chelmsford CM2 0QH
01245 287440
BABCP

TUNE, David
Body Psychotherapist, Integrative
Psychotherapist
23 Rectory Road
Wivenhoe CO7 9EP
01206 827863
CCBP

TURNER, Diana
Psychoanalytic Psychotherapist
2 Parsonage Terrace
Vicarage Road
Finchingfield CM7 4LD
01245 493622/01371 810727
ARBS

WALKER, Steven
Family Therapist
Naze Crest, 4 Sunny Point
Walton on the Naze CO14 8LD
01255 677830
AFT

WARNAKULA, Amina Bibi
Systemic Psychotherapist
5 Howard Road
Ilford IG1 2EX
KCC

WELSH, Anne
Psychosynthesis Psychotherapist
Blacksmith's Cottage
Clavering
Nr. Saffron Walden CB11 4QL
01799 550 024/020 8202 4525
AAPP

WESTCOTT, Bernard
Group Analyst
67 Somerset Road, Laindon
Basildon SS15 6PP
01268 450402/01268 450403
IGA

WHATLEY, Ann
Family Therapist
Ansden, 9 Colehills Close
Clavering
Saffron Walden CB11 4QY
01799 550807
AFT

WHEELEY, Eleanor
Sexual and Relationship Psychotherapist
Cromwell House
7 Cromwell Avenue
Billericay CM12 0AE
01277 624961
BASRT

WILLIAMS, Dorothea
Cognitive Behavioural Psychotherapist
14 Pudsey Hall Lane, Canewdon
Rochford SS4 3RY
01702 258764
BABCP

WOODCRAFT, Paul N
Cognitive Behavioural Psychotherapist
Chelmsford and Essex Centre
New London Road
Chelmsford CM2 0QH
01245 318611
BABCP

YUSEF, Dori Fatima
Transpersonal Psychotherapist
Dickens Lodge, High Road
Chigwell IG7 6QB
020 8502 7095
CCPE

GLOUCESTERSHIRE

ADAMS, Eve
Integrative Psychosynthesis
Psychotherapist
Lantern Cottage
Stockend, Edge
Stroud GL6 6PN
01452 813355
RE.V

AGAR, James
Transactional Analysis Psychotherapist
Spring Cottage, High Street
South Woodchester
Stroud, GL5 5EL
01453 872703
ITA

ALLAN, Kay
Psychoanalytic Psychotherapist
111 Promenade
Cheltenham GL50 1NW
01242 224779/01242 252902
SIP

ARREDONDO, Beverly
Transactional Analysis Psychotherapist
7 Mountpellier House
Suffolk Square
Cheltenham GL50 2DY
01242 243917/0958 945 496
ITA

BATTEN, Cecilia
Psychoanalytic Psychotherapist
58 Leckhampton Road
Cheltenham GL53 0BG
01242 521768
SIP

BAUM, Stefanie
Biodynamic Psychotherapist
16 Black Thorn End
Cheltenham GL53 0QB
01242 261197
BTC

BRUCE, Sue
Humanistic and Integrative
Psychotherapist
Pike Cottage, Pike Lane, Stroud GL6
01453 836823
BCPC

BURRITT, William
Analytical Psychologist-Jungian Analyst
1 Merestones Drive, The Park
Cheltenham GL50 2SU
01242 244744
IGAP

CARTER, Paula
Sexual and Relationship Psychotherapist
Seeps Barn
Calcot Farm, Calcot
Cheltenham GL54 3JZ
01285 720996
BASRT

CROSS, John
Psychoanalytic Psychotherapist
The Old Coach House
Lye Lane, Cleeve Hill
Cheltenham GL54 5DQ
01242 678895/01242 620125
AGIP

**DE HOOGH-ROWNTREE,
Patricia**
Analytical Psychologist-Jungian Analyst
Ivy Cottage, Church Lane
Sapperton
near Cirencester GL7 6LQ
01285 760209
CAP

DIEPEVEEN, Johanna Maria
Psychosynthesis Psychotherapist
Highfield Cottage
Ocker Hill, Randwick
Stroud GL6 6HY
01453 764215
AAPP

ELLIOTT, Lea K.
Psychoanalytic Psychotherapist
6 Halland Road, Leckhampton
Cheltenham GL53 0DG
01242 518 642
WMIP

FRYE, Helen
Psychoanalytic Psychotherapist
52 Gratton Road
Cheltenham GL50 2BY
01242 518113
SIP

GOODRICH, Anne
Psychoanalytic Psychotherapist
6 Wychbury Close
Leckhampton
Cheltenham GL53 0HT
01242 262526
FPC

GOWLING, David
Transactional Analysis Psychotherapist
Red House Farm
Foxmoor Lane, Westrip
Stroud GL5 4PL
01453 750716
ITA

GRACIE, Jane
Psychoanalytic Psychotherapist
10 Somerford Road
Cirencester GL7 1TN
01285 650143
SIP

GREATOREX, Christopher
Psychosynthesis Psychotherapist
Spout Cottage
Northfield Road
Nailsworth GL6 0NB
01453 836 077
AAPP

GROCOTT, Annie
Psychoanalytic Psychotherapist
20 Moorend Crescent
Leckhampton
Cheltenham GL53 0EL
01242 572290
SIP

HALL, Kelvin
Humanistic and Integrative
Psychotherapist
Cherry Tree Cottage, Shortwood
Nailsworth GL6 0SB
01453 833 861
BCPC

HEDLEY, Karen
Psychosynthesis Psychotherapist
47 Bisley Old Road
Stroud GL5 1LY
01453 763943
AAPP

HUMPHRIES, Harold
Psychoanalytic Psychotherapist
Praha
11 Heazle Place
Stroud GL5 1UW
01453 757900/020 7272 7013
AGIP

LESTER, Clare
Integrative Psychotherapist
24 Acre Street
Stroud GL5 1DR
01453 755241
MC

LUTHY, Barbara
Humanistic and Integrative
Psychotherapist
College Farm, Beacon Lane
Haresfield GL10 3ES
01452 720934
BCPC

MASLEN, Gill
Humanistic and Integrative
Psychotherapist
17 Gloucester Street
Cirencester GL7 2DP
01285 656280
BCPC

MCOSTRICH, June
Psychosynthesis Psychotherapist
Forge House
Kemble GL7 6AD
01285 770 538
AAPP

MILLAR, Peter
Analytical Psychologist-Jungian Analyst
Thistledown, Down Ampney
Cirencester GL7 5QU
0285/0285
AJA

MOGGRIDGE, Cass
Psychodrama Psychotherapist
Priory Mill
Kelmscott Road
Lechlade GL7 3HB
01367 253334
BPA

MOORE, Alan
Humanistic and Integrative
Psychotherapist
1 Jubilee Cottages
Brownshill
Stroud GL6 8AR
BCPC

MORRIS, Elizabeth
Humanistic and Integrative
Psychotherapist
Buckholdt House, The Street
Frampton on Severn GL7 7ED
01452 741106
AHPP

MORRIS, Stephen
Psychoanalytic Psychotherapist
53 Slad Road, Stroud GL5 1QT
01453 750765
SIP

PETERS, Maggie
Transpersonal Psychotherapist
Atcombe Court Wing
South Woodchester
Stroud GL5 5ER
01453 872709
CTP

SACKETT, Kate
Cognitive Analytic Therapist
Clinton Cottage
Silver Street, Chalford Hill
Stroud GL6 8EL
01453 882765
ACAT

SEIGAL, Elizabeth
Psychoanalytic Psychotherapist
Westbourne
43 Middle Street, Stroud GL5 1DZ
01453 751114
SIP

SHAW, Annie
Humanistic and Integrative
Psychotherapist
17 The Wordens, Stroud GL5 4RX
01453 752 484
BCPC

SILMON, Mary
NLP Psychotherapist
114 London Road GL2 0RR
01452 414976
ANLP

SKAILES, Claire
Analytical Psychotherapist
5 Fairview Terrace
Wallsquarry, Brimscombe
Stroud GL5 2PB
01453 885229
WMIP

STEPHENS, Lyn
Psychoanalytic Psychotherapist
9 Montpellier Grove
Cheltenham GL50 2XB
01242 521945
AGIP

THOMAS, Penny
Humanistic and Integrative
Psychotherapist
6 Wallow Green
Horsley, Nailsworth
Stroud GL6 0PB
0117 942 7889/01453 833752
BCPC

WARD, Shona
Transactional Analysis Psychotherapist
Spring Cottage, High Street
South Woodchester
Stroud GL5 5EL
01453 872703
ITA

WATKINS, Judy
Psychoanalytic Psychotherapist
Broadwell
Church Road, Leckhampton
Cheltenham GL51 5XX
01242 580214
SIP

WHITWELL, John
Group Analytic Psychotherapist
The Old Post Office
Somerford Keybes
Cirencester GL7 6DP
01285 861694
LCP

ZINKIN, Hindle
Analytical Psychologist-Jungian Analyst
The Coach House
Paradise
Painswick GL6 6TN
020 7435 9219/01452 812272
FIP

HAMPSHIRE

AMEZ, Susana
Child Psychotherapist
Child & Fam. Therapy Services
Battenburg Avenue Clinic
Battenburg Avenue, Northend
Portsmouth PO2 0TA
023 92653433
ACP

ANTHIAS, Louise
Family Therapist
Psychological Therapies
Dept of Psychiatry
Royal South Hants Hospital
Burtons Terrace SO14 0YG
02380 825392
IFT

ASHCROFT, Dinah
Gestalt Psychotherapist, Integrative
Psychotherapist
6–8 The Soke,
Alresford SO24 9DB
01962 733 219
GPTI

ATTRIDGE, Brian
Core Process Psychotherapist
Flat 1
16 Victoria Grove
Southsea PO5 1NE
023 92863266 (t/f)
AAPP

BARDEN, Nicola
Analytical Psychotherapist
9b Worsley Road, Southsea
Portsmouth PO5 3DY
01705 297585/01705 297585
WMIP

BARING, Anne
Analytical Psychologist-Jungian Analyst
White Lodge, Grange Park
Alresford SO24 9TG
01962 732744
AJA

BEACH, Jan D.
Cognitive Behavioural Psychotherapist
G Block
Royal Hospital Haslar
Gosport PO12 2AA
01705 762178/762421
BABCP

BENNETT, Ross
Humanistic and Integrative
Psychotherapist
Kwanti
Jermyns Lane, Ampfield
Romsey SO51 0QA
01794 368012
SPEC

BERRY, Eileen
Group Analyst
4 Eastgate Street
Winchester SO23 8EB
01962 854439
IGA

BLACK, Nicholas J.
Cognitive Behavioural Psychotherapist
Clinical Psychology Service
Royal Hampshire County Hospital
Romsey Road
Winchester SO22 5DG
01962 824351/023 80255568
BABCP

BOLTON, Jan
Systemic Psychotherapist
26 High Street, Odiham
Hants RG29 1LG
01483 782900/01256 701049
KCC

BORGHGRAEF, Guy
Sexual and Relationship Psychotherapist
Myrtle Cottage, Hastards Lane Selborne
GU34 3LB
01420 511440
BASRT

BOULD, Jane
Psychodrama Psychotherapist
17 Tudor Avenue
Emsworth PO10 7UG
01705 814545/01243 431637
BPA

BOYD, Ann A
Humanistic Psychotherapist
17 Kipling Close
Yateley GU46 6YA
01252 871731/01252 860486
AHPP

BRANDWOOD, Pat
Psychodrama Psychotherapist
59 Bassett Green Road
Southampton SO16 3DW
023 80556562
BPA

BROCK, Sue
NLP Psychotherapist
4 Paddockfields
Old Basing
Basingstoke RG24 7DB
01256 326176/354688
ANLP

CARRUTHERS, Dianna
Humanistic and Integrative
Psychotherapist
Portsmouth Natural Health &
Psychotherapy Centre
20 Landport Terrace
Portsmouth PO1 2RG
01705 830558
SPEC

CASSON, Isabel
Psychoanalytic Psychotherapist
7 Archery Lane
Winchester SO23 8GG
01962 878065
AGIP

CHARLEY, Geoff
Transpersonal Psychotherapist
2 Northend Farm Cottages
Milland
Near Liphook GU30 7LT
01428 741533
CCPE

CLANCY, J Patricia
Cognitive Behavioural Psychotherapist
Ravenswood House
Knowles Hospital
Fareham PO17 5NA
01329 836023
BABCP

CLARKE, Isabel
Cognitive Behavioural Psychotherapist
Psychological Therapies Service
Department of Psychiatry
Royal South Hants Hospital
Southampton SO14 0YG
023 80825531
BABCP

CLIFFORD-POSTON, Andrea
Educational Therapist
Osborne House
Kingsley GU35 9LW
01420 476042
FAETT

CLIFTON, Sandra
Sexual and Relationship Psychotherapist
3 Hermitage Gardens
Waterlooville PO7 7PR
BASRT

COLES, Peter J.
Cognitive Behavioural Psychotherapist
100B London Road
Cowplain
Waterlooville PO8 8EW
01705 251936
BABCP

COPLEY, Brian
Cognitive Behavioural Psychotherapist
Marchwood Priory Hospital
Hythe Road, Marchwood
Southampton SO4 4WU
023 80840044
BABCP

DAHLE, Josephine
Humanistic and Integrative
Psychotherapist
Grove Natural Therapy Centre
22 Grosvenor Road
Highfield
Southampton SO13 1RT
023 80582245
SPEC

DANIELS, Mo
Psychodrama Psychotherapist
14 Sir Georges Road
Southampton SO15 3AT
023 80227778
BPA

DE JONG, Corrie
Group Analytic Psychotherapist
47 Telegraph Lane
Four Marks GU34 5AX
01420 562802
FPC

DOLLERY, Jayne
Cognitive Behavioural Psychotherapist
Ravenswood House
Knowle Hospital
Fareham PO17 5NA
0958 311636/01329 836189
BABCP

DRAPER, Rosalind
Family Therapist, Systemic
Psychotherapist
37 Lower Wardown
Herne Farm
Petersfield GU31 4PA
029 20226532/01730 260023
IFT

DUPONT-JOSHUA, Aisha
Psychoanalytic Psychotherapist
32 Lark Rise
Liphook GU30 7QT
01428 727 694
NAFSI

DYER, Paula
Sexual and Relationship Psychotherapist
11 Basingbourne Close
Fleet GU13 9TF
01252 628744
BASRT

ELLIOTT, John
NLP Psychotherapist
Woolston Lodge Surgery
66 Portsmouth Road
Southampton SO19 9AL
023 80363568(f)/023 80363566
ANLP

ELLIOTT, Peter
Cognitive Behavioural Psychotherapist
Dept. of Psychology
Shackleton Building
University of Southampton
Highfield
Southampton SO17 1BJ
0589 658295/023 80595322
BABCP

EVANS, Peter L.
Child Psychotherapist
24 Chequers Road
Basingstoke RG21 7PU
01256 422771
ACP

FAWKES, Liz
Cognitive Analytic Therapist
Psychological Therapies Service
Dept of Psychiatry
Royal South Hants Hospital
Southampton
023 80634288 x2527
ACAT

FRY, Julie
Gestalt Psychotherapist
28 Church Road
Bishopstoke SO50 6BJ
01483 892599/023 80618582
MET

GLASSPOOL, Patricia
Hypno-Psychotherapist
The Southgate Natural Therapy Clinic
13 Southgate Street
Winchester SO23 9DZ
01962 866903/023 80255678
NRHP

GOOLD, Peter
Personal Construct Psychotherapist
Coudray House, Herriard
Nr Basingstoke RG25 2PN
01256 381787
CPCP

GORDON, P. Kenneth
Cognitive Behavioural Psychotherapist
Psychology Services
Winchester & Eastleigh HC Trust
59 Romsey Road
Winchester SO22 5DE
01962 825600
BABCP

GOSS, Diana S
Sexual and Relationship Psychotherapist
136 Highland Road
Southsea PO4 9NH
01705 830671
BASRT

GRAY, Sally
Cognitive Analytic Therapist
Psychotherapy Department
Royal Sourth Hants Hospital
Brintons Terrace
Southampton SO14 0YG
023 80634288
ACAT

GREAVES, Margaret
Humanistic and Integrative
Psychotherapist
85 Park Road, Chandler's Ford
Eastleigh SO53 1GL
023 80236604/01705 830558
SPEC

GREGORY, Peter
Sexual and Relationship Psychotherapist
19 Chatsworth Road
Boyatt Wood
Eastleigh SO5 4PE
023 80617990
BASRT

GURR, Rosalie
Sexual and Relationship Psychotherapist
The Old Village Stores
Braishfield
Romsey SO51 0PQ
01794 368315
BASRT

GUTHRIE, Barbara
Integrative Psychotherapist
44 Stanmore Lane
Winchester SO22 4AJ
023 80333778/01962 868990
RCSPC

HALL, Linda
Transpersonal Psychotherapist
The Maples
Lingmala Grove, Church Crookham
Fleet GU13 0JW
01252 628506 (t/f)
CCPE

HANNIGAN, David J.
Cognitive Behavioural Psychotherapist
Totton and Waterside L.M.H.T.
67-69 Ringwood Road
Totton SO40 8DX
023 80868886
BABCP

HATSWELL, Valerie
Psychoanalytic Psychotherapist
Stillions
Alton GU34 2RY
01420 82385
GCP

HENDRA, Theresa
Family Therapist
Portsmouth Healthcare NHS
The Merlin Centre,
19 Villiers Road
Southsea PO5 2NR
01705 293669/01705 821912
AFT

HOOK, Beatrice
Group Analyst
31 Southview Road, Shirley
Southampton SO15 5JD
023 80496488
IGA

HOOK, John
Group Analyst
31 Southview Road, Shirley
Southampton SO15 5JD
023 80825529/023 80496488
IGA

HOOPER, Christine M.
Family Therapist
"Ellesmere", The Crescent
Romsey SO51 7NG
01794 512102
IFT

HOPKINS, Vera M.
Psychodynamic Psychotherapist
"Oakwood"
4 The Grange, Everton
Lymington SO41 0ZR
01590 643335
HIP

HOWARTH, Kay
Sexual and Relationship Psychotherapist
175 Tangier Road
Copnor
Portsmouth PO3 6PG
BASRT

HURST, Hannah
Attachment-based Psychoanalytic
Psychotherapist
2 Oak Hurst Farm Cottage
Mill Lane
Steep GU32 2DJ
0498 765986
CAPP

JACKSON, Paul
Sexual and Relationship Psychotherapist
66 Middle Brook Street
Winchester SO23 8DQ
01962 622235
BASRT

**KIRKLAND-HANDLEY,
Nick V.**
Psychoanalytic Psychotherapist
c/o 89 Springvale Road
Kingsworthy
Winchester SO23 7RB
01962 880603
LPDO

LANE, Jeff
Humanistic and Integrative
Psychotherapist
1 Brooklands Road
Havant PO9 3NS
01705 782987/023 80582245
SPEC

LANG, Christine
Sexual and Relationship Psychotherapist
15 Douro Close
Baughurst
Tadley RG26 5PG
0118 981 2748
BASRT

LETHBRIDGE, Sue
Psychoanalytic Psychotherapist
41 Laburnum Grove
North End
Portsmouth PO2 0HQ
01626 867210/01705 662715
AGIP

LEVER, Maureen
Integrative Psychotherapist
Nelson House, 15 High Street
Old Portsmouth PO1 2LP
01705 838625
RCSPC

LIPPITT, Gwenda
Psychoanalytic Psychotherapist
Loyal Cottage
3 The Street, Old Basing
Nr. Basingstoke RG24 0BH
01256 21178
CPP

LUNT, Aidan
Psychoanalytic Psychotherapist
The Firs, 1 Barrs Wood Road
New Milton BH25 5HS
07803 766478
NWIDP

LYON, Heather
Group Analyst
University of Poertsmouth, Counselling
Service
Gun House, Hampshire Terrace
Portsmouth
01705 843 157
IGA

MALONE, Sue
Sexual and Relationship Psychotherapist
Tresco
Forest Road
Liss Forest GU33 7BL
01730 893034
BASRT

MASSARA, Catharine
Integrative Psychotherapist
Westfield Farm Cottage
Westfield Farm
Chariton SO24 0NT
01962 771 965
RCSPC

MATTHEWS, Helen P.
Cognitive Behavioural Psychotherapist
Western Community Hospital
Walnut Grove, Millbrook
Southampton SO16 4XE
01277 634817/01277 631554
BABCP

MELDRUM, Ron
Rational Emotive Behaviour Therapist
12 Atherley Road
Upper Shirley
Southampton SO15 5DQ
07970 3366471/023 80631308
BABCP

MEREDITH, Judith
Transpersonal Psychotherapist
1 Green Leys
Church Crookham
Fleet GU13 0PN
01252 628428
CCPE

MOORE, Terry
NLP Psychotherapist
58 Northern Parade
Portsmouth PO2 8NE
01705 291867
ANLP

MULVEY, Josephine
Sexual and Relationship Psychotherapist
3 Combe Down, Shawford
Nr. Winchester SO21 2AA
01962 715130
BASRT

O'CONNOR, Michael
Systemic Psychotherapist
136 Alexandra Road
Farnborough GU14 6RN
01252 515053
KCC

PARRACK, Norma
Rational Emotive Behaviour Therapist
Central Hall, St Marys Street
Southampton SO16 7DL
023 80237230
BABCP

PERCY, David
Psychoanalytic Psychotherapist
10 Nightingale Close
Winchester SO22 5QA
0788 1511824/01962 877962
GUILD

PIDGEON, Patricia
Systemic Psychotherapist
Family Consultancy
Charlton Road Health Centre
Andover
01264 835356
KCC

PLATTS, June Elizabeth
Cognitive Behavioural Psychotherapist
24 Telegraph Lane, Four Marks
Alton GU34 5AX
01420 561797
BABCP

PUGH, Anna
Body Psychotherapist, Integrative
Psychotherapist
Old Place, 91 Manor Way
Lee-on-the-Solent PO13 9JQ
01705 550757
CCBP

QUIN, Barbara
Family Therapist, Psychodrama
Psychotherapist
9 Campbell Road
Southsea PO5 1RH
01705 294818
BPA

RICKETTS, Susan
Child Psychotherapist
Child & Family Health Centre
Ashurst Hospital
Lyndhurst Road, Ashurst
Southampton SO40 7AR
023 80743031
ACP

RIDLEY, Stella*
Lacanian Analyst, Psychoanalytic
Psychotherapist
"Empatjy",C&N Gosport Marina
Mumby Road
Gosport PO12 1AH
0411 756040
CFAR

ROBINSON, Margaret
Family Therapist, Systemic
Psychotherapist
Merryways, Owslebury
Winchester SO21 1LP
01962 777368
IFT

ROSE-SMITH, Gillian
Humanistic and Integrative
Psychotherapist
Portsmouth Natural Health &
Psychotherapy Centre
20 Landport Terrace
Portsmouth PO1 2RG
01705 830558
SPEC

ROSS, Susan M.
Cognitive Behavioural Psychotherapist
Clinical Psychology Department
Department of Psychiatry
Royal South Hants Hospital
Southampton SO14 6HW
023 80825531
BABCP

SALTER, Gill
Humanistic and Integrative
Psychotherapist
The Grove Centre
22 Grosvenor Road
Southampton SO17 1RT
023 80582245
SPEC

SCHEMBRI, Veronica
Humanistic Psychotherapist
67 Monarch Close
Hatch Warren
Basingstoke RG22 4XS
01978 860337/01256 465853
AHPP

SCOTT, Brigitte
Biodynamic Psychotherapist
6 Alden Drive, Aldenholt
Fordingbridge SP6 3EP
01425 652577
BTC

SEYMOUR, E. John
Psychoanalytic Psychotherapist
Racton
36 Breach Avenue
Emsworth PO10 8NB
01243 373608
GCP

SHELLEY, Trevor
Sexual and Relationship Psychotherapist
Fernside, Crookhill
Braishfield SO51 0QB
01794 368169
BASRT

SMITH, Peter
Psychoanalytic Psychotherapist
53 North Street
Pennington
Lymington SO41 8GB
01590 688064
ARBS

STANDEN, Ruth
Sexual and Relationship Psychotherapist
26 West Downs Close
Fareham PO16 7HW
01329 319283
BASRT

STANWOOD, Frederick
Psychoanalytic Psychotherapist
34 St. David's Road
Southsea
Portsmouth PO5 1QN
01705 793983
AGIP

STIMPSON, Quentin
Transpersonal Psychotherapist
2 Derlyn Road
Fareham PO16 7TJ
01329 826 621
CCPE

STOLTE, Eva
Psychoanalytic Psychotherapist
34 St. David's Road
Southsea
Portsmouth PO5 1QN
01705 793983
AGIP

SWINDEN, Penni
Autogenic Psychotherapist
Meadow Thatch
Mount Pleasant Lane, Sway
Lymington SO41 8LS
01590 683 653/01590 683 963
BAS

SYMES, Jan
Systemic Psychotherapist
Butts Cottage, The Butts
Alton GU34 1RD
01420 84622
BASRT

THOMPSON, Fiona
Integrative Psychotherapist
69 Roselands Gardens
Highfields
Southampton SO17 1QJ
023 80581109
RCSPC

WILLIAMS, Ann
Hypno-Psychotherapist
Centre for Personal & Professional
Development
The Brewery, Twyford, Nr Winchester
SO21 1RQ
01962 714621/01962 715838
NRHP

WILLIAMS, Katherine
Integrative Psychotherapist
No 5 Oxford Street
Southampton SO14 3DJ
023 80652268/023 80476717
RCSPC

HEREFORDSHIRE

ANDERSON, Christine
Cognitive Behavioural Psychotherapist
Old House, Yarpole
Near Leominster HR6 0BE
01568 780621
BABCP

ASTON, John
Integrative Psychotherapist
Community Mental Health
Rose Cottage
Belle Orchard, Ledbury HR8 1DD
01531 633872/01989 740232
RCSPC

BRUNT, Mervyn
Transactional Analysis Psychotherapist
Willow Glen, 19 Clive Street
Hereford HR1 2SB
01432 370760/01432 342789
ITA

BURROWS, Joanna
Family & Systems Therapist
Clifton Lodge, Tedstone Delamere
Bromyard HR7 4PR
07974 378081/0161 495 4902
AFT

BURSTON, Helen
Humanistic and Integrative
Psychotherapist
4 Velot Barns, Much Marcle
nr Ledbury HR8 2ND
01531 660 465
BCPC

BYRNE, Deidre
Psychoanalytic Psychotherapist
Aricon, Bromsash
Ross-on-Wye HR9 9PJ
01989 7504267
IPSS

DAVIES, Stephen
Cognitive Behavioural Psychotherapist
Alcohol Service Herefordshire
Stonebow Unit
County Hospital
Union Walk HR1 2ER
0468 750591/01432 355 444
BABCP

ELLIS, Blythe
Psychoanalytic Psychotherapist
Shinns Croft
Bosbury Ledbury HR8 1QD
01531 640 552
WMIP

FENTON, Christopher M T
Psychoanalytic Psychotherapist
The Leys, Aston, Kingsland
Leominster HR6 9PU
01568 708632
FPC

FORRYAN, Barbara
Psychoanalytic Psychotherapist
5 Dormington Drive
Tupsley
Hereford HR1 1SA
SIP

FOSTER, Lesley
Humanistic and Integrative
Psychotherapist
Keepers Cottage, 67 Stoke Editt
Hereford HR1 4HQ
01432 761366
BCPC

JACOBS, Paula
Transpersonal Psychotherapist
The Wren's Nest
Brampton Road, Madley
Hereford HR2 9LU
01981 250597
CCPE

OLIVER, Jenny
Psychosynthesis Psychotherapist
The Willows, Yarkhill
Hereford HR1 3TE
01531 670 477
AAPP

PALMER BARNES, Fiona
Analytical Psychologist-Jungian Analyst,
Psychoanalytic Psychotherapist
Rock Cottage
Newton, St. Margarets HR2 0QW
01932 370760/01981 510613
AJA

SHORE, Barbara
Systemic Psychotherapist
7 Hagley Orchard, Bartestree
Hereford HR1 4BU
01432 851210
FIC

STERN, Michele
Child Psychotherapist
Hereford Child & Family Guidance
Centre
Gaol Street
Hereford HR1 2HU
01432 357351
ACP

TURNER, Philip
Psychoanalytic Psychotherapist
Roundway House
48 Southbank Road
Hereford HR1 2TL
01432 355746
SIP

HERTFORDSHIRE

ADCOCK, Margaret
Family Psychotherapist
1 Cunningham Hill Road
St. Albans AL1 5BX
01727 858276
IFT

ALDRED, Sue
Transpersonal Psychotherapist
18 Baldock Road
Letchworth SG6 3JX
01462 480 336
CCPE

ALLPORT, Maggie
Gestalt Psychotherapist
65 Mymms Drive
Brookmans Park
Hatfield AL9 7AE
01707 661301
GCL

ANDERSON, Eleanor
Systemic Psychotherapist
9 Moneyhill Road
Rickmansworth WD3 2EE
KCC

BACTAWAR, Charles D.
Cognitive Behavioural Psychotherapist
82 St Annes Road, London Colney
St. Albans AL2 1NY
01727 823675
BABCP

BALLANCE, Gillian
Analytical Psychologist-Jungian Analyst
30 Westminster Court
St. Albans AL1 2DX
01727 858361
CAP

BARRATT, Sara
Systemic Psychotherapist
26 Bushey Grove Road
Bushey WD2 2JQ
020 7435 7111/01923 817247
IFT

BEAUMONT, Anne
Integrative Psychotherapist
2 Field Lane
Letchworth SG6 3LE
01462 625674
MC

BERGER, Iris
Sexual and Relationship Psychotherapist
18 Chalk Lane, Cockfosters
Barnet EN4 9HJ
BASRT

BERRY, Peter*
Psychoanalytic Psychotherapist
9 Sandridgebury Lane
St. Albans AL3 6DD
01727 761789
GUILD

BEVAN, Judith
Systemic Psychotherapist
14 Cranfield Crescent
Cuffley, nr. Potters Bar EN6 4EA
KCC

BIRD, Jane
Autogenic Psychotherapist
18 Holtsmere Close
Garston
Watford WD2 6NG
01923 675501
BAS

BLACKER, Sandra Rosamond
Systemic Psychotherapist
7 Jill Grey Place
Queens Gate Mews
Hitchin SG4 9YH
KCC

BUCHAN, Ann
Group Analytic Psychotherapist
121 Leggatts Way
Watford WD2 6BQ
01923 676278
FPC

BUCKROYD, Julia
Psychoanalytic Psychotherapist
15 Heath Road
St. Albans AL1 4DS
01727 841007
GUILD

BUDGELL, Rosemary
Integrative Psychotherapist
32 Hobbs Hill road
Hemel Hempstead HP3 9QH
01442 390556/01582 488808
RCSPC

BUDNICK, Susan
Psychoanalytic Psychotherapist
58 Shenley Hill
Radlett WD7 7BD
01923 469041
ARBS

BUSOLINI, Don
Hypno-Psychotherapist
45 Valley Road
Welwyn Garden City AL8 7DH
01707 330557
NSHAP

BUTCHER, Marilyn
Integrative Psychosynthesis
Psychotherapist
7 Yew Grove
Welwyn Garden City AL7 2HY
01582 794762/01707 895623
RE.V

BYNG, R K
Sexual and Relationship Psychotherapist
The Flint Cottage, Harthall Lane
Kings Langley WD4 8JW
BASRT

CHARTER, Anne
Attachment-based Psychoanalytic
Psychotherapist
2 The Brambles, Prospect Road
St. Albans AL1 2DP
01727 848532
CAPP

CLOVER, Gillian
Psychosynthesis Psychotherapist
19 Chapel Street
Tring HP23 6BL
01442 825706
AAPP

CLULOW, Christopher
Psychoanalytic Marital Psychotherapist
62 Clarence Road
St Albans AL1 4NG
020 7435 7111/01727 868 108
TMSI

COBDEN, Vivienne
Psychoanalytic Psychotherapist
53 Little Bushey Lane
Bushey WD2 3SD
020 8950 4301
FPC

COHEN, Barbara
Family Therapist
57 Valley Road
Chorleywood WD3 4DT
01923 773 984
AFT

COLLINS, Leila
Integrative Psychotherapist
2 King Edward Road
Barnet EN5 5AP
020 8362 6734/020 8440 9776
RCSPC

COLMAN, Warren
Analytical Psychologist-Jungian Analyst,
Psychoanalytic Marital Psychotherapist
2nd Floor, 16 Chequer Street
St. Albans AL1 3YD
01727 858380/01727 810337
TMSI

CORDER, Elizabeth
Family Therapist
6 St Albans Road, Codicote
Hitchin SG4 8UT
01438 820059
AFT

CROFT, Janet
Core Process Psychotherapist
24 Long View
Berkhamsted HP4 1BY
01442 872 822
AAPP

CULLINAN, Deborah
Child Psychotherapist
209 Ebberns Road
Hemel Hempstead HP3 9RD
01442 218478
ACP

DAVIES, Lorraine
Systemic Psychotherapist
Ripley, 1a Beechcroft Road
Bushey WD2 2JU
01923 492215
IFT

DAVIS, Gill
Systemic Psychotherapist
Double Two Consultancy
P O Box 251
Hatfield AL10 8ZL
KCC

DOREY, Mary
Psychodynamic Psychotherapist
6 Victoria Crescent
Royston SG8 7AX
01763 242157
AIP

EGAN, Jude
Systemic Psychotherapist
33 North Road
Berkhamstead HP4 3DU
KCC

ELDON, Martin
NLP Psychotherapist
Broomfield Cottage, The Heath
Hatfield Heath CM22 7DZ
01279 731649
ANLP

EVEREST, Pauline
Psychoanalytic Psychotherapist
79 Whitney Drive
Stevenage SG1 4BL
01438 357151
AIP

FALKOWSKA, Merlyn
Biodynamic Psychotherapist
Dovedale Cottage
28 Chipperfield Road, Apsley
Hemel Hampstead HP3 0AS
01442 264203
BTC

FAUSSET, Ann
Systemic Psychotherapist
21 Royal Oak Lane, Pirton
Hitchin SG5 3QT
01462 712343
KCC

FEENEY, Michael
Group Analyst
34 Money Hill Road
Rickmansworth WD3 2EQ
01923 775 875
IGA

FERNANDEZ, Florence
Systemic Psychotherapist
22 Firwood Avenue
St Albans AL4 0TF
01727 857575
KCC

FOX, Annie
Transpersonal Psychotherapist
11 Fishers Close
Bushey WD2 2GY
CCPE

FREE-PEARCE, Carolyn
Autogenic Psychotherapist
13 Northaw Park
off Coopers Lane Road, Northaw
Nr. Potters Bar EN6 4BY
01707 664224
BAS

FRIEND, Sue
Systemic Psychotherapist
1 The Cottages
Bull Stag Green
Hatfield AL9 5DE
01707 273894
KCC

GOODMAN, Jenny
Integrative Psychotherapist
83 Clifford Road
Barnet EN5 5NZ
020 8441 8779
RCSPC

GOURNAY, Kevin
Behavioural Psychotherapist
14 Cassandra Gate
Cheshunt EN8 0XE
01992 446817/020 8882 8191
BABCP

GRAFF, Avril
Group Analytic Psychotherapist
12 Evelyn Road
Cockfosters EN4 9ST
020 8441 6905
FPC

GRAY, Anne
Psychoanalytic Psychotherapist
55 Watford Road
St. Albans AL1 2AE
01727 852669
GUILD

GRUBER, Angela
Transpersonal Psychotherapist
204 Nevells Road
Letchworth SG6 4TZ
01462 635027
CCPE

GUNTON, Gaye
Integrative Psychotherapist
106 Oaklands Avenue, Oxhey
Watford WD1 4LW
01923 828948/01923 241626
RCSPC

HADDON, Jarmaine
Systemic Psychotherapist
Greenacres, Staines Green
Nr Hertford SG14 2LN
01992 583965
KCC

HALE, John
Systemic Psychotherapist
9 Park Avenue
Watford WD1 7HR
01923 461553
AFT

HALLETT, Caroline
Psychoanalytic Psychotherapist
111 Ware Road
Hertford SG13 7EE
01992 504662/01992 503544
AGIP

HAMILTON, Kim
Psychoanalytic Psychotherapist
224 Hagden Lane
Watford WD1 8LS
0467 264510/01923 212230
AGIP

HARRIS, Dianne
Analytical Psychologist-Jungian Analyst
6 Whitelands Avenue, Chorleywood
Rickmansworth WD3 5RD
01923 283600
CAP

HARRISON-MAYOR, Susan
Analytical Psychologist-Jungian Analyst,
Integrative Psychotherapist
86 Handside Lane
Welwyn Garden City AL8 6SJ
01707 320782
AJA

HARVEY, Pam
Systemic Psychotherapist
42 Barleycroft Road
Welwyn Garden City AL8 6JU
020 8970 8434/01707 322 339
KCC

HONIG, Peter
Family Therapist
Hope Cottage, 77 Orchard Road
Melbourn SG8 6BB
01763 262906/01763 261696
AFT

HOWELLS, Megan
Psychoanalytic Psychotherapist
11 Broad Green Wood
Bayford SG13 8PS
01992 511294
IPSS

HUISH, Margot
Sexual and Relationship Psychotherapist
96 Hadley Road
New Barnet EN5 5QR
020 8440 4092
BASRT

HUMPHREYS, David
Family Therapist
Family Works, Thorley Health
Thorley Centre
Bishops Stortford CM23 2TE
0850 193501/01279 757571
IFT

HUSZCZA, Anna K.
Cognitive Behavioural Psychotherapist
Watton Place Clinic, 60 High Street
Watton-At-Stone SG14 3TA
01582 757765
BABCP

JAMIESON, Eileen
Family Therapist
4a Hubbards Road
Chorleywood WD3 5JJ
01923 282965
AFT

KANJI, Nasim
Autogenic Psychotherapist
147 Hampermill Lane
Oxhey WD1 4PH
01923 225402
BAS

KELL, Midge
Psychoanalytic Psychotherapist
6 Hall Grove
Welwyn Garden City AL7 4PN
01707 34552(t/f)
FPC

LAKEMAN FRASER, Judith
Analytical Psychotherapist
3 Old London Road
St Albans AL1 1QE
01727 842739
AIP

LAW, Heather
Psychoanalytic Psychotherapist
22 Legatts Close
Watford WD2 6BG
01923 671311
IPSS

LEARY-JOYCE, John
Gestalt Psychotherapist
64 Warwick Road
St. Albans AL1 4DL
01727 864806
GCL

LETTS, Muriel
Psychoanalytic Psychotherapist
67 Strafford Gate
Potters Bar EN6 1PR
01707 665423
IPSS

LOVE, Jasminder Kaur
Psychoanalytic Psychotherapist
2 Abrams Lane, Chrishall SG8 8QD
01763 838 510
NAFSI

MAUDLING, Caroline
Gestalt Psychotherapist
7 Holwell Court, Hertford Road
Essendon, Nr. Hatfield AL9 5RE
01707 257366
SPTI

MCCANN, Anita
Child Psychotherapist
Barnet Child & Family Consultation
Service
Vale Drive Child Guidance Clinic
Vale Drive
Barnet EN5 2ED
020 8440 8668/020 7538 3698
ACP

MCCANN, Damian
Family Therapist, Sexual and Relationship
Psychotherapist, Systemic
Psychotherapist
35 Hart Road
St. Albans AL1 1NF
01727 856690
IFT

MCCARTNEY, Meryl
Child Psychotherapist
Marlowes Health Centre
Marlowes
Hemel Hempstead HP1 1HE
01442 259132
ACP

MILANI, Belinda
Systemic Psychotherapist
Westfield Gardener's Cottage
Grubbs Lane, Nr. Hatfield AL9 6EF
01707 659326
KCC

MITCHELL, Richard
Individual and Group Humanistic
Psychotherapist
31 Chiswell Green Lane
St. Albans AL2 3AJ
01727 851251
AHPP

MOORE, Maureen
Integrative Psychotherapist
Avoca
18 Albury Ride
Chestnut EN8 8XF
01992 633100
MET

MORGAN, Barbara
Gestalt Psychotherapist
32 Church Road, Stotford
Hitchin SG5 4NB
01767 601259/01462 733267
GCL

MORRISON, Barbara
Integrative Psychotherapist
35 Drury Road, Hadley Green
Barnet EN5 5PU
020 8440 4584
MC

NAYLOR-SMITH, Alan
Psychoanalytic Psychotherapist
2 Fishery Passage
Horsecroft Road
Hemel Hempstead HP1 1RF
01442 247230
GUILD

NGONE, Mary
Integrative Psychotherapist
19 On-the-hill
Carpenders Park
Watford WD1 5DS
020 8950 9090 x240/1/
020 8421 2419
RCSPC

O'LEARY, Brid
Systemic Psychotherapist
3 Langley Crescent
St Albans AL3 5RS
KCC

PALLENBERG, Sue
Sexual and Relationship Psychotherapist
101 St. Albans Road, Sandridge
St. Albans AL4 9LH
01727 832403
BASRT

PARR, Meriel A
Integrative Psychotherapist
"Derwood", Todds Green
Stevenage SG1 2JE
01438 748478/01438 361491
RCSPC

PATCHETT, Angela
Transpersonal Psychotherapist
Mimosa Cottage
9 Springhead
Ashwell SG7 5LL
01462 743109
CCPE

PAWSON, Chris
Biodynamic Psychotherapist
10 Hunters Park
Berkhamstead HP4 2PT
01442 862029
BTC

PAWSON, Sheila
Biodynamic Psychotherapist
10 Hunters Park
Berkhamstead HP4 2PT
01442 862029
BTC

PAYNE, Helen
Humanistic Psychotherapist
1 The Wick
High Street
Kimpton SG4 8SA
01438 833440/01707 285861
AHPP

PIKE, Margery
Family Therapist
19d Hill Street
St. Albans AL3 4QS
01727 830059
IFT

PINCH, Christine
Autogenic Psychotherapist
37 Ramsbury Road
St. Albans AL1 1SN
01727 851574
BAS

POOLEY, Jane
Systemic Psychotherapist
Saw Mill Cottage
Water End Lane, Ayot Green
Welwyn AL6 9BB
01707 395006
IFT

POPPLE, Gillian
Integrative Psychotherapist
27 St. John's Road
Watford WD1 1PY
01923 247567
RCSPC

POZZI, Maria E.
Child Psychotherapist
North Herts Consultation Clinic
Southgate Health Centre
Stevenage SG1 1HB
01438 781406/7/020 8340 6167
ACP

REDMILL-SORENSEN, Bernice
Integrative Psychotherapist
9 Selwyn Avenue
Hatfield AL10 9WR
01707 273457
RCSPC

RENWICK, John
Transactional Analysis Psychotherapist
101 St. Albans Road, Sandridge
St. Albans AL4 9LM
01727 832403
MET

RICHARDSON, Elizabeth
Analytical Psychologist-Jungian Analyst
43 Barleycroft Road
Welwyn Garden City AL8 6JX
01707 336696
FIP

RICHTER, Nicola
Transpersonal Psychotherapist
63 Doggetts Way
St Albans AL1 2NF
01727 750088
CCPE

RICKETT, Marion
Psychoanalytic Psychotherapist
15 George Street, Old Town
Hemel Hampstead HP2 5HJ
01442 250294/01442 261712
GUILD

ROSSOTTI, Nicole
Personal Construct Psychotherapist
22 Church End, Redbourn
Nr. St Albans AL3 7DU
01582 792 970
CPCP

SHERNO, Peggy
Gestalt Psychotherapist
22 Garden Row
Hitchin SG5 1QD
01462 432439
GCL

SLADDEN, Anna
Analytical Psychologist-Jungian Analyst
45 Kings Road
Berkhamsted HP4 3BJ
01442 862072
CAP

SPROUL-BOLTON, Robin
Group Analyst
c/o Shrodell's Unit
Watford General Hospital
Vicarage Road
Watford WD1 8HD
01923 217 561
IGA

SPYROPOULOS, Nick
Child Psychotherapist
74 Normandy Road
St. Albans AL3 5PW
01727 54402
ACP

STACEY, Linda
Psychosynthesis Psychotherapist
218 Stanstead Road
Bishops Stortford CM23 2AR
01279 504048
AAPP

STEEL, Sandra
Integrative Psychotherapist
10 Abbotts Park, London Road
St Albans AL1 1TW
01727 830378
MC

STOLEAR, Meir
Rational Emotive Behaviour Therapist
10 Hammond Close
Stevenage SG1 3JQ
01438 364638
BABCP

STOVELL, Joy
Psychoanalytic Psychotherapist
46 Oakroyd Avenue
Potters Bar EN6 2EL
01707 655464
IPSS

TAGUE, Jackie
Systemic Psychotherapist
88 Common Rise
Hitchin SG4 0HS
KCC

THIEL, Geoffrey
Transpersonal Psychotherapist
17 Browning Road
Harpenden AL5 4TS
01582 764579
CCPE

THORMAN, Chris
Personal Construct Psychotherapist
115 Pickford Hill
Harpenden AL5 5HJ
01582 712454
CPCP

TIDY, Deirdre
NLP Psychotherapist
8 Herkomer Road
Bushey WD2 3NL
020 8950 1825
ANLP

TIMMANN, S.P
Cognitive Behavioural Psychotherapist,
Hypno-Psychotherapist, Transpersonal
Psychotherapist
16 Brackendene
Bricket Wood
St. Albans AL2 3SX
01923 672880
NRHP

TOMPKINS, Susan E
Psychoanalytic Psychotherapist
43 Ridge Lea
Hemel Hempstead HP1 2AZ
01442 249919
FPC

VINE, Mike
Family Therapist
27 Eastbury Court
St Albans AL1 3PS
01727 841610
AFT

WALKER, Jillian
Integrative Psychotherapist
209 Chambersbury Lane
Hemel Hempstead HP3 8BQ
01442 256738/01442 221651
RCSPC

WANLESS, Anna
Integrative Psychotherapist
36 Cedar Road
Berkhamstead HP4 2LB
01442 864 708/020 7328 7641
MC

WANLESS, Peter
Integrative Psychotherapist
36 Cedar Road
Berkhamsted HP4 2LB
01442 864708/020 7328 7641
MC

WEBB, Ann
Systemic Psychotherapist
30 Royal Oak Lane, Pirton
Hitchin SG5 3QT
01462 712304
KCC

WHAN, Michael
Analytical Psychologist-Jungian Analyst
25 Cravells Road
Harpenden AL5 1BA
01582 763062
IGAP

WHEELER, Maria
Systemic Psychotherapist
64 Gloucester Road
New Barnet EN5 1NB
01432 781 406/020 8440 8693
KCC

WINDER, Joy Ruth
Integrative Psychotherapist
86 Gurney Court Road
St Albans AL1 4RG
01727 852 035
MC

WISEMAN, Anna
Integrative Psychotherapist
Kettle Barn, Kettle Green
Much Hadham SG10 6AE
01279 842739
MC

WOODER, Bernard
Core Process Psychotherapist
17 Farrant Way
Borehamwood WD6 4TE
020 8207 3457
AAPP

WOODWARD, Jan
Systemic Psychotherapist
19 Valley Road, Codicote
Hitchin SG4 8YA
01438 820681
KCC

WOOLF, Ralph
Psychoanalytic Psychotherapist
3 Burywick, Beeson End
Harpenden AL5 2AD
01582 761472
FIP

BLACKBURN, Paul
Systemic Psychotherapist
Station House
Station Road
Gt. Hatfield
Hull
East Yorkshire HU11 4UY
01964 536327
IFT

BLAKE, Nancy
NLP Psychotherapist
102 Park Avenue
Kingston upon Hull
North Humberside HU5 3ET
01482 447765 (t/f)
ANLP

BOLSOVER, G.N.
Family Therapist, Psychoanalytic
Psychotherapist
6A Station Road, Brough, Nr. Hull
East Yorkshire HU15 1DX
01482 641579/01482 665412
HIP

DERRICK, Stephen
Gestalt Psychotherapist
7 Highfield, Sutton
Hull HU7 4TW
01482 712283
SPTI

EMM, Susan
Transpersonal Psychotherapist
The Rectory, Church Lane
North Thoresby, Lincs DN36 5QG
01472 840029
CCPE

FISHER, Paul
Integrative Psychotherapist
23 Eastfield Road, Keyingham
Hull HU12 9RY
01946 662 3768
SPTI

HOSTICK, Kathie
Transactional Analysis Psychotherapist
"Belcarres", 735 Holderness Road
Hull HU8 9AR
01482 701268
ITA

HUBBARD, Leslie
Systemic Psychotherapist
242 Great Thornton Street, Hull
East Yorks HU3 2LS
01482 321470
IFT

LEHAIN, Daniel
Gestalt Psychotherapist
34 Beverley Parklands, Beverley
East Yorkshire HU17 0RA
01482 870458
SPTI

LITTLEDALE, Nadine
Psychodrama Psychotherapist
33 Barrow Lane, Hessle HU13 0PJ
BPA

PARKER, Jonathan
Cognitive Behavioural Psychotherapist
Family Assessment & Support Unit
School Community & Health Studies
University of Hull, Hull HU6 7RX
01482 465011
BABCP

PETTY, Susan
Family Therapist
21 Colleridge Grave
Beverley, E Yorks HU17 8XD
01482 864105
IFT

URQUHART, Peta A
Psychoanalytic Psychotherapist
Middle Farm, Walkington, Beverley
East Yorkshire HU17 8SZ
01430 827278
UPA

WANG, Michael
Cognitive Behavioural Psychotherapist
Dept of Clinical Psychology
School of Medicine
University of Hull
Hull HU6 7RX
01482 465416
BABCP

JACQUES, Roma
Transpersonal Psychotherapist
5 Dower House
80 Mitchell Avenue
Ventnor PO38 1DS
01983 856 365
CCPE

KENNEDY, Fiona C
Cognitive Behavioural Psychotherapist
The Gables, Halberry Lane
Newport PO30 2ER
01983 525326
BABCP

PASSEY, Miranda
Child Psychotherapist
Department of Child & Family Psychiatry
7 Pyle Street, Newport
01983 523602/01983 531312
ACP

SIMON, Dave
Family Therapist
Ashton House, 4 West Street
Ryde PO33 2NN
01983 614795
AFT

WHITE, Eve
Psychodrama Psychotherapist
21 Shippards Road
Brighstone
Newport PO30 4BG
01983 52525/01983 740429
BPA

KENT

ADAMSON, Niki
Psychosynthesis Psychotherapist
Hog Hole Lane Cottage
Lamberhurst TN3 8BN
020 7377 5738/01892 890 304
AAPP

ANDREWS, Ruth
Psychoanalytic Psychotherapist
23 Brittania Avenue
Whitstable CT5 4TA
01227 273125
CSPK

ASKIN, Pauline
Systemic Psychotherapist
22 Cadogan Close
Albemarle Road
Beckenham BR3 5XY
0771 337 6932
IFT

AVERBECK, Marcus
Family Therapist
Orchard House
Family Mental Health Centre
17 Church Street, St. Peters
Broadstairs CT10 2TT
01843 604777/01843 862211
AFT

BAMBER, Nicola
Psychoanalytic Psychotherapist
Monckton Manor Mountain Street
Culham
Canterbury CT4 8DQ
FIP

BEARD, Dorrie
Analytical Psychologist-Jungian Analyst,
Psychoanalytic Psychotherapist
4 Groveland Road
Beckenham BR3 3QA
020 8650 9057
FPC

BHUNNOO, Z.
Behavioural Psychotherapist
305 Maidstone Road
Bridgewood
Chatham ME5 9SE
01223 204150/01634 861440
BABCP

BLENCH, Graeme
Integrative Arts Psychotherapist
Kenfield Cottage
Kenfield Hall, Petham
Nr. Canterbury CT4 5RN
01227 700775
IATE

BOSANQUET, Camilla
Analytical Psychologist-Jungian Analyst
Wyndside, Church Road, Ryarsh
West Malling ME19 5LB
01732 842351/020 7262 3899
GUILD

BOTHA, Marie
Group Analytic Psychotherapist
70 Bradbourne Road
Sevenoaks TN13 3QA
01732 455903
FPC

BOUSFIELD, Anne
Systemic Psychotherapist
NCH Action for Children
479 Margate Road
Broadstairs CT10 2QA
01843 601101
IFT

BOYD, Suzanne
Transactional Analysis Psychotherapist
The Old Farm House
Biddenden Road, Frittenden
Cranbrook TN17 2BE
01580 852414
ITA

BRINDLE, Elisabeth
Sexual and Relationship Psychotherapist
Milestones,
Packhorse Road
Sevenoaks TN13 2QP
01732 461745
BASRT

BROOKS, Carole
Gestalt Psychotherapist, Integrative
Psychotherapist
Wheelspin, The Street
Ulcombe, Nr Maidstone ME17 1DR
01622 842979
GPTI

BUCKNALL, Valerie
Attachment-based Psychoanalytic
Psychotherapist
26 Burnt Ash Lane
Bromley BR1 4DH
020 8290 6817
CAPP

BUNKER, Carol
Psychoanalytic Psychotherapist
Ivy Cottage
The Lees, Boughton Aluph
Ashford TN25 4JB
01233 620000
CSPK

BUNKER, Nigel
Psychoanalytic Psychotherapist
Ivy Cottage
The Lees, Boughton Aluph
Ashford TN25 4JB
01233 620000
CSPK

BURGESS, Mary
Cognitive Behavioural Psychotherapist
7 Pickhurst Lane
Hayes BR2 7JE
020 8325 8506/
020 7346 3363/4096
BABCP

CAIRNS, Mary
Psychoanalytic Psychotherapist
39 Chapel Lane, Blean
Canterbury CT2 9HE
01227 472439
CSPK

CANT, Diana
Child Psychotherapist
Breeches Field Oast
Egerton TN27 9HA
01233 756552
ACP

CAREY, Jean
Psychoanalytic Psychotherapist
1 The Close, Bridge
Canterbury CT4 5NJ
01227 831405
CSPK

CARSLEY, Carol
Integrative Psychotherapist
Boulders
Beckenham Place Park
Beckenham BR3 5BP
020 8650 7264
RCSPC

CARTWRIGHT, Alan
Psychoanalytic Psychotherapist
Little Yockletts
Duckpit Lane, Waltham
Canterbury CT4 5PZ
01227 700849
CSPK

CARTWRIGHT, Kate
Psychoanalytic Psychotherapist
Little Yockletts
Duckpit Lane, Waltham
Canterbury CT4 5PZ
01227 700849
CSPK

CHALLENDER, David
Family & Systemic Psychotherapist,
Integrative Psychotherapist
Flat 2, Lardergate
29a The Precincts
Canterbury CT1 2EP
01227 700067
AFT

CHIN, John C L
Cognitive Behavioural Psychotherapist
Cedar Lodge
88 Singledge Lodge, Whitfield
Nr Dover CT3 EP
BABCP

CLARK, Christine
Group Analytic Psychotherapist
Lydens
28 Pembury Road
Tonbridge TN9 2HX
01732 352637
FPC

CLIFT, Lynda
Psychoanalytic Psychotherapist
Marlowe Cottage
Gravel Hill, Chartham Hatch
Canterbury CT4 7NH
01227 738779
CSPK

COLEBY, Gillian
NLP Psychotherapist
The Albany Clinic
11 Station Road
Sidcup DA15 7EN
020 8300 4361
ANLP

COOPER, Heather
Cognitive Behavioural Psychotherapist
40 Stone Road
Broadstairs CT10 1DZ
01843 863643
BABCP

COOPER, Ian
Psychoanalytic Psychotherapist
2 Ashwood Court, 16 Albemarle Road
Beckenham BR3 5XN
020 8658 6967
FPC

COUTTS, Linda
Hypno-Psychotherapist
4 Ashleigh Gardens
Headcorn TN27 9TW
01622 890720
NSHAP

CRONIN, Jeremiah*
Psychoanalytic Psychotherapist
13 Redbrooks Way
Hythe CT21 4DN
01303 267946/01303 770509
GUILD

CUNNINGHAM, Diane J
Psychoanalytic Psychotherapist
Willow Farmhouse
Upper Harbeldown
Nr. Canterbury CT2 9AL
01227 823691/01227 768131
AGIP

CUNNINGHAM, Valerie
Integrative Psychotherapist, Transactional
Analysis Psychotherapist
19 Birling Road
Tunbridge Wells TN2 5LX
018925 29903
ITA

CURWEN, Bernadette
Cognitive Behavioural Psychotherapist
Gravesend C.M.H.T.
6 High Street, Gravesend DA11 0BQ
01474 534200
BABCP

DANIELS, Deborah
Integrative Psychotherapist
17 Chantry Hall, Dane John Gardens
Canterbury CT1 2QS
RCSPC

DANIELS, Kate
Family Therapist
15 Ashburnham Road
Tonbridge TN10 3DU
01732 359 120
AFT

DARNLEY, Hazel
Psychoanalytic Psychotherapist
Dove Cot
Anvil Green, Waltham
Canterbury CT4 7EU
01227 700752
CSPK

DAVIES, Peggy
Transactional Analysis Psychotherapist
11 Oakhurst Close
Walderslade ME5 9AN
01634 861262 (t/f)
ITA

DAWSON, Joyce
Psychoanalytic Psychotherapist
23 Mapledene
Kemnal Road
Chislehurst BR7 6LX
020 8295 0286
FPC

DAY, Elizabeth
Systemic Psychotherapist
Howbury Centre
Slade Green Road
Erith DA8 2HX
020 8303 7777 ext. 6321/mobile: 07801
854 561
KCC

DOOLAN, Moira
Family Therapist
27 Barnmead Road
Beckenham BR3 2JF
020 8676 8495/020 8402 2984
AFT

DUCK, Dorothy M.
Hypno-Psychotherapist
Fairhaven
Station Road, Pluckley
Ashford TN27 0Q2
01233 840263
NSHAP

FRASER, Daphne
Transpersonal Psychotherapist
Herne Bay
01227 740 580
CCPE

FREEMAN, David
Analytical Psychologist-Jungian Analyst
222 Mackenzie Road
Beckenham BR3 4SJ
020 8325 8211/020 8659 0108
AJA

FREEMAN, Susan
Hypno-Psychotherapist
5 King Arthur's Drive
Strood
Rochester ME2 3LZ
01634 715141
NSHAP

GAFFNEY, Mahin
Psychoanalytic Psychotherapist
1 Chart Place, Wigmore
Gillingham ME8 0LN
01634 373015
CSPK

GAUSDEN, Christopher
Hypno-Psychotherapist
Alsirat
1 Village Green Way
Biggin Hill TN16 3NB
01959 540601
NRHP

GRANT, Vera
Cognitive Behavioural Psychotherapist
Oxleas NHS Trust Mental Health
CATT, Bexleyheath Centre
Bexley Hospital
Old Bexley Lane DA5 3BU
01322 526282 ext 2340
BABCP

GREEN, Eliott
Transactional Analysis Psychotherapist
St. Mary's Health Centre
Vicarage Road, Strood
Rochester ME2 4DG
01634 868809
ITA

HARMAN, Josephine
Integrative Psychotherapist
96 Springhead Road
Northfleet DA11 9QY
01474 574022/01474 535335
RCSPC

HAUKE, Christopher
Analytical Psychologist
46 The Drive
Bexley DA5 3DE
CAP

HEADON, Christopher
Sexual and Relationship Psychotherapist
79 Goodhart Way
West Wickham BR4 0ET
020 8777 6422
BASRT

HEINITZ, Karin
Biodynamic Psychotherapist
Flat 2, 12 Tankerton Road
Whitstable CT5 2AB
01227 273580
BTC

HEWITT, Philip J.
Psychoanalytic Psychotherapist
27 Barnmead Road
Beckenham BR3 1JF
020 8402 2984
FIP

HEYWARD, Julie
Sexual and Relationship Psychotherapist
Hayes Grove Priory Hospital
Prestons Road
Hayes BR2 7AS
020 8462 7722
BASRT

HILLS, John
Family Therapist
47 St Augustines Road
Canterbury CT1 1XR
01227 786322/01227 452155
AFT

HIRONS, Ruth
Psychoanalytic Psychotherapist
1 Lavender Bank, Beesfield Lane
Farningham DA4 0DA
01322 862629
CSPK

HOLLIS, Peter
Group Analyst
Hayes Grove Priory Hospital
Prestons Road
Hayes BR7 2AS
020 8462 7722
IGA

HUGHES, Jennifer
Psychoanalytic Psychotherapist
2 The Cheynes, Broad Street
Sutton Valence
Maidstone ME17 3AJ
01622 844937
FPC

JAKES, Simon
Cognitive Behavioural Psychotherapist
Psychological Services
Gablestones
Stone House Hospital
Dartford DA2 6AU
01322 6220661
BABCP

JAYNES, Eddie
Gestalt Psychotherapist
11 Greenway, Davington Court
Faversham ME13 7TE
01795 532932
GCL

JOGESSAR, Yashmi
Hypno-Psychotherapist
12 Broadcroft
Tunbridge Wells TN2 5UG
CTIS

JONES, Deborah
Psychoanalytic Psychotherapist
Woodlands
Smeeth TN25 6QL
01303 813031
CSPK

JONES, Margaret*
Psychoanalytic Psychotherapist
Mill Cottage
120 Heathfield Road
Keston BR2 6BA
01689 853881
GUILD

JONES, Pamela
Hypno-Psychotherapist
25 Harrow Way, Weavering
Maidstone ME14 5TU
01795 431266/01622 739266
NSHAP

KELLY, Bridget
Psychoanalytic Psychotherapist
54 Beacon Drive, Bean
Dartford DA2 8BG
01474 705171
ARBS

KING, Desmond
Group Analyst
4 Avondale Road
Bromley BR1 4EP
020 8402 0847
IGA

LANCZI, Katalin
Psychoanalytic Psychotherapist
37 Preston Lane
Faversham ME13 8LG
01795 590653
ARBS

LEIPER, Rob
Psychoanalytic Psychotherapist
Huntley Cottage
122 Wateringbury Road
East Malling ME19 6JD
01622 776355/01732 842349
CSPK

LENNOX, Graham
NLP Psychotherapist
72 Queens Road, Tankerton
Whistable CT5 2JQ
01227 273042
ANLP

LETTINGTON, Lisa
Cognitive Analytic Therapist
9 Waldegrave Road, Bickley
Bromley BR1 2JP
020 8290 0010/020 8467 5513
ACAT

LEWIS, Penny
Psychoanalytic Psychotherapist
Mill View, Mill Lane
Eastry CT13
01304 611434
CSPK

LOMAX, Vivien
Psychoanalytic Psychotherapist
28 Fisher Street
Sandwich CT13 9EJ
01304 613041
CSPK

LOVEL, Mary
Psychoanalytic Psychotherapist
7c Spencer Road
Bromley BR1 3SU
IPSS

MALTBY, Michael
Group Analyst
Centre for Applied Social and
Psychological
Development Salomons
Broomhill Road,
Tunbridge wells TN3 0TG
01892 507674
IGA

MCANDREW, Brigitte
Psychoanalytic Psychotherapist
80 Shalloak Road
Broad Oak
Nr Canterbury CT2 0QE
01227 713911
ARBS

MCCOY, Sean
Cognitive Behavioural Psychotherapist
1 Sussex Road
West Wickham BR4 0JX
020 8777 9837/01622 686123
BABCP

MCLEWIN, Ali
Psychoanalytic Psychotherapist
6 Albion Place
Canterbury CT1 1LH
01227 764710
CSPK

MENDELSSOH, Penny
Family Therapist
The Coach House
Uckfield Lane, Hever
Nr. Edenbridge TN8 7LQ
01732 862865
AFT

MILLAIS, Suzy
Transpersonal Psychotherapist
Old Tar Cottage, Sea Wall
Whistable CT5 1BX
01227 264 529
CTP

MORGAN, Ruth
Integrative Psychotherapist
206 Croydon Road
Beckenham BR3 4DE
020 8658 3791
MC

MORRISH, Susan
Transactional Analysis Psychotherapist
Savannah
Sheerwater Road, Elmstone
Canterbury CT3 1HJ
01227 721 783(t/f)
ITA

NELSON, Denise
Sexual and Relationship Psychotherapist
4 St Anns Court
Maidstone ME16 0UQ
0585 427 659
BASRT

NELSON, Margaret
Existential Psychotherapist
39 Winchelsea Street
Dover CT17 9ST
01304 213508
RCSPC

NUAIMI, Christine
Family Therapist
Bromley Child & Adolescent NHS
28–29 Carlton Parade
Orpington BR6 0JB
01689 829364/01689 829577
AFT

O'BRIEN, Sally
Psychoanalytic Psychotherapist
Old Church Cottage, High Street
Marden TN12 9HN
01622 831292
CSPK

O'SULLIVAN, Renee
Integrative Psychotherapist
Brook House
49 Lower Road, River
Dover CT17 0QU
01227 459700/01304 829098
RCSPC

OWENS-WARD, Lyn
Integrative Psychotherapist
58 Hayes Road
Bromley BR2 9AA
020 8466 8802
RCSPC

PAE, Linda L S
Integrative Psychotherapist
93 Elwill Way, Park Langley
Beckenham BR3 6RX
020 7793 7113/020 8658 5735
RCSPC

PALANISAMY, Shan
Cognitive Behavioural Psychotherapist
6 Upper Abbey Road
Belvedere DA17 5AJ
07957 431332/01322 463332
BABCP

PALGRAVE, Lesley
Cognitive Analytic Therapist
2 Gainsborough Square
Bexleyheath DA6 8BU
020 8306 6090
ACAT

PARKER, Niki
Child Psychotherapist
Child and Adolescent Mental Health
Service
18 Crook Log
Bexleyheath BR6
020 8303 4786/020 8693 3805
ACP

PENWARDEN, Mary M.
Child Psychotherapist
Lenworth Clinic
Dept. of Child & Family Psychiatry
329 Hythe Road
Ashford TN24 0QE
020 7351 9429/01233 204180
ACP

PIPER, Robin
Group Analytic Psychotherapist,
Psychoanalytic Psychotherapist
2 Well Place Farm Cottage
Well Place
Penshurst TN11 8BH
01892 870387/020 7272 4002
FIP

POVER, Jane .S.E
Group Analytic Psychotherapist
1 St Mary's Close, St Mary's Platt
Sevenoaks TN15 8NH
020 7873 5182/5100/
01732 887 346
UPA

POWELL, Helen
Gestalt Psychotherapist
22 Weald Close, Weald
Sevenoaks TN14 6QH
01732 455587
GCL

QUINN, John J
Systemic Psychotherapist
41 Highfield Road
Chislehurst BR7 6QY
01689 875090/0973 254385
KCC

RAE, Frances
Systemic Psychotherapist
21 Court Road
Tunbridge Wells TN4 8EB
020 8543 3025
KCC

READING, Bill
Psychoanalytic Psychotherapist
1 Denstead Oast, Chartham Hatch
Canterbury CT4 7SH
01227 730808
CSPK

REILLY, Anne
Psychoanalytic Psychotherapist
20 Beverly Road
Canterbury CT2 7EN
01227 462295
CSPK

REYNOLDS, Helen
Psychoanalytic Psychotherapist
5 Shepherdsgate, Roper Road
Canterbury CT2 7RU
01227 760344
CSPK

RICHARDS, Maureen Veronica
Sexual and Relationship Psychotherapist
5 Lapins Lane, Kings Hill
West Malling ME19 4LA
01732 875096
BASRT

RIDING, Ann
Psychoanalytic Psychotherapist
32 Cromwell Road
Canterbury CT1 3LE
01227 462511
CSPK

RIDING, Nick
Psychoanalytic Psychotherapist
Kent Institute of Medicine and Health
Science
The University
Canterbury CT2 7PD
01227 823380/01227 462511
CSPK

RIGNEY, Ann
Transactional Analysis Psychotherapist
20 Nags Head Lane
St. Margaret's Bank
Rochester ME11
ITA

RILEY, Brenda
Hypno-Psychotherapist
Gainborough Clinic
Station Road
Tenterden TN30 6HN
01424 851739
NRHP

ROBERTS, Jane
Psychoanalytic Psychotherapist
61 Radnor Cliff
Sandgate CT20 2JL
01303 249385
CSPK

ROBERTS, Pauline
Psychoanalytic Psychotherapist
2 Knoll Road
Bexley DA5 1AZ
01322 553807
FPC

ROGERS, Lesley A.
Cognitive Behavioural Psychotherapist
48 Parrock Avenue
Gravesend DA12 1QQ
01322 622494/01474 363584
BABCP

ROWLAND, Gail
NLP Psychotherapist
The Red House
Burnt Oak Lane, Waldron
Nr Heathfield TN2 4DZ
01435 810050
ANLP

ROYSTON, Robin
Analytical Psychologist-Jungian Analyst
The Red House
Stonewall Park Road
Langton Green
Tunbridge Wells
01892 863858
AJA

RUSSELL, Tina
Integrative Psychotherapist
84 Thong Lane, Chalk
Gravesend DA12 4LD
01474 357748
RCSPC

SCHAEDEL, Maggie
Psychoanalytic Psychotherapist,
Psychodynamic Psychotherapist
The Spinney Cottage
Knockholt Road, Halstead
Sevenoaks TN14 7EX
01959 532510
ARBS

SHARPE, Tracey
Rational Emotive Behaviour Therapist
Child & Adolescent MH Services
Gatland House, Gatland Lane
Maidstone ME16 8PF
01622 723600
BABCP

SHAW, Maureen
Psychoanalytic Psychotherapist
20 Westbere Lane, Westbere
Canterbury CT2 0HH
01227 710505
CSPK

SMITH, Ged
Family Therapist
18 Crook Log
Bexleyheath DA6 8BP
020 8303 4786/020 8298 0554
AFT

SMITH, Susan Diane
Hypno-Psychotherapist
The Bromley Stress Management Centre
67-69 Widmore Road
Bromley BR1 3AA
0780 875 5295/020 8460 2528
NRHP

SPALDING, John
Psychoanalytic Psychotherapist
32 Aldermary Road
Bromley BR1 3PH
020 8466 2500/020 8464 8292
AGIP

SPARKS, Rebecca
Sexual and Relationship Psychotherapist
Bromley
020 8460 6832
BASRT

STEVENSON, Alice
Transactional Analysis Psychotherapist
Upper Green, Sandhurst
Hawkhurst TN18 5JX
ITA 01580 850361

STEVERSON, Jill
Psychosynthesis Psychotherapist
27 Baywell
Leybourne ME19 5QQ
01732 872 290/01732 873 658
AAPP

THOMASON, June
Psychoanalytic Psychotherapist
South Cottage, High Street
Staplehurst TN12 0BH
01580 891402
CSPK

TILL, Patricia
Cognitive Behavioural Psychotherapist
76 Pine Avenue
Gravesend DA12 1QZ
01322 622222/01474 332379
BABCP

TOTMAN, Maria
Psychosynthesis Psychotherapist
61 Avenue Road
Erith DA8 3AT
01322 334139
AAPP

TOYNE, Joy K.
Hypno-Psychotherapist
Oast Meadow
Burns Hill, Brenchley
Tonbridge TN12 7AT
01892 723799
NRHP

TRAYLING, Laurie
Psychoanalytic Psychotherapist
Crane Hurst Hill
Crane Surey, Rectory Fields
Cranbrook
01580 713929/07060 008274
FPC

TRUSCOTT, Frances
Child Psychotherapist
9 Sandown Close
Sandown Park
Tunbridge Wells TN2 4RL
01892 822093
ACP

TSE, Claude
Behavioural Psychotherapist
Dillywood Corner
Dillywood Lane, Higham
Rochester ME3 7NT
01634 714842
BABCP

TUBBS, I.A.
Cognitive Behavioural Psychotherapist
Englewood, Farningham Hill Road
Farningham
Kent DA4 0JR
01322 862158
BABCP

TWELVETREES, Heidy
Gestalt Psychotherapist, Humanistic
Psychotherapist
Park Lodge, 38 Longlands Road
Sidcup DA15 7LT
020 8302 3800
AHPP

VAN-LOO, Douglas
Systemic Psychotherapist
5 Foxdown Close
Canterbury CT2 7RR
01227 781045
IFT

VIRGO, Leslie Canon
Integrative Psychotherapist
The Rectory, Skibbs Lane
Chelsfield BR6 7RH
01689 825749
MC

WALKER, David
Group Analyst
Dairy Cottage
17 Dower House Crescent
Southborough TN4 0TT
01892 520239
IGA

WARREN, Yvonne
Integrative Psychotherapist
The Archdeaconry
Rochester ME1 1SX
01634 842527
RCSPC

WATTERS, Tamara
Integrative Psychotherapist
26 Glen Iris Avenue
Canterbury CT2 8HP
01227 463342
MET

WEAVER, David
Group Analyst
24 Beltring Road
Tunbridge Wells TN4 9UA
01892 517710
UPA

WESTCOTT, Rosemary*
Psychoanalytic Psychotherapist
235 Southlands Road
Bromley BR1 2EG
020 8464 3136
GUILD

WHITMORE, Diana
Psychosynthesis Psychotherapist
Southfield, Leigh
Nr. Tonbridge TN11 8PJ
020 7403 2100
AAPP

WILLIS, James
Cognitive Behavioural Psychotherapist
19 Milton Street, Maidstone ME16 8JT
01622 204752
BABCP

WILSON, Ronni
Humanistic Psychotherapist, Integrative
Arts Psychotherapist
1 Hunts Hill, Moons Green
Wittersham TN30 7PR
01797 270621
IATE

WOODROFFE, Roe
Integrative Psychosynthesis
Psychotherapist
Tunbridge Wells TN2 5HU
01892 543 596
RE.V

LANCASHIRE

ALEXANDER-GRAHAM, Cassy
Psychodrama Psychotherapist
Lane End Cottage
Cockerham Road, Bay House
Lancaster LA2 0HG
01253 294780/01524 792076
BPA

ARKWRIGHT, Lynda
Psychoanalytic Psychotherapist
Hazeldene
48 Lytham Road, Fulwood
Preston PR2 3AQ
NWIDP

ASHWORTH, Freda
Hypno-Psychotherapist
Mulsanne
16 Harefield Drive
Heywood nr. Rochdale OL10 1RN
01706 368193
NRHP

BARTON, Alan
Psychodrama Psychotherapist
18 Jubilee Street
Read
Burnley BB12 7PR
0161 763 2314/01282 774136
BPA

BENTLEY, Ros
Gestalt Psychotherapist
Preston Therapy Centre
57 Garstang Road
Preston PR1 1LB
01524 841993/01772 886994
GPTI

BLACK, Margaret
Hypno-Psychotherapist
9 Greengate Close, Wardle
Rochdale OL12 9PX
01706 631099
NSHAP

BROWN, Philip
Psychoanalytic Psychotherapist
Department of Psychotherapy
1 Albert Road, Fulwood
Preston PR2 8PS
01772 401370
NWIDP

CARTWRIGHT, Tony
Family Psychotherapist
The Department of Specialist
Psychological Therapi
Guild Community Trust
1 Albert Road
Preston PR2 8PJ
FIC

CASSON, John
Psychodrama Psychotherapist
62 Shaw Hall Bank Road
Greenfield
Saddleworth OL3 7LE
01457 877161
BPA

COLE, Shanti
Hypno-Psychotherapist
2 Yealand House
1 Yealand Road, Yealand Conyers
Carnforth LA5 9SF
01524 730095
NSHAP

COOPER, Patricia
Hypno-Psychotherapist
16 Waterside Terrace
Waterside
Darwen BB3 3PD
01254 773 754
CTIS

CORNELL, Maria
Psychoanalytic Psychotherapist
Dept. Clinical Psychology
St. Leonard's House
St. Leonard'd Gate
Lancaster LA1 1NN
01524 687380
NWIDP

CREGEEN, Simon
Child Psychotherapist
Child & Family Service
Adcote House, Columbia Road
Oxton
Birkenhead LA3 6TU
0151 670 0031
ACP

CRICHTON, N
Cognitive Behavioural Psychotherapist
16 Darwen Street
Blackburn BB2 2BY
01732 162811/01254 706604
BABCP

CROSSLING, Paddy
Systemic Psychotherapist
Psychotherapy Team
Mental Health Directorate
Tameside General Hospital
Ashton-under-Lyme OL6 9RW
0161 3315082
FIC

CUTNER, Adrienne
Hypno-Psychotherapist
28 Tithebarn Hill
Glasson Dock
Lancaster LA2 0DQ
01524 752080
CTIS

DOYLE, Alan
Hypno-Psychotherapist
2 Westview
Ormskirk L39 2DJ
01695 575001
CTIS

DUNN, Michael
Gestalt Psychotherapist
49 Vale Road
Lancaster LA1 2JN
SPTI

FAGBADEGUN, Rufus
Group Analyst
Elton Grange Farm, Elton Vale Road
Bury BL8 2RZ
IGA

FERGUSON, Mary
Psychoanalytic Psychotherapist
Psychiatric Outpatient Department
Royal Oldham Hospital
Rochdale Road
Oldham OL1 2JH
0161 627 8330
LPDO

FLANAGAN, June D
Cognitive Behavioural Psychotherapist
Palmers Greave, Lovely Hall Lane
Salesbury BB1 9EQ
0161 772 3612
BABCP

FOWLER, Barry
Cognitive Behavioural Psychotherapist
Clinical Psychology Department
Birch Hill Hospital
Union Road
Rochdale OL12 9QB
01706 755 744
BABCP

GALLAGHER, Eileen
Group Analyst
Higher Whittaker Farm
Longworth Road, North Belmont
Bolton BL7 8BH
IGA

HAYWARD, Marjorie
Hypno-Psychotherapist
Mahogany, 38 Merefield
Astley Village
Chorley PR7 1UR
01257 233039/00 349 476 1169
CTIS

JARRETT, Betty
Psychodynamic Psychotherapist
449 Padham Road
Burnley BB12 6TE
01282 412291
VAPP

JUDKINS, Malcolm
Psychoanalytic Psychotherapist
Adelphi House Psychotherapy Unit
12 Queen Street
Blackpool FY1 1PD
01253 628653/01253 291336
NWIDP

KIEMLE, Gundi
Psychoanalytic Psychotherapist
Department of Clinical Psychology
Royal Bolton Hospital
Minerva Road
Farnworth BL4 0JR
01204 390 6807/01924 390 6675
LPDO

LAMB, Kirsten
Psychoanalytic Psychotherapist
Department of Clinical Psychology
Royal Bolton Hospital
Minerva Road, Farnworth
Bolton BL4 0JR
01204 390680
LPDO

LEGGATT, Claire
Psychoanalytic Psychotherapist
2 Lindow Square
Lancaster LA1 1SE
01524 68738/01524 383822
AGIP

LIDDLE, Helen
Psychoanalytic Psychotherapist
9 Olive Grove
Blackpool FY3 9AS
01253 751155
NWIDP

LUCKRAFT-VOGES, Julie
Integrative Psychotherapist
7 Haighton Drive
Fulwood
Preston PR2 9LU
0305/01772 709 782
SPTI

MACALISTER, Eileen
Group Analyst
14 Oulder Hill Drive
Rochdale OL11 5LB
01706 45883
IGA

MAGUIRE, Claire
Psychoanalytic Psychotherapist
Dept. of Clinical Psychology
Bury NHS Trust
Rochdale Old Road
Bury BL9 7TD
0161 705 3538
LPDO

MAKIN, Anne
Gestalt Psychotherapist
27 Beeston Close
Bolton BL1 7RT
01204 594000
GPTI

MARKOVIC, Olivera
Family Therapist
Clinical Psychology Department
Whitegate Drive
Blackpool FY3 9HG
01253 763740/01253 763232
AFT

MAY, Kathryn
Sexual and Relationship Psychotherapist
The Psychosexual Clinic
Larkhill Health Centre
Blackburn BB1 6BE
01254 660210
BASRT

MCALLISTER, Susan
Psychoanalytic Psychotherapist
Specialist Psychological Therapy Services
1 Albert Road, Fulwood
Preston PR2 8PJ
01772 787197
NWIDP

MOON, Barbara
Hypno-Psychotherapist
90 Watkin Road, Clayton-le-Woods
Chorley PR6 7PX
01257 275169
CTIS

PAMPHLETT, Nicholas
Transactional Analysis Psychotherapist
The Corner House
97 Woone Lane
Clitheroe BB7 1BJ
01200 429450
ITA

QUARMBY, David
Psychoanalytic Psychotherapist
30 College Avenue
Oldham OL8 4DS
0161 626 2771
UPA

ROSS, Julie
Psychoanalytic Psychotherapist
Psychology Department
314–316 Oldham Road
Royton
Oldham OL2 5AS
0161 624 0420 × 5350
LPDO

SAVAGE, Peter J.D.
Hypno-Psychotherapist
National College of Hypnosis &
Psychotherapy
12 Cross Street
Nelson BB9 7EN
01282 699378
NRHP

SCOTT, Catherine
Hypno-Psychotherapist
1 Deep Cutting Farm, Ashton Road
Lancaster LA2 0AA
01524 388788
NRHP

SHELDON, Helen
Psychoanalytic Psychotherapist
Department of Clinical Psychology
Bolton General Hospital
Minerva Road, Farnworth
Bolton BL4 0JR
01204 390675
NWIDP

SPRATT, Graham S.
Cognitive Behavioural Psychotherapist
Dept. of Clinical Psychology
Billinge Hospital, Billinge
Wigan WN5 7ET
01695 626181
BABCP

STOKES, Fergus
Hypno-Psychotherapist
6 Kensington Road
Lytham St. Annes FY8 4ET
01253 730588
CTIS

SUDBURY, John
Psychodynamic Psychotherapist
139 Calderbrook Road
Littleborough OL15 9JW
01706 377577
HIP

SUMMERS, Graeme
Transactional Analysis Psychotherapist
Langtree, Hollins Lane
Arnside LA5 0EG
0161 225 2202/01524 762 607
ITA

TAYLOR, Elizabeth
Hypno-Psychotherapist
Holistic Resources, Cribbden House
Rossendale Hospital
Rossendale BB4 6NE
01706 240080
CTIS

TAYLOR, Theresa
Psychoanalytic Psychotherapist
Psychotherapy Service
1 Albert Road, Fulwood
Preston PR2 8PJ
01772 401370
NWIDP

TURTON, Mike
Gestalt Psychotherapist
Preston Therapy Centre
57 Garstang Road
Preston PR1 1LB
01772 886994
GPTI

VANNEN-HYLAND, Joan
Hypno-Psychotherapist
2 Prescot Green
Ormskirk L39 4US
01695 580288
CTIS

VORA, Valerie
Sexual and Relationship Psychotherapist
196 Manchester Road
Westhoughton
Bolton BL5 3LA
01942 813647
BASRT

WALLACE, Daphne
Psychoanalytic Psychotherapist
The Vicarage, Skipton Road
Earby Colne BB8 6JL
01282 841608
LPDO

WALSH, Stuart
Family Therapist, Psychodrama
Psychotherapist
4 Woodlea, Church Road
Todmorden OL14 8EZ
01706 819873/0161 276 5370
BPA

WASHINGTON, Sue
Hypno-Psychotherapist
145 Chapel Lane, Longton
Preston PR4 5NA
01772 617663
CTIS

WELLER, Celia
Gestalt Psychotherapist
11 Park Avenue
Lancaster LA1 3DX
01524 63812
GPTI

WESSON, Peter M.J.
Hypno-Psychotherapist
Bury Complementary Health Centre
12 Tenterden Street
Bury BL9 0EG
0161 763 1660 (t/f)
NRHP

WILLIAMS, Jane
Group Analyst
45 York Street
Haywood OL10 4NN
IGA

LEICESTERSHIRE

BAILEY, James
Psychoanalytic Psychotherapist
Leicester Psychotherapy Dept. (NHS)
Humberstone Grange Clinic
Thurmaston Lane
Leicester LE5 0TA
0116 225 6430
STTDP

BALL, Derek
Sexual and Relationship Psychotherapist
Baker Vaughan Counselling Services
Victoria House
172-174 London Road LE2 1ND
0116 247 0880
BASRT

BARKER, John F.
Psychoanalytic Psychotherapist
Highways
Main Street
Cold Newton LE7 9DA
WMIP

BRADLEY, Marie
Psychoanalytic Psychotherapist
Leicester Psychotherapy Department
(NHS)
Humberstone Grange Clinic
Thurmaston Lane
Leicester LE5 0TA
0116 225 6430
STTDP

BUTTON, Eric
Personal Construct Psychotherapist
Brandon Mental Health Unit
Leicester General Hospital
Gwendolen Road
Leicester LE5 4PW
0115 225 6250
CPCP

CHALLIS, Raymond Thomas
Hypno-Psychotherapist
Aysa Cottage, 2c Hollytree Close
Hoton
Loughborough LE12 5SE
0115 960 6116/01509 881536
NRHP

CHALLIS, Suzy
Psychoanalytic Psychotherapist
City East Community Mental Health
Team (Adult)
The Maidstone Centre
Maidstone Road
St. Peters LE2 0TW
0116 225 5888
LPDO

COLLS, Jennifer
Gestalt Psychotherapist
75 Park Lane
Sutton Bonnington
Loughborough LE12 5NQ
01509 673 204
GCL

COUPE, Aileen
Integrative Psychotherapist
13 Banbury Drive, Shepshed
Lough LE12 9PL
01509 503635
SPTI

CREW, Jan
Gestalt Psychotherapist
7 Hudson Street
Loughborough LE11 1EJ
01509 552972
SPTI

DAVIES, Rae
Gestalt Psychotherapist
171 Main Street
Willoughby-on-the-Wolds
Nr. Loughborough LE12 6SY
01509 880850
SPTI

DENT, Peter
Psychodynamic Psychotherapist
40 Leicester Road
Hinckley LE10 1LS
01455 63340
VAPP

DUGGAN, Conor
Cognitive Behavioural Psychotherapist
East Midlands Centre for Forensic Mental
Health
Arnold Lodge, Cordelia Close
Leicester LE5 0LE
0116 225 6060
UPA

GOULD, Geraldine
Hypno-Psychotherapist
8 Moat Close
Thurlaston
Leicester LE9 7TM
01455 888276
NSHAP

HILES, David
Transpersonal Psychotherapist
Leicester
0116 212 8194
CCPE

HILLS, Janet
Body Psychotherapist, Integrative
Psychotherapist
105 North Street, Barrow-on-Soar
Leicester LE12 8PZ
01509 621376
CCBP

HIRST, Hazel
Transactional Analysis Psychotherapist
Holly Cottage, 26 Church Street
Billesdon LE7 9AE
0116 259 6851
ITA

HOWELLS, Kate
Transactional Analysis Psychotherapist
228 Uppingham Road
Leicester LE5 2BD
0116 2766837
ITA

HURWOOD, Judith
Psychodynamic Psychotherapist
21 Park Road
Blaby
Leicester LE8 4ED
0116 277 0778
VAPP

JACOBS, Michael
Psychodynamic Psychotherapist
22 Brookside Drive
Oadby
Leicester LE2 4PD
0116 271 8469
VAPP

JONES, Richard
Psychoanalytic Psychotherapist
Leicester Psychotherapy Dept. (NHS)
Humberstone Grange Clinic
Thurmaston Lane
Leicester LE5 0TA
0116 225 6430
STTDP

KEEN, Caroline
Gestalt Psychotherapist
119 Ashby Road
Loughborough LE11 3AB
SPTI

KING, Gail
Psychodynamic Psychotherapist
4 Hillcrest Avenue
Market Harborough LE16 7AR
01858 461570
VAPP

LEIPER, Elizabeth
Gestalt Psychotherapist
Fir Tree House
6 Sandy Lane, Scalford
Nr. Melton Mowbray LE14 4DS
01753 842800/01664 444266
MET

LOUMIDIS, K
Cognitive Behavioural Psychotherapist
Centre for Applied Psychology
(Clinical Sect)Faculty of Medicine
New Building, University Road
Leicester LE1 7RH
0116 252 2466
BABCP

MACKENZIE, Liz
Gestalt Psychotherapist
69 Dulverton Road
Leicester LE3 0SE
0116 233 4726
GPTI

MADDEN, Felicity W.
Psychoanalytic Psychotherapist
182 London Road
Leicester LE2 1ND
01536 770320/0116 2544498
WMIP

MARSHALL, Hazel
Transpersonal Psychotherapist
52 Station Road, Cropston
Leicester LE7 7HD
01162 364256
CTP

MARSHALL, Pam
Psychoanalytic Psychotherapist
Leister Psychotherapy Dept (NHS)
Humberstone Grange Clinic
Thurmaston Lane
Leicester LE5 0TA
0116 225 6430
STTDP

MCFARLAND, Alf
Analytical Psychotherapist
29 Gimson Road
Western Park
Leicester LE3 6DZ
0116 255 3549
VAPP, WMIP

MONK-STEEL, Barbara
Transactional Analysis Psychotherapist
43, Stoneygate Road
Leicester LE2 2BP
ITA

MONK-STEEL, John
Transactional Analysis Psychotherapist
43 Stoneygate Road
Leicester LE2 2BP
0116 2700 290
ITA

MOUNTAIN, Anita
Transactional Analysis Psychotherapist
Beechwood, 56 Main Street
Desford, Leicester LE9 9GR
01455 824475
ITA

PAYNE, Katherine Elizabeth
Family Therapist
17 Barkby Road
Queniborough LE7 3FE
0116 269 5580
IFT

PERRY, Janet
Sexual and Relationship Psychotherapist
78 Holmfield Road
Leicester LE2 1SB
0116 273 9912
BASRT

PORTER, Jim
Hypno-Psychotherapist
3 Ashmead Crescent, Birstall
Leicester LE4 4GS
0116 2672612
NSHAP

RANDALL, Lynda
Psychoanalytic Psychotherapist
Leicester Psychotherapy Department
(NHS)
Humberstone Grange Clinic
Thurmaston Lane
Leicester LE5 0TA
0116 225 6430
STTDP

RATIGAN, Bernard
Psychoanalytic Psychotherapist,
Psychodynamic Psychotherapist
36 Arthur Street
Leicester LE11 3AY
0115 952 9454/01509 213 7709
STTDP

RICHARDSON, Sacha
Transpersonal Psychotherapist
71 Highfield Street
Market Harborough LE16 9AL
01858 463211
CCPE

RIDGEWELL, Margaret
Gestalt Psychotherapist
68 Elms Road
Leicester LE2 3JB
0116 2707197
GPTI

RUSSELL, Gillean
Psychoanalytic Psychotherapist
10 Renishaw Drive
Leicester LE5 5TY
0116 274 5424
FPC

SCHAVERIEN, Joy
Analytical Psychologist-Jungian Analyst
1 The Square, South Luffenham
Oakham LE15 8NS
01780 720117 (t/f)
CAP

STEWART, Naomi
Psychoanalytic Psychotherapist
Leicester Psychotherapy
Department(NHS)
Humberstone Grange Clinic
Thurmaston Lane
Leicester LE5 0TA
0115 225 6430
STTDP

STRANG, Jenny
Psychodynamic Psychotherapist
University of Leicester Counselling
Service
161 Welford Road
Leicester LE2 6BF
0116 255 2550
VAPP

THORNLEY, John
Hypno-Psychotherapist
Mind and Body
70 Ashby Road
Loughborough LE11 3AE
01509 232322/0956 846173
NRHP

TWIST, Graham
Cognitive Analytic Therapist
9 wellesbourne Drive
Glenfield
Leicester LE3 8ER
0116 233 1939
ACAT

WALKER, Catriona Jane
Psychoanalytic Psychotherapist
The Counselling Service
University of Leicester
161, Welford Road
Leicester LE2 6BF
01509 881632/0116 255 2550
STTDP

WALKER, Moira
Psychodynamic Psychotherapist
22 Brookside Drive, Oadby
Leicester LE2 4PD
0116 271 8469
VAPP

WHITWORTH, Patricia
Integrative Psychotherapist
93 Melton Road, Barrow-on-Soar
Leicester LE12 8NT
01509 413327
SPTI

WHYTE, Chris
Psychoanalytic Psychotherapist
Leicester Psychotherapy Dept. (NHS)
Humberstone Grange Clinic
Thurmaston Lane
Leicester LE5 0TA
0116 225 6430
STTDP

WILLIAMS, Sherly
Psychoanalytic Psychotherapist
31 Kingsway Road
Evington, Leicester LE5 5TN
0116 273 7713
FPC, VAPP, WMIP

LINCOLNSHIRE

BUCKLEY, Nicky
Psychoanalytic Psychotherapist
Lincoln Department of Psychotherapy
(NHS)
1 St. Anns Road, Lincoln LN2 5RA
01522 512000
ARBS

CLEGG, Ian
Hypno-Psychotherapist
5 Richards Avenue, Lincoln LN6 8SJ
01522 688142
NSHAP

DIXON, Linda
Psychoanalytic Psychotherapist
44 High Street, Nettleham
Lincoln LN2 2PL
01552 752226
HIP

EAST, Patricia
Psychodynamic Psychotherapist
Frogs Leap
615 Newark Road
Lincoln LN6 8SA
01522 681510
VAPP

ELLIS, Roger
Psychodynamic Psychotherapist
Frogs Leap
615 Newark Road, Lincoln LN6 8SA
01522 681 510
VAPP

FISK, Geoff
Psychoanalytic Psychotherapist
Lincoln Dept. of Psychotherapy (NHS)
1 St Anne's Road
Lincoln LN2 5RA
01522 512000
STTDP

FLANNERY, Jean
Psychoanalytic Psychotherapist
8 Church Drive
Lincoln LN6 7AX
01522 526777/01522 514453
UPA

HASSALL, Alan
Integrative Psychotherapist
"Cobblers"
34 High Street, Navenby
Lincoln LN5 0DZ
01522 810940
NSAP

HEADWORTH, Jean
Psychoanalytic Psychotherapist
Glenbrooke
Morden Close, Metheringham
Lincoln LN4 3DU
STTDP

JANICKYJ, John
Psychodynamic Psychotherapist
22 Main Street
Ewerby
Sleaford NG34
01529 460546
VAPP

LOHMAN, Frans
Psychoanalytic Psychotherapist
35 Linden Walk
Louth LN11 8HT
01507 610746
UPA

MILLER, Lynda R
Psychoanalytic Psychotherapist
8 Meynell Avenue
Lincoln LN6 7UT
01522 530267
AGIP

NORTON, Sheila
Psychoanalytic Psychotherapist,
Psychodynamic Psychotherapist
Lincoln Department of Psychotherapy
1 St Anns Road
Lincoln LN2 5PA
01522 512 000/01623 824762
STTDP

PARIS, Jan
Integrative Psychotherapist
20 Drury Lane
Lincoln LN1 3BN
01522 533169
SPTI

SCOTT COMBES, Jacqueline
Gestalt Psychotherapist
11 Main Street, Wilsford
Grantham NG32 3NS
01400 230224
SPTI

SUTHERLAND, Janet
Biodynamic Psychotherapist
Celandine House,
4 St Andrews Street, Heckington
Sleaford NG34 9RE
01529 461571
BTC

THOMSON, Alan
Personal Construct Psychotherapist
Highfield House, Glentham
Market Rasen LN8 2EU
01673 878 508
CPCP

WALLIS, Valerie A
Sexual and Relationship Psychotherapist
9 Chestnut Close, Sudbrooke
Lincoln LN2 2RD
01522 751211
BASRT

WARD, Ruth
Psychoanalytic Psychotherapist
The Old Rectory
Church Lane, East Keal
Spilsby PE23 4AT
01790 752477
HIP

LONDON CENTRAL

ALTMAN, Michelle
Cognitive Behavioural Psychotherapist
262 Shakespeare Tower
Barbican
London EC2Y 8DR
020 7628 9719
BABCP

ARMSTRONG-PERLMAN, Eleanore*
Psychoanalytic Psychotherapist
1 Endsleigh Place
London WC1H 0PL
020 7387 8914
GUILD

ASHWIN, Mary
Integrative Psychotherapist
9 Nottingham Mansions
Nottingham Street
London W1M 3FJ
020 7486 3574
RCSPC

BEECHER-MOORE, Naona
Humanistic Psychotherapist,
Psychosynthesis Psychotherapist
3 Temple Gardens
Middle Temple Lane
London EC4 9AU
020 7353 2101
AAPP

BIRCHARD, Thaddeus
Sexual and Relationship Psychotherapist
10 Harley Street
London W1N 1AA
020 7706 0917
BASRT

BOADELLA, David
Individual and Group Humanistic
Psychotherapist
BCM Chesil
London WC1N 3XX
0041 71 8916855
AHPP

BOSWOOD, Bryan
Group Analyst
88 Montagu Mansions
London W1H 1LF
020 7935 3103
IGA

BRADLEY, Jonathan
Child Psychotherapist
London
020 8444 4733
ACP

BROWN, Dennis
Group Analyst
The Group-Analytic Practice
88 Montagu Mansions
London W1H 1LF
020 7935 3103
IGA

BROWN, Ian B
Integrative Psychotherapist
Flat 4
9 Welbeck Street
London W1M 3PB
020 7486 8914/020 7935 6687
RCSPC

BURCH, Nigel
Psychoanalytic Psychotherapist
29a Northampton Square
London EC1N 0ES
020 7253 7798
ARBS

CAMPHER, Rosemary
Integrative Psychotherapist
140 Harley Street
London W1N 1AH
020 7224 3387/020 7722 8992
RCSPC

CROSS, Malcolm C
Personal Construct Psychotherapist
Department of Psychology
City University
Northampton Square
London EC1V 0HB
020 7477 8531
CPCP

CUTTERIDGE, Simon
Systemic Psychotherapist
Covent Garden Counselling
23 Bedfordbury
London WC2N 4BL
020 7240 1911
KCC

DACHY, Vincent*
Lacanian Analyst
London W1
020 7580 9708
CFAR

DALY, Kevin
Cognitive Behavioural Psychotherapist
49 Queen Victoria Street
London EC4N 4SA
020 7431 1794
BABCP

DAVIDSON, Brian
Autogenic Psychotherapist
86 Harley Street
London W1N 5AE
020 7580 4188
BAS

DEAHL, Kieron
NLP Psychotherapist
Ability
29 Crawford Street
London W1H 1PL
020 7419 9657
ANLP

DENNIS, Diana Mary
Analytical Psychologist-Jungian Analyst
32 Bourdon Street
London W1X 0HX
020 7629 6537
CAP

DIAMOND, Vera
Autogenic Psychotherapist
10 Sherwood Court
Seymour Place
London W1H 5TH
020 7723 2184
BAS

DRANEY, Sue*
Psychoanalytic Psychotherapist
Flat 1, Clare Court
Judd Street
London WC1H 9QW
020 7833 4156
GUILD

DU RY, Marc*
Lacanian Analyst, Psychoanalytic
Psychotherapist
31 Wimpole Street
London W1M 7AE
020 7224 1259/0370 888116
CFAR

EHLERS, Hella
Psychoanalytic Psychotherapist
Flat 12, Byron Court
26 Mecklenburgh Square
London WC1N 2AF
020 7278 2212
ARBS

FARLEY, Nancy M.
Cognitive Behavioural Psychotherapist
London Medical Centre
144 Harley Street
London W1N 4AH
020 79350023
BABCP

FEIGN, Cathy Tsang
Family Therapist
10 Harley Street
London W1N 1AA
020 7467 8464/020 8378 5460
AFT

GANN, Sandra
Sexual and Relationship Psychotherapist
Dept. of Social Work
St. Bartholomew's Hospital
West Smithfields
London EC1V 7BE
020 7601 8718
BASRT

GLADSTONE, Guy
Individual and Group Humanistic
Psychotherapist, Psychoanalytic
Psychotherapist
The Open Centre, 188 Old Street
London EC1V 9FR
020 7272 6672
IPSS

GLENN, Liza
Group Analyst
The Group-Analytic Practice
88 Montagu Mansions
London W1H 1LF
020 7935 3103/020 7935 3085
IGA

GREEN, Brian
Psychoanalytic Psychotherapist
91 Bedford Court Mansions
Bedford Avenue
London WC1B 2AE
020 7354 3119
FPC

GREENBERG, Maurice
Group Analyst
Group Analytic Practice
88 Montagu Mansions
London W1H 1LF
020 7935 3103/020 7935 1397
IGA

GREENE, Alice
Autogenic Psychotherapist
86 Harley Street
London W1N 5AE
020 7580 4188 (t/f)
BAS

GREW, Lesley
Hypno-Psychotherapist
11 Clare Court, Judd Street
London WC1H 9QW
020 7837 9772
NRHP

HALLAM, Richard S
Cognitive Behavioural Psychotherapist
319 Endsleigh Court
Upper Woburn Place
London WC1H 0HF
020 7387 0069
BABCP

HANNA, Gilli
Transpersonal Psychotherapist
23 Bentinck Street
London W1M 5RL
020 7935 6887
CCPE

HAY, Jennifer
Integrative Psychotherapist
Pathways to Change
44 Harley Street
London W1N 1AD
020 8392 3000 x4266/
020 7580 9431
RCSPC

HODGES, Jill
Child Psychotherapist
Dept. of Psychological Medicine
Great Ormond Street Hospital
Great Ormond Street
London WC1N 3JH
020 7829 8888 X 5578/
020 8809 2834
ACP

HOLDEN, John W
Psychoanalytic Psychotherapist
Priest's Court, 4 Foster Lane
London EC2V 6HH
020 7606 1863
FPC

KALITOWSKI, Matthew
Hypno-Psychotherapist
27, Midhope House
Midhope Street
London WC1H 8HH
020 7916 3681
NSHAP

KEE, Cynthia
Educational Therapist
35 Goodge Street
London W1P 1FD
020 7636 3243
FAETT

KENRICK, Jennifer
Child Psychotherapist
London
020 7352 2525
ACP

KINGSLEY, Joan
Integrative Psychotherapist
56E Upper Montague Street
London W1Y 3RH
020 7723 1747/020 7629 0441
RCSPC

KOHON, Valli
Child Psychotherapist
London
020 7455 4173
ACP

KOPPELMAN, Liora
Psychoanalytic Marital Psychotherapist
5 Albert Mansions
Luxborough Street
London W1M 3LN
020 7487 3766/020 8455 3092
TMSI

KORTE, Achim
Biodynamic Psychotherapist
Flat 8, 52 Langham Street
London House
London W1N 5RF
020 7636 7514
BTC

LEADER, Darian*
Lacanian Analyst
Flat 2, 5 Bulstrode Street
London W1
020 7487 5415
CFAR

LILLEY, Davina
Group Analyst
13a Chadwell Street
London EC1R
IGA

LILLIE, Francis
Cognitive Behavioural Psychotherapist
27a Harley Place
London W1N 1HB
020 7323 2370
BABCP

LLOYD, Patricia
Sexual and Relationship Psychotherapist
3 De Walden Street
London W1M 7PJ
020 7224 6872
BASRT

LOOSE, Judith Green
Child Psychotherapist
6 Montagu Square
London W1H 1RA
020 7224 6028/020 7935 0802
ACP

MAGAGNA, Jeanne
Child Psychotherapist
Dept. of Psychological Medicine
Great Ormond Street Hospital
Great Ormond Street
London WC1N 3JH
020 7829 8679
ACP

MAGUIRE, Anne
Analytical Psychologist-Jungian Analyst
23 Harley Street
London W1N 1DA
020 7436 5262/01254 59910
IGAP

MARKOVIC, Desa
Systemic Psychotherapist
23 Bedfordbury
London WC2N 4BL
020 7240 1511
KCC

MAYER-JOHNSON, Jessica
Group Analyst
91 Bedford Court Mansions
Bedford Avenue, London WC1 3AE
020 7359 4925
IGA

MCCABE, Jennifer
Psychoanalytic Psychotherapist
c/o Healthworks, 15 Great St. Thomas
London EC4V 2BB
020 7213 9833
UPA

MOSES, Susan
Psychoanalytic Psychotherapist
9 Amen Court
Warwick Lane
London EC4M 7BU
020 7489 0779
FPC

MYCROFT, Jessica
Psychoanalytic Psychotherapist
26 Northampton Square
London EC1V 0ES
020 7253 6963/020 7253 3765
IPSS

NIELSEN-CERNKOVICH, Rudy
Psychoanalytic Psychotherapist
Avenue Psychotherapy Services Ltd.
127 City Road
London EC1V 1JB
0800 783 3750/020 7490 3311
ARBS

PACEY, Susan
Sexual and Relationship Psychotherapist
82 Harley Street
London W1N 1AE
020 7916 7055
BASRT

PARISSIS, Maria
Integrative Psychotherapist
5a Nottingham Mansion
Nottingham Street
London W1M 3FY
020 7935 9995
RCSPC

PERRING, Michael
Integrative Psychotherapist, Sexual and
Relationship Psychotherapist
Optimal Health, 114 Harley Street
London W1N 1AG
020 7935 5651
MET

RAESIDE, Dominic
Family Therapist
The Family Law Consortium
2 Henrietta Street
Covent Garden
London WC2E 8PS
020 7420 5000
AFT

RAMAGE, Margaret
Sexual and Relationship Psychotherapist
82 Harley Street
London W1N 1AE
020 7935 0616
BASRT

READ, Tim
Group Analyst
Group Analytic Practice
88 Montagu Mansions
London W1H 1LF
020 7935 3103
IGA

ROBERTS, Jeff
Group Analyst
The Group Anlaytic Practice
88 Montagu Mansions
London W1H 1LF
020 7935 3103
IGA

ROBINSON, Marlene
Child Psychotherapist
1 Harley Street
London W1N 1DA
020 7637 1828/020 7486 6765
ACP

SAABOR, Geraldine
Transpersonal Psychotherapist
1 York Street
London W1H 1PZ
020 7487 4912
CTP

SEGAL, Barbara
Child Psychotherapist
Department of C&A Psychological
Services
Middlesex Hospital
North House, Cleveland Street
London W1N 8AA
020 7380 9089
ACP

SEGLOW, Ruth M.
Child Psychotherapist
London
020 8340 9145
ACP

SHERLOCK, Teresa
NLP Psychotherapist
46 Harley Street, London W1N 1AD
020 7580 9431
ANLP

SHULMAN, Graham
Child Psychotherapist
London
020 8453 1702
ACP

SIPOS-SARHANDI, Zsuzsa
Group Analyst
University College London
3 Taviton Street
Student Counselling Service
London WC1
020 739 1483
IGA

TAIT, Mike
Group Analyst
City University Counselling Service
Medical Centre,
20 Sebastian Street
Islington EC1V 0HB
020 7477 8000 x4093
IGA

TREVATT, David
Child Psychotherapist
6 Montagu Square
London W1H 1RA
020 7272 3982
ACP

TYRRELL, Susannah
Transpersonal Psychotherapist
c/o CTP
86a Marylebone High Street
London W1M 3DE
020 7935 7350
CTP

VIBERT, Eva
Integrative Psychosynthesis
Psychotherapist, Transpersonal
Psychotherapist
22 Queen Anne Street
London W1M 9LB
020 7631 1334
CTP

VICK, Philippa
Transpersonal Psychotherapist
44 Gloucester Place Mews
London W1H 3PL
020 7935 2294/01458 822 3099
CTP

WATTS, Mary
Cognitive Behavioural Psychotherapist
Department of Psychology
City University
Northampton Square
London EC1V 0HB
020 7477 8528
BABCP

WHITFIELD, Gwyn
Systemic Psychotherapist
The Pink Practice
5 Tavistock Place
London WC1H 9SN
01535 635444
KCC

WILLIAMSON, Ian
Child Psychotherapist, Jungian Child
Analyst
17 Wimpole Street
London W1M 7AD
020 8809 3549/020 8802 9189
ACP

WILSON, Peter
Child Psychotherapist, Psychoanalytic
Psychotherapist
Young Minds, 2nd Floor
102-108 Clerkenwell Road
London EC1M 5SA
020 7336 8445/020 8883 6370
ACP

WOLF, Darren
Integrative Psychotherapist
5c Peabody Building
Herbrand Street
London WC1N 1JJ
020 7209 1285
RCSPC

WRIGHT, Laurie Jo
Attachment-based Psychoanalytic
Psychotherapist
16 Bingham Place
London W1M 3FH
01435 882756/020 7486 2608
CAPP

YAPP, Robin
Cognitive Behavioural Psychotherapist
25 Galway House, Radnor Street
London EC1V 3SL
020 7336 6349
BABCP

LONDON EAST

ADAMS, Martin
Existential Psychotherapist
84 Middleton Road
London E8 4LN
020 7254 2707
RCSPC

AGGETT, Percy
Family Therapist, Systemic
Psychotherapist
69 Glenarm Road
London E5 0LY
020 8218 7440/020 8533 0594
IFT

ANSON, Carol
Systemic Psychotherapist
7 Upper Walthamstow Road
Walthamstow
London E17 3QG
020 8521 7932
KCC

ATKINSON, Paul
Psychoanalytic Psychotherapist
6A St. Mark's Rise
London E8 2NJ
020 7241 2506
GUILD

BANNISTER, Gill
Psychoanalytic Psychotherapist
78 Lichfield Road, Bow
London E3 5AL
020 8981 2244
FPC

BARTLETT, Francesca
Child Psychotherapist
Donald Winnicott Centre
Coate Street
London E2 9AG
020 7608 6500/020 7254 3581
ACP

BEASLEY, Rachel
Integrative Psychotherapist
10 Onslow Gardens
South Woodford
London E18 1NE
07957 232739/020 8262 1763
RCSPC

BENDER, Helen
Child Psychotherapist
Child & Family Consultation Centre
Royal London Hospital
London E1 1BB
020 7377 7390/020 8445 4798
ACP

BICKERTON, Tricia
Psychoanalytic Psychotherapist
86 Eleanor Road, Hackney
London E8 1DN
020 7249 2770
GUILD

BOND, Lesley
Transpersonal Psychotherapist
59 Godwin Road, Forest Gate
London E7 0LF
020 8555 8869
CCPE

BOND, Sharon
Systemic Psychotherapist
Chiron Consultation Service
153-159 Bow Road
London E3 2SE
020 8257 7915
KCC

BOULTON, John
Psychoanalytic Psychotherapist
10 Cardigan Road, Bow
London E3 5HU
CPP

BRENNAN, Joady
Personal Construct Psychotherapist
14 Strahan Road, Bow
London E3 5DB
07931 425 261/020 8980 9290
CPCP

BRION, Marion
NLP Psychotherapist
59 Osborne Road
London E7 0PJ
020 8534 5494
ANLP

BURGESS, Shanti
Hypno-Psychotherapist
64 Queenswood Gardens
Wanstead
London E11 3SF
020 8530 4413
NSHAP

BURLINGTON, Maggie
Psychosynthesis Psychotherapist
56 Gordon Road, Wanstead
London E11 2RB
020 8521 3269
AAPP

CAIN, Dennis
Transpersonal Psychotherapist
Psychotherapy & Counselling Unit
Eastwood Medical Centre
Eastwood Road, South Woodfrod
London E18 1BN
020 8491 7077
CCPE

CATO, Jane
Integrative Psychotherapist
28 Daubeney Road
London E5 0EF
020 8533 7699
MC

CHAPMAN, Sandy
Analytical Psychologist-Jungian Analyst
148 Millfields Road
London E5 0AD
020 8986 3792
CAP

CHESNER, Anna
Psychodrama Psychotherapist
64 Manchester Road
London E14 3BE
020 7515 6342
BPA

COLLINS, Natalie
Psychoanalytic Psychotherapist
133 Larkshall Road
North Chingford
London E4 6PE
020 8529 4986
GUILD

CONNOLLY, Cath
Systemic Psychotherapist
8a Albert Road
London E10 6NX
020 8928 0569
IFT

COOPER, Rebecca
Humanistic Psychotherapist
99 Eleanor Road
London E8 1DN
020 7254 7186
AHPP

CORBETT, Martyn
Group Analyst
73 Richmond Road
London E8 3AA
020 7923 4549
IGA

COX, Philip
Analytical Psychologist-Jungian Analyst
63 Somerset Road
London E17 8QN
020 8520 9391
AGIP

CRAWFORD, Joan
Integrative Psychosynthesis
Psychotherapist
56 Gordon Road
London E11 2RB
020 8518 8699
RE.V

CROMBIE, Clare
Gestalt Psychotherapist
103 Wellington Row
London E2 7BN
020 7366 0221
GCL

DANIEL, Barbara
Family Therapist, Psychoanalytic
Psychotherapist
78 Rushmore Road, Lower Clapton
London E5 0EX
020 8986 8377
GUILD

DANIEL, Catherine
Educational Therapist
11b Grosvenor Road
London E11 2EW
020 8530 4866
FAETT

D'ARDENNE, Patricia
Sexual and Relationship Psychotherapist
Head of Clinical Psychology
City & Hackney Community Services
NHS Trust, 50-52 Clifden Road
London E5 0LJ
020 8510 8661
BASRT

DAVID, Anna
Integrative Psychotherapist
22B Montague Road, Hackney
London E8 2HW
020 7923 1019
RCSPC

DAWSON, Linda
Child Psychotherapist
Wellington Way Centre
1A Wellington Way, Bow
London E3 4NE
020 8980 3510
ACP

DELVE, Stuart
Family & Couple Therapist
33 Sherrard Road
London E7 8DN
020 8471 7498
AFT

DUFFY, Rosemary
Child Psychotherapist
Newham Child and Family Consultation
Service
84 West Ham Lane
London E15 4PT
020 7250 7347
ACP

ECCLES, Barbara
Child Psychotherapist
Newham Child and Family
252 Katherine Road
London E7 8PW
020 8552 5171
ACP

FARUKI, Shirley
Hypno-Psychotherapist
38 Pulteney Road
South Woodford
London E18 1PS
020 8989 6734
NRHP

FEE, Angie
Humanistic and Integrative
Psychotherapist
18 Queensdown Road
London E5 8NN
020 8986 0069
AHPP

FRANKS, Julia
Transpersonal Psychotherapist
61 Nightingale Road
London E5 8NB
020 7682 0090/0060
CCPE

FROSHAUG, Ann
Analytical Psychotherapist
196 Queensbridge Road
London E8 4QE
020 7254 4041
FIP

GAWLER-WRIGHT, Pamela
Hypno-Psychotherapist, NLP
Psychotherapist
Beeleaf House, 34 Grove Road
London E3 5AX
020 8983 9699
ANLP

GIBSON, Jenny
Transactional Analysis Psychotherapist
36 Morecambe Close
Beaumont Square, Stepney Green
London E1 4NH
020 7790 4784
ITA

GLOVER, Nicholas
Psychoanalytic Psychotherapist
71 Woodford Road, Forest Gate
London E7 0DL
020 8534 2205
UPA

GOLDBERG, Henia
Family Therapist
108a Forest Road
London E8 3BH
AFT

GOOD, Simon*
Psychoanalytic Psychotherapist
14 Belgrave Road
London E11 3QN
020 8201 8525/020 8989 6529
GUILD

GOODES, Deborah
Psychoanalytic Psychotherapist
78a Leybourne Road, Leytonstone
London E11 3BT
020 8926 0797
ARBS

GOODING, Kim
Integrative Psychotherapist
213 St Stephens Road, Bow
London E3 5JW
020 8981 8388/020 8981 8477
RCSPC

GRAVES, Jane
Psychoanalytic Psychotherapist
1a Albert Road, Silvertown
London E16 2DW
020 7511 8703
CPP

GRAY, Kati
Psychoanalytic Psychotherapist
30 Skelton Road
London E7 9NJ
020 8471 8016
GUILD

GROVES, Paramabandhu
Core Process Psychotherapist
51 Roman Road
London E2 0HU
020 8983 1316
AAPP

HARDING, Celia
Psychoanalytic Psychotherapist
36 Richmond Road, Leytonstone
London E11 4BU
020 8556 5089
FPC

HARRINGTON, Finola
Cognitive Behavioural Psychotherapist
23 Wheler Street
London E1 6NR
020 7377 7530/0802 934771
BABCP

HASLAM, Deirdre
Cognitive Analytic Therapist, Humanistic
Psychotherapist
85 Rushmore Road
London E5 0EX
020 8986 3051
AHPP

HAWKES, Bernadette
Psychoanalytic Psychotherapist
32 Canning Road, Walthamstow
London E17 6LT
020 8509 1484
IPSS, NAFSI

HAYES, Cheyl
Sexual and Relationship Psychotherapist
25 St Mary Grace's Court
Cartwright Street
London E1 8NB
020 7481 4007
BASRT

HENDERSON, John
Child Psychotherapist
Newham Child & Family Consultation
Service
252 Katherine Road
London E7 8PW
020 8552 5171
ACP

HERINGTON, Steve
Family Psychotherapist
7 Upper Walthamstow Road
London E17 3QG
020 8521 7932
IFT

HOANG, Astrid
Group Analytic Psychotherapist
"Gratton Lodg"
40 Spruce Hills Road, Walthamstow
London E17 4LD
020 8527 7258
FPC

HOPE, Francis
Psychosynthesis Psychotherapist
84 Albion Drive
London E8 4LY
020 7226 9798/020 7226 4900
AAPP

HUGHES, Margaret
Child Psychotherapist
Walthamstow Child & Family
Consultation Service
Shernhall Street
London E17 3EA
020 8509 0424
ACP

HUSON, Richard
Psychosynthesis Psychotherapist
Flat 7, Sugar Loaf Walk
London E2 0JQ
020 8981 2428
AAPP

JACQUES, Glenys
Gestalt Psychotherapist
15 Kemey's Street, Homerton
London E9 5RQ
020 8533 2948
GPTI

JONES, Dave
Humanistic Psychotherapist
8 Forest Glade, Leytonstone
London E11 1LU
020 8989 6565
AHPP

KANE, Ros
Psychoanalytic Psychotherapist
15 Matcham Road
London E11 3LE
020 8555 5248
GUILD

KEANE, Agnes
Transpersonal Psychotherapist
29 Dunton Road, Leyton
London E10 7AF
CCPE

KIRKLAND, Margot
Psychosynthesis Psychotherapist
Ashwin Street Practice
The Print House, 18 Ashwin Street
London E8 3DL
020 7254 9202
AAPP

LAMPRELL, Michael
Psychoanalytic Psychotherapist
36 Richmond Road, Leytonstone
London E11 4BU
020 8556 5089
FPC

LEVINE, Hanelle G
NLP Psychotherapist
148 Sewardstone Road
Bethnal Green
London E2 9HN
020 8983 0581
ANLP

MALKIN, Julius
Cognitive Behavioural Psychotherapist
Professional Development Foundation
21 Limehouse Cut, 46 Morris Road
London E14 6NQ
020 8340 2692/020 7987 2805
BABCP

MANGLANI, Dona
Psychoanalytic Psychotherapist
72 Elderfield Road
London E5 0LF
07977 594 993/020 8691 9771
IPSS

MAZARAKI, Angeliki
Psychoanalytic Psychotherapist
26 Chopwell Close
Bryant Street, Stratford
London E15 1RG
020 8519 6227
ARBS

MCCANN, Linda
Systemic Psychotherapist
67 Clapton Common
London E5 9AA
020 8986 7351/020 8806 9370
IFT

MCCARRON, Gerard
Cognitive Psychotherapist
92 Onslow Gardens
South Woodford
London E18 1NB
020 8442 6528/020 8491 7756
BABCP

MCGRATH, Rita
Family Therapist
17 Warwick Road, Wanstead
London E11 2DZ
020 8360 6771/020 8989 2834
IFT

MCWILLIAM, Jill
Educational Therapist
93 Crofton Road, Plaistow
London E13 8QT
020 7476 1777
FAETT

MESSENT, Philip
Family Psychotherapist
Emanuel Miller Centre
Gill Street
London E14 8HQ
020 7515 6633
IFT

MOOREY, Stirling
Cognitive Behavioural Psychotherapist
City and Hackney Community Services
50–52 Clifen Road
London E5 0LJ
020 8510 8242
BABCP

MORGAN, Mary
Psychoanalytic Marital Psychotherapist
191 Mornington Road, Leytonstone
London E11 3DT
020 8558 8929/020 7447 3821
TMSI

MULLER, Nina
Psychodynamic Psychotherapist
888 Lea Bridge Road
London E17 9DW
020 8539 8793
AIP

NESBIT, Judith
Psychoanalytic Psychotherapist
32 Thornby Road
London E5 9QL
020 8986 5286
AGIP

O'BRIEN, Ann
Hypno-Psychotherapist
88b Antill Road, Bow
London E3 5BP
020 8981 6938/020 8981 3082
NSHAP

O'KEEFFE, Tim
Psychoanalytic Psychotherapist
60 St Mary Road, Walthamstow
London E17 9RE
020 8520 3766
AGIP

O'LEARY, Carmen
Group Analyst
14 Queen's Grove Road
London E4 7PT
020 8529 3536
IGA

PAPADOPOULOS, Renos
Analytical Psychologist-Jungian Analyst,
Family Psychotherapist
20 Woodriffe Road
London E11 1AH
020 8556 3180
IGAP

PEARMAIN, Rosalind
Psychoanalytic Psychotherapist
69 Gordon Road, Wanstead
London E11 2RA
020 8989 8891
GUILD

PHILBIN, Mairead
Psychosynthesis Psychotherapist
St. Joseph's Hospice
Mare Street, Hackney
London E8 4SA
020 8986 2285
AAPP

PIXNER, Stefanie
Integrative Psychotherapist
94 Colvestone Crescent, Hackney
London E8 2LJ
020 7254 6216
MC

POTKONJAK, Dusan
Psychodrama Psychotherapist
Ansell Ward
St Clement's Hospital, Bow Road
London E3
020 7377700 x 4088/
020 7377 7984
BPA

PRENTICE, Hilary
Integrative Psychotherapist
54 Tower Hamlets Road
Walthamstow
London E17 4RH
020 8533 6565/020 8520 1601
MET

RICKMAN, Chrisse
Integrative Psychotherapist
87a Dawlish Road, Leyton
London E10 6QB
020 8556 2764
MET

ROBERTS, Laurence*
Psychoanalytic Psychotherapist
40 Boleyn Road, Upton Lane
Forest Gate
London E7 9QE
020 8472 2430
GUILD

ROWAN, John
Individual and Group Humanistic
Psychotherapist
70 Kings Head Hill
North Chingford
London E4 7LY
020 8524 7381
AHPP

SANDELSON, Jennifer
Sexual and Relationship Psychotherapist
9 Meynell Crescent
London E9 7AS
020 8525 0772
BASRT

SCOTT, Tricia
Individual and Group Humanistic
Psychotherapist
8 Shrubland Road
London E8 4NN
020 7254 4490
AHPP

SHEARMAN, Christine
Integrative Psychotherapist, Transactional
Analysis Psychotherapist
Hawthorn, 24 Hollybush Hill
London E11 1PP
020 8989 5206
ITA

SHETLAND, Ilrich
Psychoanalytic Psychotherapist
76A Lauriston Road, London E9 7HA
020 8986 5889
IPSS

SHUTTLEWORTH, Alan
Child Psychotherapist
Walthamstow Child & Family
Consultation Service
Shernhall Street, London E17 3EA
020 8509 0424/020 8883 7908
ACP

SLADE, John
Integrative Psychotherapist
86 Clifden Road, London E5 0LN
020 8533 0022
MC

SMART, Tanya
Systemic Psychotherapist
East Ham Day Centre
Shrewsbury Road, Forest Gate
London E7 8QR
020 8586 5100
KCC

SMITH, Gerrilyn
Family Psychotherapist
P O Box 6568, London E5 0XD
020 7391 9150/020 8985 8081
IFT

SOMERVILLE, Gwynnedd
Psychoanalytic Psychotherapist
23 Mornington Grove, London E3 4NS
020 8983 1085
FPC

SPENDELOW, Lyndsay
Integrative Psychotherapist
9 Mountague Place, Poplar
London E14 0EX
020 7987 2275
RCSPC

STERN, Julian
Psychodynamic Psychotherapist
Royal London Hospital
(St. 2 A Bow Road Clements)
London E3 4LL
020 73777966
UPA

STIASNY, Jennifer
Child Psychotherapist
Newham Child & Family Consultation
Service
84 West Ham Lane, London E15 4PT
020 8250 7347
ACP

SUTHERLAND, Elisabeth
Psychosynthesis Psychotherapist
50 Blondin Street, Bow
London E3 2TR
020 8981 1553
AAPP

TAYLOR, Mary
Psychoanalytic Psychotherapist
118 Glenarm Road, Hackney
London E5 0NA
020 8986 1108
FIP

TAYLOR, Sheena
Integrative Psychotherapist
Flat 8, James Hilton House
23 Woodford Road
South Woodford
London E18 2EL
020 8989 5458
MET

TOGHER, Margaret
Systemic Psychotherapist
Chingford Health Centre
109 York Road, Chingford
London E4 8LF
020 8523 8479
KCC

TOMLIN, Patrick
Psychosynthesis Psychotherapist
31 Antill Road, Bow
London E3 5BT
020 8980 7107
AAPP

TRISTRAM, Sue
Body Psychotherapist, Integrative
Psychotherapist
231 Glyn road
London E5
020 8986 4923
CCBP

URWIN, Catherine
Child Psychotherapist
Emanuel Miller Centre
The Health Centre
11 Gill Street
London E14 8HQ
020 7515 6633/020 8802 8593
ACP

VAS DIAS, Susan
Attachment-based Psychoanalytic
Psychotherapist, Child
Psychotherapist
69 Gordon Road
London E18 1DT
020 7739 8422 x 6425/
020 8559 1244
CAPP

VINCENT, David
Group Analyst
15 Draycot Road, Wanstead
London E11 2NX
020 8989 6028
IGA

VIRTANEN, Helena
Family Therapist, Systemic
Psychotherapist
64 Goldsmith Road
Walthamstow
London E17 6AW
020 8527 5460
IFT

WARWICK, Kate
Child Psychotherapist
Lower Clapton Child & Family
Consultation Service
36 Lower Clapton Road
London E5 0PQ
020 8809 7791/
020 8986 7351
ACP

WEIXEL-DIXON, Karen
Integrative Psychotherapist
19 St Davids Square
Consort House, Westferry Road
London E14 3WA
07970 879770/020 7510 8949
RCSPC

WILLIAMS, Gwen
Psychoanalytic Psychotherapist
226 Twickenham Road, Leytonstone
London E11 4BH
020 8539 4992
IPSS

WOOLLISCROFT, Jessica
Gestalt Psychotherapist, Humanistic
Psychotherapist
28 Whitehall Gardens
London E4 6EH
020 8559 3568
AHPP

LONDON NORTH

ABELES, Margi (Margaret)
Systemic Psychotherapist
London N2
020 8374 0634
KCC

ABLACK, Joanne
Body Psychotherapist, Gestalt
Psychotherapist
71 Burghley Road
London N8 0QG
020 8888 6010
CCBP

ABRAHAMS, Elisabeth M
Integrative Psychotherapist
57 Holdenhurst Avenue, Finchley
London N12 0JA
020 8346 7104
MC

ABSE, Susanna
Psychoanalytic Marital Psychotherapist
17 Muswell Avenue, Muswell Hill
London N10 2EB
020 8883 5746
TMSI

ADAMS, Sue
Humanistic and Integrative
Psychotherapist
Flat 4, 30c Alexandra Road
Hornsey
London N8 0PP
020 8889 9524
BCPC

AIRD, Eileen
Psychoanalytic Psychotherapist
Flat 8, Fortior Court
100 Hornsey Lane
London N6 5LD
020 7272 5738
NAAP

AL JARRAH, Nadina
Psychoanalytic Psychotherapist
12 Regina Road, Islington
London N4 3PP
020 7272 3253
NAFSI

AL RUBAIE, Talal
Hypno-Psychotherapist
41 Denison Close
East End Road, East Finchley
London N2 0JU
020 8444 9567
NSHAP

ALBRECHT, Gisela
Psychoanalytic Psychotherapist
45 Ashley Road
London N19 3AG
020 7281 1265
FPC

ALEXANDER, Sandra
Sexual and Relationship Psychotherapist
39 Outram Road
London N22 4AB
020 8888 8873
BASRT

ALFEROFF, Tamara
Transpersonal Psychotherapist
London N19 3BG
020 7272 3589
CCPE

ALHADEFF, Christine
Child Psychotherapist
Hackney Child & Family Consultation
Servie
Woodberry Down Unit
John Scott Health Centre
Green Lanes
London N4 2NU
020 8809 5577/020 8986 7351
ACP

ALLAN, Brenda
Family Psychotherapist
61 Woodland Rise
London N10 3UN
020 8883 0385/020 8444 0851
AFT

ALLSOP, Paul
Gestalt Psychotherapist, Humanistic and
Integrative Psychotherapist
Spectrum, 7 Endymion Road
London N4 1EE
020 8341 2277/020 8883 3246
SPEC

AMIAS, David
Family Therapist
60 Clifton Road
London N3 2AR
020 8346 2121
IFT

AMIEL, Olivia
Psychoanalytic Psychotherapist
16 Elms Avenue
London N10 2JP
020 8442 0753 (t/f)
GUILD

ANDERSON, Elizabeth
Psychoanalytic Psychotherapist
140 Muswell Hill Road
London N10 3JD
020 8444 2507
AGIP

ANDERSON, Phil
Integrative Psychotherapist
29 Bristall Road
London N15 5EN
020 8809 0064
MET

ANKER, Ofra
Psychosynthesis Psychotherapist
13 Oldfield Mews
London N6 5XA
020 8341 1759 (t/f)
AAPP

ARAM, Eliat
Gestalt Psychotherapist
Flat 3, 210 Tufnell Park Road
London N7 0PZ
020 8202 1023/020 7263 0411
GPTI

ARIEL, Seema
Psychoanalytic Psychotherapist
22 Durham Road
London N2 9DN
020 8883 7386
AGIP

ARNOLD, Katherine
Child Psychotherapist
57 Cecile Park, Crouch End
London N8 9AX
020 8340 2922
ACP

ARNOLD, Rosemary*
Psychoanalytic Psychotherapist
3 Stanmore Road
London N15 3PR
020 8889 7335
GUILD

ASHERI, Shoshi
Body Psychotherapist, Integrative
Psychotherapist
22b Uplands Road, Crouch End
London N8 9NL
020 8340 7168
CCBP

AZGAD, Rachel
Contemporary Psychotherapist
67 Dollis Road
London N3 1RD
020 8346 1525
SITE

BAKER, Adrienne
Integrative Psychotherapist
16 Sheldon Avenue, Highgate
London N6 4JT
020 8340 5970/020 7487 7644
RCSPC

BALOGH HENGHES, Tessa
Child Psychotherapist
92 Highgate Hill
London N6 5HE
020 8348 7731
ACP

BAR, Vivien
Lacanian Analyst, Psychoanalytic
Psychotherapist
5 Stanmore Road
London N15 3PR
020 8889 5925
GUILD

BARADON, Tessa
Child Psychotherapist
22 Edmund Walk
London N2 0HU
020 8455 6886/020 8883 9308
ACP

BARKER, Gina
Attachment-based Psychoanalytic
Psychotherapist
50 Burma Road
London N16 9BJ
020 7275 8002
CAPP

BARRY, Anne
Integrative Psychotherapist
43 Dukes Avenue, Muswell Hill
London N10 2PX
020 8365 3261
NSAP

BEAUMONT, Mia
Psychoanalytic Psychotherapist
13 Highbury Terrace
London N5 1UP
020 7226 8103
GUILD

BEBER, Ray
Group Analyst
16 Grasmere Road
London N10 2DJ
020 8883 4737
UPA

BECKER, Amely
Gestalt Psychotherapist, Individual and
Group Humanistic Psychotherapist
15a Langdon Park Road, Highgate
London N6 5PS
020 8348 6253
GCL

BECKETT, Dale
NLP Psychotherapist
18 Ockenden Road, Islington
London N1 3NP
020 7704 9999
ANLP

BEDDINGTON, Jenny
Analytical Psychologist-Jungian Analyst
39 Waterlow Road, Highgate Hill
London N19 5NJ
01727 858361
CAP

BEHR, Harold
Group Analyst
The North London Centre fro Group
Therapy
138 Bramley Road, Oakwood
London N14 4HU
020 8440 1451
IGA

BENNETT, Angela
Analytical Psychologist-Jungian Analyst
6 Cyprus Road, Finchley
London N3 3RY
020 8349 2073
CAP

BENSIMON, Marlene
Psychoanalytic Psychotherapist
31 Rookfield Avenue
London N10 3TG
020 8444 5878
IPSS

BENTLEY, Patrick
Systemic Psychotherapist
44 Sydney Road, London N10 2RL
KCC

BERESFORD, Marie
Psychosynthesis Psychotherapist
153c Brecknock Road, Tufnell Park
London N19
020 7267 7643
AAPP

BERKE, Joseph
Psychoanalytic Psychotherapist
5 Shepherd's Close, London N6 5AG
020 8348 4492
ARBS

BERRY, Sally
Psychoanalytic Psychotherapist
11 Cecile Park, London N8 9AX
020 8340 5161
ARBS

BHATT, Vibha*
Psychoanalytic Psychotherapist
85 Sydney Road
London N8 0ET
020 8348 9313
GUILD

BIANCO, Vicky
Family Therapist
16 Willow Bridge Road, Canonbury
London N1 2LA
020 7301 3414/020 7226 1931
IFT

BIERSCHENK, John Henry
Analytical Psychologist-Jungian Analyst
58 Queen's Avenue
London N10 3NU
020 8883 3567 (T/F)
AJA

BILDER MA, Tessa
Transpersonal Psychotherapist
61 Huntingdon Road
London N2 9DX
CCPE

BINNINGTON, Linda
Psychoanalytic Marital Psychotherapist
6 Tyndale Terrace, Canonbury Lane
London N1 2AT
TMSI

BLACKWELL, Frances
Psychoanalytic Psychotherapist
28 Kirkstall Avenue
Tottenham
London N17 6PH
020 8880 9553
IPSS

BLAIR, Dana-Jane
Psychoanalytic Psychotherapist
11 Fieldway Crescent
Highbury
London N5 1PU
020 7609 2969
IPSS

BOR, Robert
Family Therapist
35 West Hill Court
Millfield Lane
London N6 6JJ
020 7320 1086/020 7477 8523
IFT

BOWMAN, Heather
Integrative Psychotherapist
9 Leadale Road
Stamford Hill
London N16 6BZ
020 8800 8476
MC

BOWNAS, Jo
Systemic Psychotherapist
4 Clyro Court,
Tollington Park
London N4 3AQ
020 7263 1897
KCC

BOYDEN, Christina
Hypno-Psychotherapist
69 Goddard Place
off Monnery Road
London N19 5GT
020 7281 9663
ANLP

BRADLEY, Catrin
Child Psychotherapist
Hackney Child & Family Consultation
Service
Woodbury Down Unit
John Scott Health Centre
Green Lanes
London N4 2NU
020 8809 5577/020 8444 4733
ACP

BRATERMAN, Eleanor
Hypno-Psychotherapist
36E Portland Rise
London N4 2PP
020 8802 9206
NSHAP

BRAUNER, Rita
Integrative Psychotherapist, Transactional
Analysis Psychotherapist
Upper Flat, 69 Rectory Road
London N16 7PP
020 7241 1477
ITA, MET, NAFSI

BRAVE-SMITH, Anna
Psychoanalytic Psychotherapist
59 Holmesdale Road
London N6 5TH
020 8340 9037
IPSS

BREATHNACH, Eibhlin
Psychoanalytic Psychotherapist
156 Drayton Park
London N5 1LX
020 7226 9390
AGIP

BRENNAN, Damian
Personal Construct Psychotherapist
81 Sperling Road, Tottenham
London N17 6UJ
020 7911 0456/020 8808 2205
CPCP

BRENNAN, Stan
Humanistic and Integrative
Psychotherapist
Spectrum, 7 Montague Road
London N8 9JP
020 8340 9690
SPEC

BROADBENT, Keith
Cognitive Behavioural Psychotherapist
15 Linzee Road, Hornsey
London N8 7RG
0956 353041
BABCP

BROWN, Sara
Psychoanalytic Psychotherapist
6 Carlingford Road, Turnpike Lane
London N15 3EH
020 8889 3464
AGIP

BURGOYNE, Bernard*
Lacanian Analyst
5 Stanmore Road
London N15 3PR
020 8889 5925
CFAR

BURRIDGE, Ellora Polly
Educational Therapist
34 Mercers Road
London N19 4PJ
020 7272 2069
FAETT

**BURROUGHES,
Christopher H**
Family Therapist
143 Kyverdale Road
London N16 6PS
020 8806 3577
AFT

BURY, Dennis R.
Cognitive Behavioural Psychotherapist,
Personal Construct Psychotherapist
47 Mayfield Road, Hornsey
London N8 9LL
020 8348 9181/05989 884081
CPCP

BUSS-TWACHTMANN, Christel
Psychoanalytic Marital Psychotherapist
Flat 1, 75 Cromwell Avenue
London N6
020 8341 1358
TMSI

BYGOTT, Catherine
Analytical Psychologist-Jungian Analyst
28 Cornwall Avenue
London N22 4DA
020 8881 0929
AJA

BYRING, Carola
Biodynamic Psychotherapist
32 Rosemary Avenue
London N3 2QN
020 8343 0255
BTC

CAMERON, Anna
Psychoanalytic Psychotherapist
37 Orpington Road
Winchmore Hill
London N21 3PD
020 8482 0787
ARBS

CAMERON, Michael John
Rational Emotive Behaviour Therapist
3A Thyra Grove, Finchley
London N12 8HD
020 8445 1369
BABCP

CAMERON, Roderick
Psychoanalytic Psychotherapist
37 Orpington Road
Winchmore Hill
London N21 3PD
020 8482 0787
ARBS

CANTWELL, Maureen H E
Analytical Psychologist-Jungian Analyst
7 Phoenix House, 5 Waverly Road
London N8 9QU
020 8482 5943
IGAP

CARROLL, Penny
Psychosynthesis Psychotherapist
38 Ridgeway Gardens
Hornsey Lane, Highgate
London N6 5XR
020 7281 2300
AAPP

CATHIE, Sean
Psychoanalytic Psychotherapist
23 Brookfield Mansions
Highgate West Hill
London N6 6AS
020 8347 7050
FPC

CAVISTON, Paul
Psychoanalytic Psychotherapist
54 Leswin Road
London N16 7NH
020 8924 6301/020 7254 7188
PA

CHAMLEE-COLE, Laurena
NLP Psychotherapist
38 Middle Lane
London N8 8PG
020 8340 8156
ANLP

CHANDLER, Philip
Psychoanalytic Psychotherapist
31 Huntingdon Road
London N2 9DX
020 8444 7690
GUILD

CHARALAMBOUS, Praxoulla
Psychoanalytic Psychotherapist
48 Old Park Road
Palmers Green
London N13 4RE
020 8886 8488
WTC

CHINA, Jacques*
Psychoanalytic Psychotherapist
54 Compton Road
London N1 1EJ
020 7354 1533
GUILD

CHRISTOPHER, Elphis
Analytical Psychologist-Jungian Analyst
35 Wood Vale
London N10 3DJ
020 8442 6810/020 8883 0085
CAP

CLIFFORD, Jennifer
Psychoanalytic Psychotherapist
10 Alwyne Place
London N1 2NL
020 7354 3930
FPC

CLIFFORD, Victoria
Attachment-based Psychoanalytic
Psychotherapist
Pure Balance Mind & Body Centre
1A Leicester Mews, Leicester Road
London N2 9DJ
020 8883 4316
CAPP

COHEN, Maggie
Child Psychotherapist
Neonatal Intensive Care Unit
Whittington Hospital, Highgate
London N19 5NF
020 7288 5530
ACP

COHEN, Sylvia
Psychoanalytic Psychotherapist
11 Clifton Avenue
London N3 1BN
020 8343 4097 (t/f)
GUILD

CONOLLY, J M P*
Lacanian Analyst, Psychoanalytic
Psychotherapist
48 Beresford Road
London N8 0AJ
020 8340 6044
CFAR

COOKLIN, Alan
Family Therapist
89 Southwood Lane
London N6 5TB
020 8340 5895/020 7390 8377
IFT

COOPER, Howard
Psychoanalytic Psychotherapist
37 Lansdowne Road
London N3 1ET
020 8349 3891
AGIP

COOPER, Jillian
Existential Psychotherapist
24 Rocliffe Street
London N1 8DT
020 7253 1651
RCSPC

COOPER, Sara
Psychoanalytic Psychotherapist
37 Lansdowne Road
London N3 1ET
020 8349 3891
GUILD

COOPER, Terry
Body Psychotherapist, Humanistic and
Integrative Psychotherapist, Somatic
Emotional Therapist
Spectrum, 7 Endymion Road
London N4 1EE
020 8341 2277/020 8340 0426 (f)
SPEC

COULSON, Susan
Child Psychotherapist
Hornsey Rise Child Guidance Unit
Beaumont Rise
London N19 3YU
020 7530 2444/020 8348 5726
ACP

COUZYN, Jeni*
Psychoanalytic Psychotherapist
30 Chestnut Avenue
London N8 8NY
020 8340 5697
GUILD

COWAN-JENSSEN, Susan
Primal Psychotherapist
West Hill House, 6 Swains Lane
Highgate
London N6 6QU
020 7267 9616
LAPP

CRACE, Gay
Psychoanalytic Psychotherapist
125 Ashurst Road
London N12 9AD
020 8446 1251
AIP

CRAWFORD, Stephen
Psychoanalytic Psychotherapist
29 Cromwell Close, East Finchley
London N2 0LL
020 8444 8570
FPC

CRITCHLEY, Bill
Gestalt Psychotherapist, Integrative
Psychotherapist
1 Northolme Road
London N5 2UZ
020 7354 0745
MET

CROWLEY, Julia
Psychoanalytic Psychotherapist
5 Inkwell Close,
Woodside Grove, Finchley
London N12 8QQ
020 8446 5161
FPC

CROWTHER, Catherine
Analytical Psychologist-Jungian Analyst
50 Leconfield Road
London N5 2SN
020 7226 3112
CAP

CRYER, Valerie
Psychoanalytic Psychotherapist
40 Oakleigh Park South
London N20 9JN
020 8445 5535
AGIP

CUNDY, Linda
Attachment-based Psychoanalytic
Psychotherapist
100a Cazenove Road
London N16 6AD
020 8806 8092
CAPP

CURTI-GIALDINO, Francesca
Family Therapist
29 Parolles Road
London N19 3RE
020 7281 3861
AFT

DALAL, Farhad
Group Analyst
24 Kyverdale Road,
Stoke Newington
London N16 7AH
020 7502 7536
IGA

DANIELS, Orpa
Psychoanalytic Marital Psychotherapist
4 Shortgate, Woodside Park
London N12 7JP
020 8922 5223
TMSI

DANIELS, Susan
Psychoanalytic Psychotherapist
4 Finsbury Park Road
London N4 2JZ
020 7503 8154
IPSS

DARLING, Liv
Psychoanalytic Psychotherapist
318 Long Lane, East Finchley
London N2 8JP
CPP

DAVENPORT, Marie-Laure
Psychoanalytic Psychotherapist
28 Onslow Gardens
London N10 3JU
020 8444 4695
PA

DAVIS, Susan
Psychosynthesis Psychotherapist
40 Leadale Road
London N16
020 8809 1096
AAPP

DE BOTTON, Susan
Integrative Psychotherapist
56 Priory Road
London N8 7EX
0468 532 308/020 8348 9130
RCSPC

DECO, Sarah
Group Analyst
5 Southwood Lawn Road, Highgate
London N6 5SD
020 8348 6476
IGA

DIANIN, Gianni
Psychoanalytic Psychotherapist
24 Morley Avenue, Wood Green
London N22 6LY
020 8888 7338
ARBS

DOBBS, Wendy
Psychodynamic Psychotherapist
2 Giesbach Road
London N19 3EH
020 7272 4207
AGIP

DOMB, Yair
Child Psychotherapist
1 Coleraine Cottages, Fortis Green
London N2 9HJ
020 8883 7694
ACP

DORRIAN, Maeve
Integrative Psychotherapist
19a Mount Pleasant Villas
Hornsey
London N4 4HH
020 7609 8401/020 7263 0750
RCSPC

DOUST, Gill
Humanistic and Integrative
Psychotherapist
1 Duckett Road
London N4 1BJ
020 8348 4111/020 8341 9168
SPEC

DRIVER, Christine
Psychoanalytic Psychotherapist
71 Umfreville Road, Harringay
London N4 1RZ
020 8340 3324
FPC

DUFFELL, Nick
Psychosynthesis Psychotherapist
128a Northview Road, Hornsey
London N8 7LP
020 8341 4885
AAPP

DUNN, Jenny
Psychoanalytic Psychotherapist
3 Monsell Road
London N4 2EF
020 7354 2100
GUILD

DUNN, Mark
Cognitive Analytic Therapist
155 Alexandra Park Road
London N22 7UL
020 7378 3210/020 8888 9629
ACAT

DUTTON, Jane
Systemic Psychotherapist
97 Foulden Road
London N16 7UH
020 8362 5333/020 7249 3993
IFT

EGERT, Susan
Psychoanalytic Psychotherapist
136 Winston Road
London N16 9LJ
020 83621 5651/020 7254 0526
GUILD

EINHORN, Sue
Group Analyst, Psychoanalytic
Psychotherapist
37 Stanhope Gardens
London N4 1HY
020 8800 7247/020 7607 2789
IGA

EINZIG, Hetty
Psychosynthesis Psychotherapist
42 Norcott Road
London N16 7EL
020 7843 6099/020 8806 3730
AAPP

EISEN, Susan
Psychoanalytic Psychotherapist
53 Benthal Road
London N16 7AR
020 8806 8313/020 8806 8703
GUILD

ELEFTHERIADOU, Zack
Integrative Psychotherapist
9 Woodside Avenue
London N6 4SP
020 8444 4042
NAFSI, RCSPC

ELLIOTT, Lois
Psychoanalytic Psychotherapist
112 Nelson Road
London N8 9RN
020 8348 8419
ARBS

ELLIS, Mary Lynne
Psychoanalytic Psychotherapist
78 Huddleston Road
London N7 0EG
020 7687 2206
SITE

ELLIS, Michael
Gestalt Psychotherapist, Humanistic
Psychotherapist
5a Cromartie Road
London N19 3SJ
020 7263 4778
GCL

EMANUEL, Louise
Child Psychotherapist
52 Inderwick Road
London N8 9LD
020 8348 7032
ACP

EMERY, Pamela
Transpersonal Psychotherapist
66 Whitehall Park
London N19 3TN
020 7263 8689
CCPE

ENDER, Beckett
Psychosynthesis Psychotherapist
124b Northview Road, Hornsey
London N8 7LP
020 8340 9423
AAPP

ENDER, Dorry
Psychosynthesis Psychotherapist
36 Heysham Road
London N15 6HL
020 8809 6061/020 7380 0608
AAPP

EPSTEIN, Bunny (F.C)
Integrative Psychotherapist
156 Gladesmore Road
London N15 6TH
020 8802 0761
RCSPC

ERNST, Sheila
Group Analyst, Psychoanalytic
Psychotherapist
53 Manor Road
London N16 5BH
020 8800 7371
IGA

FAGAN, Margaret
Psychoanalytic Psychotherapist
76 Twyford Avenue
London N2 9NN
020 8883 9095
ARBS

FARMER, Sarah
Analytical Psychologist
54 Muswell Hill Road
London N10 2BE
CAP

FARRELL, Em
Integrative Psychotherapist
26 Freegrove Road
London N7 9RQ
020 7609 0507/020 7607 8306
RCSPC

FAWKES, Caroline
Psychoanalytic Psychotherapist
90 Woodland Gardens
London N10 3UB
020 8372 0728
ARBS

FELDBERG, Marilyn
Psychosynthesis Psychotherapist
21 Clifton Avenue
London N3 1BN
020 8349 9429
AAPP

FELDMAN, Wendy
Child Psychotherapist
5 Cholmeley Crescent, Highgate
London N6 5EZ
020 7340 0878
ACP

FERGUSON, Geoff
Psychoanalytic Psychotherapist
113 Wargrave Avenue
London N15 6TX
020 8802 4353
FIP

FERNANDEZ, Valentina
Cognitive Behavioural Psychotherapist
18C Beaconsfield Road
London N11 3AB
020 8361 3108
BABCP

FIELD, Nathan
Analytical Psychologist-Jungian Analyst,
Analytical Psychotherapist
14 Talbot Road, Highgate
London N6 4QR
020 8341 0904
CAP

FINLAY, Rosalind
Analytical Psychologist-Jungian Analyst
31 Hampstead Lane
London N6 4RT
020 8340 6211
AJA

FITZGERALD, J
Analytical Psychologist-Jungian Analyst
30 St.Johns Road
London N15 6QP
020 8802 6395
IGAP

FLATT, Raymond
Psychoanalytic Psychotherapist
89 Swain's Lane, Highgate
London N6 6PJ
020 8341 9407
FPC

FLINSPACH, Elisabeth
Integrative Psychotherapist
50c Albert Road, Finsbury Park
London N4 3RP
01536 373 058/020 7263 2098
MC

FLOWER, Steven
Psychosynthesis Psychotherapist
47 Winton Avenue
London N11 2AS
020 8881 4155
AAPP

FOGELBERG, Don
Personal Construct Psychotherapist
16 Hewitt Road
London N8 0BL
020 8340 9612
CPCP

FORD, Susan
Psychoanalytic Psychotherapist
48 Crayford Road
London N7 0ND
020 7609 4800
FIP

FORTI, Laura
Psychoanalytic Psychotherapist
38 Berkeley Road
London N8 8RU
020 8348 6933
ARBS

FOX, Loretta
Psychosynthesis Psychotherapist
1 Helen Court
Hendon Lane, Finchley
London N3 3SX
020 8349 0448
AAPP

FRAZER, Diane
Psychoanalytic Psychotherapist
c/o AGIP
1 Fairbridge Road
London N19 3EW
020 7272 7013
AGIP

FREEMAN, Catherine
Psychoanalytic Psychotherapist
c/o AGIP
1 Fairbridge Road
London N19 3EW
020 8442 6528/020 7272 7013
AGIP

FREEMAN, Sue
Psychoanalytic Psychotherapist
5a Winchester Road
London N6 5HW
020 8348 8889
FPC

GALLAGHER, Teresa
Integrative Psychotherapist
c/o Immigrant counselling &
Psychotherapy
79½ Tollington Park
London N4 3AG
020 7272 7906
RCSPC

GAUCI, Kate
Cognitive Behavioural Psychotherapist
Psychology Department
St Ann's Hospital, St Ann's Road
London N15 3TH
020 7502 1582
BABCP

GHIACI, Golshad
Psychoanalytic Psychotherapist
2 Lincoln Road
London N2 9DL
FIP

GILBERT, Gillie
Biodynamic Psychotherapist
27 Sandringham Gardens
North Finchley
London N12 0NY
020 8445 8424
BTC

GODSIL, Geraldine
Analytical Psychologist-Jungian Analyst
60 Ealing Park Gardens
London N5 4EU
020 8960 5744
CAP

GOODRICH, Diana*
Psychoanalytic Psychotherapist
Open Door
12 Middle Lane
London N8
020 8374 6397
GUILD

GORDON, Elizabeth
Analytical Psychologist-Jungian Analyst
68 Hornsey Lane
London N6 5LU
020 7263 3725
IGAP

GOSLETT, Kate
Psychoanalytic Psychotherapist
83 Axminster Road
London N7 6BS
020 7272 8322
IPSS

GOW, Marion
Psychoanalytic Psychotherapist
76b Inderwick Road
London N8 9JY
020 8347 8748
GUILD

GRAHAM, Judith
Humanistic Psychotherapist
12 Almeida Street
London N1 1TA
020 7354 2240/020 7487 5244
AHPP

GRANOWSKI, Margaret
Integrative Psychotherapist
191 Brecknock Road
London N19 5AB
020 7485 5274
MC

GREALLY, Brid
Psychoanalytic Psychotherapist
25 Clonmell Road
London N17 6JY
020 8885 1866
GBREALLY@YAHOO.CO.UK
FPC

GREEN-THOMPSON, Cyril
Hypno-Psychotherapist
4 Alexandra National House
330 Seven Sisters Road
London N4 2PF
020 8802 7103
NSHAP

GROSS, Grete
Autogenic Psychotherapist
21 Walfield Avenue
London N20 9PS
020 7445 8215
BAS

GROSS, Stephen
Analytical Psychotherapist
5 Barnard Hill
London N10 2HB
020 8444 0598
AIP

GROSS, Vivien
Family Therapist, Systemic
Psychotherapist
5 Barnard Hill, Muswell Hill
London N10 2HB
020 8672 9911 x42192/
020 8444 0598
IFT

GÜNGÖR, Dilek
Psychoanalytic Psychotherapist
7 Palace Gates Road, Woodgreen
London N22 4BW
020 7263 4130/020 8881 1921
NAFSI, UPA

GURION, Michal
Child Psychotherapist
28 Princes Avenue
London N22 4SA
020 8881 0026
ACP

HADARY, Orna
Psychoanalytic Psychotherapist
31 Templar Crescent
London N3 3QR
020 8346 0594
CPP

HALL, Guy
Psychoanalytic Psychotherapist
13 Falkland Avenue
London N3 1QR
020 8343 0069
FIP

HALL, Kirsty
Psychoanalytic Psychotherapist
134 Dukes Avenue
London N10 2QB
020 8883 9681
FIP

HALTON, William
Child Psychotherapist
10 Lincoln Road
London N2 9DL
020 8444 7497
ACP

HAMILTON, Dorothy
Psychoanalytic Psychotherapist
1 Fairbridge Road
London N19 3EW
020 7272 7013
AGIP

HAMILTON-DUCKETT, Paule
Psychoanalytic Psychotherapist
132 St. James Lane, Muswell Hill
London N10 3RH
020 8444 3577
FPC

HAMROGUE, Tom
Group Analyst
33 Victoria Road
London N22 4XA
01707 297 9000/020 8440 1451/020
8888 6315
IGA

HANCOCK, Maureen
Gestalt Psychotherapist
233 Biddestone Road
London N7 9UE
020 8700 3298
GCL

HANNON, Sr. Mary Letizia
Educational Therapist
53 Bethune Road
London N16 5EE
020 8802 3430
FAETT

HANSON, Carol
Child Psychotherapist
253 Alexandra Park Road
London N22 7BJ
020 8888 5508
ACP

HARGREAVES, Judy
Humanistic and Integrative
Psychotherapist
Spectrum, 7 Endymion Road
London N4 1EE
020 8749 1964
SPEC

HARLEY, Ki
Transactional Analysis Psychotherapist
25 Grove Avenue, Finchley Central
London N3 1QS
020 8349 9827
ITA

HARPER, Anita
Transpersonal Psychotherapist
62 Highgate Hill
London N19 5NQ
020 7263 2005
CCPE

HARRIS, Tirril
Psychoanalytic Psychotherapist
6 Tufnell Park Road
London N7 0DP
020 7272 9235
FIP

HARRISON, Jane
Psychosynthesis Psychotherapist
60 Beaconsfield Road
London N15 4SJ
020 8800 3704
AAPP

HARTMAN, Wendy
Psychoanalytic Psychotherapist
19 Baalbec Road, Highbury Fields
London N5 1QN
020 7226 4775
FPC

HARWARD, Matthew
Psychoanalytic Psychotherapist
154 Evering Road
London N16 7BD
020 8525 9565
ARBS

HASKINS, Nicola
Transpersonal Psychotherapist
Highbury
London N5
020 7226 6680
CCPE

HAUGH, Sheila
Integrative Psychotherapist
101 Albert Road
Alexandra Palace
London N22 7AG
020 8888 6636
RCSPC

HAZELTON, Sally
Integrative Psychotherapist
10 Glaserton Road
London N16 5QX
020 7502 8129/020 8802 9313
RCSPC

HEARST, Lisbeth E
Group Analyst
The North London Centre for Group
Therapy
138 Bramley Road, Oakwood
London N14 4H
020 8440 1451
IGA

HEISMANN, Elisabeth
Systemic Psychotherapist
81–83b Arlington Avenue
London N1 7BA
020 7226 3946
KCC

HEMMING, Judith
Gestalt Psychotherapist
79 Ronalds Road
London N5 1XB
020 7359 3000
GPTI

HENDERSON, David
Analytical Psychotherapist
Basement Flat
16 Marlborough Road
London N19 4NB
020 7281 6219
AIP

HEWITT, Amanda
Family Therapist
Home Farm, Totteridge Green
London N20 8PH
020 8446 9930/020 8445 7882
AFT

HIGH, Helen
Child Psychotherapist, Educational
Therapist, Psychoanalytic Psychotherapist
7 Hillside Gardens
London N6 5SU
020 8340 7037
FAETT

HILDER, Alison
Child Psychotherapist
7 Quick Street
London N1 8HL
020 7278 2088
ACP

HILLER, Ruth
Analytical Psychologist-Jungian Analyst
20 Canonbury Park North
London N1 2JT
020 7226 3723
IGAP

HOLLAND, Stevie
Attachment-based Psychoanalytic
Psychotherapist
7 Cheverton Road
London N19 3BB
020 7263 4184/020 7281 3190
CAPP

HOLLINGS, Avril
Humanistic and Integrative
Psychotherapist
56 Manor Park Road
London N2 0SJ
020 8341 7214
SPEC

HOLLOWAY, Sheila
Educational Therapist
175 Albert Road
London N22 7AQ
020 8888 8851
FAETT

HOSKINS, John
Attachment-based Psychoanalytic
Psychotherapist
58 Woodlands Gardens
London N10 3UA
020 8444 3664
CAPP

HOWELL, Carolyn
Transpersonal Psychotherapist
130 St Paul's Road
London N1 2LP
940 047/020 7 359 1439
CCPE

HUDSON, Inge
Group Analyst, Psychoanalytic
Psychotherapist
22 Scarborough Road
Stroud Green
London N4 4LT
020 7281 1710
IGA

HUDSON, Pauline
Systemic Psychotherapist
68 Tetherdown, Muswell Hill
London N10 1NG
020 7515 6633/020 8883 7662
KCC

HUNT, Maggie
Psychosynthesis Psychotherapist
79 Grange Park Avenue
London N21 2LN
020 8360 1024
AAPP

INLANDER, Antonia
Psychoanalytic Psychotherapist
Flat 7, Victoria Mansions
135 Holloway Road
London N7 8LZ
020 7272 7013/020 7607 9805
AGIP

IVESON, Diana
Family Psychotherapist
77 Muswell Avenue
London N10 2EH
020 8968 0070/020 8883 5731
IFT

JACKSON, Eve
Analytical Psychologist-Jungian Analyst
54 Eade Road
London N4 1DH
020 8800 1418 (t/f)
IGAP

JACKSON, Maureen
Hypno-Psychotherapist
Phoenix House, 12 Overton Road
Oakwood
London N14 4SY
020 8360 7019
NRHP

JAMES, Jessica
Group Analyst, Psychoanalytic
Psychotherapist
26 Kyverdale Road, Hackney
London N16 7AH
020 8806 4920
IGA

JARVIS, Charlotte
Child Psychotherapist
Open Door, 12 Middle Lane
London N8 8PL
020 8348 5947
ACP

JEFFERIES, Alison
Integrative Psychotherapist
16 Summerlee Gardens
East Finchley
London N2 9QN
020 8883 3070
MC

JENNINGS, Lyn C.
Educational Therapist
25 Hoodcote Gardens
London N21 2NG
020 8360 5423
FAETT

JENSSEN, Einar D.
Primal Psychotherapist
West Hill House, 6 Swains Lane
Highgate
London N6 6QU
020 7267 9616
LAPP

JN-BAPTISTE, Louisa
Psychoanalytic Psychotherapist
2 Newcombe, Aberdeen Park
London N5 2AU
020 7383 5405
IPSS

JOHANSSON, Birgitta
Psychoanalytic Psychotherapist
45 Ashley Road
London N19 3AG
020 7281 9567
GUILD

JORDAN, Ruth
Integrative Psychotherapist
10 Brighton Road
Stoke Newington
London N16 8EG
020 7249 0897
MC

KATZMAN, Stewart
Analytical Psychologist-Jungian Analyst
35 Creighton Avenue, Muswell Hill
London N10 1NX
020 8444 0724
CAP

KAY, David Louis
Analytical Psychologist-Jungian Analyst
The End House
56 Hendon Avenue, Finchley
London N3 1UH
020 8346 3320
CAP

KEEDY-LILLEY, Ray
Hypno-Psychotherapist
28 Finsbury Park Road
London N4 2JX
020 7226 6963
NSHAP

KELLY, Michael
Psychoanalytic Psychotherapist
132 Stapleton Hall Road
London N4 4QB
020 8340 9597
ARBS

KENNY, Angela
Psychoanalytic Psychotherapist
Gardnen Flat, 128 Nevill road
Stoke Newington
London N16 OSX
020 7254 8558
AGIP

KENNY, Miranda
Analytical Psychologist-Jungian Analyst
63 Maury Road
Stoke Newington
London N16 7BJ
020 8806 9202
FIP

KERR, Libby
Integrative Psychotherapist
93B Shakespeare Walk
London N16 8TB
020 7254 0384
RCSPC

KERRY, Richard
Cognitive Behavioural Psychotherapist
Department of Psychotherapy
St Ann's Hospital
St Ann's Road
London N15 3TH
020 8442 6458
BABCP

KESSEL, Inge
Humanistic and Integrative
Psychotherapist
1 Uplands Road, Crouch End
London N8 9NN
020 8348 2315
BCPC

KIDD, Lee
Psychoanalytic Psychotherapist
13 Brambledown Mansions
Crough Hill
London N4 4SA
020 7281 3435
FPC

KINGSLEY, Mary
Transpersonal Psychotherapist
6 Avenue Lodge
13 Avenue Road, Highgate
London N6 5DJ
020 8348 4487
CCPE

KLEANTHOUS, Dina
Psychoanalytic Psychotherapist
41 Cheverton Road
London N19 3BA
020 7263 8084/020 7263 7270
ARBS

KNOWLES, Valerie
Psychoanalytic Psychotherapist
1 Florence Villas, Holmesdale Road
London N6 5TJ
020 8348 3251
FPC

KOSTIC, Jasna
Primal Psychotherapist
West Hill House
6 Swains Lane, Highgate
London N6 6QU
020 7267 9616
LAPP

KREEGER, Angela
Psychoanalytic Psychotherapist
37c Cromwell Avenue, Highgate
London N6 5HN
020 8347 5337
SITE

KRZOWSKI, Sue
Psychoanalytic Psychotherapist
39A Axminster Road
London N7 6BP
020 7272 6379
GUILD

LALLAH, Regine
Psychoanalytic Psychotherapist
2 Greville Lodge, 40 Avenue Road
London N6 5DP
020 8340 9943
FPC

LANG, Richard
Integrative Psychotherapist
87B Cazenove Avenue
London N16 6BB
020 8806 3710
MC

LAWLEY, James
NLP Psychotherapist
9 Southwood Lawn Road, Highgate
London N6 5SD
020 8341 1062 (t/f)
ANLP

LAZARUS, Myrna
Family Therapist
30 Jackson's Lane, Highgate
London N6 5SX
020 8348 2886
AFT

LEDERMAN, Tsafi
Biodynamic Psychotherapist
15 Harberton Road
London N19 3JS
020 7263 8551
BTC

LEPPER, Georgia
Analytical Psychologist-Jungian Analyst
99 Sotheby Road
London N5 2UT
020 7226 9353
CAP

LEVENS, Mary
Psychodrama Psychotherapist
12 Edmunds Walk
Hampstead Garden Suburb
London N2 0HU
020 8444 5869
BPA

LEVITT, Olga
Systemic Psychotherapist
"Normandy"
Northcliffe Drive
London N20 8JX
020 8446 1313
KCC

LEWIS, Jacqueline
Integrative Psychotherapist
17 Woodside Avenue
London N6 4SP
020 8444 9457
RCSPC

LEYGRAF, Bernd
Humanistic Psychotherapist, Sexual and
Relationship Psychotherapist
58 Lankaster Gardens
East Finchley
London N2 7AJ
BASRT

LIEBLING, Lauren
Biodynamic Psychotherapist
6 Crescent Street, Barnsbury
London N1 1BT
BTC

LIMBARDET, Jean-Pierre
Sexual and Relationship Psychotherapist
Flat 1, Bridge House
79 Hornsey Lane
London N6 5LQ
020 8348 6358
BASRT

LIPMAN, Amanda
Integrative Psychotherapist
35 Lavers Road
London N16 0DU
020 7254 0863
RCSPC

LISTER, Patricia Anne
Cognitive Behavioural Psychotherapist
23 Wray Crescent, Islington
London N4 3LN
020 7686 4048
BABCP

LODRICK, Michael
Psychoanalytic Psychotherapist
The Garden Flat
20 Poets Road
London N5 2SL
020 7226 6939
FPC

LOUSADA, Olivia
Psychodrama Psychotherapist
14 Allerton Raod
London N16 5UJ
020 8802 5284
BPA

LUCA-STOLKIN, Maria
Integrative Psychotherapist
22 de Beauvoir Square
London N1 4LE
020 7487 7582/020 7249 8050
RCSPC

LUCKCOCK, Ronald Cosmo
Hypno-Psychotherapist
11 Laseron House
Tottenham Green East
London N15 4UA
020 8801 4137
NSHAP

MAKGOBA, Sindi
Systemic Psychotherapist
36 Thackeray Avenue
London N17 9DY
KCC

MANDIKATE, Patrick
Group Analyst
Flat A, 57 Victoria Road
London N22 7XA
020 8888 4756/020 7530 6842
IGA

MARCUS-JEDAMZIK, Deena
Psychosynthesis Psychotherapist
37 The Grove, Finchley
London N3 1QT
020 8346 0282
AAPP

MARHSALLSAY, Nicholas
Analytical Psychologist-Jungian Analyst
10 Wavel Mews
Park Avenue Street, Crouch End
London N8 8LQ
020 8340 0169
CAP

MARSHALL, Antoinette
Psychoanalytic Psychotherapist
73 Alexandra Park Road
London N10 2DG
020 8444 9357
IPSS

MARTIN, Stephen
Child Psychotherapist
22 Blythwood Road
London N4 4EU
020 7272 5090
ACP

MASON, Barry
Family Psychotherapist, Systemic
Psychotherapist
21 Manor Road, Stoke Newington
London N16 5BQ
020 8802 9165
IFT

MASSIL, Ros
Integrative Psychotherapist
62 Dresden Road
London N19 3BQ
07930 914537/020 7263 0691
RCSPC

MAYER, Robert
Family Therapist
36 Park Avenue South
London N8 8LT
020 8340 6628/020 8340 4712
IFT

MAZURE, David
Integrative Psychotherapist
169 Avenue Mews
London N10 3NN
020 8365 3545
MC

MCBRIDE, Nigel
Attachment-based Psychoanalytic
Psychotherapist
45a Freegrove Road
London N7 9RS
020 7609 5001/015223 110933
CAPP

MCCAFFERTY, Stewart
Systemic Psychotherapist
PO Box 13936
London N21 2WA
0956 377685
KCC

MCCLOUD-ICETON, Janet
Psychoanalytic Psychotherapist
23 Highgate Avenue
London N6 5SB
020 8348 0791
GUILD

MCCLURE, John
Cognitive Behavioural Psychotherapist
Grovelands Priory Hospital
The Bourne, Southgate
London N14 6RA
020 8882 8191
BABCP

MCDERMOTT, Ian
NLP Psychotherapist
73 Brooke Road
London N16 7RD
020 8442 4133
ANLP

MCGEE, Colin
Psychoanalytic Psychotherapist
24 Palace Road
Crouch End
London N8 8QJ
020 8348 1848
IPSS

MCHUGH, Brenda
Family Psychotherapist
24a Compton Terrace
London N1 2UN
020 7704 5112
IFT

MCKENNA, Clare
Integrative Psychotherapist
London N7
RCSPC

MCKENZIE, Maggie
Humanistic and Integrative
Psychotherapist
Spectrum, 7 Endymion Road
London N4 1EE
020 8341 2277
SPEC

MCKEON, Mary
Psychoanalytic Psychotherapist
219 Fox Lane, Palmers Green
London N13 4BB
020 8886 0766
FPC

MCNAIR, Ann G
Systemic Psychotherapist
29 Halstead Road, Winchmore Hill
London N21 3DY
020 8360 2942
KCC

MCNEIL, Delcia
Humanistic and Integrative
Psychotherapist
Flat 2, 56 Queens Avenue
London N10 3NU
015395 52047/020 8442 0391
SPEC

MEAD, Betty
Psychoanalytic Psychotherapist
13 St. Marks Mansions
60 Tollington Park
London N4 3QZ
020 7263 5822
AGIP

MELLOWS, David
Psychoanalytic Psychotherapist
34 Curzon Road
London N10 2RA
0956 370111/020 8883 6230
FIP

MELLOWS, Hilary
Psychoanalytic Psychotherapist
34 Curzon Road
London N10 2RA
FIP

METHUEN, Oriel
Gestalt Psychotherapist, Humanistic and
Integrative Psychotherapist
Spectrum, 7 Endymion Road
London N4 1EE
020 8341 2277/020 8883 3246
SPEC

MEZA, Ann L.
Transpersonal Psychotherapist
25 Crane Grove
London N7 8LD
020 7607 6805
CCPE

MICHAEL, Jess
Attachment-based Psychoanalytic
Psychotherapist
40 Leadale Road, Stamford Hill
London N16 6DE
020 8800 5533
CAPP

MILLER, Penny
Attachment-based Psychoanalytic
Psychotherapist
3 Carysfort Road
toke Newington
London N16 9AA
020 7249 7846
CAPP

MILLER, Riva
Systemic Psychotherapist
24 Wood Lane, Highgate
London N6 5UB
020 8340 3548/020 7830 2807
IFT

MILLICHAMP, Stacey
Psychosynthesis Psychotherapist
4 Pembroke Mews, Muswell Hill
London N10 2JL
020 8444 2670/020 8444 0956
AAPP

MILLWARD, Christopher
Transpersonal Psychotherapist
97 Pemberton Road
London N4 1AY
020 8341 2723
CCPE

MODEL, Elizabeth
Child Psychotherapist
London
020 7226 8339
ACP

MONTERO, Isabel
Psychoanalytic Psychotherapist
55 Birley Road
London N20 0HB
020 8446 2581
ARBS

MORDECAI, Kay
Psychoanalytic Psychotherapist
76 Grove Avenue
London N10 2AN
020 8883 3707 (f)/020 8883 9996
FIP

MORDICAI, Aslan
Psychoanalytic Psychotherapist
Dukebury House
76 Grove Avenue, Muswell Hill
London N10 2AN
020 8883 9996
FIP

MORLEY, Elspeth
Psychoanalytic Psychotherapist,
Psychoanalytic Marital
Psychotherapist
43 Highbury Place
London N5 1QL
020 7359 2282
TMSI

MORLEY, Robert
Psychoanalytic Psychotherapist,
Psychoanalytic Marital
Psychotherapist
43 Highbury Place
London N5 1QL
020 7359 2282
FIP

MORRIS, Allan
Family Therapist
127 Mount View Road
London N4 4JH
020 8292 4404/020 8341 9238
IFT

MORRIS, Shosh
Psychoanalytic Psychotherapist
23C Milner Square
London N1 1TL
020 7359 0258
GUILD

MORTON, Gillian
Educational Therapist
London
020 8340 5686
FAETT

MULHERN, Alan
Analytical Psychologist-Jungian Analyst
30 Danvers Road
London N8 7HH
020 8348 9809
AJA

MUSIC, Graham
Integrative Psychotherapist
90 Huddleston Road
London N7 0EG
020 7281 1989
MC

MYERS, Piers
Integrative Psychotherapist
London N5
020 7359 5844
RCSPC

NAISH, Julia
Humanistic and Integrative
Psychotherapist
Spectrum, 7 Endymion Road
London N4 1EE
020 8341 2277
SPEC

NAOR, Lillie
Integrative Arts Psychotherapist
9 Beechwood Lodge, 5 East Bank
London N16 5RX
020 8809 0659
IATE

NAVARRO, Trinidad
Psychoanalytic Psychotherapist
Garden Flat, 13 Christchurch Road
London N8 9QL
020 8348 9244
ARBS

NEIVA, Judith
Psychoanalytic Psychotherapist
Flat 2, 26 Lofting Road
London N1 1ET
020 7609 7049
AGIP

NEUMANN, Anton
Psychoanalytic Psychotherapist
26 Orchard Road
London N6 5TR
020 8348 5472
AGIP

NEVINS, Peter
Psychoanalytic Psychotherapist
45 Queen's Head Street, Islington
London N1 8NQ
020 7354 9430
SITE

NGAH, Zah
Child Psychotherapist
47 Pentoville Road
London N1 9LP
020 7278 8018
ACP

NITSUN, Morris
Group Analyst
31 Onslow Gardens
London N10 3JT
020 8590 6060 x2260/
020 8883 6885
IGA

NOACK, Amelie
Analytical Psychologist-Jungian Analyst
The Garden Flat
213 Tufnell Park Road
London N7 OPX
020 7609 8380
AJA

NOBLE, Jane
Psychoanalytic Psychotherapist
54 Redston Road
London N8 7HE
020 8348 2801
GUILD

NODELMAN, Marsha
Primal Psychotherapist
West Hill House
6 Swains Lane, Highgate
London N6 6QU
020 7267 9616
LAPP

O BRIAIN, Ciaron
Psychoanalytic Psychotherapist
34 Dunloe Avenue
London N17 6LA
020 8365 0582
IPSS

O'CARROLL, Madeline
Cognitive Behavioural Psychotherapist
174a St. Ann's Road
London N15 5RP
BABCP

O'CONNOR, Ann
Integrative Psychosynthesis
Psychotherapist
32 Avenue Road
London N6 5DW
020 8348 571
RE.V

O'CONNOR, Noreen
Psychoanalytic Psychotherapist
78 Huddleston Road
London N7 0EG
020 7687 2206
SITE

OHENE, Margaret D.
Systemic Psychotherapist
16 Wilton Road, Muswell Hill
London N10 1LS
020 8444 9662
KCC

OLIVER, Rosamund
Core Process Psychotherapist
29 Beversbrook Road, Islington
London N19 4QQ
020 7272 3666/020 7272 9355
AAPP

PALAMOUNTAIN, Alan
Integrative Psychotherapist
144 Warwick Road
Upper Edmonton
London N18 1RT
020 8884 0881
RCSPC

PANETTA-CREAN, Simona
Analytical Psychologist-Jungian Analyst
15 Landrock Road
London N8 9HR
020 8374 9556/020 8374 9234
CAP

PARKER, Rosie
Psychoanalytic Psychotherapist
17 Archibald Road
London N7 0AN
020 7700 2097
FPC

PARKS, Val
Psychoanalytic Psychotherapist
18 Rosemary Avenue, Finchley
London N3 2QN
020 8346 6188
FPC

PATERSON, Stuart
Body Psychotherapist, Humanistic and
Integrative Psychotherapist, Somatic
Emotional Therapist
Spectrum, 7 Endymion Road
London N4 1EE
020 8342 9594
SPEC

PATON, Julia
Analytical Psychologist-Jungian Analyst
30 Stormont Road, Highgate
London N6 4NP
020 8341 7746
CAP

PATTERSON, Anna
Humanistic and Integrative
Psychotherapist
Spectrum, 7 Endymion Road
London N4 1EE
020 8341 2277
SPEC

PEARCE, George
Psychoanalytic Psychotherapist
288 Park Road
London N8 8JY
01603 300701/020 8340 1233
ARBS

PENALOSA-CLARKE, Adriana
Systemic Psychotherapist
Flat 5, 75 Torrington Park
London N12 9PN
020 8446 5683
KCC

PENGELLY, Paul
Psychoanalytic Marital Psychotherapist
103 Tottenham Road
London N1 4EA
01932 872010/020 7254 3581
TMSI

PENNYCOOK-GREAVES, Wil
Group Analyst
Flat B, Malpas Cottage, Edison Road
London N8 8AE
020 8341 3747
IGA

PEPELI, Hara*
Lacanian Analyst
10 The Avenue
London N8 0JR
020 8888 7104
CFAR

PERICLEOUS, Christine
Psychoanalytic Psychotherapist
47 Ecclesbourne Gardens
London N13 5JD
020 8372 8760
ARBS

PERRY, Ann
Psychoanalytic Psychotherapist
35 Huntingdon Street
London N1 1BP
020 7609 3378
AIP

PETRIE, Bill
Transpersonal Psychotherapist
123 Dukes Avenue
London N10 2QD
020 8372 9474
CCPE

PETTLE, Sharon
Systemic Psychotherapist
10 Priory Avenue, Crouch End
London N8 7RN
020 8846 7806/020 8340 2539
IFT

PHILO, Judith
Analytical Psychologist-Jungian Analyst
194 Tufnell Park Road
London N7 0EE
020 7263 1952
CAP

PICKSTOCK, Keith
Psychosynthesis Psychotherapist
105 Clissold Crescent
Stoke Newington
London N16 9AS
020 7254 4975
AAPP

PIERIDES, Stella
Psychoanalytic Psychotherapist
15 Victoria Road
London N4 3SH
020 7272 5957
ARBS

PIMENTEL, Edna
Humanistic Psychotherapist
41 Springcroft Avenue
London N2 9JH
020 8883 0511
AHPP

POLEDRI, Patricia
Psychoanalytic Psychotherapist
2, Southview
162 Oakleigh Road
London N11 1HE
020 8368 1475
CPP

POPE, Michael
Core Process Psychotherapist
41 Defoe Road
London N16 0EH
020 7254 8544
AAPP

POPLE, Sue
Group Analytic Psychotherapist
37 Lancaster Avenue
Hadley Wood, Barnet
London N4 0ER
020 8440 4642/020 8367 2333
FPC

PRESANT, Fern
Integrative Psychotherapist
22 Osbaldeston Road
London N16 7DP
020 8806 8119
MC

PRIEST, Caroline
Systemic Psychotherapist
Flat 8, 38 Mayfield Road
London N8 9LP
020 8341 6488
KCC

RADLETT, Marty
Existential Psychotherapist
46 Noel Road
London N1
020 8868 5836
RCSPC

RAIMES, Peter
Group Analytic Psychotherapist
129 Shakespeare Walk
Stoke Newington
London N16 8TB
020 7923 1355/020 89376333
UPA

RAINSFORD, Helena
Group Analytic Psychotherapist
12 Effingham Road, Hornsey
London N8 0AB
020 8341 9524
UPA

RAWAT, Shenaz
Personal Construct Psychotherapist
2c Queen Elisabeth's Walk
Stoke Newington
London N16 0HX
020 8809 3336
CPCP

REA, Judith
Psychoanalytic Psychotherapist
11 Anson Road
London N7 0RB
020 7607 0546
GUILD

REDISH, Elisabeth
Psychoanalytic Psychotherapist
16 Chardmore Road
London N16 6JD
020 8806 9857
CPP

RÉGUIS, Marie-Christine
Psychoanalytic Psychotherapist
36 Warrender Road
London N19 5EF
020 7263 8105
ARBS

REID, Liz
Lacanian Analyst, Psychoanalytic
Psychotherapist
376 Hornsey Road, Islington
London N19 4HT
020 7272 6609/0860 250553
CFAR

RENOUX, Martine
Integrative Psychotherapist
4 Canning Crescent, Wood Green
London N22 5SR
020 8889 9980
MC

RHIND, Sue
Psychosynthesis Psychotherapist
35 Long Lane
Church End, Finchley
London N3 2PS
020 8922 0661
AAPP

RICHARDS, Val*
Psychoanalytic Psychotherapist
28 Ravensdale Avenue
London N12 9HT
020 8445 6120/020 8446 8449
GUILD

RIDLEY, Wendy
Psychosynthesis Psychotherapist
15 Elmar Road
London N15 5DH
020 8802 7984
AAPP

RITCHIE, Sheila
Psychoanalytic Psychotherapist
Flat 2, 18 Alexandra Grove
London N4 2LF
020 8802 2908
AGIP

ROBERTS, Sylvia M
Systemic Psychotherapist
12 Redston Road, Haringey
London N8 7HJ
09797 960 335
KCC

ROBERTSON, Ruth
Educational Therapist
14 Sanford Terrace
London N16 7LH
020 7254 6408
FAETT

ROGNERUD, Tove
Psychoanalytic Psychotherapist
96 Talbot Road, Highgate
London N6 4RA
020 8340 9153
IPSS

ROMISCH-CLAY, Liza
Integrative Psychotherapist
7 Rookfield Close
London N10 3TR
020 8883 6575
RCSPC

ROSS, Alistair
Analytical Psychologist-Jungian Analyst
33 Lancaster Road
London N4 4PJ
020 7272 8854
CAP

ROSS, Maureen
Psychoanalytic Psychotherapist
46 Jenner Road
London N16 7SA
020 8806 4263
AGIP

ROTH, Jenner
Humanistic and Integrative
Psychotherapist
Spectrum, 7 Endymion Road
London N4 1EE
020 8341 2277
SPEC

ROWAN, Alan*
Lacanian Analyst, Psychoanalytic
Psychotherapist
113 Lichfield Grove
London N3
020 8346 3599
CFAR

ROWE, Dorothy
Personal Construct Psychotherapist
The Garden Flat
40 Highbury Grove
London N5 2AG
020 7354 3498
CPCP

ROZENBERG, Rosette
Psychoanalytic Psychotherapist
26 Orchard Road
London N6 5TR
020 8348 5472
AGIP

RUND, Malcolm
Psychoanalytic Psychotherapist
42 Market Place
London N2 8BB
020 8444 6354
ARBS

RUSSELL, Marion
Humanistic and Integrative
Psychotherapist
Spectrum, 7 Endymion Road
London N4 1EE
020 8341 3413
SPEC

RYAN, Jane
Attachment-based Psychoanalytic
Psychotherapist
36a Mildmay Road
London N1 4NS
020 7254 2323
CAPP

RYAN, Joanna
Psychoanalytic Psychotherapist
44 Lordship Road
London N16 0QT
020 8802 1641
SITE

RYAN, Tom
Psychoanalytic Psychotherapist
11 Cecile Park
London N8 9AX
020 8292 8908
ARBS

RYDE, Julia
Analytical Psychologist-Jungian Analyst
101 Sotheby Road
London N5 2UT
020 7266 3765
CAP

RYZ, Patsy
Child Psychotherapist
36 Essex Park
London N3 1NE
020 8349 2263
ACP

SABBADINI, Andrea
Psychoanalytic Psychotherapist
38 Berkeley Road, Crouch End
London N8 8RU
020 8340 2936
ARBS

SALLES, Miriam
Biodynamic Psychotherapist
38 Onslow Gardens
London N10 3JU
020 8883 9698
BTC

SALTIEL, Adam
Psychoanalytic Psychotherapist
35 Corbyn Street
London N4 3BY
020 7281 9875
ARBS

SAMUELS, Andrew
Analytical Psychologist-Jungian Analyst
148 Mercers Road
London N19 4PX
020 7272 1292
CAP

SAVILLE, Sue
Psychoanalytic Psychotherapist
9 Twyford Avenue, East Finchley
London N2 9NU
020 8444 4826
FPC

SCHAFFER-FIELDING, Wendy
Child Psychotherapist
25 Wickliffe Avenue
London N3 3EL
020 8346 1483
ACP

SCHIMMELSCHMIDT, Michael
Transpersonal Psychotherapist
66 Whitehall Park
London N19 3TN
020 7263 2718
CCPE

SCHONFIELD, Tamar
Psychoanalytic Psychotherapist
71 Woodland Rise
London N10 3UN
020 8365 3226
ARBS

SELBY, Marilyn
Educational Therapist
34 Arden Road
London N3 3AN
020 8349 2507
FAETT

SERFATY, Marc A.
Cognitive Behavioural Psychotherapist
Senior Lecturer & Consultant
Grovelands Priory Hospital
The Bourne, Southgate
London N14 6RA
020 8882 8191
BABCP

SEYMOUR, Charlotte
Family Therapist
65 Muswell Road
London N10 2BS
020 8883 9367
AFT

SHABAN, Dervishe
Transpersonal Psychotherapist
Powys Lane
New Southgate
London N11
020 8881 5164
CCPE

SHAPIRO, Adella
Integrative Psychotherapist
41a Fairmead Road
London N19 4DG
020 7272 5868
MC

SHARIFI, Pury
Analytical Psychologist-Jungian Analyst
27 Fortismere Avenue
London N10 3BN
020 7444 8234
CAP

SHARP, Belinda
Psychoanalytic Psychotherapist
54 Park Drive
London N21 2LS
020 8351 8774/020 8360 6020
FPC

SHAW, Elizabeth
Cognitive Behavioural Psychotherapist
Psychology Service
St Ann's Hospital, St Ann's Road
London N15 3TH
020 8442 6458
BABCP

SIMMONS, Gloria
Family Therapist
'Timbers'
64 Manor Drive, Whetstone
London N20 0DU
020 8361 3740/020 8368 7878
AFT

SINGH, Satwant
Cognitive Behavioural Psychotherapist
68 Sutherland Road, Edmonton
London N9 7QG
0961 394438
BABCP

SKYNNER, Robin
Group Analyst
17 Belvedere Court
Lytterton Road
London N2 0AG
IGA

SMITH, Jonathan
Psychoanalytic Psychotherapist
59 Holmesdale Road
London N6 5TH
020 8340 9137
IPSS

SMITH, Maggie
Systemic Psychotherapist
40 Vallance Road
Wood Green
London N22 7UB
020 8809 5577/020 8889 0358
KCC

SMOSARSKI, Lizzie
Integrative Arts Psychotherapist
47 Crescent Road, Alexandra Park
London N22 7RU
020 8245 2556
IATE

SOLEMANI, Hannah
Psychoanalytic Psychotherapist
82 Cecile Park
London N8 9AU
020 8341 1612
ARBS

SOLOWAY, Clare
Humanistic Psychotherapist, Integrative
Psychotherapist
100 Sydney Road, Muswell Hill
London N10 2RN
020 8442 0928
MC

SPENCE, Mary
Systemic Psychotherapist
Community Psychology
Child & Adolescent
St Leonards, Nuttal Street
London N1 3LZ
KCC

SPITZER, Shayne
Analytical Psychologist-Jungian Analyst
42 Priory Avenue
London N8 7RN
020 8341 7031
AJA

SQUIRES, Brenda
Psychosynthesis Psychotherapist
7 Elm Grove
London N8 9AH
020 8341 1315
AAPP

STACEY, Ralph
Group Analyst
32 Mayfield Avenue
London N12 9JD
020 8446 1075
IGA

STEIN, Yvonne
Family Therapist, Integrative
Psychotherapist
48 Finchley Park, North Finchley
London N12 9JL
020 8905 6693/79/020 8446 4913
AFT

STEVENS, Ann Penberthy
Family Therapist
54 Pulford Road, South Tottenham
London N15 6SP
020 8809 1502
IFT

STEVENSON, Kate
Systemic Psychotherapist
12 Hampstead Lane, Highgate
London N6 4SB
020 7720 7301/020 8342 9391
KCC

STEVENSON, Krystyna
Hypno-Psychotherapist
52 Windermere Avenue
London N3 3RA
020 8346 8648
NRHP

STOGDON, Mark
Family Therapist
70 Corbyn Street, Stroud Green
London N4 3BZ
020 7281 4570
IFT

STUART, Gillian
Analytical Psychologist-Jungian Analyst
68 Tottenham Lane, Crouch End
London N8 7EE
020 8341 6477
AJA

SUMMER, Jennifer
Systemic Psychotherapist
59 Dollis Road
London N3 1RD
020 8922 0224
IFT

SUNDERLAND, Margot
Gestalt Psychotherapist, Integrative Arts
Psychotherapist
'Terpsichore', 70 Cranwich Road
London N16 5JD
020 8809 5866/020 7704 2534
IATE

SÜNKEL, Sue
Psychoanalytic Psychotherapist
1 Foxham Road
London N19 4RR
020 7281 5193
IPSS

SVEINSDOTTIR, Bjorg
Psychoanalytic Psychotherapist
56 Ferme Park Road
London N4 4ED
020 8374 7051
ARBS

SWYNNERTON, Richard
Existential Psychotherapist
11 Links View, Dollis Road
Finchley Central
London N3 1RN
020 8371 0443/020 8371 1604
RCSPC

TAYLOR, Alan
Analytical Psychotherapist
8 Victoria Mansions
135 Holloway Road
London N7 8LZ
020 7607 0210
AIP

TAYLOR, Harvey
Psychoanalytic Psychotherapist
c/o AGIP
1 Fairbridge Road
London N19 3EW
020 7272 7013/020 8349 9792
AGIP

THOMAS, Mark
Gestalt Psychotherapist
54 Windus Road
London N16 6UB
020 8806 4055
GPTI

TIBBETTS, Coral
Psychodynamic Psychotherapist
136 Church Road
London N17 8AJ
020 8808 8078
UPA

TILLETT, Penny
Educational Therapist
2 The Drive
Fordington Road
London N6 4TD
020 8444 7073
FAETT

TOMPKINS, Penny
NLP Psychotherapist
9 Southwood Lawn Road
Highgate
London N6 5SD
020 8341 1062 (t/f)
ANLP

TUTTON, Catherine
Integrative Psychosynthesis
Psychotherapist
33 Lausanne Road
London N8 0HJ
020 8374 0905
RE.V

USISKIN, Judith
Child Psychotherapist
110 Chanctonbury Way
London N12 7AB
020 7445 5671
ACP

UTTING, Julia
Psychoanalytic Psychotherapist
15 Dagmer Road, Wood Green
London N22 7RT
020 8881 1775
IPSS

VALENTINE, Marguerite
Psychoanalytic Psychotherapist
56 Osbaldeston Road
London N16 7DR
020 8806 3655
ARBS

VALENTINE, Victoria
Integrative Psychotherapist
21 Thorpedale Road
London N4 3BH
020 7263 2518
MET

VAN GOGH, Mark
Integrative Psychosynthesis
Psychotherapist
30 Chandos Road, East Finchley
London N2 9AP
020 8883 2558
RE.V

VASTARDIS, Gethsimani
Child Psychotherapist
London
020 7272 3894
ACP

VEALE, Maurice
Gestalt Psychotherapist, Individual and
Group Humanistic Psychotherapist
148 Corbyn Street, Finsbury Park
London N4 3DB
020 7263 4079
GCL

VELING, Rolf
Psychoanalytic Psychotherapist
12 Cromwell Close, East Finchley
London N2 0LL
020 8444 0533
FIP

VERNON, Paul
Psychoanalytic Psychotherapist
46B Ferntower Road
London N5 2JH
020 7359 4943/020 8806 6046
FIP

WADDELL, Margot
Child Psychotherapist, Psychoanalytic
Psychotherapist
5 Cardozo Road
London N7 9RJ
020 7607 3492/020 7435 7111
ACP

WATERFIELD, Hilary
Psychoanalytic Psychotherapist
160 Albion Road
London N16 9JS
020 7690 9048
ARBS

WATT, Ferelyth
Psychoanalytic Psychotherapist
23 Mercers Road
London N19 4PH
020 7272 7421
ACP

WEAVER, Ziva
Body Psychotherapist, Integrative
Psychotherapist
226c Brecknock Road
London N19 5BG
020 7681 8098
CCBP

WEERAMANTHRI, Tara
Family Therapist
12c Petherton Road
London N5 2RD
020 7226 2731/020 7701 8697
AFT

WHITBY, Susan
Psychoanalytic Psychotherapist
1A Windsor Road, Finchley
London N3 3SZ
020 8346 1698
IPSS

WHITE, Jean*
Psychoanalytic Psychotherapist
Flat 5, 77 Sunnyside Road
London N19 3SL
020 7263 7417
GUILD

WHITE, Nuala
Gestalt Psychotherapist
10 Alexander Road, Holloway
London N19 3PQ
020 7263 2076
GCL

WHITTLE, Sonia J
Psychoanalytic Psychotherapist
11 St Margaret's Avenue, Tottenham
London N15 3DH
020 8374 1288
ARBS

WHYTE, Miranda
Transpersonal Psychotherapist
Flat 5, 14 Clifton Road, Crouch End
London N8 8HY
020 8348 1825
CTP

WIELAND, Christina
Psychoanalytic Psychotherapist
50 Fernleigh Road
London N21 3AL
020 7272 7013/020 8882 9531
AGIP

WIESELBERG, Huguette
Family Therapist
8 Broughton Avenue
London N3 3ER
020 8349 9780
IFT

WILCE, Gillian
Psychoanalytic Psychotherapist
3 Farleigh House
25/27 Halton Road
London N1 2EL
020 7354 2942
GUILD

WILLIAMS, Kate
Humanistic and Integrative
Psychotherapist
126 Chase Way, Southgate
London N14 5DH
020 8368 9868
SPEC

WILLMOTT, Serena
Analytical Psychologist-Jungian Analyst
127 Dynevor Road
London N16 0DA
020 7254 5915
CAP

WILLMOTT, Susan
Humanistic and Integrative
Psychotherapist
Spectrum, 7 Endymion Road
London N4 1EE
020 8341 3413/020 8374 8728
SPEC

WILSON, Carol
Integrative Psychotherapist
88 Talbot Road
London N6 4RA
020 7935 1207/1900/
020 8348 1988
RCSPC

WILSON, Jilian
Child Psychotherapist
74 Dukes Avenue
London N10 2PU
020 8883 6370
ACP

WILSON, Shula
Integrative Psychotherapist
50 Mayfield Avenue
London N12 9JD
020 8359 5341/020 8445 7541
RCSPC

WINSHIP, Gary
Group Analytic Psychotherapist
117 Beresford Road
London N8 0AG
0118 9561250/020 8340 8284
UPA

WOOD, Rob
Psychoanalytic Psychotherapist
19 Baalbec Road
London N5 1QN
020 7226 4775
FPC

WOODCOCK, Therese M-Y.
Child Psychotherapist
4 Earlham Grove, Wood Green
London N22 5HJ
020 8889 3353
ACP

WOODHEAD, Louise
Psychoanalytic Psychotherapist
26 Ripon Road
London N17 6PP
020 8885 5958
GUILD

WOODWARD, Nicola
Child Psychotherapist
17 Bryanstone Road
London N8 8TN
020 8347 6831
ACP

WOOLF, Tanya
Integrative Psychotherapist
6 Hungerford Road
London N7 9LX
020 7697 0628
RCSPC

WORRALL, Chrysoula*
Psychoanalytic Psychotherapist
15 Gresley Road
London N19 3LA
020 7272 4133
GUILD

WYNANT, Vivienne
Psychosynthesis Psychotherapist
1 Blythwood Road, Islington
London N4 4EU
020 7272 0780
AAPP

YATES, Tony
Group Analytic Psychotherapist
27 Toyne Way
London N6 4EG
020 8374 9788
FPC

YOUNG, Margot
Integrative Psychotherapist
132 Highbury Hill
London N5 1AT
020 7690 9326
MC

YOUNG, Robert M.
Psychoanalytic Psychotherapist
26 Freegrove Road
London N7 9RQ
020 7607 8306
FIP

LONDON NORTH WEST

ABBASI, Shafika
Group Analyst, Psychoanalytic
Psychotherapist, Sexual and Relationship
Psychotherapist
34 Priory Terrace
London NW6 4DH
IGA

ACQUARONE, Stella
Child Psychotherapist
27 Frognal Street
London NW3 6AR
020 7794 2521
ACP

ADLER, Hella
Analytical Psychologist-Jungian Analyst
19 Burgess Hill
London NW2 2DD
020 7435 7424
AJA

AIREY, Gabriela
Cognitive Behavioural Psychotherapist
85 Yeats Close
London NW10 0BW
020 8451 6082
BABCP

ALBRIGHTON, Sylvia
Body Psychotherapist, Integrative
Psychotherapist
28 Marley Walk, Lennon Road
London NW2 4PX
020 8452 2201
CCBP

ALLEN, Dorothy
Gestalt Psychotherapist, Transpersonal
Psychotherapist
20 Fleetwood Road
Dollis Hill
London NW10 1ND
020 8830 6434
CTP

ALLEN, Lesley
Systemic Psychotherapist
Marlborough Family Service
38 Marlborough Place
London NW8 0PJ
020 7624 8605/020 7284 2596
KCC

ALTSCHULER, Jenny
Family Therapist
Tavistock Clinic
120 Belsize Lane
London NW3
020 7435 7111
AFT

ALVAREZ, Anne
Child Psychotherapist
Children & Families Department
Tavistock Clinic
120 Belsize Lane
London NW3 5BA
0171 435 7111
ACP

ANDERSON, Linda
Group Analyst
60 All Soul Avenue
London NW10 3BG
020 8965 5872
IGA

ANDERTON, Michael
Analytical Psychologist-Jungian Analyst
100 Harvist Road
London NW6 6HL
020 8960 4780
IGAP

ARNOTT, Biddy
Group Analyst
21 Constantine Road
London NW3 2LN
020 7267 1732
IGA

ARTHUR, Andrew R.
Psychoanalytic Psychotherapist
23 College Crescent
London NW3 5LL
020 7388 6990
WMIP

AUSTIN, Lesley
Integrative Psychotherapist
48 Carlton Hill
St.Johns Wood NW8 0ES
0956 484 139/020 7624 6862
RCSPC

AUSTIN, Neil
Psychoanalytic Psychotherapist
23 College Crescent
London NW3 5LL
020 7431 1395
ARBS

AUSTIN, Susan
Psychoanalytic Psychotherapist
23 College Crescent
London NW3 5LL
020 7431 1395
ARBS

BAILEY-SMITH, Yvonne A
Systemic Psychotherapist
110 Brondesbury Park
London NW2 5JR
020 8459 6579
KCC

BANDLER BELLMAN, Debbie
Child Psychotherapist
27 Somali Road
London NW2 3RN
020 7794 3519
ACP

BARNETT, Madeleine
Integrative Psychotherapist
29 Dollis Hill Avenue
London NW2 6EG
020 8452 9767
MC

BARNETT, Ruth
Psychoanalytic Psychotherapist
73 Fortune Green Road
London NW6 1DR
020 7431 0837
FIP

BARTELS-ELLIS, Phillida
Psychoanalytic Psychotherapist
12 Blenheim Gardens
London NW2
020 8450 4048
NAFSI

BAR-YOSEPH, Talia Levine
Gestalt Psychotherapist, Integrative
Psychotherapist
18a Heriot Road
London NW4 2DG
020 8202 1023
GPTI

BATHAI, Parizad
Integrative Psychotherapist
Flat C, 85 Melrose Avenue
London NW2 4LR
020 8208 1095
MC

BATTERSBY, Audrey
Psychoanalytic Psychotherapist
83 Belsize Lane
London NW3 5AU
020 7722 2784
GUILD

BAYNES, Gay
Psychoanalytic Psychotherapist
56 Aberdare Gardens
London NW6 3QD
020 7624 1728
FPC

BENJAMIN, Haydene
Child Psychotherapist
7 Turners Wood
London NW11 6TD
020 8455 2065
ACP

BENSON, Pauline
Cognitive Behavioural Psychotherapist
54 Hendon Hall Court
Parson Street
London NW4 1QY
020 8203 6060
BABCP

BENTOVIM, Arnon
Family Psychotherapist
12 Falcon Lodge, Oakhill Park
London NW3 7LD
020 7390 8377/020 7435 2255
IFT

BLANDY, Evanthe M*
Child Psychotherapist, Psychoanalytic
Psychotherapist
2 Montrose Avenue, Queens Park
London NW6 6LB
020 8964 3813
GUILD

BLUM, Anita
Sexual and Relationship Psychotherapist
London
020 8202 9282
BASRT

BODGENER, Sue
Gestalt Psychotherapist
9 Brownlow Road
Harlesden
London NW10 9QN
020 8961 2763
GPTI

BOND, Frank W
Cognitive Behavioural Psychotherapist
Flat 2, 2 Ginsberg Yard
London NW3 1EW
0973 817992/020 7431 8573
BABCP

BORSIG, Su
Integrative Psychotherapist
90 Harvist Road
London NW6 6HL
020 8964 2719
MET

BRAIN, Sara
Analytical Psychotherapist, Transpersonal
Psychotherapist
50 Waterlow Court, Heath Close
London NW11 1DT
020 8455 9024
CTP

BRUGGEN, Joan
Family Therapist
21 Makeson Road
London NW3 2LU
020 7485 6771
AFT

BURCK, Charlotte
Family Therapist, Systemic
Psychotherapist
Senior Clinical Lecturer in Social Work
Tavistock Clinic
120 Belsize Lane
London NW3 5BA
020 7447 3780/
IFT

BURNS, Alex
Psychoanalytic Psychotherapist
Flat 26, 119 Haverstock Hill
Belsize Park
London NW3 4RS
020 7586 7076/01788 536446
IPSS

BURTT, Isobel Lucy
NLP Psychotherapist
147 Bathurst Gardens
London NW10 5JJ
020 8964 9843
ANLP

CAMPBELL, Donald
Child Psychotherapist
Portman Clinic
8 Fitzjohns Avenue
London NW3 5NA
020 7794 8262/020 7722 7573
ACP

CAMPBELL, Elizabeth*
Psychoanalytic Psychotherapist
2 Provost Road
London NW3 4ST
020 7722 7573
GUILD

CARLSON, Theresa
Transpersonal Psychotherapist
18 Chalcot Crescent, Primrose Hill
London NW1 8YD
020 7722 2317
CCPE

CARROLL, Roz
Body Psychotherapist, Integrative
Psychotherapist
30A The Loning, Colindale
London NW9 6DR
020 8200 4944
CCBP

CAVE, Prue
Psychoanalytic Psychotherapist
Top Flat, 41 Buckland Crescent
London NW3 5DJ
020 7284 1578
ARBS

CAZALET, Deborah
Psychoanalytic Psychotherapist
Flat 1, 12 Abercorn Place
London NW8 9XP
020 7286 6024
FPC

CHANDWANI, Lilian
Psychoanalytic Psychotherapist
18 Park Drive
London NW11 7SP
020 8458 8204
IPSS

CHAPPELL, Claire
Educational Therapist, Transpersonal
Psychotherapist
46 Princess Road
London NW1 8JL
020 7722 9716
FAETT

CHARVET, Anne
Systemic Psychotherapist
60 Compayne Gardens
London NW6 3RY
020 7328 4174
KCC

CHINA, Giselle
Psychoanalytic Psychotherapist
24B South Hill Park Gardens
London NW3 2TG
020 7435 6361
IPSS

CHRISTMANN, Cornelia
NLP Psychotherapist
147 Bathurst Gardens
Kensal Green
London NW10 5JJ
020 8964 9843
ANLP

COHEN, Pauline
Child Psychotherapist
4 Kidderpore Gardens
London NW3 7SR
020 7794 6046
ACP

COHEN, Vivienne
Group Analyst
9 Heathcroft, Hampstead Way
London NW11
020 8455 4781
IGA

COLAHAN, Mireille
Family Therapist
9 Lyme Street
London NW1 0EH
020 7209 9149/020 7482 0303
AFT

COLLIS, Jeffrey
Sexual and Relationship Psychotherapist
Turning Point, The Junction Project
27 Station Road
London NW10 4UP
020 8961 7007
BASRT

CONNOLLY, Christopher
Psychosynthesis Psychotherapist
28a Hampstead High Street
London NW3 1QA
020 7794 4066
AAPP

COOPER, Hilary
Psychoanalytic Psychotherapist
14 Dartmouth Road
London NW2 4EU
020 8208 3349
PA

COOPER, Robin
Group Analyst, Psychoanalytic
Psychotherapist
14 Dartmouth Road
London NW2 4EU
020 8208 3349
IGA

COPLEY, Beta
Child Psychotherapist
LONDON NORTH WEST
020 7794 4780
ACP

CORBETT, Gemma
Integrative Psychotherapist
83 St. Gabriels Road
London NW2 4DU
020 8830 5064/020 8452 3844
RCSPC

CORNISH, Ursula
Systemic Psychotherapist
3a Chalcot Square
London NW1 8YP
020 7387 6567/020 7586 2582
IFT

COSTELLO, Marie
Psychoanalytic Psychotherapist
Flat 3, 7 Eton Avenue
Swiss Cottage
London NW3 3EL
FPC

COULTER, Theresa
Psychoanalytic Psychotherapist
Flat 30, 35-36 Belsize Square
London NW3 4HL
020 7794 7930
IPSS

COUSINS, Jan
Child Psychotherapist
102 Prince of Wales Road
London NW5 3NE
020 7482 4923
ACP

CUDMORE, Lynne
Psychoanalytic Marital Psychotherapist
T.M.S.I.
Tavistock Centre
120 Belsize Lane
London NW3 5BA
020 7435 7111/020 8993 1534
TMSI

DALE, Barbara
Systemic Psychotherapist
Child & Family Dept.
Tavistock Clinic
120 Belsize Lane
London NW3 5BA
020 7435 7111
IFT

DANIELL, Diana
Psychoanalytic Marital Psychotherapist
23 College Crescent
London NW3 5LL
020 7794 9782
TMSI

DAUM, Minna
Family Therapist
The Anna Freud Centre
21 Maresfield Gardens
London NW3 5SD
020 7794 2313/020 7794 6506
AFT

DAVIDE, Adele
Analytical Psychologist-Jungian Analyst
49 Llanvanor Road
Child's Hill
London NW2 2AR
020 8922 0471
AJA

DAVIDS, Jennifer
Child Psychotherapist
Flat 2, 16 Priory Terrace
London NW6 4DH
020 7372 3403
ACP

DAVIES, Judy
Attachment-based Psychoanalytic
Psychotherapist
128 Goldhurst Terrace
London NW6 3HR
020 7624 3908
CAPP

DAVIS, Diana
Psychoanalytic Psychotherapist
39 Eton Hall
Eton College Road
London NW3 2DP
020 87586 4876
IPSS

DAVIS, Helen
Integrative Psychotherapist
73 Staverton Road
London NW2 5HA
020 8451 7802
MC

DAVIS, Wendy
Humanistic Psychotherapist
St. Mildreds
35 Flower Lane
London NW7 2JG
020 7482 3293/020 8906 9204
AHPP

DAWS, Dilys
Child Psychotherapist, Psychoanalytic
Psychotherapist
43 Heath Hurst Road
London NW3 2RU
020 7435 9248
ACP

DE BOER, Onno
Family Therapist
53 Stanbury Court, 99 Haverstock Hill
London NW3 4RR
020 7419 0847
AFT

DE HAAS CURNOW, Penny
Analytical Psychologist-Jungian Analyst
16 Rosecroft Avenue
London NW3 7QB
020 7435 0513
CAP

DE LASZO, Alexandra
Systemic Psychotherapist
The Delphi Practice
The Therapy Rooms
68-70 Chalk Farm Road
London NW1 8AN
020 7267 0110
KCC

DE MARE, Patrick
Group Analyst
5 Holly Place
London NW3 6QU
020 7794 3171
IGA

DELL, Judith
Humanistic Psychotherapist
45 Litchfield Way
London NW11 6NU
020 8458 7893
AHPP

DENTON, Marika
Group Analyst, Psychoanalytic
Psychotherapist
11 Oakhill Avenue
London NW3 7RD
020 7435 2086
IGA

DICKINSON, Adrian
Analytical Psychotherapist
84a Hillfield Road
West Hampstead
London NW6 1QA
020 7435 9079
FIP

DIYALJEE, Angeli
Hypno-Psychotherapist
Flat 6, 346 Finchley Road
Hampstead
London NW3 7AJ
020 7431 4943
NRHP

DODGE, Elizabeth
Family Therapist
Royal Free Eating Disorder Service
Royal Free Hospital
Pond Street
London NW3 2QG
020 7830 2737
IFT

DOGMETCHI, Geri
Psychoanalytic Psychotherapist
18 Spencer Rise
London NW5 1AP
020 7485 2883
IPSS

DOORLEY, Damien
Analytical Psychologist-Jungian Analyst
75 Goldhurst Terrace
London NW6 3HA
020 7624 6524
AJA

DOVER, Jennifer
Educational Therapist
11 Gainsborough Gardens
London NW3 1BJ
020 7794 6510
FAETT

DOWLING, Emilia
Family Psychotherapist
Child & Family Department
Tavistock Clinic
120 Belsize Lane
London NW3 5BA
020 7435 7111/020 8444 6795
IFT

DRESNER, Ora
Child Psychotherapist
17 St. George's Road
London NW11 0LU
020 8458 6763
ACP

DRYDEN, Windy
Rational Emotive Behaviour Therapist
14A Winchester Avenue
London NW6 7TU
020 7328 9687
BABCP

DUBINSKY, Helene
Child Psychotherapist
Child and Family Department
Tavistock Clinic
120 Belsize Lane
London NW3 5BA
020 7435 7111/020 7794 5047
ACP

DUCKWORTH, Moira
Analytical Psychologist-Jungian Analyst,
Psychoanalytic Psychotherapist
24 Achilles Road
London NW6 1EA
020 7431 0811
AJA

DUNBAR, Gill
Analytical Psychologist-Jungian Analyst
31 Llavanor Road
Childs Hill
London NW2 2AR
020 8201 9062
CAP

DUNN, Nicola
Integrative Psychotherapist
53 Shirlock Road, Gospel Oak
London NW3 2HR
020 7267 4106
MC

EAGLES, Marjorie
Group Analyst, Psychoanalytic
Psychotherapist
107 Frognal, Hampstead
London NW3 6SR
020 8954 6745/020 7431 1465
IGA

EASTER, Judith
Psychoanalytic Psychotherapist
77 Torbay Road
London NW6 7DU
020 7328 6250
GUILD

EDGCUMBE, Rose
Child Psychotherapist
5 Sandringham Road
London NW11 9DR
020 8455 9385
ACP

EDWARDS, Dagmar
Gestalt Psychotherapist, Integrative
Psychotherapist
28 Blenheim Gardens
London NW2 4NS
020 8208 1235
GPTI

EDWARDS, Judith
Child Psychotherapist
Bishop Harvey Family Service
6 Eggertpm Gardens
London NW4 4BA
020 7435 7111/020 8202 5115
ACP

EISENHAUER, Gary
Integrative Psychotherapist
80 Ashburnham Road
Kensal Green
London NW10 5SE
020 8968 4568
RCSPC

ELKAN, Judith
Child Psychotherapist
31 Coleridge Walk
London NW11 6AT
020 8455 8845
ACP

ELLIOTT, Barbara
Group Analyst
36 Dennington Park Road
London NW6 1BD
020 7794 6014
IGA

EMANUEL, Ricky
Child Psychotherapist
Dept. of Child & Adolescent Psychiatry
Royal Free Hospital
Pond Street
London NW3 2QG
020 7830 2931/020 8348 7032
ACP

ERSKINE, Archibald
Analytical Psychotherapist, Psychoanalytic
Psychotherapist
130 Walm Lane
London NW2 4RT
020 8452 9251
FIP

ESSENHIGH, Caroline
Child Psychotherapist
Flat 1, 47 Compayne Gardens
London NW6 3DB
020 7328 1114
ACP

EVANS, Joan
Psychosynthesis Psychotherapist
Institute of Psychosynthesis
65A Watford Way, Hendon
London NW4 3AQ
020 8202 4525
AAPP

EVANS, Roger
Psychosynthesis Psychotherapist
Institute of Psychosynthesis
65A Watford Way, Hendon
London NW4 3AQ
020 8202 4525
AAPP

FALK, Helen
Analytical Psychologist-Jungian Analyst
6 Reeds Place
London NW1 9NA
020 7267 5435
AJA

FANNING, Alexandra
Psychoanalytic Psychotherapist
46 Westbere Road
London NW2 3RU
020 7794 4010/020 7435 5712 (f)
FIP

FARHI, Nina
Psychoanalytic Psychotherapist
11 North Square
London NW11 7AB
020 8455 5329/020 8731 6109 (f)
GUILD

FARZIM, Pari
Family Therapist
52 Teignmouth Road
London NW2 4DX
020 8452 3585
IFT

FELDBERG, Tom
Psychoanalytic Psychotherapist
24 Brookfield Park
London NW5 1ER
020 7267 2577
IPSS

FENTIMAN, John
Transpersonal Psychotherapist
Flat 1, 62 Canfield Gardens
London NW6 3EB
020 7328 7083
CCPE

FERID, Heidi
Attachment-based Psychoanalytic
Psychotherapist, Psychoanalytic
Psychotherapist
20 South Hill Park, Hampstead
London NW3 2SB
020 7794 9130
IPSS

FESTENSTEIN, Geraldine
Group Analyst
8 Briardale Gardens
London NW3 7PP
020 7435 2741
IGA

FIASCHE, Mara
Psychoanalytic Psychotherapist
29 Fordwych Court
Shoot-Up Hill, Kilburn
London NW2 3HP
020 8830 6955
IPSS

FICARRA, Berthe*
Psychoanalytic Psychotherapist
7 Estelle Road
London NW3 2JX
020 8482 3399
GUILD

FIELDER, Michael
Psychoanalytic Psychotherapist
Top Flat, 41 Buckland Crescent
London NW3 5DJ
020 7722 2589
PA

FIELDHOUSE, Pauline
Transpersonal Psychotherapist
12 Goldhurst Terrace
London NW6 3HU
020 7624 2787
CTP

FINAR, Ruth
Gestalt Psychotherapist
Flat 1, 18 Holmdale Road
London NW6 1BN
020 7435 0057
GPTI

FRANKLYN, Frank
Psychoanalytic Psychotherapist
26 Sydney Grove, Hendon
London NW4 2EH
020 8202 7546
IPSS

FRIEDMAN, Debbie
Psychosynthesis Psychotherapist
1189a Finchley Road
London NW11 0AA
020 8458 5760
AAPP

FRIEDMAN, Joe
Psychoanalytic Psychotherapist
Top Flat, 41 Buckland Crescent
London NW3 5DJ
020 7722 5077
PA

FRY, Richard P.W.
Family Therapist
4 Plympton Avenue, Brondesbury
London NW6 7TJ
020 7461 0379
AFT

FYVEL, Susan
Family Therapist
Marlborough Family Service
38 Marlborough Place
London NW8 0PJ
020 7624 8605/020 7328 2185
AFT

GABRIELA, Airey
Cognitive Behavioural Psychotherapist
85 Yeats Close
London NW10 0BW
020 8451 6082
BABCP

GAL, Oshrat*
Psychoanalytic Psychotherapist
54a Woodstock Avenue
London NW11 9RG
020 7377 8865/020 8455 5333
GUILD

GANS, Steve
Psychoanalytic Psychotherapist
c/o Diorama Arts
34 Osnaburgh Street
London NW1 3ND
020 7916 5433
PA

GASTER, Yishai
Body Psychotherapist, Integrative
Psychotherapist
5 Shakespeare Road, Mill Hill
London NW7 4BA
0976 853267/020 8906 2590
CCBP

GAVSHON, Audrey
Child Psychotherapist
Anna Freud Centre
21 Maresfield Gardens
London NW3 5SH
020 7794 2313/020 8348 0276
ACP

GEEN, Sheryle
Integrative Psychotherapist
95b Leighton Road
London NW5 2QJ
020 7482 4537
MC

GEORGE, Dorothy
Integrative Psychotherapist
610 Jacqueline House
52 Fitzroy Road
London NW1 8UA
020 7586 8862
RCSPC

GIBSON, Walter
Integrative Psychotherapist
12 Parkfield Road
Willesden
London NW10 2BJ
020 8537 2302
MC

GILDEBRAND, Katarina
Integrative Psychotherapist, Transactional
Analysis Psychotherapist
17 Midland Terrace
London NW2 6HQ
020 8450 6802
MET

GODINHO, Bernadette
Systemic Psychotherapist
24 Ulysses Road
London NW6 1EE
KCC

GOLD, Bonnie
Group Analyst
1 Daleham Gardens
London NW3 5BY
020 8203 2279
IGA

GOLDENBERG, Harriet
Existential Psychotherapist
31a Buckland Crescent
London NW3 DJ
020 7722 2510
RCSPC

GOMEZ, Lavinia
Humanistic Psychotherapist, Integrative
Psychotherapist
21 Mill Lane
London NW6 1NT
020 7794 5308
AHPP

GOOD, Elizabeth
Psychoanalytic Psychotherapist
47a Golders Green Road
London NW11 8EL
020 8989 6529/020 8208 8526
AGIP

GORDON, Paul
Psychoanalytic Psychotherapist
74 Victoria Road
London NW6 6QA
020 7624 3053
PA

GORMAN, Susan
Group Analyst
Flat 4, 9 Ambleside Road
London NW10 3UH
020 8451 0070
IGA

GORNEY, Carry
Systemic Psychotherapist
43 Spencer Rise
London NW5 1AR
020 7482 2939
KCC

GOTTESMANN, Ewa
Group Analyst
1 Daleham Gardens
London NW3 5BY
020 7431 2693
IGA

GRANT, Iona
Psychoanalytic Psychotherapist
75 Fleetwood Road, Dollis Hill
London NW10 1NR
020 8452 4479
ARBS

GRAY, Dennis
Group Analytic Psychotherapist
20 Pheonix Court
Purchese Street
London NW1 1EL
020 7916 6675
FPC

GRAY, Elizabeth
Family Therapist
11 Well Road
London NW3 1LH
020 7435 9228
AFT

GREEN, Viviane
Child Psychotherapist
Anna Freud Centre
21 Maresfield Gardens
London NW3 5SH
020 7794 2313/020 7435 4960
ACP

GREENFIELD, Frances
Core Process Psychotherapist
Milton Cottage
Vale of Heath
London NW3 1AX
020 7431 6747
AAPP

GRUNBERG, Sheena
Child Psychotherapist
Child & Family Dept., Tavistock Clinic
120 Belsize Lane
London NW3 5BA
020 7435 7111/020 7267 1379
ACP

GUILFOYLE, John Francis
Sexual and Relationship Psychotherapist
40 Brooksville Avenue
Queen's Park
London NW6 6TG
020 8969 7856
BASRT

GULCZ, Magdalena
Cognitive Behavioural Psychotherapist
13 Belsize Grove
Flat 1, London NW3 4UX
020 7586 0482
BABCP

HACKER, Roger
Psychoanalytic Psychotherapist
5 Chalcot Gardens
London NW3 4YB
020 7586 4144
ARBS

HAINE, Stephen R
Psychoanalytic Psychotherapist
96c Fortess Road
London NW5 2HJ
020 7813 9069
AGIP

HALL, Albyn
Integrative Psychotherapist
41a Lady Somerset Road
London NW5 1TY
0403 630 576/020 7485 7790
RCSPC

HARDING, Michael
Existential Psychotherapist
24 Birchington Court
West End Lane
London NW6 4PB
020 7487 7694/020 7328 1823
RCSPC

HARLAP, Nahum
Integrative Psychotherapist
5a Northgate
Prince Albert Road
London NW8 7RD
020 7586 4228
RCSPC

HARRIS, Jonathan
Transpersonal Psychotherapist
65 Clifford Gardens
London NW10 5JE
020 8964 9599
CCPE

HARRIS, Mary
Integrative Psychotherapist
100 Canfield Gardens
London NW6 3EE
020 7487 7684/020 7372 9951
RCSPC

HARVARD-WATTS, Olivia*
Psychoanalytic Psychotherapist
44 Woodsome Road
London NW5 1RZ
020 7424 0233/020 7485 6582
GUILD

HARVEY, Natasha
Psychoanalytic Psychotherapist
Flat 5, 130 Fellows Road
Swiss Cottage
London NW1 5BL
020 7483 4649
FPC

HAUSSMAN, Rochelle
Educational Therapist
46 Lodore Gardens
Kingsbury
London NW9 0DR
020 8930 1876
FAETT

HAXELL, Susan
Analytical Psychologist-Jungian Analyst
10 Riffel Road, Willesden
London NW2 2PH
020 7452 9169
CAP

HENRY, John
Attachment-based Psychoanalytic
Psychotherapist
27 Elm Grove
London NW2 3AE
020 8452 8865
CAPP

HERST, Edward
Analytical Psychologist-Jungian Analyst
9 Fitzroy Road
London NW1 8TU
020 7722 1661
CAP

HERTZMANN, Leezah
Attachment-based Psychoanalytic
Psychotherapist
The Child & Family Department
Tavistock Clinic
120 Belsize Lane
London NW3 5BA
0956 670 410/020 7435 7111 x2513
CAPP

HEWISON, David
Analytical Psychologist-Jungian Analyst
The Tavistock Centre
120 Belsize Lane, London NW3 5BA
020 8883 9734
CAP

HILDEBRAND, Judy
Family Therapist, Systemic
Psychotherapist
43 Oak Village
London NW5 4GL
020 7267 2910
IFT

HILL, Philip*
Lacanian Analyst, Psychoanalytic
Psychotherapist
1 Hillside, Highgate Road
London NW5
020 8340 9941
CFAR

HOLDEN, Maxine
Transpersonal Psychotherapist
8A Lymington Road
London NW6 1HY
020 7431 8757
CTP

HOLLAND, Ray
Integrative Psychotherapist
25 Greenhill Road, Harlesden
London NW10 8UD
020 8838 3424/07990 764694
CCBP

HOLM, Kirsti E.
Hypno-Psychotherapist
871a Finchley Road
London NW11 8RR
020 8202 3654
NSHAP

HOLMES, Carol
Integrative Psychotherapist
50 Murray Mews
London NW1 9RH
020 7487 7428/020 7284 1367
RCSPC

HOPPER, Earl
Group Analyst, Psychoanalytic
Psychotherapist
11 Heath Mansions
The Mount, Heath Street
London NW3 6SN
020 7435 2053/020 7435 4350
IGA

HORNE, Ann
Child Psychotherapist
Portman Clinic
8 Fitzjohns Avenue
London NW3 5NA
020 7794 8262
ACP

HOUSTON, Gaie
Gestalt Psychotherapist
8 Rochester Terrace
London NW1 9JN
020 7485 9265
GCL

HOWARD, Angela
Psychoanalytic Psychotherapist
1 Tower Close, Lyndhurst Road
London NW3 5TB
020 7431 6410
GUILD

HUMPHREY, Anna
Integrative Psychotherapist
17 Grafton Road
London NW5 3DX
020 7485 1167
MC

HURRY, Anne
Child Psychotherapist, Psychoanalytic
Psychotherapist
Anna Freud Centre
21 Maresfield Gardens
London NW3 5SH
020 7794 2313/020 7794 1762
ACP

HUSAIN-SHACKLE, Shakrukh
Psychoanalytic Psychotherapist
29 Winchester Avenue
London NW6 7TT
020 7624 6324
NAFSI

HUTCHINSON, Sylvia
Group Analyst
2 St. Gabriel's Road
London NW2 4RY
020 8450 2791
IGA

INGLEBRIGHT, Shanti
Family Psychotherapist
Marlborough Family Service
38 Marlborough Place
London NW8 0PJ
020 7624 8605
IFT

ISAACSON, Zelda
Integrative Psychotherapist
19 Windermere Avenue
London NW6 6LP
020 8960 5121
RCSPC

ISAKSSON-HURST, Gun I.E.
Transactional Analysis Psychotherapist
137B Goldhurst Terrace
London NW6 3EU
020 7372 5537
MET

JACKSON, Diana
Integrative Psychotherapist
26 Willifield Way
London NW11 7XT
020 8458 5791
SPTI

JACOBS, Joe
Child Psychotherapist
Flat 3, 50 Well Walk
London NW3 1BT
020 7433 1927
ACP

JOFFE, Riva
Psychoanalytic Psychotherapist
6 Peploe Road, Queens Park
London NW6 6EB
020 8969 0288/07775 636642
IPSS

JOHNSON, Geoffrey
Core Process Psychotherapist
179 Ashford Court, Ashford Road
London NW2 6BU
020 8450 9016
AAPP

JOHN-WILSON, Deb'bora
Gestalt Psychotherapist
Flat 6, Carlton House
319 West End Lane
London NW6 1RN
020 7431 9041
GCL

JOLLIFFE, John
Attachment-based Psychoanalytic
Psychotherapist
Flat 4, Laurier Court, Laurier Road
London NW5 1SE
020 7284 4334
CAPP

JONES, Janet
Psychoanalytic Psychotherapist
1A Exeter Road
London NW2 4SJ
020 8452 5860
FPC

JUDD, Dorothy
Child Psychotherapist, Psychoanalytic
Marital Psychotherapist
20 Mount Pleasant Road
London NW10 3EL
020 8459 1118
TMSI

JUKES, Adam
Group Analyst
7 Hylda Court, St Albans Road
London NW3 1RE
IGA

KAHR, Brett
Integrative Psychotherapist
Suite 6, 4 Marty's Yard
17 Hampstead High Street
Hampstead, London NW3 1QW
020 7435 2955
RCSPC

KAPLAN, Myron R
Psychoanalytic Psychotherapist
1 Clarence Gate Gardens
Glentworth Street
London NW1 6AY
020 7724 3062
AGIP

KARBAN, Barbara
Existential Psychotherapist
Flat 3, 15 Alma Square
London NW8 9QA
020 8967 5099 x8201/
020 7286 0019
RCSPC

KELLY, Caro
Gestalt Psychotherapist
CHOICE Psychotherapy Practice
18a Heriot Road, Hendon
London NW4 2DG
020 8520 4595/020 8202 1023
GPTI

KERBEKIAN, Rosalie
Child Psychotherapist
Garden Flat, 31 Willow Road
London NW3 1TL
020 7431 1888
ACP

KERNOFF, Marilyn
Psychosynthesis Psychotherapist
Flat 3, 64 Aberdare Gardens
London NW6 3QD
020 7624 0587
AAPP

KESHET-ORR, Judi
Individual and Group Humanistic
Psychotherapist, Sexual and Relationship
Psychotherapist
181 Hampstead Way
London NW11 7YA
020 7288 3074/020 8455 4511
BASRT

KLEINOT, Pamela
Psychoanalytic Psychotherapist
12 Sherriff Road
London NW6 2AU
020 7624 2936
ARBS

KNIGHT, Michael
Cognitive Analytic Therapist
Garden Flat, 66 Belsize Park
London NW3 4EH
020 7722 9007
ACAT

KRAEMER, Sebastian
Family Therapist
Child & Family Department
Tavistock Clinic
Tavistock & Portman NHS Trust
120 Belsize Lane
London NW3 5BA
020 7435 7111
IFT

LA TOURELLE, Maggie
NLP Psychotherapist
70A Caversham Road
London NW5 2DS
020 7485 4215
ANLP

LAPORT-STEUERMAN, M.
Child Psychotherapist
34 Ornan Road
London NW3 4QB
020 7435 4376
ACP

LAUNER, John
Family Therapist
Child and Family Department
Tavistock Clinic
120 Belsize Lane
London NW3 5BA
020 7435 7111
AFT

LAWLOR, Virginia Katherine
Integrative Psychotherapist
c/o Dewey, 43 Shirlock Road
London NW3 5HR
0973 353 702
RCSPC

LEDER, Catherine
Humanistic Psychotherapist
12a Ravenshaw Street
LondonNW6 1NN
020 7794 2995
AHPP

LEHRER, Pam
Psychoanalytic Psychotherapist
Heath Riding, 32 Wildwood Road
London NW11 6XB
020 8458 8750
IPSS

LEMA, Juan Carlos
Systemic Psychotherapist
Flat 1A, 13 York Terrace East
London NW1 4PT
020 7720 7301/020 8883 8562
KCC

LEMMA, Alessandra
Integrative Psychotherapist
23 Cantelowes Road
London NW1
020 8846 6051/020 7428 9909
RCSPC

LINDEN, Roger
NLP Psychotherapist, Psychoanalytic
Psychotherapist
14 Boscastle Road
Dartmouth Park
London NW5 1EG
020 7485 2292
ANLP

LINDSEY, Caroline
Family Psychotherapist, Systemic
Psychotherapist
23 Gresham Gardens
London NW11 8NX
020 7435 7111/020 8455 2882
IFT

LORET DE MOLA, Maria
Child Psychotherapist
Top Flat, 59 Parson Street
London NW4 1QT
020 8202 4740
ACP

LOVENDAL-SORENSEN, Helena
Psychosynthesis Psychotherapist
18b North End Road
London NW11 7LP
020 8341 4885
AAPP

LOW, James
Cognitive Analytic Therapist, Integrative
Arts Psychotherapist,
Psychoanalytic Psychotherapist, Sexual
and Relationship Psychotherapist
78B Princess Road
London NW6 5QX
020 7328 4450
BASRT

LUMBIS, Gerald
Integrative Psychotherapist
21c Bramshill Gardens
Dartmouth Park
London NW5 1JJ
020 7586 4170/020 7281 6605
RCSPC

LUNARDON, Francesco
Psychoanalytic Psychotherapist
69 Hamilton Road
London NW10 1NH
020 8450 5332
ARBS

LYNDON, Barbara
Educational Therapist
8 Honiton Road
London NW6 6QE
020 7372 8009
FAETT

MACGREGOR, Catherine
Psychosynthesis Psychotherapist
24 Harley Road, Hampstead
London NW3 3BN
020 8969 3587/020 7722 6067
AAPP

MACHADO, Danuza*
Lacanian Analyst, Psychoanalytic
Psychotherapist
14 Eton Hall
Eton College Road
London NW3 2DW
020 7722 7383
CFAR

MAGRIEL, Nicolas
Body Psychotherapist, Integrative
Psychotherapist
Flat 8, 118 Haverstock Hill
London NW3 2BA
020 7722 6072/020 7240 3237
CCBP

MAITRA, Begum
Analytical Psychologist-Jungian Analyst
38 Nant Road
London NW2 2AT
020 8846 7806/020 8458 2510
AJA

MALKIN, Marion
Integrative Psychotherapist
108C Priory Road
South Hampstead
London NW6 3NH
020 7372 3979
RCSPC

MALTBY, Jane
Child Psychotherapist
Bishop Harvey Family Service
St. Josephs Way
The Burroughs
London NW4 4TY
020 8202 5115
ACP

MANDER, Gertrud
Psychoanalytic Psychotherapist
24 Chalcot Crescent
London NW1 8YD
020 7722 0033
FPC

MANDIN, Philippe
Family Therapist, Systemic
Psychotherapist
Marlborough family Service
38 Marlborough Place
London NW8
020 7624 8605
IFT

MANIFOLD, Claire
Integrative Psychotherapist
23 Lawn Road
London NW3 2XR
020 8853 2395/020 7586 3077
RCSPC

MARKS, Gaby
Psychoanalytic Psychotherapist
39 Goldhurst Terrace
London NW6 3HB
020 7624 7185/020 8455 9783
FIP

MARRONE, Mario
Group Analyst, Psychoanalytic
Psychotherapist
6 Oman Avenue
London NW2 6BG
020 8452 3088
IGA

MARTIN, Christine
Child Psychotherapist
South Brent Child & Family Clinic
Warranty House
Dudden Hill Lane
London NW10 1DL
020 8208 7200/1
ACP

MARX, Philippa
Group Analytic Psychotherapist
88 Olive Road, Cricklewood
London NW2 6UP
020 8450 3385
FPC

MCDERMOTT, Paul
Transpersonal Psychotherapist
64 Fleet Road, Hampstead
London NW3 2QT
020 7482 4296
CCPE

MCEVOY, Patricia Elaine
Systemic Psychotherapist
The American School in London
2–8 Loudoun Road
London NW8 0NP
020 7435 6597
KCC

MCKENZIE-SMITH, Bryce
Psychoanalytic Psychotherapist
34 Dudley Court, Finchley Road
London NW11 6AE
020 8731 6861
AGIP

MCLEAN, Julienne
Analytical Psychologist-Jungian Analyst
Flat 21, Christchurch Court
171 Willesden Lane
London NW6 7XF
020 8451 5255 (t/f)
AJA

MCNULTY, Claire
Analytical Psychotherapist
13, The Marlowes
London NW8 6NB
07957 463 494
AJA

MEAKINS, Elizabeth
Psychoanalytic Psychotherapist
8 Spencer Rise
London NW5 1AP
020 87485 1160
GUILD

MENDELSOHN, Annette
Child Psychotherapist
Department of Child & Adolescent
Psychiatry
Royal Free Hospital
Pond Street
London NW3 2QG
020 7830 2931/020 7794 8708
ACP

MILLER, Ann
Family Therapist
Marlborough Family Service
38 Marlborough Place
London NW8 0PJ
020 7624 8605
IFT

MILLER, John Andrew
Psychoanalytic Psychotherapist
22 Fitzjohns Avenue
London NW3 5NB
020 8905 5937/020 7435 1079
AGIP

MILLER, Lisa
Child Psychotherapist
Child & Family Department
Tavistock Clinic
120 Belsize Lane
London NW3 5BA
020 7435 7111
ACP

MILLINGTON, Malcolm
Psychoanalytic Marital Psychotherapist
T.M.S.I.
The Tavistock Centre
120 Belsize Lane NW3 5BA
020 7435 7111
TMSI

MITTWOCH, Adele
Group Analyst, Psychoanalytic
Psychotherapist
1 Chesterford Gardens
London NW3 7DD
020 7435 8589
IGA

MOJA-STRASSER, Lucia
Existential Psychotherapist
144A Abbey Road
London NW6 4SR
020 7487 7406/020 7372 6407
RCSPC

MONDADORI, Roberta
Child Psychotherapist
11 Melina Place
London NW8 9SA
020 7286 0422
ACP

MOORE, Julia
Integrative Psychotherapist
126 College Road
London NW10 3PE
020 8969 2726
MC

MORRIS, Monique
Psychoanalytic Psychotherapist
35 Highcroft Gardens
London NW11
020 8216 4000/020 8455 4306
GUILD

MOURATOGLOU, Vassilis
Family Therapist
90 Grove End Gardens
Grove End Road, St John's Wood
London NW8 9LP
020 7286 3126
AFT

MUFFET, Ruth
Analytical Psychologist-Jungian Analyst
No 4, 39 Belsize Square
London NW3 4HL
020 7794 9854
CAP

MURPHY, Alan
Transpersonal Psychotherapist
42 Georgiana Street
London NW1 0EB
020 7485 0358
CCPE

NABARRO, Elizabeth
Psychoanalytic Psychotherapist
58 Croftdown Road
London NW5 1EN
020 7485 3597
GUILD

NAFIE, Omar Ibrahim
Systemic Psychotherapist
21 Viceroy Court
58-74 Prince Albert Road
London NW8 7PP
KCC

NAGLE, Robin
Child Psychotherapist
020 7435 6038
ACP

NANCARROW, Christine
Cognitive Behavioural Psychotherapist
19 Linacre Road
London NW2 5AY
07930 391055/020 8451 0647
BABCP

NATHAN, Gill
Group Analyst
31 Langland Gardens
London NW3 6QE
020 7794 7136
IGA

NEAL, Charles
Humanistic and Integrative
Psychotherapist
23 Rossendale Way
Elm Village, Camden
London NW1 0XB
020 7387 6758
SPEC

NELSON, Sandy
Integrative Psychotherapist
80 Ashburnham Road
London NW10 5SE
020 8968 4568
MC

NORBURN, Veronica
Psychoanalytic Psychotherapist
18a Tanza Road
London NW3 2UB
020 7794 8697
IPSS

NOYES, Elizabeth
Cognitive Behavioural Psychotherapist
33 Downside Crescent
London NW3 2AN
020 7794 8321
BABCP

OAKLEY, Haya*
Psychoanalytic Psychotherapist
62 Upper Park Road
London NW3 2UX
020 7722 1628
GUILD

OATEN, Gae
Integrative Psychotherapist
50 Murray Mews
London NW1 6RJ
020 7267 6030
RCSPC

O'CALLAGHAN, Lesley
Integrative Psychotherapist
53 Okehampton Road
London NW10 3EN
020 8830 1912
MC

OCLANDER GOLDIE, Silvia
Child Psychotherapist
40 Parkhill Road
London NW3 2YP
020 7485 6558
ACP

O'CONNELL, Victoria
Psychoanalytic Psychotherapist
93 Chevening Road
London NW6 6DA
FIP

ODGERS, Andrew
Attachment-based Psychoanalytic
Psychotherapist
36b South Hill Park
London NW3 2SJ
020 7431 0687
CAPP

O'GORMAN, Mary Pat
Integrative Psychotherapist
17 Lambolle Road
London NW3 4HS
020 7794 5468
MC

OLIVER-BELLASIS, Elizabeth
Child Psychotherapist
76 Burghley Road
London NW5 1UN
020 7485 6998
ACP

OLNEY, Felicia
Psychoanalytic Marital Psychotherapist
T.M.S.I.
Tavistock Centre
120 Belsize Lane
London NW3 5BA
020 7435 7111
TMSI

ORBACH, Susie
Psychoanalytic Psychotherapist
2 Lancaster Drive
London NW3 4HA
020 7794 8226
WTC

ORFORD, Eileen
Child Psychotherapist
30 Regents Park Road
London NW1 7TR
020 7485 4012
ACP

ORLANS, Vanja
Gestalt Psychotherapist, Humanistic
Psychotherapist, Integrative
Psychotherapist
28 Blenheim Gardens
London NW2 4NS
020 8208 1235
GPTI

ORMAY, Tom
Group Analyst, Psychoanalytic
Psychotherapist
113 Goldhurst Terrace
London NW6 3HA
020 7625 6576
IGA

PARSONS, Marianne
Child Psychotherapist
62 Brondesbury Road
London NW6 6BS
020 7624 0600
ACP

PATALAN, Anna-Maria
Group Analyst
Willesden Centre for Psychological
Treatment
Willesden Hospital
Harlesden Road
London NW10 3RY
020 8451 8283
IGA

PAULSON, Diana
Family Therapist
34 Alma Street
London NW5 3DH
020 7530 2940/020 7267 4857
IFT

PECOTIC, Branka
Child Psychotherapist
1 West Heath Lodge, Branch Hill
London NW3 7LU
020 7433 1940
ACP

PETERS, Linda
Psychoanalytic Psychotherapist
6 Sandwell Crescent
West Hampstead
London NW6 1PB
020 7794 0836
FPC

PLATT, Sue
Integrative Psychotherapist
6 Marion Road, Mill Hill
London NW7 4AN
020 8959 6560
MC

PLUNKETT, Eileen
Integrative Arts Psychotherapist
San Damiano
St.Mary's Abbey, The Ridgeway
Mill Hill, London NW7 4HX
020 8959 4854
IATE

POKORNY, Michael R*
Group Analytic Psychotherapist,
Psychoanalytic Psychotherapist
167 Sumatra Road
London NW6 1PN
020 7431 4693
UPA

POWELL, Angela
Psychoanalytic Psychotherapist
167 Sumatra Road
London NW6 1PN
020 7794 1433/020 8830 3773
ARBS

POWER, Kevin
Group Analytic Psychotherapist
c/o 167 Sumatra Road
London NW6 1PN
07071 226980
FIP

PRALL, Werner
Integrative Psychotherapist
61 Riffel Road, Willesden Green
London NW2 4PG
020 8452 9438
CCBP

PREISINGER, Kristiane
Humanistic and Integrative
Psychotherapist
14 Richborough Road
London NW2 3LU
020 8452 6703
CCBP

PUDDY, Jane Kahan
Gestalt Psychotherapist
78 Tennyson Road
London NW6 7SB
020 7624 9109
GCL

PURPURA, Davide
Integrative Psychotherapist
47 Asmuns Place
London NW11 7XE
020 8731 8249
RCSPC

RABIN, Judith
Existential Psychotherapist
33 West Heath Drive
London NW11 7QG
020 8458 1007
RCSPC

RABIN, Norman
Psychoanalytic Psychotherapist
33 West Heath Drive
London NW11 7QG
020 8458 1007
IPSS

RADFORD, Patricia
Child Psychotherapist, Psychoanalytic
Psychotherapist
Flat 2, 14 Ferncroft Avenue
London NW3 7PH
020 7435 4265
ACP

RAMSDEN, Sandra
Child Psychotherapist
Malborough Family Service
38 Marlborough Place
London NW8 0PJ
020 7624 8605
ACP

RAPHAEL, Francesca
Integrative Arts Psychotherapist
16 Aldershot Road
London NW6 7LG
020 7624 3146
IATE

RAPP, Hilde
Psychoanalytic Psychotherapist
21 Priory Terrace
London NW6 4DG
020 7625 4287
UPA

RAVENSDALE, Verity
Psychoanalytic Psychotherapist
2 Gloucester Crescent
London NW1 7DS
020 7485 4514
ARBS

REDLER, Leon
Psychoanalytic Psychotherapist
c/o Diorama Arts
34 Osnaburgh Street
London NW1 3ND
020 7916 5191
PA

REID, Susan
Child Psychotherapist
Child & Family Department
Tavistock Clinic
120 Belsize Lane
London NW3 5BA
020 7435 7111/
020 7435 0467
ACP

REIK, Herta
Group Analyst
7 Oakhill Park Mews
London NW3 7LH
020 7794 7517
IGA

RENTON, Mirjana
Child Psychotherapist
24 Silsoe House
50 Park Village East
London NW1 7QH
020 7387 5689
ACP

RICHARDS, Diana M
Psychoanalytic Psychotherapist
71 The Avenue
London NW6 7NS
020 8459 3180
NAFSI

RIDLEY, Elizabeth
Hypno-Psychotherapist
58 Cumberland Terrace
London NW1 4HJ
020 7224 2874
NSHAP

ROBERTS, Phil
Family Therapist
127 Olie Road
London NW2 6UT
020 8450 6243
AFT

ROBERTSON, Chris
Integrative Psychosynthesis
Psychotherapist
Re.Vision
97 Brondesbury Road
London NW6 6RY
020 8357 8881
RE.V

ROBERTSON, Ewa
Integrative Psychosynthesis
Psychotherapist
Re.Vision
97 Brondesbury Road
London NW6 6RY
020 8451 2165/020 8357 8881
RE.V

ROBINSON, Hazel
Psychoanalytic Psychotherapist
75A Hartland Road
London NW6 6BH
020 7624 0877
GUILD

ROEMMELE, CAROLINE
Integrative Arts Psychotherapist
3 Gloucester Avenue
London NW1 7AS
IATE

ROMM-BARTFELD, Goldie
Psychoanalytic Psychotherapist
28 Bentinck Close
Prince Albert Road
London NW8 7RY
020 8458 9611
CPP

ROSE, Kevin
Psychoanalytic Psychotherapist
37 Ashbourne Avenue
London NW11 0DT
020 8455 5936
IPSS

ROSENTHALL, Joanna
Psychoanalytic Marital Psychotherapist
T.M.S.I.
Tavistock Centre
120 Belsize Lane
London NW3 5BA
020 7435 7111
TMSI

ROTH, Priscilla
Child Psychotherapist
12 Parkhill Road
London NW3 2YN
020 7485 4038/020 7284 3331
ACP

ROTH, Ruth
Humanistic and Integrative
Psychotherapist
16 Oman Avenue
London NW2 6BG
020 8452 7376
BCPC

ROYLE, Anthony
Integrative Psychotherapist
4 Denning Road, Hampstead
London NW3 1SU
020 7435 4798
RCSPC

RUSBRIDGER, Richard
Child Psychotherapist
27 Normanby Road
London NW10 1BU
020 8452 1880
ACP

RUSSELL, Julian
NLP Psychotherapist
86 South Hill Park
London NW3 2SN
020 7435 0731
ANLP

RUSTIN, Margaret
Child Psychotherapist
3a Exeter Road
London NW2 4SJ
020 8452 9276
ACP

SACHS, Adah
Integrative Psychotherapist
23 College Crescent
London NW3 5LL
020 7722 4246
RCSPC

SALISBURY, Claire
Humanistic Psychotherapist
43b Hemstal Road
London NW6 3AD
020 7624 4322
AHPP

SAUNDERS, Sonia
Autogenic Psychotherapist
22 West Heath Avenue
London NW11 7QL
020 7432 2828/020 8455 2217
BAS

SAWYERR, Alice
Family Therapist
The Marlborough Family Service
38 Marlborough Place
St. John's Wood
London NW8 0PJ
020 7624 8605/020 7328 2185
AFT

SCARLETT, Jean
Psychoanalytic Psychotherapist
3 Byron Villas, Vale of Heath
Hampstead
London NW3 1AR
020 7435 2362
FIP

SCHATZMAN, Morton
Psychoanalytic Psychotherapist
35 Croftdown Road
London NW5 1EL
020 7267 0304
ARBS

SCHIEMANN, Margot
Integrative Psychotherapist
17b Frognal
London NW3 6AR
020 7431 1810
MC

SCHILD, Maureen
Psychosynthesis Psychotherapist
15 Christchurch Avenue
London NW6 7QP
020 8451 4772
AAPP

SCHMITT-CASTILLA, Maria
Existential Psychotherapist
30 Ormonde Terrace
London NW8 7LR
020 7722 9633
RCSPC

SCHNEIDER, Evelyne
Group Analyst
Garden Flat, 8 Belsize Park
London NW3 4ET
020 7794 8834
IGA

SCHNURMANN, Anneliese
Child Psychotherapist
Flat 5, 11 Netherall Gardens
London NW3 5RN
020 7435 9315
ACP

SCHOENFELD, Hilde
Attachment-based Psychoanalytic
Psychotherapist
47 Hardinge Road
London NW10 3PN
020 8537 0314
CAPP

SCHWARTZ, Joe
Attachment-based Psychoanalytic
Psychotherapist
2 Lancaster Drive
London NW3 4HA
020 7794 8226
CAPP

SELWYN, Ruth
Child Psychotherapist
2 Edis Street
London NW1 8LG
020 7284 4231
ACP

SENGUN, Seda
Group Analyst
6 Walter North Cott House
Fortune Green Road
London NW6
IGA

SEU, Irene Bruna
Psychoanalytic Psychotherapist
40 King's Road
London NW10 2BP
020 8459 3423
ARBS

SEYMOUR, Eileen Watkins
NLP Psychotherapist
The Ravenscroft Centre
6 Ravenscroft Avenue
London NW11 0RY
020 8455 3743
ANLP

SHEARER, Ann
Analytical Psychologist-Jungian Analyst
26 Lambolle Place
London NW3 4PG
020 7794 4913
IGAP

SHERMAN, Arthur
Analytical Psychologist-Jungian Analyst
14B Springfield Court, Eton Avenue
London NW3 3ER
020 7431 1175
AIP

SHIVAKUMAR, H.
Analytical Psychotherapist
14B Portsdown Avenue
London NW11
020 8731 7181
CAP

SHMUKLER, Diana
Integrative Psychotherapist, Transactional
Analysis Psychotherapist
23a Bracknell Gardens, Hampstead
London NW3 7EE
SPTI

SILVERMAN, Carl M.
Analytical Psychologist-Jungian Analyst
34 Douglas Road
London NW6 7RP
020 7912 0803
AJA

SILVESTER, Keith
Psychosynthesis Psychotherapist
5 Kings College Court
Primrose Hill Road
London NW3 3EA
020 7722 8183/020 7586 4594
AAPP

SIMMONDS, Tina
Integrative Psychotherapist
14 Park Avenue
London NW11 7SJ
020 8455 9102
MC

SIMPSON, Richard
Sexual and Relationship Psychotherapist
29 Lupton Street
London NW5 2HS
020 7428 0260
BASRT

SINASON, Valerie
Child Psychotherapist
Children & Families Department
Tavistock Clinic
120 Belsize Lane
London NW3 5BA
O71 435 7111/020 7794 1655
ACP

SINEY, Sky
Psychoanalytic Psychotherapist
43 Rudall Crescent
London NW3 1RR
020 7431 8498
AGIP

SINGER, Daniela
Integrative Psychotherapist
167 Sumatra Road
London NW6 1PN
020 7431 2883/020 7586 3125
RCSPC

SLESS, Deborah
Integrative Psychotherapist, Transactional
Analysis Psychotherapist
23 Patshull Road
London NW5 2JX
020 7485 2664
ITA

SMITH, Alison
Personal Construct Psychotherapist
61b Cambridge Road
London NW6 5AG
020 7624 2597/020 8960 0880
CPCP

SOLOMON, Hester McFarland
Analytical Psychologist-Jungian Analyst
Flat C 262 Finchley Road
London NW3 7AA
020 7794 7402
CAP

SOOKDEB, S.
Cognitive Behavioural Psychotherapist
The Courtyard. 5–6 Avenue Road
Harlesden
London NW10 4UG
020 8937 6360/020 8204 9030
BABCP

SOUTHGATE, John
Attachment-based Psychoanalytic
Psychotherapist
12 Nassington Road
London NW3 2UD
020 7433 1263
CAPP

SPECTERMAN, Liz
Psychosynthesis Psychotherapist
26 Priory Terrace, West Hampstead
London NW6 4DH
020 7624 8569
AAPP

SPEYER, Josefine
Body Psychotherapist, Humanistic
Psychotherapist
20 Heber Road
London NW2 6AA
020 8208 0670
AHPP

SPURLING, Laurence
Psychoanalytic Psychotherapist
4 Marty's Yard
17 Hampstead High Street
London NW3 1PX
020 7431 5471
GUILD

SPYER, Natalie
Psychoanalytic Psychotherapist
38 Temple Fortune Lane
London NW11 7UD
020 8455 3050
IPSS

STADLEN, Anthony
Existential Psychotherapist,
Psychoanalytic Psychotherapist
64 Dartmouth Park Road
London NW5 1SN
020 7485 3896/020 7485 3896
RCSPC

STEELE, Miriam
Child Psychotherapist
Anna Freud Centre
21 Maresfield Gardens
London NW3 5SH
020 7794 2313
ACP

STERNBERG, Janine
Child Psychotherapist
Tavistock Mulberry Bush Day Unit
33 Daleham Gardens
London NW3
020 7794 8129
ACP

STEVENSON, Bruce
Body Psychotherapist, Integrative
Psychotherapist
20 Goodhall Street
London NW10 6TU
020 8961 7802
CCBP

STEWART, John A
Psychoanalytic Psychotherapist
51 Hendale Avenue, Hendon
London NW4 4LP
020 8203 9079
FPC

STEYN, Angela
Group Analytic Psychotherapist
5 Denman Drive
London NW11 6RE
020 8458 1214
FPC

STOBEZKI, Yael
Transpersonal Psychotherapist
Flat E, 46 Fairhazel Gardens
London NW6 3SJ
CCPE

STONE, Anthony
Humanistic and Integrative
Psychotherapist
7 Westholm
London NW11 6LH
020 8455 0794
SPEC

STONE, Martin
Analytical Psychologist-Jungian Analyst
Consulting Room, Flat 1
62 Rosslyn Hill
London NW3 1ND
020 7794 8445
AJA

STONE, Miriam
Psychoanalytic Psychotherapist
39 Parliament Hill, Hampstead
London NW3 2TA
020 7435 6072
FPC

STONE, Sandra
Child Psychotherapist
31 Alma Square
London NW8 9PY
020 7286 3331
ACP

STRASSER, Freddie
Existential Psychotherapist
99 West Heath Road, Hampstead
London NW3 7TN
020 8455 0118
RCSPC

SULLIVAN, Anita
Individual and Group Humanistic
Psychotherapist
143 Melrose Avenue
London NW2 4LY
020 8450 2107
AHPP

SULLIVAN, Christopher
Psychosynthesis Psychotherapist
143 Melrose Avenue
London NW2 4LY
020 8450 2107
AAPP

SULLIVAN, Gerry*
Lacanian Analyst
c/o CFAR
76 Haverstock Hill
London NW3 2BE
00 353 868 575180
CFAR

SUTTERS, Amabel
Integrative Psychotherapist
140 Iverson Road
London NW6 2HH
020 7372 1329
MC

SYZ, Ann
Child Psychotherapist
Howard House, Garden Flat
30 Belsize Park Gardens
London NW3 4AU
020 7431 4430/020 7722 2121
ACP

TAUBE, Idonea
Educational Therapist
15 Church Row
London NW3 6UP
020 7431 4543
FAETT

TAYLOR, Marsha
Integrative Psychotherapist
21 Lyncroft Gardens
London NW6 1LB
020 7433 1080
RCSPC

TAYLOR, Mary
Systemic Psychotherapist
39 Dartmouth Park Road
London NW5 1SU
020 7485 5719/020 7833 9939
KCC

TAYLOR-THOMAS, Caroline
Psychoanalytic Psychotherapist
9 Hayland Close
London NW9 0LH
020 8200 1609
FPC

TESTA, Rita
Child Psychotherapist
Department of Child & Adolescent
Psychiatry
Royal Free Hospital
Pond Street
London NW3 2QG
01932 842633/020 7830 2931
ACP

THOMSON, Jean
Analytical Psychologist-Jungian Analyst
1 Beatty Street
London NW1 7LN
020 7388 5508
CAP

TOUBKIN, Rita
Psychosynthesis Psychotherapist
77 Hampstead Way
London NW11 7LG
020 8455 4515
AAPP

TOUTON-VICTOR, Patricia
Psychoanalytic Psychotherapist
63 Cholmeley Gardens
Fortune Green Road
London NW6 1AJ
020 7435 7056
PA

TOWNLEY, Judy Rifkin
Child Psychotherapist
3 North Square
London NW11 7AA
020 8435 8934
ACP

TURKIE, Janine
Psychodrama Psychotherapist
32 Well Walk, Hampstead
London NW3 1BX
020 7794 88
BPA

URBAN, Elizabeth
Child Psychotherapist
South Brent Child & Family Clinic
Warranty House
Dudden Hill Lane
London NW10 1DL
020 8208 7200/1
ACP

VAN HEEL, Carlien
Biodynamic Psychotherapist
Flat 4. 1a Laurier Road
London NW5 1SD
020 7485 2922
BTC

VELLA, Norman
Group Analyst
45 Constantine Road
London NW3 2LN
020 7837 6736/020 7267 2587
IGA

VETERE, Arlene
Family Therapist
Tavistock Centre
120 Belsize Lane
London NW3 5BA
020 7435 7111/020 7447 3733
AFT

WALBY, Jane Kathryn
Systemic Psychotherapist
96 Savernake Road
London NW3 2JR
020 7820 6487/020 7267 3241
KCC

WATSON, Lindsay*
Lacanian Analyst, Psychoanalytic
Psychotherapist
95 Parliament Hill Mansions
Lissenden Gardens
London NW5 1NB
020 7485 1274
CFAR

WEIDER, Bilha
Family Psychotherapist
4 Cranbourne Gardens
London NW11 0HP
020 8455 6668
AFT

WEINRICH, Hildegard
Analytical Psychologist-Jungian Analyst
38 Cranhurst Road
London NW2 4LP
IGAP

WEISENSEL, Karin
Integrative Psychotherapist
18 Bartholomew Villas
London NW5 2LL
020 7813 2145
RCSPC

WELLS, Lindsay James
Psychoanalytic Psychotherapist
19 Brondesbury Court
235 Willesden Lane
London NW2 5RR
020 8830 3562
AGIP

WETHERELL, Jean
Analytical Psychologist-Jungian Analyst
31 Brondesbury Road
London NW6 6BA
020 7328 1135
CAP

WHITE, Kate
Attachment-based Psychoanalytic
Psychotherapist
12 Nassington Road
London NW3 2UD
020 7433 1263
CAPP

WICKS, Alan
Existential Psychotherapist
22 Twisden Road
London NW5 1DN
020 7284 2621
RCSPC

WILKE, Gerhard
Group Analyst
75 St. Gabriels Road
London NW2 4DU
020 8450 0469
IGA

WILLIAMS, Gianna
Child Psychotherapist
Child and Family Department
Tavistock Clinic
120 Belsize Lane
London NW3 5BA
020 7435 7111/020 8455 5682
ACP

WILLIAMS, Ruth
Integrative Psychotherapist
The Garden Flat
33 Croftdown Road
London NW5 1EN
020 7515 2012/0958 711151
MC

WISE, Penny
Psychoanalytic Psychotherapist
17 Lisburne Road
London NW3 2NS
020 7485 0005
IPSS

WITTENBERG, Isca
Child Psychotherapist
18 Helenslea Avenue
London NW11 8ND
020 8455 4344
ACP

WOODS, Roberts
Analytical Psychologist-Jungian Analyst
63A Belsize Lane
London NW3 5AU
CAP

WORRELL, Michael
Existential Psychotherapist
83 Riffel Road
Willesden Green
London NW2 4PG
020 8450 8930/020 8453 2306
RCSPC

WRIGHT, Susanna
Analytical Psychologist-Jungian Analyst
36 Upper Park Road
London NW3 2JT
020 7722 9291
CAP

YASS, Marion
Psychoanalytic Marital Psychotherapist
5a Templewood Avenue
London NW3 7UY
020 7794 2221
TMSI

ZAPHIRIOU WOODS, Marie
Child Psychotherapist
21 Hillfield Road
London NW6 1QD
020 7794 6276
ACP

LONDON SOUTH EAST

ADAMS, Tessa*
Psychoanalytic Psychotherapist
122 Erlanger Road
London SE14 5TS
020 7919 7205/020 7358 0018
GUILD

ALABASTER, Nigel
Family Psychotherapist
Greenwich Child Guidance Service
Plumstead Health Centre
Tewson Road
London SE18 1BH
020 8317 8319/020 8855 9254
AFT

ALLEYNE, Aileen
Psychoanalytic Psychotherapist
35 Pellatt Road, East Dulwich
London SE22 9JA
020 8693 4159
NAFSI

ALLISON, Lyn
Psychoanalytic Psychotherapist
51a Trafalgar Avenue
London SE15 6NP
AGIP

ANSARI, Shakir Shiyam
Cognitive Analytic Therapist
York Clinic, Thomas Guy House
London SE1 9RT
01322 526282
ACAT

ANTHONY, Monica
Transpersonal Psychotherapist
43 Gomm Road
London SE16 2TY
020 7232 2562
CTP

ATTIAS, Sandra
Transpersonal Psychotherapist
4 Sydcote, Rosendale Road
Dulwich
London SE21 8LH
020 8766 0101
CCPE

ATTWOOD, Peter
Family Therapist, Systemic
Psychotherapist
317b Upland Road, East Dulwich
London SE22 0DL
020 8659 2632/020 8299 3014
IFT

AYLWARD, P J
Psychoanalytic Psychotherapist
1A Glenlyon Road, Eltham
London SE9 1AL
020 8859 0617
FPC

AYRES, Anthony
Psychoanalytic Psychotherapist
37 Donaldson Road
London SE18 3JZ
020 8856 1542
GUILD

BARRETT, Jean
Psychoanalytic Psychotherapist
8 Meadowcourt Road
London SE3 9DY
020 8297 0276
GUILD

BARTER, Ruth
Child Psychotherapist
29 Colte Road
London SE23 2ES
020 8291 1675
ACP

BASSAM, Bruce
Cognitive Behavioural Psychotherapist
Dept of Child and Fam.Psychiatry
Lambeth Healthcare NHS Trust
35 Black Prince Road
Kennington SE11 6JJ
020 7737 3527/020 7793 7113
BABCP

BEARD, Hilary
Cognitive Analytic Therapist,
Psychoanalytic Psychotherapist
4 Grangewood Terrace
Grange Road, South Norwood
London SE25 6BA
020 8771 4475
ACAT

BELL, Frances
Analytical Psychologist-Jungian Analyst
296 Commercial Way, Peckham
London SE15 1QN
020 7732 9709
AJA

BENNETT, Lesley
Psychoanalytic Psychotherapist
167 Brockley Rise, Forest Hill
London SE23 1NL
020 8690 7537
IPSS

BHAT, Radha
Group Analyst
186 Beulah Hill, Upper Norwood
London SE19 3UX
020 8240 7489
IGA

BISHOP, Patricia
Psychoanalytic Psychotherapist
No 2, Spencer House
23 Dartmouth Row, Greenwich
London SE10 8AW
020 8691 9800
IPSS

BLACK, Judith
Hypno-Psychotherapist
31 Merritt Road, Crofton Park
London SE4 1DT
020 8691 1168
NSHAP

BLACK, Sandra
Psychoanalytic Psychotherapist
112 Friern Road
London SE22 OAX
020 8693 7524
IPSS

BLAND, John
Cognitive Behavioural Psychotherapist
92 Tuam Road, Plumstead Common
London SE18 2QU
020 8308 3124/020 8473 5937
BABCP

BLOMFIELD, Valerie
Psychosynthesis Psychotherapist
12 Woodlands Park Road
Greenwich
London SE10 9XD
020 8853 0772
AAPP

BOAKES, Janet
Group Analyst
134 Grove Lane, Denmark Hill
London SE5 8BP
020 7274 3598
IGA

BORONSKA, Teresa W.
Group Analytic Psychotherapist
9C Crystal Palace Park Road
Sydenham
London SE26 6EG
020 7919 7233/020 8778 236
UPA

BOURNE, Juliet
Systemic Psychotherapist
36 Burney Street, Greenwich
London SE10 9NP
020 8853 0642
IFT

BRIGHT, Jenifer A
Cognitive Behavioural Psychotherapist
Department of Clinical Psychology
Institute of Psychiatry
De Crespigny Park
Denmark Hill SE15 8AF
020 7919 3242
BABCP

BRITTAIN, Charlie
Transpersonal Psychotherapist
120 Sandyhill Road
London SE18 7BA
020 8691 5408/020 8316 4907
CCPE

BROOKS, Beverly
Cognitive Analytic Therapist
15 Cibber Road, Forest Hill
London SE23 2EF
020 8699 8836
ACAT

BRUCE, Ann
Analytical Psychologist-Jungian Analyst
54 Uffington Road
London SE27 0ND
020 8670 3783
CAP

BUCKINGHAM, Linda
Child Psychotherapist, Psychoanalytic
Psychotherapist
8 Meadowcourt Road
London SE3 9DY
020 8297 0276
ACP

BURGIN, Hazel
Group Analytic Psychotherapist
48 Sunnydale Road, Lee Green
London SE12 8JN
020 7815 1523/020 8852 8088
UPA

BYERS, Angela
Group Analytic Psychotherapist
10 Cintra Court, Patterson Road
London SE19 2LB
020 8653 5330
UPA

CANTY, Josephine
Group Analyst
125 Taunton Road, Lee Green
London SE12 9PA
020 8318 9023
IGA

CARUANA, Charles Victor
Psychoanalytic Psychotherapist
Flat 6, 50 New Cross Road
London SE14 5BD
020 7277 7402(t/f)
AGIP

CHESSELL, Karen
Psychoanalytic Psychotherapist
329 Upland Road, East Dulwich
London SE22 0DL
020 8299 2890
IPSS

CLARK, Debra
Sexual and Relationship Psychotherapist
Ground Floor Flat
250 Leahurst Road, Lewisham
London SE13 5LT
020 8851 2269
BASRT

CLEMINSON, Dorel
Integrative Psychotherapist
36 Seymour Gardens, Brockley
London SE4 2DN
020 7639 5055/020 7635 6206
RCSPC

CLOUGH, Andrea
Psychosynthesis Psychotherapist
37 Harefield Road, Brockley
London SE4 1LW
020 8691 5303
AAPP

COMBES, Ann
Group Analytic Psychotherapist
53 South Norwood Hill
South Norwood
London SE25 6BX
020 8771 2057
FPC

CORNECK, Susan
Psychoanalytic Psychotherapist
41 Creek Road
London SE8 3BU
020 8694 0221
AGIP

COWMEADOW, Pauline
Cognitive Analytic Therapist
45 Beauval Road, Dulwich
London SE22 8UG
020 8693 1812
ACAT

CREAMER, Mary
Transpersonal Psychotherapist
21 Archery Road, Eltham
London SE9 1HF
020 8850 8357
CCPE

CROWE, Michael
Sexual and Relationship Psychotherapist
Maudsley Hospital, Denmark Hill
London SE5 8AZ
020 7919 2371
BASRT

CURRAN, Annalee
Cognitive Analytic Therapist
108 Norwood Road, Herne Hill
London SE24 9BB
020 8674 8702
ACAT

CZUBINSKA, Grazyna
Psychoanalytic Psychotherapist
2 Greenwich Park Street Greenwich
London SE10 9AA
020 8853 0156
FPC

DABOR, Thelma
Cognitive Behavioural Psychotherapist
19 Ridgeway, Central Hill
Upper Norwood
London SE19 1EH
020 8305 2388/020 8766 6258
BABCP

DAVIES, Roger
Group Analyst
7A St Austell Road, Lewisham
London SE13 7EQ
020 8852 8009
IGA

DAWSON, Peter
Transpersonal Psychotherapist
8a Peabody Buildings
Camberwell Green
London SE5 7BD
020 7708 5399
CCPE

DE ZULUETA, Felicity
Group Analyst
Traumatic Stress Service
Maudsley Hospital
Denmark Hill
London SE5 8AZ
020 7919 2969
IGA

DEARNLEY, Barbara K.
Psychoanalytic Marital Psychotherapist
186 Court Lane
London SE21 7ED
020 8693 2603
TMSI

DENFORD, Lindsey D.
Cognitive Behavioural Psychotherapist
Section of Psychiatric Nursing
Institute of Psychiatry
De Crespigny Park
London SE5 8AZ
020 7919 3505
BABCP

DENIFLEE, Ursula
Biodynamic Psychotherapist
30 Styles House, The Cut
London SE1 8DF
020 7401 3582
BTC

DERES, Mebrat
Systemic Psychotherapist
8(b) Ulverstone Road
West Norwood
London SE27 0AJ
020 8670 8438
KCC

DILKS, Sarah L E
Cognitive Behavioural Psychotherapist
Community Rehabilitation Team
South London & Maudsley NHS Trust
8 Belmont Hill
Lewisham SE13 5BD
020 8297 0021
BABCP

DONOVAN, Marlyn
Psychosynthesis Psychotherapist
20 Farley Road, Catford
London SE6
020 8698 5664
AAPP

DOWBER, Hilary
Psychoanalytic Psychotherapist
4 Walden Park Road, Forest Hill
London SE23 2PN
020 8694 2408/020 8291 3436
IPSS

DUCKWORTH, Rosemary
Psychoanalytic Psychotherapist
14 Ashton Heights
51 Horniman Drive, Forest Hill
London SE23 3BS
020 8291 2916
IPSS

DUPUY, Alan
Personal Construct Psychotherapist
Flat 16, Dominic Court
43 The Gardens
Dulwich, London SE22 9QG
020 8693 5769
CPCP

EGERT, Stella
Family Psychotherapist
183 Rosendale Road
West Dulwich
London SE21 8LW
020 8670 3417
IFT

EISLER, Ivan
Family Therapist
Institute of Psychiatry
De Crespigny Park, Denmark Hill
London SE5 8AF
020 7919 3184
IFT

EISLER, Zuzana
Sexual and Relationship Psychotherapist
London SE26 4BY
020 8291 7744
BASRT

EKDAWI, Isabelle
Systemic Psychotherapist
11 Lacon Road, East Dulwich
London SE22 9HE
020 8333 5681
KCC

ELLIOTT, Sandra A.
Cognitive Behavioural Psychotherapist
Community Clinical Psychology Service
Clinical Treatment Centre
Maudsley Hospital
Denmark Hill, London SE5 8AZ
020 7919 2194
BABCP

ELLIOTT, Victoria
Child Psychotherapist
Plumstead Child Guidance Unit
Plumstead Health Centre
Tewson Road
London SE18 1BH
020 8244 4732/020 8855 9254
ACP

ENNIS, Sally-Anne
Cognitive Analytic Therapist
C.A.T. Clinic
York Clinic, Thames Guy House
47 Weston Street
London SE1 3RR
020 7350 1034
ACAT

ERSKINE, Judith
Attachment-based Psychoanalytic
Psychotherapist
1 Halifax Street, Sydenham
London SE26 6JA
020 8291 1736
CAPP

ERSKINE, Ruth
Family Psychotherapist
Childrens Department
Maudsley Hospital
De Crespigny Park
London SE5
020 7919 2546/020 8340 4642
IFT

FARQUHAR, Kate
Lacanian Analyst, Psychoanalytic
Psychotherapist
169 Peckham Rye
London SE15 3HZ
020 7277 6890/020 7732 9431
CFAR

FINDLAY, David Alistair
Integrative Psychosynthesis
Psychotherapist
207 Waller Road, Telegraph Hill
London SE14 5LX
020 7639 9732
RE.V

FISHER, Linda
Cognitive Behavioural Psychotherapist
CFS Research Unit
The New Medical School
Bessemer Road
London SE5 9PL
020 7346 3363/020 8693 4473
BABCP

FITZSIMMONS, Michele Anne
Cognitive Behavioural Psychotherapist
York Clinic, Guy's Hospital
47 Weston Street
London SE1 3RR
020 7955 2881
BABCP

FLEMING, Robert W.K.
Child Psychotherapist, Psychoanalytic
Psychotherapist
29 Croxted Road, West Dulwich
London SE21 8AZ
020 8693 0019
ACP

FLETCHER, Joan
Humanistic and Integrative
Psychotherapist
171 Algernon Road, Lewisham
London SE13 7AP
020 8690 8987
SPEC

FOX, Catherine
Psychosynthesis Psychotherapist
95a Herne Hill
London SE24 9LY
020 7924 0369
AAPP

FRENCH, Eileen
Analytical Psychologist-Jungian Analyst
London Practice
LF 1.9 The Leather Market Weston
Street
London SE1 4XE
020 7357 0357/020 7485 1533
AJA

GARDINER, Margaret
Psychoanalytic Psychotherapist
44 Granville Park
London SE13 7DX
020 7837 2613/020 8318 3303
AGIP

GERAGHTY, Wendy
Family Therapist
Lewisham Child and Family Therapy
78 Lewisham Park
London SE13 6QJ
020 8690 1086/020 8690 5521
AFT

GINSBORG, Robby
Analytical Psychologist-Jungian Analyst
84 Thornlaw Road
London SE27 0SA
020 8761 3607
IGAP

GOODFELLOW, Joanna
Gestalt Psychotherapist
27 Ansdell Road
London SE15 2DT
020 7771 6323
GPTI

GOODMAN, Susan
Analytical Psychologist-Jungian Analyst
114 Court Lane
Dulwich SE21 7EA
020 8693 9926
CAP

GOTTSCHALK, Margaret S
Integrative Psychotherapist
21 Marsden Road, East Dulwich
London SE15 4EE
020 7267 5658
MC

GREENWOOD, Anthony
Group Analytic Psychotherapist
19 Brunswick Quay, Rotherhithe
London SE16 1PU
020 7231 4309
UPA

GREY, David
Psychoanalytic Psychotherapist
93 Alleyn Park
London SE21 8AA
020 8299 9918
IPSS

GRIFFIN, Mary
Sexual and Relationship Psychotherapist
Out-Patient Department
Maudsley Hospital
Denmark Hill
London SE5 8AZ
020 7919 2371
BASRT

GRIFFITH, John
Psychoanalytic Psychotherapist
42 Elm Grove, Peckham
London SE15 5DE
020 7272 7013/020 7639 4963
AGIP

GURNEY, Paul
Psychoanalytic Psychotherapist
Flat 1, 13 Romola Road
London SE24 9BA
020 8244 4840
SITE

HADDINGTON, Janet
Psychoanalytic Psychotherapist
2a Bromar Road, Camberwell
London SE5 8DL
020 7725 1036/020 7326 1332
FIP

HANCHEN, Thomasz
NLP Psychotherapist
55 Cressingham Road, Lewisham
London SE13 5AQ
020 8318 3102 (t/f)
ANLP

HANCOCK, Pauline
Psychosynthesis Psychotherapist
Flat 1, 194 Peckham Rye
East Dulwich
London SE22 9QA
020 8299 1767
AAPP

HANNA, Dorothy
Psychosynthesis Psychotherapist
74 Auckland Hill, West Norwood
London SE27 9QQ
020 8761 2855
AAPP

HARGADEN, Helena
Integrative Psychotherapist, Transactional
Analysis Psychotherapist
43 Brockley Park
London SE23 1PT
020 8690 3175 (t/f)
MET

HEDGES, Fran
Systemic Psychotherapist
213 New Cross Road
London SE14 5UH
020 8392 3632
KCC

HENDRY, Evelyn R.
Cognitive Behavioural Psychotherapist
York Clinic, Guy's Hospital
London SE1 1NP
020 7955 4933
BABCP

HODGKISS, Andrew*
Lacanian Analyst
Department of Liaison
Psychiatry, Riddell House
St Thomas'Hospital
London SE1 7EH
020 7960 5735
CFAR

HOWARD, Heather
Psychoanalytic Psychotherapist
83 Blackheath Park
London SE3 0EU
020 8852 6564
IPSS

HUGHES, Carol
Child Psychotherapist
Belgrave Department of Child Psychiatry
King's College Hospital
Denmark Hill
London SE5
020 7346 3219/01795 531605
ACP

JACOBS, Brian W
Family Therapist, Systemic
Psychotherapist
8 Mabenley Road, Upper Norwood
London SE19 2JB
020 8771 0342
IFT

JEFFORD, Adam
Group Analytic Psychotherapist
Maurice Craig Ward
York Clinic
47 Western Street
London SE1 3RR
020 7955 4901
UPA

JENKINS HANSEN, Anne
Group Analyst
1 Clink Wharf, Clink Street
London SE1 9DG
020 7234 0207
IGA

JENKINS, Hugh
Systemic Psychotherapist
83 Hurstbourne Road, Forest Hill
London SE23 2AQ
020 8291 4791
IFT

JIAH, Hildah
Cognitive Behavioural Psychotherapist
Deptford Primary Care MHTeam
Lind Clinic, James Lind House
Grove Street SE8 3QF
020 8691 3237/020 8769 7843
BABCP

JONES, Merryn
Group Analytic Psychotherapist
8 Broadwall
London SE1 9QE
020 7401 2393
FPC

JUDE, Julia
Group Analytic Psychotherapist
62 Woodvale, Forest Hill
London SE23 3ED
020 8299 1538
UPA

KERR, Anna
Psychoanalytic Psychotherapist
3 Talbot Place
London SE3 0TZ
020 8852 1751
GUILD

KERRIDGE, Jack*
Psychoanalytic Psychotherapist
96 Langton Way
London SE3 7JU
020 8305 1287
GUILD

KING, Christine
Hypno-Psychotherapist
Flat 3, St Johns Park, Blackheath
London SE3 7JB
020 8305 2317
NRHP

KOEPPELMANN, Marianna
Psychosynthesis Psychotherapist
73 Lawnside, Blackheath
London SE3 9HL
020 8318 0792
AAPP

KOWSZUN, Grazyna
Integrative Psychotherapist
127 Kinveachy Gardens, Charlton
London SE7 8EQ
020 8854 0604
MET

LANG, Susan
Systemic Psychotherapist
40 Rosenthorpe Road
London SE15 3EG
020 7720 7301
KCC

LANGDON, Monica
Psychoanalytic Psychotherapist
6 Upwood Road
London SE12 8AA
020 8318 0110
AGIP

LANYADO, Monica
Child Psychotherapist
30 Brookway, Blackheath
London SE3 9BJ
020 8852 1521
ACP

LASK, Judith
Family Therapist, Systemic
Psychotherapist
99 Underhill Road
London SE22 0QR
020 7391 9150/020 8693 6048
IFT

LEE, Joan Mary
Analytical Psychologist-Jungian Analyst
69 Beaconsfield Road, Blackheath
London SE3 7LG
020 8858 3133
CAP

LEEMING, Gareth
Psychoanalytic Psychotherapist
Flat 8, 82 Wickham Road
Brockley
London SE4 1LS
020 8469 0666
FPC

LESTER, Hilary
Humanistic Psychotherapist
235 Barry Road, East Dulwich
London SE22 0JU
020 8299 4368
AHPP

LINESS, Sheena
Cognitive Behavioural Psychotherapist
Maudsley Hospital
99 Denmark Hill
London SE5 8AZ
020 7919 3458
BABCP

LIVANOU, M.
Cognitive Behavioural Psychotherapist
Traumatic Stress Service
Maudsley Hospital
99 Denmark Hill
London SE5 8AF
020 7919 3458
BABCP

LONGLEY, Joan
Psychoanalytic Psychotherapist
Lavender Cottage, 9b Tudor Road
London SE19 2UH
020 8659 8486/020 8768 0224
AGIP

LOVE, Derek
Group Analyst
15 Thorncombe Road
London SE22 8PX
020 8693 1155
IGA

LOWDEN, Barbara
Transpersonal Psychotherapist
99A Griffin Road, Plumstead
London SE18 6NE
020 8854 4074
CCPE

LOWE, Judith
NLP Psychotherapist
6 Denman Road
London SE15 5NP
020 7708 2358 (t/f)
ANLP

LYONS, Kathleen
Psychosynthesis Psychotherapist
Cenacle Sisters, 142a Rodney Road
Walworth, London SE17 1RA
020 7708 3541
AAPP

MACDONALD, Laurie
NLP Psychotherapist
24 Robinscroft Mews, Greenwich
London SE10 8DN
01732 763491
ANLP

MAKATINI, Zethu
Systemic Psychotherapist
31 Langford House
Evelyn Street, Deptford
London SE8 5QJ
KCC

MARSH, Jennifer*
Psychoanalytic Psychotherapist
96 Elfindale Road, Herne Hill
London SE24 9NW
020 7274 3467
GUILD

MARTIN, Edward
Analytical Psychologist-Jungian Analyst
17 Honor Oak Rise
London SE23 3QY
020 8699 2303
CAP

MAUNDER, Brian Lawrence
Psychoanalytic Psychotherapist
Badgers' Oak
12 Chinbrook Road, Grove Park
London SE12 9TH
020 8851 5702
FPC

MCALPINE, A M
Cognitive Behavioural Psychotherapist
Dept Neuropsychiatry Room32
Outpatients, The Maudsley Hospital
Denmark Hill
London SE5 8AZ
020 7919 2330
BABCP

MCCUTCHEON, Moira
Child Psychotherapist
Camberwell Child Guidance Centre
Lister Health Centre
1 Camden Square, Peckham Road
London SE15 5LA
020 7701 7371
ACP

MCFARLANE, Kay
Gestalt Psychotherapist
Flat B, 242 Brownhill Road
London SE6 1AU
020 8697 8285
SPTI

MCKENZIE-MAVINGA, Isha
Psychoanalytic Psychotherapist
10 Wall Button Road, Brockley
London SE4 2NX
020 7652 1361
NAFSI

MCLOUGHLIN, Brendan Nicholas
Cognitive Behavioural Psychotherapist
Behavioural Psychotherapy Unit
99 Denmark Hill
Maudsley Hospital
London SE5 8AZ
020 7919 2101
BABCP

MCMAHON, Gladeana
Cognitive Behavioural Psychotherapist
11 Streetfield Mews
Blackheath Park
London SE3 0ER
020 8852 4854
BABCP

MCMILLAN, Penny
Attachment-based Psychoanalytic
Psychotherapist
32 Congers House, Bronze Street
London SE8 3DT
020 8691 7199
CAPP

MEARS, Sylvia
Psychoanalytic Psychotherapist
5 Quentin Road, Blackheath
London SE13 5DG
020 8852 0399
FIP

MILES, Fiona
Psychosynthesis Psychotherapist
104 Humber Road, Blackheath
London SE3 7LX
020 8858 7338
AAPP

MILES, Natalie
Integrative Psychotherapist
7 The Lane, Blackheath
London SE3 9SL
020 8318 3423
RCSPC

MILLAR, Gerry
Psychosynthesis Psychotherapist
1 Greenstreet Hill. Drakefell Road
London SE14 5SR
020 7635 7754
AAPP

MONTICELLI, Wendy
Psychoanalytic Psychotherapist
19 Brunswick Quay, Rotherhithe
London SE16 1PU
020 7231 4309
FPC

MORIN, Terry
Gestalt Psychotherapist
97 Fawnbrake Avenue
London SE24 0BG
020 7737 2173
GPTI

MORLEY, Jane
Group Analytic Psychotherapist
11 Tylney Avenue
London SE19 1LN
020 7250 2316
UPA

MUDARIKIRI, Maxwell Magondo
Systemic Psychotherapist
5 Armistice Gardens,
Penge Road, South Norwood
London SE25 4EZ
020 8688 1605
KCC

MUKUMA, Diana
Gestalt Psychotherapist
Flat 3, 194 Kennington Lane
London SE11 5DL
020 7735 5442
GPTI

MURPHY, Denis
Group Analyst
24 Oakcroft Road, Lewisham
London SE13 7EF
020 8852 8749
IGA

MURPHY, Sue
Integrative Psychotherapist
4 Egremont Road
London SE27 0BH
020 7323 6334/020 8670 6139
RCSPC

MURRAY, Christine
Integrative Psychotherapist
50 Ormiston Road
London SE10 0LW
020 8858 7350
MET

NEWBIGIN, Alison
Integrative Psychotherapist
48 Surrey Square
London SE17 2JX
020 7703 9544
MC

NKUMANDA, Rachel
Psychoanalytic Psychotherapist
6 Kelso Court, 94 Anerley Park
London SE20 8NZ
020 8778 2929
NAFSI

OAKLEY, Madeleine
Family Therapist, Psychoanalytic
Psychotherapist
Institute of Psychiatry, Dept of Psychiatry
Section of Psychotherapy,
De Crespigny Park, Denmark Hill
London SE5 8AF
020 7919 3190
IPSS

O'CALLAGHAN, Diane
Psychoanalytic Psychotherapist
16 Colwell Road, East Dulwich
London SE22 8QP
020 8516 5906
AGIP

PALMER, Stephen
Cognitive Behavioural Psychotherapist
Centre for Stress Management
156 Westcombe Hill, Blackheath
London SE3 7DH
020 8293 4114
BABCP

PARKINSON, Judy
Psychoanalytic Psychotherapist
Newlands Park Natural Health Care
Centre
48 Newlands Park, Sydenham
London SE26 5NE
020 8659 5001
FPC

PAWSEY, Jack
Psychoanalytic Psychotherapist
20 Addington Square
London SE5 7JZ
020 7701 8920
FPC

PETERS, Sheila
Hypno-Psychotherapist
102A Holmesdale Road
South Norwood
London SE25 6JF
020 8653 4242
NRHP

PHILLIPS, Virginia
Analytical Psychologist-Jungian Analyst
74 Dovercourt Road
Dulwich SE22 8UW
020 8693 4111/020 7601 7945
CAP

PRICE, Annie
Psychoanalytic Psychotherapist
9 Pickwick Road
London SE21 7JN
020 7738 7565
AGIP

PRICE, Susan
Psychoanalytic Psychotherapist
15 Boyne Road
London SE13 5AL
020 8318 4410
GUILD

RANCE, Christopher
Group Analyst
43 Rosendale Road, Dulwich
London SE21 8DY
020 8670 5023
IGA

RIMMER, Annie
Integrative Psychotherapist, Transactional
Analysis Psychotherapist
10 Mount Ash Road
London SE26 6LZ
020 8291 4091
MET

ROBERTSON, Judith
Psychoanalytic Psychotherapist
76 Crawthew Grove
London SE22 9AB
020 8516 1173
IPSS

ROBINSON, Ferga
Cognitive Behavioural Psychotherapist
44 Brockwell Park Gardens
Herne Hill
London SE24 9BJ
020 8674 2359
BABCP

ROGERS, Cynthia
Group Analyst
178 Turney Road, Dulwich
London SE21 7JL
020 7274 4655
IGA

RUDDELL, Peter
Cognitive Behavioural Psychotherapist
Centre for Rational Emotive B.T.
156 Westcombe Hill, Blackheath
London SE3 7DH
020 8293 4114
BABCP

RUMNEY, Boris*
Psychoanalytic Psychotherapist
1 Foxes Dale
London SE3 9BD
020 8852 9015
GUILD

RUSHFORTH, Catherine
Systemic Psychotherapist
20 Gifford House, Eastney Street
Greenwich
London SE10 9NT
KCC

RYLEY, Brigitte
Humanistic Psychotherapist
Flat 1, 39a Glengarry Road
London SE22 8QA
020 8693 6953
AHPP

SALMON, Gillian
Educational Therapist
46 Pepys Road
London SE14 5SB
020 7639 3062 (t/f)
FAETT

SCHAFFER, Tom
Core Process Psychotherapist
1 Faversham Road, Catford
London SE6 4XE
020 8690 1769
AAPP

SCHMIDT, Martin
Analytical Psychologist-Jungian Analyst
71 Ivanhoe Road
London SE5 8DH
020 7274 3758
CAP

SEIGAL, Anthony
Sexual and Relationship Psychotherapist
148 Woodwarde Road
London SE22 8UR
020 8288 2383
BASRT

SHEEHAN, Margaret
Analytical Psychologist-Jungian Analyst
70 Fawnbrake Avenue
London SE24 0BZ
020 7924 0514
CAP

SHERRIFF, Deanne
Cognitive Behavioural Psychotherapist
92 Tuam Road
Plumstead Common
London SE18 2QU
020 8473 5937/020 8312 6380
BABCP

SHORROCK, Andrew
Psychosynthesis Psychotherapist
14 Lovell Place
London SE16 6QQ
020 8231 8016
AAPP

SIEDERER, Carol
Gestalt Psychotherapist
76 Erlanger Road
London SE14 5TH
020 7787 2813
GCL

SIRET, Eiran R
Group Analytic Psychotherapist
28 Bromley Road
London SE6 2TP
020 8690 6672
UPA

SMITH, David L.
Integrative Psychotherapist
8 Brenchley Gardens
London SE23 3QS
UPA

SMITH, Paola Valerio
Analytical Psychologist-Jungian Analyst
Upland Lodge
359 Upland Road, Dulwich
London SE22 0SL
020 8693 8421
CAP

SMITH, R.L
Cognitive Behavioural Psychotherapist
Mental Health Advice Centre
1 Southbrook Road, Lee
London SE12 8LH
020 8333 3030 x8117/
020 8318 1339
BABCP

SMITH, Ruthie
Psychoanalytic Psychotherapist
2a Banning Street, Greenwich
London SE10
WTC

SMITH, Trevor E.L.
Cognitive Behavioural Psychotherapist
22 Pleydell Avenue
Upper Norwood
London SE19 2LP
020 8653 0924/020 8993 7892
BABCP

SPINELLI, Ernesto
Existential Psychotherapist
69 Oglander Road, East Dulwich
London SE15 4DD
020 7487 7406/020 8693 9332
RCSPC

STANTON, Martin
Psychoanalytic Psychotherapist
169 Peckham Rye
London SE15 3HZ
020 7732 9431/020 7358 1748 (t/f)
FIP

STEEL, Marion
Integrative Psychotherapist
115 Ivanhoe Road
London SE5 8DJ
020 7733 7703
RCSPC

STOPHER, Andy
Psychoanalytic Psychotherapist
5 Manwood Road, Crofton Park
London SE4 1AA
020 8690 6821
IPSS

STRICKLAND, Lynda
Cognitive Behavioural Psychotherapist
120 Sangley Road, Catford
London SE6 2JR
020 8858 8557/020 8461 2075
BABCP

STUART, Lilly H.
Transactional Analysis Psychotherapist
106 Heathwood Gardens, Charlton
London SE7 8ER
020 8854 3606
ITA

TANNER, Claire
Cognitive Analytic Therapist
26 Vancouver Road, Forest Hill
London SE23 2AF
020 8699 7996
ACAT

TOPLISS, Nick
Family Therapist
162 Kilmonie Road, Forest Hill
London SE23 2SR
020 8244 0284
IFT

WACH, Karin Marie
Psychoanalytic Psychotherapist
2 Pottery Street
Cherry Garden Pier
London SE16 4PH
020 7252 3947
ARBS

WALSH, Carys
Integrative Psychotherapist
36 Glenhurst Court, Farquhar Road
London SE19 1SR
07931 750526
MC

WARDLEY, Jean
Cognitive Behavioural Psychotherapist
Suite 7, Woodrow Business Centre
Woodrow
London SE18 5DH
020 8854 3014
BABCP

WATERS, Kathleen
Family Therapist
75 Lyndhurst Grove, Peckham
London SE15 5AW
020 8699 5881/020 8690 1086
IFT

WATSON, James P
Sexual and Relationship Psychotherapist
UMDS Div. of Psychiatry
Guy's Hospital
London SE1 9RT
020 7955 4247
BASRT

WAY, Patsy
Systemic Psychotherapist
72 Alleyn Road, Dulwich
London SE21 8AH
020 8670 5315
KCC

WEINBERG, Jane
Integrative Psychosynthesis
Psychotherapist
6 Arbuthnoth road, New Cross
London SE14 5NP
020 7358 9721
RE.V

WELLS, Peter
Sexual and Relationship Psychotherapist
10 Wincott Street
London SE11 4NT
020 7820 9445
BASRT

WHITE, Jeremy
Group Analyst
4a Spenser Road, Herne Hill
London SE24 0NR
020 7733 0834
IGA

WHITE, Lauren E
Analytical Psychotherapist, Group
Analytic Psychotherapist,
Psychoanalytic Psychotherapist
31 Embleton Road
London SE13 7DH
020 8692 2969
UPA

WILLIAMS, Chris
Gestalt Psychotherapist
2b Plough Lane
East Dulwich
London SE22 8JL
020 8693 1129
GPTI

WILLIAMS, Diana
Transpersonal Psychotherapist
17 Chestnut Road
London SE27 9EZ
020 8670 1035
CTP

WILLIAMS, Pat
Integrative Psychotherapist
79 Ermine Road, Lewisham
London SE13 7JJ
020 8690 1229
MC

WILLIAMS, Ruth M.
Cognitive Behavioural Psychotherapist
Department of Psychology
Institute of Psychiatry
De Crespigny Park
London SE5 8AF
020 7919 3242
BABCP

WILSON, Mary
Analytical Psychologist-Jungian Analyst
46 Erlanger Road, New Cross
London SE14 5TG
020 7639 1867
CAP

WINDERS, Suzanne
Psychoanalytic Psychotherapist
21B Holmdene Avenue
London SE24 9LB
020 7274 7517
FPC

WOODLEY, Ermine
Psychoanalytic Psychotherapist
40 Siddons Road, Forest Hill
London SE23 2JQ
020 8291 3185
IPSS

WOOSTER, Frances
Psychoanalytic Psychotherapist
28 Holly Grove
London SE15 5DF
020 7635 0448
GUILD

YAZAR, Jale
Psychoanalytic Psychotherapist
46A Milton Road
London SE24 0NP
020 7652 0056
IPSS, NAFSI

LONDON SOUTH WEST

ADAMS, Melissa
Family Therapist
Child & Adolescent Psychiatry
Chelsea and Westminster Hospital
379 Fulham Road
London SW10 9NP
020 8746 8620
IFT

ADAMS-LANGLEY, Stephen
Integrative Psychotherapist
24 Fairmount Road
London SW2 2BL
020 8678 0473
RCSPC

AFFORD, Peter
Psychosynthesis Psychotherapist
12 Kendoa Road, Clapham
London SW4 7NB
020 7498 7447
AAPP

AGUIRREGABIRIA, Ana
Psychodrama Psychotherapist
40B Althea Street
London SW6 2RY
020 7384 2059
BPA

AKINBORO-COOPER, Bobbie
Child Psychotherapist
21 Lower Common South
London SW15 1BP
020 8788 1642
ACP

ALLAWI, Nadia
Psychoanalytic Psychotherapist
Woolborough House
40 Roedean Crescent, Roehampton
London SW15 5JU
020 8876 4182
IPSS

ALLSOP, Pamela
Transpersonal Psychotherapist
68 Redcliffe Square
London SW10 9BN
020 7373 0891
CTP

AMBROSE, Tony
Gestalt Psychotherapist
46 Dorien Road, Raynes Park
London SW20 8EJ
020 8542 5930
GCL

ANDREW, Elizabeth
Psychoanalytic Psychotherapist
3 Camp View, Wimbledon
London SW19 4UL
020 8947 2732
FPC

ARCHER, Ruth
Psychoanalytic Psychotherapist
8 Roundacre, Inner Park Road
Wimbledon
London SW19 6DB
020 8788 5128
FPC

AZU-OKEKE, Okeke
Group Analyst
118 Streatham Vale
London SW16 5TB
020 8764 8894
IGA

BARNES, Tricia
Sexual and Relationship Psychotherapist
7 Grange Park Place
Thurstan Road, Wimbledon
London SW20 0EE
020 7935 0640/020 8241 1201
BASRT

BEATTIE, Anya
Hypno-Psychotherapist
34 Algarve Road
London SW18 2HG
0976 943030
NSHAP

BERGER, Jocelyn
Integrative Psychotherapist
15 Sandgate Lane
London SW18 3JP
020 8874 0763
RCSPC

BIBBY, Keith
Hypno-Psychotherapist
49 Klea Avenue, Clapham Common
London SW4 9HG
020 8673 6311
NSHAP

BIRKETT, Diana
Psychoanalytic Psychotherapist
95 Elspeth Road
London SW11 1DP
020 7652 6749
CPP

BLAND, Roger
Integrative Psychotherapist
15 Coleherne Court
The Little Boltons
London SW5 0DL
020 7373 2014
RCSPC

BOLL, Antonia
Analytical Psychologist-Jungian Analyst
51 Coniger Road
London SW6 3TB
020 7736 0226
AJA

BORGES, Sheila
Integrative Psychotherapist
71 Mantilla Road
London SW17 8DY
020 8767 6595
MC

BOWDERY, Sally
Humanistic Psychotherapist
132 Babington Road
London SW16 6AH
020 8769 5298
AHPP

BOYLE, Alexander
Psychosynthesis Psychotherapist
25 Killyon Road
London SW8 2XS
020 7498 6367
AAPP

BRADY, Kate
Integrative Psychosynthesis
Psychotherapist
226 Links Road
London SW17 9ER
020 8769 0675
RE.V

BRIDGE, Jenny
Transactional Analysis Psychotherapist
569 Upper Richmond Road West
Richmond TW10 5DX
020 8878 2658
ITA

BRITTON, Julia
Child Psychotherapist
Department of Child & Adolescent
Mental Health
Chelsea & Westminster Hospital
369 Fulham Road
London SW10 9NH
020 7263 7558
ACP

BROOKES, Sasha
Psychoanalytic Psychotherapist,
Psychoanalytic Marital
Psychotherapist
44a Bramham Gardens
London SW5 0HQ
020 7370 4689
ARBS

BROOKS, Cynthia M
Group Analytic Psychotherapist,
Psychoanalytic Psychotherapist
50 Madeira Road, Streatham
London SW16 2DE
UPA

BRYAN, Angus
Gestalt Psychotherapist
3 Streatham Place
London SW2 4PY
0956 905191
GCL

BUCKLEY, Marie-Noël (Billie)
Psychoanalytic Psychotherapist
6 Trevor Place, Knightsbridge
London SW7 1LA
020 7581 3987/020 7589 1763
FPC

BURNARD, John
Analytical Psychologist-Jungian Analyst
76 Ryecroft Road
London SW16 3EH
020 8670 9400
CAP

BUTLER SMITH, Catherine
Personal Construct Psychotherapist
30 Cleveland Gardens
London SW13 0AG
020 8878 3017
CPCP

BUTLER, John
Hypno-Psychotherapist
37 Orbain Road, Fulham
London SW6 7JZ
020 7385 1166
NRHP

CAMPBELL, Christine
Integrative Psychotherapist
33 Montpelier Walk
London W7 1JG
020 7581 3374
RCSPC

CARDWELL, Amynta
Systemic Psychotherapist
Brent Kensington & Chelsea and
Westminster Trust
Child and Adolescent Psychiatry
In Patient Unit
5 Collingham Grds
London SW5 0YR
KCC

CASEY, Jan
Transpersonal Psychotherapist
1 Vere House
15 Cheyne Row, Chelsea
London SW3 5HR
0850 354339/020 7352 6964
CCPE

CHANCER, Anne*
Psychoanalytic Psychotherapist
35 Temple Sheen Road
London SW14 7QF
020 8876 1523
GUILD

CHILDS, Margaret
Systemic Psychotherapist
45 Becmead Avenue, Streatham
London SW5 0HR
KCC

CHILTON, Maggie
Group Analyst
35 Brompton Square
London SW3 2AE
020 7584 1589
IGA

CLERY, Cairns
Family Therapist
50 Girdwood Road, Southfields
London SW18 5QS
020 8333 8400
AFT

CLIFTON, Elaine
Integrative Psychotherapist
Flat 3, 55 Onslow Square
London SW7 3LR
MET

COLERIDGE, Jane
Psychoanalytic Psychotherapist
85 Erpingham Road
London SW15
020 8785 9891
GUILD

COLES, Walter
Educational Therapist
18 Spencer Road, Wandsworth
London SW18 2SW
020 7738 2455
FAETT

COLLARD, Patrizia C
Cognitive Behavioural Psychotherapist
(Peking) Foreign & Commonweath
Office
King Charles Street
London SW1A 2AH
86 10 6532 6121
BABCP

COLSON, Louise
Cognitive Behavioural Psychotherapist
The Hans Place Practice
43 Hans Place
London SW1X 0JZ
020 8674 6920/0411 963467
BABCP

CORONAS, Ita
Gestalt Psychotherapist, Humanistic
Psychotherapist
37 Barkston Gardens
London SW5 OER
020 7373 3989
GCL

COSTELLO, John
Analytical Psychologist-Jungian Analyst
122 Lupus Street
London SW1V 4AN
020 7834 1708 (t/f)
IGAP

COTTON, Naomi
Psychoanalytic Psychotherapist
Flat 4, 14 The Chase
London SW4 0NH
020 7720 6466
IPSS

COUMONT GRAUBART, Valerie
Integrative Psychotherapist
18 Laitwood Road, Balham
London SW12 9QL
020 8265 5504
MC

COURTAULT, Susie
Psychoanalytic Psychotherapist
8 Clifford Avenue
London SW14 7BS
020 8876 3552
IPSS

CULLIS, Andrew
Psychoanalytic Psychotherapist
23 Amesbury Avenue
Streatham Hill
London SW2 3AE
020 8671 0732
IPSS

DARE-BRYAN, Arminal
Psychoanalytic Psychotherapist
15 Melrose Road, Southfields
London SW18 1ND
020 8874 3138/020 83338600
FPC

DAVIDSON, Steve
Psychoanalytic Psychotherapist
19 Chantrey Road
London SW9 9TD
020 7274 0426
IPSS

DAVIS, Emerald
Attachment-based Psychoanalytic
Psychotherapist
64 Lyndhurst Avenue, Norbury
London SW16 4UF
020 8764 6740
CAPP

DE MARQUIEGUI, Asun
Sexual and Relationship Psychotherapist
Clapham Common Clinic
1st Floor
151-153 Clapham High Street
London SW4 7SS
020 8627 8890
BASRT

DENMAN, Cara
Analytical Psychologist-Jungian Analyst
23 Lawrence Street
London SW3 5NF
020 7351 7336
IGAP

DENNIS, Suzanne
Integrative Psychosynthesis
Psychotherapist
54 Baldry Gardens, Streatham
London SW16 3DJ
020 8679 3572
RE.V

DENNISON, Paul
Integrative Psychotherapist
9 Mossbury Road
London SW11 2PA
020 7924 5601
RCSPC

DIGHTON, Rosemary
Systemic Psychotherapist
Claremont House
44 High Street, Wimbledon Village
London SW19 5AU
020 8946 1097
BASRT

DONINGTON, Laura
Core Process Psychotherapist
39 Blenkarne Road
London SW11 6HZ
020 7585 0909
AAPP

DRUMMOND, Lynne M
Cognitive Behavioural Psychotherapist
Behaviour Cognitive Psychotherapy
Top floor, White Lodge
Springfield Hospital
Glenburnie Road
London SW17 7DJ
020 8725 5561/020 8682 6961
BABCP

DU PLOCK, Simon
Existential Psychotherapist
20 Macaulay Road
Clapham Old Town
London SW4 0QX
020 7487 7680/020 7627 8741
RCSPC

DUNFORD, Kathy
Psychoanalytic Psychotherapist
50 Edge Hill Court
Edge Hill, Wimbledon
London SW19 4LW
020 8944 5949
IPSS

ECONOMIDOU, Nitsa
Transpersonal Psychotherapist
102 Disareali Road
London SW15 2DX
020 8788 5687/07957 346972
CCPE

EDELMANN, Robert J.
Cognitive Behavioural Psychotherapist
6 Galveston Road
London SW15 2SA
020 8871 4219
BABCP

EDGELL, Marjory
Hypno-Psychotherapist
23 Crescent Grove
London SW4 7AF
020 7622 4755
NRHP

EDINGTON, Jane
Integrative Arts Psychotherapist
7 St Simons Avenue, Putney
London SW15 6DU
020 8788 7691
IATE

EGLIN, Patricia
Integrative Psychotherapist
36 Turret Grove
London SW4 0ET
020 7978 1180
RCSPC

EILES, Clive
Psychoanalytic Psychotherapist
21 Trelawn Road, Brixton
London SW2 1DH
020 7326 0084
ARBS

ELLIOT, Patricia
Psychosynthesis Psychotherapist
4 Denmark Avenue
London SW19 4HF
020 8946 6059/020 8947 6059
AAPP

ELVIN, Gill R
Group Analytic Psychotherapist
69 Muncaster Road
London SW11 6NX
020 7585 3025
UPA

EMELEUS, Frances
Sexual and Relationship Psychotherapist
303 Duncan House
Dolphin Square
London SW1V 3PW
01/01
BASRT

ENGLISH, Marjorie P
Sexual and Relationship Psychotherapist
Wimbledon and Merton Relate
30/32 Worple Road
London SW19 4EF
020 8946 1788
BASRT

EVANS, Chris
Group Analyst
12 Kingsmeade Road, Tulse Hill
London SW2 3JB
020 8725 2540
IGA

FARMER, Eddie
Psychoanalytic Psychotherapist
122 Hambalt Road, Clapham Park
London SW4 9EJ
020 8673 2044/01748 886 500
FPC

FERGUSON, Joyce
Transpersonal Psychotherapist
407 Grenville House
Dolphin Square
London SW1V 3LP
020 7798 8073
CCPE

FIRMAN, Judith
Psychosynthesis Psychotherapist
2 Bournemouth Road
London SW19 3AP
020 8545 0873
AAPP

FLATT, Debbie
Transactional Analysis Psychotherapist
Bramwell, 95a Earlsfield Road
London SW18 3DA
020 8870 2821
ITA

FLEMING, Peter
Humanistic Psychotherapist
Pellin Institute, 15 Killyon Road
London SW8 2XS
020 7720 4499
AHPP

FLOWER, Michael
Systemic Psychotherapist
26 Keildon Road
London SW11 1XH
020 7223 6166/020 7274 3225
KCC

FREDMAN, Glenda
Systemic Psychotherapist
Department of Psychological Therapies
South Kensington & Chelsea MHC
Nightingale Place
London SW10 9NG
020 8846 6051
KCC

FULLER, Victoria Graham
Analytical Psychologist-Jungian Analyst,
Group Analyst
10 Onslow Gardens
London SW7 3AP
020 7584 7939
IGA

GAIRDNER, Wendy
Family Therapist
17 Larpent Avenue
London SW15 6UP
01/020 8788 7953
AFT

GANDY, Rus
Biodynamic Psychotherapist
5 Avenue Mansions, Battersea
London SW11 5SL
020 7223 4269
BTC

GARNER, Cheryl
Transpersonal Psychotherapist
11 Allestree Road
London SW6 6AD
020 7381 3484
CCPE

GATTI-DOYLE, Fiorella G.
Existential Psychotherapist, Personal
Construct Psychotherapist
Flat 2a, Sloane Avenue Mansions
Sloane Avenue
London SW3 3JF
020 7224 3387/020 7584 9589
CPCP

GIBBS, Elizabeth
Transpersonal Psychotherapist
London SW6
020 7736 9265
CCPE

GODFREY-ISSACS, Godfrey
Psychoanalytic Psychotherapist
105 Christchurch Road, East Sheen
London SW14 7AT
020 8876 5223
FIP

GOLDEN, Sylvia
Integrative Psychotherapist
The Mowll Flat, Christchurch North
Brixton, 88-96 Brixton Road
London SW9 6BE
020 8587 0375/020 7735 7229
RCSPC

GORDON, Virginia
Systemic Psychotherapist
64 Prospect Quay
98 Point Pleasant
London SW18 1PR
020 8516 3745
KCC

GRAHAM, Nancy
Family Therapist
54 Heythorpe Street, Southfields
London SW18 5BN
020 8870 0399
IFT

GREEN, Roberta
Group Analyst
41 Woodlawn Road, Fulham
London SW6 6BQ
020 8846 7987/020 7385 3408
IGA

GREENWOOD, John
Psychoanalytic Psychotherapist
98 White Hart Lane
London SW13 0QA
020 8286 3533
ARBS

GULLIVER, Pamela
Psychoanalytic Psychotherapist
6 Cardinal Place, Putney
London SW15 1NX
020 8785 7149
FPC

GUNDRY, Caroline
Psychoanalytic Psychotherapist
15 Genoa Avenue, Putney
London SW15 6DY
020 8785 1550
FPC

HABERLIN, Jane
Psychoanalytic Psychotherapist
73 Huddlestone Road, Turfnell Park
London SW13 0QA
0961 355792/020 8366 0505
ARBS

HARDY, Jo
Core Process Psychotherapist
39 Gleneldon Road
London SW16 2AX
020 8769 1074
AAPP

HARTNUP, Trevor
Child Psychotherapist
William Harvey Centre
313-315 Cortis Road
London SW15 6XG
020 8788 0074/020 8287 0620
ACP

HAY BURNS, Jean
Transpersonal Psychotherapist
1 Woolneigh Street
London SW6 3AU
020 7736 2397
CCPE

HAYES, Michael
Psychosynthesis Psychotherapist
Digby Stuart College
Roehampton Institute London
Roehampton Lane
London SW15 5PH
020 8878 9863
AAPP

HEAVEY, Anne
Family Therapist
51A Nightingale Lane
London SW12 8ST
020 8700 8730/1/020 8675 3983
IFT

HELLER, Fawkia
Psychodynamic Psychotherapist
1 Dungaravan Avenue, Putney
London SW15 5QU
020 8878 3309
UPA

HENNY, Lindy
Group Analytic Psychotherapist
Colne Denton
106 Cheyne Road
London SW10 0DG
020 7352 3977
FPC

HENRIQUES, Marika
Humanistic Psychotherapist,
Psychoanalytic Psychotherapist
54 Campbell Court
Gloucester Road
London SW7 4PD
020 7584 9793
GUILD

HERALALL, Ellen
Integrative Psychotherapist
93 Barcombe Avenue
Streatham Hill
London SW2 3BQ
RCSPC

HERSHKOWITZ, Annie
Group Analyst
14 Wynter Street, Battersea
London SW11 2TZ
020 8874 7881
UPA

HIPPS, Hilary
Integrative Psychotherapist
21 Malbrook Road
London SW15 6UH
020 8785 6707
MET

HITCHMAN, Nini
Psychosynthesis Psychotherapist
4 First Avenue, Mortlake
London SW14 8SR
020 8876 9056
AAPP

HOLDEN, Sarah
Group Analyst
Art Therapies Department
Springfield Hospital, Tooting Bec
London SW17 7DJ
020 8682 6236
IGA

HOPPING, Geoff
Transactional Analysis Psychotherapist
Flat 8, 126 Streatham Hill
London SW2 4RS
020 8674 7890
MET

HOPWOOD, Ann
Analytical Psychologist-Jungian Analyst
127 Grandison Road
London SW11 6LT
020 7924 5171
CAP

HORNBY, Jackie
Integrative Psychotherapist
15 Dingwall Road, Earlsfield
London SW18 3AZ
0961 826823/020 8874 5941
RCSPC

HORNE, David C
Existential Psychotherapist
Flat 3, 10 Bernay's Grove
London SW9 8DF
020 7733 0944
RCSPC

HOWELL, Sylvia
Transpersonal Psychotherapist
Barnes
London SW13 9QE
020 8748 3722
CCPE

HUGHES, Janet
Gestalt Psychotherapist
72 Elms Crescent
Clapham Common
London SW4 8QX
020 7622 1847
MET

HUNTER, Margaret
Child Psychotherapist
Brixton Child Guidance Clinic
19 Brixton Water Lane
London SW2 1NU
020 7274 5459/01795 4280971
ACP

IRVING, Susan
Psychoanalytic Psychotherapist
33 Greyhound Lane
Streatham Common
London SW16 5NP
FIP

ISAACS, Joy
Psychoanalytic Psychotherapist
105 Christchurch Road, East Sheen
London SW14 7AT
FIP

JACOB, Emily
Sexual and Relationship Psychotherapist
16 Avenue Gardens, East Sheen
London SW14 8BP
020 8878 5835
BASRT

JAMES, Jo
Integrative Arts Psychotherapist
67 Rosebank, Holy Park Road
Fulham SW6 6LJ
020 7385 2029
IATE

JARVIS, Eileen
Systemic Psychotherapist
7b Ellerton Road
Wandsworth Common
London SW18 3LP
020 8870 0037
KCC

JOHNSTONE, Mog
Cognitive Analytic Therapist
13a Abbeville Road
London SW4 9LA
020 8673 8503
ACAT

JONES, David
Humanistic Psychotherapist
39 Blenkarne Road
London SW11 6HZ
020 7223 7020/
01237 441691/441969
AHPP

KEANE, Pamela
Transpersonal Psychotherapist
234 Worple Road, West Wimbledon
London SW20 8RH
020 8946 8522
CCPE

KEMMIS BETTY, Sally
Systemic Psychotherapist
Family Therapy & Counselling Service
30 Lillian Road
London SW13 9JG
020 8563 7909
KCC

KENNEDY, Michael*
Lacanian Analyst
43 Hans Place
London SW1X 0JI
020 7584 2990/020 7267 3003
CFAR

KERRY, Sue
Transpersonal Psychotherapist
Flat 2, 42 Streathbourne Road
London SW17 8QX
020 8672 6573
CCPE

KIND, Gill
Analytical Psychologist-Jungian Analyst
12 Daisy Lane
London SW6 3DD
020 7736 3140
IGAP

KIRBY, Babs
Humanistic Psychotherapist
194 Ferndale Road
London SW9 8AH
020 7733 2748
AHPP

KITSON, Nicholas
Psychoanalytic Psychotherapist
65 Church Road, Wimbledon
London SW19 5DQ
020 8944 9951
LCP

KOLB, Peter John
Cognitive Behavioural Psychotherapist
White Lodge, Springfield Hospital
Glenburnie Road
Tooting, London SW17 0QT
020 8672 9911 ext 42961
BABCP

KOLBUSZEWSKI, Marianne
Integrative Psychotherapist
187 Latchmere Road, Battersea
London SW11 2JZ
020 7228 1560
MC

KUTEK, Ann
Analytical Psychologist-Jungian Analyst
32 Lillie Road
London SW6 1TN
020 7385 4299
CAP

LANG, Peter
Systemic Psychotherapist
Kensington Consultation Centre
2 Wyvil Court, Trenchold Street
London SW8 2TG
020 7720 7301
KCC

LAWRENCE, Margaret
Psychoanalytic Psychotherapist
14 Lancaster Gardens, Wimbledon
London SW19
020 8789 0614
GUILD

LAYTON, Sandy
Child Psychotherapist
70A Leopold Road
London SW19 7JQ
020 8946 0865
ACP

LE BRUN, Christine
Integrative Psychotherapist
56 Haldon Road
London SW18 1QG
020 8788 3729/020 8874 5439
RCSPC

LEE, John
Group Analyst
C.A.A
Fielden House
13 Little College Street
London SW1P 3SH
IGA

LEON, Sara
Humanistic Psychotherapist, Integrative
Arts Psychotherapist
17 Josephine Avenue
London SW2 2JX
020 8674 3074
IATE

LEWIS, Joan
Systemic Psychotherapist
111 Gleneagle Road, Streatham
London SW16 6AZ
020 8769 6736
KCC

LEWIS, Richard
Integrative Psychotherapist
63 Franciscan Road
London SW17 8EA
020 8672 5035
MC

LITTLE, Martin
Systemic Psychotherapist
Kensington Consultation Centre
2 Wyvil Court, Trenchold Street
London SW8 2TG
020 7720 7301
KCC

LOEWENTHAL, Del
Psychoanalytic Psychotherapist
70 Kenilworth Avenue
London SW19 7LR
01483 300800 x 3143/
020 8947 7085
PA

LOUDEN, Penny
Systemic Psychotherapist
Counselling and Therapy Service
30 Lillian Road
London SW13 9JG
020 8563 7909
KCC

LYON, Josephine
Hypno-Psychotherapist
15 Brunswick Court
Regency Street
London SW1P 4AE
020 7834 7418
NSHAP

MAGNER, Valerie
Integrative Psychotherapist
203 Crowborough Road
London SW17 9QE
020 8672 8569
MET

MAGUIRE, Marie
Psychoanalytic Psychotherapist
6 Stockwell Park Road
London SW9 0AJ
020 7820 1344
GUILD

MARCUS, Marietta
Analytical Psychologist-Jungian Analyst
16 Sunbury Avenue, East Sheen
London SW14 8RA
020 8876 1040
CAP

MARLING, Frances
Psychosynthesis Psychotherapist
6 Kenilworth Avenue, Wimbledon
London SW19 7LW
020 8946 4063
AAPP

MARSDEN, Patricia
Psychoanalytic Psychotherapist
48 Wandle Road
London SW17 7DW
020 8767 0563
FPC

MATHERS, Carola
Analytical Psychologist
63 Brianwood Road
London SW4 9PJ
CAP

MATHERS, Dale
Analytical Psychologist-Jungian Analyst
63 Briarwood Road Clapham
London SW4 9PJ
020 7270 5681
AJA

MCMANUS, Gaynor
Systemic Psychotherapist
35 Sutherland Street
London SW1V 4JU
020 7834 3113
KCC

MEADEN, Rosaleen
Psychoanalytic Psychotherapist
78 Ringford Road
London SW18 1RR
020 8355 9569/020 8870 0743
FPC

MERZ, Juliet
Cognitive Analytic Therapist
93 Clarence Road, Wimbledon
London SW19 8QB
020 8542 2412
ACAT

MICCIARELLI, Felicia
Systemic Psychotherapist
84 Engadine Street
London SW18 5DA
020 8870 2793
KCC

MIKARDO, Julia
Child Psychotherapist
Wandsworth Town Child & Family Clinic
7 Ram Street
London SW18 1TJ
020 8870 0161/020 8549 3815
ACP

MILBURN, Irene*
Psychoanalytic Psychotherapist
33 Boscobel Place
London SW1W 9PE
020 7235 3533
GUILD

MILLAR, Wilma
Body Psychotherapist, Integrative
Psychotherapist
52 Finborough Road
London SW10
020 7351 4830
CCBP

MILLIER, Sylvia
Psychoanalytic Psychotherapist
18 Mercier Road
London SW15 2AR
020 8788 9016
FPC

MITCHELL, Ruth
Sexual and Relationship Psychotherapist
41 Nassau Road
London SW13 9QF
020 8748 3978
BASRT

MOHLALA, Morris
Systemic Psychotherapist
119 Edgeley Road
London SW4 6HD
020 7622 5494
KCC

MUNT, Stephen
Humanistic Psychotherapist
27 Pines Court, Victoria Drive
London SW19 6BG
020 8789 9257
AHPP

NANCARROW, Kiya
Core Process Psychotherapist
50 Elmhurst Mansions
Edgeley Road
London SW4 6ET
020 8450 9514
AAPP

NAPPEZ, Sue
Transpersonal Psychotherapist
147 The High, Streatham High Road
London SW16 1HD
020 8769 5101
CCPE

NEAL, Lalage
Psychoanalytic Psychotherapist
2 Rossdale Road, Putney
London SW15 1AD
020 8780 3171
FPC

NEATE, Patricia
Systemic Psychotherapist
2 Daylesford Avenue, Putney
London SW15 5QR
020 8876 1902
KCC

NETZER-STEIN, Antje
Child Psychotherapist
40 Ryecroft Road
London SW16 3EQ
020 8766 0406
ACP

NOLAN, Michael A
Group Analytic Psychotherapist
10 Turret Grove
London SW4 0EU
01/01
UPA

NOONAN, Mairead
Systemic Psychotherapist
Roehampton Institute
London Counselling Service
Froebel College, Roehampton Lane
London SW15 5PU
KCC

NUTTALL, Serena
Cognitive Analytic Therapist
5 Paultons Square
London SW3 5AS
020 7352 6464/5172
ACAT

O'KELLY, Marie
Psychosynthesis Psychotherapist
66 Charlmont Road, Tooting
London SW17 9AH
020 8682 3997
AAPP

OLIVER, Christine
Systemic Psychotherapist
3 Beverley Gardens, Barnes
London SW13 0LZ
020 8878 3601
KCC

O'NEILL, James
Psychoanalytic Psychotherapist
20 Elms Crescent
Clapham Common
London SW4 8RA
020 7622 0607
PA

PARIKH, Prakash
Family Therapist
218 Mitcham Lane
London SW16 6NT
020 8769 8708
AFT

PARKER, Mary
Humanistic and Integrative
Psychotherapist
66 Brixton Water Lane
London SW2 1QB
020 7274 6531
AHPP

PARKIN, Gwendolyn
Integrative Psychotherapist
26 Clareville Street
London SW7 5AW
07775 664568/020 7370 1855
RCSPC

PARKINSON, Phil
Transpersonal Psychotherapist
Tooting Bec
London SW17
020 8767 7464
CCPE

PAVINCICH, Lesley
Psychoanalytic Psychotherapist
20 Rydal Road
London SW16 1QN
020 8677 5776
ARBS

PEACOCK, Anne
Hypno-Psychotherapist
83 St. George's Square Mews
Pimlico
London SW1V 3RZ
020 7976 5352
NSHAP

PICK, Geoff
Psychoanalytic Psychotherapist
78 Aylward Road, Merton Park
London SW20 9AF
020 8408 2975
ARBS

PICK, Rachel
Child Psychotherapist
Imperial College Health Service
South Side, Watt's Way
14 Prince's Garden
London SW7 1NA
020 8584 6301/020 7359 2461
ACP

PICKLES, Penny
Analytical Psychologist-Jungian Analyst
2 Marmion Road
London SW11 5PA
020 7228 2384
CAP

POLLITZER, Juliette
Transactional Analysis Psychotherapist
Flat 5, 64 Rutland Gate
London SW7 1PJ
020 7584 4951
ITA

PRESTWOOD, Christopher
Family Therapist
144 Nimrod Road
London SW16 6TJ
020 8677 7700
AFT

PRIESTLEY, John
Analytical Psychologist-Jungian Analyst
29 Ryde Vale Road
London SW12 9JQ
020 8675 0280
CAP

QUAINE, Mary K
Group Analytic Psychotherapist
7 Harwood Terrace, Fulham
London SW6 2AF
020 7736 4606
FPC

QUINN, Asha
Transpersonal Psychotherapist
Putney
London 020 8874 6955
CCPE

RANI, R S
Cognitive Behavioural Psychotherapist
Behavioural/Cognitive Psychotherapy
Unit
Cottage Day Hospital
Springfield Hospital
61 Glenburnie Rd.
London SW17 7DJ
020 8682 6548
BABCP

RAZZAQ-BAINS, Saira
Integrative Psychotherapist
8 Waldemar Road, Wimbledon
London SW19 7LJ
020 8971 5091
MET

REARDON, Paula
Integrative Psychotherapist
28 Seaton Close, Lynden Gate
Portsmouth Road
Putney Heath, London SW15 3TJ
020 8332 8302/020 8788 7020
RCSPC

REID, Marguerite
Child Psychotherapist
Dept. of Child & Adolescent Mental
Health
Chelsea & Westminster Hospital
Fulham Road
London SW10 9NH
020 7746 8617/020 7946 0647
ACP

REUVID, Jennie
Autogenic Psychotherapist, Sexual and
Relationship Psychotherapist
26 Birley Street, Battersea
London SW11 5XF
020 7223 9236
BASRT

RIDDY, Paula
Integrative Psychotherapist
12 Marryat Road
London SW19 5BD
020 8946 9293
RCSPC

ROSE, Wendy
Transpersonal Psychotherapist
101 Elsenham Street
London SW18 5NY
020 8870 2446/0780 123 3296
CCPE

SANDERS, Susie
Transpersonal Psychotherapist
11 Thurloe Square
London SW7 2TA
020 7584 5251
CCPE

SAYYAH, Shahrzad
Existential Psychotherapist
Flat 6, 116 Queens Gate
London SW7 5LP
020 7580 8173/020 7581 5228
RCSPC

SCHOFIELD, Lynn-Ella
Psychoanalytic Psychotherapist
105 Warwick Way
London SW1V 1QL
020 7834 1012/020 7821 0518
GUILD

SHIFRIN-EMANUEL, Beverley
Child Psychotherapist
St. George's Hospital
Lanesborough Wing
Blackshaw Wing
Blackshaw Rd.London SW17 0QT
020 8725 3716
ACP

SILVER-LEIGH, Vivienne
Transpersonal Psychotherapist
64B Princes Way
London SW19 6JF
020 8788 5291
CCPE

SIMPSON, Ian
Group Analyst
195 Fallsbrook Road
Streatham
London SW16 6DY
020 8769 1469
IGA

SMAIL, Richard
Cognitive Behavioural Psychotherapist
Clinical Psychology & Psychotherapy
409 King's Road
London SW10 0LR
0956 862731/020 7351 1766
BABCP

SMALLWOOD, Imogen
Integrative Psychotherapist
98 Bonneville Gardens
London SW4 9LE
020 8675 6836
RCSPC

SMITH, Anne
Psychoanalytic Psychotherapist
39 Dornton Road, Balham
London SW12 1NB
020 8675 3098
GUILD

SMOLIRA, David
Family Psychotherapist, Hypno-
Psychotherapist
21 Helix Gardens, Brixton Hill
London SW2 2JJ
020 8671 8061
NSHAP

SMYLY, Penelope
Transpersonal Psychotherapist
13a Fieldhouse Road
London SW12 0HL
020 8673 6190
CCPE

SNOW, Randa
Psychoanalytic Psychotherapist
8 Gunter Grove
London SW10 0UJ
020 7 351 7105
FPC

SPENCER, Janet
Analytical Psychologist-Jungian Analyst
7a Carlton Drive, Putney
London SW15 2BZ
020 8785 0390/020 8789 3727
IGAP

SPY, Terri
Humanistic and Integrative
Psychotherapist
12 Derwent Road
London SW20 9NH
020 8330 4045
AHPP

STEFFENS, Dorothee
Analytical Psychologist-Jungian Analyst
156 Hurlingham Road
London SW6 3NG
020 7384 2251
CAP

STOKES, Jean
Analytical Psychologist-Jungian Analyst,
Psychoanalytic Psychotherapist
5 Sispara Gardens, Southfields
London SW18 1LG
020 8874 6631
FPC

STRACEY, Amarilla
Body Psychotherapist, Integrative
Psychotherapist
22 Elms Crescent
London SW4 8RA
020 7720 4601
CCBP

STRUTHERS, Cassandra
Psychoanalytic Psychotherapist
31 Cambridge St.
London SW1V 4PR
020 7976 6973
AGIP

SWATTON, Richard
Transpersonal Psychotherapist
Clapham
London SW4
020 7266 3006
CCPE

TAJET-FOXELL, Britt
Cognitive Behavioural Psychotherapist
Eton House
23 Sudbourne Road
London SW2 5AE
020 7733 8348
BABCP

TANDY (PILBROW), Alannah
Psychosynthesis Psychotherapist
25 Lamont Road
London SW10 OHR
020 7352 9540
AAPP

TANGUAY, Daniel
Biodynamic Psychotherapist
Flat 1, Langley Mansions
Langley Lane
London SW8 1TJ
020 7582 4287
BTC

TAUSSIG, Maggie
Integrative Psychotherapist
30 Bathgate Road, Wimbledon
London SW19 5PJ
020 8879 7437
MET

TAYLOR, Jackie
Transpersonal Psychotherapist
36 Babington Road, Streatham
London SW16 6AH
020 8677 9212
CCPE

TAYLOR, Jane
Sexual and Relationship Psychotherapist
136 Sutherland Grove
London SW18 5QN
020 8780 9890
BASRT

THOLSTRUP, Margaret
Integrative Psychotherapist
10 Parkmead, Roehampton
London SW15 5BS
020 8789 0090 (t/f)
MET

THOMAS, Marcia
Gestalt Psychotherapist
25 Guildersfield Road, Streatham
London SW16 5LS
020 8679 4338
GPTI

TODD, Janet
Psychosynthesis Psychotherapist
Flat 3, 114 Lower Richmond Road
Putney
London SW15 1LN
020 8785 2750
AAPP

TOWNSEND, Anne
Psychoanalytic Psychotherapist
89E Victoria Drive
London SW19 6PT
020 8785 7675
GUILD

TUBY, Molly
Analytical Psychologist-Jungian Analyst
60 Stanhope Gardens
London SW7 5RR
IGAP

TURNER, Annie
Systemic Psychotherapist
81 Pendle Road
London SW16 6RX
020 8677 5026
IFT

VAN HEESWYK, Paul
Child Psychotherapist
58 Briarwood Road, Clapham Park
London SW4 9PX
020 7622 6493
ACP

WAINWRIGHT, Claire
Systemic Psychotherapist
128 Rectory Lane, Tooting
London SW17 9PX
KCC

WAINWRIGHT, Richard
Psychoanalytic Psychotherapist
4 Ormonde Road, East Sheen
London SW14 7BG
01707 285335/020 8876 4325
AJA

WALLINE, Sandra
Analytical Psychologist-Jungian Analyst
26 Disraeli Road
London SW15 2DS
020 8785 9647
CAP

WALROND-SKINNER, Sue
Family Therapist
78 Stockwell Park Road
London SW9 0DA
020 7733 8676
AFT

WALSH, Aine (Anne)
Psychoanalytic Psychotherapist
56c Sarsfeld Road, Balham
London SW12 8HN
020 8767 8997
FPC

WARBURTON, Geoff
Gestalt Psychotherapist
6 Thorncliffe Road
London SW2 4JQ
020 8674 4061
GPTI

WATSON, Gordon
Psychoanalytic Psychotherapist
149 Faraday Road
London SW19 8PA
020 8540 7825
PA

WAY, Jean
Psychoanalytic Psychotherapist
Ground floor flat
31 Cavendish Road
London SW12 0BH
WMIP

WEBSTER, Anne
Psychoanalytic Psychotherapist
92 Rossiter Road, Balham
London SW12 9RX
020 8675 1397
FPC

WEINSTEIN, Jeremy
Gestalt Psychotherapist
21 Parklands Road
London SW16 6TB
020 8677 6869
GCL

WEST, Virginia
Cognitive Analytic Therapist
37 Blenkarne Road
London SW11 6HZ
020 7223 8502
ACAT

WHITE, H.
Psychodynamic Psychotherapist
8 Thirlmere Road, Streatham
London SW16 1QW
020 8769 6535
WMIP

WHITTON, Eric
Humanistic Psychotherapist
31 Ovington Street, Chelsea
London SW3 2JA
020 7584 8819
AHPP

WIDLAKE, Bernard C.
Psychodrama Psychotherapist
210 Tildeseley Road, Putney Heath
London SW15 3BG
020 8788 3794
BPA

WIGHAM, Avril
Psychosynthesis Psychotherapist
21 Elms Road
London SW4 9ER
020 7622 9530
AAPP

WILKINSON, Heward
Integrative Psychotherapist
1 Quinton Street
London SW18 3QR
01723 376246
SPTI

WILKS, Frances
Integrative Psychotherapist
115 Alderney Street
London SW1V 4HE
020 7834 9264
RCSPC

WILLIAMS, Averil
Analytical Psychologist-Jungian Analyst
78 Kenilworth Avenue
London SW19 7LR
020 8946 6857
CAP

WILSON, Catherine
Analytical Psychologist-Jungian Analyst
21 Trelawn Road
London SW2 1DH
020 7326 0084
CAP

WILSON, Norman
Sexual and Relationship Psychotherapist
16 Lower Common South, Putney
London SW15 1BP
020 8785 7895
BASRT

WILSON, Teresa
Systemic Psychotherapist
55 Cloudesdale Road
London SW17 8ET
020 8946 1097/020 8675 7848
KCC

WILTON, Angela
Cognitive Analytic Therapist
27F Bramham Gardens
London SW5 0JE
020 7373 7520
ACAT

WOOD, Jane
Transactional Analysis Psychotherapist
27 Barker Walk
Mount Ephraim Road, Streatham
London SW16 1AT
020 8677 0108
ITA

WOODCOCK, Jeremy
Family Therapist
13 Barnwell Road, Brixton
London SW2 1PN
020 7274 6543
IFT

WORTHINGTON, Anne*
Psychoanalytic Psychotherapist
47A Upper Tulse Hill
London SW2 2SQ
020 8671 5684
GUILD

WYNN-PARRY, Charlotte
Integrative Psychotherapist
19 Furzedown Drive
London SW17 9BL
020 8677 1677
MC

YOUNG, Sabine
Transpersonal Psychotherapist
284 Cowley Mansion
Mortlake High Street
London SW14 8SL
020 8876 2439
CCPE

YOUNG, Sarah
Integrative Psychotherapist
21 Broomhouse Road
London SW6 3QU
020 7736 1343
RCSPC

ZAGORSKA, Joan Krystyna
Cognitive Behavioural Psychotherapist
29 Glebe Place
London SW3 5LD
020 7352 5315
BABCP

LONDON WEST

ARBIA, G. Nicoletta
Transpersonal Psychotherapist
Flat 4, 79 Randolph Avenue
Maida Vale
London W9 1DW
020 7266 5701
CCPE

ARMSTRONG, Caroline
Biodynamic Psychotherapist
22 Bolton Road
London W4 3TB
020 8994 0951
BTC

ARNOLD, Lynn
Integrative Psychotherapist
296 Westbourne Park Road
London W11 1EH
020 7727 0688
MC

ARZOUMANIDES, Yiannis
Integrative Psychotherapist
218D Randolph Avenue
London W9 1PF
020 7328 8955
RCSPC

ASSEILY, Alexandra
NLP Psychotherapist
13 Addison Road
London W14 8DJ
020 7602 5647(f)/020 7602 1402
ANLP

AVERY, Trisha
Transpersonal Psychotherapist
Flat b, 40 St Lawrence Terrace
London W10 5ST
020 8969 7136
CCPE

AYO, Yvonne
Systemic Psychotherapist
28 Chatsworth Gardens
London W3 9LW
020 8807 7179/020 8992 7430
KCC

BABARIK, Anthony
Integrative Psychotherapist
106 Sutherland Avenue
London W9 2QP
020 7700 1323/020 7286 8154
RCSPC

BAKER, Jan
Integrative Psychotherapist
30 Beaconsfield Road, Ealing
London W5 5JE
020 8840 3849
MC

BAMBER, James
Analytical Psychologist-Jungian Analyst,
Group Analyst
115 Ladbroke Grove, Notting Hill
London W11 1PG
020 7727 6368
IGA

BARCLAY, Elizabeth
Transpersonal Psychotherapist
Flat 4, 43 Ladbroke Grove
London W11 3AR
020 7727 4613
CTP

BARHAM, Peter
Psychoanalytic Psychotherapist
23 Randolph Crescent
London W9 1DP
020 7289 4026
GUILD

BARTLETT, Beatrice
Psychoanalytic Psychotherapist
73c St. Charles' Square
London W10 6EJ
020 8969 0092
FPC

BASHARAN, Harika
Transpersonal Psychotherapist
9 Fletcher Road, Chiswick
London W4 5AT
020 7589 6414/020 8995 3836
CCPE

BEGUIN, Agnes
Psychoanalytic Psychotherapist
Flat 3, 88 Holland Park
London W11 3RZ
020 7727 9448
FPC

BENTLEY, Radhe
Family Therapist
28 Ashchurch Grove
London W12 9BU
AFT

BISHOP, Beata
Transpersonal Psychotherapist
27 Waldeck Road
Strand-on-the-Green
London W4 3NL
020 8994 8895
CTP

BLOOMFIELD, Irene
Psychoanalytic Psychotherapist
3 Marlborough
38/40 Maida Vale
London W9 1RW
020 7286 8265
AGIP

BOENING, Joachim
Integrative Psychotherapist
1 Studley Grange Road, Hanwell
London W7 2LU
020 8579 2993
CCBP

BOENING, Michaela
Body Psychotherapist, Integrative
Psychotherapist
1 Studley Grange Road, Hanwell
London W7 2LU
020 8579 2993
CCBP

BONADIE-ARNING, Sondra
Psychoanalytic Psychotherapist
38 Stamford Brook Road
London W6 0XL
020 8743 4023
NAFSI

BONNER, David Calvert
Hypno-Psychotherapist
26 Compton Crescent, Chiswick
London W4 3JA
020 8892 2356
NRHP

BOYESEN, Ebba
Biodynamic Psychotherapist
170 Goldhawk Road
London W12
020 8743 2437
BTC

BOYESEN, Gerda
Biodynamic Psychotherapist
170 Goldhawk Road
London W12
BTC

BOZOVIC, Zoran
Group Analyst
38 Chepstow Road
London W2 5BE
020 7229 6399
IGA

BROWNE, Margaret
Integrative Psychotherapist
28 West Lodge
London W3 9SF
020 7628 3380/020 8896 1046
RCSPC

BROWNE, Maureen
Body Psychotherapist, Integrative
Psychotherapist
16 Cavendish Avenue, Ealing
London W13 0JQ
020 8998 1168
CCBP

BUIRSKI, Diana
Transpersonal Psychotherapist
Basement Flat, 3 Essendine Road
London W9 2LS
020 7289 9368
CCPE

CALEB, Ruth
Integrative Psychotherapist
31 Emlyn Road, Stamford Brook
London W12 9TF
020 8357 0987
RCSPC

CANTELO, Frances
Transpersonal Psychotherapist
London W12
020 8749 5974
CCPE

CARDILE, Pietro
Transactional Analysis Psychotherapist
10e Cumberland Park, Acton
London W3 6SY
020 8993 0177
ITA

CARRINGTON, Linda
Transpersonal Psychotherapist
c/o CCPE
Beauchamp Lodge
2 Warwick Crescent
London W2 6NE
020 7266 3006
CCPE

CASATELLO, Giovanna
Integrative Psychotherapist
19 Princedale Road. Holland Park
London W11 4NW
020 7229 2016
MET

CASEMENT, Ann
Analytical Psychologist-Jungian Analyst
5 Kensington Park Gardens
London W11 3HB
020 7727 8218
AJA

CATOVSKY, Mina
Integrative Psychotherapist
68 Salisbury Road, Ealing
London W13 9TT
020 8567 1958
CCBP

CHATAWAY, Carola
Systemic Psychotherapist
66 Maida Vale
London W9 1PR
020 7624 4052
KCC

**CHOUDREE,
Sangamithra U.D.**
Cognitive Analytic Therapist
72 Cardross Street
London W6 0DR
020 8741 4466
ACAT

CLANCY, Catherine
Psychoanalytic Psychotherapist
48 Sutton Court Road, Chiswick
London W4 4NL
020 8747 9202
FPC

CLARE, John
Psychoanalytic Psychotherapist
15 Waldeck Road, Chiswick
London W4 3NL
020 8747 9424
IPSS

CLARK, Corah
Transpersonal Psychotherapist
c/o CCPE
Beauchamp Lodge
2 Warwick Crescent
London W2 6NE
020 7266 3006
CCPE

CLARKSON, Petruska
Individual and Group Humanistic
Psychotherapist, Integrative
Psychotherapist, Transactional Analysis
Psychotherapist
12 North Common Road, Ealing
London W5 2QB
020 8567 0388
UPA

COLTART, Ingrid
Analytical Psychologist-Jungian Analyst
76 Castellain Mansions,
Castellain Road
London W9 1HA
020 7286 8486
CAP

COLVERSON, John
Integrative Psychotherapist
Beauchamp Lodge
2 Warwick Crescent
London W2 6NE
0795 731 8423/020 7266 3006
MC

CROCKATT, Gabrielle
Child Psychotherapist
Parkside Clinic
63-65 Lancaster Road
London W11 1QG
020 7221 4656
ACP

CRONIN SUTCLIFFE, Pauline
Family Therapist
52a Oxford Gardens
London W10 5UN
020 8960 4355
AAPP

CROOK, Didi
Biodynamic Psychotherapist
15 Powis Court
29-39 Powis Square
London W11 1JQ
020 7221 4912
BTC

DAINTRY, Penelope
Gestalt Psychotherapist
83 Stile Hall Gardens
London W4 3BT
020 8995 4531
GPTI

DALAL, Caroline
Systemic Psychotherapist
Child & Family Consultation Centre
1 Wolverton Gardens
Hammersmith
London W6 7DQ
020 8846 7806/020 8876 6323
KCC

DALTON, Peggy
Personal Construct Psychotherapist
20 Cleveland Avenue, Chiswick
London W4 1SN
020 8994 7959
CPCP

DALY, John
Transpersonal Psychotherapist
c/o CCPE
2 Warwick Crescent
London W2 6NE
020 7266 3006
CCPE

DANKS, Alan
Psychoanalytic Psychotherapist
33 Park Road, Chiswick
London W4 3EY
020 8994 3131
FPC

DAVIDGE, Maggie
Gestalt Psychotherapist
36 Newburgh Road, Acton
London W3 6DQ
020 8993 0868
GCL

DAVIS, Joyce
Analytical Psychologist-Jungian Analyst
66 South Edwardes Square
London W8 6HL
020 87602 6348
IGAP

DAWSON, Liz
Integrative Psychotherapist
118 Studley Grange Road, Hanwell
London W7 2LX
020 8840 1441
MET

DE LEON, Heather
Psychoanalytic Psychotherapist
11 Whitehall Gardens
London W4 3LT
020 8741 0661/020 8994 2930
SITE

DE NORDWALL, Luci
Transpersonal Psychotherapist
23 Bath Road
London W4 1LJ
01/01
CCPE

DE SERDICI-PARKER, Simona
Transpersonal Psychotherapist
11 Brackley Road
London W4 2HW
020 8995 5320
CTP

DINWOODIE, John
NLP Psychotherapist
68 Fielding Road
Chiswick London W4 1HL
020 8995 0384
ANLP

DOE, Anthony
Psychoanalytic Psychotherapist
The Lodge, Carmelite Monastery
87 St Charles Square
London W10 6EA
020 8964 3800
AGIP

DOLPHIN, Eve
Integrative Psychotherapist
17 Stamford Brook Road
London W6 0XJ
020 7573 5332/020 87419474
RCSPC

DONALDSON, Gillian
Integrative Psychotherapist
Flat 2, 7 Tring Avenue
London W5 3QA
020 8992 3177
MET

EICHELBERGER CLEESE, Alyce Faye
Child Psychotherapist
43 Holland Park Mews
London W11 3SP
020 7229 6344
ACP

EIDEN, Bernd
Body Psychotherapist, Individual and
Group Humanistic Psychotherapist,
Integrative Psychotherapist
26 Eaton Rise, Ealing
London W13 2ER
020 8997 5219
CCHP

ELLIOTT, Dena
Integrative Psychotherapist
9 Flanchard Road
London W12 9ND
020 8735 2853
CCBP

ENCOMBE, Jock
Cognitive Analytic Therapist
14 Hartswood Road
London W12 9QN
020 8743 9648/020 8743 5467
ACAT

ERRINGTON, Meg
Psychoanalytic Psychotherapist
19 Hanover Court, Uxbridge Road
London W12 9EP
020 8740 1981
FPC

FISHER, Susan
Analytical Psychologist-Jungian Analyst
5 Connaught Close
London W2 2AD
020 7262 6189
CAP

FORSSANDER, Jennifer
Transpersonal Psychotherapist
27 Bathurst Mews
London W2 2SB
020 7402 0290
CCPE

FREEMAN, Linda
Analytical Psychologist-Jungian Analyst
23 Chilworth Mews
London W2 3RG
020 7402 2204
IGAP

FREEMAN, Martin
Analytical Psychotherapist
2 Clarendon Place
London W2 2NP
020 7262 3693
FIP

FRY, Caroline*
Psychoanalytic Psychotherapist
5 Ranelagh Mews, Ealing
London W5 5RN
020 8567 3071
GUILD

GARCIA-LLOVONA, Cristina M
Cognitive Behavioural Psychotherapist
Studio flat, 20 Norland Square
London W11 4PU
007931 792289/01245 345345
BABCP

GEORGE, Evan
Family Psychotherapist
Brief Therapy Practice
4d Shirland Mews
London W9 3DY
020 8968 0070
IFT

GIBSON, Melanie
Psychoanalytic Psychotherapist
99 Vicarage Court
Vicarage Gate, Kensington
London W8 4HQ
020 7937 6280
FPC

GILBERT, Maria
Integrative Psychotherapist, Transactional
Analysis Psychotherapist
35 Bradley Gardens Ealing
London W13
020 8997 6062
MET

GIONTA, Ralph
Family Therapist
12 Chiswick High Road
London W4 1TH
020 8742 8755
AFT

GLANVILLE, Tony
Gestalt Psychotherapist
39 Spring Grove
London W4 3NH
020 8671 9192
GPTI

GLYNN, Paul
Humanistic Psychotherapist
17 Jeddo Road, Shepherds Bush
London W12 9EB
020 8749 0783
AHPP

GOLDMAN, John
Sexual and Relationship Psychotherapist
22 De Walden Street
London W1M 7PH
020 7486 5148
BASRT

GRACE, Carole
Existential Psychotherapist
170 Valetta Road, Acton
London W3 7TP
020 8743 8096
RCSPC

GRANT, Bob
Psychoanalytic Psychotherapist
72 Sinclair Road
London W14 0NJ
020 7603 0529
ARBS

GREEN, Charlotte H
Cognitive Behavioural Psychotherapist
Psychology Department
St Charles Hospital, Exmoor Street
London W10 6DZ
020 8962 4332
BABCP

GRIFFITHS, Pamela
Integrative Psychotherapist, Transpersonal
Psychotherapist
10 Livingstone Mansions
Queens Club Gardens
London W14 9RW
020 7385 8937
CCPE

GURNANI, Prem D.
Cognitive Behavioural Psychotherapist
237 The Colannades
34 Porchester Square
London W2 6AS
020 7402 7047
BABCP

HADZANESTI, Nelly
Analytical Psychologist-Jungian Analyst
Flat 11, 1 Stanley Gardens
London W11 2ND
020 7727 5303
CAP

HALL, Francesca
Integrative Arts Psychotherapist
68 Tavistock Crescent, Notting Hill
London W11 1AL
020 7243 8355
IATE

HAMILTON, Nigel
Transpersonal Psychotherapist
Beauchamp Lodge
2 Warwick Crescent
London W2 6NE
020 7266 3006
CCPE

HAMILTON, Susan
Transpersonal Psychotherapist
40 Finstock Road
London W10 6LU
020 8969 5715
CCPE

HANMAN, Elke
Transpersonal Psychotherapist
c/o CCPE
2 Warwick Crescent
London W2 6NE
020 7266 3006
CCPE

HARRIS, Michele
Biodynamic Psychotherapist
126 Rainville Court
Rainville Road
London W6 9HJ
020 7385 3570
BTC

HAUPTS, Brigitte
Transpersonal Psychotherapist
Flat 2, 64 Kensington Gardens Square,
Bayswater
London W2 4DG
020 7221 2501
ACAT

HAUSER, Susan
Biodynamic Psychotherapist
20 Goldsmith Road
London W3 6PX
020 8992 9586
BTC

HAYES, Susan
Transpersonal Psychotherapist
c/o CCPE
2 Warwick Crescent
London W2 6NE
020 7266 3006/0421 927714
CCPE

HENDERSON, Andrew
Integrative Psychotherapist
178 Lancaster Road
London W11 1QU
020 7229 6790
MET

HEUER, Gottfried
Analytical Psychologist-Jungian Analyst,
Individual and Group Humanistic
Psychotherapist
13 Mansell Road
London W3 7QH
020 8749 4388
AJA

HIRST, Diane Zervas
Analytical Psychologist-Jungian Analyst
19 Avondale Park Gardens
London W11 4PR
020 7792 1654/020 7603 0767
IGAP

HOLMES, Lynne
Body Psychotherapist, Integrative
Psychotherapist
21 Woodfield Crescent
London W5 1PD
020 8997 0942
CCBP

HORROCKS, Roger
Individual and Group Humanistic
Psychotherapist
5 West Kensington Mansions
North End Road
London W14 9PE
020 7385 4091
AHPP

IVESON, Chris
Family Therapist
The Brief Therapy Practice
4d Shirland Mews
London W9 3DY
020 8883 5731/020 8968 0070
IFT

JARVIS, Cecilia
Psychosynthesis Psychotherapist
11 Walmer Gardens, Ealing
London W13 9TS
020 8567 1331
AAPP

JOYCE, Philip
Gestalt Psychotherapist
2 Richmond Road, Ealing
London W5 5NS
020 8567 9217
GPTI

KAFTON, Maggie
Transpersonal Psychotherapist
5A Ladbroke Gardens
London W11 2PT
020 7221 8717
CCPE

KARAN, Alexandra
Psychoanalytic Psychotherapist
47 Lanark Road
London W9 1DE
020 7286 7090
GUILD

**KAVANAGH,
Sister Catherine**
Systemic Psychotherapist
9 Rosemont Road, North Acton
London W3 9LU
020 8992 4461/020 8896 2438
KCC

KAVNER, Ellie
Systemic Psychotherapist
51a Faraday Road
London W10 5SF
020 8968 0510
IFT

KEAL, Susan
Integrative Psychotherapist
68D Netherwood Road
London W14 0BG
020 7603 1604
RCSPC

KEARNS, Anne
Gestalt Psychotherapist, Integrative
Psychotherapist
83 Stile Hall Gardens, Chiswick
London W4 3BT
020 8995 4531
MET

KEGERREIS, Susan
Child Psychotherapist
67 Addison Gardens
London W14 0DT
020 7603 9609
ACP

KEGGEREIS, Duncan
Group Analyst
67 Addison Gardens
London W14 0DT
020 7603 9609
IGA

KINDER, Diana
Group Analyst
23 Woodville Gardens
London W5 2LL
020 8997 1207
IGA

KUJAWSKI, Pedro
Analytical Psychologist-Jungian Analyst
Flat 4, 57 Holland Park
London W11 3RS
020 7229 3527
IGAP

LAMPLOUGH, Lyn
Transpersonal Psychotherapist
41 Craven Avenue, Ealing
London W5 2SY
020 8579 9955
CCPE

LEE, Graham
Psychoanalytic Psychotherapist
21 Poplar Grove
London W6 7RF
020 7603 1021
AGIP

LEE, Jan*
Psychoanalytic Psychotherapist
85 Speldhurst Road
London W4 1BY
020 8994 1430
GUILD

LETLEY, Emma
Psychoanalytic Psychotherapist
24 Princedale Road
London W11 4NJ
ARBS

LEVEQUE, Brigitte
Integrative Psychotherapist
7 Rivercourt Road
London W6 9LD
020 8748 9656
RCSPC

LEVY, Colette
Psychoanalytic Psychotherapist
Flat 3, Hamilton Court
149 Maida Vale
London W9 1QR
020 7289 5044
FPC

LITTLE, Ray
Transactional Analysis Psychotherapist
16 Hatfield Road, Chiswick
London W4 1AF
020 8994 2905
ITA

LOCK, Josephine
Integrative Psychotherapist
74 Elgin Avenue
London W9 2HB
020 7286 4996
MC

LOEFFLER, Harriet
Analytical Psychologist-Jungian Analyst
9 Monk's Drive
London W3 0EG
020 8992 5289
CAP

LUBBOCK, Philippa
Gestalt Psychotherapist
15 Lena Gardens
London W6 7PY
020 7602 8816
GPTI

LUCIANI, Dorothy
Child Psychotherapist
17 Wimpole Street
London W1M 7AD
020 7436 1144
ACP

LUDE, Jochen
Body Psychotherapist, Integrative
Psychotherapist
26 Eaton Rise, Ealing
London W5 2ER
020 8997 5219
CCBP

MANOJLOVIC, Jelena
Systemic Psychotherapist
3 St Mary's Place
Kensington Green
London W8 5UE
KCC

MARK, Peter
Group Analyst
Parkside Clinic
63–65 Lancaster Road, Notting Hill
London W11 1QE
020 7221 4656
IGA

MASOLIVER, Chandra
Psychoanalytic Psychotherapist
Flat 15, Argyll Mansions
Hammersmith Road
London W14 8QG
020 7602 1525
ARBS

MATTHEWS, Carol
Psychoanalytic Psychotherapist
122 St. Albans Avenue, Chiswick
London W4 5JR
020 8987 8786
FPC

MAY, Ian
Transpersonal Psychotherapist
51A Boscombe Road
London W12 9HT
mobile: 07939043759/
020 8743 3276
CCPE

MCCREANOR, Teresa
Group Analytic Psychotherapist
65a Randolph Avenue
London W9 1DW
020 7286 6435
LCP

MCDERMOTT, Cathy
Transpersonal Psychotherapist
c/o CCPE
2 Warwick Crescent
London W2 6NE
020 7266 3006/020 8776 9590
CCPE

MCELDOWNEY, Dennis
Psychoanalytic Psychotherapist
39 Leythe Road, Acton
London W3 8AW
020 8993 1559
IPSS

MCGLASHAN, Judy
Integrative Psychotherapist
21 Hollingbourne Gardens, Ealing
London W13 8EN
020 8997 9449
MET

MCGUINNESS, Mark
Hypno-Psychotherapist
The Life Centre, 15 Edge Street
London W8 7PN
020 7221 4602
NSHAP

MCSHANE, Oliver
Analytical Psychologist-Jungian Analyst
33 Foliot Street
London W12 0BQ
020 8743 6784
CAP

MEAD, Christine
Psychosynthesis Psychotherapist
41 Cromwell Grove
London W6 7RQ
020 7603 2490
AAPP

MELEAGROU-DIXON, Mando
Child Psychotherapist, Psychoanalytic
Psychotherapist
The Garden Flat
90 Cambridge Gardens
London W10 6HS
020 8354 0747/020 7262 5373
ACP

MENDOZA, Hilda
Integrative Arts Psychotherapist
16 Brook Green
London W6 7BL
020 7603 0845
IATE

MENDOZA, Steven
Psychoanalytic Psychotherapist
34 Thornfield Road
London W12 8JQ
020 8749 5027
FIP

MENEZES, Ray
Transpersonal Psychotherapist
c/o CCPE
2 Warwick Crescent
London W2 6NE
020 7266 3006
CCPE

MICHAELS, Ruth
Integrative Psychotherapist
11 St Dunstans Road, Hanwell
London W7 2EY
020 8840 7316
MET

MILLER, Juliet
Analytical Psychotherapist
60 Grove Park Terrace, Chiswick
London W4 3QE
020 8742 2322/020 8994 5724
AJA

MOORE, Joan
Transactional Analysis Psychotherapist
90 Cumberland Road, Hanwell
London W7 2EB
020 8840 3087
ITA

MORANTE, Flavia
Psychoanalytic Psychotherapist
65 Victoria Road
London W8 5RH
020 7937 8371
IPSS

MORRIS, Clare
Personal Construct Psychotherapist
65 Braybrook Street
London W12 0AL
020 8749 9059
CPCP

MURPHY, Katherine
Integrative Psychotherapist
48a Overdale Road
London W5
0961 106545/020 8769 5536
MET

NADIRSHAW, Zenobia
Cognitive Behavioural Psychotherapist
Psychology Department
Riverside Mental Health Trust
20 Kingsbridge Road
London W10 6PU
020 8746 5858
BABCP

NIEBOER, Sarah
Transpersonal Psychotherapist
8 Kinnoul Road
London W6 8NQ
020 7385 7123
CCPE

NIPPODA, Yuko
Psychoanalytic Psychotherapist
P O Box 26259
London W3 9WG
0958 213456
AHPP

O'HAGAN, Judith
Transpersonal Psychotherapist
29 Baron's Court Road
London W14 9DZ
020 7610 2246
CTP

OPIENSKI, Jacek
Gestalt Psychotherapist
13 Clovelly Road, Ealing
London W5 5HF
020 8579 9013
MET

OWEN, Mike
Family Therapist
Alembic Behavioural Health Ltd
11 Stowe Road
London W12 8BQ
0280 740 0603
AFT

PARKER, Gabrielle
Systemic Psychotherapist
34 Heathstan Road, White City
London W12 0RA
020 8746 0809
KCC

PEARCE, Peter
Integrative Psychotherapist
8 Pembroke Mews
London W8 6ER
020 7794 7152
MET

PHILLIPS, Adam
Child Psychotherapist, Psychoanalytic
Psychotherapist
Flat 2, 99 Talbot Road
London W11 2AT
020 7221 9237
GUILD

PIMENTEL, Allan
Transpersonal Psychotherapist
c/o CCPE, Beauchamp Lodge
2 Warwick Crescent
London W2 6NE
020 7266 3006
CCPE

PLOTEL, Angela
Hypno-Psychotherapist
168A Coningham Road
Shepherds Bush
London W12 8BY
020 8740 4674
NRHP

POOLE, Robert
Group Analytic Psychotherapist
59/61 Ladbroke Grove
London W11 3AT
020 7727 9551
LCP

POPE, Alan
Psychoanalytic Psychotherapist
38 Greenside Road
London W12 9JG
020 8723 1785
SITE

PORTER, Christine
Child Psychotherapist
London
020 7262 4289
ACP

PRENDERGAST, Teresa
Body Psychotherapist, Integrative
Psychotherapist
Ground Floor Flat, 19 Essex Road
London W3 9JA
020 7725 2526/020 8993 1697
CCBP

PRONER, Karen
Child Psychotherapist, Psychoanalytic
Psychotherapist
83 Strand on the Green
London W4 3PU
020 8995 8319
ACP

PUGH, Gabrielle
Systemic Psychotherapist
5 Ravenscourt Road
London W6 0UH
020 8748 2281
KCC

RANSLEY, Cynthia
Integrative Psychotherapist
3 Binden Road
London W12 9RJ
020 8740 7580
MET

RATNER, Harvey
Family Psychotherapist
Brief Therapy Practice
4D Shirland Mews
London W9 3DY
020 8968 0070/020 8444 3390
IFT

RATTIGAN, Bridget
Integrative Psychotherapist
18 Blossom Close
London W5 4YF
MET

READ, Jane
Sexual and Relationship Psychotherapist
16 Hatfield Road, Chiswick
London W4 1AF
020 8994 2905
BASRT

REED, Keith
Analytical Psychologist-Jungian Analyst
8 Wilton Avenue
London W4 2HY
020 8994 3978
CAP

RICHARDSON, Ann
Transpersonal Psychotherapist
Chiswick
London W4 5EH
020 8994 5964
CCPE

ROBINSON, Sue
Family Therapist, Psychoanalytic
Psychotherapist
7 Richford Street
London W6 7HH
020 8740 1120
GUILD

ROGERS, Maggie
Psychoanalytic Psychotherapist
137 Fielding Road, Chiswick
London W4 1DA
020 8994 3580
IPSS

RYAN, Frank
Cognitive Behavioural Psychotherapist
5 Wolverton Gardens
Hammersmith
London W6 7DY
020 8846 7870
BABCP

SANDERS, Gill
Sexual and Relationship Psychotherapist
1 Sandown House
Heathfield Terrace
London W4 4JP
020 8995 7541
BASRT

SCHAIBLE, Monika
Body Psychotherapist, Integrative
Psychotherapist
31 Berrymead Gardens, Acton
London W3 8AA
020 8752 0246
CCBP

SCOTT, Janice
Gestalt Psychotherapist
2 Oak Cottages
Green Lane, Hanwell
London W7 2PE
020 8840 4886
MET

SELL, Patrick
Body Psychotherapist, Integrative
Psychotherapist
5 Shalimar Road
London W3 9JD
0956 192 121/020 8248 5631
CCBP

SHARMAN, Geoffrey
Cognitive Analytic Therapist
209 Hammersmith Grove
London W6 0ND
020 8749 4095
ACAT

SHARMAN, Juliet
Psychoanalytic Psychotherapist
209 Hammersmith Grove
London W6 0NP
020 8749 0270
FPC

SHARPE, Meg
Group Analyst
The Group Analytic Practice
88 Montagu Mansions
London W1H 1LF
020 7935 3103/3085
IGA

SHERIDAN, Dolores
Transpersonal Psychotherapist
53 Matlock Court
Kensington Park Road
London W11 3BS
020 7221 0331
CCPE

SHERWIN-WHITE, Sue
Child Psychotherapist
Child & Family Consultation Centre
1 Wolverton Gardens
London W6
020 8846 7807/020 7278 2188
ACP

SHIPTON, Sunita
Biodynamic Psychotherapist
132 Kings Street
London W6 0QU
020 8748 2061
BTC

SHREEVES, Rosa
Humanistic and Integrative
Psychotherapist, Integrative Arts
Psychotherapist
24 Strand-on-the-Green
London W4 3PH
020 8995 5904
SPEC

SICHEL, David
Integrative Psychotherapist
194 Sutton Court Road, Chiswick
London W4 3HR
020 8995 7175
MC

SIGNORA, Susanna Jamila
Transpersonal Psychotherapist
c/o CCPE
Beauchamp Lodge
2 Warwick Crescent
London W2 6NE
01483 720 587
CCPE

SILLS, Charlotte
Integrative Psychotherapist, Transactional
Analysis Psychotherapist
Rectory Lawn, 2 Richmond Road
London W5 5NS
020 8567 9217
MET

SIM, Camilla
Integrative Psychotherapist
18a Dunraven Road
London W12 7QY
020 8743 3251
RCSPC

SIMPSON, Steve
Psychosynthesis Psychotherapist
13a Bridge Avenue
London W6 9JA
020 8741 2839
AAPP

SKINNER, Charmian
Psychoanalytic Psychotherapist
6 Ruston Mews
London W11 1RB
020 7792 2145
FPC

SLADE, Laurie*
Psychoanalytic Psychotherapist
71 Netheravon Road
London W4 2NB
020 8995 0528
GUILD

SMITH, H Judith
Psychoanalytic Psychotherapist
59 Greenside Road
London W12 9JQ
020 8743 9096/01225 315702
SIP

SMITH, Jonathan
Gestalt Psychotherapist
36 Newburgh Road
London W3 6DQ
020 8993 0868
GCL

SMITH, Patsy
Psychoanalytic Psychotherapist
4 Ealing Park Gardens
Ealing W5 4EU
020 8568 3811
CPP

SOMERS, Barbara
Transpersonal Psychotherapist
20 Norland Square, Holland Park
London W11 4PU
020 7727 6412
AAPP

SOUTHWELL, Clover
Biodynamic Psychotherapist
3 Bulstrode Street
London W1M 5FS
020 7935 5107
BTC

SPITZ, Shirley
Integrative Psychotherapist
Flat 4, 2 Hyde Park Gardens
London W2 2LT
020 7486 2393
SPTI

STANG, Pamela
Psychoanalytic Psychotherapist
3 Irving Mansions
Queens Club Gardens
London W14 9SL
020 7385 4476
FPC

STEEDS, Leila
Integrative Psychotherapist
135 Gloucester Terrace
London W2 6DX
020 8444 8867/020 7262 4503
RCSPC

SYRETT, Karin
Analytical Psychologist-Jungian Analyst
27 Royal Crescent
London W11 4SN
020 7602 0864
AJA

SZYMANSKA, Kasia (Y.L.C)
Cognitive Behavioural Psychotherapist
83 Felix Road, Ealing
London W13 0NZ
0370 478880/07071 8803947
BABCP

TARKOW-REINISCH, Lili
Integrative Psychotherapist
135 Gloucester Terrace
London W2 6DX
020 7724 3465/020 7402 2240
RCSPC

TAYLOR, Sajada Katalin
Transpersonal Psychotherapist
c/o CCPE
Beauchamp Lodge
2 Warwick Crescent
London W2 6NE
020 7266 3006
CCPE

THACKRAY, Dayle
Analytical Psychologist-Jungian Analyst
52 Elliot Road, Chiswick
London W4 1PE
020 8995 8607
CAP

THOMAS, Graham
Hypno-Psychotherapist
56 Biddulph Mansions
Elgin Avenue, Maida Vale
London W9 1HT
020 7286 0887
NSHAP

THOMAS, Kerry
Analytical Psychologist
93 Bleinham Crescent
London W11 2EQ
020 7727 8572
FIP

THORPE, C
Psychoanalytic Psychotherapist
Flat 10, Old Court House
24 Old Court Place
London W8 4PD
020 7937 3030
AGIP

TUGENDHAT, Julia
Systemic Psychotherapist
Basement Flat
35 Westbourne Park Road
London W2 5QD
020 7221 9036
KCC

**VAN DER WATEREN,
Jan-Floris**
Biodynamic Psychotherapist
52 Blenheim Crescent
London W11 1NY
020 7221 6221
BTC

VON BRITZKE, Michaela
Integrative Psychotherapist
28F Leinster Square
London W2 4NQ
020 8962 4192/020 7221 2107
RCSPC

WALLER, Charlotte
Transpersonal Psychotherapist
c/o CCPE
Beauchamp Lodge
2 Warwick Crescent
London W2 6NE
020 7266 3006
CCPE

WALLSTEIN, Richard S
Gestalt Psychotherapist
15 Lena Gardens
London W6 7PY
020 87602 2053
GPTI

WALSH, Eileen
NLP Psychotherapist
Flat 13, 9 Devonhurst Place
Heathfield Terrace
Chiswick W4 4JB
020 8995 1934
ANLP

WANJA KIRIMA, Ruth
Integrative Psychotherapist
73 Ealing Park Gardens
London W5 4ET
020 8560 7113
RCSPC

WARD, Sharron
Transpersonal Psychotherapist
c/o CCPE
2 Warwick Crescent
London W2 6NE
020 72663006
CCPE

WARNER, Barbara
Family Therapist
41 Wallingford Avenue
London W10 6PZ
020 8968 5372
AFT

WATERMAN, Zak
Transpersonal Psychotherapist
16 Bradiston Road
London W9
020 8969 4077
CCPE

WELLS, Lesley
Psychoanalytic Psychotherapist
1 Hart Grove
London W5 3NA
020 8992 4920
GUILD

WENHAM, Jane
Psychoanalytic Psychotherapist
1 Dale Street, Chiswick
London W4 2BJ
02018 9958426
FPC

WIGRAM, Penny
Psychoanalytic Psychotherapist
2 Clarendon Place, London W2 2NP
020 7723 8925
FPC

WILLIAMS, Claerwen
Integrative Psychotherapist
4 Wellesley Avenue
London W6 0UP
020 8743 7823
RCSPC

WOODWARD, Gillian
Integrative Psychotherapist
18d Blenheim Crescent
Notting Hill
London W11 1NW
020 7371 7477/020 7221 4587
MET

WRIGHT, James
Psychoanalytic Psychotherapist
4 Playfair Mansions
Queens Club Gardens
London W14 9TR
020 7385 6279/01394 450497
FPC

YAWETZ, Christine
Sexual and Relationship Psychotherapist
2 Aubrey Road, Campden Hill
London W8 7JJ
020 7727 6121
BASRT

ZARBAFI, Ali
Psychoanalytic Psychotherapist
30 Magnolia Road
Strand-on-the-Green, Chiswick
London W4 3QW
020 8747 0408
IPSS

ZINOVIEFF, Nicholas
Existential Psychotherapist
26 Claireville Gardens
London W7 3HZ
020 8995 5265/020 8567 7604
RCSPC

MANCHESTER

APPLEBY, Joy
Gestalt Psychotherapist
3 The Beeches,
West Didsbury M20 2BG
0161 445 0766
GPTI

BACHA, Claire
Group Analyst, Psychoanalytic
Psychotherapist
20 Kersal Road
Prestwich M25 8SJ
0161 773 0409
IGA

BANNISTER, Anne
Psychodrama Psychotherapist
Glebe Cottage, Church Road
Mellor
Stockport SK6 5LX
0161 794 4252/0161 427 3307
BPA

BARLEY, Andrew
Gestalt Psychotherapist
18 Atwood Road
Didsbury M20 6TD
0161 446 2470
SPTI

BARNETT, Gillian
Psychoanalytic Psychotherapist
Uni. of Manchester and UMIST
Counselling Service
Crawford House, Precinct Centre
Oxford Road M13 9QS
0161 275 2859
NWIDP

BEACHAM, Sonja
Gestalt Psychotherapist
Manchester M16
0161 2268489/0378 635050
SPTI

BENBOW, Susan
Systemic Psychotherapist
Carisbrooke Resource Centre
Wenlock Way
Gorton M12 5LF
0161 2734383
FIC

BERMAN, Linda
Psychoanalytic Psychotherapist
Gaskell House
Swinton Grove M13 0EU
0161 273 2762
NWIDP

BROOKHOUSE, Shaun
Hypno-Psychotherapist
Richmael House
25 Edge Lane
Chorlton M21 9JH
0161 881 1677
CTIS

BUCKLEY, Michael
Psychoanalytic Psychotherapist
Macartney House
Psychotherapy Service
Beech Mount
Rochdale Road M9 1XS
0161 205 7555
NWIDP

BUROW, Birgit
NLP Psychotherapist
Flat 3,
114 Kingsbrook Road M16 8QX
0161881 8779
ANLP

CHURCHER, John
Psychoanalytic Psychotherapist
Hampden House Psychotherapy Centre
2–4 Palatine Road M20 3JA
0161 445 2099
NWIDP

COLDRIDGE, Liz
Psychoanalytic Psychotherapist
University of Salford
Department of Social Work
Allerton Annexe, Fredrick Rd
Campus,
Salford M6 6PU
0161 295 2484
NWIDP

COOKE, Bob
Transactional Analysis Psychotherapist
The Manchester Institute for
Psychotherapy
454 Barlow Moor Road
Chorlton M21 1BQ
0161 862 9456
ITA

COSTA, Jan
Psychodrama Psychotherapist
6 Bethel Avenue
Failsworth M35 OAG
0161 794 0875/0161 684 8660
BPA

DAVENPORT, Sarah
Psychoanalytic Psychotherapist
Dept of Rehabilitation Mental Health
Services of Salford
Bury New Road M25 3BL
0161 772 3607
NWIDP

DAVIS, Jim
Transactional Analysis Psychotherapist
7 Talbot Road
Ladybarn M14 6TA
0161 225 2556
ITA

ELLIS, Robin Margaret
Family Therapist
6 Sudbury Road
Chorlton M21 8XN
0161 861 9979
AFT

EMINSON, Mary
Family Therapist
23 Egerton Park
Worsley M28 2TR
01204 390 660/0161 794 1696
AFT

FEASEY, Don
Psychoanalytic Psychotherapist
16 Raynham Avenue
Didsbury M20 6BW
0161 445 3612
WMIP

FISCHER, Michael
Group Analyst, Psychoanalytic
Psychotherapist
Red House Psychotherapy
78 Manchester Road
Swinton M27 5FG
0161 794 0875
IGA

GATRELL, Jane
Psychoanalytic Psychotherapist
Macartney House
Psychotherapy Centre
Beech Mount
Rochdale Road M9 1XS
0161 205 7555
NWIDP

GOWRISUNKUR, Jaya
Psychoanalytic Psychotherapist
Gaskell House
Department of Psychotherapy
Swinton Grove M13 0EU
0161 273 2762
NWIDP

GUTHRIE, Else
Psychoanalytic Psychotherapist
The Rawnsley Building
Department of Psychiatry
Manchester Royal Infirmary
Oxford Road M13 9BX
0161 276 5383
NWIDP

HANNAH, Francesca
Transactional Analysis Psychotherapist
Manchester Institute for Psychotherapy
454 Barlow Moor Road
Chorlton M21 1BQ
0161 431 5968/07957 482 676
ITA

HORNE, Alan
Psychoanalytic Psychotherapist
Gaskell House
Swinton Grove M13 0EU
0161 273 2762
NWIDP

HYDE, Keith
Group Analyst, Psychoanalytic
Psychotherapist
The Red House Psychotherapy Service
78 Manchester Road
Swinton M27 5FG
0161 794 0875/0161 727 8661
IGA

JACKSON, Elizabeth
Gestalt Psychotherapist
Manchester Gestalt Centre
7 Norman Road
Rusholme M14 5LF
0161 257 2202
GPTI

JONES, Freda Anne
Cognitive Behavioural Psychotherapist
87 Coniston Avenue
Worsley M38 9NZ
0161 720 2810/0161 799 9868
BABCP

JUKES, Rachel
Psychoanalytic Psychotherapist
The Red House
78 Manchester Road
Swinton M27 5FG
0161 794 0875
NWIDP

KABERRY, Susan
Psychoanalytic Psychotherapist
8 Grenfell Road
Disbury M20 6TQ
0161 448 1475
NWIDP

KINCEY, John
Cognitive Behavioural Psychotherapist
Dept Clinicial & Health Psychology
Central Manchester Healthcare Trust
Gaskell House
Swinton Grove M13 0EU
0161 273 3271
BABCP

LAYFIELD, Kate
Psychoanalytic Psychotherapist
Manchester University and UMIST
Counselling Servic
5th Floor, Crawford House
Prcint Centre
Oxford Road M13 9QS
0161 275 2866/0161 445 6806
NWIDP

LEVER, Maria A.
Cognitive Behavioural Psychotherapist
Palliative Care Counselling Service
Ordsall Health Centre
Belfort Drive
Salford M5 3PP
0161 872 2004 x 161
BABCP

LINDSAY, Marion
Psychoanalytic Psychotherapist
The Red House Psychotherapy Service
78 Manchester Road
Swinton M27 5FG
0161 794 0875
LPDO

LITTLEJOHN, Sarah
Integrative Psychotherapist
5 Stephens Terrace
Didsbury M20 6WB
0161 446 1311
MC

LOBEL, Sidney
Sexual and Relationship Psychotherapist
84 Langham Court
Mersey Road
Didsbury M20 3QA
0161 434 9804
BASRT

MARGISON, Frank
Psychoanalytic Psychotherapist
Gaskell House
Swinton Grove M13 0EU
0161 273 2762
NWIDP

MARRIOT, Alison
Family Therapist
SCOPE
Carisbrooke Resource Centre
Wenlock Way
West Gorton M12 5LF
0161 273 3818/0161 274 4173
AFT

MCDONNELL, Fokkina
NLP Psychotherapist
65 Norwood Road M32 8PN
0161 865 3193
ANLP

MCGRATH, Graeme
Psychoanalytic Psychotherapist
Gaskell House
Psychotherapy Service
Swinton Grove M13 0EU
0161 273 2762
NWIDP

MEREDITH, Joan
Psychoanalytic Psychotherapist,
Psychodynamic Psychotherapist
11 Shaftesbury Road M8 0WL
0161 795 8365/hard of hearing/lip
reading
HIP

MITCHELL, Lesley
Psychoanalytic Psychotherapist
Macartney House Psychotherapy Service
Beech Mount, Rochdale Road
Harpurhey M9 1XS
0161 205 7555
NWIDP

MORLEY, Michael
Cognitive Behavioural Psychotherapist
Dept. Clinical & Health Psychotherapy
Central Manchester Healthcare Trust
Swinton Grove M13 0EU
0161 273 3271
BABCP

NICHOLSON, Jane
Psychoanalytic Psychotherapist
Gaskell House
Psychotherapy Service
Swinton Grove M13 0EU
0161 273 2762
NWIDP

O'NEILL, Thomas
Family Therapist
301 Brantingham Road
Chorlton cum Hardy M21 0GU
0161 881 5463
AFT

PERRIOLLAT MUNRO, Elizabeth
Psychoanalytic Psychotherapist
43 Pine Grove
Eccles M30 9JP
0797 049 9042
ARBS

PHILIPPSON, Peter
Gestalt Psychotherapist
Manchester Gestalt Centre
7 Norman Road
Rusholme M14 5LF
0161 257 2202 (t/f)
GPTI

POOLE, Nick
NLP Psychotherapist
386 Kingsway
Burnage M19 1PL
0161 432 8624
ANLP

POTTER, Steve
Psychoanalytic Psychotherapist
Uni. of Manchester & UMIST Counselling
Service
5th Flr.Crawford House
Precinct Centre
Oxford Road M13 9QS
0161 275 2854
LPDO

PRODGERS, Alan
Psychoanalytic Psychotherapist
The Red House Psychotherapy Service
78 Manchester Road
Swinton M27 5FG
0161 794 0875
NWIDP

RAWSTHORNE, Jean
Psychoanalytic Psychotherapist
The Red House Psychotherapy Service
78 Manchester Road
Swinton M27 5FG
0161 794 0875
NWIDP

RHODES, Adrian M.
Psychoanalytic Psychotherapist
58 Errwood Road
Burnage M19 2QH
0161 224 1739
NWIDP

SAWYER, Albert
Hypno-Psychotherapist
5 Lyndene Avenue
Roe Green
Worsley M28 2RJ
0161 727 8551/0161 799 5537
NSHAP

SHARPLES, Geraldine M
Psychoanalytic Psychotherapist
85 Baines Avenue
Irlam M44 6AS
0161 775 7498
LPDO

SIDDLE, Ronald
Cognitive Behavioural Psychotherapist
Dept. of Clinical Psychology
North Manchester General Hospital
Delaunays Road
Crumpsall M8 5RB
0161 720 2810
BABCP

STEIN, Nathan Bernard
Personal Construct Psychotherapist
12 Ravensway
Prestwich M25 0EU
0161 7952898/0161 7202088
CPCP

SUTTON, Adrian
Psychoanalytic Psychotherapist
Winnicott Centre
Child .Adult Service
195 Hathersage Road M13 0JE
0161 248 9494
NWIDP

SYKES, Kathleen
Psychoanalytic Psychotherapist
Macartney House
Psychotherapy Unit
Beech Mount
Harpurhey M9 1XS
0161 205 7555
NWIDP

TATHAM, Alan
Cognitive Behavioural Psychotherapist
Psychology Services
M.H.Services of Salford NHS Trust
Bury New Road
Prestwich M25 3BL
0161 834 4122/0161 772 3487
BABCP

TOWSE, Esme
Psychoanalytic Psychotherapist
Hampden House Psychotherapy Centre
2 Palatine Road
Withington M20 3JA
NWIDP

VERDUYN, Christine M.
Cognitive Behavioural Psychotherapist,
Family Therapist
Dept. of Clinical Psychology
Royal Manchester Children's Hospit.
Hospital Road
Pendlebury M27 4HA
0161 727 2125
AFT

WATTS, Susan
Cognitive Behavioural Psychotherapist
MH Services of Salford NHS Trust
Bury New Road
Prestwich M25 3BL
0161 772 3481
BABCP

WEBSTER, Jeni
Family Psychotherapist
Red House Psychotherapy Service
78 Manchester Road
Swinton M27 5FG
0161 794 0875/0161 727 8661
AFT

WEBSTER, Lynne
Sexual and Relationship Psychotherapist
Department of Psychiatry
Manchester Royal Infirmary
Manchester
0161 276 5365
BASRT

WELFORD, Enid
Transactional Analysis Psychotherapist
41 Derby Road
Fallowfield M14 6UX
0161 225 0514
ITA

WHITMORE, Robert
Psychoanalytic Psychotherapist
15 Moorland Road
Didsbury M20 6BB
0161 445 2941
NWIDP

MERSEYSIDE

ASHCROFT, Jennifer
Cognitive Behavioural Psychotherapist
Hope Farm Medical Centre
Hope Farm Road, Great Sutton
Ellesmere Port
Wirral CH66 2WW
0151 357 3777
BABCP

BERGEL, Edith
Psychoanalytic Psychotherapist
41 Menlove Gardens West
Liverpool L18 2ET
0151 722 5936
LPDO

BERRY, Margaret
Hypno-Psychotherapist
37 Orton Road
Liverpool L16 6AR
0151 280 1021
CTIS

BIELICZ, Paul
Psychoanalytic Psychotherapist
33 Great George's Road, Waterloo
Liverpool L22 1RA
0151 920 8905
FPC

BLUNDELL, Suzanne
Child Psychotherapist
Crosby Hall
Little Crosby
Liverpool L23 4UA
0151 924 8590
ACP

BRYSON, Sandra
Family Therapist, Psychoanalytic
Psychotherapist
59 Vaughan Road
Wallasey L45 1LJ
0151 639 7830
AFT

BURGESS, Jo
Group Analyst
3 Bluesfield Street
Liverpool L8 1YT
0151 708 0719
IGA

CAMPBELL, Hedda A.
Cognitive Behavioural Psychotherapist
3 Poulton Hall Cottages
Poulton Road
Bebington
Wirral CH63 9LN
0151 346 1354
BABCP

CAWLEY, Anthony
Hypno-Psychotherapist
44 Wellesley Road
Liverpool L8 3SU
0151 727 1485
NRHP

DICKINSON, Paul
Psychoanalytic Psychotherapist
Liverpool Psychotherapy & Consultation
Service
Mossley Hill Hospital
Park Avenue
Liverpool L18 8BU
0151 250 6128
LPDO

DOOGAN, Kevin
Sexual and Relationship Psychotherapist
Community Day Hospital(Psychiatry)
Clatterbridge Hospital
Bebington, Wirral
0151 334 4000
BASRT

DOYLE, Elizabeth
Psychoanalytic Psychotherapist
18 Dunraven Road
Little Neston
South Wirral L64 9QU
0151 336 4692
LPDO

ESSEX, Delia
Psychoanalytic Psychotherapist
18 Garth Drive, Liverpool L18 6HW
LPDO

FAIRHURST, Pat
Hypno-Psychotherapist
55 Wyndham Avenue
Liverpool L14 0LA
0151 449 2399
CTIS

FARRELL, Derek P.
Cognitive Behavioural Psychotherapist
Dept Community Psychiatry & Psychol
Clatterbridge Hospital
Wirral CH63 6JY
0151 482 7646/0151 342 2765
BABCP

FINLAYSON, Sara
Cognitive Behavioural Psychotherapist
Department of Clinical Psychology
Rathbone Hospital
Mill Lane, Liverpool L13 4AW
0151 250 3035
BABCP

FOSTER, Paul
Psychoanalytic Psychotherapist
The counselling Service
University of Liverpool
14 Oxford Street
Liverpool L7 7BL
0151 794 3304
LPDO

GABBAY, Mark
Psychoanalytic Psychotherapist
Department of Primary Care
University of Liverpool
Whelan Building Quarangle
Brownlow Hill
Liverpool L69 3GB
0151 794 5610
LPDO

GAUTHIER, Jean-Baptise
Family Therapist
Child Mental Health Services
The Wellcroft Centre
Wellcroft Road
Huyton L36 7TA
0151 489 6137/0151 480 2460
AFT

GLASSCOE, Claire
Family Therapist
Child Mental Health Unit
Royal Liverpool Children's Hospital
Alder Hey, Mulberry House
Eaton, Liverpool L12 2AP
0151 252 5509/0151 625 8575
IFT

GOODSON, Christina
Hypno-Psychotherapist
29 Pilkington Road
Southport PR8 6PD
01704 537753
CTIS

GOPFERT, Michael
Psychoanalytic Psychotherapist
Liverpool Psychotherapy & Consultation
Service
Mossley Hill Hospital
Park Avenue, Liverpool L18 8BU
0151 250 6128
LPDO

GRAY, Pat
Family Therapist
Barnardo's
Mornington Terrace
29 Upper Duke Street
Liverpool L1 9DY
0151 709 0540
AFT

HAGAN, Patricia
Psychoanalytic Psychotherapist
District Psychology Service
University of Liverpool
Whelan Building Quarangle
Brownlow Hill
Liverpool L69 3BG
0151 794 5534
LPDO

HAMILTON, Sheila L.L.
Psychoanalytic Psychotherapist
Department of Clinical Psychology
Oakdale Unit
Fazakerley Hospital
Longmoor Lane
Liverpool L9 7AL
0151 529 3249
LPDO

HARDMAN, Anne
Hypno-Psychotherapist
22 Lawton Road
Rainhill L35 0PP
0151 426 1795
CTIS

HARMSWORTH, Peter
Family Psychotherapist
33 Sydenham Avenue
Liverpool L17 3AU
0151 734 3832
AFT

HAZLEHURST, Jean
Hypno-Psychotherapist
Grange Hall
Blackhorse Hill
West Kirby L48 7EF
0151 625 1809
NRHP

HELLIN, Kate
Psychoanalytic Psychotherapist
Ashworth Hospital
Parkbourn, Maghull
Liverpool L31 1HW
0151 471 2201
NWIDP

HENDRICKSE, Begum
Sexual and Relationship Psychotherapist
25 Riverbank Road
Heswall L60 4SQ
0151 342 7222/0151342 5510
BASRT

HIGGO, Robert J.
Psychoanalytic Psychotherapist
Park Lodge, Orphan Drive
Liverpool L6 7UN
0151 287 6917
LPDO

HOOPER, Molly
Cognitive Behavioural Psychotherapist
"Panache", Venables Close
Spital Bebington
Wirral CH63 9HS
0151 334 6619
BABCP

JAMESON MILNER, Jane
Gestalt Psychotherapist
Hope Street Natural Health Centre
37 Hope Street
Liverpool L1 9EA
0151 707 1311/0151 727 5501
GPTI

JONES, Caroline M
Sexual and Relationship Psychotherapist
Parkfield Medical Centre
Sefton Road, New Ferry
Wirral CM62
BASRT

JONES, Judith
Sexual and Relationship Psychotherapist
Irby Farm, Thingwall Road, Irby
Wirral CH61 3UA
0151 648 1728
BASRT

KEENAN, Paul Stephen
Cognitive Behavioural Psychotherapist
Phychological Therapy Department
St Katherines Hospital
Church Road, Birkenhead
Wirral CH42 0LQ
0151 604 7276/0151 327 5867
BABCP

KENNEDY, Des
Gestalt Psychotherapist
Shalom
36 Hillside Road, West Kirby
Wirral L48 8BB
0151 625 9839
MET

LEWIS, Kate A
Group Analytic Psychotherapist
37 Prospect Vale, Fairfield
Liverpool L6 8PE
0151 228 0166
UPA

LYON, Martin
Child Psychotherapist
Child & Family Services
Royal Liverpool Childrens NHS Trust
Scarisbrook Ave., Litherland
Liverpool L21 6NJ
0151 928 5045
ACP

MARKS, Helen
Family Therapist
South Sefton Child & Family Team
Scarisbrick Avenue
Litherland L21 6NJ
0151 928 5045
FIC

MARTIN, Susan
Hypno-Psychotherapist
10 Moss Lane
Orrell Park
Liverpool L9 8AJ
0151 474 8211/0151 286 5650
CTIS

MATTISON, Sheila
Psychoanalytic Psychotherapist
Wellcroft Centre
Wellcroft Road, Huyton
Liverpool L36 7RT
0151 489 6136
LPDO

MCALEER, Eileen
Integrative Psychotherapist
Flat 6, 80-82 Egerton Street
Wallasey L45 2LT
0151 637 0219
RCSPC

MCCLATCHEY, E.P.(Toni)
Hypno-Psychotherapist
12 Rodney Street
Liverpool L1 2TE
0151 727 3448
CTIS

MCGRATH, Adrian
Hypno-Psychotherapist
82 St. Georges Road
Wallasey L46 6TX
0151 639 6660
CTIS

MCNAB, Stuart
Psychoanalytic Psychotherapist
Bridge House Clinic
73 Village Road
Higher Bebington
Wirral L63 8PS
0151 608 1991
LPDO

MCVEY, Damien
Hypno-Psychotherapist
12 Rodney Street
Liverpool L1 2TE
0151 722 1044
CTIS

MERCER, Annie
Psychoanalytic Psychotherapist
Paediatric Liaison Department
Mulberry House
Alder Hey Children's Hosp.
Eaton Rd.
Liverpool L12 2AP
0151 252 5586
LPDO

MULLINS, Pat
Hypno-Psychotherapist
70 Kingston Crescent
Southport PR9 9RQ
01704 211460
CTIS

NELKI, Julia
Family Therapist
Seymour House
43 Seymour Terrace
Liverpool L3 5TE
0151 708 9200/0151 707 0101
AFT

PITT, Chris
Family Therapist
Flat 4, 8 Mannering Road
Liverpool L7 8TR
0151 728 8716
AFT

PROFFITT, Dorothea
Hypno-Psychotherapist
1 Whitham Avenue
Great Crosby
Liverpool L23 0RD
0151 928 4442
CTIS

PROTHERO, Peggy
Psychoanalytic Psychotherapist
Vine House
26 Parkgate Road, Neston
South Wirral L64 9XE
0151 336 2423
LPDO

RICHMAN, Sheila
Psychodrama Psychotherapist
19 Halkyn Avenue
Liverpool L17 2AH
0151 250 6128/0151 733 0983
BPA

ROFF, Hermione
Family Therapist
Academic Child Mental Health Unit
Royal Liverpool Children's Hospital
Eaton Road
Liverpool L12 2AP
0151 252 5509/0151 252 5285
AFT

SALTER, Audrey J
Cognitive Behavioural Psychotherapist
30 The Ridgeway, Meols
Hoylake
Wirral L47 9SA
0777 162 4042/0151 632 6968
BABCP

SAVAGE, Patrick
Family Therapist
The Wellcroft Centre
Wellcroft Road
Huyton L36 7TA
0151 4896137/0151 4802460
AFT

SCOTT, Michael
Cognitive Behavioural Psychotherapist
39 Hayles Green
Liverpool L25 4SG
0151 428 6846
BABCP

SMITH, Flo M.F.
Psychoanalytic Psychotherapist
Psychological Therapies Services
Saint Catherines Hospital
Church Road, Birkenhead
Wirral L42 0LQ
0151 604 7276
LPDO

SMITH, Margaret E
Psychoanalytic Psychotherapist
13 St. Anthony's Road
Blundellsands
Liverpool L23 8TN
0151 931 5194
LPDO

STEWART, June
Psychoanalytic Psychotherapist
Sunnyside
Reeds Brow, Rainford
St Helens WA11 8PD
01744 882968
LPDO

TAYLOR, Patsy
Psychoanalytic Psychotherapist
8 Victoria Mount
Birkenhead L43 5TH
0151 651 0558
LPDO

TRANTER, Paul
Family Therapist
Royal Liverpool Children's NHS Trust
Aldey Hey Hospital
Eaton Road
Liverpool L12 2AP
0151 252 5503
AFT

WOODS, Angie
Psychoanalytic Psychotherapist
Occupational Therapy/Physiotherapy
Department
Whiston Hospital
Prescot L35 5DR
0151 430 1131
LPDO

WOODWARD, Raie
Psychoanalytic Psychotherapist
c/o Directorate of Psychological Services
St. Catherine's Hosp., Derby Rd.
Birkenhead
Wirral L42 0LQ
0151 604 7276
LPDO

WYNN, Michelle
Cognitive Behavioural Psychotherapist
11 Rosslyn Drive
Moreton
Wirral L46 0SU
0151 678 4620
BABCP

MIDDLESEX

AIZENBERG, Eldad
Psychoanalytic Psychotherapist
22 Garrick Road
Ealing
London UB6 9HT
020 8813 1241
IPSS

ALLSOP, Wendy
Group Analyst
6 Southfield Gardens
Twickenham TW1 4SZ
IGA

ARDEMAN, Jacqueline
Family Therapist
44 Stanmore Hill,
Stanmore HA7 3BN
020 8954 1163
AFT

ASMALL, Ismail
Existential Psychotherapist
134 Priory Road
Hampton TW12 2PS
020 7381 8778/020 8941 1460
RCSPC

AVIGAD, Jocelyn
Systemic Psychotherapist
26 Rosecroft Walk
Pinner HA5 1LL
020 8429 0884
IFT

BAILEY, Catalena
Integrative Psychotherapist
41 Eastbury Road
Northwood HA6 3AN
01923 239495/01923 822209
RCSPC

BANKS, Jan
Transactional Analysis Psychotherapist
116 Thornbury Road
Osterley
Isleworth TW7 4NH
020 8560 5989
ITA

BRISTOW, John
Cognitive Analytic Therapist
261 St. Margaret's Road
Twickenham TW1 1NJ
020 8891 4997
ACAT

BROWN, Lesley
Gestalt Psychotherapist, Integrative
Psychosynthesis Psychotherapist
'Brightwater', Dunally Park
Shepperton TW17 8LJ
01932 220590
RE.V

BRUNT, Clare
Humanistic Psychotherapist
97 Warren Road, Whitton
Twickenham TW2 1DJ
020 8755 0353
AHPP

BUCKLEY, Judy
Psychoanalytic Psychotherapist
21 Private Road
Bush Hill Park
Enfield EN1 2EH
020 8363 3716
IPSS

CARROLL, Helen
Integrative Psychosynthesis
Psychotherapist
191 High Road
Harrow Weald
Harrow HA3 5EA
020 8427 6209
RE.V

CHILDS-CLARKE, Adrian
Cognitive Behavioural Psychotherapist
Clinical Psychology, Counselling and
Training
Psychology Department
Northwick Park Hospital
Watford Rd. HA1 3UJ
020 8869 2325/6
BABCP

CLARK, Nita
Analytical Psychologist-Jungian Analyst
16 Bellfield Avenue
Harrow Weald HA3 6SX
020 8421 1879
AJA

CLEAVELY, Evelyn
Psychoanalytic Marital Psychotherapist
8 Cox's Avenue
Grange Farm, Upper Halliford
Shepperton TW17 8TE
01932 789088 (t/f)
TMSI

COHEN, Pat
Attachment-based Psychoanalytic
Psychotherapist
Noahs Ark, 6 Spring Lake
Stanmore HA7 3BX
020 8954 9366
CAPP

COHEN, Ruth
Cognitive Behavioural Psychotherapist
6 Regent Close, Kenton
Harrow HA3 0SF
020 8907 3928/07931 881770
BABCP

COLE, Laurence E
Psychodynamic Psychotherapist
35A The Grove
Teddington TW11 8AT
020 8614 8027
UPA

COOPER, Cassie
Personal Construct Psychotherapist,
Psychodynamic Psychotherapist
12 Coniston Court
High Street
Harrow on the Hill HA1 3LP
020 8423 9386
CPCP

COOPER, Suzanne
Body Psychotherapist, Integrative
Psychotherapist
5 Lawrence Road
Pinner HA5 1LH
020 8866 1521
CCBP

COURTMAN, Anita
Psychosynthesis Psychotherapist
252 St. Margarets Road
Twickenham TW1 1PR
020 8893 2324
AAPP

CRICK, Verena
Child Psychotherapist
Barnet Child & Family Consultation
Service
Edgware General Hospital
Edgware HA8 OAD
020 8905 6679/020 7431 1761
ACP

CUSSINS, Anne
Psychoanalytic Psychotherapist
55a Pope's Avenue, Strawberry Hill
Twickenham TW2 5TD
020 8898 1366
IPSS

DARCY, Gillian*
Lacanian Analyst, Psychoanalytic
Psychotherapist
2 Willow Court Surgery
Stone Grove Road
Edgware HA8 8AG
01945 475212
CFAR

DAY, Lesley
Integrative Psychotherapist
41 Ailsa Avenue
St. Margarets
Twickenham TW1 1NF
020 8892 2076
MET

DAY, Michael
Family Therapist
1 Burtons Road
Hampton Hill TW12 1DB
020 8941 1348/020 8977 7280
AFT

DAY, Sally
Psychoanalytic Psychotherapist
27 Trafalgar Road
Twickenham TW2 5EJ
020 8894 1609
FPC

DEAN, Paul
Integrative Arts Psychotherapist,
Individual and Group Humanistic
Psychotherapist
74 Lincoln Avenue
Twickenham TW2 6NP
020 8898 2522
MET

DEAN, Sally
Group Analyst, Psychoanalytic
Psychotherapist
74 Lincoln Avenue
Twickenham TW2 6NP
020 8898 2522
FPC

DREWNOWSKA, Alicja
Body Psychotherapist, Integrative
Psychotherapist
72 Hindes Road
Harrow HA1 1SL
020 8427 9516
CCBP

EISEN, Shelley
Sexual and Relationship Psychotherapist
Kings Oak Hospital
Chase Farm (North Side)
The Ridgeway
Enfield EN2 8SD
020 8370 9500
BASRT

FASHT, Ruth
Group Analyst
'Gayton'
23 Aylmer Drive
Stanmore HA7 3EJ
020 8954 4710
IGA

FITZGERALD-BUTLER, Albina
Hypno-Psychotherapist
'Ivy Cottage'
Ealing Road
Northolt Village UB5 6AA
020 8841 4092
NRHP

FLACKE, Theresa
Group Analytic Psychotherapist
24 Barnes Close
Enfield EN1 4BN
020 83676617
UPA

GALLIERS, Mary
Psychoanalytic Psychotherapist
185 Rochester Avenue
Feltham TW13 4EH
020 8893 2351
AGIP

GEDDES, Heather
Educational Therapist
8 Blagdon Walk
Teddington TW11 9LN
020 8977 2418
FAETT

GILLI, Liliana
Psychosynthesis Psychotherapist
16 Clovelly Close
Ickenham UB10 8PT
01895 677405
AAPP

GOLDEN, Ellen
Child Psychotherapist
Enfield Child & Family Service
8 Dryden Road, Bush Hill Park
Enfield EN1 2PP
020 8360 6771/020 8450 0624
ACP

GOLDSTEIN, Pam
Systemic Psychotherapist
18 Hazeldene Drive
Pinner HA5 3NJ
020 8429 1640
KCC

GOLTEN, Carole
Transpersonal Psychotherapist
Stanmore 020 8958 4708
CCPE

GORDON, Deidre
Core Process Psychotherapist
19 Sudbury Court Drive
Harrow HA1 3SZ
020 8904 6488
AAPP

GORODENSKY, Arlene
Integrative Psychotherapist
9 Orchard Drive
Edgware HA8 7SE
020 8958 7021
RCSPC

GRAHAM, Marilyn
Gestalt Psychotherapist
29 Court Close
Twickenham TW2 5JH
020 8755 1029
GPTI

GREEN, June
Psychoanalytic Psychotherapist
'Redholme', 15 Ducks Hill Road
Northwood HA6 2NW
01923 824858
IPSS

HAMMOND, Margaret
Analytical Psychologist-Jungian Analyst
Fulford Sandhills Meadow
Shepperton TW17 9HY
01932 222712
CAP

HARARI, Michael
Analytical Psychologist-Jungian Analyst,
Child Psychotherapist
15 Woodside Road
Northwood HA6 3QE
01923 825880
CAP

HARRINGTON, Rufus
Cognitive Behavioural Psychotherapist
The Shakespeare Suite
Ashford Hospital NHS Trust
Lakeside Mental Health Unit
West Middlesex
Isleworth TW15 3AA
01784 884111/0961 378329
BABCP

HARVEY, Ann
Transactional Analysis Psychotherapist
44 Clifden Road
Twickenham TW1 4LX
020 8892 6136
ITA

HILL, Jennifer
NLP Psychotherapist
30 Wakehams Hill
Pinner HA5 3BQ
020 8601 3021/020 8866 6729
ANLP

HOBBS, Anita
Sexual and Relationship Psychotherapist
89 Syon Park Gardens
Osterley TW7 5NF
020 8568 4967
BASRT

HUGHES, Jacqui
Gestalt Psychotherapist
86 Colne Road
Twickenham TW2 6QE
020 8755 0992
GPTI

HUSSAIN, Nasima
Family Therapist
273 Carr Road
Northolt UB5 4RN
020 8723 0627
IFT

IKKOS, George
Group Analyst
Edgware Postgraduate Medical Centre
Edgware Community Hospital
Burnt Oak Broadway
Edgware HA8 0AD
01426 917231
IGA

JOHNSON, Deirdre
Analytical Psychologist-Jungian Analyst
16 Barrow Point Avenue
Pinner HA5 3HF
020 7431 9649/020 8866 9006
AJA

JOHNSON, Patricia
Integrative Psychotherapist
29 High Mead
Harrow HA1 2TX
020 8861 4749
RCSPC

KINGSNORTH, Wendy
Psychoanalytic Psychotherapist
91 First Avenue, Bush Hill Park
Enfield EN1 1BW
020 8363 3821
FPC

KULYK, Michael
Hypno-Psychotherapist
313 Martindale Road
Hounslow TW4 7HG
020 8570 3795
NRHP

LASCHINGER, Bernie
Attachment-based Psychoanalytic
Psychotherapist
27 Chalkhill Road
Wembley Park HA9 9DS
020 8904 2176
CAPP

LAVENDER, Lesley
Transpersonal Psychotherapist
Flat 8, Watertower
1 The Straight
Southall UB1 1QU
CCPE

LESLEY, Alison
Psychoanalytic Psychotherapist
44 Park Road
Asford TW15 1EY
01784 253146
IPSS

LEVIN, Barbara
Integrative Psychotherapist
94 Hartland Drive
Edgware HA8 8RH
020 895 85378
SPTI

LUCAS, Tina
Group Analyst
24 Montpelier Row
Twickenham TW1 2NQ
020 8892 6584
IGA

LYNCH, Maria
Analytical Psychologist-Jungian Analyst
34 Abbottsmede Close
Strawberry Hill
Twickenham TW1 4RL
020 8891 4242
CAP

MAPLE, Norma Anderson
Cognitive Analytic Therapist, Group
Analyst
Weir View, Towpath
Shepperton TW17 9LL
01932 224 717
IGA

MARSDEN, Veronica
Gestalt Psychotherapist
59 Manor Lane
Sunbury on Thames TW16 5EB
01932 786147/020 7485 2316
GCL

MARTIN, Brandy
Transpersonal Psychotherapist
1 Amhurst Gardens
Isleworth TW7 6AN
CCPE

MATTAR, Gretta
Hypno-Psychotherapist
14 Chestnut Manor Close
Staines TW18 1AQ
01784 464567
NRHP

MEINRATH, Monica
Group Analyst
31 Bushey Park Gardens
Teddington TW11 0LQ
020 8977 2242
IGA

MENCKHOFF, Beckie
Analytical Psychologist-Jungian Analyst
22 The Chase, Eastcote
Pinner HA5 1SJ
020 8866 9093
CAP

MICHAUD-LENNOX, Suzanne
Psychoanalytic Psychotherapist
20 Heming Road
Edgware HA8 9AE
020 8952 2418
IPSS

MILLER, Joanna
Integrative Psychotherapist
9 Georgian Close
Stanmore HA7 3QT
0956 225899/020 8954 5530
RCSPC

MOORHOUSE, Anni
Systemic Psychotherapist
CFCS,
Windmill Lodge
Uxbridge Road
Southall UB1 3EU
020 8967 5485
IFT

MORRIS, Bridget
Transpersonal Psychotherapist
65 Francis Road
Harrow HA1 2RA
020 8861 1265
CCPE

MOSTAEDDI, Bahman
Child Psychotherapist
Adolecent Community Team
Windmill Lodge, Ealing Hospital
Uxbridge Road
Southall UB1 3EU
020 8967 5484
ACP

MULDOON, Nuala
Integrative Psychotherapist
11 Flemming Avenue
Ruislip HA4 9LE
020 8967 5207/020 8429 2893
RCSPC

NEWNS, David
Transpersonal Psychotherapist
110 Waterloo Road
Uxbridge UB8 2QY
01895 467046
CCPE

NORSA, Giuliana
Child Psychotherapist
Enfield Child & Family Service
8 Dryden Road, Bush Hill
Enfield EN1 2PP
020 8360 6771/020 8455 7290
ACP

PARTRIDGE, Karen
Systemic Psychotherapist
Maddison Centre
140 Church Road
Teddington TW11 8QL
KCC

PERRY, Christopher
Analytical Psychologist-Jungian Analyst
64 Sidney Road
St. Margarets
Twickenham TW1 1JR
020 8892 3126
CAP

PETKOVA, Petia
Family Therapist
Child & Family Consultation Services
Windmill Lodge, Uxbridge Road
Southall UB1 8PN
020 8967 5248/
020 8967 5485/5190
AFT

PETRIE-KOKOTT, Julie
Body Psychotherapist, Integrative
Psychotherapist
19 Clitherow Road
Brentford TW8 9JT
020 8568 0589
CCBP

PHILLIPS, Asha
Child Psychotherapist
Stanmore
020 8954 4909
ACP

RAWSON-JONES, Elizabeth
Hypno-Psychotherapist
96 Highland Road
Northwood Hills HA6 1JU
01923 824744
NRHP

REES-ROBERTS, Diane
Psychoanalytic Psychotherapist
12 Cambridge Crescent
Teddington TW11 8DY
020 8287 7417/020 8977 7282
FPC

RISHIRAJ, Narinder S
Cognitive Behavioural Psychotherapist
321 Lady Margaret Road
Southall UB1 2PY
020 8575 7896
BABCP

ROBERTS, June
Psychoanalytic Psychotherapist
57 St. Margaret's Road
Twickenham TW1 2LL
020 8891 1205
IPSS

ROBERTSON, Judith
Psychoanalytic Psychotherapist
2 Belgrade Road
Hampton TW12 2AZ
020 8941 8241/094885
GUILD

ROSS, Suzanne
Transpersonal Psychotherapist
15 Holmes Road
Twickenham TW1 4RF
020 8891 3234
CCPE

ROUHIFAR, Zhila
Cognitive Behavioural Psychotherapist
Ealing Hammersmith and Fulham MH
NHS
local Secure Directorate,
St Bernards Wing, C Block
Uxbridge Rd,
Southall UB1 3EU
020 8354 8640
BABCP

RUTHERFORD, Penny Anne
Family Therapist
9 College Drive
Ruislip HA4 8SD
01895 636193
AFT

SHORTALL, Thomas R.
Cognitive Behavioural Psychotherapist
Bowden House clinic
London Road
Harrow on-the-Hill HA1 3JL
BABCP

SHUTTLEWORTH, Judy
Child Psychotherapist
Enfield Child & Family Service
Avenue House
8 Bycullah Avenue
Enfield EN2 8DW
020 8367 8844/020 8883 7908
ACP

SINGER, Iris
Attachment-based Psychoanalytic
Psychotherapist
1 Fairfield Avenue
Edgware HA8 9AG
020 8952 3931
CAPP

SLATER, Joan
Integrative Psychotherapist
17 Blenheim Close
Greenford UB6 8ET
020 8813 2235
RCSPC

SPICER, Janet
Psychosynthesis Psychotherapist
Northlands
24 Parkfield Gardens
Harrow HA2 6JR
020 8863 1931
AAPP

STOCKLEY, Rosalind
Integrative Psychotherapist
103 Copse Wood Way
Northwood HA6 2TU
01923 842351/01923 829190
RCSPC

STORRING, Susan
Child Psychotherapist
Barnet Child & Family Consultation
Service
Child Guidance Centre
East Road, Burnt Oak
Edgware HA8 0BT
020 8445 5539/020 8359 3801
ACP

SUSSMAN, Susan
Transpersonal Psychotherapist
Ruislip
01895 622202
CCPE

SUTHERLAND, Robert I.
Hypno-Psychotherapist
69 Sherwood Avenue
Greenford UB6 OPQ
020 8864 8795
NRHP

SWIFT, Joanna
Psychoanalytic Psychotherapist
5 Beresford Avenue
Twickenham TW1 2PY
020 8892 4722
SITE

SWINBURNE, Barbara C.
Cognitive Behavioural Psychotherapist
Thelma Golding Health Centre
Room 26
92 Bath Road
Hounslow TW3 3EL
020 8321 2320/020 8641 6108
BABCP

TAYLOR, Jill
Biodynamic Psychotherapist
65 Mereway Road
Twickenham TW2 6RF
020 8898 2805
BTC

TAYLOR, Maureen
Integrative Psychotherapist
21 Horne Road
Shepperton TW17 0DJ
01932 564198
UPA

THOMAS, Carmel
Cognitive Behavioural Psychotherapist
152 Somervell Road
South Harrow HA2 8TS
01344 773111 x4661/
020 8248 7422
BABCP

THORNDYCRAFT, Bill
Group Analytic Psychotherapist
90 Court Way
Twickenham TW2 7SW
020 8892 4376
FPC

TRAYNOR, Barbara
Gestalt Psychotherapist, Transactional
Analysis Psychotherapist
24 Bristow Road
Hounslow TW3 1UP
020 8572 0650
ITA

VENTHAM, Brian
Integrative Psychotherapist
68 Gloucester Road
Hampton TW12 2UJ
0802 764 119
RCSPC

VICKERS, Salley*
Psychoanalytic Psychotherapist
Top Flat, 5 The Butts
Brentford TW8 8BJ
020 8560 6490/01225 442086
GUILD

WADLAND, Liz
Family Therapist
Child & Adolescent Mental Health
Service
Windmill Lodge
Uxbridge Road
Southall UB1 3EU
020 8967 5485/020 8967 5248
AFT

WARD, John
Psychoanalytic Psychotherapist
123 Amyand Park Road
Twickenham TW1 3HN
020 8744 2780/0780 3086197
AGIP

WHINES, Jonathan
Gestalt Psychotherapist
86 Colne Road
Twickenham TW2 6QE
020 8755 0992/01603 663186
GPTI

WILKINS, David
Hypno-Psychotherapist
9 Burbidge Road
Shepperton TW17 0ED
020 8715 1145/01939 232401
NRHP

WINTER, David
Personal Construct Psychotherapist
Psychology Department
Edgware Community Hospital
Burnt Oak Brd. Way
Edgware HA8 0AD
020 8732 6984
CPCP

WISHART, Marian
Transpersonal Psychotherapist
197 Jersey Road
Osterley, Isleworth TW7 4QJ
020 8560 5363
CTP

WOLFE, Pamela
Psychosynthesis Psychotherapist
48 Fairacres, Ruislip HA4 8AW
01845 631 094
AAPP

NORFOLK

AQUARONE, Luc-Remy
Psychoanalytic Psychotherapist
11 Pottergate
Norwich NR2 1DS
0958 956871/01603 633115
FIP

CAMIDGE, Diana
Autogenic Psychotherapist
93 Fakenham Road
Gryburgh,
Fakeniham NR21 7AQ
01328 829 503
BAS

COULSON, Christopher J
Individual and Group Humanistic
Psychotherapist
63 Bury Street
Norwich NR2 2DL
01394 448435/01603 611394
AHPP

DAYKIN, Amanda
Group Analyst
6 Elvenden Close
Norwich NR4 6AS
01603 458 620
IGA

DOCKING, Raymond Fredrick
Systemic Psychotherapist
1 Kettlewell Lane
King's Lynn PE30 1PW
01553 767520
KCC

ENDER, Christine
Psychosynthesis Psychotherapist
8 Russell Terrace
Trowse
Norwich NR14 8TQ
01603 626 831
AAPP

FORBES, Constanze N
Family Therapist
Eartsea House, Berry's Lane
Honingham NR9 5AX
01603 880889/01603 880 603
AFT

HARBEN, Ursula
Systemic Psychotherapist
The Bethel Child and Family Centre
Hotblack Road
Norwich NR2 6HN
01603 630 681
KCC

HART, Sally
Humanistic Psychotherapist
26 Grant Street
Norwich NR2 4HA
01603 623795
AHPP

HENDERSON, Ned
Integrative Psychotherapist
Sawmill Cottage
The Street
Aylmerton NR11 8AA
01263 837 489
CCBP

HOARE, Elizabeth
Systemic Psychotherapist
Roydon Hall
Diss IP22 3XL
01379 651762
KCC

HUGHES, Ann
Psychoanalytic Psychotherapist
Millhouse
Homersfield
Suffolk IP20 0ET
01986 788273
GUILD

HUGHES, William
Analytical Psychologist-Jungian Analyst
The Coach House
Church Avenue
Norwich NR2 2AQ
01603 503845
CAP

IRVING, Nicholas
Transactional Analysis Psychotherapist
22 Lynn Road, Hillington
King's Lynn PE31 6DD
ITA

JESS, Carrie
Sexual and Relationship Psychotherapist
3 Ampthill Street
Norwich NR2 2RG
01603 612196
BASRT

JONES, Sue
Integrative Psychotherapist
Stubbs Cottage
Stubbs Green
Loddon
Norwich NR14 6EA
01508 528800
MET

JOSLIN, Laura
Autogenic Psychotherapist
28 Avenue Road
King's Lynn PE30 5NW
01553 766932
BAS

KERKHAM, Patricia
Psychoanalytic Psychotherapist
Banklands
Clenchwarton
King's Lynn PE34 4DB
0370 724787/01553 773854
IPSS

LITTLE, Jon
Integrative Psychotherapist
14 Central Close
Hethersett
Norwich NR9 3ER
01603 810946
RCSPC

MACGREGOR, Wynne
Integrative Psychotherapist
20 Neville Street
Norwich NR2 2PR
01603 461864
MET

MACKINNON, Sylvia
Hypno-Psychotherapist
4 Witton Close
Heacham
King's Lynn PE31 7TD
01485 572547
NSHAP

MARSH, Colin
Autogenic Psychotherapist
25 Daseleys Close
King's Lynn PE30 3SL
01553 675916
BAS

MCINTOSH, Stuart
Hypno-Psychotherapist
Three Gables, Chapel Road
Spooner Row
Wymondham NR18 9LN
07979 888229/01953 605970
NRHP

MIDDLECOAT, Andrew
Systemic Psychotherapist
Grange Cottage
Chapel Road
Dilham NR28 9PZ
01692 536558
IFT

MUNDY, Jean
Biodynamic Psychotherapist
7 Castreward
Great Yarmouth NR30 7AS
01493 850867
BTC

PITTMAN, Karen
Behavioural Psychotherapist
Admirality House
Northgate Hospital
Northgate Street
Great Yarmouth NR30 1BU
01493 337677
BABCP

POLDEN, Jane
Psychoanalytic Psychotherapist
16 Catton Grove Road
Norwich NR3 3NH
01603 404363
AGIP

REYNOLDS, Francois
NLP Psychotherapist
8 Town Close Road
Norwich NR2 2NB
01603 622542
ANLP

RICHARDSON, Susan
Hypno-Psychotherapist
25 Cypress Close, Taverham
Norwich NR8 6QG
01603 861019 (t/f)
NRHP

RUSSELL, Doug
Integrative Psychotherapist
35 Beech Road, Beetley
East Dereham NR20 4EZ
01362 861194
RCSPC

SHETTY, Grish Chander
Psychoanalytic Psychotherapist
The Norvic Clinic
St Andrews Business Park, Thorpe
Norwich NR7 0HT
01603 631215
LPDO

WALKER, Anne
Cognitive Behavioural Psychotherapist
The Priscilla Bacon Lodge
Unthank Road
Norwich NR2 2PJ
07931 556712/020 7467 8459
BABCP

WILKINSON, Mary
Systemic Psychotherapist
Yew Tree Cottage
Stocks Hill
Bawburgh
Norwich NR9 3LL
01603 811456
KCC

WILMOT, David
Family Therapist
The White House, Brandon Creek
Downham Market PE38 0PR
01353 676365
AFT

WOOD-BEVAN, Rosemary
Integrative Psychotherapist
Norwich Psychotherapy and Counselling
Centre
26 St. Augustine's Street
Norwich NR3 3BZ
01603 633791
MC

NORTHAMPTONSHIRE

BEECH, Julie C.
Cognitive Psychotherapist
Psychology Department
3 Spencer Parade, Northampton
01604 250445
BABCP

BHATTACHARYYA, Amit
Psychodynamic Psychotherapist
44 Greenfield Avenue
Northampton NN3 2AF
01604 234138/01604 411718
UPA

CLARK, Alec
Family Therapist
280 Wellingborough Road
Rushden NN10 9XP
01933 386354
AFT

FITZGERALD, Pen
Psychodrama Psychotherapist
91 Upper Thrift Street
Northampton NN1 5HR
01604 28769
BPA

GARDNER, Damian
Cognitive Behavioural Psychotherapist,
Integrative Psychotherapist
Dept. of Clinical Psychology
St Mary's Hospital, 77 London Road
Kettering NN15 1JP
01536 493033/01536 411004
BABCP

JANE, Susan
Psychodynamic Psychotherapist
103 Queens Park Parade
Northampton NN2 6LR
01604 717763
VAPP

LEE-EVANS, J Michael
Cognitive Behavioural Psychotherapist
Department of Psychology
St Andrews Hospital
Biling Road, Northampton NN1 5DG
01604 629696 X 6420
BABCP

LLOYD, Patricia
Psychoanalytic Psychotherapist
Fernvilla, Daventry Road
Newnham NN11 3HF
01327 879524
IPSS

LONG, Clive G.
Cognitive Behavioural Psychotherapist
St. Andrews Hospital
Billing Road
Northampton NN1 5DG
01604 629696
BABCP

MACPHERSON, David
Hypno-Psychotherapist
The Rectory
Great Brighton
Northampton NN7 4JB
01604 770402
CTIS

MARSDEN-ALLEN, Peter
Family Therapist
33 Alfred Street
Rushden NN10 9YS
01933 411476
AFT

MARSHALL, Clare
Integrative Psychotherapist
The Stables, Cold Ashby Road
Thornby
Northampton NN6 8SH
01604 740911/01604 235841
SPTI

MILNE, Pamela J.E
Cognitive Behavioural Psychotherapist
St. Andrew's Hospital
Billing Road
Northampton NN1 5DG
01604 29696 x6580
BABCP

O'NEILL, Helen M.
Cognitive Behavioural Psychotherapist
Occupational Therapy Dept
St. Andrews Hospital
Northampton NN1 5DG
01604 629696 x6269/
01604 696959
BABCP

PHILLIPS, Marianne
Psychoanalytic Psychotherapist
Cattleshed Cottage
1 Bakers Lane
Shutlanger
Nr. Towcester NN12 7RT
01604 863313
ARBS

REES, Myfanwy
Analytical Psychologist-Jungian Analyst
Ford Cottage, 1 High Street
Denford NN14 4EQ
01832 733502
IGAP

ROBERTS, Julie
Group Analyst
Department of Psychotherapy
Cheyne Walk Clinic
3 Cheyne Walk
Northampton NN1 5PT
01604 231 438
IGA

SPRINCE, Jenny
Child Psychotherapist
Thornby Hall
Peper Harrow Foundation
Northampton NN6 8SW
01604 740001/020 8800 5735
ACP

STEVENS, Penny
Cognitive Behavioural Psychotherapist
Lakeside Surgery
Cottingham Road
Corby NN17 2UR
01536 204154
BABCP

TOUGH, Harry
Group Analyst
106 Church Way
Weston Favell
Northampton NN3 3BQ
01604 28984
IGA

VAN DER EIJK, Mike
Systemic Psychotherapist
Rose Cottage
Spencer Gardens
Bozeat NN29 7JL
01604 604608/01933 665119
KCC

WHEATLEY, Malcolm
Cognitive Behavioural Psychotherapist
St Andrews Hospital
Billing Road
Northampton NN1 5DG
01604 629696
BABCP

NORTHERN IRELAND

ADAMS, Clare E A
Psychoanalytic Psychotherapist
100 Kings Road
Belfast BT5 7BW
028 90655056/028 90401141
UPA

BENSON, Jarlath
Psychoanalytic Psychotherapist,
Psychosynthesis Psychotherapist
10 Mill Road, Drumaness
Ballynahinch, Co.Down
01238 562712/
AAPP

BROWN, Avril
Sexual and Relationship Psychotherapist
113 University Street
Belfast BT7 1HP
028 90312 942
BASRT

BURNS, Maura
Psychosynthesis Psychotherapist
35 St James's Road
Belfast BT12 6EA
028 90779 922/028 90247 363
AAPP

CAIRNS, Mary
Psychoanalytic Psychotherapist
171 Barnett's Road
Belfast BT5 7BG
028 90877936
ARBS

COULTER, Stephen
Family Therapist
20 Kingsway Park
Belfast BT5 7EU
028 90795140
AFT

CROMEY, Terry
Cognitive Behavioural Psychotherapist
'Brakken', 43 Sheridan Drive
Helen's Bay
Co. Down BT19 1LB
01247 853473
BABCP

CUNNINGHAM, Gerry
Family Therapist
c/o Old Railway Station
Duke Street
Londonderry BT48 1DH
028 71343501
AFT

DAVIS, Patrick
Psychoanalytic Psychotherapist
28 Brookvale Avenue
Belfast BT14 6BW
028 90744676
WMIP

DAVREN, Moira
Family Therapist
Child and Family Clinic
Bocombra Lodge
2 Old Lurgaw Road
Portadown BT63 5SQ
01762 392 112/01762 361 968
AFT

GILLESPIE, Kate
Cognitive Behavioural Psychotherapist
Cognitive Therapy Centre
Erne House
T & F Hospital
Omagh BT79 0NS
028 82245211 x2528
BABCP

GRANT, Mary
Transpersonal Psychotherapist
Lifespring
111 Cliftonville Road
Belfast BT14 6JQ
028 90753658/087 2436496
CTP

HANLEY, Ian G.
Cognitive Behavioural Psychotherapist
7 Lynnehurst Drive
Comber
Co. Down BT23 5LN
01247 873644
BABCP

HEALEY, Arlene
Family Therapist
The Family Trauma Centre
1 Wellington Park
Belfast BT9 6DJ
028 90204 700
AFT

HERRON, Stephen
Cognitive Behavioural Psychotherapist
Ards Mental Health Outpatient Centre
Ards Hospital, Church Street
Newtownards,
Co Down BT23 4AS
01247 510106
BABCP

JOHNSON, Duncan B.
Hypno-Psychotherapist
28 Drumill Road
Cullyhanna, Newry
Co. Down BT35 0ND
01693 868715
NRHP

KELLY, Anne
Cognitive Behavioural Psychotherapist
39 Malone Road
Belfast BT9 6AG
0836 318636/028 90491759
BABCP

KENNY, Brigid
Psychosynthesis Psychotherapist
Dumshancorick, Roslea
Fermanagh
028 66751465
AAPP

LAFARGUE, Martine
Primal Psychotherapist
50 Lisnauar Court
Gelvin Grange
Derry City BT47 2NE
028 7134 75 89
LAPP

LAWSON, Ruth
Cognitive Behavioural Psychotherapist
Redburn Clinic
364 Old Holywood Road
Co. Down BT18 8QH
028 90425102/028 90421235
BABCP

LOVE, Patrick T
Cognitive Behavioural Psychotherapist
Carryduff Clinic
Killynure House, Church Road
Carryduff
Co Down BT8 8DT
028 90812835/028 90813969
BABCP

MCGOWAN, Dominica
Gestalt Psychotherapist
30 North Parade
Belfast BT7 2GG
028 90326803/028 90647410
MET

MCGREEVY, Edith
Hypno-Psychotherapist
238 Townhill Road, Portglenone,
Ballymena
Co Antrim BT44 8HA
0780 804 5417/028 29571625
NSHAP

MCKEOWN, Patricia
Transpersonal Psychotherapist
2 Beechvale Court, Banbridge
Co. Down BT32 3YR
028 40624806
CCPE

O'NEILL, Arthur
Family Therapist
Whitefield House, 2 The Hawthorns
Belfast BT10 0NR
028 90301611
AFT

PALMER, Brigid
Family Therapist
28A Wilsons Town, Aughatarra, Killylea
Co Armagh
AFT

QUINN, Paul
Cognitive Behavioural Psychotherapist
38 Garland Hill
Belfast BT8 4YL
028 90797139
BABCP

NORTHUMBERLAND

JELLEMA, Anna
Cognitive Analytic Therapist
"Denethorpe"
Stockton Road, Ryhope
Sunderland SR2 0NE
0191 569 9408
ACAT

REED, Alex
Family Therapist
1a Leazes Terrace
Hexham NE46 3DL
01434 601928
AFT

NOTTINGHAMSHIRE

ACKROYD, Elaine
Sexual and Relationship Psychotherapist
The Hollies, Bleasby Road
Thurgarton NG14 7FW
01636 830871
BASRT

ADLINGTON, Jethro
NLP Psychotherapist
Hollydean House
12 Nelson Road
Daybrook
Nottingham NG5 6JE
0706 0706 666
ANLP

AITKEN, Fiona
Integrative Psychotherapist
12 Rufford Road
Sherwood
Nottingham NG5 2NR
0115 8478090
SPTI

ANDERSON, Judith
Psychoanalytic Psychotherapist (Jungian)
6 The Park, Newark
Nottingham NG24 1SD
01636 701996
WMIP

AVERY, Anna
Gestalt Psychotherapist
Clovers, Little Lane
Clarborough, Retford
Nottingham DN22 9LR
01777 869913
SPTI

BASSETT, George
Gestalt Psychotherapist
4 Fullmonty House
27 Orlando Dr, Gedling
Nottingham NG4 3FN
0115 9617911
SPTI

BATTEN, Francis
Psychodrama Psychotherapist
16 Milner Road
Sherwood
Nottingham NG5 2ES
0115 9625964
BPA

BEECHCROFT, Diane
Transactional Analysis Psychotherapist
178 Harrington Drive, Lenton
Nottingham NG7 1JH
01159 414378
ITA

BELLE-BOULE, Annabell
Gestalt Psychotherapist
10 Gardenia Crescent, Mapperley
Nottingham NG3 6JA
0115 952 5089
SPTI

BROCK, Martin J
Cognitive Behavioural Psychotherapist
Nottingham Psychotherapy Unit
St Annes House
114 Thorneywood Mount
Thorneywood
Nottingham NG3 3PZ
0115 956 4911
BABCP

BROWNING, Peter
Gestalt Psychotherapist
15 Curzon Avenue
Nottingham NG4 1GN
0115 987 6922/07971 366955
SPTI

BRYANT, Pat
Integrative Psychotherapist
6 Clumber Road, West Bridgford
Nottingham NG2 6DQ
0115 989463
SPTI

CARRETTE, Timothy
Gestalt Psychotherapist
274 Porchester Road
Nottingham NG3 6GT
0115 9444521
SPTI

CHERRY-SWAINE, Janine
Child Psychotherapist
Thorneywood Child & Adolescent Unit
Porchester Road
Mapperley NG3 6LF
0115 959479
ACP

CLEMENTS, Wendy
Integrative Psychotherapist
21 Walcote Drive
West Brigford
Nottingham NG2 7JQ
0115 9844647
SPTI

COOPER, Penny
Sexual and Relationship Psychotherapist
199 Main Street, Newthorpe
Nottingham NG16 2DL
BASRT

DUNN, Katie
Behavioural Psychotherapist
32A George Road, West Bridgford
Nottingham NG2 7QG
0115 945 5990
BABCP

EAGLE, Gillian
Integrative Psychotherapist
c/o Sherwood Psychotherapy Training
Institute
2 St James Terrace
Nottingham NG1 6FW
0115 924 3994
SPTI

ERSKINE, Richard
Integrative Psychotherapist
2 St. James Terrace
Nottingham NG1 6FW
0115 924 3994
SPTI

EVANS, Kenneth
Integrative Psychotherapist
31 Foxhill Road, Burton Joyce
Nottingham NG14 5DB
0115 924 3994
SPTI

FOOKES, Andrew
Gestalt Psychotherapist
2 St Jame's Terrace
Nottingham NG1 6FW
0115 924 3994
SPTI

GILBOY, Carol A.
Cognitive Behavioural Psychotherapist
The Wellbeing Centre
11 Musters Road
West Bridgford
Nottingham NG2 7PP
0115 982 5353
BABCP

GRAHAM, Hilary E.
Hypno-Psychotherapist
25 George Road
West Bridgford
Nottingham NG2 7PT
01159 455290
NRHP

GREENWAY, Ian
Gestalt Psychotherapist
100 Gertrude Road
West Bridgeford
Nottingham NG2 5DB
0115 982 1834
GPTI

HAYMAN, Penny
Integrative Psychotherapist
37 Chaworth Road
West Bridgford NG2 7AE
0115 9825770
SPTI

HELPS, Davina
Sexual and Relationship Psychotherapist
Grove Farm, Epperstone
Nottingham NG14 6AU
0115 966 3919
BASRT

HINDLE, Deborah
Child Psychotherapist
Thornywood Child & Adolescent
Psychiatry Unit, Porchester Road
Mapperley
Nottingham NG3 6LF
01159 587888
ACP

HOWARD TAYLER, Jacky
Gestalt Psychotherapist
Northfield House, 21 Station Road
Southwell
Nottingham NG25 OET
SPTI

HOWELL, Julia
Psychodrama Psychotherapist
16 Milner Road, Sherwood
Nottingham NG5 2ES
0115 9625964
BPA

HUTCHBY, Rosemary
Gestalt Psychotherapist
Thiskney House, 2 St James Terrace
Nottingham NG1 6FW
0115 924 3994
SPTI

JANKS, Ann
Integrative Psychotherapist
c/o Sherwood Psychotherapy Training
Institute
25 St James Terrace NG1 6FW
0115 924 3994
SPTI

KERRY, Helen
Gestalt Psychotherapist
3 Dagmar Grove
Alexandra Park NG3 4JE
0115 962 1107
SPTI

KINSELLA, Philip
Cognitive Behavioural Psychotherapist
41 Gladstone Street, Beeston
Nottingham NG9 1EU
0115 943 6378/0115 952 9453
BABCP

LAKE, Dorry
Integrative Psychotherapist
8 Fourth Avenue
Sherwood Rise
Nottingham NG7 6JB
0115 9625092
SPTI

LAVENDER, Peter
Gestalt Psychotherapist
37 Thackeray Lane
Woodthorpe
Nottingham NG5 4HG
0115 9200186
SPTI

LAW, Anne M
Sexual and Relationship Psychotherapist
Church Meadow, Calverton
Nottingham NG14 6HG
0115 965 3684
BASRT

LAWES, Ginny
Integrative Psychotherapist
36 Carrfield Avenue, Longeaton
Nottingham NG10 2BW
0115 946 0295
MET

LEE, Adrienne
Transactional Analysis Psychotherapist
2 Castle Grove, The Park
Nottingham NG7 1DN
01509 673649/01159 473296
ITA

LEE, Helen
Psychoanalytic Psychotherapist
Nottingham Psychotherapy Dept.(NHS)
St. Ann's House
114 Thorneywood Mount
Nottingham NG3 2PZ
0115 952 9452
STTDP

MANN, David
Gestalt Psychotherapist
Ashtree Cottage
1 Maythorpe Cottages
Southwell NG25 0RS
01636 815733
SPTI

MCKAY, Lynn
Psychodynamic Psychotherapist
Kirkland House
Church Street
Southwell NG25 0HG
01636 815509
VAPP

MORLEY, Ann
Analytical Psychotherapist, Psychoanalytic
Psychotherapist (Jungian)
36 Crosby Road
West Bridgford NG6 5GH
0115 914 0256
WMIP

MOULDING, Jacqueline
Integrative Psychotherapist
24 Cobwell Road
Retford DN22 7BW
01777 702565
SPTI

O'REILLY, Thomas J
Psychoanalytic Psychotherapist
132 Edward Road
West Bridgford
Nottingham NG2 5GF
0115 974 9953
LPDO

ORLANDI-FANTINI, Claire
Gestalt Psychotherapist
58 Bridle Road, Burton Joyce
Nottingham NG14 5FS
0115 9313951
SPTI

ORLANDI-FANTINI, Peter
Gestalt Psychotherapist
58 Bridle Road
Burton Joyce
Nottingham NG14 5FS
0115 931 3951
SPTI

PAGE, Jonathan
Gestalt Psychotherapist
153 Simkin Avenue, Mapperley
Nottingham NG3 6HU
0115 922 8231/0115 962 3180
SPTI

PEARSON, Mark
Systemic Psychotherapist
Child & Adolescent Mental Health
Service
Thorneywood Unit
Porchester Road
Nottingham NG3 6LF
0115 958 7888/0115 982 0633
KCC

PHILLIPS, Susan
Integrative Psychotherapist, Transactional
Analysis Psychotherapist
103 Westgate, Southwell
Nottingham NG25 0LS
01636 813 794 (t/f)
MET

PIGOTT, Sheila
Gestalt Psychotherapist
St. Paul's House, Boundary Road
West Bridgeford
Nottingham NG2 7DB
0115 922 3492
SPTI

PUGSLEY, Stephanie
Gestalt Psychotherapist
Northfield House
21 Station Road, Southwell
Nottingham NG25 0ET
SPTI

REGEL, Stephen
Cognitive Behavioural Psychotherapist
2 Second Avenue, Sherwood Rise
Nottingham NG7 6JJ
0115 960 8527/07666 798909
BABCP

RICHARDS, Paul
NLP Psychotherapist
Flat 2, 12a Alexandra Street
Sherwood Rise
Nottingham NG5 1AY
0115 985 7372
ANLP

SALISBURY, Jonathan
Psychodrama Psychotherapist
21 Church Drive, Arnold
Nottingham NG5 6JD
01159 200470
BPA

SENIOR, Maggie
Gestalt Psychotherapist
5 Second Avenue
Sherwood Rise NG7 6JT
0115 9243994/0115 9693180
SPTI

SEXTON, Sylvia
Psychoanalytic Psychotherapist
The Mallows
Mill Lane, Caunton
Newark NG23 6AJ
01636 636055
UPA

SHARPE, Rob
Integrative Psychotherapist
84 Victoria Road, Sherwood
Nottingham NG5 2ND
0115 962 2252
SPTI

SHORT, Deborah
Gestalt Psychotherapist
3a Main Street, Jacksdale
Nottingham 01773 602064
SPTI

SPICER, Robert
Gestalt Psychotherapist
274 Porchester Road
Mapperley
Nottingham NG3 6GT
0115 9858116/01585 537793
SPTI

STAINES, Jill
Psychoanalytic Psychotherapist
Nottingham Psychotherapy Unit (NHS)
St. Ann's House
114 Thorneywood Mount
Nottingham NG3 2PZ
0115 952 9452
STTDP

STALMEISTERS, Dzintra
Gestalt Psychotherapist
The Dovecote
Harlow Wood Farm, Park Lane
Lambley NG4 4QA
0115 931 4389
SPTI

STEPHENS, June
Gestalt Psychotherapist
22 The Paddocks, London Road
Newark
Nottingham NG24 1SS
01636 707491/01636 73456
SPTI

STEVENS, Christine
Gestalt Psychotherapist
Malvern House
41 Mapperley Road
Nottingham NG3 5AQ
0115 841 2006
SPTI

STEWART, Ian
Transactional Analysis Psychotherapist
Old School House
Kingston on Soar
Nottingham NG11 0DE
01509 673 649/01509 673569
ITA

SWAN PARENTE, Alison
Child Psychotherapist, Psychoanalytic
Psychotherapist
Welbeck Abbey, Welbeck
Worksop S80 3LN
01909 500263/01909 531 054 (f)
ACP

THOMPSON, Jean Mary
Psychodrama Psychotherapist
21 Church Drive, Arnold
Nottingham NG5 6JD
01602 200470
BPA

TOMS, David A.
Psychodynamic Psychotherapist
2 Regent Street
Nottingham NG1 5BQ
WMIP

VICTORY, Sian
Gestalt Psychotherapist
17 Riverside
Southwell NG25 0HA
01636 814 778
SPTI

WARD, Keltie A
Sexual and Relationship Psychotherapist
64 Musters Road, West Bridgford
Nottingham NG2 7PR
BASRT

WATERSTONE, Carolyn
Gestalt Psychotherapist
10 Hampden Grove, Beeston
Nottingham NG9 1FG
0115 925 9083
GPTI

WATTERS, Catherine
Child Psychotherapist
Oakdene
51 Anston Avenue, Worksop
Nottingham S81 7HU
01909 479327
ACP

WOOD, Christine Jones
Transactional Analysis Psychotherapist
The Oakwood Centre
64 Henry Road, West Bridgford
Nottingham NG2 7ND
0115 982 5498
ITA

WOOLFSON, Myra
Psychodynamic Psychotherapist
87 Sherwood Vale, Mapperley
Nottingham NG5 4EB
0115 960 3355
HIP

WYATT, Gill
Integrative Psychotherapist, Transactional
Analysis Psychotherapist
17 Denison Street, Beeston
Nottingham NG9 1AY
01159 177 287
MET

YOUNG, Raymond
Psychoanalytic Psychotherapist
Nottingham Psychotherapy Unit (NHS)
St. Ann's House
114 Thorneywood Mount
Nottingham NG3 2PZ
0115 952 9452
STTDP

OXFORDSHIRE

ALEXANDER, Gina M V
Analytical Psychologist-Jungian Analyst
The Old Chapel
Fawler, Kingston Lisle
Wantage OX12 9QJ
012357 820 324
FIP

ALLEN, Patricia M.
Transactional Analysis Psychotherapist
Oxford Centre for Psychotherapy
Training
142 Gidley Way, Horspath
Oxford OX33 1TD
ITA

AMIES, Peter
Cognitive Psychotherapist
77 Victoria Road
Summertown
Oxford OX2 7QG
01865 556322/01793 491917
BABCP

ARMITAGE, Pamela
Psychoanalytic Psychotherapist
2 Dudley Gardens
Oxford OX4 1BH
01865 771059
GUILD

BLOCH, Linda
Group Analyst
33 Manor Road, South Hinksey
Oxford OX1 5AS
01865 730733
IGA

BLOW, Kirsten
Family Therapist
Oxford Family Institute
2 Woodlands , Mill End
Kidlington
Oxon OX5 2ER
01865 842407
AFT

BLUM, Arna
Psychoanalytic Psychotherapist
Abbey Cottage
Sutton Courtenay
Abingdon
Oxford OX14 4AF
01235 848719
FPC

BLYTH, Fiona
Transactional Analysis Psychotherapist
Longbarn, 22 St. Georges Road
Wallingford
Oxon OX10 8HP
01189 561251/01491 201213
MET

BRADLEY, Lorne-Natalie
Psychoanalytic Psychotherapist
29 Boulter Street
St. Clements
Oxford OX4 1AX
01865 246879
CPP

BRANKIN, Maire
NLP Psychotherapist
19 Norham Road
Oxford OX2 6SF
01865 310320
ANLP

BREWER, Madelyn
Psychoanalytic Psychotherapist
38 Rectory Road, St Clements
Oxford OX4 1BU
01865 725588
SITE

BRINER, Wendy
Systemic Psychotherapist
51 Gravel Hill
Henley-on-Thames
Oxon RG9 2EF
KCC

BROSNAN, Judi
Psychoanalytic Psychotherapist
2 Wootten Drive, Iffley
Oxford OX4 4DS
01865 718159
SIP

BROWN, Robin Richard
Psychoanalytic Psychotherapist
23 Alexandra Road
Oxford OX2 0DD
01865 514806/01865 242400
SIP

BRYANT, Roger
Transpersonal Psychotherapist
10 Foxburrow Lane, Hailey
Oxon OX8 5UN
01993 704345
CCPE

BUTLER, Gillian
Cognitive Behavioural Psychotherapist
Department of Psychology
The Warneford Hospital
Headington
Oxford OX3 7JX
01865 226419
BABCP

CAMPBELL, Margaret
Psychoanalytic Psychotherapist
Kiln House, Church Road
Sanford on Thames OX4 4XZ
01865 226518/01865 779556
CFAR

CARLING, Katharine
Child Psychotherapist
Isis Cottage, New Road
Marcham OXFORDSHIRE
OX13 6NL
01865 391371
ACP

CARR, Jean
Analytical Psychologist-Jungian Analyst
12 Windsor Street, Headington
Oxford OX3 7AP
01865 750796
CAP

CHRISTOPHAS, Sheelagh
Humanistic Psychotherapist
70 West Way, Botley
Oxford OX2 9JT
01865 790687
AHPP

DANIEL, Gwyn
Family Therapist
8 Chalfont Road
Oxford OX2 6TH
01865 311518 (t/f)
IFT

DOUGLAS, Sue
Humanistic and Integrative
Psychotherapist
Fawler Barn, Kingston Lisle
Nr. Wantage
Oxon OX12 9QJ
BCPC

DOWNES, Vanessa Susan
Cognitive Behavioural Psychotherapist
Cotswold House
Warneford Hospital
Headington
Oxford OX3 7JX
01865 451632/01856 226248
BABCP

DUFFIN, Lorna
Psychodynamic Psychotherapist
16 Southmoor Road
Oxford OX2 6RD
01865 12915
VAPP

ELWELL, Louise
Cognitive Analytic Therapist
57 Western Road, Grandpont
Oxford OX1 4LF
01865 202546
ACAT

GAGE, Michael
Sexual and Relationship Psychotherapist
West Street Surgery
12 West Street, Chipping Norton
Oxon
01295 258452
BASRT

GALLOP, Margaret
Group Analyst
16a New Road
East Hagbourne
Didcot OX11 9JU
IGA

GERHARDT, Sue
Psychoanalytic Psychotherapist
12 Kingston Road
Oxford OX2 6RB
01865 556592
AIP

GIRLING, Gail
Humanistic Psychotherapist
The Yard, Lands Farm, Swerford
Chipping Norton, Oxon OX7 4BG
020 7631 0156/01608 730812
AHPP

GOSS, Thomas
Psychosynthesis Psychotherapist
Rose Cottage
Pound Lane, Stanton St. John
Oxon OX33 1HF
01865 351765
AAPP

GUY, Liana
Psychoanalytic Psychotherapist
33 Marlborough Road
Oxford OX1 4LW
01865 251 812
GUILD

HANAWAY, Monica
Integrative Psychotherapist
79 Fairacres Road
Iffley Fields
Oxford OX4 1TQ
01865 450027/01865 436538
RCSPC

HARRIS, Gordon
Analytical Psychologist-Jungian Analyst
Hillside, 72 Honey Lane
Cholsey, Wallingford
Oxon OX10 9NJ
01491 651 271
SIP

HAWORTH, Peter
Psychodrama Psychotherapist
8 Rahere Road, Cowley
Oxford OX4 3QC
01865 747604/01865 242334
BPA

HAYES, Lesley
Humanistic Psychotherapist
Celastrina Cottage
26 Cherwell Street
Oxford OX4 1BG
01865 249975
AHPP

HAYHURST, Sohani
Integrative Psychotherapist
1 Upper Fisher Row
Oxford OX1 2EZ
01865 727351
MC

HERBERT, Claudia
Cognitive Behavioural Psychotherapist
The Oxford Development Centre
The Oxford Stress & Trauma Centre
8a Market Square
Witney, Oxon OX8 7BB
01993 779994/01865 428426
BABCP

HILL, Penny
Psychoanalytic Psychotherapist
17 Norreys Avenue
Oxford OX1 4ST
01865 722259
SITE

HOBBS, Michael
Group Analyst
Psychotherapy Department
Warneford Hospital
Headington
Oxford OX3 7JX
01865 226 330
IGA

HOCK, Gaby
Psychodynamic Psychotherapist,
Transpersonal Psychotherapist
63 Warwick Street
Oxford OX4 1SZ
01865 247851
CTP

HODSON, Pauline
Psychoanalytic Marital Psychotherapist
14 Brookside, Headington
Oxford OX3 7PJ
01865 762991
TMSI

HOLMAN, Christopher
Group Analyst
111 East Parade, Old Marston
Oxford OX3 0PH
IGA

HOLMES, Anne
Group Analyst
59 Oxford Road, Old Marston
Oxford OX3 0PH
01865 794 916
IGA

HUNT, Susan
Sexual and Relationship Psychotherapist
The Rainbow House
Wellsprings
Brightwell-Cum-Sotwell
Wallingford OX10 0RN
01491 835787
BASRT

HUTCHINSON, Peter
Psychodrama Psychotherapist
95 Sunningwell Road
Oxford OX1 4SY
01865 246194
BPA

JAQUES, Penny
Psychoanalytic Psychotherapist
7 Stanley Road
Oxford OX4 1QY
01865 724141
FIP

JOHNSTON, Linda Ann May
Family Therapist
62 Sadlers Court, Abingdon
Oxon OX14 2PA
01235 530274
AFT

KEATING, Jacqueline
Analytical Psychologist-Jungian Analyst
Abbots Piece, Church Lane
Islip OX5 2TA
01865 376162
IGAP

KUECHEMANN, Christine
Psychoanalytic Psychotherapist
62 Victoria Road
Oxford OX2 7QD
01865 512410
AGIP

LANDALE, Margaret
Body Psychotherapist, Integrative
Psychotherapist, Transpersonal
Psychotherapist
Mill House, Mill Lane
Dyers Hill, Charlbury
Oxon OX7 3QG
01608 810485
CCBP

LEA, Tan
Psychodrama Psychotherapist
54 St Mary's Road
Oxford OX4 1PY
01865 794037/01865 726496
BPA

LEVICK, Barbara
Psychoanalytic Psychotherapist
12 Frenchay Road
Oxford OX2 6TG
01865 512683/01865 552394 (F)
FPC

LINDLEY-JONES, Kerstin
Transpersonal Psychotherapist
15 Warwick Street
Oxford OX4 1SZ
01865 243351
CTP

LUTYENS, Marianna
Psychoanalytic Psychotherapist
99 Woodstock Road
Oxford OX2 6HL
01865 331104
FPC

LUXMOORE, Nick
Psychodrama Psychotherapist
176 Divinity Road
Oxford OX4 1LR
01865 245510
BPA

MACK SMITH, Catharine
Child Psychotherapist
23 Alexandra Road
Oxford OX2 0DD
01865 242400
ACP

MILLARD MACKINTOSH, Sheila
Group Analyst, 78 Cumnor Hill
Oxford OX2 9HU
01865 862 224
IGA

MILLER, John
Analytical Psychologist-Jungian Analyst
19 Stanley Road, Cowley
Oxford OX4 1QY
01865 725203
AJA

MILLS BURTON, M.
Psychoanalytic Psychotherapist
The Old Rectory
Childrey OX12 9UP
WMIP

MORRIS, Lesley Anne
Humanistic Psychotherapist
3 Church Green, Witney
Oxon OX8 6AZ
01993 776445
AHPP

MORRIS, Petrina
Analytical Psychologist-Jungian Analyst
7 Dovehouse Close
Oxford OX2 8BG
01845 557253
IGAP

MORRISON, Philippa
Existential Psychotherapist
Church Wing, The Old Rectory
Church Street, Somerton
Bicester
Oxfordshire OX6 4NB
020 7706 6936
RCSPC

NATHAN, (Jennifer) Ruth
Gestalt Psychotherapist, Integrative
Psychotherapist
The Old Scholl House, Merton
Bicester OX6 0NF
01865 331899
GPTI

NISSIM, Ruth
Family Therapist
Dores Cottage, 17 High Street
Finstock
Oxon OX7 3DA
01604 859580/01993 868147
AFT

O'BRIEN, Maja**
Psychoanalytic Psychotherapist
28 Wytham Street
Oxford OX1 4TS
01865 728111
FIP

OFFER, Leah
Humanistic Psychotherapist
15 Hamilton Road
Oxford OX2 7PY
01865 553380
AHPP

ORTON, Jane
Humanistic and Integrative
Psychotherapist
28 Bloxham Road
Banbury OX16 9JN
BCPC

PEGORARO, Carla
Transpersonal Psychotherapist
The Red House
372 Woodstock Road
Oxford OX2 8AE
01865 556053
CCPE

PORTER, Barbara
Transactional Analysis Psychotherapist
Silver Birches, Kingwood Common
Henley-on-Thames
Oxon RG9 5LR
01491 628609
MET

POWELL, Andrew
Group Analyst, Psychoanalytic
Psychotherapist, Psychodrama
Psychotherapist
Dept. of Psychotherapy
Warneford Hospital
Warneford Lane, Headington
Oxford OX3 7PT
01865 226337
BPA

RENDALL, Davina
Sexual and Relationship Psychotherapist
5 Abberbury Avenue
Iffley Village
Oxford OX4 4EU
01865 717994
BASRT

REYNAL, Carmen
Analytical Psychologist-Jungian Analyst
31 Warnborough Road
Oxford OX2 6JA
01865 511063/01451 810156
IGAP

ROWLAND, Catherine
Group Analytic Psychotherapist
522 Banbury Road, Oxford
Oxon OX2 8LG
01865 558190
UPA

RUGGIERI, Gloria
Integrative Psychotherapist
40 Cavendish Road
Summertown, Oxford
Oxon OX2 7TW
01865 513363
RCSPC

RUSCOMBE-KING, Gillie
Psychodrama Psychotherapist
12 The Green, Cuddesdon
Oxford OX44 9JZ
01865 873 721/01865 873721
BPA

RYAN, Elizabeth
Sexual and Relationship Psychotherapist
The Old Stores
Wellshead Lane, Harwell
Oxon OX11 0HD
01235 832847
BASRT

SHADBOLT, Carole
Transactional Analysis Psychotherapist
11 Alexandra Square
Chipping Norton
Oxon OX7 5HL
01608 644 748
ITA

SHAW, Sue
Sexual and Relationship Psychotherapist
8 Stoke Place
Headington
Oxford OX3 9BX
01865 763821
BASRT

SHEWAN, Doreen
Psychoanalytic Psychotherapist
19 Stanley Road
Oxford OX4 1QY
01865 725203
SIP

SMITH, Eva
Cognitive Analytic Therapist
9 Western Road
Oxford OX1 4LF
01865 724 351
ACAT

SOTH, Michael
Body Psychotherapist, Integrative
Psychotherapist
14 Hawthorn Close
Oxford OX2 9DY
01865 725205
CCBP

SPARKES, Frances
Personal Construct Psychotherapist
Finches, Hill Top Lane
Chinnor OX9 4BH
020 7530 4238/01844 351411
CPCP

SPEED, Bebe
Family Therapist, Psychodynamic
Psychotherapist
Brock Leys, Pullens Lane
Headington
Oxford OX3 OBX
01865 763848
WMIP

SPILIOS, Joanne
Analytical Psychologist-Jungian Analyst
99 Woodstock Road
Oxford OX2 6HL
07020 921286
AJA

STANDISH, Elizabeth
Psychoanalytic Psychotherapist
46 Park Street, Abingdon
Oxon OX14 1DG
01235 528806
SIP

STAUNTON-SOTH, Theresa
Body Psychotherapist, Integrative
Psychotherapist
16 Riverside Road
Oxford OX2 0HU
01865 723613
CCBP

STEVENSON, Beaumont
Group Analyst
School House, School Lane
Stanton St John
Oxford OX33 1ET
01865 351 635
IGA

STEWARD, Jill
Psychoanalytic Psychotherapist
Kenricks, Hambleden
Henley-on-Thames
Oxon RG9 6RP
01491 571 320
FPC

STRICH, Sabina
Group Analyst
1 Folly Bridge Court
Thames Street
Oxford OX1 1SW
01865 251741
IGA

TAYLOR, Susie
Psychodrama Psychotherapist
St. Brelades
15 Swinbourn Road, Littlemore
Oxford OX4 4PQ
01865 454932
BPA

TAYLOR-BROOK, Delia
Transpersonal Psychotherapist
Sweetbriar Cottage, Bridge Street
Bampton OX18 2HA
020 7266 3006/01993 852629
CCPE

THOMPSON, Patricia
Integrative Psychotherapist
"Beggars Roost"
28 Whittall Street, Kings Sutton
Banbury
Oxon OX17 3RD
01295 812232
RCSPC

THOMSON, Simon
Psychodrama Psychotherapist
13 Harcourt Road, Wantage
Oxon OX12 7DQ
01734 561250/01235 771344
BPA

TUCKER, Joanna
Psychoanalytic Psychotherapist
42, Oakthorpe Road
Oxford OX2 7BE
01865 557 244
WMIP

WATSON, Andrea
Child Psychotherapist
12 Rectory Road
St. Clements
Oxford OX4 1BW
01865 243491
ACP

WAYGOOD, Rob
Transpersonal Psychotherapist
59 Warwick Street
Oxford OX4 1SZ
01865 247851
CTP

WILLIAMS, Gill
Psychodrama Psychotherapist
121 Southfield Road
Oxford OX4 1NY
BPA

SCOTLAND— ABERDEEN

HOUGHTON, Judith E
Cognitive Behavioural Psychotherapist
Cathkin, Glenfarquhar Road
Auchenblae
Laurencekirk AB30 1WU
01224 211055/01561 320222
BABCP

HOWIE, David D.
Hypno-Psychotherapist
9B Millburn Street, Aberdeen
Grampian AB11 6SS
01224 574190
NRHP

KOHLER, Christiane
Hypno-Psychotherapist
51 Cairngrassie Circle
Portlethen
Aberdeen AB12 4TZ
01224 781747
NSHAP

LOUGH, Mark
Integrative Psychotherapist
235 Union Grove
Aberdeen AB10 6TF
01224 572295
NGP

MACPHERSON, Malcolm
Psychoanalytic Psychotherapist
Patagonian Heights
15/17 Belmont Street
Aberdeen AB10 1JR
NAAP

MILNE, Frances
Analytical Psychologist-Jungian Analyst
3 Northcote Hill
Aberdeen AB15 7TW
01224 620 303/01224 311468
IGAP

ROBINSON, J.G.
Child Psychotherapist
South Leylodge Farmhouse
Leylodge, Kintore
Aberdeen AB5 0XY
01330 860333
ACP

SAWYER, Ken
Hypno-Psychotherapist
31 Cairngrassie Circle
Portlethen
Aberdeen AB1 4TZ
01224 781452
CTIS

WRIGHT, W. Harry
Psychoanalytic Psychotherapist
Psychotherapy Department
Upper Garden Villa
Royal Cornhill Hospital
Aberdeen AB25 2ZH
01224 663131 x57937
WMIP

SCOTLAND– AYRSHIRE

BRYANS, Sally
Sexual and Relationship Psychotherapist
Lynnholm, Laighpark Road
By Ayr KA6 6LT
01292 570415
BASRT

ROSS, Michael Killoran
Cognitive Behavioural Psychotherapist
c/o CCPS
Stradoon House
50 Racecourse Road KA7 2UZ
0141 632 9231/01292 285607
BABCP

SMITH, Alica
Hypno-Psychotherapist
17 Fotheringham Road
Ayr KA8 0EY
01292 281793
NRHP

TOLLAN, John H
Hypno-Psychotherapist
22 Stable Wynds
Loans
Troon KA10 7LY
01292 319772
CTIS

WIGHT, Zena J.
Cognitive Behavioural Psychotherapist
Clinical Psychology Services
Strathdoon House
50 Racecourse Road
Ayr KA7 2UZ
01292 285607
BABCP

SCOTLAND–BORDERS

HUNT OVERZEE, Anne
Core Process Psychotherapist
Newburgh Cottage
Ettrick
Selkirk TD7 5HS
01750 622 36
AAPP

STARK, Lynda
Core Process Psychotherapist
Old School House
Nenthorn
By Kelso TD5 7RY
01573 225 567/01573 223 001/0131
553 6660
AAPP

STILL, Arthur
Rational Emotive Behaviour Therapist
6-7 Hadden Farm Cottage
Sprouston
Kelso TD5 8HU
01890 830364
BABCP

SCOTLAND–DUMFRIES

CAMPBELL, Colin B.G.
Hypno-Psychotherapist
Scaleridge Cottage
Waterbeck
Lockerbie DG11 3EU
01461 600288
NRHP

HEPPEL, Valerie
Transactional Analysis Psychotherapist
Smithy Cottage
Kirkpatrick Durham
Castle Douglas DG7 3HT
01556 650 437
ITA

ISLES, Rosaleen
Cognitive Psychotherapist
Glebe House
Kirkmahoe
Dumfries DG1 1SY
01387 710202
BABCP

SCOTLAND–DUNDEE

ANTONSON, Kathleen Scott
Family Therapist
Child & Family Psychiatry
Centre for Child Health
19 Budhope Terrace
Dundee 01382 204004
AFT

MALCOLM, Hanne
Hypno-Psychotherapist
29 Bell Street, Tayport
Fife DD6 9AP
01382 553596
NRHP

MORTON, Richard Victor
Cognitive Behavioural Psychotherapist
40 Carlogie Road, Carnoustie,
Angus DD7 6EY
01382 632410/01241 853002
BABCP

NESS, Thomas William
Family Therapist
St. Helens
29 Mount Road, Montrose
Angus DD10 8SP
AFT

SMART, Kate
Cognitive Behavioural Psychotherapist
Lour Road Surgery
3 Lour Road, Forfar
Angus DD8 2AS
01307 463 122
BABCP

STEWART, Henry B.
Cognitive Behavioural Psychotherapist
43 Provost Reid's Road
Montrose
Angus DD10 8DZ
01674 673823
BABCP

STOCKS, Samantha
Systemic Psychotherapist
13 Smiddy Park
Kinneff
Montrose DD10 0UD
KCC

SWAN, John S.
Cognitive Behavioural Psychotherapist
Ardbeg
55 Brechin Road, Kirriemuir
Angus DD8 4DE
01575 575427
BABCP

WILSON, Fiona
Cognitive Behavioural Psychotherapist
Community Mental Health Team 2
Wedderburn House
1 Edward Street
Dundee DD1 5NS
01382 346055
BABCP

SCOTLAND–EDINBURGH

ADAMSON, Fiona
Humanistic Psychotherapist
88 Morningside Drive
Edinburgh EH10 5NT
0131 228 3841/0131 446 9436
AHPP

ANGOLD, Monica
Sexual and Relationship Psychotherapist
17 Morningside Park
Edinburgh EH10 5HD
0131 447 4342
BASRT

AYRES, Alison
Transactional Analysis Psychotherapist
31 Mayfield Road
Edinburgh EH9 2NQ
0131 551 2989/0131 667 8435
ITA

BENNETT, Rosanagh
Transpersonal Psychotherapist
59 Ashley Terrace
Edinburgh EH11 1RX
0131 337 1579
CTP

BOYLE, Pauline
Cognitive Behavioural Psychotherapist
Edinburgh Health Care Trust
Ballanden House
28–32 Howden Street
Edinburgh EH8 9HL
0131 228 4425/07775 503467
BABCP

BRAID, Rosemary
Humanistic and Integrative
Psychotherapist
8 Clarendon Crescent
Edinburgh EH4 1DT
0131 332 1449/01592 840442
AHPP

CAMPBELL, Caroline
Hypno-Psychotherapist
7/2 Academy St. Leith
Edinburgh EH6 7EE
0131 555 3267
CTIS

CASE, Caroline
Child Psychotherapist
Ground Floor, 8th Forth Street
Edinburgh EH1 3LD
0131 558 1923
ACP

CRAWFORD, George
Child Psychotherapist
4 Melgund Terrace
Edinburgh EH7 4BU
0131 557 3039
ACP

ELSDALE, Bethan
Core Process Psychotherapist
10 kirk Street
Edindburgh EH6 5EY
0131 555 1836/0131 551 5091
AAPP

FRASER, Bobbie
Sexual and Relationship Psychotherapist
Couple Counselling Scotland
40 North Castle Street
Edinburgh EH2 3BN
0131 225 5006
BASRT

FREEMAN, Christopher
Cognitive Behavioural Psychotherapist
Department of Psychotherapy
Cullen Centre
Royal Edinburgh Hospital
Morningside Pk
Edinburgh EH10 5HF
0131 225 5320/0131 537 6708
BABCP

GERRY, Marian
Family Therapist
18 Gladstone Terrace
Edinburgh EH9 1LS
0131 668 3063/0131 536 0545
AFT

GRAHAM, Patricia
Cognitive Behavioural Psychotherapist
11 Dean Park Street (1F2)
Edinburgh EH4 1JR
0131 343 6107
BABCP

GRAY, Maggie
Cognitive Behavioural Psychotherapist
Cullen Centre
29 Morningside Park
Edinburgh EH10 5HF
0131 537 6797
BABCP

HART, Mary A.M.
Hypno-Psychotherapist
3 Sciennes Road
Edinburgh EH9 1LE
0131 668 3051
NRHP

HERRMANN, Joan
Child Psychotherapist
Scottish Institute of Human Relations
56 Albany Street
Edinburgh EH1 3QR
0131 556 0924/0141 2119069
ACP

HIGGS, Jody
Core Process Psychotherapist
12 Saxe Coburg Street
Edinburgh EH3 5BN
0131 332 7987
AAPP

KENNEDY, Helen
Gestalt Psychotherapist
Edinburgh Gestalt Institute
51 Lothian Road
Edinburgh EH9 1NR
0131 228 3841
GPTI

KJELLSTROM, Laila
Psychodrama Psychotherapist
16 Roseneath Place
Edinburgh EH9 1JB
0131 553 66/0131 229 3310
BPA

KUNKLER, Jane
Cognitive Behavioural Psychotherapist
Department of Health Psychology
Astley Ainslie Hospital
133 Grange Loan
Edinburgh EH9 2HL
0131 537 9128/0131 667 3454
BABCP

LENDRUM, Susan
Psychoanalytic Psychotherapist
9 Randolph Cliff
Edinburgh EH3 9TZ
0131 225 2848
NWIDP

LONIE, Dorothy
Hypno-Psychotherapist
15 Warriston Terrace
Edinburgh EH3 5LZ
0131 552 5247
CTIS

MACNICOL, Annie
Cognitive Behavioural Psychotherapist
Dept. of Psychological Medicine
Royal Infirmary
Edinburgh EH3 9YW
0131 536 2875
BABCP

MAXWELL, Sue
Sexual and Relationship Psychotherapist
C/o 40 North Castle Street
Edinburgh EH2 3BN
0131 225 5006
BASRT

MCFARLANE, Alison M.
Cognitive Behavioural Psychotherapist
Cullen Centre
29 Morningside Park
Edinburgh EH10 5HF
0131 537 6797
BABCP

MILTON, Harry
Hypno-Psychotherapist
14 House O'Hill Road
Edinburgh EH4 2AP
0131 332 6363
NRHP

MWELWA, Edward
Hypno-Psychotherapist
4 (2F2) Hermand Terrace
Edinburgh EH11 1QZ
0131 538 0189
CTIS

NICOLSON, Elaine
Cognitive Behavioural Psychotherapist
Cullen Centre
Royal Edinburgh Hospital
29 Morningside Park
Edinburgh EH10 5HF
0131 537 6797
BABCP

PETRIE, Clare
Transpersonal Psychotherapist
17 Quality Street
Davidson's Mains
Edingburgh EH4 5BP
0131 336 4754
CCPE

RITCHIE, Robert
Hypno-Psychotherapist
The Whole Works
Jacksons Close
209 Royal Mile
Edinburgh EH1 1PZ
0131 225 8092/0131 669 1481
CTIS

ROBINSON, Peter
Cognitive Behavioural Psychotherapist
The Young People's Unit
Royal Edinburgh Hospital
Tipperlinn Road
Edinburgh EH10 5HF
0131 537 6364
BABCP

RUSSELL, Wilson J
Group Analyst
27 Falcon Avenue
Edinburgh EH10 4AN
IGA

SHEWAN, Alistair
Hypno-Psychotherapist
3 Castle Wynd North
Edinburgh EH1 2NQ
0131 225 6537
NRHP

SHORTER, Bani
Analytical Psychologist-Jungian Analyst
9 South East Circus Place
Edinburgh EH3 6TJ
0131 225 1297
IGAP

SIBLEY, Susan
Child Psychotherapist
17 Ferryfield
Edinburgh EH5 2PR
0131 551 2613
ACP

SMITH, Gerry
Transpersonal Psychotherapist
Tara Rokpa Edinburgh
250 Ferry Road
Edinburgh EH3 5AN
01968 660786/0131 552 1431
CTP

SMITH, Nora
Analytical Psychologist-Jungian Analyst
30/5 Elbe Street
Edinburgh EH6 7HW
0131 553 5082
CAP

STEVEN, David B.
Hypno-Psychotherapist
The Brunstsfield Centre
16 Granville Terrace
Edinburgh EH10 4PQ
0131 229 7823
NRHP

WILLIAMS, Guinevere
Gestalt Psychotherapist
4 East Brighton Crescent
Portobello
Edinburgh EH15 1LR
0131 228 3841/0131 657 3496
GPTI

SCOTLAND-FALKIRK

KENNEDY, Kay
Individual and Group Humanistic
Psychotherapist
Dalmore, 15 High Station Road
Falkirk FK1 5LP
01324 621930
AHPP

LINDSAY, Robert
Family Therapist
Glenoonah
Kippey
Stirling FK8 2EW
01786 870414
AFT

WILSON, Tom C
Cognitive Behavioural Psychotherapist
Westbank Day Clinic
Westbridge Street
Falkirk FK1
01324 624111
BABCP

SCOTLAND-FIFE

AGNEW, Joyce
Personal Construct Psychotherapist
Citra, Cupar Road
Ceres
Fife KY15 5LP
01334 828340
CPCP

KNOWLES, Elisabeth A
Psychoanalytic Psychotherapist
Ivy Cottage
Letham Toll, By Cupar
Fife KY15 7RT
01337 810239
UPA

MIDDLETON, Margaret
Hypno-Psychotherapist
Glenesk
20 Lade Braes, St. Andrews
Fife KY16 9DA
01334 475270
CTIS

SCOTLAND-GLASGOW

ANDREW, Alison
Family Therapist
10 Belhaven Terrace
Great Western Road
Glasgow G12
0141 357 6404
AFT

BATES, Helen Mary
Family Therapist
12 Skaterigg Drive
Jordanhill
Glasgow G13 1SR
0141 959 4975
AFT

BEGG, Deike
Psychosynthesis Psychotherapist
30 Westbourne Gardens
Glasgow G12 9PF
0141 334 1963
AAPP

BEGG, Ean
Analytical Psychologist-Jungian Analyst
30 Westbourne Gardens
Glasgow G12 9PF
0141 334 8391
IGAP

BROWN, Teresa
Psychodrama Psychotherapist
Stoneleigh
48 Cleveden Drive, Kelvinside
Glasgow G12 0NU
0141 3348908
BPA

CARRUTHERS, Barbara
Humanistic Psychotherapist
115 Downanhill Street
Glasgow G12 9EQ
0141 357 3371/01555 860371
AHPP

CHRISTIE, Jim
Group Analyst
The Garnethill Centre Ltd.
28 Rose Street
Glasgow G3 6RE
0141 333 0730/0141 333 0737
IGA

CHRISTIE, Marilyn
Cognitive Behavioural Psychotherapist
SCOTACS
201a Bath Street
Glasgow G2 4HZ
0141 226 4373
BABCP

COIA, Grace
Hypno-Psychotherapist
10 Carment Drive
Glasgow G41 3PP
0141 632 6663
NRHP

DUNCAN, E.A.S
Cognitive Behavioural Psychotherapist
2/2 44 Albert Avenue
Queens Park
Glasgow G42 8RE
01555 840293/0141 423 2592
BABCP

DUNCAN, Sheila
Family Therapist
Department of Child & Family Psychiatry
Yorkhill NHS Trust
Glasgow G3 8SJ
0141 201 0228
AFT

ELLWOOD, Jane
Child Psychotherapist
Department of child & Family Psychiatry
Royal Hospital for Sick Children
Glasgow G3 8SJ
0141 201 0228
ACP

FISCHER, Ulrich J
Cognitive Behavioural Psychotherapist
The Arndale CMHT
80-90 Kinsfauns Drive
Glasgow G15 7TS
0141 211 6184/01360 620845
BABCP

FRASER, Douglas A.
Psychoanalytic Psychotherapist
5 Hampden Terrace
Mount Florida
Glasgow G42 9XG
01772 401370/0141 632 3800
WMIP

HAMILTON, Angela
Psychoanalytic Psychotherapist
The Garnethill Centre
28 Rose Street
Glasgow G3 6RE
0141 333 0730
LPDO

HAY, Patricia
Core Process Psychotherapist
13 North Gardner Street
Glasgow G11 5BU
0141 334 3700/0141 334 7965
AAPP

HOGG, Christine Retson
Hypno-Psychotherapist
26 Westbourne Crescent
Bearsden
Glasgow G61 4HD
0141 570 1425
NRHP

JEWSON, Sue
Psychodynamic Psychotherapist
5 Buckingham Terrace
Great Western Road
Glasgow G12 8EB
VAPP

MACDONALD, Ross
Hypno-Psychotherapist
Aros
2 Campbell Drive
Dumbarton G82 3QH
01389 732104
NRHP

MACKINNON, Hetty
Autogenic Psychotherapist
An Airigh
20 Borden Road
Glasgow G13 1QX
0141 959 3230
BAS

MCCONNOCHIE, Charlie
Cognitive Behavioural Psychotherapist
Scottish Society of therapy
andCounselling Studies
201a Bath Street
Glasgow G2 4HZ
0141 226 4373
BABCP

MCMASTER, Catherine
Cognitive Psychotherapist
SCOTACS
201A Bath Street
Glasgow G2 4HZ
0141 226 4373
BABCP

MOLLESON, John Ivitsky
Cognitive Behavioural Psychotherapist
Scottish Training & Counselling Serv.
201A Bath Street
Glasgow G2 4HZ
0141 226 4373
BABCP

MOODIE, Alastair
Transactional Analysis Psychotherapist
5 Buckingham Terrace
Glasgow G12 8EB
0141 357 6790
ITA

PUSZTAI, Edit E.
Cognitive Behavioural Psychotherapist
Department of Psychiatry
Southern General Hospital
1345 Govan Road
Glasgow G5 4TF
0141 201 1906
BABCP

SCANLAN, Celia
Psychodrama Psychotherapist
Heather Cottage
The Clachan
Rosneath
Argyll Bute G84 0RF
01436 831735
BPA

SCOTT, Jan
Cognitive Behavioural Psychotherapist
Dept of Psychological Medicine
Gartnavel Royal Hospital
1055 Great Western Road
Glasgow G12 0XH
BABCP

SHEARER, Annette
Hypno-Psychotherapist
The Phoenix Centre
201 St. James Road
Glasgow G4 0NT
01899 830288/0141 553 2353
NRHP

TURNER, Martin S.
Cognitive Behavioural Psychotherapist
Larkfield Centre
Garngaber Avenue
Lenzie
Glasgow G66 3UG
0141 776 7100
BABCP

SCOTLAND-HIGHLANDS

EDMONSTONE, Yvonne G.
Cognitive Behavioural Psychotherapist
Craig Dunain Hospital
Inverness IV3 6JU
01463 234001
BABCP

SCOTLAND-LANARKSHIRE

CHILD, Nick
Family Therapist
Child 7 Family Clinic
49 Airbley Road, Motherwell ML1 2TJ
01689 254551
AFT

HUME, Anne J.A.
Cognitive Behavioural Psychotherapist
The Coach House
67a Carlisle Road
Crawford, Bigger
Lanarkshire ML12 6TP
01698 711405
BABCP

STRUTHERS, Morag
Sexual and Relationship Psychotherapist
Couple Counselling Inverclyde
195 DaLrymple Street
Greenock, Renfrewshire PA15 1LD
01475 714100
BASRT

SULLIVAN, E. Mary
Integrative Psychotherapist
11 Gilmour Street
Paisley PA1 1DD
0141 840 1455/020 7739 2329
RCSPC

SCOTLAND-LOTHIAN

AUSTRIN, Chris
Transpersonal Psychotherapist
5 Ugston Farm Cottage
Haddington, East Lothian EH41 3SR
CCPE

BIENKOWSKI, Geraldine
Cognitive Behavioural Psychotherapist
Psychology Department
St John's Hospital
Howden, Livingston EH54 6PP
01506 422769
BABCP

BROWN, Thomas M.
Cognitive Behavioural Psychotherapist
St Johns Hospital at Howden
Livingston, West Lothian EH54 699
01506 419666
BABCP

MACFADYEN, John
Core Process Psychotherapist
'Morhamloanhead'
Morham, by Haddington
East Lothian EH41 4LH
0162 082 5300/01506 823 118
AAPP

MCDONALD, Christina
Transpersonal Psychotherapist
39 West Crescent, East Saltoun
East Lothian EH34 5EF
01875 341191
CTP

TENNANT, Duncan
Family Therapist
Department of Family Psychiatry
St John's Hospital
Howden Road, West Livingstone,
West Lothian EH54 6PP
01506 419666/01506 811727
AFT

SCOTLAND-MORAY

SHERIFFS, Alison
Psychosynthesis Psychotherapist
Fishermans Bothies
The Mains of Sluie
Dunphail, Forres
Moray
01309 611 263
AAPP

YOUNG, Courtenay
Humanistic Psychotherapist
The Park
Findhorn, Forres
Moray IV36 0TZ
01309 690251
AHPP

SCOTLAND-PERTH

DOLAN, Lesley Catherine
Cognitive Behavioural Psychotherapist
Murray Royal Hospital
Perth PH2 7BH
01738 621 151
BABCP

YATES, Kathleen
Integrative Psychotherapist,
Psychodynamic Psychotherapist
Blairs Farm
Trinity Gask
Madderty, Auchterarder
Perthshire PH3 1LL
01764 683385
WMIP

SCOTLAND-STIRLING

TURNER, Senga
Transpersonal Psychotherapist
7 Allan Park
Stirling FK8 2QG
01786 465211
CTP

YOUNG, Katherine
Cognitive Behavioural Psychotherapist
20 Kellie Place
Alloa
Clackmannanshire FK10 2DW
01786 434000 x 78413/
01259 314623
BABCP

SHEFFIELD

ALLEN, Penny
Integrative Psychotherapist
415 Fulwood Road S10 3GF
0114 230 5702
SPTI

ARNESEN, E
Educational Therapist
21 Horndean Road S5 6UJ
0114 2442171
FAETT

BARKER, Lily
Psychodynamic Psychotherapist
14 Southbourne Road S10 2QN
0114 266 2565
HIP

BEARD, Hilary
Psychodynamic Psychotherapist
177 Rustlings Road S11 7AD
0114 268 5884
HIP

BENNISON, Judy
Psychodynamic Psychotherapist
Moorland View Farm
Commonside Road
Barlow
Derbyshire S18 5SJ
0114 289 0898
HIP

BERRY, Juliet
Psychodynamic Psychotherapist
Cobb Barn, Smalldale
Hope Valley S33 2JQ
01433 620618
HIP

BLACKBURN, John
Rational Emotive Behaviour Therapist
Specialist Psychotherapy Directorate
St. Georges CMHC
Winter Street S3 7ND
0114 271 6926
BABCP

BLACKER, Polly
Psychoanalytic Psychotherapist,
Psychodynamic Psychotherapist
32 Havelock Street S10 2FP
0114 272 1814
HIP

BOYSAN, Zehra
Psychoanalytic Psychotherapist
2 Moorbank Close S10 5TP
0114 230 1050
HIP

BRADY, Alec
Cognitive Behavioural Psychotherapist
25 Hunshelf Park
Stocksbridge S36 2BT
0468 593117/0114 288 3276
BABCP

COLVER, Stephen
Psychoanalytic Psychotherapist
16 Alms Hill Road
Parkhead S11 9RS
0114 2620364
GUILD

COOPER, Faye
Sexual and Relationship Psychotherapist
The Porterbrook Clinic
Woofinden Road S10 3TL
BASRT

DAINES, Brian
Psychoanalytic Psychotherapist,
Psychodynamic Psychotherapist, Sexual
and Relationship Psychotherapist
Ferndale
61 Fern Road S6 5AX
0114 233 5641
BASRT

DALE, Carole
Psychodrama Psychotherapist
99 Meersbrook Park Road S8 9FP
0114 258 8088
BPA

DAVIES, John
Cognitive Behavioural Psychotherapist
Specialist Psychotherapy Directorate
Brunswick House
299 Glossop Road S10 2HL
0114 271 8140/0973 305578
BABCP

DE CARTERET, John
Psychodynamic Psychotherapist
Springwoods
Thornhill, Bamford
Hope Valley S33 0BR
01433 651865
HIP

DONOVAN, Maxine
Psychodynamic Psychotherapist
20 Birkendale View S6 3NN
0114 233 4034
HIP

DRUCQUER, Helen
Analytical Psychotherapist,
Psychodynamic Psychotherapist
84 Southgrove Road S10 2NQ
0114 268 5240
HIP

EDWARDS, David
Psychodynamic Psychotherapist
93 Fraser Road,
Woodseats S8 0JU
0114 274 9117
HIP

ELLIS, Lynda
Psychoanalytic Psychotherapist
16 East Grove Road S10 2NN
0114 266 9616
HIP

EMBLETON-TUDOR, Louise
Integrative Psychotherapist
Temenos, 13a Penrhyn Road
Hunter's Bar S11 8UL
0114 266 3931
MC

FARQUHARSON, Graeme
Group Analyst
Centre for Psychotherapeutic Studies
University of Sheffield
16 Claremont Crescent S10 2TA
01765 608452
IGA

FITZGERALD, Geariod
Psychoanalytic Psychotherapist
Brunswick House
299 Glossop Road S10 2HL
0114 271 6890
HIP

GARLOVSKY, Rita
Psychoanalytic Psychotherapist
41 Oakhill Road
Nether Edge S7 1SJ
0114 258 7190
GUILD

GEORGE, Stephen
Gestalt Psychotherapist
52 Wadbrough Road S11 8RG
0114 2662044
SPTI

GUDJONSSON, Ingolf
Psychoanalytic Psychotherapist,
Psychodynamic Psychotherapist
69 Nether Edge Road S7 1RW
01302 734793/5/0114 255 3516
HIP

GUITON, Anita
Psychoanalytic Psychotherapist
88 Upperthorpe S6 3NF
0114 233 6525/07974 545 202
HIP

HADDOCK, Ray
Analytical Psychotherapist, Group Analyst
Brunswick House
229 Glossop Road S17 3QU
0114 271 6894
IGA

HALLAM-JONES, R.A.
Sexual and Relationship Psychotherapist
c/o The Porterbrook Clinic
Woofinden Road S10 3TL
0114 271 6671
BASRT

HALLY, Diane
Psychoanalytic Psychotherapist
61 Crescent Road
Nether Edge S7 1HN
0114 255 3780
HIP

HART, Carolyn
Child Psychotherapist
Shirle Hill Hospital
6A Cherry Tree Road S11 9AA
0114 268 4480/0114 271 6860
ACP

HAWKSWORTH, Janet
Gestalt Psychotherapist
90 Brincliffe Edge S11 9BW
0114 2586192
SPTI

HOPE, David
Gestalt Psychotherapist
40 The Quadrant
Totley S17 4DB
0114 236 2009
SPTI

HOWLETT, Stephanie
Psychoanalytic Psychotherapist
66 Psalter Lan S11 8YQ
0114 268 2483
HIP

HUNT, Patricia A.
Psychoanalytic Psychotherapist
Share Psychotherapy Agency
176 Crookesmoor Road S6 3FS
0114 268 2883
HIP

HUWS, Rhodri
Sexual and Relationship Psychotherapist
St George's CHC
Winter Street S3 7ND
0114 271 8939
BASRT

KENDALL, Tim
Psychoanalytic Psychotherapist,
Psychodynamic Psychotherapist
Lightwood House
Lightwood Lane S8 8BG
0114 271 8740/8710/
0114 271 6695
UPA

KITCHIN, Duncan
Gestalt Psychotherapist
Flat 8
18 Endcliffe Crescent S10 3ED
0114 2670118
SPTI

KNOWLES, Louise
Gestalt Psychotherapist
127 Alexandra Road
Heeley S2 3EH
SPTI

LEESON, Julie
Psychodrama Psychotherapist
93 Fraser Road
Woodseats S8 0JH
01246 552562/01142 749117
BPA

LIDMILA, Alan
Psychoanalytic Psychotherapist
5 Cliffe House
10 Whitworth Road
Ranmoor S10 3HD
0114 230 9163
HIP

LOBATTO, Wendy
Family Therapist
Child and Family Therapy Team
Beighton Community Hospital
Sevenairs Road S2 6NZ
0114 271 6542
IFT

LOFTUS, Patrick A.
Psychodynamic Psychotherapist
114 Industry Street
Walkley S6 2WX
0114 233 6570
HIP

MACASKILL, Norman D.
Cognitive Behavioural Psychotherapist
52 Linden Avenue S8 0GA
01132 439000/0114 281 7561
BABCP

MACNEILL, Enid
Psychodrama Psychotherapist,
Psychodynamic Psychotherapist
21 Knaresborough Road S7 2LA
0114 236 4349
BPA

MAITLIS, Marion
Psychoanalytic Psychotherapist,
Psychodynamic Psychotherapist
13 Park Avenue S10 3EY
0114 266 0888
HIP

MARSHALL, Myra
Psychoanalytic Psychotherapist
11 Rutland Park
Broomhill S10 2PB
HIP

MCAULEY, John
Psychodynamic Psychotherapist
Share Psychotherapy Agency
176 Crookesmoor Road S6 3FS
HIP

METTAM, Lisa
Cognitive Behavioural Psychotherapist
Specialist Psychotherapy Services
Brunswick House
299 Glossop Road S10 2HL
0114 271 6890
BABCP

MITCHELL, Paul Christoph
Integrative Psychotherapist
28 Edgedale road
Nether Edge S7 2BQ
0114 258 1192
SPTI

MONACH, Jane
Psychodynamic Psychotherapist
Cocked Hat Cottage
100 Bolehill Lane
Crookes S10 1SD
0114 266 7395
HIP

MOORE, Margaret C
Sexual and Relationship Psychotherapist
Goatscliff Farm
Stoke Grindleford
Hope Valley S30 2HW
01433 631259
BASRT

ORAM, John E.D.
Psychodynamic Psychotherapist
John Oram & Associates Psy. Centre
13 Rustlings Road S11 7AA
0114 266 3910/0114 221 4982
HIP

PARDOE, Kathleen A
Psychoanalytic Psychotherapist
14 Steade Road S7 1DS
0114 2589123
UPA

PARRY, Glenys
Cognitive Analytic Therapist
Director of Research & Development
Comm. Health Sheffield NHS Tru
Fulwood House
Old Fulwood Rd. S10 3TH
0114 271 8804
ACAT

PERRETT, Angelina
Sexual and Relationship Psychotherapist
53 Endowood Road S7 2LY
0114 236 5973
BASRT

PETHEN, Susan
Psychodynamic Psychotherapist
62 Brincliffe Edge Road S11 9BW
0114 255 1576
HIP

PICKVANCE, Deborah
Psychodynamic Psychotherapist
108 Carr Road S6 2WZ
HIP

PORTEOUS, Louise
Psychodynamic Psychotherapist
151 Chelsea Road S11 9BQ
0114 258 1644
HIP

RAYNER, Beryl Ann
Psychoanalytic Psychotherapist,
Psychodynamic Psychotherapist
5 Sherwood Chase
Totley Brook Road S17 3QT
0114 236 2825/0114 236 0890
HIP

READ, Nicholas W
Psychoanalytic Psychotherapist
74 Nairn Street S10 1UN
0114 267 8633
HIP

REJAIE, Carol
Psychoanalytic Psychotherapist
12 Lawson Road
Broomhill S10 5BW
0114 268 6965
UPA

RICKETTS, Thomas N.
Cognitive Behavioural Psychotherapist
Sheffield Health Authority
Brunswick House
299 Glossop House S10 2HL
0114 271 6890
BABCP

ROBINSON, Felicity
Psychodynamic Psychotherapist
12 Brincliffe Edge Road S11 9BW
0114 255 2989
HIP

ROSEMARY, Margaret
Gestalt Psychotherapist
3 Strathtay Road
Greystones S11 7GU
0114 266 0229
GPTI

ROSENFELD, Angela
Group Analyst
78 Carr Road
Walkley S6 2RW
01742 330523
IGA

ROSENTHAL, Hat A
Group Analytic Psychotherapist
Fairview
Primrose Bank, Gilstead
Bingley S10 5BW
01274 562903
UPA

SADGROVE, Jenny
Analytical Psychologist-Jungian Analyst
Provosts Lodge
22 Hallamgate Road S10 5BS
0114 266 2373
WMIP

SHIPTON, Geraldine
Psychoanalytic Psychotherapist
7 Psalter Lane S11 8YL
0114 222 2980/0114 255 4326
HIP

SMITH, Val
Group Analyst
Flat 2, Hopton House
27 Collegiate Crescent S10 2BJ
0114 271 6894/0114 268 6429
IGA

TANTAM, Digby
Group Analyst, Psychodynamic
Psychotherapist
Centre for Psychotherapeutic Studies
16 Claremont Crescent S10 2TA
0114 222 2000/2979
UPA

THOMSON, Pat
Psychodynamic Psychotherapist
35 Slayleigh Avenue S10 3RA
0114 230 7471
HIP

TODD, Margaret C
Psychodynamic Psychotherapist
16 Prospect Road
Coal Aston
Dronfield
N E Derbeyshire S18 6EA
01246 415 175
HIP

TUDOR, Keith
Transactional Analysis Psychotherapist
13A Penrhyn Road
Hunter's Bar S11 8UL
0114 266 2275/0114 266 3931
MET

VAN DEURZEN, Emmy
Existential Psychotherapist
The Cottage, 3 Hollow Meadows Mews
Hollow Meadows
Peak National Park S6 6GJ
020 7928 4344/0114 230 9990
UPA

WARD, Carol
Cognitive Psychotherapist
53 Woodstock Road
Loxley S6 6TG
0114 233 0101/01484 303007
BABCP

WILSON, Llynwen
Sexual and Relationship Psychotherapist
25 Meadow Bank Avenue S7 1PB
0114 255 1234
BASRT

WRATTEN, Stephen
Family Therapist
Child & Family Therapy Team North
Rivermead Unit
Northern General Hospital S5 7AU
0114 226 1921/0114 226 1923
AFT

WYLIE, Kevan R.
Sexual and Relationship Psychotherapist
Porterbrooke Clinic, Whiteley Wood
Clinic
Woofinden Road S10 3TL
0114 271 8011
BASRT

SHROPSHIRE

BLACK, Teresa J.
Psychoanalytic Psychotherapist
Upper House
Buildwas Road
Ironbridge
Salop TF8 7DW
01952 433373
NWIDP

FOX, Margaret
Family Therapist
83 King Street
Cherry Orchard
Shrewbury SY2 5ET
01743 367114
AFT

FRASER, Mary Elizabeth
Psychoanalytic Psychotherapist
10 Holywell Terrace
Holywell Street
Shrewsbury SY2 SDF
WMIP

GILLINGHAM, Michael
Cognitive Behavioural Psychotherapist
9 Farmlodge Lane
Shrewsbury SY1 3ST
0161 419 5766/01743 243961
BABCP

GOODWILLIE, Gill
Systemic Psychotherapist
"Invergarry"
15 North Hermitage
Belle Vue SY3 7JW
01743 249 194
KCC

GRIFFITHS, Tina C
Cognitive Analytic Therapist
The Mount Day Hospital
1 Haygate Road
Wellington
Telford TF1 1QX
01952 641580
ACAT

HARVEY, Sandra
Integrative Psychotherapist
The Oaklands
Shrewsbury Road
Pontesbury SY5 0PY
01743 790019
RCSPC

MATTHEWS, Sharon
Cognitive Behavioural Psychotherapist
The Mount
1 Haygate Road
Wellington
Teleford TF1 1QX
01952 641580
BABCP

MORGAN, Elizabeth A
Sexual and Relationship Psychotherapist
Holly's Corner, 70 Kingston Drive
London Road
Shrewsbury SY2 6SJ
01743 354007
BASRT

OWEN, Ian
Integrative Psychotherapist
21 Woodhouse Lane
Horsehay
Telford TF4 3BL
RCSPC

PURNELL, Chris
Attachment-based Psychoanalytic
Psychotherapist
Fern Cottage
5 St Luke's Road
Doseley
Telford TF4 3BE
01952 503523
CAPP

RATOFF, Tammy
Psychoanalytic Psychotherapist
1 Greyfriars
Bridgenorth WV16 4JX
01746 768675(t/f)
WMIP

SPENCER, Margaret
Psychoanalytic Psychotherapist
44 Underdale Road
Shrewsbury SY2 5DT
01743 232103
WMIP

THORLEY, Helen
Psychoanalytic Psychotherapist
Black Firs
Birks Drive, Ashley Heath
Near Market Drayton TF9 4PQ
01630 672636
LPDO

WARD, Dawn
Hypno-Psychotherapist
2 Fairfields
Chapel Lane, Yorton Heath
Shrewbury SY4 3HA
01548 876113
NSHAP

WINTER, Sophia
Transpersonal Psychotherapist
Gable End
Livesey Road
Ludlow SY8 1EY
01584 879124
CCPE

SOMERSET

ALEXANDER, Paul T.
Cognitive Behavioural Psychotherapist
Pain Clinic
Taunton & Somerset Hospital
Musgrove Park
Taunton TA1 5DA
01823 343 770
BABCP

BODDAERT, Michael
Transpersonal Psychotherapist
"Earlwood"
22 Hexton Road
Glastonbury BA6 8HL
01458 830063
CTP

BROUGHTON, Vivian
Gestalt Psychotherapist
Fox Cottage, 49 Witham Friary
Near Frome BA11 5HF
01985 217158/01749 850661
GPTI

BURBACH, Frank
Cognitive Behavioural Psychotherapist
Psychology Department
Rosebank
Priory Parks
Wells Somerset BA5 1TH
01749 670445
BABCP

CASHFORD, Jules
Analytical Psychologist-Jungian Analyst
Woolmington Farmhouse
Ilford, Ilminster TA19 9EB
01460 53280
AJA

GOTTLIEB, Sue
Psychoanalytic Psychotherapist
Babbs Farm
Westhill Lane, Watchfield
Highbridge TA9 4RF
01278 793244
SIP

GOTTO, Jane
Humanistic and Integrative
Psychotherapist
The Terrace
Therapy and Natural Health Centre
35 Staplegrove Road
Taunton TA1 1DU
01823 338968
SPEC

GREGORY, Kirby
Cognitive Analytic Therapist
2 Exeter Close
Burnham on Sea TA8 1JF
01278 795406
ACAT

GROVES, Stephanie
Humanistic and Integrative
Psychotherapist
Steps Farm
7 St Mary's Road
Meare
Glastonbury BA6 9SL
0458/01458 860 243
BCPC

HOPKINS, Jill
Psychoanalytic Psychotherapist
Badger's Hay, Lodes Lane
Kingston St. Mary
Taunton TA2 8HU
01823 451656
GUILD

HOWE, Patricia
Psychosynthesis Psychotherapist
27 Roman Way
Glastonbury BA6 8AB
01458 833864
AAPP

LOCKIE, Gisela
Body Psychotherapist, Integrative
Psychotherapist
215 Greenway Road
Taunton TA2 6LN
01823 323240
CCBP

MITCHELL, John
Gestalt Psychotherapist
Fox Cottage
Witham Friary
Nr. Frome BA11 5HF
01985 217158/01749 850661
GPTI

NOWLAN, Kate
Psychoanalytic Psychotherapist
3 West End
Frome BA11 3AD
01373 464919/0589 979 686
FPC

PARFITT, Will
Psychosynthesis Psychotherapist
27 Roman Way
Glastonbury BA6 8AB
01458 833864
AAPP

PROCTER, Harry
Family Therapist, Personal Construct
Psychotherapist
Petrel House
Barclay Street
Bridgwater TA6 5YA
01278 446782/01278 446909
CPCP

PROCTOR, Ann
Transpersonal Psychotherapist
Coombe Quarry
Keinton Mandeville
Nr Somerton TA11 6DQ
01458 223215
CTP

QUARRY, Andrew
Cognitive Behavioural Psychotherapist
Beech Court, Southgate Park
Taunton Road
Bridgwater TA6 3LS
01278 444737
BABCP

ROBINSON, Louise
Humanistic and Integrative
Psychotherapist
38 Belvedere Road
Taunton TA1 1HD
01823 353009
MC

ROSE, Alivia
Gestalt Psychotherapist
22 Holmoaks
Butleigh BA6 8UB
0145/8 851016
GCL

SANDERS, Jane
Core Process Psychotherapist
10 High Street
Glastonbury
01458 833382/01458 834 236
AAPP

SCHOLEFIELD, Miranda
Humanistic and Integrative
Psychotherapist
Cedar Cottage, Barrow Lane
Pilton BA4 4BH
0749/0749
BCPC

SCOTT, Judy
Integrative Psychotherapist
The Old School House
Church Street
Croscombe
Near Wells BA5 3QS
01749 343069
MET

SCOVELL, Michael
Psychoanalytic Psychotherapist
8a St.James Street
Taunton TA1 1JH
01823 323006
SIP

TAIT, Adrian
Psychoanalytic Psychotherapist
Flat 3, 62 Trull Road
Taunton TA1 4QL
01823 321588
GUILD

THOMAS, Madeleine
Cognitive Behavioural Psychotherapist
Ashford Lodge
Cannington
Bridgwater TA5 2NL
01278 671595
BABCP

VOSS, Tony
Gestalt Psychotherapist
Cedar Cottage
Barrow Lane
Pilton BA4 4SA
01749 899036
GPTI

WEDDERKOPP, Abigail
Psychoanalytic Psychotherapist
St Michael's
3 Upper High Street
Tauton TA1 3PX
01823 353409/01823 327917
SIP

WELLINGS, Nigel
Psychoanalytic Psychotherapist
Wells Cootage
Kingweston Road
Charlton Mackrell TA11 6AH
01458 223099/020 7935 2294
AGIP

WELLS, Roger
Psychoanalytic Psychotherapist
Prioryfield House
20 Canon Street
Taunton TA1 1SW
01823 323363/01392 494466
GUILD

WILLIAMS, Nigel
Humanistic and Integrative
Psychotherapist
38 Belvedere Road
Taunton TA1 1HD
01823 353009
MC

WILSON, Jim
Humanistic and Integrative
Psychotherapist
6 Malvern Terrace
Taunton TA2 7PN
BCPC

WINDLE, Ruth
Analytical Psychologist-Jungian Analyst,
Psychoanalytic Psychotherapist
25 Vallis Way
Frome BA11 3BH
020 8459 5442/01373 467 661
AJA

YOUNG, Raymond
Transpersonal Psychotherapist
25 Chamberlain Street
Wells BA5 2PQ
CCPE

ZEAL, Paul
Psychoanalytic Psychotherapist
12 Elm Grove
Taunton TA1 1EG
01823 323099
SIP

STAFFORDSHIRE

ADAMS, Megan
Hypno-Psychotherapist
Hawthorn Cottage
Church Farm
Church Road, Dosthill
Tamworth B77 1PU
01827 281233
NSHAP

ANEES, Nabil
Psychoanalytic Psychotherapist
3 Cooke Close
Penkridge
Stafford ST19 5SL
01785 715595
WMIP

BONNEBAIGHT, Andre
Hypno-Psychotherapist
17 Spruce Park
Rode Heath
Alsager
Cheshire ST7 3SQ
01270 876672
CTIS

BREEZE, Graham
Integrative Psychotherapist
87 Basford Bridge Lane
Cheddleton
Nr. Leek ST13 7EQ
01538 361193
NSAP

BROUGH, Sue
Psychoanalytic Psychotherapist
38 Gable Croft
Lichfield WS14 9RY
01543 301050
WMIP

BROWN, Kate
Gestalt Psychotherapist
11 Rockfield Avenue
Baddeley Edge
Stoke on Trent ST2 7NQ
01782 545301
SPTI

CLEGG, Alison
Sexual and Relationship Psychotherapist
4 Park Lane, Bonehill
Tamworth B78 3HX
01827 289534
BASRT

CORKER, Enid
Psychoanalytic Psychotherapist
55 Ther Avenue, Hartshill
Stoke-on-Trent ST4 6BT
01782 662655
AGIP

COX, Margaret
Analytical Psychotherapist
18, The Charters
Lichfield WS13 7LX
01543 263916
WMIP

CRISP, Jennifer
Psychodynamic Psychotherapist
Department of Psychotherapy, Richmond
Complex
Richmond Terrace
Shelton
Stoke on Trent ST1 4ND
01782 425184
WMIP

DUFFY, Gerry
Transactional Analysis Psychotherapist
19 Chapel Street
Measham
Swadlincote
S Derbys DE12 7JD
01530 272772
ITA

DUNN, Elizabeth
Psychodynamic Psychotherapist
The Mount
Longton Road
Barlaston
Stoke on Trent ST12 9AA
01782 372424
VAPP

FELTON, Mo
Transactional Analysis Psychotherapist
Hynch Cottage
34 Church Road
Dordon
Tamworth B78 1RW
01827 897733
ITA

FOULKES, Michael
Systemic Psychotherapist
North Cliffs Centre for
Psychotherapy&Counselling
2 Gower Street
Newcastle ST5 1JQ
FIC

GHENT, Rita
Integrative Psychotherapist
7 Tolkien Way
Hartshill Road, Hartshill
Stoke on Trent 01782 849474
NSAP

GRAY, Peter
Family Therapist
33 Church Lane, Oulton
Nr. Stone ST15 8UB
01785 819217
AFT

GREGORY, Kayt
Integrative Psychotherapist
28 Lichfield Drive
Great Haywood
Stafford ST18 0SX
01889 882435
NSAP

GREGORY, Mary
NLP Psychotherapist
268 Branston Road
Burton-On-Trent DE14 3BS
01283 565596
ANLP

GRIFFITHS, E Anne
Psychoanalytic Psychotherapist
59 Stockwood Road
Seabridge
Newcastle ST5 3LQ
01782 611972
UPA

HALLARD, Sharon
Group Analyst
31a St Edward Street
Leek ST13 5DN
0831 295599
IGA

HARRINGTON, Leslie
Psychoanalytic Psychotherapist
The Spires Practice
St Chad Health Centre
Dimbles Lane
Linchfield WS13 7HT
01543 258987
WMIP

HORROCKS, Pam
Psychodynamic Psychotherapist
36 Station Road
Alsager
Stoke on Trent ST7 2PP
01270 877284
VAPP

KUNDU, Arabinda
Sexual and Relationship Psychotherapist
Coach House
St Michaels Hospital
Trent Valley Road
Lichfield, WS13 6EF
01543 414555
BASRT

MOYES, Theresa
Cognitive Behavioural Psychotherapist
The Chartley Centre
The Foundation NHS Trust
Corporation Street
Stafford ST16 3AG
01785 57888 x 5656
BABCP

NEWELL, Adrian
Cognitive Psychotherapist
Clinical Psychology Service
Foundation NHS Trust
Corporation Street
Stafford ST16 3AG
01785 221429
BABCP

OSBORN, James
Family Therapist
Child & Fam.Consultation Centre
161 Eccleshall Road
Stafford ST16 1PD
01785 222708
FIC

REAGAN, Catherine
Integrative Psychotherapist
18 Hartington Street
Wolstanton
Newcastle-under-Lyme ST5 8DR
01782 866973
NSAP

WHEELEY, Shirley
Psychoanalytic Psychotherapist (Jungian)
70 Fecknam Way, Lichfield
Staffs WS13 6AN
01543 264801
WMIP

WILES, Margaret
Integrative Psychotherapist
18 Cornwall Avenue
Clayton
Newcastle under Lyme ST5 3DJ
01782 614222
NSAP

ALLEN, Tessa
Psychoanalytic Psychotherapist
63 Victoria Road
Woodbridge IP12 1EL
01394 388654
NWIDP

BARRETT, Jenny
Psychoanalytic Psychotherapist
"Hardle" Monk Soham Green
Woodbridge IP13 7EZ
01728 628538
CSP

BUCKLER, Jackie
Sexual and Relationship Psychotherapist
9 Gurdon Road
Grundisburgh
Woodbridge IP13 6XA
0797 990 6848
BASRT

CRAIB, Ian
Group Analytic Psychotherapist
Mill House, Kitchen Hill
Bulmer Road
Sudbury CO10 7EZ
01787 310210
LCP

CULLUM, Sylvia
Sexual and Relationship Psychotherapist
Briar Hill, Aldringham
Leiston IP16 4QL
01728 452442
BASRT

FAULL, Keith
Family Therapist
46 Oxford Road
Ipswich IP4 1NL
01473 211700
AFT

FRANCES, Jane
Humanistic Psychotherapist
Juniper Cottage
The Commons, Ashfield Road
Norton
Bury St Edmunds IP31 3NF
01359 241498
AHPP

GRAHAM, Hilary
Family Therapist
29 Benhall Green, Benhall
saxmundham IP17 1HL
01728 602563
AFT

HUGHES, Linda
Humanistic Psychotherapist
Fox Hall
The Croft
Bures CO8 5JB
01787 227195
AHPP

KEITH, Charlotte
Hypno-Psychotherapist
The Old School House
Westleton Saxmundham IP17 3AD
01728 648650
NSHAP

MCCABE, Ruth
Group Analyst
Threeways,
Coles Hill, Wenhaston
Halesworth IP19 9DS
01502 478 295
IGA

MCCORMICK,
Elizabeth Wilde
Cognitive Analytic Therapist,
Transpersonal Psychotherapist
East Friars, Dunwich
Nr. Saxmundham IP17 3DW
01728 648672
CTP

MOHAN, Terry
NLP Psychotherapist
20 Nelson Road
Bury St. Edmunds IP33 3AG
01284 701505
ANLP

PLEN, Rene
Systemic Psychotherapist
30 Grantham Crescent
Ipswich IP2 9PD
01473 411499
BASRT

RANSOME, Helen
Psychoanalytic Psychotherapist
31 Crown Street
Bury St. Edmunds IP33 1QU
01284 769205
GUILD

READER, Frances
Sexual and Relationship Psychotherapist
The Old Rectory
100 Seckford Street
Woodbridge IP12 4LZ
01394 388755
BASRT

VAIZEY, Philippa
Integrative Psychotherapist
Dragon Tye, Church Street
Belchamp St.Paul
Sudbury CO10 7DJ
01787 278704
CTP

WHITTAKER, Ruth
Sexual and Relationship Psychotherapist
Low Farm, Westleton
Saxmundham IP17 3BT
01728 648380
BASRT

WOOD-BEVAN, Martyn
Group Analytic Psychotherapist
Ipswich Psychotherapy & Counselling
Centre
10 St. Margaret's Green
Ipswich IP4 2BS
01473 216559/01603 633791
FPC

WRIGHT, Kenneth
Psychoanalytic Marital Psychotherapist
48 High Street, Hadleigh
Ipswich IP5 5AL
01473 828976
TMSI

SURREY

ASHLEY, Anne
Analytical Psychologist-Jungian Analyst
Timmynoggy House
49 Godstone Road
Purley CR8 2AN
020 8660 3099
CAP

ASTOR, Bronwen
Psychoanalytic Psychotherapist
Tuesley Manor
Godalming GU7 1UD
01483 417281
AGIP

ATKINS, Lorna
Family Therapist
25 Mayflower Drive
Yately GU46 7RR
01252 683040
AFT

BAKER, Moke
Psychoanalytic Psychotherapist
59 Hillside Road
Ashtead KT21 1RZ
01372 275885
FPC

BATCHELOR, Carol
Humanistic Psychotherapist
46 Westville Road
Thames Ditton KT7 0UJ
020 8398 1053
AHPP

BAYLEY, Eva
Psychosynthesis Psychotherapist
125 Addison Road
Guildford GU1 3QE
01483 31552
AAPP

BEER, Margaret
Psychoanalytic Psychotherapist
7 Fabyc House
Cumberland Road
Kew Gardens TW9 3HH
020 8940 7353
FPC

BENJAMIN, Joan E
Psychoanalytic Psychotherapist
The Roses
Farnham Lane GU27 1HA
01428 644605
AGIP

BENNETT, Margaret
Family Therapist
285 Kings Road
Kingston KT2 5JJ
020 8390 8151/020 8546 9785
IFT

BESSANT, Irene
Integrative Psychotherapist
15 Rockfield Close
Oxted RH8 0DN
01883 716313
RCSPC

BLACKWOOD, Renate
Psychoanalytic Psychotherapist
7 Esher Park Avenue
Esher KT10 9NP
01372 462852
FPC

BLAIR, George
Integrative Psychotherapist
Flat 6, 6 Uxbridge Road
Kingston upon Thames KT1 2LL
020 8974 6127
CCBP

BOA, Cherry
Cognitive Analytic Therapist
3 Holmesdale Road
Kew Gardens
Richmond TW9 3JZ
020 8940 1501
ACAT

BOA, Quint
Integrative Psychotherapist
300 Kings Road
Kingston KT2 5JL
020 8546 5190
RCSPC

BOFF, Roger
Hypno-Psychotherapist
88 Ingleboro Drive
Purley CR8 1EF
020 8668 1128
NSHAP

BOWER, Margaret
Family Therapist
5 Old Compton Lane
Farnham GU9 8BS
01252 722556
AFT

BROADBENT, Sara
Psychoanalytic Psychotherapist
4 Dynevor Road
Richmond TW10 6PF
020 8940 2228
IPSS

BROWN, Gillian A.
Family Psychotherapist
May Bank
29 Mountside
Guildford GU2 5JD
01483 504360
AFT

BUCHANAN, Sarah-Jill
Autogenic Psychotherapist
Lanercost, Lynx Hill
East Horsley KT24 5AX
01483 284497
BAS

BUCKINGHAM, Sarah
Integrative Psychotherapist
Rock Hill House
Rock Hill
Hambledon GU8 4DT
01276 678292/01428 683141
RCSPC

BUKOVICS-HEILLER, Birgit
Integrative Psychotherapist, Transactional
Analysis Psychotherapist
More House
13 Warwicks Bench
Guildford GU1 3SZ
BirgutBH@aol.com/01483 574 304
ITA

BURDEN, Michele A
Group Analytic Psychotherapist
104 The Chase
Wallington SM6 8LY
020 86883745
UPA

BURKEMAN, Fiona
Sexual and Relationship Psychotherapist
Warren Oak
Warren Road
Kingston KT2 7HB
020 8949 6714
BASRT

BURNS-LUNDGREN, Eva
Cognitive Analytic Therapist
Kingston University Student Services
Health & Counselling Section
Penrhyn Road
Kingston upon Thames KT1 2EE
020 8547 7204
ACAT

BUSH, Malcolm
Sexual and Relationship Psychotherapist
Crossway Counselling
35 Crossways
South Croydon CR2 8JQ
020 8657 2868
BASRT

CARR, Brede
Psychoanalytic Psychotherapist
9 Chepstow Rise
Croydon CR0 5LX
020 8667 0970
FPC

CARROLL, Helen
Humanistic Psychotherapist
42 Ross Road
Wallington SM6 8QR
020 8669 4474
AHPP

CASSIDY, Mandy
Integrative Psychotherapist
13 Victoria Road
Guildford GU1 4DJ
01483 566928
MET

CEDRO, Karin
Integrative Psychotherapist
175 Lichfield Court
Sheen Road
Richmond TW9 1AZ
RCSPC

CHANDLER, Diana
Psychosynthesis Psychotherapist
9 Basil Gardens
Shirley Oaks Village
Croydon CR0 8XD
020 8656 9209
AAPP

CHILD, Melanie
Family Therapist
Child Associates
83 South Street RH4 2JU
01306 741698
AFT

CHIMERA, Kathleen
Family Psychotherapist, Systemic
Psychotherapist
39 Church Walk
Leatherhead KT22 8HH
0411 731138/01372 376 577
IFT

CHINOY, Freni
Child Psychotherapist
Sutton Child & Family Clinic
Robin Hood Lane Health Centre
Camden Road
Sutton SM1 2SH
020 8770 6781
ACP

CHURCH, John
Cognitive Behavioural Psychotherapist
The Counselling Concern
66 Avenue Road, Belmont
Sutton SM2 6JB
020 8715 4547/0958 651 322
BABCP

CLARK, Margaret
Psychoanalytic Psychotherapist
11 The Broadway
Manor Lane
Sutton SM1 4BU
020 8661 0007
FPC

COHN, Hans W.
Existential Psychotherapist
7 Fabyc House
Cumberland Road
Kew TW9 3HH
020 8940 3748
RCSPC

COLDICOTT, Tim
Family Therapist
The White Cottage
Hamlash Lane
Frensham GU10 3AU
01252 792 609
AFT

COOMBES, Clare
Primal Psychotherapist
64 Montacute Road
Morden SM4 6RL
020 8640 7665
LAPP

COOPER, Jane
Gestalt Psychotherapist
67 Southdown Road
Hersham
Walton-on-Thames KT12 4PJ
01932 246 407
SPTI

COPSEY, Nigel
Humanistic Psychotherapist
30 Devon Road
Merstham RH1 3EU
01737 789824/01737 642522
AHPP

DAVENPORT, Hilary
Psychodrama Psychotherapist
4 Bradstone Brook Cottages
New Road
Chilworth GU4 8LS
01483 504882
BPA

DAVIES, Ann
Psychoanalytic Psychotherapist
The Old Dog
Kennel Hill House
Woodside Road
Chiddingfold GU8 4RF
01428 683102
AGIP

DAWSON, Neil
Family Psychotherapist
10 Grena Gardens
Richmond TW9 1XP
020 7624 8605/020 7704 6112
IFT

DAY, Laurie
Integrative Psychotherapist
4 Squirrels Way
Epsom KT18 7AQ
01372 747616
MET

DE BERKER, Patricia
Psychoanalytic Psychotherapist
Ferndown Cottage
3 Hillier Road
Guildford GU1 2JG
01483 504554
GCP

DE BERKER, Paul
Psychoanalytic Psychotherapist
Ferndown Cottage
3 Hillier Road
Guildford GU1 2JG
GCP

DHILLON-STEVENS, Harbrinder
Integrative Psychotherapist
Corner Cottage
Guildford Road
Ottershaw KT16 9RU
01932 874902 (t/f)
MET

DODSWORTH, Evelyn
Sexual and Relationship Psychotherapist
8 Croham Close
South Croydon CR2 0DA
020 8688 1468
BASRT

DOOLEY, Patricia
Psychoanalytic Psychotherapist
43 Guildford Road
Croydon CR0 2HL
020 8683 1041
FPC

DOWLING, Deirdre
Child Psychotherapist
Cassel Hospital
Ham Common
Richmond TW10 7JF
020 8390 4548/020 8940 8181
ACP

DUBINSKY, Alexandre
Child Psychotherapist
Richmond Child & Family Consultation
Centre
Windham Road Clinic
Windham Road
Richmond TW9 2HP
020 8940 4775/020 7794 5047
ACP

DUCKHAM, Jennifer
Analytical Psychologist-Jungian Analyst
7 Upper Park Road
Kingston-upon-Thames KT2 5LB
020 8546 4173
CAP

DUDLEY, Jane M
Group Analytic Psychotherapist
21 Downsway
Wjyteleafe CR3 0EW
020 86601402/020 79147233
UPA

DUFFIELD, Ruth
Transpersonal Psychotherapist
3 Albany Place
Egham TW20 9HG
01784 472069
CCPE

DUNCAN, Sally B
Sexual and Relationship Psychotherapist
The Ark,
1 George Denyer Close, Pathfields
Haslemere GU27 2BH
01428 654743
BASRT

DURBAN, Ann
Transpersonal Psychotherapist
Omega, Shaftesbury Road
Bisley GU24 9ER
01483 799277
CCPE

DYKES, Andrea
Analytical Psychologist-Jungian Analyst
Fox Glade, Bunch Lane
Haslemere GU27 1ET
01428 652363
AJA

EDELEANU, Andrea K
Cognitive Behavioural Psychotherapist
Dept. Comm. Health Psychology
Buryfields Clinic, Lawn Road
Guildford GU2 5AZ
01483 783344
BABCP

EVANS, Helen
Sexual and Relationship Psychotherapist
122 Addiscombe Court Road
Addiscombe
Croydon CR0 6TS
020 8656 3620
BASRT

EVANS, Ray
Personal Construct Psychotherapist
6 Fabyc House
8–14 Cumberland Road, Kew
Richmond TW9 3HH
020 8940 1597
CPCP

EVANS, Tricia
Sexual and Relationship Psychotherapist
38 Blackborough Road
Reigate RH2 7BX
01737 240952
BASRT

EZEKIEL, Lyn
Psychoanalytic Psychotherapist
Flat 1, June Rose House
23 Havelock Road
Croydon CR0 6QQ
020 8654 2210
GUILD

FELIX, Susie
Sexual and Relationship Psychotherapist
Tilewood
Seale Lane, Seale
Farnham GU10 1LE
01252 782509
BASRT

FIELD, Kate
Psychoanalytic Psychotherapist
31 Havelock Road
Croydon CR0 6QQ
020 8656 3666/020 8654 1566
GUILD

FISHER-NORTON, Jane
Psychoanalytic Psychotherapist
Henderson Outreach Service Team
c/o Henderson Hospital
2 Homeland Drive
Sutton SM2 5LT
020 8549 3233
ARBS

FRANCIS, Anne M.
Psychoanalytic Psychotherapist
1 Orchard Close, Epsom Road
Guildford GU1 2PR
01483 567688
AGIP

FREEMAN, Patricia Ann
Family Therapist
5 Shaftesbury Road
Richmond upon Thames TW9 2LD
020 8948 7197
AFT

GARDNER, Philippa
Cognitive Analytic Therapist
12 Mayfield Road
Weybridge KT13 8XD
01932 827374
ACAT

GLAISTER, Brian
Cognitive Behavioural Psychotherapist
135 Foxley Lane
Purley CR8 3HR
020 8660 7465
BABCP

GOWER, Myrna
Family Therapist
Cranford
14 The Crest
Surbiton KT5 8JZ
020 8390 6002/020 8399 2012
AFT

GRAYSON, Juliet
NLP Psychotherapist
268 Canbury Park Road
Kingston KT2 6LG
020 8974 5573
ANLP

GREGORY, Josie M
Transactional Analysis Psychotherapist
14 Buff Avenue
Banstead SM7 2DW
ITA

GRIMSHAW, Francoise
Personal Construct Psychotherapist
Alternatives
8 Cosdach Avenue
Wallington SM6 9RA
020 8288 2796
CPCP

HAMM, Alexandra
Integrative Psychotherapist
12 The Orangery
Ham Street
Richmond TW10 7HJ
020 8940 7266
RCSPC

HARRISON, Jacqueline
Psychoanalytic Psychotherapist
4 Wheatfield Way
Kingston Upon Thames KT1 2QS
020 8974 6862
GUILD

HART, Azina
Systemic Psychotherapist
55 Aveley Lane
Farnham GU9 8PS
01252 710 427/0973 695 884
KCC

HART, Robert
Analytical Psychologist-Jungian Analyst
7 Hallowell Avenue
Beddington CR0 4ST
020 8667 1846
CAP

HASHEMI, Beth
Psychoanalytic Psychotherapist
7 Nightingale Road
Guildford GU1 1ER
01483 563135
FPC

HASLER-WINTER, Susan
Group Analyst
25 Bodley Road
New Malden KT3 5QD
020 8949 6461
IGA

HEATLEY, John
Group Analyst
4 Pine Cottages
174 Forest Road
Liss GU3 7BX
IGA

HEAVENS, Anita
Psychoanalytic Psychotherapist
60 Melfort Road
Thornton Heath CR7 7RL
020 8684 3579
AGIP

HEDINGER-FARRELL, Korinna
Body Psychotherapist, Integrative
Psychotherapist
36 Woodbines Avenue
Kingston KT1 2AY
020 8255 3468
CCBP

HELM, Caroline
Child Psychotherapist
40 Park Road
Hampton Wick KT1 4AS
020 8977 2950
ACP

HENLEY, June
Family Therapist
Walwood House, Park Road
Banstead SM7 3ER
01737 352626
IFT

HEWETT, Rachael
Transactional Analysis Psychotherapist
13 Cambrian Road
Richmond TW10 6JQ
ITA

HOLLAND, Nicki
Integrative Psychosynthesis
Psychotherapist
Overton, Weston Green
Thames Ditton KT7 0JX
020 8398 8401
RE.V

HOLVE, Harriet
Psychoanalytic Psychotherapist
16 West End Lane
Esher KT10 8LA
01372 464529
GCP

HOPWOOD, Jean
Psychoanalytic Psychotherapist
Waverley, Somerswey
Shalford
Guildford GU4 8EQ
01483 568669
GCP

HOPWOOD, Michael
Analytical Psychotherapist
Waverley, Somerswey
Shalford
Guildford GU4 8EQ
020 7723 3584/01483 568669
GCP

HOUGHTON, Christine
Integrative Psychotherapist
3 Locke King Road
Weybridge Road KT13 0SY
01932 844478
GPTI

HUDSON, Marjorie
Psychoanalytic Psychotherapist
19 Downsview Gardens
Dorking RH4 2DX
01306 888281
FPC

HUET, Valerie
Group Analytic Psychotherapist
5 Vicarage Garden
Mitcham CR4 3BL
020 8646 5598/020 8287 4116
UPA

HUGHES, Janet
Integrative Psychotherapist
39 Mosslea Road
Whyteleafe CR3 0DR
0985 680 748/020 8668 1186
RCSPC

HUSSAIN, Fakhir
Integrative Psychotherapist
7 Kingswood Court
Marchmont Road
Richmond TW10 6EU
020 8948 4551
MC

HYDE, Dennis H
Integrative Psychotherapist
32 Amis Avenue
New Haw
Addlestone KT15 3ET
01932 345526
MC

INGHAM, Nida
Autogenic Psychotherapist, Transpersonal
Psychotherapist
Heath Cottage
Pitch Hill, Ewhurst
Nr. Cranleigh GU6 7NP
020 7379 7662/01483 277333
CCPE

JAKOBI, Sally
Analytical Psychologist-Jungian Analyst
Bench House, Ham Street
Richmond TW10 7HR
020 8940 9059/020 8332 2810
CAP

JEFFERIES, J.I.
Psychodrama Psychotherapist
15 Audley Road
Richmond TW10 6EY
020 8948 5595
BPA

JESSON, Alison
Transactional Analysis Psychotherapist
85 Fairfield Drive
Dorking RH4 1JG
01306 882357
MET

JONATHAN, Arthur
Existential Psychotherapist
'The Jays'
27 Aultone Way
Sutton SM1 3LD
020 7487 7406/020 8641 1601
RCSPC

JONES, Alan
Humanistic Psychotherapist
3 Bushey Road
Sutton SM1 1QR
020 8641 1792
AHPP

KEITH, Joyce
Sexual and Relationship Psychotherapist
Ashtead
Nr Leatherhead
Surrey
01372 275703
BASRT

KNIGHTS, Jean
Integrative Psychotherapist
Barn Close
Portsmouth Road
Milford GU8 5HP
04868/01483424024
SPTI

LAFON, Robert George
Family Therapist
36 Hardman Road
Kingston upon Thames KT2 6RH
020 8549 1922
IFT

LAKE, Moira
Gestalt Psychotherapist
11 St. John's Road
Kingston-on-Thames KT1 4AN
020 8943 5507
GPTI

LAUCHLAN, Sheila
Systemic Psychotherapist
3 Weston Avenue
Thames Ditton KT7 0NB
020 8398 8572
KCC

LAW, Susan
Body Psychotherapist, Integrative
Psychotherapist
Flat 6, 6 Uxbridge Road
Kingston-upon-Thames KT1 2LL
020 8974 6127
CCBP

LAWSON, Christine
Psychoanalytic Psychotherapist
19 The Vineyard
Richmond TW10 6AQ
020 8940 7184
PA

LIEBERMAN, Stuart
Family Therapist
The Lynbrook Priory Hospital
Chobham Road, Knaphill
Woking GU21 2QF
01483 485112/01483 797053
AFT

LINGARD, Shirley Ruth
Systemic Psychotherapist
Rosemead, Churt
Nr. Farnham GU10 2NX
KCC

LLEWELLYN, Martha Raquel
Biodynamic Psychotherapist
103 Richmond Hall Court
Richmond TW10 6BG
020 8940 4726
BTC

LOOMS, Suzanne
NLP Psychotherapist
Pinehurst
18 Southcote Road
Croydon CR2 OEQ
020 8651 5898(t/f)
ANLP

LOVETT-DARBY, Linda
Transpersonal Psychotherapist
Rua
66 Reigate Road
Ewell KT17 3DT
020 8786 7664
CCPE

LUDEN, Maureen
Transactional Analysis Psychotherapist
17 Chester Close, Kings Road
Richmond TW10 6NR
020 8940 3366
ITA

LUND, Leslie Ann
Integrative Psychotherapist
"Suncroft"
3 Norrels Ride
East Horsley KT24 5EH
01483 281435/01483 285905
RCSPC

LYNCH, Valerie
Psychoanalytic Psychotherapist
2 Church Court, Foxenden Road
Guildford GU1 4DY
01483 562204
GCP

MACKENNA, Christopher
Analytical Psychologist-Jungian Analyst,
Psychoanalytic Psychotherapist
Hascombe Rectory
Godalming GU8 4JA
01483 208362
CAP

MAHER, Michael
Group Analyst
56 Nappers Wood, Fernhurst
Nr Haslemere GU27 3PE
01428 653392
IGA

MANICOM, Hilary
Systemic Psychotherapist
A.T.S. Kingsdown
112 Orchard Road
Sanderstead CR2 9LQ
020 8651 5611
KCC

MARSHALL, Janet
Autogenic Psychotherapist
12 Churchfields Avenue
Weybridge KT13 9YA
01932 821721
BAS

MARSHALL, Jill
Hypno-Psychotherapist
6 Perryfield Way
Richmond TW10 7SP
020 8948 1573
NRHP

MARSHALL, Vivien
Psychoanalytic Psychotherapist
29 Dale Road
Purley CR8 2ED
020 8668 2148
FPC

MARTIN, Gloria
Systemic Psychotherapist
89 Durlston Road
Kingston upon Thames KT2 5RS
020 8546 8317/020 8390 8445
KCC

MAXWELL, Brian
Group Analyst
60 Chiltern Drive
Surbiton KT5 8LW
IGA

MAYNERD, Cynthia
Family Therapist
15 Smoke Lane
Reigate RH2 7HJ
01737 242051
AFT

MCCARRY, Nicola
Systemic Psychotherapist
180 Acre Road
Kingston upon Thames KT2 6EU
KCC

MCDERMOTT, Gerry
Cognitive Behavioural Psychotherapist
68 Cherry Tree Avenue
Haslemere GU27 1JP
01428 653722/07980 500248
BABCP

MELLER, Carolyn
Sexual and Relationship Psychotherapist
52 Park Hill Road
Wallington SM6 0SB
020 8669 0805
BASRT

MILTON, Martin
Integrative Psychotherapist
Department of Psychology
University of Surrey
204 Acre Road
Kingston upon Thames
01483 259176/020 8546 1686
RCSPC

MITCHELL, Diana
Existential Psychotherapist
32 Cambridge Road
Walton-on-Thames KT12 2DP
07957 181087/01932 225599
RCSPC

MORICE, Lisa
Child Psychotherapist
Cassel Hospital
Ham Common
Richmond TW10 7JF
020 8940 8181/020 8940 4199
ACP

MORICE, Michael
Child Psychotherapist
Child and Family Consultation Service
Richmond Royal Hospital
Kew Foot Road
Richmond TW10 6EF
020 8940 4199/020 8355 1984
ACP

MORRISON, Lesley
Psychoanalytic Psychotherapist
The Cottage
27 Burghley Avenue
New Malden KT3 4SW
020 8949 5628
FPC

MOUNTJOY, Lesleen
Hypno-Psychotherapist
16 Middle Bourne Lane
Lower Bourne
Farnham GU10 3NE
01252 725574
NRHP

NATH, Krish
Cognitive Behavioural Psychotherapist
72 Chaffers Mead
Ashtead KT21 1NH
01372 278831/0831 425712
BABCP

NEILL, Christopher
Psychosynthesis Psychotherapist
9 Park Avenue, Peper Harrow
Godalming GU8 6BA
020 7978 1683/01483 423560
AAPP

O'BRIEN, Pat
Family Psychotherapist
"Corner Cottage"
Abinger Lane
Abinger Common
Dorking RH5 6JH
020 8725 5055/01306 730818
IFT

O'DELL, Tricia
Psychoanalytic Psychotherapist
Lichfield
161 New Haw Road
Addlestone
Weybridge KT15 2DP
01932 857818
FPC

O'DWYER, Annegret
Integrative Psychotherapist
Brabant House Clinic
Portsmouth Road
Kingston KT7 0EY
020 8398 7592/020 7935 5651
MET

OLDMAN, David
Psychoanalytic Marital Psychotherapist
5 Buckland Court
Bletchworth RH3 7EA
020 7487 3766/01737 844079
TMSI

O'NEILL, Christopher J.
Hypno-Psychotherapist
14 Chapelfields
Charterhouse Road
Godalming GU7 2BS
01483 291671/01483 414437
NSHAP

OSBORNE, Lynda
Gestalt Psychotherapist
Crossways
8 Lancaster Avenue
Farnham GU9 8JY
01252 724403
MET

OWTRAM, Peter
Psychoanalytic Psychotherapist
14 Busbridge Lane
Godalming GU7 1PU
01483 417443 (t/f)
GCP

PEARMAN, Cathy
Psychosynthesis Psychotherapist
'Tzaneen'
Blackhorse Road
Woking GU22 0RE
01483 232030
AAPP

PEARSE, Joanna
Family Therapist
105 Burlington Road
Thorton Heath CR7 8PJ
020 8653 1281
AFT

PEET, Sandra
Transpersonal Psychotherapist
Chestnuts
31 Firfield Road
Addlestone KT15 1QU
01932 853667
CTP

PERERA, Ajit
Cognitive Behavioural Psychotherapist
Sandy Ridge
2 Park Lane East
Reigate RH2 8HN
07808 732132/01737 222246
BABCP

PHILLIPS, Mary
Sexual and Relationship Psychotherapist
The Tudors
20a Fernhill Lane
Upper Hale
Farnham GU9 0JJ
01252 723522
BASRT

PLATT, Monique
Integrative Psychotherapist
1 South Lodge
Ham Common
Richmond TW10 7JL
020 8940 8890
RCSPC

POUTEAUX, Diana
Sexual and Relationship Psychotherapist
Thorsby, 26 Crownpits Lane
Godalming GU7 1PB
01483 416984
BASRT

PRATT, Sheila
Psychoanalytic Psychotherapist
44 East Meads
Onslow Village
Guildford GU2 5SP
01483 572 093
GUILD

PRESTON, Kay
Attachment-based Psychoanalytic
Psychotherapist, Group Analytic
Psychotherapist
4 Ringley Park Road
Reigate RH2 7BJ
01737 243 177
CAPP

QUOILIN-LEBRUN, Michelle
Biodynamic Psychotherapist
4 Mornington Avenue
Finchamstead, Wokingham
Surrey RG11 4UE
01189 730870
BTC

RABE, Marie-Louise
Psychoanalytic Psychotherapist
23 Addiscombe Court Road
Croydon CR0 6TT
020 8656 7954
ARBS

REID, Rosamund
Psychoanalytic Psychotherapist
The Cottage, Ivy Lane
Woking GU22 7BY
01483 764146
GCP

RENWICK, Fran
Hypno-Psychotherapist
15 Knightwood
Goldworth Park
Woking GU21 3PU
01483 767442
CTIS

REYNOLDS, Hilary
Psychoanalytic Psychotherapist
11 The Waldrons
Oxted RH8 9DY
01883 712783/020 7483 4649
FPC

RIDLEY, Jane
Sexual and Relationship Psychotherapist
77 Church Road
Richmond TW10 6LX
020 8940 7678
BASRT

SAGE, Nigel A.
Cognitive Behavioural Psychotherapist
Primary Care Pschol & Counselling
2 Barossa Road
Camberley GU15 4JE
01276 66772
BABCP

SAGOE, Pauline
Transpersonal Psychotherapist
84 South Terrace
Surbiton KT6 6HU
020 8399 9973
CCPE

SANDBANK, Audrey
Family Therapist
30 Beech Road
Reigate RH2 9NA
01737 221347
AFT

SAROFF, Rahel
Integrative Psychotherapist
"Westside"
142 Nutfield Road
Merstham RH1 3HG
01737 646068
RCSPC

SCANLON, Chris
Group Analyst
Henderson Outreach Service Team
Henderson Hospital
2 Homeland Drive
Sutton SM2 5LT
020 8661 1611
IGA

SCOTT-CHINNERY, Jean
Cognitive Behavioural Psychotherapist
173 Southway
Guildford GU2 6DJ
01483 502787/01483 278100
BABCP

SEVITT, Michael
Group Analyst
7 Upper Park Road
Kingston-upon-Thames KT2 5LB
020 8546 4173
IGA

SHAPIRO, Philip
Child Psychotherapist
Surrey
01252 719751
ACP

SHAWE-TAYLOR, Metka
Cognitive Behavioural Psychotherapist
Clarendon House
28 West Street
Dorking RH4 1QJ
01344 842282/01306 502400
BABCP

SHEPPARD FIDLER, Angela
Family Therapist
3 Sunnybank
Epsom KT18 7DY
01372 727200
AFT

SIMMONS, Linda
Psychosynthesis Psychotherapist
12 Rydens Park
Walton on Thames KT12 3DP
01932 228582
AAPP

SNOWDEN, Patricia
Sexual and Relationship Psychotherapist
15 Hookfield
Epsom KT19 8JQ
01372 725874
BASRT

SPENDER, Quentin
Family Therapist
16 Hemingford Road
Cheam SM3 8HG
020 8644 8245
AFT

STEWART, Lisa
Cognitive Behavioural Psychotherapist
Practise 2
York House Medical Centre
Heathside Road
Woking GU22 7XL
01483 766736
BABCP

SUTTON, Bobbie
Psychoanalytic Psychotherapist
17 Sheen Park
Richmond TW9 1UN
020 8940 7628
FPC

SYKES, Ann
Systemic Psychotherapist
9 Windemere Way
Farnham GU9 0DE
KCC

TABAK, Carolyn
Integrative Psychotherapist
15 Melvin Court
High Park Avenue, Kew
Richmond TW9 4BW
020 8876 0858
MET

TARSH, Helen
Psychoanalytic Marital Psychotherapist
Wentworth House
The Green
Richmond upon Thames TW9 1PB
020 8332 0597/020 8948 1913
TMSI

THORNTON, Suzanne
Integrative Psychotherapist
Ivy Cottage
Clockhouse Lane East
Egham TW20 8PF
01784 433480
RCSPC

TOMLIN, Minoo
Analytical Psychotherapist
Oaktrees
Bishopswalk
Shirley Hills CR0 5BA
020 8654 5335
UPA

TOMS, Moira
Family Therapist
Bramblewood
Guildford Road
Cranleigh GU6 8PR
01483 274183
AFT

UNSWORTH, Gisela
Integrative Psychotherapist
5 Rodwell Court
Hersham Road
Walton-on-Thames KT12 1RE
01932 846069/01932 229306
RCSPC

VALLINS, Yvonne
Psychoanalytic Psychotherapist
21 Hardwicke Road
Reigate RH2 9HJ
01737 247 608
GUILD

VEASEY, Helen
Psychoanalytic Psychotherapist
8 Hilgay Close
Guildford GU1 2EN
01483 259051/01483 538077
GUILD

VOLLANS, Audrey
Gestalt Psychotherapist
36 Gumbrells Close, Fairlands
Guildford GU3 3NG
01483 234861
GPTI

WALKER, Mary J.
Child Psychotherapist, Psychoanalytic
Psychotherapist
Merton Child, Adolescent & Family
Service
Birches Close
Cricket Green Polyclinic
Mitcham CR4 4LQ
020 8770 8828
ACP

WALLACE, Norma
Integrative Psychotherapist
100 Grosvenor Road
Langley Vale
Epsom Downs KT18 6JB
01372 274779
MET

WALTON, Michael
Integrative Psychotherapist
18 Fern Close
Frimley
Camberley GU16 5QU
01276 27151
RCSPC

WHEELER, Judith
Cognitive Behavioural Psychotherapist
Wickets, 71 Highlands Road
Leatherhead KT22 8NW
01372 373791
BABCP

WHITAKER, Christine
Transpersonal Psychotherapist
Home Farmhouse
The Street, Puttenham
Guildford GU3 1AR
01483 810632
CCPE

WHITELEY, J. Stuart
Group Analyst
Wheelwright's Cottage
Wheeler's Lane
Brockham RH3 7LA
01737 843446/01737 843634
IGA

WIDDICOMBE, Howard
Humanistic and Integrative
Psychotherapist
32 Armadale Road
Goldsworth Park
Woking GU21 3LB
01483 721458
SPEC

WILFORD, Gerti
Family Therapist
30 Spencer Road
East Moseley KT8 0SR
AFT

WILLIAMS, Heather
Psychosynthesis Psychotherapist
76 Deerings Road
Reigate RH2 0PN
01737 240638
AAPP

WILLIAMS, Jill
Integrative Psychotherapist
91 Sandy Lane South
Wallington SM6 9RF
RCSPC

WILLIS, Sally
Group Analyst
50D Maple Road
Surbiton KT6 4AE
020 8399 3334
IGA

WILMOT, Vivienne
Psychoanalytic Psychotherapist
"Ithaca"
62 Petworth Road
Haslemere GU27 3AU
01428 643912
GCP

WILSON, James
Psychoanalytic Psychotherapist
115 Longdown Lane
South Epsom KT17 4JL
01372 745089
IGA

WODDIS, Helena
Sexual and Relationship Psychotherapist
Heatherfield
181a Queens Road
Weybridge KT13 0AH
01932 851561
BASRT

WOOD, Margarita
Child Psychotherapist
13 Uxbridge Road
Kingston-upon-Thames KT1 2LH
020 8546 4668
ACP

WOOLMER, Tim
Group Analyst
79 North Road
Richmond TW9 4HQ
020 7937 6956/020 8878 1259
IGA

WYSE, Gill M
Family Therapist
47 Ashcombe Road
Carshalton Park SM5 3ET
020 8647 8568
AFT

WYSE, Hymie
Integrative Psychotherapist
47 Ashcombe Road
Carshalton SM5 3ET
020 8647 8568
MC

YALLOP, Melanie
Psychoanalytic Psychotherapist
11 Mount Pleasant
Weybridge KT13 8EP
01932 844688
FPC

SUSSEX (EAST)

ACKET, Marijke
Psychosynthesis Psychotherapist
46 Elm Grove, Brighton
East Brighton BN2 3DD
01273 622424/01273 622424
AAPP

ALEXANDER, Gail
Analytical Psychotherapist
47 Rugby Place
Kemptown
Brighton BN2 5JB
01273 600307
FIP

ALLARD, Alain
Transpersonal Psychotherapist
2 Middleway
Lewes BN7 1NH
01273 478643
CTP

ANDERSON, Tony
Psychoanalytic Psychotherapist
4 Elmstead Road
Bexhill on Sea TN40 5NJ
01424 734027
CSPK

ARCARI, Sallie R
Group Analytic Psychotherapist
43 Rutland Gardens
Hove BN3 5PD
01273 273882
UPA

BAKER, Kevin
Core Process Psychotherapist
3 Earls Garden
St John Street
Lewes BN7 2QE
01273 471 367/01273 621 841/474
AAPP

BARNETT, Mary
Psychoanalytic Psychotherapist
33 Southdown Avenue
Brighton BN1 6EH
01273 778383/01273 506258
GUILD

BEAZLEY-RICHARDS, Joanna
Integrative Psychotherapist, Transactional
Analysis Psychotherapist
2 Quarry View, Whitehill Road
Crowborough TN6 1JT
01892 655195
MET

BLOWERS, Colin M.
Cognitive Behavioural Psychotherapist
Glenside, Wincombe Road
Brighton BN1 5AR
01273 504980/020 8876 8261
BABCP

BOBSIN, Mica
Integrative Psychosynthesis
Psychotherapist
33 Wilbury Road
Hove BN3 3PB
01273 774917
RE.V

BONHAM, Elizabeth
Cognitive Behavioural Psychotherapist
"Mountains"
Station Road
Mayfield TN20 6BN
01732 740538/01435 873617
BABCP

BOTT, David
Systemic Psychotherapist
Preston House
200 High Street
Lewes BN7 2NS
01273 477529
AFT

BRENNAN, Clare
Group Analytic Psychotherapist,
Psychoanalytic Psychotherapist
The Merchant House
English Passage
Cliffe High Street
Lewes BN7 2AP
01273 479157
WTC

BROSSKAMP, Cornelia
Biodynamic Psychotherapist
94 Graham Avenue
Brighton BN1 8HD
01273 385228
BTC

BUFFERY, Elli Patricia
Systemic Psychotherapist
The Old Stables
Cottage Lane
Westfield TN35 4QG
KCC

BUTTON, Rachel
Transpersonal Psychotherapist
Old End Cottage
Priory Road
Forest Row RH18 5HS
01342 822871
CCPE

CASARES, Jonathan
Transpersonal Psychotherapist
34 Lower Market Street
Hove BN2 2NX
CCPE

CHARLTON, Patricia S.
Group Analytic Psychotherapist
14 Pelham Terrace
Lewes BN7 2DR
01273 472393
UPA

CLAIRMONTE, Tosin
Group Analyst
Hillview, 1 Hope Villas, Highcross
Rotherfield
East Sussex TW6 3QD
0892 852997
IGA

CLEMINSON, Richard
Biodynamic Psychotherapist
8 Harrington Villas
Brighton BN1 6RG
01273 500 797
BTC

COLE, Barbara
Humanistic Psychotherapist
4 Offham Terrace
Lewes BN7 2QP
01273 473113
AHPP

COOPER, Michael
Existential Psychotherapist
24 Buckingham Street
Brighton BN1 3LT
01273 643486/01273 779176
RCSPC

COTTRELL, Sue
Integrative Psychotherapist
50 Waldegrave Road
Brighton BN1 6GE
01273 507776
MET

COX, Christine Sarah
Hypno-Psychotherapist
28 Fern Road
St Leonards on Sea TN38 0UH
01424 424797
NRHP

CRELLIN, Clare*
Psychoanalytic Psychotherapist
2 Tott Cottages
Etchingham Road
Burwash TN19 7BE
01435 882347/0144416606
SITE

CROSBY, Simon
Personal Construct Psychotherapist
Hindleap Corner
Priory Road
Forest Row RH18 5JF
01342 824545
CPCP

CRUTHERS, Helen
Integrative Arts Psychotherapist
24 Buckingham Street
Brighton BN1 3LT
01273 779 176
IATE

DARGERT, Guy
Humanistic Psychotherapist
175 Preston Drove
Brighton BN1 6FN
01273 557503
AHPP

DE LUCHI, Martin
Gestalt Psychotherapist
25 Meeching Road
Newhaven BN9 9RL
01273 612942
GCL

DESMOND, Hanora
Transpersonal Psychotherapist
30 The Esplanade
Seaford BN25 1JJ
020 7630 0515/01323 490 721
CCPE

DIXON-NUTTALL, Rosemary
Group Analytic Psychotherapist
30 Brooklands Avenue
Crowborough TN6 3BP
01892 663192
FPC

DRIJVER, Caroline
Cognitive Behavioural Psychotherapist
37 Princes Terrace
Brighton BN2 5JS
01273 240018/01273 690770
BABCP

DUNCAN-GRANT, Alec John
Cognitive Behavioural Psychotherapist
22 The Cross Ways
Stone Cross
Pevensey BN24 5EH
01323 765 401
BABCP

EASTHAM, Peter
Cognitive Behavioural Psychotherapist
School Hill Medical Practice
School Hill House
33 High Street
Lewes BN7 2LU
01273 480888
BABCP

EISENBARTH, Heiner
Biodynamic Psychotherapist
94 Graham Avenue
Brighton BN1 8HD
01273 385228
BTC

ELDRIDGE, Melanie
Psychodrama Psychotherapist
7 Hartington Terrace
Brighton BN2 3LT
01323 84582/01273 608987
BPA

FELLOWS, Ron
Family Therapist
Lavender Cottage
90 Turkey Road
Bexhill on Sea TN39 5HE
0870 054 8497/01424 213200
AFT

FIELD, Rosalind
Integrative Psychotherapist
The Pines
Spithurst Road
Barcombe BN8 5ED
01273 401161
MC

FLOWER, Charles
Transpersonal Psychotherapist
4 Dale Hill Cottages
Ticehurst
Wadhurst TN5 7DG
01580 201495
CCPE

FOSBURY, Jacqueline
Cognitive Analytic Therapist
29 Upper Abbey Road
Brighton BN2 2AD
01273 693269
ACAT

GALLIVAN, Patricia
Cognitive Behavioural Psychotherapist
39 The Glades
Bexhill TN40 2NE
01424 218377/01424 710110
BABCP

GODDARD, Lynne
Transactional Analysis Psychotherapist
137 Montgomery Street
Hove BN3 5FP
01273 202721
ITA

GORDON, Inger
Systemic Psychotherapist
31 Castlefields
Hartfield TN7 4JA
01892 770651/020 7720 7301
KCC

GRACIA, Olga
Psychosynthesis Psychotherapist
Derwent
Burwash Road
Broad Oak
Nr Heathfield TN21 8ST
01435 863 494/01825 766 888
AAPP

GREEN, Joe
Family Therapist, Systemic
Psychotherapist
114 Havelock Road
Brighton BN1 6GQ
01273 327 221/01273 502 674
IFT

GREEN, Prudence
Psychoanalytic Psychotherapist
22 St Swithun's Terrce
Lewes BN7 1UJ
01273 471 422
PA

GRIFFITHS, Anne
Psychoanalytic Psychotherapist
Bedford Cottage
36 Prince Edward's Road
Lewes BN7 1BE
01273 478365
GUILD

HALL, Jill
Gestalt Psychotherapist
22 Collier Road
Hastings TN34 3JR
01424 431154 (t/f)
GCL

HALPIN, Jill
Psychoanalytic Psychotherapist
Stonerunner Cottage
Rye Harbour TN31 7TT
01797 224351
GUILD

HAMER, Neil
Psychoanalytic Psychotherapist
18 Wolstonbury Road
Hove BN3 6EJ
01273 734020
GUILD

HANCOCK, Sarah
Family Therapist
27 Cornwall Gardens
Brighton BN1 6RH
01273 327221/01273 552500
IFT

HARDCASTLE, Mark
Cognitive Behavioural Psychotherapist
10 Wannock Avenue
Eastbourne BN20 9RS
01323 483988/0976 886027
BABCP

HARVEY, Andrew
Cognitive Behavioural Psychotherapist
Seaford Day Hospital
Sutton Road
Seaford BN25 1SS
01323 843414/01323 490989
BABCP

HOLLAND, Sue
Psychosynthesis Psychotherapist
16 Bavant Road
Preston Park
Brighton BN1 6SW
01273 563098
AAPP

HOLMES, Paul
Psychodrama Psychotherapist
23 Western Street
Brighton BN1 2PG
01273 776640
BPA

HOWELL, Simon
Systemic Psychotherapist
NSPCC
2 Sedlecombe Road South
St Leonards on Sea TN38 0TA
01424 428833
IFT

HUETING, Margaret
NLP Psychotherapist
31 Elm Grove
Hampden Park
Eastbourne BN22 9NN
01323 511150/01323 520372 (f)
ANLP

HUTTON, Francoise
Analytical Psychologist-Jungian Analyst
10 Albion Street
Lewes BN7 2ND
01273 473850
CAP

IREMONGER, Sue
Hypno-Psychotherapist
Strangford House
5 Downs View Close
North Chailey
Lewes BN8 4HA
01825 723017
NRHP

IRONSIDE, Lesley
Child Psychotherapist
35 Clermont Terrace
Brighton BN1 6SJ
01273 709660
ACP

JONES, Helen
Biodynamic Psychotherapist
52 Newmarket Road
Brighton BN2 3QF
01273 621347
BTC

JONES, Ros
Transpersonal Psychotherapist
Flat 1, Clermont Court
Clermont Road
Brighton BN1 6SS
01273 540875
CCPE

JOSEPH, Jerome Devakumar
Cognitive Psychotherapist
Gilgal
17 Nyetimber Hill
Brighton BN2 4L
01273 604404
BABCP

JUPP, Elizabeth
Group Analytic Psychotherapist
33 Beechwood Avenue
Brighton BN1 8ED
01273 559306
UPA

KAPLINSKY, Catherine
Analytical Psychologist-Jungian Analyst
Mill Brook, Barcombe Mills
Nr Lewes BN8 5BP
01273 401167
CAP

LAMBOR, Florangel
Psychoanalytic Psychotherapist
82 Hythe Road
Brighton BN1 6JS
01273 334421
CPP

LEEBURN, Jennifer
Psychoanalytic Psychotherapist
12 Priory Crescent
Lewes BN7 1HP
FIP

LEWIN, Melanie
Transactional Analysis Psychotherapist
24 Kedale Road
Seaford BN25 2BX
01323 892720
ITA

LIDSTER, Wendy
Sexual and Relationship Psychotherapist
19 Shirley Drive
Hove BN3 6NQ
01273 330262
BASRT

LILLEY, Tim
Core Process Psychotherapist
34 Jersey Street
Brighton BN2 2NU
01273 688 060/01273 222 834
AAPP

LLOYD, Elizabeth*
Psychoanalytic Psychotherapist
12 Preston Park Avenue
Brighton BN1 6HJ
01273 555017
GUILD

LOVE, Mollie
Group Analytic Psychotherapist,
Psychoanalytic Psychotherapist
Larkswood
162 Warren Road
Woodingdean
Brighton BN2 6DD
01273 607529
LCP

LOWN, Judy
Core Process Psychotherapist
Flat 1, 8 Preston Park Avenue
Brighton BN1 6HJ
020 7556 6163/01273 500193
AAPP

MACKENZIE, Nancy
Group Analyst
18 Wolston Bury Road
Hove BN3 6EJ
01273 736740
IGA

MARSHALL, Susan
Integrative Psychotherapist
Moat Mill Farm
Newick Lane
Mayfield TN20 6RF
01435 873483
RCSPC

MASANI, Peter
Analytical Psychologist-Jungian Analyst
7 Clare Road
Lewes BN7 1PN
01273 474800
CAP

MAXWELL, Hugh
Psychodrama Psychotherapist
Westwood Day Hospital
Westwood House
7 Holmesdale Gdns
Hastings TN34 1LY
BPA

MCLEOD, Paula
Biodynamic Psychotherapist
68 Stanley Road
Brighton BN1 4NH
01273 383429
BTC

MENZIES, Heather
Psychoanalytic Psychotherapist
17 Lewes Crescent
Brighton BN2 1GB
01273 600053/0273
CFAR

MICHAELSON, Sue
Transpersonal Psychotherapist
34 St Mary's Terrace
Hastings TN34 3LR
01424 429858
CTP

MILLS, Jeremy George
Cognitive Behavioural Psychotherapist
Flat 1, 12 Denton Road
Eastbourne BN20 7SU
01323 419172/0976 716540
BABCP

MORGAN-JONES, Richard
Psychoanalytic Psychotherapist
25 Lewes Road
Eastbourne BN21 2BY
FIP

MULVEY, Jean
Analytical Psychologist-Jungian Analyst
Aldsworth Lewes Road
Ringmer, Lewes BN8 5ER
01273 812944
CAP

NICOL, Sara
Sexual and Relationship Psychotherapist
Little Bernhurst
77 London Road, Hurst Green
Etchingham TN19 7PN
01580 860345
BASRT

NORMAN, Caroline
Group Analytic Psychotherapist
36 Buxton Road
Brighton BN1 5DE
01273 542208
UPA

O'BRIEN, John
Integrative Psychotherapist
Foxes
Berwick BN26 6TB
020 7290 2627/01323 871081
RCSPC

PARKINSON, Jane
Attachment-based Psychoanalytic
Psychotherapist
61b Beaconsfield Villas
Brighton BN1 6HB
01293 739281
CAPP

REEVES, Alan
Transpersonal Psychotherapist
213b Ditchling Road
Brighton BN1 6JD
01273 541 194
CCPE

RICHARDS, Michael
Psychoanalytic Psychotherapist
65 Southover High Street
Lewes BN7 1JA
01273 478244
FPC

RICHARDSON, Madeleine J.
Sexual and Relationship Psychotherapist
221 Preston Road
Brighton BN1 5BE
01273 504385
BASRT

RIGNELL, John
Psychoanalytic Psychotherapist
4 Temple Gardens
Brighton BN1 3AE
01273 204314
FPC

ROBINSON, Judy
Psychoanalytic Psychotherapist
St Laurence House
Park Street, Falmer
Brighton BN1 9PG
01273 606928
GUILD

ROLAND, Saskia
Integrative Psychotherapist
Tillingham, Peasmarsh
Nr. Rye TN31 6XG
01797 230 796
RCSPC

SALAMANDER, Jas Ananda
Transpersonal Psychotherapist
24 Lancaster Road, Brighton BN1 5DG
01273 382289
CCPE

SANDERS, Peter
Transactional Analysis Psychotherapist
"Midsummer House"
66 St. Helen's Park Road
Hastings TN34 2JJ
01424 420615
ITA

SAVINS, Charlotte
Integrative Arts Psychotherapist
11 Hanover Street, Brighton BN2 2ST
01273 691166
IATE

SECRETT, David
Family Therapist
37 Princes Terrace, Brighton BN2 5JS
01273 690 770
AFT

SELLERS, Duncan
Integrative Psychotherapist
18 Shepherds Croft
Withdean
Brighton BN1 5JF
01273 552747
MC

SHORT, Nigel Patrick
Cognitive Behavioural Psychotherapist
34 Emmanuel Road
Hastings TN34 3LB
01424 444951
BABCP

SIDHU, Frankie
Psychosynthesis Psychotherapist
4 Gerard Street
Brighton BN1 4NW
01273 603896/01273 887303
AAPP

SOUTAR, Sarah
Psychoanalytic Psychotherapist
Star Breweries Workshops and Studios
Castleditch Lane
Lewes BN7 1YJ
01273 486782
AGIP

SPRINGFORD, Kate
Psychoanalytic Psychotherapist
21 St.Anne's Crescent
Lewes BN7 1SB
01273 473125
GUILD

STEHLE, Peter
Existential Psychotherapist
2 Wickham Manor Cottage
Pannel Lane, Winchelsea
East Sussex TN36 4AG
01797 227 009
RCSPC

STREETER, Elaine
Family Therapist
54 Southover Street
Hanover
Brighton BN2 2UF
01273 700745
AFT

SUSS, Lawrence
Psychoanalytic Psychotherapist
135 Preston Drive
Brighton BN1 6LE
01273 502900/01273 508688
AGIP

TIERNEY, Sue
Hypno-Psychotherapist
Fairwalk
Hugletts Lane
Cade Street TN21 9BX
01435 866547
NRHP

TOMLINSON, Moya
Sexual and Relationship Psychotherapist
53 Southover High Street
Lewes BN7 1JA
01273 473255
BASRT

TOYE, Janet
Sexual and Relationship Psychotherapist
Counselling & Clinical Psychology Dept
Hove Polyclinic, Nevil Road
Hove BN3 7HY
01273 242016
BASRT

VALLELY, Patricia M.
Transpersonal Psychotherapist
Brighton BN2 5RF
01273 691 162
CCPE

VAN HALM, Corrie
Transactional Analysis Psychotherapist
St. John's Lodge
Burgh Hill
Etchingham TN19 7PE
01580 860 780
ITA

VELARDE, Dominique
Integrative Arts Psychotherapist
Flat 1, 24 Belvedere Terrace
Brighton BN1 3AF
01273 208525
IATE

WALLER, Diane E
Group Analytic Psychotherapist
11A Richmond Road
Brighton BN2 3RL
01273 685852
UPA

WHITE, Anne
Systemic Psychotherapist
33 Ridgeway, Hurst Green
Etchingham TN19 7PJ
01580 860355
KCC

WHITE, Jennifer
Gestalt Psychotherapist
46 Shaftesbury Road
Brighton BN1 4NF
01273 689580
GCL

WHITE, Lela Ljiljana
Psychoanalytic Psychotherapist
37 Surrenden Road
Brighton BN1 6PQ
01273 554543
FPC

WITHERS, Roberts
Analytical Psychologist-Jungian Analyst
113 Freshfield Road
Brighton BN2 2BR
01273 671729
CAP

SUSSEX (WEST)

ADAMS, Sarah K
Educational Therapist
Tinkers Green
Nutbourne Common
Pulborough RH20 2HB
023 80652822
FAETT

ADDENBROOKE, Mary
Analytical Psychologist-Jungian Analyst
Oaks
Forest Road, Colgate
Horsham RH12 4SZ
01293 851826
GUILD

ADDENBROOKE, Peter
Analytical Psychologist-Jungian Analyst
Oaks
Forest Road, Colgate
Horsham RH12 4SZ
01293 851362
CAP

ALDRIDGE, Janet
Integrative Psychotherapist
64 Stocks Lane
East Wittering PO20 8NJ
01243 816042/01243 670924
RCSPC

ANSTICE, Christine
Sexual and Relationship Psychotherapist
10 Selham Close
Ifield
Crawley RH11 0GH
01293 535654
BASRT

AYRES, Kathleen
Hypno-Psychotherapist
Oakwood House, 6 Marshall Avenue
Bognor Regis PO21 2TJ
01243 822263
NRHP

BARDELLE-CARRIER, Rosemary
Biodynamic Psychotherapist
1 Copper Hall Close
Rustington BN16 3RZ
01903 850050
BTC

BAYNE, Brenda Therese
Transpersonal Psychotherapist
5 The Gatehouse
Edinburgh Square
Midhurst GU29 9NL
01730 812063
CTP

BODDINGTON, Daphne
Sexual and Relationship Psychotherapist
28 Heathfield Park
Midhurst GU29 9HN
01730 814767
BASRT

COLEMAN, Eva
Integrative Psychotherapist
Lattenbells
Farm Lane, Ditching
Hassocks BN6 8UR
01273 622886/01273 844142
RCSPC

DAVIDSON, John
Cognitive Behavioural Psychotherapist
Greenwoods, Selsey Road
Sidlesham
Chichester PO20 7LR
01444 416778/01243 641436
BABCP

DAVIS, Paul E.
Cognitive Behavioural Psychotherapist
The Summit
22 Sudley Road
Bognor Regis PO21 1ER
01243 869234
BABCP

DUFFY, Kathleen
Integrative Psychotherapist
8 Malthouse Road
Crawley RH10 6BG
01293 531443
RCSPC

ESPOSITO, Claude
Family Psychotherapist
Smiles Cottage
47 High Street
Ardingly RH17 6TB
01444 892 497
IFT

EVANS, Richard
Gestalt Psychotherapist
Brook House
Quay Meadow
Bosham PO18 8LY
01243 573475
GPTI

FIELD, John C.
Cognitive Analytic Therapist
64 Wickham Hill
Hurstpierpoint BN6 9NP
01273 534716/01273 843012
ACAT

FILBY, Erica
Family Therapist
The Archdeaconry, Itchingfield
Horsham RH13 7NX
01403 790315
AFT

HAGENBACH, Kitty
Transpersonal Psychotherapist
Nenthorne West
Hammerwood Road
Ashurst Wood RH19 3RU
01342 823461
CCPE

HARLING, Biljana
Transactional Analysis Psychotherapist
21 Kingsham Avenue
Chichester PO19 2AW
0956 654 597/01243 532033
MET

HERDMAN, Linda
Cognitive Behavioural Psychotherapist
Bedale Mental Health
1 Glencathara Road
Bognor Regis PO21 2SF
01243 841041
BABCP

HILLMAN, Christine
Psychosynthesis Psychotherapist
2 The Old Convent
East Grinstead RH19 3RS
01343 315097
AAPP

KANE, Janine
Integrative Psychotherapist
Whyke Bakery House
Whyke Lane
Chichester PO19 2AS
01243 776489
MC

LITTLE, Marie
Psychoanalytic Psychotherapist
Spindrift
24 Warner Road, Selsey
Chichester PO20 9DD
01243 601073
IPSS

MARTIN, Linda
Gestalt Psychotherapist
14 Garden House Lane
East Grinstead RH19 4JT
01342 312974
GCL

MCMINNIES, Patricia
Psychoanalytic Psychotherapist
149 Western Road
Hurstpierpoint
Hassocks BN6 9SZ
01273 834454
AGIP

MIDDLEHURST, Daniel
Cognitive Behavioural Psychotherapist
Child & Family Service for MH
Orchard House, 9 College Lane
Chichester PO19 4PQ
01243 815514
BABCP

MILLER, Bob
Attachment-based Psychoanalytic
Psychotherapist
68 Clarence Road
Horsham RH13 5SS
01403 255387
CAPP

PALMER, Marion Macintosh
Family Therapist
St Francis Cottage
Singleton
Chichester PO18 0EZ
01243 811776
AFT

QUINN, Susan
Transpersonal Psychotherapist
The Psychology Service for Sexual
Health
16 Liverpool Gardens
Worthing BN11 1RY
CTP

REILLY, Nicole
Transpersonal Psychotherapist
28 St. George's Road
Worthing BN11 2DR
01903 203533
CCPE

ROSE, Teresa
Integrative Psychotherapist
48 Burleigh Way
Crawley Down RH10 4UQ
01342 717480
UPA

SCOTT, Liz
Sexual and Relationship Psychotherapist
30 Haywards Road
Haywards Heath RH16 4JB
01444 410715
BASRT

SKEGG, Roz
Integrative Psychotherapist
20 Furnace Farm Road
Furnace Green
Crawley RH10 6QA
01293 516212
MET

SPEARMAN, Penny
Psychoanalytic Psychotherapist
244 Harbour Way
Shoreham-By-Sea BN43 5HZ
01273 463033
LCP

THOMAS, Jennifer
Sexual and Relationship Psychotherapist
11 East Bank, Selsey
Chichester PO20 0SP
BASRT

THORPE, Ivan
Integrative Psychotherapist
20 Hailsham Road
Worthing BN11 5PA
01903 606440
RCSPC

WALKER, Jim
Psychoanalytic Psychotherapist
Westlake
Broad Street
Cuckfield RH17 5LL
01444 440204
IPSS

WALKER, Rosalind
Family Therapist, Systemic
Psychotherapist
Westlake, Broad Street, Cuckfield,
Haywards Heath RH17 5LL
01444 440204
AFT

WEST, Marcus
Analytical Psychologist-Jungian Analyst
Highbank 45
Cross Lane Findon BN14 0UB
01903 877039/01903 874140
FIP

WOODMAN-SMITH, Gillian
Child Psychotherapist
31 Whyke Road
Chichester PO19 2HW
01243 782513/020 7387 7704
ACP

TYNE & WEAR

BATCHELOR, Henrietta
Sexual and Relationship Psychotherapist
East Moorhouses, Matfen
Newcastle Upon Tyne NE20 0RG
01661 886362
BASRT

BIANCARDI, Jenny
Psychodrama Psychotherapist
9 Stratford Grove
Heaton
Newcastle Upon Tyne NE6 5AT
0191 281 6243/0191 265 9664
BPA

BIRCH, James Williams
Family Therapist
Kiln Riggs
High Brunton, Wall, Hexham,
Northumberland NE46 4ET
01434 681018
AFT

BLACK, Patricia Anne
Psychoanalytic Psychotherapist
Claremont House
off Framlington Road
Newcastle NE2 4AA
0191 232 5131
NAAP

BLACKBURN, Ivy-Marie
Cognitive Behavioural Psychotherapist
Newcastle Cognitive Therapy Centre
Plummer Court, Carliol Place
Newcastle upon Tyne NE1 6UR
0191 219 6288/0191 281 1117
BABCP

BRAZIER, David
Psychodrama Psychotherapist
Quannon House
53 Grosvenor Place, Jesmond
Newcastle Upon Tyne NE2 2RD
0191 281 5592
BPA

CROMARTY, Paul
Cognitive Behavioural Psychotherapist
Newcastle Cognitive Therapy Centre
Plummer Court, Carliol Place
Newcastle upon Tyne NE1 6UR
0191 219 6288
BABCP

DAVIS, Edna
Psychodrama Psychotherapist
60 Northumberland Avenue
Gosforth
Newcastle upon Tyne NE3 4AQ
0191 281 5024
BPA

DOBSON, Mary
Psychoanalytic Psychotherapist
10 Meadway, Forest Hall
Newcastle upon Tyne NE12 9RB
0191 266 6501
NAAP

GILLETT, Timothy P.
Cognitive Behavioural Psychotherapist
Sir Martin Roth Young Peoples Unit
Newcastle General Hospital
Westgate Road
Newcastle upon Tyne NE4 6BE
0191 219 5023
BABCP

GILLMAN, Maureen
Family Therapist
Division of Adult and Community Care
Studies
Northumbria University
Coach Lane Campus
Newcastle NE7 7XA
0191 2273280
AFT

ISH, Chandra
Hypno-Psychotherapist
13 Montrose Drive
Gateshead NE10 8BP
0191 469 4667/0191 420 4200
NRHP

JOHN, Carolyn H.
Cognitive Behavioural Psychotherapist
11 Tankerville Terrace, Jesmond
Newcastle upon Tyne NE2 3AH
0191 281 0411
BABCP

KAT, Bernard J B
Cognitive Behavioural Psychotherapist
Psynapse
11 Tankerville Terrace, Jesmond
Newcastle upon Tyne NE2 3AH
0191 281 0411/0191 333 3499
BABCP

KENDAL, Jo Reed
Psychoanalytic Psychotherapist
Southern Wood
2 Ridgeway Fenham
Newcastle upon Tyne NE4 9UL
0191 275 0612
NAAP

LAMBERT, Louise
Psychodrama Psychotherapist
Myrtle Cottage
Westmorland Avenue
Willington Quay, Walls NE28 6SN
0191 478528/0191 262383
BPA

LUND, Charles
Psychoanalytic Psychotherapist
Regional Department Psychotherapy
Claremont House
off Framlington Place
Newcastle NE2 4AA
0191 2275087
NAAP

MAHMOOD, Janet
Analytical Psychologist, Psychoanalytic
Psychotherapist
11 Roseworth Avenue
Gosforth
Newcastle upon Tyne NE3 1NB
0191 285 7463
NAAP

MCGREGOR-HEPBURN, Jan
Psychoanalytic Psychotherapist
Post Office Cottage
Station Bank
Mickley, Stocksfield
Northumberland NE43 7BX
01661 842727
NAAP

MITCHISON, Sally
Group Analyst
Upper Poplars
Cherry Knowle Hospital
Ryhope
Sunderland SR2 0NB
0191 569 9477
IGA

MOORE, Gordon
Cognitive Behavioural Psychotherapist
Dept Psychological Therapies & Research
St Georges Hospital
Morpeth
Northumberland NE61 2NE
01670 512121
BABCP

MORGAN, Shirley P.
Psychoanalytic Psychotherapist
High Rawgreen Cottage
Steel, Wexham
Northumberland NE47 OHL
01434 673812/01434 673090
NAAP

MORGAN, William
Cognitive Psychotherapist
Department of Social Policy
5th Floor Claremont Bridge Building
University of Newcastle
Newcastle NE1 7RU
0191 222 7540
BABCP

NEDEN, Jeanette
Family Therapist
9 Hagg Bank Cottages
Wylam
Northumberland NE41 8JT
01661 853 478
AFT

PHOENIX, Ashleigh
Psychoanalytic Psychotherapist
Claremont House
off Framlington Road
Newcastle on Tyne NAAP

PROCTOR, Susan
Psychoanalytic Psychotherapist
St Georges Hospital
Morpeth
Northumberland NE61 2NU
01670 512121
NAAP

ROBINSON, Rosalyn
Group Analyst
The Lindisfarne Suite
The Nuffield Hospital
Clayton Road
Newcastle-Upon-Tyne NE2 1JP
01670 515 707
IGA

SHRUBSOLE, Lindsay
Psychoanalytic Psychotherapist
David Grieve House
Headlam Street
Byker NE6 2DX
0191 224 2717
NAAP

STAFFORD, Amanda
Psychoanalytic Psychotherapist
Favell, Dipe Lane
East Boldon NE36 0PQ
0191 536 9503
NAAP

STANDART, Sally
Cognitive Psychotherapist
2a Holly Avenue, Jesmond
Newcastle Upon Tyne NE2 2PY
BABCP

TRIPPETT, Marie
Cognitive Psychotherapist
Psychology Department
Lobley Hill Clinic, Lobley Hill Road
Gateshead NE11 0AL
0191 443 6860
BABCP

TURKINGTON, Douglas
Cognitive Psychotherapist
Royal Victoria Infirmary
Leazes Wings, Dept of Psychiatry
Richardson Road
Newcastle-upon-Tyne NE1 4LP
0191 232 5131/0191 281 4606
BABCP

WALES (NORTH)

BUTLER, Linda
Cognitive Behavioural Psychotherapist
Child and Family Service
31 Grosvenor Road, Wrexham
Clywd LL11 1BS
01978 350050
BABCP

FEARNS, Keith
Cognitive Behavioural Psychotherapist
Llys Deinol, Garth Road
Bangor
Gwynedd LL57 2SE
01248 364215
BABCP

GILL, Martin
Psychodrama Psychotherapist
Rhuddgaer Bach
Dwyran, Llanfairpwllgwyn etc
Isle of Anglesey LL61 6BJ
01247 430445
BPA

HICKMOTT, Barbara
Psychodrama Psychotherapist
Cynefin, Glan Gors
Coed y Parc Bethesda
Gwynedd LL57 4YW
01248 602342
BPA

HUGHES, Lynette
Psychoanalytic Psychotherapist,
Psychoanalytic Marital Psychotherapist
Cartrefle, 149 Mwrog Street
Ruthin
Denbighshire LL15 1LE
0161 248 9494/01824 702656
TMSI

HURD, Joan
Psychoanalytic Psychotherapist
Cwm Hardd
Nantyr nr. Llangollen
Clywd LL20 7DD
01691 718450/0116 254 5451
PA

JENKINS, Sheila
Cognitive Behavioural Psychotherapist
Arfon Mental Health Centre
26 College Road, Bangor
Gwynedd LL57 4AN
01248 370137
BABCP

LANGLEY, Allen
Hypno-Psychotherapist
Bryn Hyfryd
Lon Sant Ffraid
Trearddur Bay, Holyhead
Anglesey LL65 2UD
01248 716297/01407 861258
NRHP

MARDULA, Jody
Transactional Analysis Psychotherapist
"Calon Y Mynydd", 30 Seiriol Road
Penmaenmawr
Conwy LL34 6HB
01492 622488
ITA

MAY, Adam
Hypno-Psychotherapist
Cefn Cana
Llanddaniel Fab, Gaerwen
Ynys Mon LL60 6EF
01248 421015
NRHP

NIESSER, Arthur
Analytical Psychologist-Jungian Analyst
Fron Olau, Mersey Street
Borth Y Gest, Porthmadog
Gwynedd LL49 9UF
01766 513041
AJA

OSBORN, Madeline Frances
Psychoanalytic Psychotherapist
Hergest Unit
Ysbyty Gwyneed
Bangor
Gwynedd LL57
01248 384038
NWIDP

PRUSSIA, Celia M.
Psychoanalytic Psychotherapist
Hoseley Bank Cottage
Park Lane, Rossett
Wrexham LL12 0BL
0800 373 488
LPDO

RICKARD, Ian
Cognitive Behavioural Psychotherapist
Green Oak, 1 Dolydd Terrace
Pentre Du
Betws y Coed LL24 0BU
01690 710647
BABCP

ROBBINS, Sonia
Integrative Psychotherapist
The Warren
Warren Road, Rhosneigr
Anglesey LL64 5QT
0385 340783
RCSPC

STEVENS, Jean
Hypno-Psychotherapist
Holmlea
48 Clwyd Park, Kinmel Bay, Rhyl
Clwyd LL18 5HH
01745 342544
NRHP

WHEELER, Anne
Psychoanalytic Psychotherapist
1 Church View
High Street, Gresford
Wrexham LL12 8RD
01978 854673
LPDO

WALES (SOUTH)

APPLETON, Richard Ionsdale
Family Therapist
47 Cilddewi Park
Johnstown, Carmarthen
Dyfed SA31 3HP
01267 237136
AFT

BELLIS, Stella
Child Psychotherapist
Pant-y-Bettws
Gwernogle
Carmarthenshire SA32 7RP
01267 220395
ACP

BISGOOD, Bill
Transactional Analysis Psychotherapist
6 Ebens Lane, Cardigan
Ceredigion SA43 1HN
01239 613996
ITA

BRAZIER, Anna Louise
Systemic Psychotherapist
Centre for Training in Clinical Psychology
Whitchurch Hopital, Whitchurch
Cardiff CF4 7XB
01223 336377/029 20336133
AFT

BRETT, John David
Systemic Psychotherapist
11 Church Park
Mumbles
Swansea SA3 4DE
01792 582139
FIC

CHATHAM, Jon
Family Therapist
Preswylfa Child and Family Centre
Clive Road, Canton
Cardiff CF5 1GN
029 20344489
AFT

COX, Brenda
Systemic Psychotherapist
The Family Institute
105 Cathedral Road
Cardiff CF1 9PH
029 20226532
FIC

CURRAN, Maureen
Psychoanalytic Psychotherapist
Penarth
Cregrina, Nr. Llandrindod Wells
Powys LD1 5SF
01982 570212
WMIP

DAVID, Johanna
Analytical Psychologist-Jungian Analyst
The Callow, Welsh Newton
Monmouth
Gwent NP25 3RL
01600 716634
IGAP

DAVIES, Mairlis
Family Therapist
Preswylfa Child & Family Centre
Clive Road, Canton
Cardiff CF5 1GN
029 20644993/029 20344489
AFT

DAVIES, Michael
Family Therapist
Bryn Ffwd
17 Rock Terrace
Old Ynysbwl
Pontypridd
Mid Glamorgan CF37 3NT
01443 791933
AFT

DAVIES, Rosina
Integrative Psychotherapist
Counselling and Training Services
Morriston Hospital
Swansea NHS Trust
Swansea SA6 6NL
01792 703312
RCSPC

DAVIES, Sue
Humanistic Psychotherapist
Half Moon Cottage
Old Chepstow Road, Penhow
Gwent NP6 3AD
01633 400829/01633 263388
AHPP

DONNAI, Andrew
Integrative Psychotherapist
1 Glenhurst Villas
Trefechan, Aberystwyth
Ceredigion SY23 1BD
01970 612673
NSAP

DRYDEN, Jan
Humanistic and Integrative
Psychotherapist
22 Talbot Street
Cardiff CF11 9BW
029 20238076
SPEC

FARIS, Jeff
Systemic Psychotherapist
The Family Institute
105 Cathedral Road
Cardiff CF11 9PH
029 20226532
FIC

FISHER, Clare
Cognitive Analytic Therapist
Psychology OPT
St Tydfil's Hospital
Merther Tydfil CF47 0SJ
01685 723244 ext 4292
ACAT

GAGG, Susan
Systemic Psychotherapist
13 Gardde
Llwynhendy, Llanelli
Dyfed SA14 9NH
01554 771885/01792 201040
FIC

GAUNT, Pamela
Transpersonal Psychotherapist
Bach Y Gwyddel
Cwmpengraig, Felindre
Llandysul SA44 5HX
01559 371427
CCPE

GIBBIN, Jane
Sexual and Relationship Psychotherapist
Mapsland
Laugharne
Carmarthen SA33 4QP
01994 427319
BASRT

GORDON CLARK, Thalia
Core Process Psychotherapist
4 Danyrallt
Llaneglwys, Builth Wells
Powys LD2 3BV
01982 560656
AAPP

GRAF, Fern
Family Therapist
Preswylfa Child and Family Centre
Clive Road, Canton
Cardiff CF5 1GN
029 20610894/029 20344489
AFT

GREGG, Annzella
Transpersonal Psychotherapist
5 Kimberley Road, Sketty
Swansea SA2 9DL
01792 536748
CCPE

HALE, Sue
Integrative Psychotherapist
Beaumont
Sandy Lane, Pennard
Swansea SA3 2ER
SPTI

HARDY, William
Systemic Psychotherapist
45 Esplanade Avenue
Porthcawl
Bridgend CF36 3YS
01656 786964
FIC

HARRIS, Anthony
Core Process Psychotherapist
"Harmony"
17 Prince's Avenue
Caerphilly County Borough
CF83 1HR
029 20451952/029 20881632
AAPP

HARRIS, Paul David Gwyn
Cognitive Behavioural Psychotherapist
Psychology Department
Cefn Coed Hospital
Waunarlwydd Road, Crockett
Swansea SA2 0GH
01792 516590/01792 884952
BABCP

HAZELL, Jeremy
Psychoanalytic Psychotherapist
9 Fairleigh Road
Pontcanna
Cardiff CF1 9JT
029 20345832
SIP

HILL, Jenny
Psychoanalytic Psychotherapist
Harpton Gardens
New Radnor, Presteigne
Powys LD8 2RE
01432 264947/01554 350698
SIP

HILLMAN, Jan
Sexual and Relationship Psychotherapist
The Gwent Counselling Centre
25 St. Mary Street, Monmouth
Gwent NP5 3BD
01600 715717
BASRT

HOWES, Kathleen Mary
Cognitive Behavioural Psychotherapist
Y Bwthyn, Battle
Brecon, Powys LD3 9RN
01874 623638
BABCP

HUGHES, Geraldine
Gestalt Psychotherapist
72 Roath Court Road
Roath, Cardiff CF2 3SD
029 20454001
GPTI

JONES, Christopher S
Cognitive Behavioural Psychotherapist
Myddfai Psychotherapy Centre
West Wales General Hospital
Carmarthen
Carmarthenshire SA31 2AF
01267 235151 ext 2085
BABCP

JONES, Elsa
Systemic Psychotherapist
The Natural Health Clinic
98 Cathedral Road
Cardiff CF1 9LP
029 20222221
IFT

KIRWIN, Mark
Psychosynthesis Psychotherapist
Old Church Cottage
Birches Road, Penallt
Monmouth NP5 4AW
01291 627417/01600 712857
AAPP

KOSTORIS, Laura
Integrative Psychotherapist
Erw yr Danty
Talybont-on-Usk, Brecon
Powys LD3 7YN
01874 676498
RCSPC

LISTER, Ian Robert
Family Therapist
Child & Family Consultation Service
West Wales Hospital
Carmarthen SA31 2AF
01267 221225/01267 222392
AFT

LOWE, Julie
Existential Psychotherapist
Flat 5, Silverton
30 Fairwater Road
Llandaff
Cardiff CF5 2LE
029 20563055
RCSPC

MACKENZIE, Ian D.
Psychoanalytic Psychotherapist
Penarth, Cregrina
Nr. Llandrindod Wells
Powys LD1 5SF
01982 570 212
WMIP

MILLS, Nigel
Cognitive Behavioural Psychotherapist
Black Cat Row, Twyn Wenallt
Gilwern
Monmouthshire NP7 0HP
01873 830716
BABCP

MYLAN, Trish
Systemic Psychotherapist
Cae Hir
Peterston-Super-Ely
Cardiff CF5 6LH
01446 760149
FIC

PARLETT, Malcolm
Gestalt Psychotherapist
The Coach House
Nether Skyborry, Knighton
Powys LD7 1TW
01547 528132
GPTI

PARSONS, Barbara
Family Therapist
Preswylfa Child & Family Centre
Clive Road, Canton
Cardiff CF5 1GN
029 20644993/029 20344489
AFT

PEACE, Susan
Hypno-Psychotherapist
The Peace Clinic
Cwm Meillion, Llangammarch Wells
Powys LD4 4EN
01591 620339
NRHP

PLOWMAN, John
Hypno-Psychotherapist
22 Goldcroft Common
Caerleon, Newport
Gwent NP6 1NG
01633 420095
NRHP

REGAN JONES, Columba
Child Psychotherapist
140 St Helen's Road
Swansea SA1 4DE
01792 411201
ACP

RIVETT, Mark
Family Therapist
3 Pitman Street, Pontcanna
Cardiff CF1 9DJ
029 20382266
AFT

ROBERTS, Susan
Core Process Psychotherapist
Brynawel
5 Mountain Road
Caerphilly CF83 1HG
029 20888 155
AAPP

ROUTLEDGE, Derek
Family Therapist
Preswylfa Child and Family Service
Clive Road, Canton
Cardiff CF5 1GN
029 20644993/029 20344489
AFT

ROWLANDS, Helen
Integrative Psychotherapist
32 Kingsland Crescent
Barry
Vale of Glamorgan CF63 4JQ
01446 740517
MET

SELIGMAN, Philippa
Systemic Psychotherapist
22 West Orchard Crescent, Llandaff
Cardiff CF5 1AR
029 20578215/029 20561491
AFT

SIMPSON, Elaine
Family Therapist
9 Elm Grove Place, Dinas Powys
Cardiff CF64 4DJ
029 20512717
AFT

STREET, Eddy
Systemic Psychotherapist
Children's Centre
Llandough Hospital NHS Trust
Penarth
South Glamorgan CF64 2XX
029 20715593
FIC

TELDERS, Martina
Psychoanalytic Psychotherapist
25 Pontcanna Street
Cardiff CF1 9HQ
029 20371391
SIP

THOMAS, Jenny
Transactional Analysis Psychotherapist
"The Highlands"
Old Llantrisant Road, Tonyrefail
Mid Glamorgan CF39 8YU
01443 676579
ITA

TOMSETT, Jean
Family Therapist
16 Stockland Street, Caerphilly
Mid Glamorgan CF8 1GD
029 20883442
AFT

VON UEXKULL, Maxine
Hypno-Psychotherapist
1 Bron-y-Myndd
Pontithel, Three Cocks, Brecon
Powys LD3 0RY
01874 712250
CTIS

WILSON, Jim
Family Therapist
The Family Institute
105 Cathedral Road
Cardiff CF11 9PH
029 20226532
FIC

WARWICKSHIRE

ABBERLEY, Colette
Psychodynamic Psychotherapist
5 Highcroft Crescent
Avonside, Milverton
Leamington Spa CV32 6BZ
WMIP

ALEXANDER, Erica
Family Therapist
83 Radford Road
Leamington Spa CV31 1JQ
01926 881640
FIC

BAGNALL, Steve
Family Therapist
Herbert Gray College
Rugby CV21 3AP
01788 563823
IFT

BARRETT, James
Psychoanalytic Psychotherapist (Jungian)
45 Clarendon Avenue
Leamington Spa CV32 4SQ
WMIP

BENNETT, John
Group Analytic Psychotherapist
1, Eastlands Road, Rugby
Warwicks CV21 3RP
01788 571508
UPA

BREWSTER, M
Sexual and Relationship Psychotherapist
Lyndhurst
Hunningham Road
Weston-under-Wetherley
Leamington Spa CV33 9BU
01926 633745
BASRT

BURNS, Paula
Psychoanalytic Psychotherapist
30 Langton Road
Rugby CV21 3UA
01788 536446
IPSS

CHAPMAN, Jane
Rational Emotive Behaviour Therapist
109 Lower Hillmorton Road
Rugby CV21 3TN
01788 551626
BABCP

DAVIS, John D
Integrative Psychotherapist
20 Beauchamp Avenue
Leamington Spa CV32 5TA
01926 336668
UPA

DAVIS, Marcia L
Integrative Psychotherapist
20 Beauchamp Avenue
Leamington Spa CV32 5TA
01926 336668
UPA

EDWARDS, Jennifer
Psychoanalytic Psychotherapist
2 Cozens Close
Bedworth CV12 8TS
024 76643606
LPDO

ENSER, Nigel
Family Therapist
Department for Children and Young
People and Family
83 Radford Road
Leamington Spa CV31 1JQ
01926 881640/01926 435207
AFT

HARRIS, Richard
Integrative Psychotherapist
41 Weston Lane, Bulkington
Nr Nuneaton CV12 9RS
024 76319872
SPTI

HILL, Brenda
Sexual and Relationship Psychotherapist
93 High Street
Bidford-on-Warwickshire B50 4BD
01789 773192
BASRT

HOLMES, Dorothy
Analytical Psychotherapist
1 Quarry Lane
Nuneaton CV11 6QB
02176 340864
WMIP

LACEY, Irene
Family Therapist
16 Keytes Lane
Barford CV35 8EP
01926 435207/01926 624543
AFT

MCNAUGHT, Janet
Sexual and Relationship Psychotherapist
Cloisters Counselling and Training
The Cloisters
Lower Leam Street
Leamington Spa CV31 1DJ
01926 882521
BASRT

MYERS, Marion
Analytical Psychologist-Jungian Analyst
44 St. Mary's Road
Leamington Spa CV31 1JP
01926 425403
WMIP

NICHOLAS, John
Psychoanalytic Psychotherapist (Jungian)
41 Portland Street
Leamington Spa CV32 5EY
01926 452891
WMIP

OWEN, W Meredith
Psychoanalytic Psychotherapist
Boscobel
Hatton Rock
Stratford-upon-Warwickshire
CV37 0NU
020 7794 4764
WMIP

PAYMAN, Barbara
Transactional Analysis Psychotherapist
40 Moseley Road
Kenilworth CV8 2AQ
01926 316500/01926 859924
ITA

SAMSON, Anne
Psychoanalytic Psychotherapist
19 St. Marys Crescent
Leamington Spa CV31 1JL
01926 883115
WMIP

SIMPSON, Elizabeth
Psychoanalytic Psychotherapist
49 Holly Street
Leamington Spa CV32 4TT
01926 883144
WMIP

SMITH, Robert
NLP Psychotherapist
5 Hall Close, Kilsby
nr. Rugby CV23 8XZ
01788 822141 (t/f)
ANLP

WATSON, Roy
Psychodrama Psychotherapist
31 Dalehouse Lane
Kenilworth CV8 2HW
01926 851328
BPA

WEIGHT, Pam
NLP Psychotherapist
4 Chetwynd Drive, Whitestone
Nuneaton CV11 1TE
024 76743139
ANLP

WREN, Pauline
Hypno-Psychotherapist
13 Hillmorton Road
Rugby CV22 5DF
01788 560793
NRHP

WEST MIDLANDS

BEEDIE, Margaret
Psychoanalytic Psychotherapist
Queen Elizabeth Psychiatric Hospital
Vincent Drive, Edgbaston
Birmingham B15 2QZ
0121 475 7808
WMIP

BEER, Charmian
Sexual and Relationship Psychotherapist
11a Salisbury Road
Moseley
Birmingham B13 8JS
0121 449 4343
BASRT

BIRLEY, Paul
Hypno-Psychotherapist
15 Lee Road, Hollywood
Birmingham B47 5NY
01564 822967
CTIS

BIRTLE, Janice
Psychoanalytic Psychotherapist
South Birmingham NHS Mental Health
Trust
Therapeutic Community Service
22 Summer Road, Acocks Green
Birmingham B27 7UT
0121 678 3244
WMIP

BLAKEY, Angela
Psychoanalytic Psychotherapist,
Psychotherapist (Family &
Relationship)
170 Hole Lane, Northfield
Birmingham B31 2DD
0121 475 3948
WMIP

BOND, Ann R.
Psychodynamic Psychotherapist
2 Dorchester Drive, Harbourne
Birmingham B17 0SW
WMIP

BRAY, Jillyan
Psychodynamic Psychotherapist
26 Maney Hill Road
Sutton Coldfield B72 1JL
0121 354 2403
WMIP

BRINSDON, Nicholas
Family Therapist
Child and Family Unit
93 Northbrook Road, Shirley
Solihull B90 3LX
0121 744 0449
AFT

BROWNE, Chris
Group Analytic Psychotherapist
12 Huntingdon Road, Coventry
Warks CV5 6PU
0976 299989/024 76713908
UPA

BURKE, Robina
Psychoanalytic Psychotherapist
39 Beaumont Road, Bournville
Birmingham B30 2EA
WMIP

BURNHAM, John
Systemic Psychotherapist
Parkview Clinic, Moseley
Birmingham B13 8QE
0121 243 2000/020 7720 7301
KCC

CALVERT, Jane
Psychoanalytic Psychotherapist
48 Hartopp Road
Four Oaks, Sutton Coldfield
Birmingham B74 2QR
0121 323 4233
WMIP

CARLISH, Sonia
Psychoanalytic Psychotherapist
8 Moor Green Lane, Moseley
Birmingham B13 8ND
WMIP

CARPENTER, Dave
NLP Psychotherapist
136 Lichfield Road, Walsall Wood
Walsall WS9 9PD
01543 820092
ANLP

CERFONTYNE, Suzanne
Systemic Psychotherapist
65 Marfield Close, Walmley
Sutton Coldfield B76 1YD
KCC

COOPER, Grahame F.
Psychoanalytic Psychotherapist, Sexual
and Relationship Psychotherapist
6 Clarence Road, Moseley
Birmingham B13 9SX
0121 449 2308
BASRT

CROWLEY, Valerie
Cognitive Analytic Therapist
Psychology Department
Brian Oliver Centre, Brooklands
Marston Green 0121 329 4945
ACAT

CUMMINS, Peter
Personal Construct Psychotherapist
Psychology Department
Gulson Hospital
Guslon Road
Coventry CV1 2HR
024 76844 061
CPCP

DOGGART, Elizabeth Anne
Cognitive Behavioural Psychotherapist
97 Wood Lane, Harborne
Birmingham B17 9AY
0850 990711/0121 427 7292
BABCP

FOKIAS, Dene
Cognitive Behavioural Psychotherapist
18 Hazelbank, Kings Norton
Birmingham B38 8BT
0121 459 6364
BABCP

GEORGE, Elizabeth
Child Psychotherapist
Beech House
Hewell Lane, Barnt Green
Worcester B45 8NZ
0121 445 1338
ACP

GILLIVER, Catherine
Psychodynamic Psychotherapist
Uffculme Clinic
Queensbridge Road
Birmingham B13 8QD
WMIP

GLADWELL, Stephen
Psychodynamic Psychotherapist
Devon House
Mindelsohn Way, Edgbaston
Birmingham B15 2QR
0121 678 5800
WMIP

GOODYEAR, P A J
Psychoanalytic Psychotherapist
139 Knightlow Road, Harborne
Birmingham B17 8PY
WMIP

HANDY, S.
Cognitive Behavioural Psychotherapist
Birmingham Children's Hospital
Steelhouse Lane
Birmingham B4 6NH
0121 333 9180
BABCP

HARRIS, Gerald A.
Hypno-Psychotherapist
78 Park View Road, Streetly
Sutton Coldfield B74 4PS
0121 353 3131
NRHP

HARRIS, Nina
Child Psychotherapist
West Midlands
0121 427 9546
ACP

HARVEY, Tricia A.
Child Psychotherapist, Psychoanalytic
Psychotherapist
6 Clarence Road, Moseley
Birmingham B13 9SX
0121 449 2308
ACP

HEATH, Suzanne
Sexual and Relationship Psychotherapist
Hatherton Centre
Challenge Building
Hatherton Street
Walsall WS1 1YB
01922 775041
BASRT

HILL, Val
Psychodynamic Psychotherapist
BAC Centre
26 Wake Green Road, Moseley
Birmingham B13 9PA
0121 449 9515/0121 449 7426
WMIP

HOAG, Linda M.
Psychoanalytic Psychotherapist (Jungian)
Rm 220, Gazette Buildings
168 Corporation Street
Birmingham B4 6TF
0121 248 5520/01952 244803
WMIP

HOGG, Rosemary
Psychoanalytic Psychotherapist
1 Barron Road, Northfield
Birmingham B31 2ER
0121 475 3912
WMIP

HOWELL, Judy
Hypno-Psychotherapist
41 Badgers Bank Road
Four Oakes
Sutton Coldfield B74 4ER
0121 308 7566
CTIS

HUR, Jung-Ae (Jane)
Cognitive Behavioural Psychotherapist
Yewcroft MHRC
Court Oak Road, Harborne
Birmingham B17 9AB
0121 678 3550/0121 443 1350
BABCP

ILES, David
Hypno-Psychotherapist
Flat 3, Bishops Court
1 Birchtree Drive, Kitts Green
Birmingham B33 0AF
0121 785 0772/0403 678331
CTIS

INGHAM, Rosie
Integrative Arts Psychotherapist
35 Holmfield Road
Coventry CV2 4DD
024 76454503
IATE

IZZARD, Susannah Amanda
Psychoanalytic Psychotherapist
2 Hemyock Road, Selly Oak
Birmingham B29 4DG
0121 243 3745
WMIP

JOHNSON, Judy
Psychoanalytic Psychotherapist
173 Beaumont Road, Bournville
Birmingham B30 1NT
0121 486 1057
WMIP

KAHN, Ashraf
Psychodynamic Psychotherapist
Woodbourne Priory Hospital
21 Woodbourne Road, Edgbaston
Birmingham B17 8BY
0121 434 4373
WMIP

KINGSLEY, L.D
Psychoanalytic Psychotherapist
131a Alcester Road
Birmingham B13 8JP
WMIP

KUETTNER, Enno
Family Therapist
Child &Fam.Service
Pennfields Health Centre
Upper Zoar Street, Penfold
Wolverhampton WV3 0JH
01902 444021/01902 444780
AFT

KYPRIDEMOS, Petros
Hypno-Psychotherapist
254 Bristol Road, Edgbaston
Birmingham B5 7SL
0121 415 5660/0831 109859
CTIS

LIEBLING, Angela J.
Psychoanalytic Psychotherapist
6 Cherry Hill Avenue, Barnt Green
Birmingham B45 8LA
0121 445 3939
WMIP

LINN, Iris
Hypno-Psychotherapist
32 Clive Road, Pattingham
Nr.Wolverhampton WV6 7BY
01902 701023
NRHP

LLOYD, Helen
Psychoanalytic Psychotherapist
65 Blakedown Road,
Halesowen B63 4NG
0121 501 3194 (t/f)
WMIP

LOWERY, I M
Psychoanalytic Psychotherapist
Flat 8
1 Melton Drive, Edgbaston
Birmingham B15 2NB
WMIP

MACE, Chris
Group Analyst
c/o Department of Psychotherapy
University of Warwick
Coventry CV4 7AL
024 76523523
IGA

MALE, David F.
Psychoanalytic Psychotherapist
81 Belle Vue, Wordsley
Nr. Stourbridge DY8 5DB
01384 278761
WMIP

MATÉ, Helen
Psychoanalytic Psychotherapist
177 Pineapple Road, Kings Norton
Birmingham B30 2SY
WMIP

MCDONALD, James T
Psychoanalytic Psychotherapist
20 Greenfields Road, Wombourne
Staffs WV5 0HP
01902 893512
WMIP

MOLONEY, Paul
Cognitive Behavioural Psychotherapist
Sutton CMHT
Patrick House, 5 Maney Corner
Sutton Coldfield B72 1QL
01670 512121
BABCP

MOREBY, Patricia Joyce
Hypno-Psychotherapist
12 Heycroft, Gibbet Hill
Coventry CV4 7HE
024 76418202
NRHP

MORGAN, Linda
Hypno-Psychotherapist
The Medical Training Centre
1 Worcester Street
Stourbridge DY8 1AJ
01384 370 713
NSHAP

MOULIN, Laurence
Family Therapist
47 Prospect Road, Moseley
Birmingham B13 9TD
0121 449 2817
AFT

O'CONNOR, Ann
Psychoanalytic Psychotherapist
160 Uplands Road, Handsworth
Birmingham B21 8BS
01527 488 637/0121 515 2798
WMIP

PARAVA, Anna
Gestalt Psychotherapist
10 Elmdon Road, Selly Park
Birmingham B29 7LF
0121 472 2769
GPTI

PHELPS, Gwyneth
Transactional Analysis Psychotherapist
77 Rowley Street
Walsall WS1 2AZ
01922 635638
ITA

RENTOUL, Robert W.
Psychoanalytic Psychotherapist
3 The Orchard
Wolverhampton WV6 9PF
01902 758504 (t/f)
WMIP

REYNOLDS, Michael John
Psychoanalytic Psychotherapist
16 Bantock Court
Broad Lane, Bradmore
Wolverhampton WV3 9DA
01902 763223
WMIP

ROBINSON, Jenny
Transactional Analysis Psychotherapist
19 Park Road, Moseley
Birmingham B13 8AB
0121 449 2204
ITA

ROPER HALL, Alison
Family Therapist
208 Mony Hull Hall Road
Kings Norton
Birmingham B30 3QJ
0121 678 3400/0121 678 3401
AFT

ROSE, Sylvia
Transactional Analysis Psychotherapist
"Amida", 58 Oxford Road, Moseley
Birmingham B13 9ES
0121 449 2822
ITA

ROY, Geraldine
Psychoanalytic Psychotherapist
174 Walmley Road
Sutton Coldfield B76 2PY
0121 351 1651
WMIP

STOKES, Jenny
Psychoanalytic Psychotherapist
51 Greenhill Road, Moseley
Birmingham B13 9SU
0121 449 1247
WMIP

STOTT, Nicki
Integrative Arts Psychotherapist
35 Holmfield Road
Coventry CV2 4DD
024 76659 376
IATE

TAYLOR, Vivienne
Analytical Psychotherapist
146 Malt House Lane, Earlswood
Solihull B94 5SD
WMIP

TILNEY, Anthony
Transactional Analysis Psychotherapist
63 Victoria Road
Sutton Coldfield B72 1SN
0121 354 4042
ITA

TOOLE, Stuart
Cognitive Behavioural Psychotherapist
24 Herondale Crescent
Stourbridge DY8 3LH
01384 481942
BABCP

TOWNEND, Michael
Cognitive Behavioural Psychotherapist
Solihull Health Care
20 Union Road
Solihull B91 3EF
0976 895298
0121 711 7171 x 2222
BABCP

TRUCKLE, Brian
Child Psychotherapist, Psychoanalytic
Psychotherapist
96 Park Hill
Birmingham B13 8DS
0121 442 6180/4499552/
0121 627 8231
ACP

TRUCKLE, Shirley
Child Psychotherapist, Psychoanalytic
Psychotherapist
96 Park Hill
Birmingham B13 8DS
0121 449 9532/0121 627 8231
ACP

VALLANCE, Fiona
Psychodynamic Psychotherapist
St. Paul Convent, Selly Park
Birmingham B29 7LL
0121 415 6103
WMIP

VAN MARLE, Susanna J
Psychoanalytic Psychotherapist
Devon House
Uffculme Psychotherapy Service
Mindelsohn Way
Edgbaston B15 2OR
0121 678 5800
WMIP

VILLIA-GOSLING, Athina
Psychoanalytic Psychotherapist (Jungian)
1075 Bristol Road, Selly Oak
Birmingham B29 6LX
0121 472 6587
WMIP

WHEELER, Sue
Psychodynamic Psychotherapist
17 Cambridge Road, Moseley
Birmingham B13 9UE
WMIP

WINKLEY, Linda
Child Psychotherapist, Psychoanalytic
Psychotherapist
Oaklands Centre
Selly Oak Hospital
Raddlebarn Road
Birmingham B29 6JB
0121 627 8231
ACP

WOODWARD, Joan
Psychoanalytic Psychotherapist
61 Selly Wick Drive, Selly Park
Birmingham B29 7JQ
0121 472 3055
CAPP

WILTSHIRE

BANKS, Ron
NLP Psychotherapist
Littlebrook House
The Brownings, Box
Corsham SN13 8HP
01225 742898
ANLP

BARKER, Elizabeth
Biodynamic Psychotherapist
8 Brunkards Lane
Pewsey SN9 5AP
01672 564 232
BTC

BROWN, Elizabeth Ann
Group Analytic Psychotherapist
Flat 30, Anthony Road
Wroughton Swindon SN4 9HN
01793 813918
FPC

CLAXTON, Brenda
Humanistic Psychotherapist, Integrative
Psychotherapist
The Folly, Folly Lane, Lacock
Chippenham SN15 2LL
0249/01249 730 213
MC

COLEMAN, Jane
Psychoanalytic Psychotherapist
'Cotswold', 99 High Street, Marshfield
Chippenham SN14 8LT
01225 891478
IPSS

DAVIS, Brenda
Cognitive Behavioural Psychotherapist
Child & Adolescent Clinical Psyc.
Child & Family Therapy Service
Trowbridge Fam.Health Centre
The Halve.Trowbridge BA14 8SA
01225 352282
BABCP

DAWKINS, Sue
Integrative Arts Psychotherapist
209 Conkwell
Bradford-on-Wiltshire BA15 2JF
0225 722006
IATE

DE SOUZA, Janice
Cognitive Psychotherapist
Kingshill House, Kingshill Road
Swindon SN1 4LG
01793 491917
BABCP

ELTON WILSON, Jennifer
Integrative Psychotherapist
The Bakehouse
Thickwood, Colerne
Nr. Chippenham SN14 8BN
01225 743081
MET

FOX, Fiona
Psychodynamic Psychotherapist
Swallow Cottage
Wylye Road, Hanging
Langford SP3 4NN
01722 790174
WMIP

GREEN, Michael
Psychoanalytic Psychotherapist
'Cotswold'
99 High Street, Marshfield
Chippenham SN14 8LT
01225 891478
IPSS

HANCOCK, Patricia
Psychoanalytic Psychotherapist
1 Hockett's Close, Lyneham
Chippenham SN15 4QX
01285 861239/01249 890254
SIP

HILLING, Richard
Cognitive Behavioural Psychotherapist
Stress Management & Post Truama
Counselling Serv.
Bentley Centre, Stratton Road
Swindon SN1 2SH
01793 616333
BABCP

LASCELLE, Hasan
Psychodrama Psychotherapist
Flat 2, 66A Hythe Road
Old Town
Swindon SN1 3NX
BPA

LEACH, Kathy
Transactional Analysis Psychotherapist
"Townsend"
Ogbourne St. Andrew
Marlborough SN8 1SE
01672 841528/01672 841254
ITA

LEGH-SMITH, Andrea
Core Process Psychotherapist
Garden Cottage
Mount Seylla, Ford
Near Chippenham SN14 8RR
01249 782516
AAPP

MACGREGOR, Alan
Cognitive Behavioural Psychotherapist
Ease Management Centre
7 Newport Street
Old Town Swindon SN1 3DZ
01793 433422
BABCP

MELLETT, Jane
Humanistic and Integrative
Psychotherapist
16 Tutton Hill, Colerne
Chippenham SN14 8DN
01225 742163
BCPC

MIDDLETON-SMITH, Virginia
Systemic Psychotherapist
1 Queensberry Road
Salisbury SP1 3PH
01722 327602
KCC

MUNDY, Pamela
Transactional Analysis Psychotherapist
Tannery House, 8 High Street
Downton SP5 3PJ
01725 513426(f)/01725 513800
ITA

POCOCK, Olga
Analytical Psychotherapist
32 Elizabeth Court
Cranebridge Road
Salisbury SP2 7UX
01722 320093
SIP

POOLE, Carol Lynn
Systemic Psychotherapist
Lowdens
Frenchmoor Lane
East Dean
Nr Salisbury SP5 1HA
KCC

PREGNALL, Sheila
Psychodrama Psychotherapist
70 Kent Road
Swindon SN1 3NG
BPA

RANCE, Sarah
Child Psychotherapist
Child & Family Therapy Service
Trowbridge Family Health Centre
The Halve
Trowbridge BA14 8SA
01225 766161
ACP

REES, Ian
Core Process Psychotherapist
60 Bristol Street
Malmesbury SN16 0AX
01666 823471
AAPP

REIMERS, Sigurd
Family Therapist
Child & Familt Therapy Service
Family Health Centre
The Halve
Trowbridge BA14 8SA
01225 352281
FIC

RHEINSCHMIEDT, Otto
Group Analyst
Ficino Cottage
78 Farleigh Road, Wingfield
Bradford on Avon BA14 9LG
01225 763531
IGA

ROBB, Melissa
Family Therapist
79 Gloucester Road
Malmesbury SN16 0AJ
01666 822945
AFT

ROYS, Clare
Systemic Psychotherapist
Child & Family Therapy Service
Chippenham Family Health Centre
Goldney Avenue
Chippenham SN15 1ND
01249 656321
FIC

SHARPE, John
Group Analyst
Clare Cottage
23 West Dean
Nr. Salisbury SP5 1JB
01794 340028
IGA

SYKES, MARGARET
Family Therapist
Child and Family Therapy Service
Chippenham Health Service
Goldney Avenue
Chippenham 01249 656 321
AFT

THAM, Anna
Autogenic Psychotherapist, Core Process
Psychotherapist
Turleigh Farm, Turleigh
Nr. Bath BA15 2HH
020 7727 6382/01225 868221
AAPP

VOELCKER, Cara
Humanistic and Integrative
Psychotherapist
Avils Farm
Lower Stanton, Quinton
Chippenham SN14 6DA
01249 720202
BCPC

WESTMAN, Stephen
Cognitive Behavioural Psychotherapist
Kingshill House, Kingshill Road
Swindon SN1 4LG
01793 491917
BABCP

WILLIAMS, Debbie Jane
Cognitive Behavioural Psychotherapist
Kingshill house, Kingshill Road
Swindon SN1 4LG
0973 769785/01793 491917
BABCP

WORCESTERSHIRE

CAMPBELL, Duine
Psychoanalytic Psychotherapist (Jungian)
Home Farm
High Park
Droitwich WR9 0AG
01905 771588
WMIP

DENHAM, Juliet
Gestalt Psychotherapist
Orchard House, Prescott,
Nr Cleobury Mortimer DY14 8RR
01746 718 231
GPTI

DENHAM-VAUGHAN, Sally
Gestalt Psychotherapist, Integrative
Psychotherapist
The Summer House
127 Columbia Drive, Lower Wick
Worcester WR2 4XX
01905 760305/01905 748772
GPTI

FEARNSIDE, Derek
Cognitive Behavioural Psychotherapist
192 Northwick Road
Worcester WR3 7EQ
01905 456277
BABCP

GILLIGAN, Toni
Gestalt Psychotherapist
22 Tileford Cottages
Long Lane, Throckmorton
Nr. Pershore WR10 2LA
01386 561528
GCL

GROOM, Nigel A
Psychoanalytic Psychotherapist
The Gap, Saleway
Nr. Droitwich Spa WR9 7JY
01905 391470
FPC

LAW, Gordon
Transactional Analysis Psychotherapist
5 Bawdsey Avenue, Malvern
Worcester WR14 2EW
01684 566268 (t/f)
ITA

MCNEILLY, Gerald
Group Analyst
159 St Georges Road
Redditch B98 8ED
01527 459067
IGA

MORGAN, Jo
Hypno-Psychotherapist
Apt.4 Birchwood
Imperial Road WR14 3AW
01684 891128
NSHAP

NEWBY, Rita
Psychoanalytic Psychotherapist
78 Victoria Avenue
Worcester WR5 1ED
01905 763552
CPP

O'LEARY, Anne
Group Analytic Psychotherapist
27 Bushley Close, Woodrow
Redditch B98 7TU
01527 501565
FPC

THOMPSON, Hilary
Psychosynthesis Psychotherapist
40D St. Johns
Worcester WR2 5AJ
01905 422 420
AAPP

TURNER, Mary
Integrative Psychotherapist
72 Lower Wyche Road
Malvern WR14 4ET
01684 891548
MET

YORKSHIRE (NORTH)

ASHTON, Carole
Gestalt Psychotherapist
9 Park Street
The Mount
York YO24 1BQ
01904 643073
SPTI

BRADSHAW, Lynn E
Psychodynamic Psychotherapist
Rose Villa
15 Bellevue Terrace
York YO10 5AZ
01904 651036/01904 656600
UPA

BRAY, Malcolm
NLP Psychotherapist
7 George Street, Carleton
Nr Skipton BD23 3HQ
01756 791110
ANLP

BRIEGER, Johanna
Analytical Psychologist-Jungian Analyst
4 Moiser Close, Hartrigg Oaks
New Earswick
York YO32 4DR
01904 750895
CAP

BULMER, Liz
Transactional Analysis Psychotherapist
The Oakdale Centre
49 Valley Drive, Harrogate
01423 508281/01423 503080
ITA

BURDETT, C.W.
Cognitive Behavioural Psychotherapist
37 Broomfield Avenue
Northallerton
North Yorkshire DL7 8RH
01609 771 528/01325 743 566
BABCP

CHAMIER, Suzanne
Hypno-Psychotherapist
18 Broadway West
Fulford
York YO1 4JJ
01904 621866
NRHP

CULLWICK, Joy
Gestalt Psychotherapist
64 Strensall Road
Huntingdon
York YO3 9SJ
01904 764608
SPTI

DAVIDOFF, Leslie
Psychoanalytic Psychotherapist
10 Devonshire Street
Skipton
North York BD23 2ET
01756 793549
IPSS

DOLAN, Bernadette
Gestalt Psychotherapist
4 Eastfield
Amotherby
Malton Nr Yorks YO17 6TJ
SPTI

DUNCAN, Ursula
Integrative Psychotherapist, Transactional
Analysis Psychotherapist
18 Mayfield Grove
Harrogate
North Yorkshire HG1 5HB
01423 569640
NGP

EVETTS-SECKER, Josephine
Analytical Psychologist-Jungian Analyst
Lidgate
Victoria Square, Lythe
Whitby, N.York YO21 3RW
01947 893338 (t/f)
IGAP

GALLOWAY, Betsy
Integrative Psychotherapist, Transactional
Analysis Psychotherapist
10 Gray Street, Scarcroft Green
York YO23 1BN
01904 647893
NGP

GREENING, Sarah
Integrative Psychotherapist, Transactional
Analysis Psychotherapist
5 South Parade, Northallerton
North Yorkshire DL7 8SE
01609 776680
NGP

HARTLEY, Phil
Group Analyst
Stockton Hall Hospital
Stockton on the Forest
York YO3 9UN
01904 400500
IGA

HESTER, Bridget A
Psychoanalytic Psychotherapist,
Psychodynamic Psychotherapist
The Old Rectory, Crayke
York YO6 4TA
01347 821593
LPDO

JONES, Helen
Personal Construct Psychotherapist
2 Heslington Court, School Lane
York YO1 5EX
01904 435138/435139/
01904 438 757(t/f)
CPCP

KELLY, Peter
Integrative Psychotherapist
51 Nunthorpe Crescent
York YO23 1DU
01904 656408
NGP

KENNARD, David
Group Analyst, Psychodynamic
Psychotherapist
The Tuke Centre for Psychotherapy and
Counselling
28 Green Dyke Lane
York YO10 3HH
01904 430370
IGA

KENNETT, Christine
Gestalt Psychotherapist, Integrative
Psychotherapist
38 Millfield Road
York YO23 1NQ
01904 638623
GPTI

LAWRENCE, Yvonne
Integrative Psychotherapist, Transactional
Analysis Psychotherapist
Shannon House
13 York Terrace
Whitby
North Yorkshire YO12 1QF
01947 603496
NGP

MARTIN, Gill
Psychodynamic Psychotherapist
34 The Old Village
Huntington
York YO32 9RB
01904 750285/01904 430370
YAPP

MASTERS, Sue
Transpersonal Psychotherapist
Haxby
York YO31
01904 612069
CCPE

MCCLUSKEY, Una
Family Therapist, Psychodynamic
Psychotherapist
The Yews, Waplington Hall
Allerthorpe
York YO42 5DD
01759 302104
YAPP

MCCROHAN, Denise
Integrative Psychotherapist
Patrick McCrohan, St John of God
Hospital
Scorton, Richmond
N Yorkshire DL10
01748 811 535
CCBP

MILLER, Liza Bingley
Family Therapist
10 St. Oswald's Road
Fulford, York YO1 4PF
01904 633417
AFT

MORGAN-WILLIAMS, Susan
Existential Psychotherapist
The Old Chapel
Thoralby, Leyburn, N.Yorkshire DL8 3SU
01696 663831
RCSPC

PAYNE, Graham
Psychoanalytic Psychotherapist
Dept. of Mental Health
Friarage Hospital
Northallerton DL6 1JG
01609 779911 3437
NAAP

REILLY, Stephen
Psychodynamic Psychotherapist
Bootham Park Hospital
York YO3 7BY
01904 610777
YAPP

RICHARDSON, Caroline
Sexual and Relationship Psychotherapist
The Oakdale Centre
49 Valley Drive
Harrogate HG2 0JH
01423 503080
BASRT

TYSON, Robert
Gestalt Psychotherapist
Forge House, 65 High Street
Snainton, Scarborough
North Yorkshire YO13 9AL
01723 859265
GPTI

WATSON, Caroline
Gestalt Psychotherapist
Horn End Cottage
East Low Mill, Farndale
York YO62 7XA
01751 431293
SPTI

WILKINSON, Kate
Gestalt Psychotherapist, Integrative
Psychotherapist
Vere House
117 Columbys Ravine
Scarborough YO12 7QU
01723 376246
SPTI

WILLIAMS, Richard
Family Therapist
18A Rectory View
Lockington, Driffield
E. Yorks YO25 9SG
01430 810446
FIC

WOJCIECHOWSKA, Ewa
Group Analyst
The Oakdale Centre
49 Valley Drive, Harrogate
North Yorkshire HG2 0JH
01432 503080
IGA

YORKSHIRE (SOUTH)

CARIAPA, Illana
Cognitive Behavioural Psychotherapist
Dept of Child & Family Psychiatry
Chatham House, Doncaster Gate
Rotherham S65 1DJ
01709 824808
BABCP

COURTNEY, Mary
Psychodynamic Psychotherapist
Dept of Psychological Medicine
Barnsley District General Hospital
Ganbar Road
Barnsley S75 2EP
01226 777958
YAPP

DONOHOE, Gillian
Cognitive Behavioural Psychotherapist
Department of Behavioural
Psychotherapy
Doncaster Royal Infirmary
Armthorpe Road
Doncaster DN2 5LT
01302 366666 x 3214
BABCP

DORNDORF-TURNER, Rhoda
Psychoanalytic Psychotherapist
22 Queensway
Moorgate, Rotherham
South Yorkshire S60 3EE
01709 366799
LPDO

LEA, Mary
Behavioural Psychotherapist
Mental Health Unit
Rotherham Dist. General Hospital
Moorgate
Rotherham S60 2UD
01709 820000 x 6032
BABCP

MACDONALD, Helen F.
Cognitive Behavioural Psychotherapist
Pain Management Unit
Montagu Hospital, Adwick Road
Mexborough, S.Yorkshire S64 0AZ
BABCP

SMITH, Eileen F.
Psychodynamic Psychotherapist
First Floor Flat
Hooton Pagnell Hall
Hooton Pagnell
Doncaster DN5 7BW
01977 642481
HIP

TWEED, Mary
Transactional Analysis Psychotherapist
Flat 2, 54 Bennetthorpe
Doncaster
South Yorkshire DN2 6AD
ITA

WRIGHT, Christine M.J.
Cognitive Behavioural Psychotherapist
Dept. of Behavioural Psychotherapy
Doncaster Royal Infirmary
Armthorpe Road
Doncaster DN4 7DT
01302 366666 x 3214
BABCP

YORKSHIRE (WEST)

AGASS, Dick
Psychodynamic Psychotherapist
5c Chapel Lane, Bingley
West Yorkshire BD16 2NG
01274 510217
HIP

ANDERSON, Larry
Family Therapist
Counselling and Therapy Services
Normanton & District Hospital
Castleford
West Yorkshire WF10 5LT
01977 605526/01977 605501
AFT

ASHTON, John
Psychodynamic Psychotherapist
16 Woodland Park Road
Leeds LS6 2AZ
0113 275 9747
HIP

BONNER, Kate
Psychodynamic Psychotherapist
17 Launds
Rochdale Road, Golcar
Huddersfield HD7 4NN
01484 654508
YAPP

BOSTOCK, Christine
Psychoanalytic Psychotherapist,
Psychodynamic Psychotherapist
55 North Park Avenue
Leeds LS8 1HP
0113 269 7194
HIP

BOSTON, Paula
Family Psychotherapist, Systemic
Psychotherapist
Psychology Department
University of Leeds
Leeds LS2 9JT
01943 601162/0113 233 6641
IFT

BRESLOFF, Valerie
Transactional Analysis Psychotherapist
418 Street Lane
Leeds LS17 6RL
0113 268 779
ITA

CANN, Lesley
Psychodynamic Psychotherapist
Lynfield Mount Hospital
(Bradford CMHT), Heights Lane
Bradford BD9 6DP
01274 363233
YAPP

CANON, Sue
Gestalt Psychotherapist
2 New Laithe, Krumlin
Barkisland
Halifax HX4 0EN
01422 823828
SPTI

CLARKSON, Barbara
Transactional Analysis Psychotherapist
6 Mead Grove
Leeds LS15 9JS
0113 264 3994
ITA

CONLON, Isobel
Analytical Psychotherapist, Psychoanalytic
Psychotherapist, Psychodynamic
Psychotherapist
1 Ancaster Road, West Park
Leeds LS16 5HH
0113 225 9724/0113 275 1958
NWIDP

COTTRELL, David
Family Therapist
Academic Unit of Child & Adolescent
Mental Health
12A Clarendon Road
Leeds LS2 9NN
0113295 1761/0113 295 1760
AFT

COWARD, Malcolm
Gestalt Psychotherapist
Bankgate Cottage
Bankgate, Slaithwaite
Huddersfield HD7 5DH
01484 843 289
SPTI

DOUGLAS, Angela
Psychodynamic Psychotherapist
5A Westgate, Otley
West Yorkshire LS21 3AT
01943 468443
YAPP

EADIE, Yvonne
Cognitive Analytic Therapist
4 Alberta Avenue
Leeds LS7 4LX
0113 294 0141
ACAT

ELLINGWORTH, Janice
Family Therapist
Leeds Social Services
Osmondthorpe One Stop Centre
81A Wykebeck Mount
Leeds LS9 0DW
0113 247 7652
AFT

EPSTEIN, Melanie Lynn
Integrative Psychotherapist
22 Primley Park Avenue
Alwoodley
Leeds LS17 7JA
0113 266 2402
NGP

GAUNTLETT, Tim
Psychoanalytic Psychotherapist
"Waske Hall"
50 Skircoat Green
Halifax HX3 0SA
01422 341391
IPSS

GILLJAM, Annika
Psychoanalytic Psychotherapist,
Psychodynamic Psychotherapist
24 Eaton Road, Ilkley
West Yorkshire LS29 9PU
01943 602449
GUILD

GLOVER, Jean
Sexual and Relationship Psychotherapist
The Rectory, Church Side
Methley
Leeds LS26 9BJ
01977 515278
BASRT

GODSIL, Susan
Psychodynamic Psychotherapist
1A Oakwood Lane
Leeds LS8 2PZ
0113 265 7169
YAPP

HAMILTON, Jane
Psychoanalytic Psychotherapist
Avenue Cottage
Harewood Avenue, East Keswick
Leeds LS17 9HL
01937 572291
WMIP

HAMLYN, Sarah
Integrative Psychotherapist
307 Harrogate Road
Leeds LS17 6PA
0113 268 2665
NGP

HANKS, Helga
Analytical Psychotherapist, Family
Therapist, Psychodynamic
Psychotherapist
Dept of Clinical & Health Psychology
St James' University Hospital
Leeds LS8 1JF
0113 206 5897
YAPP

HARROW, Anne
Analytical Psychotherapist, Group
Analyst, Psychodynamic Psychotherapist
3 Woodbine Terrace, Headingley
Leeds LS6 4AF
0113 278 6142
YAPP

HEENAN, Colleen
Analytical Psychotherapist,
Psychodynamic Psychotherapist
Heathroyd Garden Practice
4 Toller Drive, Bradford
W York BD9 5NU
01274 493125/0113 245 5725
YAPP

HELBERT, Jan
Group Analyst
Clinical Health
Psychology Department
St Lukes Hospital
Bradford BD5 0NA
01274 365176
IGA

JACKSON, Sherin
Personal Construct Psychotherapist
Highdale Cottage
217 Barnsley Road, Denby Dale
Huddersfield HD8 8TS
01484 864824
CPCP

JAKUBSKA, Aggie
Psychodrama Psychotherapist
37 Norwood Terrace
Shipley, Bradford
Yorkshire BD18 2BD
01274 582044
BPA

JOHNSTON, James
Psychoanalytic Psychotherapist
2 Spring Terrace, Guiseley
Leeds LS20 9AX
0113 295 5430/01943 870367
HIP

JONES, Maggy
Family Therapist
Farfield House
105 North Street, Keighley
West Yorkshire BD21 3AA
01535 690055
AFT

LANCELOT, Maggie
Psychodynamic Psychotherapist
5c Chapel Lane, Bingley
West Yorks BD16 2NG
01274 531607/01274 778163
NWIDP

LEWIS, Sheila*
Psychoanalytic Psychotherapist
17 Princess Road, Ilkley
West Yorkshire LS29 9NP
01484 343480/01943 601948
GUILD

LUDOLF, Monica
Hypno-Psychotherapist
4 Riviera Gardens
Chapel Allerton, Leeds
Yorkshire LS7 3DW
0113 262 2355
NRHP

MANTON, Rosie
Psychosynthesis Psychotherapist
Lower Small Shaw Farm
Pecket Well, Hebden Bridge
W.Yorks HX7 8RF
01422 843 501
AAPP

MARSHALL, Pauline
Integrative Psychotherapist
5 Daisy Road, Brighouse
West Yorks HD6 35Y
01484 710210
SPTI

MARTIN, Carol
Psychodynamic Psychotherapist
Department of Psychiatry
University of Leeds,
15 Hyde Terrac
Leeds LS2 9JT
0113 233 2736
YAPP

MASON, Christine
Psychodynamic Psychotherapist
Psychiatric Social Work Dept
Roundhay Wing
St James Hospital
Leeds LS9 1LD
0113 206 5577
UPA

MORRIS, Jane
Psychoanalytic Psychotherapist
4 Lower Chiserley
Old Town, Hebden Bridge
West Yorkshire HX7 8RZ
NWIDP

NOLAN, Philip
NLP Psychotherapist
67 Kaye Lane
Almondbury, Huddersfield
West Yorkshire HD5 8XT
01484 432847
ANLP

OAKLEY, Ian H.
Analytical Psychotherapist,
Psychodynamic Psychotherapist
Glen Royd
Birchcliffe Road, Hebden Bridge
West Yorkshire HX7 8DB
01422 843563
LPDO

PAGE, Annabel
Psychodynamic Psychotherapist
18 Crossbeck Road
Ilkley
W.Yorks LS29 9JN
01943 601184
YAPP

PARKER, John
Psychoanalytic Psychotherapist
18 Eaton Road, Ilkley
West Yorkshire LS29 9PU
01943 603837
LPDO

PATTINSON, Philip
Cognitive Behavioural Psychotherapist
Psychology Services
Northowram Hospital
Northowram, Halifax
West Yorkshire HX3 7SW
01422 201101 x 334
BABCP

PELTIER, Judy
Psychodynamic Psychotherapist
c/o Manningham Project
Little Horton, Lumb Lane
Bradford BD8 7SG
01274 543814/01274 502604
HIP

PHILLIPS, Pauline
Psychodynamic Psychotherapist
27 Gledhow Avenue
Leeds LS8 1LD
0113 266 7175
UPA

PHILLIPS, Thomas Lambton
Cognitive Behavioural Psychotherapist
90 Redwood Drive, Bradley Manor
Huddersfield
West Yorkshire HD2 1PW
01484 455150/01484 303007
BABCP

PITTOCK, Frances
Psychoanalytic Psychotherapist
St Mary's House, St Mary's Road
Leeds LS7 3JX
0113 295 2402
HIP

PYVES, Gerry
Transactional Analysis Psychotherapist
YTC
27 Clare Road
West Yorks HX1 2JP
01422 366356/01422 843384
ITA

RADCLIFFE, Mark
Psychodynamic Psychotherapist
51 Argie Road, Burley
Leeds LS7 3JX
0113 226 4701
UPA

ROSE, Sally
Psychoanalytic Psychotherapist,
Psychodynamic Psychotherapist
4 Victoria Road, Kirkstall
Leeds LS5 3JB
0113 274 5147
ARBS

ROWAN, Chris
Integrative Arts Psychotherapist
60 Victoria Road
Leeds LS6 1DL
0113 274 3065
IATE

ROWE, Celly
Psychodynamic Psychotherapist
Dept. of Psychotherapy
Southfield House
40 Clarendon Road
Leeds LS2 9PJ
0113 243 9000
YAPP

SIDEY, Brian
Psychodynamic Psychotherapist
38 Wellington Crescent
Shipley
W. Yorks BD18 3PH
01274 599327/01274 784888
YAPP

SIMON, Gail
Systemic Psychotherapist
Airedale Child & Family Centre
Mayfield Road
Off Spring Garden Lane, Keighley
West Yorkshire BO20 6LD
0113 242 4884
KCC

SMALLEY, John
Analytical Psychologist-Jungian Analyst
5a Westgate, Otley
Leeds
W Yorks 01535 665 362
IGAP

SPENCELEY, Dave
Transactional Analysis Psychotherapist
27 Clare Road, Halifax
West Yorkshire HX1 2JP
01422 366356
ITA

STEPHENSON, Keri P
Psychodynamic Psychotherapist
5 Coronation Terrace
Hebden Bridge
West Yorkshire HX7 8SF
01282 474760
UPA

STEWART, Kate
Family Therapist
Child & Adolescent Services
Fieldohead House
2-8 St Martin's Avenue
Listerhills BD7 1LG
01274 723241/01274 770369
AFT

STEWART, Phil
Cognitive Behavioural Psychotherapist
59 Hill Top Road
Paddock, Huddersfield
West Yorkshire HD1 4SQ
01484 510892
BABCP

STOKELD, Alasdair
Psychoanalytic Psychotherapist,
Psychodynamic Psychotherapist
4 Victoria Road, Kirkstall
Leeds LS5 3JB
0113 274 5147
ARBS

STRATTON, Peter M
Systemic Psychotherapist
Leeds Family Therapy and Research
Centre
School of Psychology
University of Leeds
Leeds LS2 9JT
0113 233 5728
KCC

SYME, Gabrielle
Psychodynamic Psychotherapist
Mount Farm House
Town Street, Rawdon
Leeds LS19 6QJ
0113 250 5700
YAPP

TANNA, Nick
Group Analyst, Psychodynamic
Psychotherapist
99 Netherton Lane, Netherton
W Yorkshire WF4 4HG
01924 280 424
IGA

TAYLOR, James
Integrative Psychotherapist
4 Beechwood Street
Leeds LS4 2LX
0113 226 8481
NSAP

TOWNSEND, Pat
Cognitive Behavioural Psychotherapist
Mental Health Unit
Pontefract General Infirmary
Friarwood Lane, Pontefract
W Yorks WF8 1PL
01977606331
BABCP

TREPKA, Chris
Cognitive Psychotherapist
Ashgrove CMHC
48 Ashgrove, Bradford
West Yorkshire BD7 1BL
01274 560311/01274 391671
BABCP

VACIAGO SMITH, Marta
Child Psychotherapist, Psychoanalytic
Psychotherapist
21 Milnthorpe Drive
Wakefield WF2 7HU
01924 255629
ACP

VINCENT, Jane
Psychodynamic Psychotherapist
16 Pasture Terrace
Leeds LS7 4QR
0113 295 1771/0113 228 9885
HIP

WALFORD, Jane
Transactional Analysis Psychotherapist
2a Weetwood Lane
Far Headingley
Leeds LS16 5LS
01132 789953
ITA

WALFORD, Robin
Transactional Analysis Psychotherapist
2a Weetwood Lane
Far Headingley
Leeds LS16 5LS
01132 789953
ITA

WALKER, Dawn
Family Therapist
Therapeutic Social Work Team
Osmond Thorpe One Stop Centre
81a Wykebeck Mount
Leeds LS9 0DW
0113 247 8872/0113 247 7652
AFT

WARD, Joseph B
Group Analytic Psychotherapist
100 North Park Avenue, Leeds
Yorkshire LS8 1HP
0113 2933262
UPA

WATTIS, Libby
Psychoanalytic Psychotherapist,
Psychodynamic Psychotherapist
11 Cherry Rise, Leeds LS14 2HJ
0113 273 6067/0113 240 8611
WMIP

WEBB, Joan
Psychoanalytic Psychotherapist,
Psychodynamic Psychotherapist
23 Henconner Lane
Chapel Allerton
Leeds LS27 3NX
0113 2623766
LPDO

WELCH, Lawrence
Cognitive Analytic Therapist
Psychology & Psychotherapy Service
Malham House, 25 Hyde Terrace
Leeds LS2 9LN
0113 392 2640
ACAT

WELSH, Catherine
Psychodynamic Psychotherapist
54 Ridge End Villas
Leeds LS6 2DA
0113 2750153/0113 225 6930
YAPP

WILLIAMS, Christopher John
Cognitive Behavioural Psychotherapist
Malham House, 25 Hyde Terrace
Leeds LS2 9LN
0113 292 6716
BABCP

WOLF, Runa
Gestalt Psychotherapist
8 Victoria Buildings
Cragg Vale, Hebden Bridge
W York HX7 5TJ
SPTI

OVERSEAS

AUSTRALIA

CADE, Brian
Family Therapist
PO Box 386
Eastwood, New South Wales 2122
Australia
612 9876 6068/612 9868 2606
AFT

CEBON, Ann
Child Psychotherapist
8 Coombs Avenue
Kew
Victoria 3101 Australia
0061 398 533 114
ACP

DURLACH, Stefan
Integrative Psychotherapist
20 High Street
Glenbrook
NSW 2773
Australia 02 9716 7199/
0247 393 210
RCSPC

FULLERTON, Peter B.
Psychoanalytic Marital Psychotherapist
42 Alandale Road, Eaglemont
Victoria 3084
Australia 61 3 9455 2791 (t/f)
TMSI

HENRY, Rachel M.
Child Psychotherapist
4 Wigram Road
Austinmer
NSW 2515
Australia 00612 42674531
ACP

ISSA, Soraya
Cognitive Behavioural Psychotherapist
22 Russell Street
Balgownie 2519
NSW 61 242 854736
Australia
BABCP

KENWOOD, Pat
Child Psychotherapist
Apartment 2
2 Bay Street, Brighton, Vic 3186
Australia 00 61 359 62306
ACP

KINBACHER, William
Transpersonal Psychotherapist
PO Box 4661
Cairns 4870
N. Queensland
Australia
CCPE

KONDOS, Sandra
Integrative Psychotherapist
20 High Street, Glenbrook
NSW 2773
Australia 0247 393 210
RCSPC

LEIGH, Elana
Integrative Psychotherapist
158 Wellington Street
Bondi 2026, Sydney
Australia 00 612 93009907
MET

MORRISSEY, Shirley
Cognitive Behavioural Psychotherapist
Dept. of Psychology and Sociology
James Cook University
PO Box 6811, Cairns 4870
Australia 00 61 70 939331/
00 61 70 421183
BABCP

OGILVIE, Renata
Existential Psychotherapist
P O Box 314
Blackheath, NSW 2785
Australia 0247 875514
RCSPC

SCHMIDT-NEVEN, Ruth
Child Psychotherapist
Centre for Child & Family Development
721A Riversdale Road
Camberwell, Victoria 3124
Australia 00 618 300422
ACP

STRASSER, Alison
Integrative Psychotherapist
251 Underwood Street
Paddington, NSW 2021
Australia
02 9211 2122/02 9363 5663
RCSPC

SWIFT, Sue
Transactional Analysis Psychotherapist
Apartment 15, Sunshine Vista
Duke Street, Sunshine Beach
Queensland 4567
ITA

TAYLOR, Rosemary E.B.
Transactional Analysis Psychotherapist
Oxford House, 48 Oxford Terrace, Unley
Adelaide 5061, Australia
08 8271 7555
ITA

THOMPSON, Christine
Integrative Psychotherapist
16 Breen Terrace
Ferny Creek, Victoria 3786
Australia 9755 3048
RCSPC

TOLCHARD, Barry
Cognitive Behavioural Psychotherapist
Department of Psychiatry
Flinders Medical Centre
Bedford Park, Adelaide, S Australia
5042 08 8204 4779
BABCP

VINEY, Linda
Personal Construct Psychotherapist
Department of Psychology
University of Wollongong
Northfields Avenue, Wollongong
NSW 2522
Australia 02 4221 3693
CPCP

BELGIUM

ROEX, Danielle
Gestalt Psychotherapist, Psychosynthesis
Psychotherapist
Meersstraat 95
B-9000 Gent
Belgium 00 32 9221 0901
AAPP

BRAZIL

DE SOUZA, Joney
Psychoanalytic Psychotherapist
Alamada Santos, 927–ap.52
Sao Paulo, Brazil
020 7612 7242/00-55-11-283 3815
IPSS

SAMSON, Andre
Biodynamic Psychotherapist
Rua Joao Batista Leme
Da Silva 53
05449-030 Sao Paolo
Brazil 00 55 11 3021 4122
BTC

CANADA

BATE, Dolores
Gestalt Psychotherapist
2360 Waterloo Street, Vancouver B.C.
V6R 4M6 737 7099/733 9123
GPTI

FISH, Deborah M.
Hypno-Psychotherapist
2678 W 11th Avenue
Vancover BC
Canada V6K 2L6
604 737 7563
NRHP

SALOLE, Roy
Transactional Analysis Psychotherapist
Chateau Royal, Professional Bldg
1390 Prince of Wales Drive#308
Ottawa, Canada
613 225 1044
ITA

TICKTIN, Stephen
Existential Psychotherapist
59 Hyde Park Drive
Richmond Hill
Ontario
Canada L4B 1X2
905 231 8092
RCSPC

CROATIA

BULJAN FLANDER, Gordana
Integrative Psychotherapist
PODGAT 31
10000 Zagreb
Croatia
SPTI

FRANIC TUKIC, Sanda
Integrative Psychotherapist
Ilila 160
10000 Zagreb
Croatia
SPTI

SPRAJC-BILEN, Mirjana
Integrative Psychotherapist
Matijasa Korvina 14
10430 Samobor
Croatia
SPTI

DENMARK

BOYESEN, Mona Lisa
Biodynamic Psychotherapist
Told bud Vej 3
Hals, Jylland
Denmark
BTC

VEJE, Margit
Psychoanalytic Psychotherapist
Skt. Pauls Gade 8b St.
DK-8000
Arhus C.
Denmark
00 45 86 128530
ARBS

FINLAND

RUISMAKI, Marjo
Systemic Psychotherapist
Ala-Malmintori 2,3krs
00700
Helsinki
Finland KCC

SODERSTROM, Anne-Charlotte
Psychoanalytic Psychotherapist
Villa Enhagen, Westervik
10600 Ekenas 019 2412151
Finland
IPSS

FRANCE

BURTON, Mary V.
Psychoanalytic Psychotherapist
74, Rue St.Pierre
89450 Vezelay
France FRA
00333 86323466
WMIP

FOGUEL, Brenda
Group Analyst
21 rue Beranger
75003 Paris 0033 1 42 77 04 30
France
IGA

GAVIN, Verity J
Integrative Psychotherapist
Le Bastidon, Hameau de St Pierre
St Martin de Castillon 84750
France
04 90 75 10 65/04 90 75 25 71
RCSPC

WHEELER, Meredith
Transpersonal Psychotherapist
St Martin de Dauzats
Lautrec 81440, France FRA
(33) 05 63 59 11 32
CCPE

GERMANY

CATINA, Ana
Personal Construct Psychotherapist
Centre for Psych. Research Stuttgart and
Dept
Psychotherapy. University of Ulm
Christian-Belser-Str
79A DE-70597 Stuttgart
49 711 72 45 93
CPCP

DIEFFENBACHER, Jutta
Transpersonal Psychotherapist
Malteserordensstrasse 1 f
79 111 Freiburg
Germany
(Freiburg 484858)
CTP

PERVOLTZ, Rainer
Body Psychotherapist, Integrative
Psychotherapist
Oberan 49
79102–Freiburg
Germany
07668 94532
CCBP

POLLACK, Angela
Primal Psychotherapist
Gaden 28
93326 Abensberg
Germany
0049 9443 9034 18
LAPP

GREECE

ATHANASIADIS, Loukas
Cognitive Behavioural Psychotherapist
Iktinou 6
Thessaloniki
54622
Greece
BABCP

LAYIOU-LIGNOS, Effie
Child Psychotherapist
54 Aimonos Street
Colonos 10442
Athens, Greece
00 301 514 8123
ACP

MOUTZOUKIS, Chris
Cognitive Behavioural Psychotherapist
17 Smyrnis Street
57019 Perea
Thessaloniki, Greece
00 30 392 27081/
00 30 31 288 380
BABCP

POULOPOULOS, Katerina
Integrative Psychotherapist
Litous 32
Lemos
Vouliagmenis
Athens, Greece TK16671
00 301 8963 967/00 301 3817 220
RCSPC

SAZATZOGLOU-HITZOS, M.
Child Psychotherapist
P. Levanti 8
Panorama, Salonica
Greece
00301 343741
ACP

SIMOS, Gregoris
Cognitive Behavioural Psychotherapist
69 Vas.Olgas Street
546 42 Thessalonki
Greece
0030 31 268 841/0030 31 838 755
BABCP

HONG KONG

LAU, Bernard Wai Kai
Cognitive Behavioural Psychotherapist
Nicholson Tower, Block A1, 5/F
8 Wong Nai Chung Gap Road
Happey Valley
Hong Kong
BABCP

O'BRIAN, Charles
Family Psychotherapist
Dept. of Applied Social Sciences
City University of Hong Kong
83 Tat Chee Avenue
Kowloon, Hong Kong
852 27888994
IFT

PRYDE, Nia
Sexual and Relationship Psychotherapist
14A Block 1
Tam Towers
25 Sha Wan Drive
Victoria Road, Hong Kong
852 2855 8435
BASRT

SHUEN, Dorcas
Group Analytic Psychotherapist,
Psychoanalytic Psychotherapist
42, RN 8
Fairview Park, Yuen Long
N.T., Hong Kong
248 20308
LCP

TURNER, Vivien
Cognitive Analytic Therapist
10/F Hing Wai Building
36 Queens Road Central
SAR China 00 852 2523 8044/00 852
2813 1405
ACAT

INDIA

BHARUCHA, Aiveen
Child Psychotherapist
125 Wodehouse Road
Colaba
Bombay 400005
India
009122 2151 260
ACP

BHARUCHA, Manek P E
Child Psychotherapist
125 Wodehouse Road
Colaba
Bombay 400005
India
009122 215 1257
ACP

IRELAND

BRANAGAN, Noelle
Psychodrama Psychotherapist
Auila
York Road
Dun Laoghaire
Co Dublin, Eire
BPA

Ireland

BUTCHER, Gerard
Cognitive Behavioural Psychotherapist
St. John of God Hospital
Stillorgan, Co. Dublin
Ireland
353 1 662 5148/353 1 288 1781
BABCP

CAIRD, Elizabeth J.
Hypno-Psychotherapist
22 Cherrymount Park
Dublin 7
Irish Republic
00 3531 838 9767
NSHAP

CARNEY, Joanne
Family Therapist
2 Beechview
Fahan, Co Donegal
Eire
00353 77 60553
AFT

CONROY, Kay
Psychosynthesis Psychotherapist
White House
Templeogue
Dublin 6W
Ireland
00 353 1 2801094/
00 353 1 4906615
AAPP

CULLEN, Anne M.
Cognitive Behavioural Psychotherapist
St. Mary's Hospital
Westport Road
Castlebar
Co. Mayo, Ireland
00 353 94 21 333
BABCP

DUBERRY, Mark
Integrative Psychosynthesis
Psychotherapist
9 Carrig House
Carrickbrennan Road
Monkstown, Co. Dublin
01 2300257
RE.V

FLYNN, Stephen
Psychodrama Psychotherapist
Carrig Na Floinn
Lavally, Mallow
Co. Cork, Eire
00 353 22 21937
BPA

FOLEY, Dermot
Integrative Psychotherapist
21 Leeson Park
Dublin 6
Ireland
00353 126 00773
RCSPC

HARRISON, Caroline M
Sexual and Relationship Psychotherapist
HARI Unit
Rotunda Hospital
Dublin 1
Ireland
003531 807 2732
BASRT

HOWARD, Sister Columba
Transactional Analysis Psychotherapist
1 Summerhill Heights
Wexford
Ireland
ITA

HOWLETT, Brian
Sexual and Relationship Psychotherapist
1B Belfield Court
Donnybrook
Dublin 4
Ireland
01 283 8233
BASRT

MASTERSON, Ingrid
Psychoanalytic Psychotherapist
"Alberta"
Ardtona Avenue
Lower Churchtown Road
Dublin 14, Ireland
IPSS

MCCARTHY, Rita
Analytical Psychologist-Jungian Analyst
1 Newton Villas
Newtown Avenue, Blackrock
Co. Dublin
283 2395
AJA

MCFADDEN, Hugh E.
Cognitive Behavioural Psychotherapist
"Sancta Maria"
Gortlee, Letterkenny
Co. Donegal, Ireland
353 74 21022 x 3275/
00 353 74 21919
BABCP

MCGOLDRICK, Mary
Cognitive Behavioural Psychotherapist
St. Patrick's Hospital
James's Street
Dublin 8
Ireland
00 3531 677 5423
BABCP

MCGROARY-MEEHAN, Maureen
Behavioural Psychotherapist, Sexual and
Relationship Psychotherapist
Ocala, Main Street
Bundoran
County Donegal
Ireland
00 353 73 21933
BASRT

MURPHY, Ger
Integrative Psychotherapist
23 Lower Albert Road
Sandy Cove
Co Dublin
00 3531 280 8989
MC

MURRAY, Catherine
Psychodrama Psychotherapist
Newtown House
Doneraile, Co.Cork
Eire, Ireland
00 353 222 4117
BPA

O'CONNOR, Aine
Primal Psychotherapist
45 Huntsdown Court
Clonsilla
Dublin 15
Ireland
003531 8216163
LAPP

O'CONNOR, Maureen
Transpersonal Psychotherapist
Ceathru Ban
RavensDale, Dundalk
Ireland
00353 4271901
CCPE

O'CONNOR, Nadia
Transpersonal Psychotherapist
Ardagh
Union Hall, Sikbbereen
West Cork, Ireland
CCPE

O'SHEA, Deidre
Family Therapist
St Clare's Unit
The Childrens Hospital
Temple Street
Dublin
AFT

OTTO, Joachim
Biodynamic Psychotherapist
56 Dun-na-mara
Renmore
Galway City
EIRE
00 353 91 755 693
BTC

O'CONOR, Mary
Sexual and Relationship Psychotherapist
The Albany Clinic
Clifton Court
Lower Fitzwilliam Street
Dublin 2, Ireland
01 661 2222
BASRT

O'NEILL, Julia
Biodynamic Psychotherapist
Auginish
Kinvarra, Co. Galway
Eire
BTC

O'SULLIVAN, Bernadette
Personal Construct Psychotherapist
VICO Consultation Centre
2 Dungar Terrace
Dun Laogharie
Co. Dublin, Ireland
00 3531 284 3336
CPCP

REYNOLDS, Malcolm
Psychosynthesis Psychotherapist
10 Greenlands
Sandyford, Dublin 16
Ireland
00 353 294 2239
AAPP

ROCHE, Sile
Systemic Psychotherapist
"The Cottage"
Drumnigh
Old Portmarnock
Co. Dublin, Eire
KCC

RYAN, Mairead
Behavioural Psychotherapist
The Albany Clinic
Clifton Court
Lower Fitzwilliam Street
Dublin 2, Ireland
00 353 1 661 4828
BABCP

SCOTT-MCCARTHY, Brian
Psychoanalytic Psychotherapist
Pigges Eye
South Schull, Schull
Co.Cork, Ireland
353 28 28 429
AGIP

SHIELDS, Ellen Attracta
Existential Psychotherapist
16 University Road
Galway, Ireland
091 581711/071 67140
RCSPC

STEVENS, Jill
Sexual and Relationship Psychotherapist
11 Tivoli Terrace North
Don Laoghaire
Co. Dublin, Ireland
353 1 2807338
BASRT

THORP, Terry
Hypno-Psychotherapist
179 Heathervue
Greystones, Co. Wicklow
Ireland
0 87 273 0395/353 1 287 1620
NRHP

WALSH, Deirdre
Core Process Psychotherapist
84 High Street, Cork, Ireland
021 733 4763
AAPP

WARD, Shirley
Humanistic Psychotherapist
Amethyst
28 Beech Court
Killiney, Co.Dublin
00353 1 2850976
AHPP

YOUNG, Anne
Transpersonal Psychotherapist
"Chertsey"
27 Rostrevor Road, Rathgar
Dublin 6, Ireland
003531 497 0331
CTP

GREEN, Dror
Integrative Psychotherapist
221 Ramat Razim
Safed
13200
Israel00972–6-6923941
RCSPC

HEITZLER, Morit
Body Psychotherapist, Integrative
Psychotherapist
11/9 Giboret-Israel Street
Kfar-Sava
Israel
009729 765 1030
CCBP

MAZLIACH, Yaron
Child Psychotherapist
PO Box 42
Kefar-Monsh 42875
Israel
09 648213
ACP

ITALY

BENVENUTO, Bice*
Lacanian Analyst
Via di Gallese 23
00151 Rome ITA. Italy
CFAR

CORLANDO, Annalisa
Family Therapist
Via Giacinto Collegus No. 57
110138 Torino
Italy
0039 11945 2139/
0039 11433 5706
AFT

DUNAND, Anne*
Lacanian Analyst
Via Dello Scalone 1
00187 Rome
Italy
06-67-97-211
CFAR

KENNY, Vincent
Personal Construct Psychotherapist
Via Benedetto Croce 68
Scale A:12
Roma 001 42
Italy
06 519 635 41/00 396 592 3985
CPCP

KERRIDGE, Petra
Psychosynthesis Psychotherapist
Damanhur
10080 Baldissero
Canavese (TO)
Italy
AAPP

MOLINO, Anthony
Psychoanalytic Psychotherapist
Corso Garidbaldi
107, Vasto (CH) 66054
Italy
0039 873 60386
SITE

PIONTELLI, Alessandra
Child Psychotherapist
Largo Richini 1
20100 Milan
Italy
00 392 583 07193
ACP

NETHERLANDS

CARTON, Roy
Integrative Psychotherapist
Bataviastraat 39-G
1095 Em Amsterdam
The Netherlands
SPTI

HEWSON, Polly
Integrative Psychotherapist
St Willibrordusdwars Straat 4/11
1074 XG Amsterdam
The Netherlands
+31(20)675 0723
SPTI

KALDAWAAY, Karina
Core Process Psychotherapist
Psychosynthesis Studies
Weidenheuvel, Binneweg 22
1191 AA Ouderkerk a/d
0031 20 692 9589
AAPP

SANDERS, Harmen
Integrative Psychotherapist
Moddermanlaan 5
9721 GK Groningen
Holland
050 5925800
SPTI

TJEPKEMA, Froukje
Psychoanalytic Psychotherapist
Johan De Wittstraat 7 bis
3581 XX Utrecht
The Netherlands
0031 30 233 3715/
0031 30 231 3469
FPC

VAN BEEK, Ingrid
Psychosynthesis Psychotherapist
Kooikershof 7
5256 KD Heusden
Netherlands
0031 20 676 5171/
00 31 41 62 3178
AAPP

VAN ROSSUM, Diederik
Psychosynthesis Psychotherapist
c/o Emmastraat 26
1075 HV Amsterdam
Netherlands
31 20 676 5171
AAPP

NEW ZEALAND

BULL, Graham E
Lacanian Analyst, Psychoanalytic
Psychotherapist
49 Herald Street
Berhamphore, Wellington
New Zealand 04 3897541
CFAR

FARRELL, Bill
Psychoanalytic Psychotherapist
P O Box 60297
Titirangi, Auckland 1007
New Zealand
LPDO

HART, Bruce
Family Therapist
52 Springleigh Avenue
Mount Albert, Auckland
New Zealand
09 815 6200
AFT

PETERS, Anthony
Personal Construct Psychotherapist
117 Waitoki Road
Kautapakapa, Auckland
New Zealand
64 9 420 4018/64 9 815 0888
CPCP

RYBURN, Murray
Systemic Psychotherapist
173 Fifield Terrace
Christchurch
8002
New Zealand
KCC

NORWAY

BALMBRA, Steven
Family Therapist
Bodinveien 56
8010 Bodo
Norway
47 75 58 11 90
AFT

PATRICIA, Thelma
Psychoanalytic Psychotherapist
Flaskecrokken
Flaskebekk
1450 Nesoddtangen
Norway
46 66 913075
IPSS

PERU

MONTALBETTI, M.L.
Child Psychotherapist
Santander 147
Miraflores, Lima 18
Peru
0051 2543491
ACP

RUSSIA

SIZIKOVA, Tanya
Integrative Psychotherapist, Transactional
Analysis Psychotherapist
189620 Pushkin–9–
St Petersburg
Prinvokzalnaua Square
House 2, Flat 75, Russia
0017 812 5520100
NGP

SOUTH AFRICA

GREEN, Margaret
Psychoanalytic Psychotherapist
7 Buckingham Road
Plumstead 7800
Capetown
South Africa
00 27 21 761 3027
ARBS

HARMEL, Barbara
Integrative Psychotherapist
12C Firth Avenue
Westdene 2096
Johannesburg, South Africa
00 27 477 1224
RCSPC

LEVETT, Ann
Integrative Psychotherapist
Psychology Department
University of Witwatersrand
Johannesburg
South Africa
SPTI

LOUW, Francois
Integrative Psychotherapist
PO Box 973
Cresta 2118
Republic of South Africa
012 420 2329
SPTI

MALCOLM, Charles
Integrative Psychotherapist
Psychology Department
University of Witwatersrand
Johannesburg
South Africa
SPTI

MILLER, Sheila
Child Psychotherapist
PO Box 1399
Houghton 2041
South Africa
00 2711 646 9786
ACP

ROSENBAUM, Linda Ann
Integrative Psychotherapist
PO Box 650229
Benmore 2010, Gauteng
South Africa
SPTI

SALTERS, Diane
Transactional Analysis Psychotherapist
15 Disa Road
Murdock Valley North
Simons Town 7975
Republic of South Africa
ITA

SMITH, Cora
Integrative Psychotherapist
Dept pf Psychology
University of Witwatersrand
Johannesburg
South Africa
SPTI

STRAKER, Gill
Integrative Psychotherapist
Department of Psychology
University of Witwatersrand
Johannesburg
South Africa
SPTI

SLOVENIA

PETERNEL, Franc
Group Analyst
Slovenceva 109
61113 Ljubljana
Slovenia
386 61 344 521/386 61 315 990
IGA

SPAIN

BOTELLA, Luis
Personal Construct Psychotherapist
Department of Psychology
Ramon Llull University
Cister 24-34
08022 Barcelona
CPCP

CAMPOS, Hanne
Group Analyst
Pasea San Gervasio 30
008022 Barcelona
Spain
010 34 3 2475639
IGA

CAMPOS, Juan
Psychoanalytic Psychotherapist
Transito De Los Gramaticos 3
15703 Santiago
Spain
981 572866
IPSS

DRURY, Gitta
Gestalt Psychotherapist
Casa Media Luna
03790 Orba
Alicante, Spain
00346 5583884
SPTI

IBANEZ, Julian
Psychoanalytic Psychotherapist
Alameda de Urquijo 94
Iero Dech
48013 Bilbao
Spain
00 344 4277340
ARBS

OROMI, Irene
Educational Therapist
Mallorca 239
08008 Barcelona
Spain
932157623
FAETT

TURNER, Carole
Transactional Analysis Psychotherapist
La Galera de Las Palmeras 119
03590 Altea, Alicante
Spain
00 3496 584 6191
ITA

SWEDEN

BRADSHAW-TAUVON, Kate
Psychodrama Psychotherapist
Sveavagen 52 2tr
S 111 34 Stockholm
Sweden
0046 8 411 0420
BPA

FRISCHER, Livia
Integrative Psychosynthesis
Psychotherapist
Antelopgatan 7, 412 38 Molndal
Sweden
0046 31 205602
RE.V

HAGELTHORN, Christina
Psychodrama Psychotherapist
Foreningsgatan 7
411 27 Goteborg
Sweden
0046 (0) 31 711 8732
BPA

RUSSELL, Margo
Psychosynthesis Psychotherapist
PsykosyntesAkademin
Stora Nygatan 33m
S-111 27 Stockholm
Sweden
00 46 8 641 4700
AAPP

SWITZERLAND

HANNA, Hyams
Transactional Analysis Psychotherapist
18B.ch.D
Munier, Genere
1223 Suisse
ITA

HERING-JOSEFOWITZ, Pauline
Child Psychotherapist
12 Chemin Des Eglantieres
1208 Geneva
Switzerland
00 41 22 349 1230
ACP

ITTEN, Theodor
Psychoanalytic Psychotherapist
Psychologe BPS
Psychotherapeut SPV
Bahnhofstre.15
CH-9000 St. Gallen
Switzerland
071/223 5443
PA

OHNESORG, Johanna
Biodynamic Psychotherapist
Bachlerstrasse 62
Zurich, CH-8046
Switzerland
0041 1 371 7647
BTC

STEINMANN, Christina
Psychosynthesis Psychotherapist
Dorfstrasse 57, 8037 Zurich
Switzerland
00 411 271 2239
AAPP

TURKEY

SUNGUR, Mehmet Z
Cognitive Behavioural Psychotherapist
Tunali Hilmi Caddessi
No 70/28 Kavaklidere
Ankara, Turkey
90 532 291 1277/
90 312 362 3030 x6697
BABCP

USA

BUTLER, Todd
Gestalt Psychotherapist
620 Albion Street
San Diego
Ca.92106
USA
001 619 523 6007
MET

CARLSON, Cynthia
Child Psychotherapist
2516E. Newton Avenue
Milwaukee WI 53211
USA
ACP

EPTING, Franz
Personal Construct Psychotherapist
9310 NW 10th Pl.
Gainesville, Florida
FL 32606, USA
CPCP

HAMILTON, Victoria
Child Psychotherapist
990 Hanley Avenue
Los Angeles, California 90049
USA
001310 471 1897
ACP

HERMON, Deborah
Child Psychotherapist
7120 Via Marbella
Boca
Raton, Florida
33433 00561 4173300
ACP

HOOK, Susan
Cognitive Behavioural Psychotherapist
10403 SE 98th Court
Portland, OR 97266
USA
00 1 503 771 3371
BABCP

LEITMAN, Norman
Integrative Psychotherapist
620 Albion Street
San Diego
CA 92106
001 619 523 6007
MET

LISMAN-PIECZANSKI, N.M.
Child Psychotherapist
4417 36th Street, N.W.
Washington D.C.
20008
USA
001202 363 1909
ACP

MILLER, Jill M
Child Psychotherapist
240 St. Paul Street
Suite 315, Denver
Colorado
80206 USA
001303 3559533
ACP

REDDY, William
Transpersonal Psychotherapist
8380 N.E.Beck Road
Bainbridge Island
Seattle
Washington USA
001 206 780 9226
CCPE

RYAN, Angella M.J.
Psychodynamic Psychotherapist
88 Delwyn Barnes Drive
Whitinsville
MA 01588, USA
(508)266 3041
WMIP

SIDOLI, Mara
Child Psychotherapist
4307 Massachusetts Avenue NW
Washington DC 20016
USA
001 202 362 1886
ACP

SORENSEN, Pamela
Child Psychotherapist
928 Rugby Road
Charlottesville
Virgnia 22903
USA
010 1180 49795669
ACP

WILLIAMS, Susan
Analytical Psychologist-Jungian Analyst
5133 Lawton Avenue
Oakland
California 94618
USA
(510) 595 1814
AJA

Alphabetical Listing

A

Abbasi, Shafika (p.85)
Abberley, Colette (p.185)
Abeles, Margi (Margaret) (p.67)
Ablack, Joanne (p.67)
Abrahams, Elisabeth M (p.67)
Abse, Susanna (p.67)
Acket, Marijke (p.174)
Ackroyd, Elaine (p.145)
Ackroyd, Rosemary (p.16)
Acquarone, Stella (p.85)
Adams, Clare E A (p.144)
Adams, Eve (p.34)
Adams, Martin (p.62)
Adams, Megan (p.163)
Adams, Melissa (p.111)
Adams, Sarah K (p.178)
Adams, Sue (p.67)
Adams, Tessa* (p.102)
Adams-Langley, Stephen (p.111)
Adamson, Fiona (p.153)
Adamson, Niki (p.47)
Adcock, Margaret (p.41)
Addenbrooke, Mary (p.179)
Addenbrooke, Peter (p.179)
Adey, John (p.23)
Adler, Eve (p.22)
Adler, Hella (p.85)
Adlington, Jethro (p.145)
Afford, Peter (p.111)
Agar, James (p.34)
Agass, Dick (p.193)
Aggett, Percy (p.62)
Agnew, Joyce (p.155)
Aguirregabiria, Ana (p.111)
Aird, Eileen (p.67)
Airey, Gabriela (p.85)
Aitken, Fiona (p.145)
Aizenberg, Eldad (p.136)
Akinboro-Cooper, Bobbie
 (p.111)
Al Jarrah, Nadina (p.67)
Al Rubaie, Talal (p.67)
Alabaster, Nigel (p.102)
Albrecht, Gisela (p.67)
Albrighton, Sylvia (p.86)
Alder, Helena (p.10)
Alder, Roger (p.10)
Alderton, Chris (p.16)
Aldred, Sue (p.41)
Aldridge, Janet (p.179)
Alexander, Erica (p.185)
Alexander, Gail (p.174)
Alexander, Gina MV (p.148)
Alexander, Paul T. (p.161)
Alexander, Sandra (p.67)
Alexander-Graham, Cassy (p.52)
Alferoff, Tamara (p.67)
Alhadeff, Christine (p.67)
Alister, Ian (p.12)
Allan, Brenda (p.67)

Allan, Kay (p.34)
Allard, Alain (p.174)
Allawi, Nadia (p.111)
Allen, Cheryl (p.20)
Allen, Dorothy (p.86)
Allen, Lesley (p.86)
Allen, Patricia M. (p.148)
Allen, Penny (p.158)
Allen, Tessa (p.164)
Alleyne, Aileen (p.102)
Allinson, Mary A. (p.21)
Allison, Lyn (p.102)
Allport, Maggie (p.41)
Allsop, Pamela (p.111)
Allsop, Paul (p.67)
Allsop, Wendy (p.136)
Altman, Michelle (p.58)
Altschuler, Jenny (p.86)
Alvarez, Anne (p.86)
Ambrose, Tony (p.111)
Amez, Susana (p.36)
Amias, David (p.67)
Amiel, Olivia (p.67)
Amies, Peter (p.148)
Anderson, Christine (p.40)
Anderson, Eleanor (p.41)
Anderson, Elizabeth (p.67)
Anderson, Janet (p.30)
Anderson, Judith (p.145)
Anderson, Larry (p.193)
Anderson, Linda (p.86)
Anderson, Naomi (p.22)
Anderson, Tony (p.174)
Anderton, Michael (p.86)
Andrew, Alison (p.155)
Andrew, Elizabeth (p.111)
Andrews, Carol (p.19)
Andrews, Ruth (p.47)
Anees, Nabil (p.163)
Angold, Monica (p.153)
Anjali, Yon (p.23)
Anker, Ofra (p.67)
Ansari, Shakir Shiyam (p.102)
Anson, Carol (p.62)
Anstice, Christine (p.179)
Antao, Ivor (p.10)
Anthias, Louise (p.36)
Anthony, Monica (p.102)
Antonson, Kathleen Scott (p.153)
Appleby, Joy (p.130)
Applegarth, Janet (p.21)
Appleton, Richard Lonsdale
 (p.182)
Aquarone, Luc-Remy (p.141)
Aram, Eliat (p.67)
Arbia, G. Nicoletta (p.121)
Arcari, Sallie R (p.174)
Archer, Ruth (p.111)
Ardeman, Jacqueline (p.136)
Ariel, Seema (p.67)
Aris, Sarajane (p.1)

Arkwright, Lynda (p.53)
Armitage, Pamela (p.148)
Armstrong, Caroline (p.121)
Armstrong-Perlman, Eleanore*
 (p.58)
Arnesen, E (p.158)
Arnold, Katherine (p.67)
Arnold, Lynn (p.121)
Arnold, Rosemary* (p.67)
Arnold, Sue (p.16)
Arnott, Biddy (p.86)
Arredondo, Beverly (p.34)
Arriens, Pamela (p.12)
Arthur, Andrew R. (p.86)
Arundell, Jane (p.30)
Arzoumanides, Yiannis (p.121)
Ash, Robert (p.1)
Ashcroft, Dinah (p.36)
Ashcroft, Jennifer (p.133)
Asheri, Shoshi (p.67)
Ashley, Anne (p.165)
Ashton, Carole (p.191)
Ashton, John (p.193)
Ashwin, Mary (p.58)
Ashworth, Freda (p.53)
Askin, Pauline (p.47)
Asmall, Ismail (p.136)
Asseily, Alexandra (p.121)
Aston, John (p.40)
Astor, Bronwen (p.165)
Athanasiadis, Loukas (p.199)
Atkins, Lorna (p.165)
Atkinson, Pamela (p.12)
Atkinson, Paul (p.62)
Attias, Sandra (p.102)
Attridge, Brian (p.36)
Attwood, Peter (p.102)
Aufflick, Julia (p.8)
Austin, Lesley (p.86)
Austin, Neil (p.86)
Austin, Susan (p.86)
Austrin, Chris (p.157)
Averbeck, Marcus (p.47)
Avery, Anna (p.145)
Avery, Trisha (p.121)
Avigad, Jocelyn (p.136)
Aylard, Paul (p.1)
Aylward, P J (p.102)
Ayo, Yvonne (p.121)
Ayres, Alison (p.154)
Ayres, Anthony (p.102)
Ayres, Kathleen (p.179)
Azgad, Rachel (p.68)
Azu-Okeke, Okeke (p.111)

B

Babarik, Anthony (p.121)
Bacha, Claire (p.130)
Bacon, Roger* (p.12)
Bactawar, Charles D. (p.41)
Bagnall, Steve (p.185)

Bailey, Catalena (p.136)
Bailey, James (p.55)
Bailey, Lorna M. (p.10)
Bailey-Smith, Yvonne A (p.86)
Baker, Adrienne (p.68)
Baker, Jan (p.121)
Baker, Kevin (p.174)
Baker, Moke (p.165)
Baldrey, Sarah (p.23)
Ball, Derek (p.55)
Ballance, Gillian (p.41)
Balmbra, Steven (p.202)
Balogh Henghes, Tessa (p.68)
Bamber, James (p.122)
Bamber, Nicola (p.47)
Bandler Bellman, Debbie (p.86)
Banks, Jan (p.137)
Banks, Ron (p.189)
Bannister, Anne (p.131)
Bannister, Gill (p.62)
Bar, Vivien (p.68)
Bar-Yoseph, Talia Levine (p.86)
Baradon, Tessa (p.68)
Barclay, Elizabeth (p.122)
Bardelle-Carrier, Rosemary
 (p.179)
Barden, Nicola (p.36)
Barham, Peter (p.122)
Baring, Anne (p.36)
Barker, Elizabeth (p.189)
Barker, Gina (p.68)
Barker, John F. (p.55)
Barker, Lily (p.158)
Barley, Andrew (p.131)
Barnes, Hugh (p.1)
Barnes, Tricia (p.111)
Barnett, Gillian (p.131)
Barnett, Madeleine (p.86)
Barnett, Mary (p.174)
Barnett, Ruth (p.86)
Barratt, Sara (p.41)
Barrett, James (p.185)
Barrett, Jean (p.102)
Barrett, Jenny (p.164)
Barrett, Julie (p.1)
Barrows, Paul (p.1)
Barry, Anne (p.68)
Bartels-Ellis, Phillida (p.86)
Barter, Ruth (p.102)
Bartlett, Beatrice (p.122)
Bartlett, Francesca (p.62)
Barton, Alan (p.53)
Barwell, Peter (p.1)
Basharan, Harika (p.122)
Bassam, Bruce (p.102)
Bassett, George (p.145)
Batchelor, Carol (p.165)
Batchelor, Henrietta (p.180)
Bates, Helen Mary (p.155)
Bathai, Parizad (p.86)
Batten, Cecilia (p.34)

Batten, Francis *(p.145)*
Battersby, Audrey *(p.86)*
Baum, Stefanie *(p.34)*
Bayley, Eva *(p.165)*
Bayley, Sydney *(p.30)*
Bayne, Brenda Therese *(p.179)*
Baynes, Gay *(p.86)*
Baynes, Monica *(p.21)*
Bazeley-White, Diana *(p.1)*
Beach, Jan D. *(p.36)*
Beacham, Sonja *(p.131)*
Beard, Dorrie *(p.47)*
Beard, Hilary *(p.158)*
Beard, Hilary *(p.102)*
Beasley, Rachel *(p.62)*
Beattie, Anya *(p.111)*
Beaumont, Anne *(p.41)*
Beaumont, Mia *(p.68)*
Beazley-Richards, Joanna *(p.174)*
Bebber, Gillian *(p.1)*
Beber, Ray *(p.68)*
Becker, Amely *(p.68)*
Beckett, Dale *(p.68)*
Beddington, Jenny *(p.68)*
Beech, Julie C. *(p.143)*
Beechcroft, Diane *(p.145)*
Beecher-Moore, Naona *(p.58)*
Beedie, Margaret *(p.186)*
Beer, Charmian *(p.186)*
Beer, Margaret *(p.165)*
Begg, Deike *(p.156)*
Begg, Ean *(p.156)*
Beguin, Agnes *(p.122)*
Behr, Harold *(p.68)*
Beighton, Chris *(p.30)*
Beijne, Sabina *(p.7)*
Bell, Frances *(p.102)*
Bell, Lydia J. *(p.12)*
Belle-Boule, Annabell *(p.145)*
Bellis, Stella *(p.182)*
Benbow, Susan *(p.131)*
Bender, Helen *(p.62)*
Benjamin, Haydene *(p.86)*
Benjamin, Joan E *(p.165)*
Bennett, Angela *(p.68)*
Bennett, Gerald A. *(p.28)*
Bennett, John *(p.185)*
Bennett, Lesley *(p.103)*
Bennett, Margaret *(p.165)*
Bennett, Rosanagh *(p.154)*
Bennett, Ross *(p.36)*
Bennison, Judy *(p.158)*
Bennun, Ian *(p.23)*
Benor, Ruth *(p.23)*
Bensimon, Marlene *(p.68)*
Benson, Jarlath *(p.144)*
Benson, Pauline *(p.86)*
Bentley, Patrick *(p.68)*
Bentley, Radhe *(p.122)*
Bentley, Ros *(p.53)*
Bentovim, Arnon *(p.86)*
Benvenuto, Bice *(p.201)*
Beresford, Marie *(p.68)*
Bergel, Edith *(p.133)*
Berger, Iris *(p.41)*
Berger, Jocelyn *(p.111)*
Berke, Joseph *(p.68)*
Berman, Linda *(p.131)*

Berman, Paul *(p.16)*
Bermingham, Donald *(p.12)*
Berry, Eileen *(p.36)*
Berry, Juliet *(p.158)*
Berry, Margaret *(p.134)*
Berry, Peter* *(p.41)*
Berry, Sally *(p.68)*
Bessant, Irene *(p.166)*
Bevan, Judith *(p.41)*
Bharucha, Aiveen *(p.199)*
Bharucha, Manek P E *(p.199)*
Bhat, Radha *(p.103)*
Bhatt, Vibha* *(p.68)*
Bhattacharyya, Amit *(p.143)*
Bhunnoo, Z. *(p.47)*
Biancardi, Jenny *(p.180)*
Bianco, Vicky *(p.68)*
Bibbey, Judy *(p.16)*
Bibby, Keith *(p.111)*
Bickerton, Tricia *(p.62)*
Bielicz, Paul *(p.134)*
Bienkowski, Geraldine *(p.157)*
Bierschenk, John Henry *(p.68)*
Biggins, Toby *(p.16)*
Bilder Ma, Tessa *(p.68)*
Bingham, Jane *(p.30)*
Binnington, Linda *(p.68)*
Birch, James Williams *(p.180)*
Birchard, Thaddeus *(p.58)*
Birchmore, Terry *(p.21)*
Bird, Jane *(p.41)*
Bird, John *(p.16)*
Birkett, Diana *(p.111)*
Birley, Paul *(p.186)*
Birtle, Janice *(p.186)*
Bisgood, Bill *(p.182)*
Bishop, Beata *(p.122)*
Bishop, Patricia *(p.103)*
Black, Judith *(p.103)*
Black, Margaret *(p.53)*
Black, Nicholas J. *(p.36)*
Black, Patricia Anne *(p.180)*
Black, Sandra *(p.103)*
Black, Teresa J. *(p.161)*
Blackburn, Ivy-Marie *(p.180)*
Blackburn, John *(p.158)*
Blackburn, Paul *(p.46)*
Blacker, Polly *(p.158)*
Blacker, Sandra Rosamond *(p.41)*
Blackwell, Frances *(p.68)*
Blackwood, Renate *(p.166)*
Blair, Dana-Jane *(p.69)*
Blair, George *(p.166)*
Blake, Nancy *(p.46)*
Blakey, Angela *(p.186)*
Blampied, Annette N *(p.16)*
Bland, John *(p.103)*
Bland, Roger *(p.111)*
Blandy, Evanthe M* *(p.86)*
Blench, Graeme *(p.47)*
Bloch, Linda *(p.148)*
Blomfield, Valerie *(p.103)*
Bloomfield, Irene *(p.122)*
Blow, Kirsten *(p.148)*
Blowers, Colin M. *(p.174)*
Blum, Anita *(p.87)*
Blum, Arna *(p.148)*
Blundell, Suzanne *(p.134)*

Blunden, Jane *(p.28)*
Blyth, Doug *(p.12)*
Blyth, Fiona *(p.148)*
Boa, Cherry *(p.166)*
Boa, Quint *(p.166)*
Boadella, David *(p.58)*
Boakes, Janet *(p.103)*
Bobsin, Mica *(p.174)*
Boddaert, Michael *(p.161)*
Boddington, Daphne *(p.179)*
Bodgener, Sue *(p.87)*
Boening, Joachim *(p.122)*
Boening, Michaela *(p.122)*
Boff, Roger *(p.166)*
Boll, Antonia *(p.111)*
Bollinghaus, Elaine *(p.10)*
Bolsover, G.N. *(p.46)*
Bolton, Jan *(p.36)*
Bonadie-Arning, Sondra *(p.122)*
Bond, Ann R. *(p.186)*
Bond, Frank W *(p.87)*
Bond, Lesley *(p.62)*
Bond, Sharon *(p.62)*
Bonham, Elizabeth *(p.174)*
Bonnebaight, Andre *(p.163)*
Bonner, David Calvert *(p.122)*
Bonner, Kate *(p.193)*
Booth, Nick *(p.24)*
Booth, Philip *(p.1)*
Bor, Robert *(p.69)*
Borges, Sheila *(p.111)*
Borghgraef, Guy *(p.36)*
Boronat, Dascha *(p.16)*
Boronska, Teresa W. *(p.103)*
Borsig, Su *(p.87)*
Bosanquet, Camilla *(p.47)*
Bostock, Christine *(p.194)*
Boston, Mary *(p.24)*
Boston, Paula *(p.194)*
Boswood, Bryan *(p.58)*
Botella, Luis *(p.203)*
Botha, Marie *(p.47)*
Bott, David *(p.174)*
Botterill, Willie *(p.28)*
Bould, Jane *(p.36)*
Boulton, John *(p.62)*
Bourne, Juliet *(p.103)*
Bousfield, Anne *(p.47)*
Bowdery, Sally *(p.111)*
Bowen, Barry *(p.16)*
Bower, Margaret *(p.166)*
Bowman, Heather *(p.69)*
Bownas, Jo *(p.69)*
Box, Sally *(p.1)*
Boyd, Ann A *(p.36)*
Boyd, Suzanne *(p.47)*
Boyden, Christina *(p.69)*
Boyesen, Ebba *(p.122)*
Boyesen, Gerda *(p.122)*
Boyesen, Mona Lisa *(p.198)*
Boyle, Alexander *(p.111)*
Boyle, Pauline *(p.154)*
Boysan, Zehra *(p.158)*
Bozovic, Zoran *(p.122)*
Bradley, Catrin *(p.69)*
Bradley, Jonathan *(p.58)*
Bradley, Linda *(p.28)*
Bradley, Lorne-Natalie *(p.148)*

Bradley, Marie *(p.55)*
Bradshaw, Lynn E *(p.191)*
Bradshaw-Tauvon, Kate *(p.203)*
Brady, Alec *(p.158)*
Brady, Kate *(p.112)*
Braid, Rosemary *(p.154)*
Brain, Sara *(p.87)*
Branagan, Noelle *(p.199)*
Brandwood, Pat *(p.36)*
Brankin, Irene *(p.30)*
Brankin, Maire *(p.148)*
Braterman, Eleanor *(p.69)*
Brauner, Rita *(p.69)*
Brave-Smith, Anna *(p.69)*
Bray, Jillyan *(p.186)*
Bray, Malcolm *(p.191)*
Bray, Stephen *(p.28)*
Brazier, Anna Louise *(p.183)*
Brazier, David *(p.180)*
Breathnach, Eibhlin *(p.69)*
Breeze, Graham *(p.163)*
Brennan, Clare *(p.174)*
Brennan, Damian *(p.69)*
Brennan, Joady *(p.62)*
Brennan, Stan *(p.69)*
Brereton, June *(p.16)*
Bresloff, Valerie *(p.194)*
Brett, John David *(p.183)*
Brewer, Madelyn *(p.148)*
Brewster, M *(p.185)*
Briant, Michael *(p.12)*
Briant, Steve *(p.12)*
Bridge, Jenny *(p.112)*
Brieger, Johanna *(p.191)*
Briggs, Andrew *(p.30)*
Briggs, Margarete *(p.30)*
Bright, Jenifer A *(p.103)*
Brindle, Elisabeth *(p.47)*
Briner, Wendy *(p.148)*
Brinsdon, Nicholas *(p.186)*
Brion, Marion *(p.62)*
Bristow, John *(p.137)*
Brittain, Charlie *(p.103)*
Britten, Stewart *(p.30)*
Britton, Julia *(p.112)*
Broadbent, Keith *(p.69)*
Broadbent, Sara *(p.166)*
Brock, Martin J *(p.145)*
Brock, Sue *(p.36)*
Brookes, Sasha *(p.112)*
Brookhouse, Shaun *(p.131)*
Brooks, Beverly *(p.103)*
Brooks, Carole *(p.47)*
Brooks, Cynthia M *(p.112)*
Brosan, Lee *(p.12)*
Brosnan, Judi *(p.148)*
Brosskamp, Cornelia *(p.174)*
Brough, Julie *(p.24)*
Brough, Sue *(p.163)*
Broughton, Vivian *(p.162)*
Brown, Avril *(p.144)*
Brown, Dennis *(p.58)*
Brown, Elizabeth Ann *(p.189)*
Brown, Gillian A. *(p.166)*
Brown, Ian B *(p.58)*
Brown, Kate *(p.163)*
Brown, Lesley *(p.137)*
Brown, Mavis *(p.7)*

Brown, Philip (p.53)
Brown, Ray (p.1)
Brown, Robin Gordon (p.1)
Brown, Robin Richard (p.149)
Brown, Sara (p.69)
Brown, Teresa (p.156)
Brown, Thomas M. (p.157)
Brown, Ulla (p.12)
Browne, Chris (p.186)
Browne, Margaret (p.122)
Browne, Maureen (p.122)
Browne, Val (p.10)
Browning, Peter (p.145)
Bruce, Ann (p.103)
Bruce, Sue (p.34)
Bruggen, Joan (p.87)
Brunt, Clare (p.137)
Brunt, Mervyn (p.40)
Bryan, Angus (p.112)
Bryans, Sally (p.152)
Bryant, Pat (p.145)
Bryant, Roger (p.149)
Bryson, Sandra (p.134)
Buchan, Ann (p.41)
Buchanan, Sarah-Jill (p.166)
Buckingham, Linda (p.103)
Buckingham, Sarah (p.166)
Buckland, Richard (p.24)
Buckler, Jackie (p.164)
Buckley, Jane (p.12)
Buckley, Judy (p.137)
Buckley, Marie-Noël (Billie)
 (p.112)
Buckley, Michael (p.131)
Buckley, Nicky (p.57)
Bucknall, Valerie (p.47)
Buckroyd, Julia (p.41)
Budgell, Rosemary (p.41)
Budnick, Susan (p.41)
Buffery, Elli Patricia (p.174)
Buirski, Diana (p.122)
Bukovics-Heiller, Birgit (p.166)
Buljan Flander, Gordana (p.198)
Bull, Graham E (p.202)
Bulmer, Liz (p.192)
Bunker, Carol (p.47)
Bunker, Nigel (p.47)
Burbach, Frank (p.162)
Burch, Jean Gillanders (p.8)
Burch, Nigel (p.58)
Burck, Charlotte (p.87)
Burden, Michele A (p.166)
Burdett, C.W. (p.192)
Burgess, Alison (p.21)
Burgess, Jo (p.134)
Burgess, Mary (p.47)
Burgess, Shanti (p.62)
Burgin, Hazel (p.103)
Burgoyne, Bernard* (p.69)
Burke, Robina (p.186)
Burkeman, Fiona (p.166)
Burland, Roger (p.24)
Burlington, Maggie (p.62)
Burnard, John (p.112)
Burnet-Smith, Tamara (p.8)
Burnham, John (p.187)
Burns, Alex (p.87)
Burns, Elizabeth (p.10)

Burns, Maura (p.144)
Burns, Paula (p.185)
Burns-Lundgren, Eva (p.166)
Burow, Birgit (p.131)
Burridge, Ellora Polly (p.69)
Burritt, William (p.34)
Burroughes, Christopher H.
 (p.69)
Burrows, Joanna (p.40)
Burston, Helen (p.40)
Burton, Jean (p.30)
Burton, Mary V. (p.198)
Burtt, Isobel Lucy (p.87)
Bury, Dennis R. (p.69)
Bush, Malcolm (p.166)
Busolini, Don (p.41)
Buss-Twachtmann, Christel (p.69)
Butcher, Barbara (p.10)
Butcher, Gerard (p.200)
Butcher, Josie (p.16)
Butcher, Marilyn (p.41)
Butler Smith, Catherine (p.112)
Butler, Gillian (p.149)
Butler, John (p.112)
Butler, Linda (p.182)
Butler, Todd (p.204)
Button, Eric (p.55)
Button, Rachel (p.174)
Byers, Angela (p.103)
Byford, Sally (p.12)
Bygott, Catherine (p.69)
Byng, R K (p.42)
Byring, Carola (p.69)
Byrne, Deidre (p.40)

C

Cadbury, Stephanie (p.28)
Cade, Brian (p.197)
Cain, Dennis (p.62)
Caird, Elizabeth J. (p.200)
Cairns, Mary (p.144)
Cairns, Mary (p.47)
Caleb, Ruth (p.122)
Callaway, Hazel (p.24)
Calvert, Jane (p.187)
Cameron, Angela (p.12)
Cameron, Anna (p.69)
Cameron, Katherine (p.30)
Cameron, Michael John (p.69)
Cameron, Roderick (p.70)
Camidge, Diana (p.141)
Campbell Nye, Aileen (p.12)
Campbell, Caroline (p.154)
Campbell, Christine (p.112)
Campbell, Colin B.G. (p.153)
Campbell, Donald (p.87)
Campbell, Duine (p.191)
Campbell, Elizabeth* (p.87)
Campbell, Hedda A. (p.134)
Campbell, Janet (p.1)
Campbell, Margaret (p.149)
Campbell, Margaret (p.24)
Campbell-Beattie, John (p.24)
Campher, Rosemary (p.59)
Campos, Hanne (p.203)
Campos, Juan (p.203)
Camps, Thomas (p.1)
Cann, Lesley (p.194)
Canon, Sue (p.194)

Cant, Diana (p.47)
Cantelo, Frances (p.122)
Cantwell, Maureen H E (p.70)
Canty, Josephine (p.103)
Carder, Misha (p.1)
Cardile, Pietro (p.122)
Cardwell, Amynta (p.112)
Carey, Jean (p.47)
Cariapa, Illana (p.193)
Carling, Katharine (p.149)
Carlish, Sonia (p.187)
Carlson, Cynthia (p.204)
Carlson, Theresa (p.87)
Carnegie, Deborah (p.24)
Carney, Joanne (p.200)
Carpenter, Dave (p.187)
Carr, Brede (p.166)
Carr, Jean (p.149)
Carr, Samantha (p.12)
Carrette, Timothy (p.145)
Carrington, Linda (p.122)
Carroll, Helen (p.166)
Carroll, Helen (p.137)
Carroll, Penny (p.70)
Carroll, Roz (p.87)
Carruthers, Barbara (p.156)
Carruthers, Dianna (p.36)
Carsley, Carol (p.47)
Carter, Paula (p.34)
Carton, Roy (p.202)
Cartwright, Alan (p.47)
Cartwright, Kate (p.48)
Cartwright, Tony (p.53)
Caruana, Charles Victor (p.103)
Casares, Jonathan (p.174)
Casatello, Giovanna (p.122)
Case, Caroline (p.154)
Casement, Ann (p.123)
Cashford, Jules (p.162)
Cassidy, Mandy (p.166)
Casson, Isabel (p.36)
Casson, John (p.53)
Catesby, Cynthia (p.19)
Cathie, Sean (p.70)
Catina, Ana (p.199)
Cato, Jane (p.62)
Catovsky, Mina (p.123)
Catton, Derek Anthony (p.1)
Cave, Prue (p.87)
Caviston, Paul (p.70)
Cawley, Anthony (p.134)
Cazalet, Deborah (p.87)
Cebon, Ann (p.197)
Cedro, Karin (p.166)
Cerfontyne, Suzanne (p.187)
Chalk, Caroline (p.1)
Chalkley, A.J. (p.1)
Challender, David (p.48)
Challis, Raymond Thomas (p.55)
Challis, Suzy (p.55)
Chamier, Suzanne (p.192)
Chamlee-Cole, Laurena (p.70)
Chancer, Anne* (p.112)
Chandler, Diana (p.166)
Chandler, Philip (p.70)
Chandwani, Lilian (p.87)
Chapman, Jane (p.185)
Chapman, Maureen R (p.30)

Chapman, Sandy (p.62)
Chappell, Claire (p.87)
Charalambous, Praxoulla (p.70)
Charley, Geoff (p.36)
Charlton, Patricia S. (p.174)
Charter, Anne (p.42)
Charvet, Anne (p.87)
Chataway, Carola (p.123)
Chatham, Jon (p.183)
Cherry-Swaine, Janine (p.145)
Cheshire, Jane (p.1)
Chesner, Anna (p.62)
Chessell, Karen (p.103)
Child, Melanie (p.166)
Child, Nick (p.157)
Childs, Margaret (p.112)
Childs-Clarke, Adrian (p.137)
Chilton, Maggie (p.112)
Chimera, Kathleen (p.166)
Chin, John C L (p.48)
China, Giselle (p.87)
China, Jacques* (p.70)
Chinoy, Freni (p.167)
Choudree, Sangamithra U.D.
 (p.123)
Christie, Jim (p.156)
Christie, Marilyn (p.156)
Christmann, Cornelia (p.87)
Christophas, Sheelagh (p.149)
Christopher H (p.69)
Christopher, Elphis (p.70)
Church, John (p.167)
Churcher, John (p.131)
Churchill-Moss, Duncan (p.12)
Clacey, Robert (p.2)
Clackson, Suzanne (p.7)
Clairmonte, Tosin (p.174)
Clancy, Catherine (p.123)
Clancy, J Patricia (p.36)
Clapham, Miles (p.8)
Clare, John (p.123)
Clare, Louise (p.7)
Clark, Alec (p.143)
Clark, Christine (p.48)
Clark, Corah (p.123)
Clark, Debra (p.103)
Clark, Margaret (p.167)
Clark, Nita (p.137)
Clarke, Elaine (p.17)
Clarke, Isabel (p.37)
Clarke, Stephen Lawrence (p.21)
Clarke, Susan Elizabeth (p.28)
Clarkson, Barbara (p.194)
Clarkson, Petruska (p.123)
Claxton, Brenda (p.189)
Clayton, Valerie (p.24)
Cleavely, Evelyn (p.137)
Clegg, Alison (p.163)
Clegg, Ian (p.57)
Clements, Sue (p.30)
Clements, Wendy (p.145)
Clements-Jewery, Sue (p.30)
Cleminson, Dorel (p.103)
Cleminson, Richard (p.174)
Clery, Cairns (p.112)
Clevely, Sarah (p.24)
Clifford, Jennifer (p.70)
Clifford, Victoria (p.70)

Clifford-Poston, Andrea (p.37)
Clift, Lynda (p.48)
Clifton, Elaine (p.112)
Clifton, Sandra (p.37)
Clough, Andrea (p.103)
Clover, Gillian (p.42)
Clowes, Brenda (p.30)
Clulow, Christopher (p.42)
Clyne, Rachel (p.2)
Cobden, Vivienne (p.42)
Cockett, Ann (p.12)
Codd, Anne Marie (p.7)
Cogan, Margaret (p.20)
Cohen, Barbara (p.42)
Cohen, Maggie (p.70)
Cohen, Pat (p.137)
Cohen, Pauline (p.87)
Cohen, Ruth (p.137)
Cohen, Sylvia (p.70)
Cohen, Vivienne (p.87)
Cohn, Hans W. (p.167)
Cohn, Nancy (p.30)
Coia, Grace (p.156)
Colahan, Mireille (p.87)
Coldicott, Tim (p.167)
Coldridge, Liz (p.131)
Cole, Barbara (p.175)
Cole, Laurence E (p.137)
Cole, Shanti (p.53)
Coleby, Gillian (p.48)
Coleman, Eva (p.179)
Coleman, Jane (p.189)
Coleridge, Jane (p.112)
Coles, Peter J. (p.37)
Coles, Walter (p.112)
Collard, Patrizia C (p.112)
Collens, Louise (p.2)
Collins, Gloria (p.17)
Collins, Jane (p.8)
Collins, Leila (p.42)
Collins, Lynda (p.30)
Collins, Natalie (p.62)
Collis, Jeffrey (p.87)
Collis, Whiz (p.2)
Colls, Jennifer (p.55)
Colman, Warren (p.42)
Colson, Louise (p.112)
Coltart, Ingrid (p.123)
Colver, Stephen (p.158)
Colverson, John (p.123)
Combes, Ann (p.103)
Conlon, Isobel (p.194)
Connolly, Cath (p.62)
Connolly, Christopher (p.88)
Conolly, J M P* (p.70)
Conroy, Jennifer J. (p.12)
Conroy, Kay (p.200)
Cook, Jane (p.21)
Cooke, Bob (p.131)
Cooklin, Alan (p.70)
Coombes, Clare (p.167)
Coombs, Suzanne* (p.20)
Cooper, Cassie (p.137)
Cooper, Faye (p.158)
Cooper, Graham (p.17)
Cooper, Grahame F. (p.187)
Cooper, Heather (p.48)
Cooper, Hilary (p.88)

Cooper, Howard (p.70)
Cooper, Ian (p.48)
Cooper, Jane (p.167)
Cooper, Janette (p.8)
Cooper, Jillian (p.70)
Cooper, Margaret H (p.21)
Cooper, Michael (p.175)
Cooper, Patricia (p.53)
Cooper, Penny (p.145)
Cooper, Rebecca (p.63)
Cooper, Robin (p.88)
Cooper, Sara (p.70)
Cooper, Suzanne (p.137)
Cooper, Terry (p.70)
Copley, Beta (p.88)
Copley, Brian (p.37)
Copsey, Nigel (p.167)
Corbett, Gemma (p.88)
Corbett, Martyn (p.63)
Corder, Elizabeth (p.42)
Corker, Enid (p.163)
Corlando, Annalisa (p.201)
Corneck, Susan (p.104)
Cornell, Maria (p.53)
Cornish, Ursula (p.88)
Coronas, Ita (p.112)
Corrigall, Jenny (p.12)
Costa, Jan (p.131)
Costello, John (p.112)
Costello, Marie (p.88)
Cottman, Barbara (p.2)
Cotton, Naomi (p.113)
Cottrell, David (p.194)
Cottrell, Sue (p.175)
Coulson, Christopher J (p.141)
Coulson, Susan (p.70)
Coulter, Stephen (p.144)
Coulter, Theresa (p.88)
Coumont Graubart, Valerie (p.113)
Coupe, Aileen (p.55)
Courtault, Susie (p.113)
Courtman, Anita (p.137)
Courtney, Mary (p.193)
Cousins, Jan (p.88)
Coussens, Kay (p.30)
Coutts, Linda (p.48)
Couzyn, Jeni* (p.70)
Cowan-Jenssen, Susan (p.70)
Coward, Malcolm (p.194)
Cowmeadow, Pauline (p.104)
Cox, Brenda (p.183)
Cox, Christine Sarah (p.175)
Cox, Keith Fredrick (p.7)
Cox, Margaret (p.163)
Cox, Mary (p.22)
Cox, Miranda (p.24)
Cox, Philip (p.63)
Coxwell-White, Jenny (p.8)
Crace, Gay (p.70)
Craib, Ian (p.164)
Cramer, William (p.20)
Craske, Sarah (p.16)
Crawford, George (p.154)
Crawford, Joan (p.63)
Crawford, Stephen (p.71)
Creamer, Mary (p.104)
Cregeen, Simon (p.53)

Crellin, Clare* (p.175)
Crew, Jan (p.55)
Crichton, N (p.53)
Crick, Verena (p.137)
Crisp, Jennifer (p.163)
Crispin, Jean (p.2)
Cristina M (p.124)
Critchley, Bill (p.71)
Crockatt, Gabrielle (p.123)
Crocker, Allen John (p.17)
Croft, Janet (p.42)
Cromarty, Paul (p.180)
Crombie, Clare (p.63)
Cromey, Terry (p.144)
Cronin Sutcliffe, Pauline (p.123)
Cronin, Jeremiah* (p.48)
Crook, Didi (p.123)
Crosby, Simon (p.175)
Cross, John (p.34)
Cross, Malcolm C (p.59)
Crossling, Paddy (p.53)
Crouch, Carol (p.30)
Crowe, Michael (p.104)
Crowley, Julia (p.71)
Crowley, Valerie (p.187)
Crowther, Catherine (p.71)
Cruthers, Helen (p.175)
Cryer, Valerie (p.71)
Cubie, Paul (p.2)
Cudmore, Lynne (p.88)
Cuff, Jenny (p.8)
Cullen, Anne M. (p.200)
Cullinan, Deborah (p.42)
Cullis, Andrew (p.113)
Cullum, Sylvia (p.164)
Cullwick, Joy (p.192)
Cummins, Peter (p.187)
Cundy, Linda (p.71)
Cunningham, Diane J (p.48)
Cunningham, Gerry (p.144)
Cunningham, Valerie (p.48)
Curran, Annalee (p.104)
Curran, Maureen (p.183)
Curti-Gialdino, Francesca (p.71)
Curwen, Bernadette (p.48)
Cussins, Anne (p.137)
Cutler, Jane (p.2)
Cutner, Adrienne (p.53)
Cutteridge, Simon (p.59)
Czubinska, Grazyna (p.104)

D

D'Aguilar, Yvonne (p.31)
D'Ardenne, Patricia (p.63)
Dabor, Thelma (p.104)
Dachy, Vincent* (p.59)
Dahle, Josephine (p.37)
Daines, Brian (p.158)
Daintry, Penelope (p.123)
Dalal, Caroline (p.123)
Dalal, Farhad (p.71)
Dale, Anne M. (p.10)
Dale, Barbara (p.88)
Dale, Carole (p.158)
Dale, Francis (p.24)
Dalton, Peggy (p.123)
Daly, John (p.123)
Daly, Kevin (p.59)
Dams, Janet (p.8)

Daniel, Barbara (p.63)
Daniel, Catherine (p.63)
Daniel, Gwyn (p.149)
Daniell, Diana (p.88)
Daniels, Deborah (p.48)
Daniels, Frank (p.22)
Daniels, Kate (p.48)
Daniels, Mo (p.37)
Daniels, Orpa (p.71)
Daniels, Susan (p.71)
Danks, Alan (p.123)
Darcy, Gillian* (p.137)
Dare-Bryan, Arminal (p.113)
Dargert, Guy (p.175)
Darling, Liv (p.71)
Darnley, Hazel (p.48)
Dasgupta, Carol (p.12)
Dates, Stephanie (p.17)
Daudy, Isabelle (p.12)
Daum, Minna (p.88)
Davenport, Hilary (p.167)
Davenport, Marie-Laure (p.71)
Davenport, Sarah (p.131)
David, Ann (p.24)
David, Anna (p.63)
David, Johanna (p.183)
David, Julian (p.24)
Davide, Adele (p.88)
Davidge, Maggie (p.123)
Davidoff, Leslie (p.192)
Davids, Jennifer (p.88)
Davidson, Brian (p.59)
Davidson, John (p.179)
Davidson, Steve (p.113)
Davies, Alison (p.13)
Davies, Ann (p.167)
Davies, John (p.158)
Davies, Judy (p.88)
Davies, Judy (p.13)
Davies, Lorraine (p.42)
Davies, Mairlis (p.183)
Davies, Michael (p.183)
Davies, Peggy (p.48)
Davies, Rae (p.55)
Davies, Roger (p.104)
Davies, Rosina (p.183)
Davies, Sheila (p.2)
Davies, Stephen (p.40)
Davies, Sue (p.183)
Davis, Brenda (p.190)
Davis, Diana (p.88)
Davis, Edna (p.180)
Davis, Emerald (p.113)
Davis, Gill (p.42)
Davis, Helen (p.88)
Davis, Jim (p.131)
Davis, John D (p.185)
Davis, Joyce (p.123)
Davis, Marcia L (p.185)
Davis, Patrick (p.144)
Davis, Paul E. (p.179)
Davis, Susan (p.71)
Davis, Wendy (p.88)
Davison, Susan (p.31)
Davren, Moira (p.144)
Dawkins, Sue (p.190)
Daws, Dilys (p.88)
Dawson, Jenny (p.24)

Dawson, Joyce (p.48)
Dawson, Linda (p.63)
Dawson, Liz (p.123)
Dawson, Neil (p.167)
Dawson, Peter (p.104)
Day, Elizabeth (p.48)
Day, Laurie (p.167)
Day, Lesley (p.137)
Day, Michael (p.137)
Day, Sally (p.137)
Daykin, Amanda (p.141)
De Berker, Patricia (p.167)
De Berker, Paul (p.167)
De Boer, Onno (p.88)
De Botton, Susan (p.71)
De Carteret, John (p.158)
De Groot, Marianne (p.10)
De Haas Curnow, Penny (p.88)
De Hoogh-Rowntree, Patricia (p.34)
De Jong, Corrie (p.37)
De Laszo, Alexandra (p.88)
De Leon, Heather (p.123)
De Luchi, Martin (p.175)
De Mare, Patrick (p.88)
De Marquiegui, Asun (p.113)
De Nordwall, Luci (p.123)
De Serdici-Parker, Simona (p.123)
De Souza, Janice (p.190)
De Souza, Joney (p.198)
De Zulueta, Felicity (p.104)
Deahl, Kieron (p.59)
Dean, Paul (p.137)
Dean, Sally (p.138)
Dearnley, Barbara K. (p.104)
Deas, Francis (p.24)
Deco, Sarah (p.71)
Deeble, Elizabeth A. (p.31)
Defries, Jeanne Margaret (p.31)
Dell, Jacqueline (p.13)
Dell, Judith (p.89)
Delve, Stuart (p.63)
Denford, Lindsey D. (p.104)
Denham, Juliet (p.191)
Denham-Vaughan, Sally (p.191)
Deniflee, Ursula (p.104)
Denman, Cara (p.113)
Denman, Chess (p.13)
Denness, Brian (p.22)
Dennis, Diana Mary (p.59)
Dennis, Stephen (p.28)
Dennis, Suzanne (p.113)
Dennison, Paul (p.113)
Dent, Peter (p.56)
Denton, Marika (p.89)
Deres, Mebrat (p.104)
Derrick, Stephen (p.46)
Desmond, Hanora (p.175)
Dewey, George (p.2)
Dhillon-Stevens, Harbrinder (p.167)
Diamond, Vera (p.59)
Dianin, Gianni (p.71)
Dickinson, Adrian (p.89)
Dickinson, Paul (p.134)
Dieffenbacher, Jutta (p.199)
Diepeveen, Johanna Maria (p.34)

Diggle, Sedwell (p.13)
Dighton, Rosemary (p.113)
Dilks, Sarah L E (p.104)
Dinwoodie, John (p.124)
Dixon, Linda (p.57)
Dixon-Nuttall, Rosemary (p.175)
Diyaljee, Angeli (p.89)
Dobbs, Wendy (p.71)
Dobson, Mary (p.180)
Docking, Raymond Fredrick (p.141)
Dodge, Elizabeth (p.89)
Dodsworth, Evelyn (p.167)
Doe, Anthony (p.124)
Doggart, Elizabeth Anne (p.187)
Dogmetchi, Geri (p.89)
Doktor, Ditty (p.13)
Dolan, Bernadette (p.192)
Dolan, Lesley Catherine (p.157)
Dollery, Jayne (p.37)
Dolphin, Eve (p.124)
Domb, Yair (p.71)
Donald, Philippa (p.8)
Donaldson, Gillian (p.124)
Donington, Laura (p.113)
Donnai, Andrew (p.183)
Donohoe, Gillian (p.193)
Donovan, Marlyn (p.104)
Donovan, Maxine (p.158)
Doogan, Kevin (p.134)
Doolan, Moira (p.48)
Dooley, Patricia (p.167)
Doorley, Damien (p.89)
Dorey, Mary (p.42)
Dorndorf-Turner, Rhoda (p.193)
Dorrian, Maeve (p.71)
Douglas, Angela (p.194)
Douglas, Dana (p.2)
Douglas, Sue (p.149)
Doust, Gill (p.71)
Dover, Jennifer (p.89)
Dowber, Hilary (p.104)
Dowling, Deirdre (p.167)
Dowling, Emilia (p.89)
Downes, Vanessa Susan (p.149)
Doyle, Alan (p.53)
Doyle, Elizabeth (p.134)
Draney, Sue* (p.59)
Draper, Pim (p.21)
Draper, Rosalind (p.37)
Dresner, Ora (p.89)
Dresser, Iain (p.2)
Drewnowska, Alicja (p.138)
Drijver, Caroline (p.175)
Driver, Christine (p.71)
Drucquer, Helen (p.158)
Drummond, Lynne M (p.113)
Drury, Gitta (p.203)
Dryden, Jan (p.183)
Dryden, Windy (p.89)
Du Plock, Simon (p.113)
Du Ry, Marc* (p.59)
Duberry, Mark (p.200)
Dubinsky, Alexandre (p.167)
Dubinsky, Helene (p.89)
Duck, Dorothy M. (p.48)
Duckham, Jennifer (p.167)
Duckworth, Moira (p.89)

Duckworth, Rosemary (p.104)
Dudley, Jane M (p.167)
Duffell, Nick (p.71)
Duffield, Ruth (p.167)
Duffin, Lorna (p.149)
Duffy, Gerry (p.163)
Duffy, Kathleen (p.179)
Duffy, Rosemary (p.63)
Duggan, Conor (p.56)
Dunand, Anne* (p.201)
Dunbar, Gill (p.89)
Duncan, E.A.S (p.156)
Duncan, Fraser (p.2)
Duncan, Sally B (p.167)
Duncan, Sheila (p.156)
Duncan, Ursula (p.192)
Duncan-Grant, Alec John (p.175)
Dunford, Kathy (p.113)
Dunn, Elizabeth (p.163)
Dunn, Jenny (p.71)
Dunn, Katie (p.145)
Dunn, Mark (p.71)
Dunn, Michael (p.53)
Dunn, Nicola (p.89)
Dupont-Joshua, Aisha (p.37)
Dupuy, Alan (p.104)
Durban, Ann (p.167)
Durlach, Stefan (p.197)
Dutton, Andrew (p.7)
Dutton, Jane (p.71)
Dyehouse, Pat (p.24)
Dyer, Ian P. (p.16)
Dyer, Paula (p.37)
Dykes, Andrea (p.168)
Dymond, Christina (p.24)
Dyson, Margaret (p.13)

E

Eadie, Yvonne (p.194)
Eagle, Gillian (p.146)
Eagles, Marjorie (p.89)
East, Patricia (p.57)
Easter, Judith (p.89)
Eastham, Peter (p.175)
Eaton, John (p.8)
Eccles, Barbara (p.63)
Economidou, Nitsa (p.113)
Edeleanu, Andrea K (p.168)
Edelmann, Robert J. (p.113)
Eden, Sharon (p.31)
Edgcumbe, Rose (p.89)
Edgell, Marjory (p.113)
Edmonstone, Yvonne G. (p.157)
Edwards, Dagmar (p.89)
Edwards, David (p.158)
Edwards, Jennifer (p.185)
Edwards, Judith (p.89)
Egan, Jude (p.42)
Egert, Stella (p.104)
Egert, Susan (p.72)
Egerton, Judy (p.22)
Eglin, Patricia (p.113)
Ehlers, Hella (p.59)
Eichelberger Cleese, Alyce Faye (p.124)
Eiden, Bernd (p.124)
Eiles, Clive (p.113)
Einhorn, Sue (p.72)
Einzig, Hetty (p.72)

Eisen, Shelley (p.138)
Eisen, Susan (p.72)
Eisenbarth, Heiner (p.175)
Eisenhauer, Gary (p.89)
Eisler, Ivan (p.104)
Eisler, Zuzana (p.104)
Ekdawi, Isabelle (p.104)
Elder, Meldene (p.31)
Eldon, Martin (p.42)
Eldridge, Melanie (p.175)
Eleftheriadou, Zack (p.72)
Elizabeth Wilde (p.165)
Elkan, Judith (p.89)
Ellingworth, Janice (p.194)
Elliot, Patricia (p.113)
Elliott, Barbara (p.89)
Elliott, Dena (p.124)
Elliott, John (p.37)
Elliott, Lea K. (p.34)
Elliott, Lois (p.72)
Elliott, Peter (p.37)
Elliott, Sandra A. (p.105)
Elliott, Victoria (p.105)
Ellis, Blythe (p.40)
Ellis, Lynda (p.158)
Ellis, Mary Lynne (p.72)
Ellis, Michael (p.72)
Ellis, Robin Margaret (p.131)
Ellis, Roger (p.57)
Ellis, Sian (p.31)
Ellwood, Jane (p.156)
Elman, Anthony (p.2)
Elsdale, Bethan (p.154)
Elton Wilson, Jennifer (p.190)
Elvin, Gill R (p.113)
Elwell, Louise (p.149)
Emanuel, Louise (p.72)
Emanuel, Ricky (p.89)
Embleton-Tudor, Louise (p.158)
Emeleus, Frances (p.114)
Emery, Pamela (p.72)
Eminson, Mary (p.131)
Emm, Susan (p.46)
Encombe, Jock (p.124)
Ender, Beckett (p.72)
Ender, Christine (p.141)
Ender, Dorry (p.72)
England, David (p.8)
English, Marjorie P (p.114)
Ennis, Sally-Anne (p.105)
Enser, Nigel (p.185)
Epstein, Bunny (F.C) (p.72)
Epstein, Melanie Lynn (p.194)
Epting, Franz (p.204)
Erich, Vicki (p.31)
Ernst, Sheila (p.72)
Errington, Meg (p.124)
Erskine, Archibald (p.90)
Erskine, Judith (p.105)
Erskine, Richard (p.146)
Erskine, Ruth (p.105)
Esposito, Claude (p.179)
Essenhigh, Caroline (p.90)
Essex, Delia (p.134)
Essex, Susanne (p.2)
Etherington, Mary Elizabeth (p.24)
Evans, Chris (p.114)

Evans, Gail (p.22)
Evans, Helen (p.168)
Evans, Joan (p.90)
Evans, Kenneth (p.146)
Evans, Peter L. (p.37)
Evans, Ray (p.168)
Evans, Richard (p.179)
Evans, Roger (p.90)
Evans, Tricia (p.168)
Everest, Pauline (p.42)
Evetts-Secker, Josephine (p.192)
Ezekiel, Lyn (p.168)

F

Fagan, Anthony F. (p.8)
Fagan, Margaret (p.72)
Fagbadegun, Rufus (p.53)
Fairhurst, Pat (p.134)
Falk, Helen (p.90)
Falkowska, Merlyn (p.42)
Fanning, Alexandra (p.90)
Farhi, Nina (p.90)
Faris, Jeff (p.183)
Farley, Nancy M. (p.59)
Farmer, Christopher (p.16)
Farmer, Eddie (p.114)
Farmer, Sarah (p.72)
Farquhar, Kate (p.105)
Farquharson, Graeme (p.158)
Farrell, Bill (p.202)
Farrell, Derek P. (p.134)
Farrell, Em (p.72)
Farrell, Margaret* (p.13)
Faruki, Shirley (p.63)
Farzim, Pari (p.90)
Fasht, Ruth (p.138)
Faull, Keith (p.164)
Fausset, Ann (p.42)
Fawkes, Caroline (p.72)
Fawkes, Liz (p.37)
Fearns, Keith (p.182)
Fearnside, Derek (p.191)
Feasey, Don (p.131)
Fee, Angie (p.63)
Feeney, Michael (p.42)
Feign, Cathy Tsang (p.59)
Feilden, Tish (p.2)
Feldberg, Marilyn (p.72)
Feldberg, Tom (p.90)
Feldman, Wendy (p.72)
Felix, Susie (p.168)
Fellows, Ron (p.175)
Felton, Mo (p.164)
Fentiman, John (p.90)
Fenton, Christopher MT (p.40)
Ferguson, Geoff (p.72)
Ferguson, Joyce (p.114)
Ferguson, Mary (p.53)
Ferid, Heidi (p.90)
Fernandez, Florence (p.42)
Fernandez, Nigel R. (p.17)
Fernandez, Valentina (p.72)
Ferris, Mary (p.24)
Festenstein, Geraldine (p.90)
Fiasche, Mara (p.90)
Ficarra, Berthe* (p.90)
Field, John C. (p.179)
Field, Kate (p.168)
Field, Nathan (p.72)

Field, Rosalind (p.175)
Fielder, Michael (p.90)
Fieldhouse, Pauline (p.90)
Filby, Erica (p.179)
Finar, Ruth (p.90)
Finch, Auberon (p.28)
Findlay, David Alistair (p.105)
Finlay, Rosalind (p.72)
Finlayson, Sara (p.134)
Firman, Judith (p.114)
Firth, Sue (p.19)
Fischer, Michael (p.131)
Fischer, Ulrich J (p.156)
Fish, Deborah M. (p.198)
Fish, Sue (p.24)
Fisher, Clare (p.183)
Fisher, Linda (p.105)
Fisher, Paul (p.46)
Fisher, Susan (p.124)
Fisher-Norton, Jane (p.168)
Fisk, Geoff (p.57)
Fitton, Freda (p.17)
Fitzgerald, Geariod (p.158)
Fitzgerald, J (p.72)
Fitzgerald, Patricia (p.22)
Fitzgerald, Pen (p.143)
Fitzgerald-Butler, Albina (p.138)
Fitzgerald-Klein, Marianne (p.13)
Fitzsimmons, Michele Anne
 (p.105)
Flacke, Theresa (p.138)
Flanagan, Diana (p.13)
Flanagan, June D (p.53)
Flannery, Jean (p.57)
Flatt, Debbie (p.114)
Flatt, Raymond (p.73)
Fleming, Peter (p.114)
Fleming, Robert W.K. (p.105)
Fletcher, Joan (p.105)
Fletcher, Karyn (p.13)
Flinspach, Elisabeth (p.73)
Flower, Charles (p.175)
Flower, Michael (p.114)
Flower, Steven (p.73)
Flynn, Stephen (p.200)
Fogelberg, Don (p.73)
Foguel, Brenda (p.198)
Fokias, Dene (p.187)
Foley, Dermot (p.200)
Fookes, Andrew (p.146)
Forbes, Constanze N (p.141)
Ford, Susan (p.73)
Forryan, Barbara (p.40)
Forssander, Jennifer (p.124)
Forsyth, Angus (p.22)
Forti, Laura (p.73)
Fortune, Rosalind (p.2)
Fosbury, Jacqueline (p.175)
Foster, Lesley (p.40)
Foster, Paul (p.134)
Foulkes, Michael (p.164)
Fowler, Barry (p.53)
Fowles, Anne (p.20)
Fox, Almuth-Maria (p.31)
Fox, Annie (p.42)
Fox, Catherine (p.105)
Fox, Delia-Ann (p.10)
Fox, Fiona (p.190)

Fox, Loretta (p.73)
Fox, Margaret (p.161)
Frances, Jane (p.165)
Francis, Anne M. (p.168)
Franic Tukic, Sanda (p.198)
Franke, Christine (p.7)
Franklyn, Frank (p.90)
Franks, Julia (p.63)
Fransella, Fay (p.20)
Fraser, Bobbie (p.154)
Fraser, Daphne (p.48)
Fraser, Douglas A. (p.156)
Fraser, Mary Elizabeth (p.161)
Frazer, Diane (p.73)
Fredman, Glenda (p.114)
Free-Pearce, Carolyn (p.42)
Freeman, Catherine (p.73)
Freeman, Christopher (p.154)
Freeman, David (p.48)
Freeman, Linda (p.124)
Freeman, Martin (p.124)
Freeman, Patricia Ann (p.168)
Freeman, Sue (p.73)
Freeman, Susan (p.48)
French, Eileen (p.105)
French, Jean (p.20)
Freshwater, Dawn (p.13)
Friedman, Debbie (p.90)
Friedman, Joe (p.90)
Friend, Sue (p.42)
Frischer, Livia (p.203)
Froshaug, Ann (p.63)
Fry, Caroline* (p.124)
Fry, Julie (p.37)
Fry, Richard P.W. (p.90)
Frye, Helen (p.34)
Fuller, Victoria Graham (p.114)
Fullerton, Peter B. (p.197)
Fyvel, Susan (p.90)

G

Gabbay, Mark (p.134)
Gabriel, Jill (p.2)
Gabriela, Airey (p.90)
Gaffney, Mahin (p.49)
Gage, Michael (p.149)
Gagg, Susan (p.183)
Gagnere, Maryline (p.13)
Gairdner, Wendy (p.114)
Gal, Oshrat* (p.90)
Gale, Derek (p.31)
Gallagher, Eileen (p.53)
Gallagher, Teresa (p.73)
Galliers, Mary (p.138)
Gallivan, Patricia (p.175)
Gallop, Margaret (p.149)
Galloway, Betsy (p.192)
Gandy, Rus (p.114)
Gann, Sandra (p.59)
Gans, Steve (p.91)
Garcia-Llovona, (p.124)
Gardiner, Margaret (p.105)
Gardiner, Vicki (p.13)
Gardner, Damian (p.143)
Gardner, Fiona (p.2)
Gardner, Peter (p.2)
Gardner, Philippa (p.168)
Gardner, Sarah (p.24)
Garlovsky, Rita (p.158)

Garner, Cheryl (p.114)
Garvey, Rachel (p.17)
Gaskell, Christine (p.2)
Gaster, Yishai (p.91)
Gatrell, Jane (p.131)
Gatti-Doyle, Fiorella G. (p.114)
Gauci, Kate (p.73)
Gaunt, Pamela (p.183)
Gauntlett, Tim (p.194)
Gausden, Christopher (p.49)
Gauthier, Jean-Baptise (p.134)
Gavin, Verity J (p.199)
Gavshon, Audrey (p.91)
Gawler-Wright, Pamela (p.63)
Geddes, Heather (p.138)
Geen, Sheryle (p.91)
Geldeard, Bryan W.J. (p.17)
Gell, Eva (p.2)
Gentry, Valerie (p.13)
George, Dorothy (p.91)
George, Elizabeth (p.187)
George, Evan (p.124)
George, Stephen (p.159)
Geraghty, Wendy (p.105)
Gerhardt, Sue (p.149)
Gerlach, Lynne (p.24)
Gerry, Marian (p.154)
Gessert, Astrid* (p.28)
Ghent, Rita (p.164)
Ghiaci, Golshad (p.73)
Gibbin, Jane (p.183)
Gibbs, Elizabeth (p.114)
Gibson, Jenny (p.63)
Gibson, Melanie (p.124)
Gibson, Walter (p.91)
Gilbert, Barbara (p.21)
Gilbert, Gillie (p.73)
Gilbert, Maria (p.124)
Gilboy, Carol A. (p.146)
Gildebrand, Katarina (p.91)
Gilkes, Pauline (p.7)
Gill, Douglas (p.2)
Gill, Martin (p.182)
Gillespie, Kate (p.144)
Gillett, Timothy P. (p.181)
Gilli, Liliana (p.138)
Gilligan, Toni (p.191)
Gillingham, Michael (p.161)
Gilliver, Catherine (p.187)
Gilljam, Annika (p.194)
Gillman, Maureen (p.181)
Gilson, Jean (p.22)
Gimblett, Jeanne (p.20)
Ginsborg, Robby (p.105)
Gionta, Ralph (p.124)
Girling, Gail (p.149)
Gladstone, Guy (p.59)
Gladwell, Stephen (p.187)
Glaister, Brian (p.168)
Glanville, Tony (p.124)
Glasscoe, Claire (p.134)
Glasspool, Patricia (p.37)
Glenn, Liza (p.59)
Glover, Jean (p.194)
Glover, Nicholas (p.63)
Glynn, Julie (p.17)
Glynn, Paul (p.124)
Goddard, Lynne (p.175)

Godfrey-Issacs, Godfrey (p.114)
Godinho, Bernadette (p.91)
Godsil, Geraldine (p.73)
Godsil, Susan (p.194)
Gold, Bonnie (p.91)
Goldberg, Henia (p.63)
Golden, Ellen (p.138)
Golden, Sylvia (p.114)
Goldenberg, Harriet (p.91)
Golding, Pauline (p.10)
Goldman, John (p.124)
Goldstein, Pam (p.138)
Golten, Carole (p.138)
Golz, Angelika (p.25)
Gomez, Lavinia (p.91)
Gonsalkorale, Wendy (p.17)
Good, Elizabeth (p.91)
Good, Simon* (p.63)
Goodchild, Margaret (p.31)
Goodes, Deborah (p.63)
Goodfellow, Joanna (p.105)
Gooding, Kim (p.63)
Goodman, Jenny (p.42)
Goodman, Susan (p.105)
Goodrich, Anne (p.34)
Goodrich, Diana* (p.73)
Goodrick, Jean (p.13)
Goodson, Christina (p.134)
Goodwillie, Gill (p.161)
Goodyear, P A J (p.187)
Goold, Peter (p.37)
Gopfert, Michael (p.134)
Gordon Clark, Thalia (p.183)
Gordon, Deidre (p.138)
Gordon, Elizabeth (p.73)
Gordon, Inger (p.175)
Gordon, John Fredrick (p.10)
Gordon, Leila (p.13)
Gordon, P. Kenneth (p.37)
Gordon, Paul (p.91)
Gordon, Virginia (p.114)
Gorman, Susan (p.91)
Gorney, Carry (p.91)
Gorodensky, Arlene (p.138)
Goslett, Kate (p.73)
Gosling, Pat* (p.2)
Goss, Diana S (p.37)
Gottesmann, Ewa (p.91)
Gottlieb, Sue (p.162)
Gotto, Jane (p.162)
Gottschalk, Margaret S (p.105)
Gould, Geraldine (p.56)
Gournay, Kevin (p.43)
Gow, Marion (p.73)
Gower, Myrna (p.168)
Gowling, David (p.34)
Gowrisunkur, Jaya (p.131)
Grace, Carole (p.124)
Gracia, Olga (p.175)
Gracie, Jane (p.35)
Graf, Fern (p.183)
Graff, Avril (p.43)
Graham, Hilary (p.165)
Graham, Hilary E. (p.146)
Graham, Judith (p.73)
Graham, Margaret (p.3)
Graham, Marilyn (p.138)
Graham, Nancy (p.114)

Graham, Patricia (p.154)
Grainger, Eve (p.31)
Granowski, Margaret (p.73)
Grant, Bob (p.124)
Grant, Iona (p.91)
Grant, Mary (p.144)
Grant, Nuala (p.3)
Grant, Vera (p.49)
Gravelle, John (p.31)
Graves, Jane (p.64)
Gray, Anne (p.43)
Gray, Dennis (p.91)
Gray, Elizabeth (p.91)
Gray, Kati (p.64)
Gray, Maggie (p.154)
Gray, Pat (p.134)
Gray, Peter (p.164)
Gray, Sally (p.37)
Grayson, Juliet (p.168)
Greally, Brid (p.73)
Greatorex, Christopher (p.35)
Greatrex, Julian (p.31)
Greaves, Margaret (p.38)
Greaves, Sarah* (p.13)
Greaves, Thomas (p.31)
Green, Barbara A. (p.17)
Green, Brian (p.59)
Green, Charlotte H (p.125)
Green, Dror (p.201)
Green, Eliott (p.49)
Green, Joe (p.176)
Green, June (p.138)
Green, Margaret (p.202)
Green, Marion (p.20)
Green, Michael (p.190)
Green, Prudence (p.176)
Green, Roberta (p.114)
Green, Sylvia (p.3)
Green, Viviane (p.91)
Green-Thompson, Cyril (p.73)
Greenan, Maria (p.3)
Greenberg, Maurice (p.59)
Greene, Alice (p.59)
Greenfield, Frances (p.91)
Greenfield, Terence Aubrey (p.17)
Greening, Sarah (p.192)
Greenland, Sue (p.13)
Greenway, Ian (p.146)
Greenwood, Angela (p.31)
Greenwood, Anthony (p.105)
Greenwood, John (p.114)
Gregg, Annzella (p.183)
Gregory, Josie M (p.168)
Gregory, Judith (p.3)
Gregory, Kayt (p.164)
Gregory, Kirby (p.162)
Gregory, Mary (p.164)
Gregory, Peter (p.38)
Gresty, Julia (p.3)
Greville, Coral (p.22)
Grew, Lesley (p.59)
Grey, David (p.105)
Griffin, Mary (p.105)
Griffith, John (p.106)
Griffiths, Anne (p.176)
Griffiths, E Anne (p.164)
Griffiths, Pamela (p.125)
Griffiths, Thelma (p.20)

Griffiths, Tina C (p.161)
Grigg, Roz (p.20)
Grimshaw, Francoise (p.168)
Grinonneau, Peter (p.10)
Grocott, Annie (p.35)
Groom, Nigel A (p.191)
Gross, Grete (p.73)
Gross, Stephen (p.74)
Gross, Vivien (p.74)
Groves, Paramabandhu (p.64)
Groves, Stephanie (p.162)
Gruber, Angela (p.43)
Grunberg, Sheena (p.91)
Gudjonsson, Ingolf (p.159)
Guest, Hazel (p.13)
Guest, Nicola (p.3)
Guild, Liz (p.13)
Guilfoyle, John Francis (p.91)
Guiton, Anita (p.159)
Gulcz, Magdalena (p.91)
Gulliver, Pamela (p.114)
Gundry, Caroline (p.114)
Güngör, Dilek (p.74)
Gunton, Gaye (p.43)
Gurion, Michal (p.74)
Gurnani, Prem D. (p.125)
Gurney, Paul (p.106)
Gurr, Rosalie (p.38)
Guthrie, Barbara (p.38)
Guthrie, Else (p.131)
Guy, Liana (p.149)

H

Haberlin, Jane (p.115)
Hacker Hughes, Jamie G.H. (p.31)
Hacker, Roger (p.92)
Hackett, Jenny (p.25)
Hadary, Orna (p.74)
Haddington, Janet (p.106)
Haddock, Ray (p.159)
Haddon, Jarmaine (p.43)
Hadwin, Peter (p.3)
Hadzanesti, Nelly (p.125)
Hagan, Patricia (p.134)
Hagelthorn, Christina (p.203)
Hagenbach, Kitty (p.179)
Hahn, Herbert (p.3)
Haigh, Rex (p.8)
Haine, Stephen R (p.92)
Hale, John (p.43)
Hale, Sue (p.183)
Hall, Albyn (p.92)
Hall, David (p.13)
Hall, Francesca (p.125)
Hall, Guy (p.74)
Hall, Jill (p.176)
Hall, Kelvin (p.35)
Hall, Kirsty (p.74)
Hall, Linda (p.38)
Hallam, Richard S (p.59)
Hallam-Jones, R.A. (p.159)
Hallard, Sharon (p.164)
Hallett, Caroline (p.43)
Hally, Diane (p.159)
Halpin, Jill (p.176)
Halton, William (p.74)
Hamblin, David (p.3)
Hamer, Neil (p.176)
Hamilton, Angela (p.156)

Hamilton, Dorothy (p.74)
Hamilton, Jane (p.194)
Hamilton, Kim (p.43)
Hamilton, Nigel (p.125)
Hamilton, Sheila L.L. (p.134)
Hamilton, Susan (p.125)
Hamilton, Victoria (p.204)
Hamilton-Duckett, Paule (p.74)
Hamlyn, Sarah (p.194)
Hamm, Alexandra (p.168)
Hammond, Margaret (p.138)
Hamrogue, Tom (p.74)
Hanaway, Monica (p.149)
Hanchen, Thomasz (p.106)
Hancock, Maureen (p.74)
Hancock, Patricia (p.190)
Hancock, Pauline (p.106)
Hancock, Sarah (p.176)
Handy, S. (p.187)
Hanks, Helga (p.194)
Hanley, Ian G. (p.144)
Hanley, Marie (p.3)
Hanman, Elke (p.125)
Hanna, Dorothy (p.106)
Hanna, Gilli (p.59)
Hanna, Hyams (p.203)
Hannah, Chris (p.7)
Hannah, Clare (p.7)
Hannah, Francesca (p.131)
Hannigan, David J. (p.38)
Hannon, Sr. Mary Letizia (p.74)
Hanson, Carol (p.74)
Harari, Michael (p.138)
Harben, Ursula (p.141)
Hardcastle, Mark (p.176)
Harding, Celia (p.64)
Harding, Michael (p.92)
Hardman, Anne (p.135)
Hardman, Jacquie (p.10)
Hardy, Jo (p.115)
Hardy, Liz (p.13)
Hardy, William (p.183)
Hargaden, Helena (p.106)
Hargraves, Annie (p.13)
Hargreaves, Judy (p.74)
Harlap, Nahum (p.92)
Harley, Ki (p.74)
Harling, Biljana (p.179)
Harman, Josephine (p.49)
Harmel, Barbara (p.203)
Harmsworth, Peter (p.135)
Harper, Anita (p.74)
Harrington, Finola (p.64)
Harrington, Leslie (p.164)
Harrington, Rufus (p.138)
Harris, Anthony (p.184)
Harris, Clare (p.3)
Harris, Dianne (p.43)
Harris, Gerald A. (p.187)
Harris, Gordon (p.149)
Harris, Jonathan (p.92)
Harris, Mary (p.92)
Harris, Michele (p.125)
Harris, Neil (p.28)
Harris, Nina (p.187)
Harris, Paul David Gwyn (p.184)
Harris, Richard (p.185)
Harris, Sue (p.8)

Harris, Tirril (p.74)
Harrison, Caroline M (p.200)
Harrison, Gillian (p.14)
Harrison, Jacqueline (p.168)
Harrison, Jane (p.74)
Harrison, Susan (p.10)
Harrison-Mayor, Susan (p.43)
Harrow, Anne (p.194)
Hart, Azina (p.168)
Hart, Bruce (p.202)
Hart, Carolyn (p.159)
Hart, Kate (p.3)
Hart, Mary A.M. (p.154)
Hart, Robert (p.168)
Hart, Sally (p.141)
Hartley, Althea (p.14)
Hartley, Phil (p.192)
Hartman, Wendy (p.74)
Hartnup, Trevor (p.115)
Harvard-Watts, Olivia* (p.92)
Harvey, Andrew (p.176)
Harvey, Ann (p.138)
Harvey, Linda Mary (p.31)
Harvey, Natasha (p.92)
Harvey, Pam (p.43)
Harvey, Paul (p.14)
Harvey, Sandra (p.161)
Harvey, Tricia A. (p.187)
Harward, Matthew (p.74)
Harwood, Matthew (p.3)
Hashemi, Beth (p.168)
Haskayne, Amanda (p.3)
Haskins, Nicola (p.74)
Haslam, Deirdre (p.64)
Hasler-Winter, Susan (p.168)
Hassall, Alan (p.58)
Hastings, Jon (p.3)
Hastings, Kim (p.3)
Hatswell, Valerie (p.38)
Haugh, Sheila (p.74)
Hauke, Christopher (p.49)
Haupts, Brigitte (p.125)
Hauser, Susan (p.125)
Haussman, Rochelle (p.92)
Haveman, Jolien (p.19)
Hawdon, Sheila (p.3)
Hawkes, Bernadette (p.64)
Hawkins, Peter (p.3)
Hawksworth, Janet (p.159)
Haworth Chester, Ann (p.17)
Haworth, Peter (p.149)
Haxell, Susan (p.92)
Hay Burns, Jean (p.115)
Hay, Jennifer (p.60)
Hay, Patricia (p.156)
Hayes, Cheyl (p.64)
Hayes, Lesley (p.149)
Hayes, Michael (p.115)
Hayes, Susan (p.125)
Hayhurst, Sohani (p.149)
Hayman, Penny (p.146)
Haynes, Eric (p.14)
Hayward, Marjorie (p.53)
Hayward, Mark (p.20)
Haywood, Carol (p.3)
Hazell, Jeremy (p.184)
Hazelton, Sally (p.74)
Hazlehurst, Jean (p.135)

Headon, Christopher (p.49)
Headworth, Jean (p.58)
Healey, Arlene (p.144)
Hearst, Lisbeth E (p.75)
Heath, Christine (p.7)
Heath, John (p.22)
Heath, Suzanne (p.187)
Heatley, John (p.168)
Heavens, Anita (p.169)
Heavey, Anne (p.115)
Hedges, Fran (p.106)
Hedinger-Farrell, Korinna (p.169)
Hedley, Karen (p.35)
Heenan, Colleen (p.195)
Heeran, Rita (p.31)
Heinitz, Karin (p.49)
Heismann, Elisabeth (p.75)
Heitzler, Morit (p.201)
Helbert, Jan (p.195)
Heley, Mary (p.10)
Heller, Fawkia (p.115)
Hellier, Mary B. (p.19)
Hellin, Kate (p.135)
Helm, Caroline (p.169)
Helps, Davina (p.146)
Hemming, Judith (p.75)
Henderson, Andrew (p.125)
Henderson, David (p.75)
Henderson, John (p.64)
Henderson, Mary (p.10)
Henderson, Ned (p.141)
Hendra, Theresa (p.38)
Hendrickse, Begum (p.135)
Hendry, Devam (p.31)
Hendry, Evelyn R. (p.106)
Henley, June (p.169)
Henley, Mavis G (p.8)
Henny, Lindy (p.115)
Henriques, Marika (p.115)
Henry, John (p.92)
Henry, Rachel M. (p.197)
Henshaw, Judith (p.25)
Heppel, Valerie (p.153)
Heralall, Ellen (p.115)
Herbert, Claudia (p.149)
Herbert, Jme (p.25)
Herdman, Linda (p.179)
Hering-Josefowitz, Pauline (p.204)
Herington, Steve (p.64)
Hermon, Deborah (p.204)
Herrmann, Joan (p.154)
Herron, Stephen (p.144)
Hershkowitz, Annie (p.115)
Herst, Edward (p.92)
Hertzmann, Leezah (p.92)
Hester, Bridget A (p.192)
Heuer, Gottfried (p.125)
Hewett, Rachael (p.169)
Hewison, David (p.92)
Hewitt, Amanda (p.75)
Hewitt, Philip J. (p.49)
Hewson, Julie Ann (p.25)
Hewson, Polly (p.202)
Heyward, Julie (p.49)
Hickman, Sue (p.7)
Hickmott, Barbara (p.182)
Hiestand, Rene (p.14)
Higgins, Judith (p.3)

Higgo, Robert J. (p.135)
Higgs, Jody (p.154)
High, Helen (p.75)
Hildebrand, Judy (p.92)
Hilder, Alison (p.75)
Hiles, David (p.56)
Hill, Brenda (p.186)
Hill, Finella (p.10)
Hill, Jennifer (p.138)
Hill, Jenny (p.184)
Hill, Penny (p.150)
Hill, Philip* (p.92)
Hill, Val (p.187)
Hiller, Ruth (p.75)
Hilling, Richard (p.190)
Hillman, Christine (p.179)
Hillman, Jan (p.184)
Hills, Janet (p.56)
Hills, John (p.49)
Hindle, Deborah (p.146)
Hipps, Hilary (p.115)
Hirons, Ruth (p.49)
Hirst, Diane Zervas (p.125)
Hirst, Hazel (p.56)
Hitchman, Nini (p.115)
Hoag, Linda M. (p.187)
Hoang, Astrid (p.64)
Hoare, Elizabeth (p.142)
Hoare, Ian (p.25)
Hobbes, Robin (p.17)
Hobbs, Anita (p.138)
Hobbs, Michael (p.150)
Hock, Gaby (p.150)
Hodd, Amanda (p.20)
Hodges, Barbara (p.25)
Hodges, Jill (p.60)
Hodgkiss, Andrew* (p.106)
Hodson, Pauline (p.150)
Hogg, Christine Retson (p.156)
Hogg, Rosemary (p.187)
Holden, John W (p.60)
Holden, Maxine (p.92)
Holden, Sarah (p.115)
Holland, Louise (p.14)
Holland, Nicki (p.169)
Holland, Ray (p.92)
Holland, Stevie (p.75)
Holland, Sue (p.176)
Hollings, Avril (p.75)
Hollingworth, Amanda (p.31)
Hollis, Peter (p.49)
Holloway, Sheila (p.75)
Holm, Kirsti E. (p.92)
Holman, Christopher (p.150)
Holmes, Anne (p.150)
Holmes, Carol (p.92)
Holmes, Dorothy (p.186)
Holmes, Jeremy (p.25)
Holmes, Lynne (p.125)
Holmes, Paul (p.176)
Holve, Harriet (p.169)
Holyoak, Patricia (p.17)
Homer, Marjorie (p.19)
Honig, Peter (p.43)
Hook, Beatrice (p.38)
Hook, John (p.38)
Hook, Susan (p.204)
Hooper, Christine M. (p.38)

Hooper, Molly (p.135)
Hope, David (p.159)
Hope, Francis (p.64)
Hopkins, Jill (p.162)
Hopkins, Vera M. (p.38)
Hopper, Earl (p.92)
Hopping, Geoff (p.115)
Hopwood, Ann (p.115)
Hopwood, Jean (p.169)
Hopwood, Michael (p.169)
Hormasji, Faridoon (p.31)
Hornby, Jackie (p.115)
Horne, Alan (p.132)
Horne, Ann (p.92)
Horne, David C (p.115)
Horrocks, Pam (p.164)
Horrocks, Roger (p.125)
Horton, Annie (p.25)
Horwood, Tone (p.3)
Hoskins, John (p.75)
Hostick, Kathie (p.46)
Houghton, Christine (p.169)
Houghton, Judith E (p.152)
House, Wyn (p.22)
Houston, Gaie (p.92)
Howard Tayler, Jacky (p.146)
Howard, Angela (p.93)
Howard, Heather (p.106)
Howard, Sister Columba (p.200)
Howard, Trevor (p.31)
Howarth, Kay (p.38)
Howe, Patricia (p.162)
Howell, Carolyn (p.75)
Howell, Judy (p.187)
Howell, Julia (p.146)
Howell, Simon (p.176)
Howell, Sylvia (p.115)
Howells, Kate (p.56)
Howells, Megan (p.43)
Howes, Kathleen Mary (p.184)
Howie, David D. (p.152)
Howlett, Brian (p.200)
Howlett, Stephanie (p.159)
Howtone, Christina (p.31)
Hubbard, Leslie (p.46)
Hudson, Inge (p.75)
Hudson, Marjorie (p.169)
Hudson, Pauline (p.75)
Hudson, Peter (p.20)
Hudson, Rachel (p.31)
Huet, Valerie (p.169)
Hueting, Margaret (p.176)
Hughes, Ann (p.142)
Hughes, Carol (p.106)
Hughes, Geraldine (p.184)
Hughes, Hatty (p.3)
Hughes, Jacqui (p.138)
Hughes, Janet (p.169)
Hughes, Janet (p.115)
Hughes, Jennifer (p.49)
Hughes, Linda (p.165)
Hughes, Lynette (p.182)
Hughes, Margaret (p.64)
Hughes, William (p.142)
Huish, Margot (p.43)
Hume, Anne J.A. (p.157)
Humphrey, Anna (p.93)
Humphreys, David (p.43)

Humphries, Harold *(p.35)*
Hunt Overzee, Anne *(p.153)*
Hunt, Maggie *(p.75)*
Hunt, Patricia A *(p.17)*
Hunt, Patricia A. *(p.159)*
Hunt, Susan *(p.150)*
Hunter, Margaret *(p.115)*
Hur, Jung-Ae *(Jane) (p.187)*
Hurd, Joan *(p.182)*
Hurry, Anne *(p.93)*
Hurst, Hannah *(p.38)*
Hurst, Margaret *(p.32)*
Hurwood, Judith *(p.56)*
Husain-Shackle, Shakrukh *(p.93)*
Huson, Richard *(p.64)*
Hussain, Fakhir *(p.169)*
Hussain, Nasima *(p.138)*
Huszcza, Anna K. *(p.43)*
Hutchby, Rosemary *(p.146)*
Hutchinson, Gary *(p.3)*
Hutchinson, Peter *(p.150)*
Hutchinson, Sylvia *(p.93)*
Hutchison, Eric *(p.14)*
Hutton, Francoise *(p.176)*
Huws, Rhodri *(p.159)*
Hyde, Dennis H *(p.169)*
Hyde, Keith *(p.132)*

I

Ibanez, Julian *(p.203)*
Ikkos, George *(p.138)*
Iles, David *(p.188)*
Ingham, Nida *(p.169)*
Ingham, Rosie *(p.188)*
Inglebright, Shanti *(p.93)*
Inlander, Antonia *(p.75)*
Iremonger, Sue *(p.176)*
Ironside, Lesley *(p.176)*
Irving, Nicholas *(p.142)*
Irving, Susan *(p.115)*
Isaac, Toni-Lee *(p.17)*
Isaacs, Joy *(p.115)*
Isaacson, Zelda *(p.93)*
Isaksson-Hurst, Gun I.E. *(p.93)*
Ish, Chandra *(p.181)*
Isles, Rosaleen *(p.153)*
Issa, Soraya *(p.197)*
Itten, Theodor *(p.204)*
Iveson, Chris *(p.125)*
Iveson, Diana *(p.75)*
Izzard, Susannah Amanda *(p.188)*

J

Jack, Bridget *(p.22)*
Jackson, Diana *(p.93)*
Jackson, Elizabeth *(p.132)*
Jackson, Eve *(p.75)*
Jackson, Jo *(p.10)*
Jackson, Maureen *(p.75)*
Jackson, Paul *(p.38)*
Jackson, Sherin *(p.195)*
Jacob, Emily *(p.115)*
Jacobs, Brian W *(p.106)*
Jacobs, Joe *(p.93)*
Jacobs, Linda *(p.32)*
Jacobs, Michael *(p.56)*
Jacobs, Paula *(p.40)*
Jacobson, Rosemary *(p.32)*
Jacques, Glenys *(p.64)*

Jacques, Roma *(p.46)*
Jakes, Simon *(p.49)*
Jakobi, Sally *(p.169)*
Jakubska, Aggie *(p.195)*
James, Glenys *(p.4)*
James, Jessica *(p.75)*
James, Jo *(p.116)*
James, Pat *(p.4)*
Jameson Milner, Jane *(p.135)*
Jameson, Anne *(p.7)*
Jamieson, Eileen *(p.43)*
Jan-Floris *(p.130)*
Jane, Susan *(p.143)*
Janickyj, John *(p.58)*
Janks, Ann *(p.146)*
Jaques, Penny *(p.150)*
Jarrett, Betty *(p.54)*
Jarvis, Cecilia *(p.125)*
Jarvis, Charlotte *(p.75)*
Jarvis, Eileen *(p.116)*
Jaynes, Eddie *(p.49)*
Jefferies, Alison *(p.75)*
Jefferies, J.I. *(p.169)*
Jefford, Adam *(p.106)*
Jeffries, Rosie *(p.4)*
Jelfs, Martin *(p.28)*
Jellema, Anna *(p.145)*
Jenkins Hansen, Anne *(p.106)*
Jenkins, Dinah *(p.25)*
Jenkins, Hugh *(p.106)*
Jenkins, Sheila *(p.182)*
Jennings, Lyn C. *(p.75)*
Jensen, Greta *(p.25)*
Jenssen, Einar D. *(p.76)*
Jess, Carrie *(p.142)*
Jesson, Alison *(p.169)*
Jewson, Sue *(p.156)*
Jezard-Clark, Pam *(p.4)*
Jiah, Hildah *(p.106)*
Jn-Baptiste, Louisa *(p.76)*
Joffe, Riva *(p.93)*
Jogessar, Yashmi *(p.49)*
Johansson, Birgitta *(p.76)*
John, Carolyn H. *(p.181)*
John-Wilson, Deb'bora *(p.93)*
Johnson, Deirdre *(p.139)*
Johnson, Duncan B. *(p.144)*
Johnson, Geoffrey *(p.93)*
Johnson, Janette *(p.21)*
Johnson, Judy *(p.188)*
Johnson, Michael *(p.22)*
Johnson, Patricia *(p.139)*
Johnson, Patricia Anne *(p.4)*
Johnston, Candace *(p.10)*
Johnston, James *(p.195)*
Johnston, Linda Ann May *(p.150)*
Johnstone, Janice Mary *(p.32)*
Johnstone, Mog *(p.116)*
Jolliffe, John *(p.93)*
Jonathan, Arthur *(p.169)*
Jones, Alan *(p.169)*
Jones, Amanda *(p.32)*
Jones, Caroline M *(p.135)*
Jones, Christopher S *(p.184)*
Jones, Dan *(p.14)*
Jones, Dave *(p.64)*
Jones, David *(p.116)*
Jones, Deborah *(p.49)*

Jones, Elsa *(p.184)*
Jones, Freda Anne *(p.132)*
Jones, Helen *(p.192)*
Jones, Helen *(p.176)*
Jones, Janet *(p.93)*
Jones, Janet D. *(p.17)*
Jones, Judith *(p.135)*
Jones, Maggy *(p.195)*
Jones, Margaret* *(p.49)*
Jones, Merryn *(p.106)*
Jones, Nicole *(p.25)*
Jones, Pamela *(p.49)*
Jones, Rhiannon Marie *(p.4)*
Jones, Richard *(p.56)*
Jones, Ros *(p.176)*
Jones, Sue *(p.142)*
Jones, Sue *(p.23)*
Jordan, Elizabeth *(p.11)*
Jordan, Karen *(p.23)*
Jordan, Ruth *(p.76)*
Joseph, Jerome Devakumar
 (p.176)
Joslin, Laura *(p.142)*
Joyce, Philip *(p.125)*
Judd, Dorothy *(p.93)*
Jude, Julia *(p.106)*
Judkins, Malcolm *(p.54)*
Jukes, Adam *(p.93)*
Jukes, Rachel *(p.132)*
Julien, Michael *(p.32)*
Jupp, Elizabeth *(p.176)*

K

Kaberry, Susan *(p.132)*
Kafton, Maggie *(p.125)*
Kahn, Ashraf *(p.188)*
Kahr, Brett *(p.93)*
Kaldawaay, Karina *(p.202)*
Kalisch, David *(p.25)*
Kalitowski, Matthew *(p.60)*
Kanakam, Jonathan *(p.9)*
Kane, Janine *(p.179)*
Kane, Ros *(p.64)*
Kanji, Nasim *(p.43)*
Kaplan, Myron R *(p.93)*
Kaplinsky, Catherine *(p.176)*
Karan, Alexandra *(p.125)*
Karban, Barbara *(p.93)*
Karp, Marcia *(p.25)*
Kat, Bernard J B *(p.181)*
Katz, Janice *(p.7)*
Katzman, Stewart *(p.76)*
Kavanagh, Sister Catherine
 (p.125)
Kavner, Ellie *(p.125)*
Kay, David Louis *(p.76)*
Kay, Malcolm *(p.17)*
Keal, Susan *(p.126)*
Keane, Agnes *(p.64)*
Keane, Pamela *(p.116)*
Kearns, Anne *(p.126)*
Keating, Jacqueline *(p.150)*
Kee, Cynthia *(p.60)*
Keedy-Lilley, Ray *(p.76)*
Keen, Caroline *(p.56)*
Keenan, Paul Stephen *(p.135)*
Kegerreis, Susan *(p.126)*
Keggereis, Duncan *(p.126)*
Keith, Charlotte *(p.165)*

Keith, Joyce *(p.169)*
Kell, Midge *(p.43)*
Kelly, Anne *(p.144)*
Kelly, Bridget *(p.49)*
Kelly, Caro *(p.93)*
Kelly, Gillian *(p.22)*
Kelly, Michael *(p.76)*
Kelly, Peter *(p.192)*
Kemmis Betty, Sally *(p.116)*
Kemps, Charmaine *(p.11)*
Kendal, Jo Reed *(p.181)*
Kendall, Tim *(p.159)*
Kendrick, Margaret *(p.32)*
Kennard, David *(p.192)*
Kennedy, Des *(p.135)*
Kennedy, Fiona C *(p.46)*
Kennedy, Helen *(p.154)*
Kennedy, Kay *(p.155)*
Kennedy, Michael* *(p.116)*
Kennett, Christine *(p.192)*
Kenny, Angela *(p.76)*
Kenny, Brigid *(p.144)*
Kenny, Miranda *(p.76)*
Kenny, Peter *(p.22)*
Kenny, Vincent *(p.201)*
Kenrick, Jennifer *(p.60)*
Kenwood, Pat *(p.197)*
Kerbekian, Rosalie *(p.93)*
Kerkham, Patricia *(p.142)*
Kernoff, Marilyn *(p.93)*
Kerr, Anna *(p.106)*
Kerr, Libby *(p.76)*
Kerridge, Jack* *(p.106)*
Kerridge, Petra *(p.202)*
Kerry, Helen *(p.146)*
Kerry, Richard *(p.76)*
Kerry, Sue *(p.116)*
Keshet-Orr, Judi *(p.93)*
Kessel, Inge *(p.76)*
Kevlin, Kunderke *(p.4)*
Kidd, Lee *(p.76)*
Kiemle, Gundi *(p.54)*
Kilgour, Joyce *(p.17)*
Kilgour, Mimi *(p.14)*
Kinbacher, William *(p.197)*
Kincey, John *(p.132)*
Kind, Gill *(p.116)*
Kinder, Diana *(p.126)*
King, Christine *(p.106)*
King, Desmond *(p.49)*
King, Gail *(p.56)*
King, Lucy *(p.14)*
King, Madeleine *(p.7)*
King, Michael *(p.20)*
Kingsley, Joan *(p.60)*
Kingsley, L.D *(p.188)*
Kingsley, Mary *(p.76)*
Kingsnorth, Wendy *(p.139)*
Kinsella, Philip *(p.146)*
Kirby, Alan *(p.25)*
Kirby, Babs *(p.116)*
Kirk, Kate *(p.17)*
Kirkland, Margot *(p.64)*
Kirkland-Handley, Nick V. *(p.38)*
Kirwin, Mark *(p.184)*
Kitchin, Duncan *(p.159)*
Kitson, Nicholas *(p.116)*
Kjellstrom, Laila *(p.154)*

Kleanthous, Dina *(p.76)*
Klein, Wendy *(p.9)*
Kleinot, Pamela *(p.94)*
Klug, Liebe *(p.14)*
Knight, Michael *(p.94)*
Knights, Jean *(p.169)*
Knowles, Elisabeth A *(p.155)*
Knowles, Jane *(p.9)*
Knowles, Louise *(p.159)*
Knowles, Valerie *(p.76)*
Koeppelmann, Marianna *(p.106)*
Kohler, Christiane *(p.152)*
Kohon, Valli *(p.60)*
Kolb, Peter John *(p.116)*
Kolbuszewski, Marianne *(p.116)*
Kondos, Sandra *(p.197)*
Koppelman, Liora *(p.60)*
Korte, Achim *(p.60)*
Kostic, Jasna *(p.76)*
Kostoris, Laura *(p.184)*
Kowalski, Reinhard *(p.9)*
Kowszun, Grazyna *(p.106)*
Kraemer, Sebastian *(p.94)*
Krause, Inga-Britt *(p.7)*
Kreeger, Angela *(p.76)*
Krzowski, Sue *(p.76)*
Kuechemann, Christine *(p.150)*
Kuettner, Enno *(p.188)*
Kuhn, Sue *(p.4)*
Kujawski, Pedro *(p.126)*
Kulyk, Michael *(p.139)*
Kundu, Arabinda *(p.164)*
Kunkler, Jane *(p.154)*
Kutek, Ann *(p.116)*
Kwei, Caryl Lesley *(p.32)*
Kwei, Daniel *(p.32)*
Kypridemos, Petros *(p.188)*

L

La Tourelle, Maggie *(p.94)*
Labworth, Yig *(p.25)*
Lacey, Irene *(p.186)*
Lacy-Smith, Jo *(p.28)*
Lafargue, Martine *(p.144)*
Lafon, Robert George *(p.169)*
Lake, Dorry *(p.146)*
Lake, Moira *(p.170)*
Lakeman Fraser, Judith *(p.43)*
Lallah, Regine *(p.76)*
Lamb, Kirsten *(p.54)*
Lambert, Louise *(p.181)*
Lambor, Florangel *(p.176)*
Lamplough, Lyn *(p.126)*
Lamprell, Michael *(p.64)*
Lancelot, Maggie *(p.195)*
Lanczi, Katalin *(p.49)*
Landale, Margaret *(p.150)*
Landman, Angus *(p.4)*
Lane, Jeff *(p.38)*
Lang, Christine *(p.38)*
Lang, Peter *(p.116)*
Lang, Richard *(p.76)*
Lang, Susan *(p.107)*
Langdon, Monica *(p.107)*
Langley, Allen *(p.182)*
Langley, Dorothy *(p.25)*
Lanyado, Monica *(p.107)*
Laport-Steuerman, M. *(p.94)*
Lapworth, Phil *(p.4)*

Lascelle, Hasan *(p.190)*
Laschinger, Bernie *(p.139)*
Lask, Judith *(p.107)*
Lau, Annie *(p.32)*
Lau, Bernard Wai Kai *(p.199)*
Lauchlan, Sheila *(p.170)*
Launer, John *(p.94)*
Lavender, Lesley *(p.139)*
Lavender, Peter *(p.146)*
Law, Anne M *(p.146)*
Law, Gordon *(p.191)*
Law, Heather *(p.43)*
Law, Susan *(p.170)*
Lawes, Ginny *(p.146)*
Lawley, James *(p.76)*
Lawlor, Virginia Katherine *(p.94)*
Lawrence, Elizabeth *(p.17)*
Lawrence, Margaret *(p.116)*
Lawrence, Yvonne *(p.192)*
Lawson, Christine *(p.170)*
Layfield, Kate *(p.132)*
Layiou-Lignos, Effie *(p.199)*
Layton, Sandy *(p.116)*
Lazarus, Myrna *(p.76)*
Le Brun, Christine *(p.116)*
Lea, Mary *(p.193)*
Lea, Tan *(p.150)*
Leach, Kathy *(p.190)*
Leader, Darian* *(p.60)*
Leakey, Peter *(p.23)*
Leary-Joyce, John *(p.43)*
Leder, Catherine *(p.94)*
Lederman, Tsafi *(p.77)*
Ledward, Judi *(p.17)*
Lee, Adrienne *(p.146)*
Lee, Denis *(p.18)*
Lee, Graham *(p.126)*
Lee, Helen *(p.146)*
Lee, Jan* *(p.126)*
Lee, Joan Mary *(p.107)*
Lee, John *(p.116)*
Lee-Evans, J Michael *(p.143)*
Leeburn, Jennifer *(p.176)*
Leeming, Gareth *(p.107)*
Leeson, Julie *(p.159)*
Leggatt, Claire *(p.54)*
Leggatt, Jenny *(p.14)*
Legh-Smith, Andrea *(p.190)*
Lehain, Daniel *(p.46)*
Lehrer, Pam *(p.94)*
Leigh, Elana *(p.197)*
Leighton, Tim *(p.4)*
Leiper, Elizabeth *(p.56)*
Leiper, Rob *(p.49)*
Leitman, Norman *(p.204)*
Lema, Juan Carlos *(p.94)*
Lemma, Alessandra *(p.94)*
Lemon, Marcia *(p.21)*
Lendrum, Susan *(p.154)*
Lennox, Graham *(p.50)*
Leon, Barbara D. *(p.11)*
Leon, Sara *(p.116)*
Lepper, Georgia *(p.77)*
Lesley, Alison *(p.139)*
Lester, Clare *(p.35)*
Lester, Hilary *(p.107)*
Lethbridge, Sue *(p.38)*
Letley, Emma *(p.126)*

Lettington, Lisa *(p.50)*
Letts, Muriel *(p.43)*
Levens, Mary *(p.77)*
Leveque, Brigitte *(p.126)*
Lever, Maria A. *(p.132)*
Lever, Maureen *(p.38)*
Levett, Ann *(p.203)*
Levick, Barbara *(p.150)*
Levin, Barbara *(p.139)*
Levine, Hanelle G *(p.64)*
Levitsky, Patricia D. *(p.11)*
Levitt, Olga *(p.77)*
Levy, Colette *(p.126)*
Lew, Clara *(p.14)*
Lewin, Melanie *(p.176)*
Lewington, Paul *(p.14)*
Lewis, Jacqueline *(p.77)*
Lewis, Jo-Ann *(p.32)*
Lewis, Joan *(p.116)*
Lewis, Kate A *(p.135)*
Lewis, Ken *(p.18)*
Lewis, Penny *(p.50)*
Lewis, Philip J. *(p.25)*
Lewis, Richard *(p.116)*
Lewis, Sheila* *(p.195)*
Leygraf, Bernd *(p.77)*
Liddle, Helen *(p.54)*
Lidmila, Alan *(p.159)*
Lidster, Wendy *(p.177)*
Lieberman, Stuart *(p.170)*
Liebling, Angela J. *(p.188)*
Liebling, Lauren *(p.77)*
Lilley, Davina *(p.60)*
Lilley, Diana *(p.18)*
Lilley, Tim *(p.177)*
Lillie, Francis *(p.60)*
Lillitos, Aleathea G. *(p.28)*
Limbardet, Jean-Pierre *(p.77)*
Linden, Roger *(p.94)*
Lindley-Jones, Kerstin *(p.150)*
Lindsay, Marion *(p.132)*
Lindsay, Robert *(p.155)*
Lindsey, Caroline *(p.94)*
Liness, Sheena *(p.107)*
Lingard, Shirley Ruth *(p.170)*
Linn, Iris *(p.188)*
Linnell, Maxine *(p.25)*
Lintott, Bill *(p.14)*
Lipman, Amanda *(p.77)*
Lippitt, Gwenda *(p.38)*
Lipsith, Josie *(p.28)*
Lisman-Pieczanski, N.M. *(p.204)*
List, Renee *(p.4)*
Lister, Ian Robert *(p.184)*
Lister, Patricia Anne *(p.77)*
Lister-Ford, Christine *(p.19)*
Little, Jon *(p.142)*
Little, Marie *(p.179)*
Little, Martin *(p.116)*
Little, Ray *(p.126)*
Littledale, Nadine *(p.46)*
Littlejohn, Sarah *(p.132)*
Littlewood, Ann *(p.18)*
Livanou, M. *(p.107)*
Llewellyn, Alice *(p.25)*
Llewellyn, Martha Raquel *(p.170)*
Lloyd, Elizabeth* *(p.177)*
Lloyd, Helen *(p.188)*

Lloyd, Patricia *(p.143)*
Lloyd, Patricia *(p.60)*
Lloyd, Roger *(p.32)*
Lobatto, Wendy *(p.159)*
Lobel, Sandra *(p.22)*
Lobel, Sidney *(p.132)*
Lock, Josephine *(p.126)*
Lockie, Gisela *(p.162)*
Lodrick, Michael *(p.77)*
Loeffler, Harriet *(p.126)*
Loewenthal, Del *(p.116)*
Loftus, Patrick A. *(p.159)*
Logue, Nancy *(p.28)*
Lohman, Frans *(p.58)*
Loiseau, Kate *(p.21)*
Lomax, Vivien *(p.50)*
Lomond, Lynne Marsha *(p.32)*
Long, Clive G. *(p.143)*
Long, Jennifer *(p.28)*
Longford, Joan *(p.22)*
Longley, Joan *(p.107)*
Lonie, Dorothy *(p.154)*
Looms, Suzanne *(p.170)*
Loose, Judith Green *(p.60)*
Lorenz, Bernice *(p.11)*
Loret De Mola, Maria *(p.94)*
Louden, Penny *(p.117)*
Loudon, Julia *(p.21)*
Lough, Mark *(p.152)*
Loumidis, K *(p.56)*
Lousada, Olivia *(p.77)*
Louw, Francois *(p.203)*
Love, Derek *(p.107)*
Love, Jasminder Kaur *(p.43)*
Love, Mollie *(p.177)*
Love, Patrick T *(p.144)*
Lovel, Mary *(p.50)*
Lovell, Karina *(p.18)*
Lovendal-Sorensen, Helena
(p.94)
Lovett-Darby, Linda *(p.170)*
Low, James *(p.94)*
Lowden, Barbara *(p.107)*
Lowe, Judith *(p.107)*
Lowe, Julie *(p.184)*
Lowery, I M *(p.188)*
Lown, Judy *(p.177)*
Loxterkamp, Lorne *(p.25)*
Lubbock, Philippa *(p.126)*
Luca-Stolkin, Maria *(p.77)*
Lucas, Carol *(p.18)*
Lucas, Rosemarie *(p.16)*
Lucas, Tina *(p.139)*
Luce, Peter James *(p.20)*
Luciani, Dorothy *(p.126)*
Luckcock, Ronald Cosmo *(p.77)*
Luckraft-Voges, Julie *(p.54)*
Lude, Jochen *(p.126)*
Luden, Maureen *(p.170)*
Ludolf, Monica *(p.195)*
Lumbis, Gerald *(p.94)*
Lunardon, Francesco *(p.94)*
Lund, Charles *(p.181)*
Lund, Leslie Ann *(p.170)*
Lunt, Aidan *(p.38)*
Luthy, Barbara *(p.35)*
Lutyens, Marianna *(p.150)*
Luxmoore, Nick *(p.150)*

Lynch, Maria *(p.139)*
Lynch, Valerie *(p.170)*
Lyndon, Barbara *(p.94)*
Lyon, Heather *(p.38)*
Lyon, Josephine *(p.117)*
Lyon, Martin *(p.135)*
Lyons, Kathleen *(p.107)*

M

Macalister, Eileen *(p.54)*
Macaskill, Norman D. *(p.159)*
Macdonald, Alasdair *(p.22)*
Macdonald, Helen F. *(p.193)*
Macdonald, Laurie *(p.107)*
Macdonald, Ross *(p.156)*
Mace, Chris *(p.188)*
Macfadyen, John *(p.157)*
Macgregor, Alan *(p.190)*
Macgregor, Catherine *(p.94)*
Macgregor, Wynne *(p.142)*
Machado, Danuza* *(p.94)*
Mack Smith, Catharine *(p.150)*
Mackenna, Christopher *(p.170)*
Mackenzie, Ian D. *(p.184)*
Mackenzie, Liz *(p.56)*
Mackenzie, Nancy *(p.177)*
Mackewn, Jennifer *(p.4)*
Mackinnon, Hetty *(p.156)*
Mackinnon, Sylvia *(p.142)*
Macneill, Enid *(p.159)*
Macnicol, Annie *(p.154)*
Macpherson, David *(p.143)*
Macpherson, Malcolm *(p.152)*
Madden, Felicity W. *(p.56)*
Magagna, Jeanne *(p.60)*
Magner, Valerie *(p.117)*
Magriel, Nicolas *(p.94)*
Maguire, Anne *(p.60)*
Maguire, Claire *(p.54)*
Maguire, Marie *(p.117)*
Maher, Michael *(p.170)*
Mahmood, Janet *(p.181)*
Mahon, David *(p.18)*
Maitlis, Marion *(p.159)*
Maitra, Begum *(p.94)*
Makatini, Zethu *(p.107)*
Makgoba, Sindi *(p.77)*
Makin, Anne *(p.54)*
Malcolm, Charles *(p.203)*
Malcolm, Hanne *(p.153)*
Male, David F. *(p.188)*
Malkin, Julius *(p.64)*
Malkin, Marion *(p.94)*
Mallardo, Renee *(p.25)*
Malone, Sue *(p.38)*
Maloney, Chris *(p.9)*
Maloney, Sean *(p.25)*
Maltby, Jane *(p.95)*
Maltby, Michael *(p.50)*
Mander, Gertrud *(p.95)*
Mandikate, Patrick *(p.77)*
Mandin, Philippe *(p.95)*
Manglani, Dona *(p.64)*
Manicom, Hilary *(p.170)*
Manifold, Claire *(p.95)*
Mann, David *(p.146)*
Manning, Anthony John *(p.32)*
Manning, Helen *(p.20)*
Manojlovic, Jelena *(p.126)*
Mansall, Cordelia *(p.23)*

Mansi, Susan *(p.4)*
Manton, Rosie *(p.195)*
Maple, Norma Anderson *(p.139)*
Maratos, Jason *(p.11)*
March-Smith, Rosie *(p.29)*
Marcus, Marietta *(p.117)*
Marcus-Jedamzik, Deena *(p.77)*
Mardula, Jody *(p.182)*
Margison, Frank *(p.132)*
Marhsallsay, Nicholas *(p.77)*
Mark, Peter *(p.126)*
Markham, Angela *(p.4)*
Markovic, Desa *(p.60)*
Markovic, Olivera *(p.54)*
Marks, Gaby *(p.95)*
Marks, Helen *(p.135)*
Marling, Frances *(p.117)*
Marlowe, Martin *(p.4)*
Marriot, Alison *(p.132)*
Marrone, Mario *(p.95)*
Marsden, Patricia *(p.117)*
Marsden, Veronica *(p.139)*
Marsden-Allen, Peter *(p.143)*
Marsh, Colin *(p.142)*
Marsh, Jennifer* *(p.107)*
Marshall, Antoinette *(p.77)*
Marshall, Cherrith A. *(p.29)*
Marshall, Clare *(p.143)*
Marshall, Hazel *(p.56)*
Marshall, Janet *(p.170)*
Marshall, Jill *(p.170)*
Marshall, Myra *(p.159)*
Marshall, Pam *(p.56)*
Marshall, Pauline *(p.195)*
Marshall, Susan *(p.177)*
Marshall, Vivien *(p.170)*
Martin, Angela *(p.14)*
Martin, Brandy *(p.139)*
Martin, Carol *(p.195)*
Martin, Christine *(p.95)*
Martin, Edward *(p.107)*
Martin, Gill *(p.192)*
Martin, Gloria *(p.170)*
Martin, Linda *(p.179)*
Martin, Stephen *(p.77)*
Martin, Susan *(p.135)*
Marx, Philippa *(p.95)*
Masani, Peter *(p.177)*
Maslen, Gill *(p.35)*
Masoliver, Chandra *(p.126)*
Mason, Barry *(p.77)*
Mason, Christine *(p.195)*
Mason, Letizia *(p.11)*
Massara, Catharine *(p.39)*
Massil, Ros *(p.77)*
Masters, Sue *(p.192)*
Masterson, Ingrid *(p.200)*
Maté, Helen *(p.188)*
Mathers, Carola *(p.117)*
Mathers, Dale *(p.117)*
Mathews, Trevor J. *(p.32)*
Mattar, Gretta *(p.139)*
Matthews, Carol *(p.126)*
Matthews, Helen P. *(p.39)*
Matthews, Shane *(p.4)*
Matthews, Sharon *(p.161)*
Mattison, Sheila *(p.135)*
Maudling, Caroline *(p.43)*

Maunder, Brian Lawrence *(p.107)*
Maxwell, Brian *(p.170)*
Maxwell, Hugh *(p.177)*
Maxwell, Sue *(p.154)*
May, Adam *(p.182)*
May, Ian *(p.126)*
May, Jo *(p.20)*
May, Kathryn *(p.54)*
Mayer, Robert *(p.77)*
Mayer-Johnson, Jessica *(p.60)*
Maynerd, Cynthia *(p.170)*
Mazaraki, Angeliki *(p.64)*
Mazliach, Yaron *(p.201)*
Mazure, David *(p.77)*
Mcaleer, Eileen *(p.135)*
Mcallister, Christopher *(p.7)*
Mcallister, Susan *(p.54)*
McAlpine, A M *(p.107)*
McAndrew, Brigitte *(p.50)*
McAuley, John *(p.159)*
McBride, Nigel *(p.78)*
McBurnie, Dolores *(p.18)*
McCabe, Jennifer *(p.60)*
McCabe, Ruth *(p.165)*
McCafferty, Stewart *(p.78)*
McCann, Anita *(p.44)*
McCann, Damian *(p.44)*
McCann, Linda *(p.65)*
McCarron, Gerard *(p.65)*
McCarry, Nicola *(p.170)*
McCarthy, Rita *(p.200)*
McCartney, Meryl *(p.44)*
McClatchey, E.P.(Toni) *(p.135)*
McCloud-Iceton, Janet *(p.78)*
McClure, John *(p.78)*
McCluskey, Una *(p.192)*
McConnochie, Charlie *(p.156)*
McCormick, Elizabeth Wilde *(p.165)*
McCormick, Helen *(p.18)*
McCoy, Sean *(p.50)*
McCreanor, Teresa *(p.126)*
McCrohan, Denise *(p.192)*
McCutcheon, Moira *(p.107)*
McDermott, Cathy *(p.126)*
McDermott, Gerry *(p.170)*
McDermott, Ian *(p.78)*
McDermott, Paul *(p.95)*
McDonald, Christina *(p.157)*
McDonald, James T *(p.188)*
McDonnell, Fokkina *(p.132)*
McDouall, Veronica *(p.14)*
McEldowney, Dennis *(p.127)*
McEvoy, Patricia Elaine *(p.95)*
McFadden, Hugh E. *(p.200)*
McFarland, Alf *(p.56)*
McFarlane, Alison M. *(p.154)*
McFarlane, Kay *(p.107)*
McGee, Colin *(p.78)*
McGlashan, Judy *(p.127)*
McGoldrick, Mary *(p.200)*
McGouran, Gill *(p.26)*
McGowan, Dominica *(p.144)*
McGowan, Fran *(p.4)*
McGrath, Adrian *(p.135)*
McGrath, Graeme *(p.132)*
McGrath, Patrick *(p.11)*
McGrath, Rita *(p.65)*

McGreevy, Edith *(p.145)*
McGregor, Tony *(p.9)*
McGregor-Hepburn, Jan *(p.181)*
McGroary-Meehan, Maureen *(p.200)*
McGuinness, Mark *(p.127)*
McGuinness, Maureen *(p.7)*
McHugh, Brenda *(p.78)*
McIntee, Jeannie *(p.18)*
McIntosh, Stuart *(p.142)*
McKay, Barbara *(p.7)*
McKay, Lynn *(p.146)*
McKay, Molly *(p.18)*
McKenna, Clare *(p.78)*
McKenzie, Maggie *(p.78)*
McKenzie-Mavinga, Isha *(p.107)*
McKenzie-Smith, Bryce *(p.95)*
McKeon, Mary *(p.78)*
McKeown, Andy *(p.4)*
McKeown, Patricia *(p.145)*
McLean, Julienne *(p.95)*
McLeod, Paula *(p.177)*
McLewin, Ali *(p.50)*
McLoughlin, Brendan *(p.4)*
McLoughlin, Brendan Nicholas *(p.107)*
McLoughlin, Una *(p.18)*
McMahon, Gladeana *(p.108)*
McManus, Gaynor *(p.117)*
McMaster, Catherine *(p.156)*
McMillan, Penny *(p.108)*
McMinnies, Patricia *(p.179)*
McNab, Stuart *(p.135)*
McNab, Sue *(p.11)*
McNair, Ann G *(p.78)*
McNamara, Barbara *(p.4)*
McNamara, Jennifer *(p.19)*
McNaught, Janet *(p.186)*
McNeil, Delcia *(p.78)*
McNeilly, Gerald *(p.191)*
McNulty, Claire *(p.95)*
McOstrich, June *(p.35)*
McQuillin, Jane *(p.22)*
McShane, Oliver *(p.127)*
McVey, Damien *(p.135)*
McWilliam, Jill *(p.65)*
Mead, Betty *(p.78)*
Mead, Christine *(p.127)*
Mead, Jannie *(p.11)*
Meaden, Rosaleen *(p.117)*
Meakins, Elizabeth *(p.95)*
Mears, Sylvia *(p.108)*
Meinrath, Monica *(p.139)*
Meldrum, Ron *(p.39)*
Meleagrou-Dixon, Mando *(p.127)*
Meller, Carolyn *(p.170)*
Mellett, Jane *(p.190)*
Mellows, David *(p.78)*
Mellows, Hilary *(p.78)*
Melton, Jane *(p.9)*
Menckhoff, Beckie *(p.139)*
Mendelsohn, Annette *(p.95)*
Mendelssoh, Penny *(p.50)*
Mendoza, Hilda *(p.127)*
Mendoza, Steven *(p.127)*
Menezes, Ray *(p.127)*
Menzies, Heather *(p.177)*
Mercer, Annie *(p.135)*

Meredith, Joan (p.132)
Meredith, Judith (p.39)
Merriott, Peter (p.26)
Merz, Juliet (p.117)
Messent, Philip (p.65)
Methuen, Oriel (p.78)
Mettam, Lisa (p.159)
Meza, Ann L. (p.78)
Micciarelli, Felicia (p.117)
Michael, Jess (p.78)
Michaels, Ruth (p.127)
Michaelson, Sue (p.177)
Michaud-Lennox, Suzanne (p.139)
Middlecoat, Andrew (p.142)
Middleton, Margaret (p.155)
Middleton, Richard (p.20)
Middleton-Smith, Virginia (p.190)
Midgley, David (p.19)
Mikardo, Julia (p.117)
Milani, Belinda (p.44)
Milburn, Irene* (p.117)
Miles, Carolyn (p.21)
Miles, Fiona (p.108)
Miles, Natalie (p.108)
Millais, Suzy (p.50)
Millar, David (p.32)
Millar, Gerry (p.108)
Millar, Peter (p.35)
Millar, Wilma (p.117)
Millard Mackintosh, Sheila (p.150)
Miller, Ann (p.95)
Miller, Bob (p.180)
Miller, Jill M (p.204)
Miller, Joanna (p.139)
Miller, John (p.150)
Miller, John Andrew (p.95)
Miller, Juliet (p.127)
Miller, Liza Bingley (p.192)
Miller, Lynda R (p.58)
Miller, Michael* (p.14)
Miller, Penny (p.78)
Miller, Riva (p.78)
Miller, Sheila (p.203)
Millichamp, Stacey (p.78)
Millier, Sylvia (p.117)
Millington, Malcolm (p.95)
Mills Burton, M. (p.150)
Mills, Christopher (p.4)
Mills, Jeremy George (p.177)
Mills, Judith (p.26)
Mills, Nigel (p.184)
Millward, Christopher (p.78)
Milne, Frances (p.152)
Milne, Pamela J.E (p.143)
Milton, Harry (p.155)
Milton, Martin (p.170)
Milton, Thelma (p.4)
Minaar, Doris (p.14)
Mitchell, Diana (p.171)
Mitchell, John (p.162)
Mitchell, Lesley (p.132)
Mitchell, Paul Christoph (p.159)
Mitchell, Richard (p.44)
Mitchell, Ruth (p.117)
Mitcheson Brown, Muriel (p.4)
Mitchison, Sally (p.181)
Mittwoch, Adele (p.95)

Model, Elizabeth (p.78)
Moggridge, Cass (p.35)
Mohan, Terry (p.165)
Mohlala, Morris (p.117)
Moja-Strasser, Lucia (p.95)
Molino, Anthony (p.202)
Molleson, John Ivitsky (p.156)
Moloney, Paul (p.188)
Monach, Jane (p.160)
Moncur, Pamela (p.9)
Mondadori, Roberta (p.95)
Monk-Steel, Barbara (p.56)
Monk-Steel, John (p.56)
Montalbetti, M.L. (p.202)
Montero, Isabel (p.78)
Monticelli, Wendy (p.108)
Moodie, Alastair (p.156)
Moon, Barbara (p.54)
Moore, Alan (p.35)
Moore, Gordon (p.181)
Moore, Jill (p.26)
Moore, Joan (p.127)
Moore, Julia (p.95)
Moore, Margaret C (p.160)
Moore, Maureen (p.44)
Moore, Rosemary* (p.7)
Moore, Terry (p.39)
Moorey, Stirling (p.65)
Moorhouse, Anni (p.139)
Morante, Flavia (p.127)
Mordecai, Kay (p.79)
Mordicai, Aslan (p.79)
Moreby, Patricia Joyce (p.188)
Morgan, Barbara (p.44)
Morgan, Elizabeth A (p.161)
Morgan, Jo (p.191)
Morgan, Linda (p.188)
Morgan, Mary (p.65)
Morgan, Ruth (p.50)
Morgan, Shirley P. (p.181)
Morgan, Sian* (p.14)
Morgan, William (p.181)
Morgan-Jones, Richard (p.177)
Morgan-Williams, Susan (p.193)
Morice, Lisa (p.171)
Morice, Michael (p.171)
Morin, Terry (p.108)
Morley, Ann (p.147)
Morley, Elspeth (p.79)
Morley, Jane (p.108)
Morley, Michael (p.132)
Morley, Robert (p.79)
Moro, Julie Ann (p.32)
Morris, Allan (p.79)
Morris, Bridget (p.139)
Morris, Clare (p.127)
Morris, David (p.20)
Morris, Elizabeth (p.35)
Morris, Jane (p.195)
Morris, Lesley Anne (p.150)
Morris, Monique (p.95)
Morris, Peter A. (p.7)
Morris, Petrina (p.150)
Morris, Shosh (p.79)
Morris, Stephen (p.35)
Morrish, Susan (p.50)
Morrison, Barbara (p.44)
Morrison, Lesley (p.171)

Morrison, Philippa (p.150)
Morrissey, Shirley (p.197)
Morton, Gillian (p.79)
Morton, Richard Victor (p.153)
Moses, Susan (p.60)
Mostaeddi, Bahman (p.139)
Moulding, Jacqueline (p.147)
Moulin, Laurence (p.188)
Mountain, Anita (p.56)
Mountjoy, Lesleen (p.171)
Mouratoglou, Vassilis (p.96)
Moutzoukis, Chris (p.199)
Mowlan, Madeleine (p.29)
Moyes, Theresa (p.164)
Mudarikiri, Maxwell Magondo (p.108)
Muffet, Ruth (p.96)
Mukuma, Diana (p.108)
Muldoon, Nuala (p.139)
Mulhern, Alan (p.79)
Muller, Nina (p.65)
Mullins, Pat (p.135)
Mulvey, Jean (p.177)
Mulvey, Josephine (p.39)
Mundy, Jean (p.142)
Mundy, Pamela (p.190)
Munro, Carole (p.5)
Munsey, Jon (p.26)
Munt, Stephen (p.117)
Murdin, Lesley (p.14)
Murphy, Alan (p.96)
Murphy, Denis (p.108)
Murphy, Derry (p.14)
Murphy, Ger (p.200)
Murphy, Katherine (p.127)
Murphy, Sue (p.108)
Murray, Catherine (p.200)
Murray, Christine (p.108)
Murray, Jane (p.9)
Muschamp, Maureen (p.23)
Music, Graham (p.79)
Mwelwa, Edward (p.155)
Mycroft, Jessica (p.60)
Myers, Marion (p.186)
Myers, Piers (p.79)
Mylan, Trish (p.184)

N

Nabarro, Elizabeth (p.96)
Nadirshaw, Zenobia (p.127)
Nafie, Omar Ibrahim (p.96)
Nagle, Robin (p.96)
Naish, Julia (p.79)
Nancarrow, Christine (p.96)
Nancarrow, Kiya (p.117)
Naor, Lillie (p.79)
Nappez, Sue (p.117)
Nath, Krish (p.171)
Nathan, (Jennifer) Ruth (p.151)
Nathan, Gill (p.96)
Navarro, Trinidad (p.79)
Naydler, Nick (p.5)
Naylor-Smith, Alan (p.44)
Neal, Charles (p.96)
Neal, Lalage (p.117)
Neate, Patricia (p.117)
Neden, Jeanette (p.181)
Neenan, Michael (p.32)
Neill, Christopher (p.171)

Neill, Denis E. (p.18)
Neiva, Judith (p.79)
Nelki, Julia (p.136)
Nelson, Denise (p.50)
Nelson, Sandy (p.96)
Nesbit, Judith (p.65)
Ness, Thomas William (p.153)
Netzer-Stein, Antje (p.118)
Neumann, Anton (p.79)
Nevin, Jaqui (p.18)
Nevins, Peter (p.79)
Newbery, Christopher (p.29)
Newbigin, Alison (p.108)
Newby, Rita (p.191)
Newell, Adrian (p.164)
Newns, David (p.139)
Newson, Mary (p.11)
Ngah, Zah (p.79)
Ngone, Mary (p.44)
Nicholas, John (p.186)
Nicholson, Elizabeth (p.26)
Nicholson, Jane (p.132)
Nick V. (p.38)
Nicol, Sara (p.177)
Nicolson, Elaine (p.155)
Nieboer, Sarah (p.127)
Nielsen-Cernkovich, Rudy (p.60)
Niesser, Arthur (p.182)
Nightingale, Eileen (p.26)
Nippoda, Yuko (p.127)
Nissim, Ruth (p.151)
Nitsun, Morris (p.79)
Nkumanda, Rachel (p.108)
Noack, Amelie (p.79)
Noack, Miké (p.26)
Noble, Jane (p.79)
Nodelman, Marsha (p.79)
Nolan, Michael A (p.118)
Nolan, Philip (p.195)
Noonan, Mairead (p.118)
Norburn, Veronica (p.96)
Norman, Caroline (p.177)
Norman, Harry (p.5)
Norsa, Giuliana (p.139)
North, Joanna (p.26)
Norton, Sheila (p.58)
Nottingham, Sue (p.29)
Nowlan, Kate (p.162)
Noyes, Elizabeth (p.96)
Nuaimi, Christine (p.50)
Nuttal, Clive (p.32)
Nuttall, Serena (p.118)
Nye, Georgiana (p.5)

O

O Briain, Ciaron (p.79)
O'Brian, Charles (p.199)
O'Brien, John (p.177)
O'Brien, Kirsty M G (p.9)
O'Brien, Maja** (p.151)
O'Brien, Pat (p.171)
O'Brien, Sally (p.50)
O'Callaghan, Diane (p.108)
O'Callaghan, Lesley (p.96)
O'Carroll, Madeline (p.79)
O'Carroll, Pierce J. (p.18)
O'Connell, Victoria (p.96)
O'Connor, Aine (p.200)
O'Connor, Ann (p.188)

O'Connor, Ann *(p.79)*
O'Connor, Maureen *(p.200)*
O'Connor, Michael *(p.39)*
O'Connor, Nadia *(p.200)*
O'Connor, Noreen *(p.79)*
O'Conor, Mary *(p.201)*
O'Dell, Tricia *(p.171)*
O'Dwyer, Annegret *(p.171)*
O'Gorman, Mary Pat *(p.96)*
O'Hagan, Judith *(p.127)*
O'Keeffe, Tim *(p.65)*
O'Kelly, Marie *(p.118)*
O'Leary, Anne *(p.191)*
O'Leary, Brid *(p.44)*
O'Leary, Carmen *(p.65)*
O'Neill, Arthur *(p.145)*
O'Neill, Christopher J. *(p.171)*
O'Neill, Helen M. *(p.143)*
O'Neill, James *(p.118)*
O'Neill, Julia *(p.201)*
O'Neill, Thomas *(p.132)*
O'Reilly, Paul *(p.26)*
O'Reilly, Thomas J *(p.147)*
O'Shea, Deidre *(p.201)*
O'Sullivan, Bernadette *(p.201)*
O'Sullivan, Renee *(p.50)*
Oakley, Haya* *(p.96)*
Oakley, Ian H. *(p.195)*
Oakley, Madeleine *(p.108)*
Oaten, Gae *(p.96)*
Oates, Stephanie *(p.18)*
Oclander Goldie, Silvia *(p.96)*
Odgers, Andrew *(p.96)*
Offer, Leah *(p.151)*
Ogilvie, Renata *(p.197)*
Ohene, Margaret D. *(p.80)*
Ohnesorg, Johanna *(p.204)*
Oldfield, Nina *(p.26)*
Oldman, David *(p.171)*
Oliver, Christine *(p.118)*
Oliver, Jenny *(p.41)*
Oliver, Rosamund *(p.80)*
Oliver-Bellasis, Elizabeth *(p.96)*
Olney, Felicia *(p.96)*
Openshaw, Sally *(p.26)*
Opienski, Jacek *(p.127)*
Oram, John E.D. *(p.160)*
Orbach, Susie *(p.96)*
Orford, Eileen *(p.96)*
Orlandi-Fantini, Claire *(p.147)*
Orlandi-Fantini, Peter *(p.147)*
Orlans, Vanja *(p.96)*
Ormay, Tom *(p.97)*
Oromi, Irene *(p.203)*
Orton, Jane *(p.151)*
Osborn, James *(p.164)*
Osborn, Madeline Frances
 (p.182)
Osborne, Lynda *(p.171)*
Ostler, Dorothy *(p.29)*
Otto, Joachim *(p.201)*
Overs, Nicola *(p.23)*
Owen, Ian *(p.161)*
Owen, Mike *(p.127)*
Owen, W Meredith *(p.186)*
Owens-Ward, Lyn *(p.50)*
Owtram, Peter *(p.171)*

P
Pacey, Susan *(p.60)*

Padgett, Louise *(p.5)*
Pae, Linda L S *(p.50)*
Page, Annabel *(p.195)*
Page, Jonathan *(p.147)*
Pain, Jean *(p.14)*
Palamountain, Alan *(p.80)*
Palanisamy, Shan *(p.50)*
Palgrave, Lesley *(p.50)*
Pallenberg, Sue *(p.44)*
Palmer Barnes, Fiona *(p.41)*
Palmer, Brigid *(p.145)*
Palmer, Dorothy *(p.29)*
Palmer, Lisa Elaine *(p.11)*
Palmer, Marion Macintosh *(p.180)*
Palmer, Stephen *(p.108)*
Pamphlett, Nicholas *(p.54)*
Panchkowry, Marion *(p.11)*
Panetta-Crean, Simona *(p.80)*
Pantall, Marlis *(p.18)*
Papadopoulos, Renos *(p.65)*
Paramour, Annabelle *(p.8)*
Parava, Anna *(p.188)*
Pardoe, Kathleen A *(p.160)*
Parfitt, Will *(p.162)*
Parikh, Prakash *(p.118)*
Paris, Jan *(p.58)*
Parissis, Maria *(p.61)*
Parker, Gabrielle *(p.127)*
Parker, John *(p.195)*
Parker, Jonathan *(p.46)*
Parker, Mary *(p.118)*
Parker, Michael *(p.11)*
Parker, Niki *(p.50)*
Parker, Rosie *(p.80)*
Parkin, Gwendolyn *(p.118)*
Parkinson, Dorn *(p.14)*
Parkinson, Jane *(p.177)*
Parkinson, Jillian *(p.23)*
Parkinson, Judy *(p.108)*
Parkinson, Phil *(p.118)*
Parks, Val *(p.80)*
Parlett, Malcolm *(p.184)*
Parmley, Alison *(p.32)*
Parr, John *(p.9)*
Parr, Meriel A *(p.44)*
Parrack, Norma *(p.39)*
Parry, Glenys *(p.160)*
Parsons, Barbara *(p.184)*
Parsons, Marianne *(p.97)*
Partridge, Karen *(p.140)*
Passey, Miranda *(p.46)*
Patalan, Anna-Maria *(p.97)*
Patchett, Angela *(p.44)*
Paterson, Stuart *(p.80)*
Paton, Julia *(p.80)*
Patricia, Thelma *(p.202)*
Patterson, Anna *(p.80)*
Patterson, Linda *(p.5)*
Pattinson, Philip *(p.195)*
Paulson, Diana *(p.97)*
Pavincich, Lesley *(p.118)*
Pawsey, Jack *(p.108)*
Pawson, Chris *(p.44)*
Pawson, Sheila *(p.44)*
Payman, Barbara *(p.186)*
Payne, Graham *(p.193)*
Payne, Helen *(p.44)*
Payne, John *(p.20)*

Payne, Katherine Elizabeth *(p.56)*
Peace, Susan *(p.184)*
Peacock, Anne *(p.118)*
Pearce, George *(p.80)*
Pearce, Peter *(p.127)*
Pearmain, Rosalind *(p.65)*
Pearman, Cathy *(p.171)*
Pearse, Joanna *(p.171)*
Pearson, Beryl *(p.19)*
Pearson, Mark *(p.147)*
Peart, Mary *(p.8)*
Peckitt, R.G. *(p.9)*
Pecotic, Branka *(p.97)*
Peet, Sandra *(p.171)*
Peglar, Graham *(p.15)*
Pegoraro, Carla *(p.151)*
Pehrsson-Tatham, Lena *(p.26)*
Peltier, Judy *(p.195)*
Penalosa-Clarke, Adriana *(p.80)*
Pengelly, Paul *(p.80)*
Penn, Joyce *(p.32)*
Pennycook-Greaves, Wil *(p.80)*
Penwarden, Mary M. *(p.50)*
Pepeli, Hara* *(p.80)*
Pepper, Marie *(p.15)*
Percy, David *(p.39)*
Perera, Ajit *(p.171)*
Pericleous, Christine *(p.80)*
Perrett, Angelina *(p.160)*
Perring, Michael *(p.61)*
Perriollat Munro, Elizabeth
 (p.132)
Perry, Ann *(p.80)*
Perry, Christopher *(p.140)*
Perry, Janet *(p.56)*
Pervoltz, Rainer *(p.199)*
Peternel, Franc *(p.203)*
Peters, Anthony *(p.202)*
Peters, Linda *(p.97)*
Peters, Maggie *(p.35)*
Peters, Sheila *(p.108)*
Pethen, Susan *(p.160)*
Petkova, Petia *(p.140)*
Petrie, Bill *(p.80)*
Petrie, Clare *(p.155)*
Petrie-Kokott, Julie *(p.140)*
Pettle, Sharon *(p.80)*
Petty, Susan *(p.46)*
Phelps, Gwyneth *(p.188)*
Philbin, Mairead *(p.65)*
Philippson, Peter *(p.133)*
Phillips, Adam *(p.127)*
Phillips, Asha *(p.140)*
Phillips, Laurie *(p.29)*
Phillips, Marianne *(p.143)*
Phillips, Mary *(p.171)*
Phillips, Pauline *(p.195)*
Phillips, Susan *(p.147)*
Phillips, Thomas Lambton *(p.195)*
Phillips, Virginia *(p.108)*
Philo, Judith *(p.80)*
Philps, Janet *(p.11)*
Phoenix, Ashleigh *(p.181)*
Pick, Geoff *(p.118)*
Pick, Rachel *(p.118)*
Pickles, Penny *(p.118)*
Pickstock, Keith *(p.80)*
Pickvance, Deborah *(p.160)*

Pidgeon, Patricia *(p.39)*
Pieczora, Marek *(p.5)*
Pierides, Stella *(p.80)*
Pigott, Sheila *(p.147)*
Pike, Margery *(p.44)*
Pimentel, Allan *(p.128)*
Pimentel, Edna *(p.80)*
Pinch, Christine *(p.44)*
Piontelli, Alessandra *(p.202)*
Piper, Robin *(p.51)*
Pirani, Alix *(p.5)*
Pitt, Chris *(p.136)*
Pittman, Karen *(p.142)*
Pittock, Frances *(p.195)*
Pixner, Stefanie *(p.65)*
Platt, Monique *(p.171)*
Platt, Sue *(p.97)*
Platts, June Elizabeth *(p.39)*
Plen, Rene *(p.165)*
Plotel, Angela *(p.128)*
Plowman, John *(p.184)*
Plowman, Polly *(p.32)*
Plummer, Glenys *(p.32)*
Plunkett, Eileen *(p.97)*
Pocock, Olga *(p.190)*
Pokorny, Michael R* *(p.97)*
Polden, Jane *(p.142)*
Poledri, Patricia *(p.80)*
Pollack, Angela *(p.199)*
Pollard, Cynthia *(p.11)*
Pollard, James *(p.15)*
Pollet, Sheena *(p.18)*
Pollitt, Mo *(p.18)*
Pollitzer, Juliette *(p.118)*
Pool, Nicky *(p.9)*
Poole, Carol Lynn *(p.190)*
Poole, Nick *(p.133)*
Poole, Robert *(p.128)*
Pooley, Jane *(p.44)*
Pope, Alan *(p.128)*
Pope, Michael *(p.80)*
Pope, Sian *(p.5)*
Pople, Sue *(p.81)*
Popple, Gillian *(p.44)*
Porteous, Louise *(p.160)*
Porter, Barbara *(p.151)*
Porter, Christine *(p.128)*
Porter, Jim *(p.57)*
Potkonjak, Dusan *(p.65)*
Potter, Steve *(p.133)*
Poulopoulos, Katerina *(p.199)*
Pouteaux, Diana *(p.171)*
Pover, Jane .S.E *(p.51)*
Powell, Andrew *(p.151)*
Powell, Angela *(p.97)*
Powell, Helen *(p.51)*
Power, Kevin *(p.97)*
Pozzi, Maria E. *(p.44)*
Prall, Werner *(p.97)*
Pratt, Sheila *(p.171)*
Preece, Rob *(p.5)*
Pregnall, Sheila *(p.190)*
Preisinger, Kristiane *(p.97)*
Prendergast, Teresa *(p.128)*
Prentice, Hilary *(p.65)*
Presant, Fern *(p.81)*
Preston, Kay *(p.171)*
Prestwood, Christopher *(p.118)*

Price, Annie *(p.108)*
Price, Susan *(p.109)*
Priest, Caroline *(p.81)*
Priestley, John *(p.118)*
Prince, Tania *(p.18)*
Procter, Harry *(p.162)*
Procter, Sue *(p.23)*
Proctor, Ann *(p.162)*
Proctor, Susan *(p.181)*
Prodgers, Alan *(p.133)*
Proffitt, Dorothea *(p.136)*
Proner, Karen *(p.128)*
Prothero, Peggy *(p.136)*
Proudley, Helen *(p.21)*
Prussia, Celia M. *(p.182)*
Pryde, Nia *(p.199)*
Puddy, Jane Kahan *(p.97)*
Pugh, Anna *(p.39)*
Pugh, Gabrielle *(p.128)*
Pugsley, Stephanie *(p.147)*
Pullen, Caroline J *(p.5)*
Pullin, Andrew *(p.5)*
Purkiss, Jane *(p.5)*
Purnell, Chris *(p.161)*
Purpura, Davide *(p.97)*
Pusztai, Edit E. *(p.156)*
Pyves, Gerry *(p.196)*

Q

Quaine, Mary K *(p.118)*
Quarmby, David *(p.54)*
Quarry, Andrew *(p.162)*
Quilter, Sally *(p.15)*
Quin, Barbara *(p.39)*
Quinn, Asha *(p.118)*
Quinn, John J *(p.51)*
Quinn, Paul *(p.145)*
Quinn, Susan *(p.180)*
Quoilin-Lebrun, Michelle *(p.172)*

R

Rabe, Marie-Louise *(p.172)*
Rabin, Judith *(p.97)*
Rabin, Norman *(p.97)*
Radcliffe, Mark *(p.196)*
Radford, Patricia *(p.97)*
Radlett, Marty *(p.81)*
Rae, Frances *(p.51)*
Raeside, Dominic *(p.61)*
Raicar, Maeja Alexandra *(p.33)*
Raimes, Peter *(p.81)*
Rainsford, Helena *(p.81)*
Raisbeck, Linde *(p.15)*
Ramage, Margaret *(p.61)*
Ramsden, Sandra *(p.97)*
Rance, Christopher *(p.109)*
Rance, Sarah *(p.190)*
Rand, Judith Ann *(p.11)*
Randall, Lynda *(p.57)*
Randall, Rosemary *(p.15)*
Rani, R S *(p.118)*
Ransley, Cynthia *(p.128)*
Ransome, Helen *(p.165)*
Raphael, Francesca *(p.97)*
Rapp, Hilde *(p.97)*
Ratigan, Bernard *(p.57)*
Ratner, Harvey *(p.128)*
Ratoff, Tammy *(p.161)*
Rattigan, Bridget *(p.128)*

Ravensdale, Verity *(p.97)*
Rawat, Shenaz *(p.81)*
Rawson-Jones, Elizabeth *(p.140)*
Rawsthorne, Jean *(p.133)*
Raymond, Caroline *(p.29)*
Rayner, Beryl Ann *(p.160)*
Razzaq-Bains, Saira *(p.118)*
Rea, Judith *(p.81)*
Read, Jane *(p.128)*
Read, Nicholas W *(p.160)*
Read, Tim *(p.61)*
Reader, Frances *(p.165)*
Reading, Bill *(p.51)*
Reading, Clive *(p.18)*
Reagan, Catherine *(p.164)*
Reardon, Paula *(p.118)*
Reay, Ruth *(p.11)*
Reddy, Michael *(p.11)*
Reddy, William *(p.204)*
Redgrave, Kenneth *(p.18)*
Redish, Elisabeth *(p.81)*
Redler, Leon *(p.97)*
Redmill-Sorensen, Bernice *(p.44)*
Reed, Alex *(p.145)*
Reed, Keith *(p.128)*
Rees, Ian *(p.190)*
Rees, Myfanwy *(p.143)*
Rees, Susan *(p.20)*
Rees-Roberts, Diane *(p.140)*
Reeves, Alan *(p.177)*
Regan Jones, Columba *(p.184)*
Regel, Stephen *(p.147)*
Réguis, Marie-Christine *(p.81)*
Reid, Liz *(p.81)*
Reid, Marguerite *(p.119)*
Reid, Rosamund *(p.172)*
Reid, Susan *(p.97)*
Reidy, Rachel *(p.11)*
Reik, Herta *(p.98)*
Reilly, Anne *(p.51)*
Reilly, Nicole *(p.180)*
Reilly, Stephen *(p.193)*
Reimers, Sigurd *(p.190)*
Rejaie, Carol *(p.160)*
Rendall, Davina *(p.151)*
Renoux, Martine *(p.81)*
Renton, Mirjana *(p.98)*
Rentoul, Robert W. *(p.188)*
Renwick, Fran *(p.172)*
Renwick, John *(p.45)*
Retallick, Malcolm *(p.20)*
Reuvid, Jennie *(p.119)*
Reynal, Carmen *(p.151)*
Reynolds, Alun *(p.15)*
Reynolds, Dorothy *(p.33)*
Reynolds, Francois *(p.142)*
Reynolds, Helen *(p.51)*
Reynolds, Hilary *(p.172)*
Reynolds, Malcolm *(p.201)*
Reynolds, Michael John *(p.189)*
Rheinschmiedt, Otto *(p.190)*
Rhind, Sue *(p.81)*
Rhodes, Adrian M. *(p.133)*
Rice, Paul *(p.33)*
Richards, Christopher *(p.5)*
Richards, Diana M *(p.98)*
Richards, Janet *(p.9)*
Richards, Maureen Veronica

(p.51)
Richards, Michael *(p.177)*
Richards, Paul *(p.147)*
Richards, Val* *(p.81)*
Richardson, Ann *(p.128)*
Richardson, Caroline *(p.193)*
Richardson, Elizabeth *(p.45)*
Richardson, Gillian *(p.5)*
Richardson, Madeleine J. *(p.177)*
Richardson, Sacha *(p.57)*
Richardson, Sue *(p.19)*
Richardson, Susan *(p.142)*
Richman, Sheila *(p.136)*
Richter, Nicola *(p.45)*
Rickard, Ian *(p.182)*
Rickett, Marion *(p.45)*
Ricketts, Susan *(p.39)*
Ricketts, Thomas N. *(p.160)*
Rickman, Chrisse *(p.65)*
Riddy, Paula *(p.119)*
Ridgewell, Margaret *(p.57)*
Ridgway, Jane *(p.18)*
Riding, Ann *(p.51)*
Riding, Nick *(p.51)*
Ridley, Elizabeth *(p.98)*
Ridley, Jane *(p.172)*
Ridley, Stella* *(p.39)*
Ridley, Wendy *(p.81)*
Rignell, John *(p.177)*
Rigney, Ann *(p.51)*
Riley, Brenda *(p.51)*
Rimmer, Annie *(p.109)*
Rishiraj, Narinder S *(p.140)*
Ritchie, Robert *(p.155)*
Ritchie, Sheila *(p.81)*
Rivett, Mark *(p.184)*
Rix, Sandy *(p.33)*
Robb, Melissa *(p.190)*
Robbins, Sonia *(p.182)*
Roberts, Alison *(p.11)*
Roberts, Jane *(p.51)*
Roberts, Jeff *(p.61)*
Roberts, Julie *(p.143)*
Roberts, June *(p.140)*
Roberts, Laurence* *(p.65)*
Roberts, Pauline *(p.51)*
Roberts, Phil *(p.98)*
Roberts, Susan *(p.185)*
Roberts, Sylvia M *(p.81)*
Robertson, Chris *(p.98)*
Robertson, Ewa *(p.98)*
Robertson, Judith *(p.140)*
Robertson, Judith *(p.109)*
Robertson, Ruth *(p.81)*
Robertson, Zuleika* *(p.26)*
Robinson, Carole *(p.15)*
Robinson, Felicity *(p.160)*
Robinson, Ferga *(p.109)*
Robinson, Gary *(p.23)*
Robinson, Hazel *(p.98)*
Robinson, J.G. *(p.152)*
Robinson, Jenny *(p.189)*
Robinson, Judy *(p.177)*
Robinson, Louise *(p.162)*
Robinson, Margaret *(p.39)*
Robinson, Marlene *(p.61)*
Robinson, Martin *(p.29)*
Robinson, Peter *(p.155)*

Robinson, Rosalyn *(p.181)*
Robinson, Sue *(p.128)*
Roche, Sile *(p.201)*
Roddick, Mary *(p.26)*
Roemmele, Caroline *(p.98)*
Roex, Danielle *(p.198)*
Roff, Hermione *(p.136)*
Rogers, Anne *(p.8)*
Rogers, Cynthia *(p.109)*
Rogers, Lesley A. *(p.51)*
Rogers, Maggie *(p.128)*
Rognerud, Tove *(p.81)*
Roland, Saskia *(p.178)*
Romisch-Clay, Liza *(p.81)*
Romm-Bartfeld, Goldie *(p.98)*
Roper Hall, Alison *(p.189)*
Rose, Alivia *(p.162)*
Rose, Kevin *(p.98)*
Rose, Sally *(p.196)*
Rose, Stuart *(p.29)*
Rose, Sylvia *(p.189)*
Rose, Teresa *(p.180)*
Rose, Wendy *(p.119)*
Rose-Smith, Gillian *(p.39)*
Rosemary, Margaret *(p.160)*
Rosenbaum, Linda Ann *(p.203)*
Rosenfeld, Angela *(p.160)*
Rosenthal, Hat A *(p.160)*
Rosenthall, Joanna *(p.98)*
Ross, Alistair *(p.81)*
Ross, Julie *(p.54)*
Ross, Maureen *(p.81)*
Ross, Michael Killoran *(p.153)*
Ross, Susan M. *(p.39)*
Ross, Suzanne *(p.140)*
Rosseter, Bill *(p.11)*
Rossotti, Nicole *(p.45)*
Rotas, Joanna *(p.26)*
Roth, Jenner *(p.81)*
Roth, Priscilla *(p.98)*
Roth, Ruth *(p.98)*
Rouhifar, Zhila *(p.140)*
Routledge, Derek *(p.185)*
Rowan, Alan* *(p.81)*
Rowan, Chris *(p.196)*
Rowan, John *(p.65)*
Rowe, Celly *(p.196)*
Rowe, Dorothy *(p.82)*
Rowe, Jill *(p.5)*
Rowland, Catherine *(p.151)*
Rowland, Gail *(p.51)*
Rowlands, Helen *(p.185)*
Roy, Geraldine *(p.189)*
Roy, Jane *(p.11)*
Royle, Anthony *(p.98)*
Roys, Clare *(p.190)*
Royston, Robin *(p.51)*
Rozenberg, Rosette *(p.82)*
Rubie, Val *(p.29)*
Ruddell, Peter *(p.109)*
Rugeley, Brenda *(p.33)*
Ruggieri, Gloria *(p.151)*
Ruismaki, Marjo *(p.198)*
Rumney, Boris* *(p.109)*
Rund, Malcolm *(p.82)*
Rusbridger, Richard *(p.98)*
Ruscombe-King, Gillie *(p.151)*
Rushforth, Catherine *(p.109)*

Russell, Doug (p.142)
Russell, Gillean (p.57)
Russell, Julian (p.98)
Russell, Margo (p.203)
Russell, Marion (p.82)
Russell, Tina (p.51)
Russell, Wilson J (p.155)
Rustin, Margaret (p.98)
Rutherford, Penny Anne (p.140)
Ryall, Sue (p.5)
Ryan, Angella M.J. (p.204)
Ryan, Elizabeth (p.151)
Ryan, Frank (p.128)
Ryan, Jane (p.82)
Ryan, Joanna (p.82)
Ryan, Mairead (p.201)
Ryan, Tom (p.82)
Ryburn, Murray (p.202)
Ryde, Judy (p.5)
Ryde, Julia (p.82)
Ryley, Brigitte (p.109)
Ryz, Patsy (p.82)

S

Saabor, Geraldine (p.61)
Sabayinda, Michael (p.33)
Sabbadini, Andrea (p.82)
Sachs, Adah (p.98)
Sackett, Kate (p.35)
Sadgrove, Jenny (p.160)
Sage, Nigel A. (p.172)
Sagoe, Pauline (p.172)
Salamander, Jas Ananda (p.178)
Salisbury, Jonathan (p.147)
Salles, Miriam (p.82)
Salmon, Cindy (p.33)
Salmon, Gillian (p.109)
Salole, Roy (p.198)
Salter, Audrey J (p.136)
Salter, Gill (p.39)
Salters, Diane (p.203)
Saltiel, Adam (p.82)
Samson, Andre (p.198)
Samson, Anne (p.186)
Samuels, Andrew (p.82)
Sandbank, Audrey (p.172)
Sandelson, Jennifer (p.65)
Sanders, Gill (p.128)
Sanders, Harmen (p.202)
Sanders, Jane (p.162)
Sanders, Peter (p.178)
Sanders, Susie (p.119)
Sangamithra U.D. (p.123)
Saroff, Rahel (p.172)
Sarra, Nicholas (p.26)
Saunders, Sonia (p.98)
Savage, Patrick (p.136)
Savage, Peter J.D. (p.54)
Saville, Sue (p.82)
Savins, Charlotte (p.178)
Sawers, Martin (p.5)
Sawyer, Albert (p.133)
Sawyer, Ken (p.152)
Sawyerr, Alice (p.98)
Sayers, Jacqui (p.5)
Sayyah, Shahrzad (p.119)
Sazatzoglou-Hitzos, M. (p.199)
Scanlan, Celia (p.157)
Scanlon, Chris (p.172)

Scarlett, Jean (p.98)
Schaedel, Maggie (p.51)
Schaffer, Tom (p.109)
Schaffer-Fielding, Wendy (p.82)
Schaible, Monika (p.128)
Schatzman, Morton (p.98)
Schaverien, Joy (p.57)
Schembri, Veronica (p.39)
Schiemann, Margot (p.99)
Schild, Maureen (p.99)
Schimmelschmidt, Michael (p.82)
Schmidt, Martin (p.109)
Schmidt-Neven, Ruth (p.197)
Schmitt-Castilla, Maria (p.99)
Schneider, Caroline (p.26)
Schneider, Evelyne (p.99)
Schnurmann, Anneliese (p.99)
Schoenfeld, Hilde (p.99)
Schofield, Lynn-Ella (p.119)
Scholefield, Miranda (p.162)
Schonfield, Tamar (p.82)
Schreiber, Kaye (p.33)
Schreiber-Kounine, Christa (p.5)
Schröder, Thomas (p.23)
Schwartz, Joe (p.99)
Scott Combes, Jacqueline (p.58)
Scott Hayward, Anna (p.26)
Scott, Brigitte (p.39)
Scott, Catherine (p.54)
Scott, Glenys (p.15)
Scott, Jan (p.157)
Scott, Janice (p.128)
Scott, Judy (p.162)
Scott, Liz (p.180)
Scott, Michael (p.136)
Scott, Michael (p.33)
Scott, Tricia (p.65)
Scott-Chinnery, Jean (p.172)
Scott-Mccarthy, Brian (p.201)
Scovell, Janet (p.9)
Scovell, Michael (p.162)
Searle, Yvonne (p.15)
Secrett, David (p.178)
Segal, Barbara (p.61)
Seglow, Ruth M. (p.61)
Seigal, Anthony (p.109)
Seigal, Elizabeth (p.35)
Selby, Anne (p.5)
Selby, Gina (p.9)
Selby, Marilyn (p.82)
Seligman, Philippa (p.185)
Sell, Patrick (p.128)
Sellers, Duncan (p.178)
Selwyn, Ruth (p.99)
Sengun, Seda (p.99)
Senior, Maggie (p.147)
Sepping, Paul (p.29)
Serfaty, Marc A. (p.82)
Serieys, Nicholas Michael (p.23)
Serpell, Vivienne (p.15)
Seu, Irene Bruna (p.99)
Sever, Michael (p.20)
Sevitt, Michael (p.172)
Sexton, Janette G. (p.18)
Sexton, Sylvia (p.147)
Seymour Clark, Vivienne (p.26)
Seymour, Charlotte (p.82)
Seymour, E. John (p.39)

Seymour, Eileen Watkins (p.99)
Shaban, Dervishe (p.82)
Shadbolt, Carole (p.151)
Shapiro, Adella (p.82)
Shapiro, Philip (p.172)
Sharifi, Pury (p.82)
Sharman, Geoffrey (p.128)
Sharman, Juliet (p.128)
Sharp, Belinda (p.82)
Sharpe, John (p.191)
Sharpe, Meg (p.128)
Sharpe, Rob (p.147)
Sharpe, Tracey (p.51)
Sharples, Geraldine M (p.133)
Shaw, Annie (p.35)
Shaw, Elizabeth (p.82)
Shaw, Maureen (p.51)
Shaw, Robert (p.23)
Shaw, Sue (p.151)
Shawe-Taylor, Metka (p.172)
Sheard, Tim (p.5)
Shearer, Ann (p.99)
Shearer, Annette (p.157)
Shearman, Christine (p.66)
Sheehan, Margaret (p.109)
Sheehan, Nuala (p.6)
Sheldon, Brian (p.26)
Sheldon, Helen (p.54)
Shelley, Trevor (p.40)
Sheppard Fidler, Angela (p.172)
Sheridan, Dolores (p.129)
Sheriffs, Alison (p.157)
Sherlock, Teresa (p.61)
Sherman, Arthur (p.99)
Sherno, Peggy (p.45)
Sherriff, Deanne (p.109)
Sherwin-White, Sue (p.129)
Shetland, Ilrich (p.66)
Shetty, Grish Chander (p.142)
Shewan, Alistair (p.155)
Shewan, Doreen (p.151)
Shields, Ellen Attracta (p.201)
Shifrin-Emanuel, Beverley (p.119)
Shipton, Geraldine (p.160)
Shipton, Sunita (p.129)
Shivakumar, H. (p.99)
Shmukler, Diana (p.99)
Shooter, Lesley (p.33)
Shore, Barbara (p.41)
Shorrock, Andrew (p.109)
Short, Deborah (p.147)
Short, Nigel Patrick (p.178)
Short, Patricia (p.9)
Shortall, Thomas R. (p.140)
Shorter, Bani (p.155)
Shreeves, Rosa (p.129)
Shrimpton, David W (p.33)
Shrubsole, Lindsay (p.181)
Shuen, Dorcas (p.199)
Shulman, Graham (p.61)
Shuttleworth, Alan (p.66)
Shuttleworth, Judy (p.140)
Sibley, Susan (p.155)
Sichel, David (p.129)
Siddle, Ronald (p.133)
Sidey, Brian (p.196)
Sidhu, Frankie (p.178)
Sidoli, Mara (p.204)

Siederer, Carol (p.109)
Sieroda, Helen (p.26)
Signora, Susanna Jamila (p.129)
Sills, Charlotte (p.129)
Sills, Franklyn (p.26)
Sills, Maura (p.26)
Silmon, Mary (p.35)
Silver-Leigh, Vivienne (p.119)
Silverman, Carl M. (p.99)
Silvester, Keith (p.99)
Sim, Camilla (p.129)
Simmonds, Tina (p.99)
Simmons, Alison (p.6)
Simmons, Gloria (p.83)
Simmons, Linda (p.172)
Simon, Dave (p.46)
Simon, Gail (p.196)
Simos, Gregoris (p.199)
Simpson, Elaine (p.185)
Simpson, Elizabeth (p.186)
Simpson, Ian (p.119)
Simpson, Kevin J. (p.21)
Simpson, Michael J A (p.15)
Simpson, Richard (p.99)
Simpson, Steve (p.129)
Sinason, Valerie (p.99)
Sinclair, Alison (p.15)
Sinclair, Fiona (p.15)
Siney, Sky (p.99)
Singer, Daniela (p.99)
Singer, Iris (p.140)
Singh, Satwant (p.83)
Singleton, Kryrin (p.16)
Sipos-Sarhandi, Zsuzsa (p.61)
Siret, Eiran R (p.109)
Sister Catherine (p.125)
Sizikova, Tanya (p.202)
Skailes, Claire (p.35)
Skeet, Maggie (p.27)
Skegg, Roz (p.180)
Skinner, Charmian (p.129)
Skynner, Robin (p.83)
Sladden, Anna (p.45)
Slade, John (p.66)
Slade, Laurie* (p.129)
Slater, Joan (p.140)
Slattery, David (p.6)
Sless, Deborah (p.99)
Smail, Richard (p.119)
Smalley, John (p.196)
Smallwood, Imogen (p.119)
Smart, Kate (p.153)
Smart, Tanya (p.66)
Smith, Alica (p.153)
Smith, Alison (p.99)
Smith, Anne (p.119)
Smith, Cora (p.203)
Smith, David (p.23)
Smith, David L. (p.109)
Smith, Donna (p.6)
Smith, Eileen F. (p.193)
Smith, Eva (p.151)
Smith, Flo M.F. (p.136)
Smith, Ged (p.51)
Smith, Gerrilyn (p.66)
Smith, Gerry (p.155)
Smith, Gill (p.6)
Smith, Gillian (p.15)

Smith, H Judith (p.129)
Smith, Hilary Frances (p.6)
Smith, Janet M. (p.23)
Smith, Jonathan (p.129)
Smith, Jonathan (p.83)
Smith, Maggie (p.83)
Smith, Margaret E (p.136)
Smith, Nora (p.155)
Smith, Paola Valerio (p.109)
Smith, Patsy (p.129)
Smith, Peter (p.40)
Smith, R.L (p.109)
Smith, Richard (p.33)
Smith, Robert (p.186)
Smith, Ruthie (p.109)
Smith, Susan Diane (p.51)
Smith, Trevor E.L. (p.109)
Smith, Val (p.160)
Smolira, David (p.119)
Smosarski, Lizzie (p.83)
Smyly, Penelope (p.119)
Snow, Randa (p.119)
Snowden, Patricia (p.172)
Soderstrom, Anne-Charlotte
 (p.198)
Solemani, Hannah (p.83)
Solomon, Hester Mcfarland
 (p.100)
Soloway, Clare (p.83)
Somers, Barbara (p.129)
Somerville, Gwynnedd (p.66)
Sones, Joanne (p.29)
Sones, Michael (p.29)
Sorensen, Pamela (p.204)
Soth, Michael (p.151)
Soutar, Sarah (p.178)
Southgate, John (p.100)
Southwell, Clover (p.129)
Spalding, John (p.52)
Sparkes, Frances (p.151)
Sparks, Rebecca (p.52)
Spearman, Penny (p.180)
Specterman, Liz (p.100)
Speed, Bebe (p.151)
Spence, Mary (p.83)
Spenceley, Dave (p.196)
Spencer, Janet (p.119)
Spencer, Margaret (p.161)
Spendelow, Lyndsay (p.66)
Spender, Quentin (p.172)
Speyer, Josefine (p.100)
Spicer, Janet (p.140)
Spicer, Robert (p.147)
Spilios, Joanne (p.151)
Spinelli, Ernesto (p.110)
Spitz, Shirley (p.129)
Spitzer, Shayne (p.83)
Sprague, Ken (p.27)
Sprajc-Bilen, Mirjana (p.198)
Spratt, Graham S. (p.54)
Sprent, Sue (p.21)
Sprince, Jenny (p.143)
Springford, Kate (p.178)
Sproston, Suzanne (p.6)
Sproul-Bolton, Robin (p.45)
Spurgeon, Richard (p.27)
Spurling, Laurence (p.100)
Spy, Terri (p.119)

Spyer, Natalie (p.100)
Spyropoulos, Nick (p.45)
Squires, Brenda (p.83)
Stableford, Joyce (p.33)
Stacey, Linda (p.45)
Stacey, Ralph (p.83)
Stacey-Ong, Lesley (p.33)
Stadlen, Anthony (p.100)
Stafford, Amanda (p.181)
Staines, Jill (p.147)
Stallard, Paul (p.6)
Stalmeisters, Dzintra (p.147)
Stanbury, Christine (p.21)
Standart, Sally (p.181)
Standen, Ruth (p.40)
Standish, Elizabeth (p.152)
Stang, Pamela (p.129)
Stanton, Martin (p.110)
Stanwood, Frederick (p.40)
Stark, Lynda (p.153)
Stathers, John (p.27)
Staunton-Soth, Theresa (p.152)
Steeds, Leila (p.129)
Steel, Marion (p.110)
Steel, Patricia (p.33)
Steel, Sandra (p.45)
Steele, Miriam (p.100)
Steffens, Dorothee (p.119)
Stehle, Peter (p.178)
Stein, Nathan Bernard (p.133)
Stein, Yvonne (p.83)
Steiner, Monika Celebi (p.11)
Steinmann, Christina (p.204)
Stephens, June (p.147)
Stephens, Lyn (p.35)
Stephenson, Keri P (p.196)
Stern, Julian (p.66)
Stern, Michele (p.41)
Sternberg, Janine (p.100)
Steven, David B. (p.155)
Stevens, Ann Penberthy (p.83)
Stevens, Christine (p.147)
Stevens, Jean (p.182)
Stevens, Jill (p.201)
Stevens, Penny (p.143)
Stevens, Yvonne J (p.6)
Stevenson, Alice (p.52)
Stevenson, Beaumont (p.152)
Stevenson, Bruce (p.100)
Stevenson, Kate (p.83)
Stevenson, Krystyna (p.83)
Steverson, Jill (p.52)
Steward, Jill (p.152)
Stewart, Henry B. (p.153)
Stewart, Ian (p.147)
Stewart, John A (p.100)
Stewart, June (p.136)
Stewart, Kate (p.196)
Stewart, Lindsey (p.27)
Stewart, Lisa (p.172)
Stewart, Naomi (p.57)
Stewart, Phil (p.196)
Steyn, Angela (p.100)
Stiasny, Jennifer (p.66)
Still, Arthur (p.153)
Stimpson, Quentin (p.40)
Stobezki, Yael (p.100)
Stockley, Rosalind (p.140)

Stocks, Samantha (p.153)
Stogdon, Mark (p.83)
Stokeld, Alasdair (p.196)
Stokes, Fergus (p.54)
Stokes, Jean (p.119)
Stokes, Jenny (p.189)
Stolear, Meir (p.45)
Stolte, Eva (p.40)
Stone, Anthony (p.100)
Stone, Martin (p.100)
Stone, Miriam (p.100)
Stone, Sandra (p.100)
Stones, Christine (p.6)
Stopher, Andy (p.110)
Storring, Susan (p.140)
Stott, Nicki (p.189)
Stovell, Joy (p.45)
Stracey, Amarilla (p.119)
Straker, Gill (p.203)
Strang, Jenny (p.57)
Strang, Susi (p.19)
Strasser, Alison (p.197)
Strasser, Freddie (p.100)
Stratford, Jacqueline Anne (p.6)
Stratton, Peter M (p.196)
Stratton-Woodward, Sally (p.15)
Street, Eddy (p.185)
Streeter, Elaine (p.178)
Strich, Sabina (p.152)
Strickland, Lynda (p.110)
Struthers, Cassandra (p.119)
Struthers, Morag (p.157)
Stuart, Gillian (p.83)
Stuart, Lilly H. (p.110)
Stunden, Patricia (p.27)
Styles, Heather (p.15)
Sucher, Ingerborg (p.33)
Sudbury, John (p.54)
Sullivan, Anita (p.100)
Sullivan, Christopher (p.100)
Sullivan, E. Mary (p.157)
Sullivan, Gerry* (p.100)
Summer, Jennifer (p.83)
Summers, Graeme (p.54)
Sunderland, Margot (p.83)
Sungur, Mehmet Z (p.204)
Sünkel, Sue (p.83)
Suss, Lawrence (p.178)
Sussman, Susan (p.140)
Sutherland, Elisabeth (p.66)
Sutherland, Janet (p.58)
Sutherland, Robert I. (p.140)
Sutters, Amabel (p.100)
Sutton, Adrian (p.133)
Sutton, Bobbie (p.172)
Sutton-Smith, Deirdre (p.6)
Sveinsdottir, Bjorg (p.83)
Swallow, Joan (p.27)
Swallow, Reynold (p.27)
Swan Parente, Alison (p.147)
Swan, John S. (p.153)
Swatton, Richard (p.119)
Sweet, Patricia (p.8)
Swift, Joanna (p.140)
Swift, Sue (p.198)
Swinburne, Barbara C. (p.140)
Swinden, Penni (p.40)
Swinfield, Ray (p.27)

Swynnerton, Richard (p.83)
Sykes, Ann (p.172)
Sykes, Kathleen (p.133)
Sykes, Margaret (p.191)
Syme, Gabrielle (p.196)
Symes, Jan (p.40)
Syrett, Karin (p.129)
Syz, Ann (p.100)
Szary, Gerard (p.19)
Szymanska, Kasia (Y.L.C) (p.129)

T

Tabak, Carolyn (p.172)
Tague, Jackie (p.45)
Tait, Adrian (p.162)
Tait, Mike (p.61)
Tajet-Foxell, Britt (p.119)
Tandy (Pilbrow), Alannah (p.120)
Tanguay, Daniel (p.120)
Tanna, Nick (p.196)
Tanner, Claire (p.110)
Tantam, Digby (p.160)
Tapang, Peter (p.33)
Tarkow-Reinisch, Lili (p.129)
Tarsh, Helen (p.172)
Tatham, Alan (p.133)
Tatham, Peter (p.27)
Taube, Idonea (p.101)
Taussig, Hanna (p.15)
Taussig, Maggie (p.120)
Taylor, Alan (p.83)
Taylor, Crispin (p.27)
Taylor, Elizabeth (p.55)
Taylor, Harvey (p.84)
Taylor, Helen (p.27)
Taylor, Jackie (p.120)
Taylor, James (p.196)
Taylor, Jane (p.120)
Taylor, Jill (p.141)
Taylor, Jon (p.23)
Taylor, Marsha (p.101)
Taylor, Mary (p.101)
Taylor, Mary (p.66)
Taylor, Maureen (p.141)
Taylor, Patsy (p.136)
Taylor, Rosemary E.B. (p.198)
Taylor, Sajada Katalin (p.129)
Taylor, Sheena (p.66)
Taylor, Susan (p.27)
Taylor, Susie (p.152)
Taylor, Theresa (p.55)
Taylor, Vivienne (p.189)
Taylor-Brook, Delia (p.152)
Taylor-Thomas, Caroline (p.101)
Telders, Martina (p.185)
Tempest, Jeanette (p.33)
Teng, Christina (p.33)
Tennant, Duncan (p.157)
Testa, Rita (p.101)
Thacker, Rose (p.19)
Thackray, Dayle (p.129)
Tham, Anna (p.191)
Thiel, Geoffrey (p.45)
Thoburn, Marjorie (p.19)
Tholstrup, Margaret (p.120)
Thomas, Alyss (p.27)
Thomas, Carmel (p.141)
Thomas, Graham (p.129)
Thomas, Jennifer (p.180)

Thomas, Jenny *(p.185)*
Thomas, Kerry *(p.130)*
Thomas, Madeleine *(p.163)*
Thomas, Marcia *(p.120)*
Thomas, Mark *(p.84)*
Thomas, Penny *(p.35)*
Thomas, Sandra V.M. *(p.19)*
Thomason, June *(p.52)*
Thompson, Christine *(p.198)*
Thompson, Fiona *(p.40)*
Thompson, Hilary *(p.191)*
Thompson, Jean Mary *(p.148)*
Thompson, Jeanette *(p.23)*
Thompson, Joan *(p.33)*
Thompson, Patricia *(p.152)*
Thomson, Alan *(p.58)*
Thomson, Jean *(p.101)*
Thomson, Pat *(p.160)*
Thomson, Simon *(p.152)*
Thorley, Helen *(p.161)*
Thorman, Chris *(p.45)*
Thorndycraft, Bill *(p.141)*
Thornley, John *(p.57)*
Thornton, Suzanne *(p.173)*
Thorp, Terry *(p.201)*
Thorpe, C *(p.130)*
Thorpe, Ivan *(p.180)*
Tibbetts, Coral *(p.84)*
Ticktin, Stephen *(p.198)*
Tidy, Deirdre *(p.45)*
Tierney, Sue *(p.178)*
Till, Patricia *(p.52)*
Tillett, Penny *(p.84)*
Tilley, Alison *(p.27)*
Tilney, Anthony *(p.189)*
Timmann, S.P *(p.45)*
Tjepkema, Froukje *(p.202)*
Tod, Ian *(p.22)*
Todd, Gillian *(p.15)*
Todd, Janet *(p.120)*
Todd, Margaret C *(p.160)*
Togher, Margaret *(p.66)*
Tolchard, Barry *(p.198)*
Tollan, John H *(p.153)*
Tomkinson, John S *(p.21)*
Tomlin, Minoo *(p.173)*
Tomlin, Patrick *(p.66)*
Tomlinson, Andy *(p.29)*
Tomlinson, Moya *(p.178)*
Tompkins, Penny *(p.84)*
Tompkins, Susan E *(p.45)*
Toms, David A. *(p.148)*
Toms, Moira *(p.173)*
Tomsett, Jean *(p.185)*
Toole, Stuart *(p.189)*
Topliss, Nick *(p.110)*
Totman, Maria *(p.52)*
Toubkin, Rita *(p.101)*
Tough, Harry *(p.143)*
Touton-Victor, Patricia *(p.101)*
Towers, Cathy *(p.27)*
Townend, Michael *(p.189)*
Townley, Judy Rifkin *(p.101)*
Townsend, Anne *(p.120)*
Townsend, Heather *(p.15)*
Townsend, Pat *(p.196)*
Towse, Esme *(p.133)*
Toye, Janet *(p.178)*

Toyne, Joy K. *(p.52)*
Tracy, Colin *(p.29)*
Tranter, Paul *(p.136)*
Travis, Mary *(p.6)*
Trayling, Laurie *(p.52)*
Traynor, Barbara *(p.141)*
Tregear, Barbara *(p.15)*
Trelfa, Joanne *(p.27)*
Trepka, Chris *(p.196)*
Trevatt, David *(p.61)*
Trewhella, John *(p.21)*
Trippett, Marie *(p.181)*
Tristram, Sue *(p.66)*
Trodden, Ian *(p.8)*
Trosh, Joanna *(p.33)*
Truckle, Brian *(p.189)*
Truckle, Shirley *(p.189)*
Truscott, Frances *(p.52)*
Trustam, Gillian *(p.8)*
Tse, Claude *(p.52)*
Tubbs, I.A. *(p.52)*
Tuby, Molly *(p.120)*
Tucker, Joanna *(p.152)*
Tudor, Keith *(p.160)*
Tugendhat, Julia *(p.130)*
Tune, David *(p.33)*
Tunwell, Ann *(p.19)*
Turkie, Janine *(p.101)*
Turkington, Douglas *(p.182)*
Turner, Annie *(p.120)*
Turner, Carole *(p.203)*
Turner, Diana *(p.33)*
Turner, Martin S. *(p.157)*
Turner, Mary *(p.191)*
Turner, Philip *(p.41)*
Turner, Senga *(p.157)*
Turner, Vivien *(p.199)*
Turton, Mike *(p.55)*
Tute, Iris *(p.6)*
Tutton, Catherine *(p.84)*
Tweed, Mary *(p.193)*
Twelvetrees, Heidy *(p.52)*
Twist, Graham *(p.57)*
Tyrrell, Susannah *(p.61)*
Tyson, Robert *(p.193)*

U

Unsworth, Gisela *(p.173)*
Urban, Elizabeth *(p.101)*
Urquhart, Peta A *(p.46)*
Urry, Amy *(p.27)*
Urwin, Catherine *(p.66)*
Usiskin, Judith *(p.84)*
Utting, Julia *(p.84)*

V

Vaciago Smith, Marta *(p.196)*
Vaizey, Philippa *(p.165)*
Valentine, Christine *(p.6)*
Valentine, Marguerite *(p.84)*
Valentine, Victoria *(p.84)*
Vallance, Fiona *(p.189)*
Vallely, Patricia M. *(p.178)*
Vallins, Yvonne *(p.173)*
Van Beek, Ingrid *(p.202)*
Van Der Eijk, Mike *(p.143)*
Van Der Wateren, *(p.130)*
Van Deurzen, Emmy *(p.160)*
Van Gogh, Mark *(p.84)*

Van Halm, Corrie *(p.178)*
Van Heel, Carlien *(p.101)*
Van Heeswyk, Paul *(p.120)*
Van Marle, Susanna J *(p.189)*
Van Rossum, Diederik *(p.202)*
Van-Loo, Douglas *(p.52)*
Vannen-Hyland, Joan *(p.55)*
Vas Dias, Susan *(p.66)*
Vastardis, Gethsimani *(p.84)*
Veale, Maurice *(p.84)*
Veasey, Helen *(p.173)*
Veje, Margit *(p.198)*
Velarde, Dominique *(p.178)*
Veling, Rolf *(p.84)*
Vella, Norman *(p.101)*
Venki, Malathi *(p.29)*
Ventham, Brian *(p.141)*
Verduyn, Christine M. *(p.133)*
Vernon, Olabisi *(p.27)*
Vernon, Paul *(p.84)*
Vetere, Arlene *(p.101)*
Vibert, Eva *(p.61)*
Vick, Philippa *(p.61)*
Vickers, Salley* *(p.141)*
Victory, Sian *(p.148)*
Villia-Gosling, Athina *(p.189)*
Vincent, Christopher *(p.9)*
Vincent, David *(p.66)*
Vincent, Jane *(p.196)*
Vine, Francis *(p.6)*
Vine, Mike *(p.45)*
Viney, Linda *(p.198)*
Virgo, Leslie Canon *(p.52)*
Virtanen, Helena *(p.66)*
Voelcker, Cara *(p.191)*
Voikhanskaya, Marina* *(p.15)*
Vollans, Audrey *(p.173)*
Von Britzke, Michaela *(p.130)*
Von Bühler, José *(p.9)*
Von Uexkull, Maxine *(p.185)*
Vora, Valerie *(p.55)*
Voss, Tony *(p.163)*

W

Wach, Karin Marie *(p.110)*
Waddell, Margot *(p.84)*
Wadland, Liz *(p.141)*
Wagstaff, Susan *(p.9)*
Wainwright, Claire *(p.120)*
Wainwright, Richard *(p.120)*
Walby, Jane Kathryn *(p.101)*
Walford, Jane *(p.196)*
Walford, Robin *(p.196)*
Walker, Anne *(p.142)*
Walker, Catriona Jane *(p.57)*
Walker, David *(p.52)*
Walker, Dawn *(p.197)*
Walker, George *(p.6)*
Walker, Jillian *(p.45)*
Walker, Jim *(p.180)*
Walker, Mary J. *(p.173)*
Walker, Moira *(p.57)*
Walker, Rosalind *(p.180)*
Walker, Steven *(p.33)*
Wallace, Daphne *(p.55)*
Wallace, Norma *(p.173)*
Wallace-Smith, Nigel *(p.29)*
Waller, Charlotte *(p.130)*
Waller, Diane E *(p.178)*

Walline, Sandra *(p.120)*
Wallis, Valerie A *(p.58)*
Wallstein, Richard S *(p.130)*
Walrond-Skinner, Sue *(p.120)*
Walsh, Aine (Anne) *(p.120)*
Walsh, Belinda *(p.23)*
Walsh, Carys *(p.110)*
Walsh, Deirdre *(p.201)*
Walsh, Eileen *(p.130)*
Walsh, Stuart *(p.55)*
Walton, Michael *(p.173)*
Wang, Michael *(p.46)*
Wanja Kirima, Ruth *(p.130)*
Wanless, Anna *(p.45)*
Wanless, Peter *(p.45)*
Warburton, Geoff *(p.120)*
Warburton, Kitty *(p.8)*
Ward, Barbara *(p.27)*
Ward, Carol *(p.161)*
Ward, Dawn *(p.161)*
Ward, Hilary *(p.9)*
Ward, John *(p.141)*
Ward, Joseph B *(p.197)*
Ward, Keltie A *(p.148)*
Ward, Ruth *(p.58)*
Ward, Sharron *(p.130)*
Ward, Shirley *(p.201)*
Ward, Shona *(p.35)*
Wardley, Jean *(p.110)*
Warin, Judy *(p.27)*
Warnakula, Amina Bibi *(p.34)*
Warner, Barbara *(p.130)*
Warner, Kerri *(p.6)*
Warren, Yvonne *(p.52)*
Warwick, Heather *(p.15)*
Warwick, Kate *(p.66)*
Washington, Sue *(p.55)*
Waterfield, Hilary *(p.84)*
Waterfield, Julia *(p.29)*
Waterman, Zak *(p.130)*
Waters, Kathleen *(p.110)*
Waterston, John *(p.15)*
Waterstone, Carolyn *(p.148)*
Watkins, Judy *(p.36)*
Watson, Andrea *(p.152)*
Watson, Caroline *(p.193)*
Watson, Gay *(p.27)*
Watson, Gordon *(p.120)*
Watson, James P *(p.110)*
Watson, Lindsay* *(p.101)*
Watson, Pauline *(p.21)*
Watson, Roy *(p.186)*
Watt, Ferelyth *(p.84)*
Watters, Catherine *(p.148)*
Watters, Tamara *(p.52)*
Wattis, Libby *(p.197)*
Watts, Mary *(p.61)*
Watts, Susan *(p.133)*
Way, Jean *(p.120)*
Way, Patsy *(p.110)*
Waygood, Rob *(p.152)*
Weaver, Carol *(p.15)*
Weaver, David *(p.52)*
Weaver, Ziva *(p.84)*
Webb, Ann *(p.45)*
Webb, Deborah *(p.6)*
Webb, Joan *(p.197)*
Webber, Wendy *(p.27)*

Webster, Anne (p.120)
Webster, Jeni (p.133)
Webster, Lynne (p.133)
Webster, Sarah Craven (p.29)
Wedderkopp, Abigail (p.163)
Weeks, Mark (p.23)
Weeramanthri, Tara (p.84)
Weider, Bilha (p.101)
Weight, Pam (p.186)
Weinberg, Jane (p.110)
Weinrich, Hildegard (p.101)
Weinstein, Jeremy (p.120)
Weir, Felicity (p.27)
Weisensel, Karin (p.101)
Weixel-Dixon, Karen (p.66)
Welch, Lawrence (p.197)
Welford, Enid (p.133)
Weller, Celia (p.55)
Wellings, Nigel (p.163)
Wells, Lesley (p.130)
Wells, Lindsay James (p.101)
Wells, Martin (p.6)
Wells, Peter (p.110)
Wells, Roger (p.163)
Welsh, Anne (p.34)
Welsh, Catherine (p.197)
Wenham, Jane (p.130)
Wesson, Peter M.J. (p.55)
West, Marcus (p.180)
West, Virginia (p.120)
Westcott, Bernard (p.34)
Westcott, Rosemary* (p.52)
Western, Simon (p.19)
Westland, Gill (p.16)
Westman, Stephen (p.191)
Wetherell, Jean (p.101)
Wetherill, Julie (p.19)
Whan, Michael (p.45)
Whatley, Ann (p.34)
Wheadon, Sylvia (p.28)
Wheatley, Malcolm (p.144)
Wheeler, Anne (p.182)
Wheeler, Judith (p.173)
Wheeler, Maria (p.46)
Wheeler, Meredith (p.199)
Wheeler, Sue (p.189)
Wheeley, Eleanor (p.34)
Wheeley, Shirley (p.164)
Whelan, P W A (p.28)
Wheway, John Kirti (p.6)
Whines, Jonathan (p.141)
Whitaker, Christine (p.173)
Whitby, Susan (p.84)
White, Anne (p.178)
White, Eve (p.46)
White, H. (p.120)
White, Jan (p.6)
White, Jean* (p.84)
White, Jennifer (p.178)
White, Jeremy (p.110)
White, Kate (p.101)
White, Lauren E (p.110)
White, Lela Ljiljana (p.178)
White, Nuala (p.84)
White, Ruth (p.9)
Whiteley, J. Stuart (p.173)

Whitfield, Erica (p.6)
Whitfield, Gwyn (p.61)
Whitley, Liz (p.22)
Whitmore, Diana (p.52)
Whitmore, Robert (p.133)
Whittaker, Ruth (p.165)
Whittam, Enid (p.19)
Whittle, Lorna (p.16)
Whittle, Sonia J (p.84)
Whitton, Eric (p.120)
Whitwell, John (p.36)
Whitworth, Patricia (p.57)
Whyte, Chris (p.57)
Whyte, Miranda (p.85)
Wicks, Alan (p.101)
Wicks, Carole Ann (p.19)
Widdicombe, Howard (p.173)
Widlake, Bernard C. (p.120)
Wieland, Christina (p.85)
Wieselberg, Huguette (p.85)
Wigham, Avril (p.121)
Wight, Zena J. (p.153)
Wigram, Penny (p.130)
Wilce, Gillian (p.85)
Wildash, Sheila (p.30)
Wilde, Deborah (p.16)
Wilde, Verina (p.19)
Wiles, Margaret (p.164)
Wilford, Gerti (p.173)
Wilke, Gerhard (p.101)
Wilkins, David (p.141)
Wilkinson, Heward (p.121)
Wilkinson, Kate (p.193)
Wilkinson, Mary (p.142)
Wilks, Frances (p.121)
Williams, Ann (p.40)
Williams, Averil (p.121)
Williams, Chris (p.110)
Williams, Chris (p.6)
Williams, Christopher John (p.197)
Williams, Claerwen (p.130)
Williams, Debbie Jane (p.191)
Williams, Diana (p.110)
Williams, Dorothea (p.34)
Williams, Gianna (p.102)
Williams, Gill (p.152)
Williams, Guinevere (p.155)
Williams, Gwen (p.66)
Williams, Heather (p.173)
Williams, Jane (p.55)
Williams, Jill (p.173)
Williams, Kate (p.85)
Williams, Katherine (p.40)
Williams, Nigel (p.163)
Williams, Pat (p.110)
Williams, Richard (p.193)
Williams, Ruth (p.102)
Williams, Ruth M. (p.110)
Williams, Sherly (p.57)
Williams, Steve (p.19)
Williams, Susan (p.204)
Williamson, Ian (p.61)
Willis, James (p.52)
Willis, Lynne (p.9)
Willis, Sally (p.173)

Willmott, Serena (p.85)
Willmott, Susan (p.85)
Willow, Angela (p.28)
Wills, Frank (p.7)
Wilmot, David (p.142)
Wilmot, Vivienne (p.173)
Wilson, Alexandra (p.7)
Wilson, Carol (p.85)
Wilson, Catherine (p.121)
Wilson, Fiona (p.153)
Wilson, Gillian (p.21)
Wilson, James (p.173)
Wilson, Jancis (p.28)
Wilson, Jilian (p.85)
Wilson, Jim (p.185)
Wilson, Jim (p.163)
Wilson, Llynwen (p.161)
Wilson, Mary (p.110)
Wilson, Mary (p.19)
Wilson, Maureen (p.22)
Wilson, Norman (p.121)
Wilson, Peter (p.61)
Wilson, Ronni (p.52)
Wilson, Shula (p.85)
Wilson, Teresa (p.121)
Wilson, Tom C (p.155)
Wilton, Angela (p.121)
Wiltshire, Gill (p.30)
Winder, Joy Ruth (p.46)
Winders, Suzanne (p.110)
Windle, Ruth (p.163)
Winkley, Linda (p.189)
Winship, Gary (p.85)
Winter, David (p.141)
Winter, Sophia (p.161)
Wise, Penny (p.102)
Wiseman, Anna (p.46)
Wishart, Marian (p.141)
Withers, Jacqueline M.J. (p.30)
Withers, Roberts (p.178)
Witt, John (p.7)
Wittenberg, Isca (p.102)
Woddis, Helena (p.173)
Wojciechowska, Ewa (p.193)
Wolf, Darren (p.61)
Wolf, Runa (p.197)
Wolfe, Pamela (p.141)
Wood, Christine Jones (p.148)
Wood, Jane (p.121)
Wood, Margarita (p.173)
Wood, Rob (p.85)
Wood, Sally (p.23)
Wood-Bevan, Martyn (p.165)
Woodcock, Jeremy (p.121)
Woodcock, Therese M-Y. (p.85)
Woodcraft, Paul N (p.34)
Wooder, Bernard (p.46)
Woodhead, Louise (p.85)
Wooding, Sandra (p.28)
Woodley, Ermine (p.111)
Woodman-Smith, Gillian (p.180)
Woodroffe, Roe (p.52)
Woods, Angie (p.136)
Woods, Roberts (p.102)
Woodward, Gillian (p.130)
Woodward, Jan (p.46)

Woodward, Joan (p.189)
Woodward, Nicola (p.85)
Woodward, Raie (p.136)
Woolf, Ralph (p.46)
Woolf, Tanya (p.85)
Woolfson, Myra (p.148)
Woolliscroft, Jenny (p.16)
Woolliscroft, Jessica (p.66)
Woolmer, Tim (p.173)
Wooster, Frances (p.111)
Worrall, Chrysoula* (p.85)
Worrell, Michael (p.102)
Worth, Piers (p.12)
Worthington, Anne* (p.121)
Wotton, Annette (p.30)
Wratten, Stephen (p.161)
Wren, Pauline (p.186)
Wright, Christine M.J. (p.193)
Wright, Elizabeth* (p.16)
Wright, James (p.130)
Wright, Kenneth (p.165)
Wright, Laurie Jo (p.62)
Wright, Maureen (p.28)
Wright, Shelagh (p.10)
Wright, Susanna (p.102)
Wright, W. Harry (p.152)
Wyatt, Gill (p.148)
Wylie, Kevan R. (p.161)
Wynant, Vivienne (p.85)
Wynn, Michelle (p.136)
Wynn-Parry, Charlotte (p.121)
Wyse, Gill M (p.174)
Wyse, Hymie (p.174)

Y

Yallop, Melanie (p.174)
Yapp, Robin (p.62)
Yariv, Gail (p.7)
Yass, Marion (p.102)
Yates, Helen (p.11)
Yates, Kathleen (p.157)
Yates, Tony (p.85)
Yawetz, Christine (p.130)
Yazar, Jale (p.111)
Young, Anne (p.201)
Young, Courtenay (p.157)
Young, Diana (p.12)
Young, Katherine (p.158)
Young, Margot (p.85)
Young, Raymond (p.163)
Young, Raymond (p.148)
Young, Robert M. (p.85)
Young, Sabine (p.121)
Young, Sarah (p.121)
Yusef, Dori Fatima (p.34)

Z

Zagorska, Joan Krystyna (p.121)
Zaphiriou Woods, Marie (p.102)
Zarbafi, Ali (p.130)
Zeal, Paul (p.163)
Zinkin, Hindle (p.36)
Zinovieff, Nicholas (p.130)

Organisation Membership Lists

AAPP—Association for Accredited Psychospiritual Psychotherapists

Acket Marijke
Afford Peter
Allen Cheryl
Anjali Yon
Anker Ofra
Arnold Sue
Attridge Brian
Baker Kevin
Bayley Eva
Bayley Sydney
Beecher-Moore Naona
Begg Deike
Benson Jarlath
Beresford Marie
Blomfield Valerie
Boyle Alexander
Brankin Irene
Burlington Maggie
Burns Maura
Campbell Margaret
Carnegie Deborah
Carroll Penny
Chalk Caroline
Chandler Diana
Clayton Valerie
Clough Andrea
Clover Gillian
Clyne Rachel
Connolly Christopher
Conroy Kay
Courtman Anita
Cox Miranda
Croft Janet
Cutler Jane
Deas Francis
Diepeveen Johanna Maria
Donington Laura
Donovan Marlyn
Douglas Dana
Duffell Nick
Dymond Christina
Eden Sharon
Einzig Hetty
Elliot Patricia
Elsdale Bethan
Ender Beckett
Ender Christine
Ender Dorry
England David
Evans Joan
Evans Roger
Feldberg Marilyn
Ferris Mary
Finch Auberon
Firman Judith
Flower Steven
Fox Catherine

Fox Loretta
Friedman Debbie
Gardner Sarah
Gilli Liliana
Gordon Clark Thalia
Gordon Deidre
Goss Thomas
Gracia Olga
Greatorex Christopher
Greatrex Julian
Greaves Thomas
Greenfield Frances
Gresty Julia
Grigg Roz
Groves Paramabandhu
Hamblin David
Hancock Pauline
Hanna Dorothy
Hardy Jo
Harris Anthony
Harrison Jane
Hay Patricia
Hayes Michael
Hedley Karen
Hendry Devam
Higgs Jody
Hillman Christine
Hitchman Nini
Holland Sue
Hope Francis
Howe Patricia
Hunt Maggie
Hunt Overzee Anne
Huson Richard
Jarvis Cecilia
Jensen Greta
Johnson Geoffrey
Kaldawaay Karina
Kalisch David
Kenny Brigid
Kernoff Marilyn
Kerridge Petra
Kevlin Kunderke
Kirkland Margot
Kirwin Mark
Koeppelmann Marianna
Kowalski Reinhard
Labworth Yig
Landman Angus
Legh-Smith Andrea
Lemon Marcia
Lilley Tim
Linnell Maxine
Lovendal-Sorensen Helena
Lown Judy
Lyons Kathleen
MacFadyen John
MacGregor Catherine
Maloney Sean
Mansi Susan
Manton Rosie

Marcus-Jedamzik Deena
Marling Frances
May Jo
McBurnie Dolores
McGuinness Maureen
McOstrich June
Mead Christine
Miles Fiona
Millar Gerry
Mowlan Madeleine
Nancarrow Kiya
Neill Christopher
Newson Mary
Nightingale Eileen
North Joanna
Nye Georgiana
Oliver Jenny
Oliver Rosamund
Padgett Louise
Parfitt Will
Pearman Cathy
Peart Mary
Philbin Mairead
Pickstock Keith
Pope Michael
Rand Judith Ann
Rees Ian
Reynolds Malcolm
Rhind Sue
Ridley Wendy
Rimmer Janet
Roberts Susan
Roex Danielle
Rotas Joanna
Russell Margo
Sanders Jane
Schaffer Tom
Schild Maureen
Sheriffs Alison
Sidhu Frankie
Sieroda Helen
Sills Franklyn
Sills Maura
Silvester Keith
Simmons Linda
Simpson Steve
Somers Barbara
Specterman Liz
Spurgeon Richard
Squires Brenda
Stacey Linda
Stark Lynda
Stathers John
Steinmann Christina
Steverson Jill
Stunden Patricia
Sullivan Christopher
Sutherland Elisabeth
Swinfield Ray
Tandy (Pilbrow) Alannah
Taylor Susan

Tempest Jeanette
Tham Anna
Thomas Alyss
Thompson Hilary
Todd Janet
Totman Maria
Toubkin Rita
Trelfa Joanne
van Beek Ingrid
van Rossum Diederik
Ward Barbara
Watson Gay
Webber Wendy
Welsh Anne
Whitfield Erica
Whitmore Diana
Wigham Avril
Williams Heather
Willow Angela
Wilson Jancis
Wolfe Pamela
Wooder Bernard
Wynant Vivienne

ACAT—Association of Cognitive Analytic Therapists

Ansari Shakir Shiyam
Beard Hilary
Bermingham Donald
Blunden Jane
Boa Cherry
Bristow John
Brooks Beverly
Burns-Lundgren Eva
Choudree Sangamithra U.D.
Clarke Susan Elizabeth
Cowmeadow Pauline
Crowley Valerie
Curran Annalee
Denman Chess
Dunn Mark
Eadie Yvonne
Elwell Louise
Encombe Jock
Ennis Sally-Anne
Fawkes Liz
Field John C.
Fisher Clare
Fosbury Jacqueline
Gardner Philippa
Gray Sally
Gregory Kirby
Griffiths Tina C
Harvey Linda Mary
Haupts Brigitte
Jellema Anna
Johnstone Mog
Knight Michael
Kuhn Sue

Leighton Tim
Lettington Lisa
Low James
Maple Norma Anderson
Marlowe Martin
McCormick Elizabeth Wilde
Mead Jannie
Melton Jane
Merz Juliet
Nuttall Serena
Palgrave Lesley
Parry Glenys
Pollard Cynthia
Reidy Rachel
Sackett Kate
Sharman Geoffrey
Sheard Tim
Smith Eva
Stevens Yvonne J
Tanner Claire
Turner Vivien
Twist Graham
Warin Judy
Welch Lawrence
West Virginia
Wilton Angela

ACP—Association of Child Psychotherapists

Acquarone Stella
Akinboro-Cooper Bobbie
Alhadeff Christine
Alvarez Anne
Amez Susana
Anderson Janet
Arnold Katherine
Balogh Henghes Tessa
Bandler Bellman Debbie
Baradon Tessa
Barrows Paul
Barter Ruth
Bartlett Francesca
Bellis Stella
Bender Helen
Benjamin Haydene
Bergese Rebecca
Bharucha Aiveen
Bharucha Manek P E
Blandy Evanthe M
Blundell Suzanne
Boston Mary
Bradley Catrin
Bradley Jonathan
Briggs Andrew
Britten Stewart
Britton Julia
Buckingham Linda
Buckland Richard
Campbell Donald
Cant Diana
Carling Katharine
Carlson Cynthia
Case Caroline
Cebon Ann
Cherry-Swaine Janine
Chinoy Freni
Cohen Maggie
Cohen Pauline

Cohn Nancy
Colloms Anita
Copley Beta
Coulson Susan
Cousins Jan
Crawford George
Cregeen Simon
Crick Verena
Crockatt Gabrielle
Cullinan Deborah
Dale Francis
Davids Jennifer
Daws Dilys
Dawson Linda
Domb Yair
Dowling Deirdre
Dresner Ora
Dubinsky Alexandre
Dubinsky Helene
Duffy Rosemary
Duguid Kathleen
Eccles Barbara
Edgcumbe Rose
Edwards Judith
Eichelberger Cleese Alyce Faye
Elkan Judith
Elliott Victoria
Ellwood Jane
Emanuel Louise
Emanuel Ricky
Essenhigh Caroline
Evans Peter L.
Feldman Wendy
Fleming Robert W.K.
Gavshon Audrey
George Elizabeth
Golden Ellen
Goodchild Margaret
Grainger Eve
Green Viviane
Grunberg Sheena
Guest Nicola
Gurion Michal
Hadary Gideon
Halton William
Hamilton Victoria
Hanson Carol
Harari Michael
Harris Nina
Hart Carolyn
Hartnup Trevor
Harvey Tricia A.
Heath Christine
Helm Caroline
Henderson John
Henry Rachel M.
Hering-Josefowitz Pauline
Hermon Deborah
Herrmann Joan
High Helen
Hilder Alison
Hindle Deborah
Hodges Jill
Holland Louise
Horne Ann
Hughes Carol
Hughes Margaret
Hunter Margaret
Hurry Anne

Hurst Margaret
Ironside Lesley
Jacobs Joe
Jarvis Charlotte
Judd Dorothy
Kegerreis Susan
Kenrick Jennifer
Kenwood Pat
Kerbekian Rosalie
Kohon Valli
Lanyado Monica
Laport-Steuerman M.
Layiou-Lignos Effie
Layton Sandy
Lillitos Aleathea G.
Lisman-Pieczanski N.M.
Loose Judith Green
Loret de Mola Maria
Loxterkamp Lorne
Luciani Dorothy
Lyon Martin
Mack Smith Catharine
Magagna Jeanne
Maltby Jane
Martin Christine
Martin Stephen
Mazliach Yaron
McCann Anita
McCartney Meryl
McCutcheon Moira
Meleagrou-Dixon Mando
Mendelsohn Annette
Mikardo Julia
Millar David
Miller Jill M
Miller Lisa
Miller Sheila
Miroslava Ross
Model Elizabeth
Mondadori Roberta
Montalbetti M.L.
Morice Lisa
Morice Michael
Mostaeddi Bahman
Nagle Robin
Netzer-Stein Antje
Ngah Zah
Norsa Giuliana
Oclander Goldie Silvia
Oliver-Bellasis Elizabeth
Orford Eileen
Parker Niki
Parsons Marianne
Passey Miranda
Pecotic Branka
Penwarden Mary M.
Phillips Adam
Phillips Asha
Philps Janet
Pick Rachel
Piontelli Alessandra
Porter Christine
Power Teresa
Pozzi Maria E.
Preston Janet
Proner Karen
Radford Patricia
Ramsden Sandra
Rance Sarah

Rees Susan
Regan Jones Columba
Reid Marguerite
Reid Susan
Renton Mirjana
Ricketts Susan
Robinson J.G.
Robinson Marlene
Ross Miroslava
Rotenberg Claudio
Roth Priscilla
Rusbridger Richard
Rustin Margaret
Ryz Patsy
Sazatzoglou-Hitzos M.
Schaffer-Fielding Wendy
Schmidt-Neven Ruth
Schnurmann Anneliese
Segal Barbara
Seglow Ruth M.
Selwyn Ruth
Shapiro Philip
Sherwin-White Sue
Shifrin-Emanuel Beverley
Shine Sharon
Shulman Graham
Shuttleworth Alan
Shuttleworth Judy
Sibley Susan
Sidoli Mara
Sinason Valerie
Sobat Milica
Sones Joanne
Sones Michael
Sorensen Pamela
Sprince Jenny
Spyropoulos Nick
Steele Miriam
Stern Michele
Sternberg Janine
Stiasny Jennifer
Stone Sandra
Storring Susan
Swan Parente Alison
Syz Ann
Testa Rita
Townley Judy Rifkin
Trevatt David
Truckle Brian
Truckle Shirley
Truscott Frances
Urban Elizabeth
Urwin Catherine
Usiskin Judith
Vaciago Smith Marta
Van Heeswyk Paul
Vas Dias Susan
Vastardis Gethsimani
Waddell Margot
Walker Mary J.
Warwick Kate
Watson Andrea
Watt Ferelyth
Watters Catherine
Weir Felicity
Williams Gianna
Williamson Ian
Wilson Gillian
Wilson Jilian

Wilson Peter
Winkley Linda
Wittenberg Isca
Wood Margarita
Woodcock Therese M-Y.
Woodman-Smith Gillian
Woodward Nicola
Zaphiriou Woods Marie

AFT—Association for Family Therapy

Alabaster Nigel
Allan Brenda
Altschuler Jenny
Anderson Larry
Andrew Alison
Antonson Kathleen Scott
Appleton Richard Ionsdale
Ardeman Jacqueline
Atkins Lorna
Averbeck Marcus
Balmbra Steven
Barnes Hugh
Bates Helen Mary
Bazeley-White Diana
Bennun Ian
Bentley Radhe
Biggins Toby
Birch James Williams
Blow Kirsten
Booth Nick
Bott David
Bowen Barry
Bower Margaret
Brazier Anna Louise
Brinsdon Nicholas
Brough Julie
Brown Gillian A.
Bruggen Joan
Bryson Sandra
Burgess Alison
Burroughes Christopher H
Burrows Joanna
Burton Jean
Cade Brian
Carney Joanne
Challender David
Chatham Jon
Child Nick
Clark Alec
Clements Sue
Clery Cairns
Cohen Barbara
Colahan Mireille
Coldicott Tim
Cooper Janette
Corder Elizabeth
Corlando Annalisa
Cottrell David
Coulter Stephen
Cox Keith Fredrick
Crocker Allen John
Cubie Paul
Cunningham Gerry
Curti-Gialdino Francesca
Daniels Kate
Daum Minna
Davies Mairlis

Davies Michael
Davren Moira
Day Michael
De Boer Onno
Delve Stuart
Doolan Moira
Duncan Sheila
Ellis Robin Margaret
Eminson Mary
Enser Nigel
Essex Susanne
Faull Keith
Feign Cathy Tsang
Fellows Ron
Filby Erica
Forbes Constanze N
Fox Margaret
Freeman Patricia Ann
Fry Richard P.W.
Fyvel Susan
Gaskell Christine
Gauthier Jean-Baptise
Geraghty Wendy
Gerry Marian
Gillman Maureen
Gionta Ralph
Goldberg Henia
Gower Myrna
Graf Fern
Graham Hilary
Gray Elizabeth
Gray Pat
Gray Peter
Hale John
Harmsworth Peter
Hart Bruce
Hayward Mark
Heath Christine
Hendra Theresa
Hewitt Amanda
Hills John
Hodd Amanda
Honig Peter
Hudson Peter
Jack Bridget
Jamieson Eileen
Johnston Linda Ann May
Jones Maggy
Kemps Charmaine
Kilgour Joyce
King Michael
Klein Wendy
Krause Inga-Britt
Kuettner Enno
Lacey Irene
Launer John
Lazarus Myrna
Lee Denis
Lieberman Stuart
Lindsay Robert
Lister Ian Robert
Macdonald Alasdair
Manning Anthony John
Markham Angela
Markovic Olivera
Marriot Alison
Marsden-Allen Peter
Maynerd Cynthia
McCluskey Una

McNab Sue
Mendelssoh Penny
Middleton Richard
Miller Liza Bingley
Moulin Laurence
Mouratoglou Vassilis
Neden Jeanette
Neill Denis E.
Nelki Julia
Ness Thomas William
Nissim Ruth
Nuaimi Christine
O'Neill Arthur
O'Neill Thomas
O'Reilly Paul
O'Shea Deidre
Owen Mike
Palmer Marion Macintosh
Papadopoulos Renos
Parikh Prakash
Parsons Barbara
Pearse Joanna
Petkova Petia
Pitt Chris
Prestwood Christopher
Procter Harry
Quin Barbara
Raeside Dominic
Reay Ruth
Reed Alex
Rivett Mark
Robb Melissa
Roberts Phil
Robinson Sue
Roddick Mary
Roff Hermione
Roper Hall Alison
Routledge Derek
Rutherford Penny Anne
Sandbank Audrey
Savage Patrick
Sawyerr Alice
Schneider Caroline
Secrett David
Seligman Philippa
Seymour Charlotte
Sheppard Fidler Angela
Simmons Gloria
Simon Dave
Simpson Elaine
Smith Donna
Smith Ged
Smolira David
Stein Yvonne
Stewart Kate
Stratford Jacqueline Anne
Streeter Elaine
Taylor Crispin
Tennant Duncan
Toms Moira
Tomsett Jean
Tranter Paul
Urry Amy
Verduyn Christine M.
Vetere Arlene
Vine Mike
Wadland Liz
Wagstaff Susan
Walker Dawn

Walker George
Walker Rosalind
Walker Steven
Walrond-Skinner Sue
Walsh Stuart
Warner Barbara
Webster Jeni
Weeramanthri Tara
Weider Bilha
Western Simon
Whatley Ann
White Jan
Wilford Gerti
Willis Lynne
Wilmot David
Wood Sally
Wratten Stephen
Wright Shelagh
Wyse Gill M

AGIP—Association for Group and Individual Psychotherapy

Allison Lyn
Anderson Elizabeth
Ariel Seema
Astor Bronwen
Benjamin Joan E
Bloomfield Irene
Breathnach Eibhlin
Brown Sara
Caruana Charles Victor
Casson Isabel
Codd Anne Marie
Cooper Howard
Corker Enid
Corneck Susan
Cox Philip
Cross John
Cryer Valerie
Cunningham Diane J
Davies Ann
Dixon-Nuttall Rosemary
Dobbs Wendy
Doe Anthony
Ellis Sian
Flannery Jean
Francis Anne M.
Frazer Diane
Freeman Catherine
Galliers Mary
Gardiner Margaret
Good Elizabeth
Griffith John
Haine Stephen R
Hallett Caroline
Hamilton Dorothy
Hamilton Kim
Heavens Anita
Humphries Harold
Inlander Antonia
Kaplan Myron R
Kenny Angela
Kuechemann Christine
Langdon Monica
Lee Graham
Leggatt Claire
Leggatt Jenny

Lethbridge Sue
Lewis Jo-Ann
Longley Joan
Love Mollie
McKenzie-Smith Bryce
McMinnes Patricia
Mead Betty
Miller John Andrew
Miller Lynda R
Neiva Judith
Nesbit Judith
Neumann Anton
O'Callaghan Diane
O'Keeffe Tim
Phillips Laurie
Pokorny Michael R
Polden Jane
Price Annie
Ritchie Sheila
Rogers Anne
Rozenberg Rosette
Scott-McCarthy Brian
Siney Sky
Soutar Sarah
Spalding John
Stanwood Frederick
Stephens Lyn
Stolte Eva
Struthers Cassandra
Taylor Harvey
Thorpe C
Trustam Gillian
Ward John
Wellings Nigel
Wells Lindsay James
Wieland Christina
Wildash Sheila
Wilson Maureen
Wotton Annette

AHPP—Association of Humanistic Psychology Practitioners

Adamson Fiona
Batchelor Carol
Becker Amely
Beecher-Moore Naona
Boadella David
Bowdery Sally
Boyd Ann A
Braid Rosemary
Brock Sue
Brunt Clare
Bukovics-Heiller Birgit
Burnet-Smith Tamara
Carroll Helen
Carruthers Barbara
Christophas Sheelagh
Clarkson Petruska
Claxton Brenda
Cole Barbara
Collis Whiz
Cooper Rebecca
Copsey Nigel
Coronas Ita
Coulson Christopher J
Dargert Guy
Davies Sue

Davis Wendy
Dell Jacqueline
Dell Judith
Eiden Bernd
Ellis Michael
Fleming Peter
Frances Jane
Gale Derek
Girling Gail
Gladstone Guy
Glynn Paul
Golz Angelika
Gomez Lavinia
Graham Judith
Guest Hazel
Hart Sally
Haslam Deirdre
Hawkins Peter
Hayes Lesley
Henriques Marika
Horrocks Roger
Hughes Linda
Jacques Glenys
Jelfs Martin
Johnson-Smith Camilla
Jones Alan
Jones Dave
Jones David
Jordan Elizabeth
Kalisch David
Kennedy Kay
Keshet-Orr Judi
Kirby Alan
Kirby Babs
Kowszun Grazyna
Leder Catherine
Leon Sara
Lester Hilary
Leygraf Bernd
Linnell Maxine
Lude Jochen
Luthy Barbara
March-Smith Rosie
Mellett Jane
Mitchell Richard
Morris Elizabeth
Morris Lesley Anne
Munt Stephen
Newbery Christopher
Nippoda Yuko
Noack Miké
Offer Leah
Orlans Vanja
Parker Mary
Payne Helen
Pimentel Edna
Pirani Alix
Preisinger Kristiane
Reynolds Alun
Rowan John
Rugeley Brenda
Ryde Judy
Ryley Brigitte
Salisbury Claire
Schembri Veronica
Scott Tricia
Singer Daniela
Smith Jonathan
Soloway Clare

Speyer Josefine
Spy Terri
Stewart Lindsey
Sullivan Anita
Tudor Keith
Tune David
Twelvetrees Heidy
Ward Shirley
Waterston John
Westland Gill
Whitton Eric
Wilson Ronni
Woolliscroft Jenny
Woolliscroft Jessica
Young Courtenay

AIP—The Association of Independent Psychotherapists

Cashford Jules
Cooper Cassie
Crace Gay
Dorey Mary
Everest Pauline
Gerhardt Sue
Gross Stephen
Henderson David
McKenzie-Smith Bryce
Muller Nina
Panetta-Crean Simona
Perry Ann
Shearer Ann
Sherman Arthur
Shivakumar H.
Shooter Lesley
Stadlen Anthony
Taylor Alan
Wellings Nigel
Wells Lindsay James

AJA—Association of Jungian Analysts

Adler Hella
Bamber James
Baring Anne
Bell Frances
Bierschenk John Henry
Boll Antonia
ByGott Catherine
Casement Ann
Cashford Jules
Clark Nita
Davide Adele
Doorley Damien
Duckworth Moira
Dykes Andrea
Falk Helen
Finlay Rosalind
Freeman David
French Eileen
Harrison-Mayor Susan
Heuer Gottfried
Johnson Deirdre
Maitra Begum
Mathers Dale
McCarthy Rita
McLean Julienne

McNulty Claire
Millar Peter
Miller John
Miller Juliet
Mulhern Alan
Niesser Arthur
Noack Amelie
Palmer Barnes Fiona
Robinson Martin
Royston Robin
Silverman Carl M.
Spilios Joanne
Spitzer Shayne
Stokes Jean
Stone Martin
Stuart Gillian
Syrett Karin
Travis Mary
Wainwright Richard
Williams Chris
Williams Susan
Windle Ruth

ANLP—Association for Neuro-Linguistic Programming

Adlington Jethro
Asseily Alexandra
Banks Ron
Beckett Dale
Blake Nancy
Boyden Christina
Brankin Maire
Bray Malcolm
Bray Stephen
Brion Marion
Brock Sue
Burow Birgit
Burtt Isobel Lucy
Carpenter Dave
Chamlee-Cole Laurena
Christmann Cornelia
Coleby Gillian
Daniels Frank
Deahl Kieron
Dinwoodie John
Eaton John
Eldon Martin
Elliott John
Gawler-Wright Pamela
Grayson Juliet
Gregory Mary
Hanchen Thomasz
Hill Jennifer
Hueting Margaret
Johnson Michael
Kilgour Mimi
La Tourelle Maggie
Lawley James
Leakey Peter
Lennox Graham
Levine Hanelle G
Lewis Philip J.
Linden Roger
Llewellyn Alice
Looms Suzanne
Lowe Judith
Macdonald Laurie

McDermott Ian
McDonnell Fokkina
Mills Judith
Mohan Terry
Moore Terry
Nolan Philip
Norman Harry
Pain Jean
Poole Nick
Pope Sian
Reynolds Francois
Richards Paul
Rowland Gail
Russell Julian
Scott Hayward Anna
Seymour Eileen Watkins
Sherlock Teresa
Silmon Mary
Smith Robert
Strang Susi
Szary Gerard
Thompson Joan
Tidy Deirdre
Tompkins Penny
Vine Francis
Walsh Eileen
Weight Pam
Worth Piers

ARBS—Arbours Association

Austin Neil
Austin Susan
Berke Joseph
Berry Sally
Brookes Sasha
Buckley Nicky
Burch Nigel
Cairns Mary
Cameron Anna
Cameron Roderick
Cave Prue
Dianin Gianni
Dyehouse Pat
Ehlers Hella
Eiles Clive
Elliott Lois
Fagan Margaret
Fawkes Caroline
Fisher-Norton Jane
Forti Laura
Goodes Deborah
Grant Bob
Grant Iona
Green Margaret
Greenwood John
Haberlin Jane
Hacker Roger
Hall Kirsty
Harward Matthew
Ibanez Julian
Kelly Bridget
Kelly Michael
Kleanthous Dina
Kleinot Pamela
Lanczi Katalin
Lunardon Francesco
Masoliver Chandra

Mazaraki Angeliki
McAndrew Brigitte
Montero Isabel
Navarro Trinidad
Nielsen-Cernkovich Rudy
Pavincich Lesley
Pearce George
Pericleous Christine
Perriollat Munro Elizabeth
Phillips Marianne
Pick Geoff
Pierides Stella
Powell Angela
Rabe Marie-Louise
Ravensdale Verity
Réguis Marie-Christine
Rose Sally
Rund Malcolm
Ryan Tom
Sabbadini Andrea
Saltiel Adam
Schaedel Maggie
Schatzman Morton
Schonfield Tamar
Seu Irene Bruna
Smith Peter
Solemani Hannah
Stokeld Alasdair
Sveinsdottir Bjorg
Turner Diana
Valentine Marguerite
Veje Margit
Wach Karin Marie
Waterfield Hilary
Whittle Lorna
Whittle Sonia J

BABCP—British Association for Behavioural & Cognitive Psychotherapies

Airey Gabriela
Alderton Chris
Alexander Paul T.
Allinson Mary A.
Altman Michelle
Amies Peter
Anderson Christine
Ashcroft Jennifer
Athanasiadis Loukas
Bactawar Charles D.
Baldrey Sarah
Bassam Bruce
Beach Jan D.
Beech Julie C.
Beijne Sabina
Bell Lydia J.
Bennett Gerald A.
Benson Pauline
Bhunnoo Z.
Bienkowski Geraldine
Black Nicholas J.
Blackburn Ivy-Marie
Blackburn John
Bland John
Blowers Colin M.
Bond Frank W
Bonham Elizabeth

Boyle Pauline
Brady Alec
Bright Jenifer A
Broadbent Keith
Brock Martin J
Brosan Lee
Brown Thomas M.
Burbach Frank
Burdett C.W.
Burgess Mary
Burland Roger
Bury Dennis R.
Butcher Gerard
Butler Gillian
Butler Linda
Cameron Michael John
Campbell Hedda A.
Cariapa Illana
Chalkley A.J.
Chapman Jane
Childs-Clarke Adrian
Chin John C L
Christie Marilyn
Church John
Churchill-Moss Duncan
Clancy J Patricia
Clarke Isabel
Clarke Stephen Lawrence
Clarke Susan Elizabeth
Cogan Margaret
Cohen Ruth
Coles Peter J.
Collard Patrizia C
Colson Louise
Conroy Jennifer J.
Cooper Heather
Copestake Sonja
Copley Brian
Crichton N
Cromarty Paul
Cromey Terry
Cullen Anne M.
Curwen Bernadette
Dabor Thelma
Daly Kevin
Davidson John
Davies John
Davies Stephen
Davis Brenda
Davis Paul E.
De Souza Janice
Deeble Elizabeth A.
Denford Lindsey D.
Dilks Sarah L E
Doggart Elizabeth Anne
Dolan Lesley Catherine
Dollery Jayne
Donohoe Gillian
Downes Vanessa Susan
Draper Pim
Drijver Caroline
Drummond Lynne M
Dryden Windy
Duncan E.A.S
Duncan-Grant Alec John
Dunn Katie
Dyer Ian P.
Eastham Peter
Edeleanu Andrea K

Edelmann Robert J.
Edmonstone Yvonne G.
Elliott Peter
Elliott Sandra A.
Farley Nancy M.
Farrell Derek P.
Fearns Keith
Fernandez Nigel R.
Fernandez Valentina
Finlayson Sara
Fischer Ulrich J
Fisher Linda
Fitzsimmons Michele Anne
Flanagan June D
Fokias Dene
Forsyth Angus
Fortune Rosalind
Fowler Barry
Freeman Christopher
Gabriela Airey
Garcia-Llovona Cristina M
Gardner Damian
Garvey Rachel
Gauci Kate
Gilboy Carol A.
Gillespie Kate
Gillett Timothy P.
Gillingham Michael
Gimblett Jeanne
Glaister Brian
Gordon P. Kenneth
Gournay Kevin
Grant Vera
Gray Maggie
Green Charlotte H
Greenan Maria
Greenfield Terence Aubrey
Gulcz Magdalena
Gurnani Prem D.
Hacker Hughes Jamie G.H.
Hallam Richard S
Handy S.
Hanley Ian G.
Hannigan David J.
Hardcastle Mark
Harrington Finola
Harrington Rufus
Harris Paul David Gwyn
Hart Kate
Harvey Andrew
Haveman Jolien
Hendry Evelyn R.
Herbert Claudia
Herdman Linda
Herron Stephen
Hiestand Rene
Hilling Richard
Holyoak Patricia
Hooper Molly
Houghton Judith E
Howes Kathleen Mary
Hume Anne J.A.
Huszcza Anna K.
Issa Soraya
Jakes Simon
Jenkins Dinah
Jenkins Sheila
Jezard-Clark Pam
Jiah Hildah

John Carolyn H.
Jones Christopher S
Jones Freda Anne
Jones Janet D.
Jones Rhiannon Marie
Joseph Jerome Devakumar
Kat Bernard J B
Keenan Paul Stephen
Kelly Anne
Kennedy Fiona C
Kerry Richard
Kincey John
Kinsella Philip
Kolb Peter John
Kunkler Jane
Lau Bernard Wai Kai
Lawson Ruth
Lea Mary
Lee-Evans J Michael
Lever Maria A.
Lewis Ken
Lillie Francis
Liness Sheena
Lister Patricia Anne
Livanou M.
Long Clive G.
Long Jennifer
Loumidis K
Love Patrick T
Lovell Karina
Lucas Rosemarie
Macaskill Norman D.
Macdonald Helen F.
MacGregor Alan
Macnicol Annie
Malkin Julius
Mathews Trevor J.
Matthews Helen P.
Matthews Sharon
May Adam
McAllister Christopher
McAlpine A M
McCarron Gerard
McClure John
McConnochie Charlie
McCoy Sean
McFadden Hugh E.
McFarlane Alison M.
McGoldrick Mary
McGroary-Meehan Maureen
McKay Molly
McLoughlin Brendan Nicholas
McMahon Gladeana
McMaster Catherine
Meldrum Ron
Mettam Lisa
Middlehurst Daniel
Mills Jeremy George
Mills Nigel
Milne Pamela J.E
Molleson John Ivitsky
Moloney Paul
Moore Gordon
Moorey Stirling
Morgan William
Morley Michael
Morris David
Morris Peter A.
Morrissey Shirley

Morton Richard Victor
Moutzoukis Chris
Moyes Theresa
Nadirshaw Zenobia
Nancarrow Christine
Nath Krish
Neenan Michael
Newell Adrian
Nicolson Elaine
Noyes Elizabeth
O'Brien Kirsty M G
O'Carroll Madeline
O'Carroll Pierce J.
O'Neill Helen M.
Palanisamy Shan
Palmer Lisa Elaine
Palmer Stephen
Parker Jonathan
Parrack Norma
Pattinson Philip
Peckitt R.G.
Perera Ajit
Phillips Thomas Lambton
Pittman Karen
Platts June Elizabeth
Pollitt Mo
Procter Sue
Pusztai Edit E.
Quarry Andrew
Quinn Paul
Rani R S
Reading Clive
Regel Stephen
Rice Paul
Rickard Ian
Ricketts Thomas N.
Ridgway Jane
Robinson Ferga
Robinson Peter
Rogers Lesley A.
Rose Stuart
Ross Michael Killoran
Ross Susan M.
Rouhifar Zhila
Ruddell Peter
Ryan Frank
Ryan Mairead
Sage Nigel A.
Salter Audrey J
Schreiber-Kounine Christa
Scott Jan
Scott Michael
Scott-Chinnery Jean
Serfaty Marc A.
Serieys Nicholas Michael
Sharpe Tracey
Shaw Elizabeth
Shawe-Taylor Metka
Sheldon Brian
Sherriff Deanne
Short Nigel Patrick
Shortall Thomas R.
Siddle Ronald
Simos Gregoris
Singh Satwant
Smail Richard
Smart Kate
Smith R.L
Smith Trevor E.L.

Sookdeb S.
Spratt Graham S.
Stallard Paul
Standart Sally
Stevens Penny
Stewart Henry B.
Stewart Lisa
Still Arthur
Stolear Meir
Strickland Lynda
Sungur Mehmet Z
Swan John S.
Swinburne Barbara C.
Szymanska Kasia (Y.L.C)
Tajet-Foxell Britt
Tatham Alan
Taylor Jon
Thomas Carmel
Thomas Madeleine
Till Patricia
Timmann S.P
Todd Gillian
Tolchard Barry
Toole Stuart
Townend Michael
Townsend Pat
Trepka Chris
Trippett Marie
Trosh Joanna
Tse Claude
Tubbs I.A.
Turkington Douglas
Turner Martin S.
Venki Malathi
Verduyn Christine M.
Walker Anne
Walsh Belinda
Wang Michael
Ward Carol
Wardley Jean
Watts Mary
Watts Susan
Westman Stephen
Wheeler Judith
Wight Zena J.
Wilde Verina
Williams Christopher John
Williams Debbie Jane
Williams Ruth M.
Williams Steve
Willis James
Wills Frank
Wilson Fiona
Wilson Mary
Wilson Tom C
Wiltshire Gill
Withers Jacqueline M.J.
Woodcraft Paul N
Wright Christine M.J.
Wynn Michelle
Yapp Robin
Young Katherine
Zagorska Joan Krystyna

BAP—British Association of Psychotherapists

O'Brien Maja

BAS—British Autogenic Society

Bird Jane
Buchanan Sarah-Jill
Burnet-Smith Tamara
Davidson Brian
Free-Pearce Carolyn
Greene Alice
Gross Grete
Ingham Nida
Kanji Nasim
MacKinnon Hetty
Marshall Janet
Pinch Christine
Reuvid Jennie
Tham Anna

BASRT—British Association for Sexual and Relationship Therapy

Ackroyd Rosemary
Adler Eve
Alexander Sandra
Angold Monica
Anstice Christine
Ball Derek
Barnes Tricia
Batchelor Henrietta
Beer Charmian
Beighton Chris
Berger Iris
Berry Mary
Birchard Thaddeus
Blum Anita
Boddington Daphne
Borghgraef Guy
Brewster M
Brindle Elisabeth
Brown Avril
Bryans Sally
Buckler Jackie
Burch Jean Gillanders
Burkeman Fiona
Bush Malcolm
Butcher Josie
Byng R K
Carter Paula
Clark Debra
Clegg Alison
Clements-Jewery Sue
Clifton Sandra
Collins Jane
Collis Jeffrey
Cooper Faye
Cooper Grahame F.
Cooper Penny
Crowe Michael
Cullum Sylvia
d'Ardenne Patricia
Daines Brian
De Groot Marianne
de Marquiegui Asun
Dighton Rosemary
Dodsworth Evelyn
Doogan Kevin
Duncan Sally B
Dyer Paula

Eisen Shelley
Eisler Zuzana
Emeleus Frances
English Marjorie P
Evans Gail
Evans Helen
Evans Tricia
Felix Susie
Fraser Bobbie
Gage Michael
Gann Sandra
Gibbin Jane
Glover Jean
Goldman John
Gregory Peter
Griffin Mary
Griffiths C A
Guilfoyle John Francis
Gurr Rosalie
Hallam-Jones R.A.
Harrison Caroline M
Harrison Susan
Hayes Cheyl
Headon Christopher
Helps Davina
Hendrickse Begum
Heyward Julie
Hill Brenda
Hillman Jan
Hobbs Anita
Hollingworth Amanda
House Wyn
Howarth Kay
Howlett Brian
Huish Margot
Hunt Patricia A
Hunt Susan
Huws Rhodri
Jackson Paul
Jacob Emily
Jess Carrie
Jones Caroline M
Jones Judith
Keith Joyce
Keshet-Orr Judi
Lang Christine
Law Anne M
Lawrence Elizabeth
Leygraf Bernd
Lidster Wendy
Limbardet Jean-Pierre
Lloyd Patricia
Lobel Sandra
Lobel Sidney
Logue Nancy
Loudon Julia
Low James
Malone Sue
Martin Angela
May Kathryn
McGroary-Meehan Maureen
McNaught Janet
Meller Carolyn
Mitchell Ruth
Moncur Pamela
Moore Jill
Moore Margaret C
Morgan Elizabeth A
Mulvey Josephine

Nelson Denise
O'Conor Mary
Openshaw Sally
Pacey Susan
Pallenberg Sue
Palmer Dorothy
Perrett Angelina
Perring Michael
Perry Janet
Phillips Mary
Plen Rene
Pouteaux Diana
Proudley Helen
Pryde Nia
Pullen Caroline J
Ramage Margaret
Read Jane
Reader Frances
Rendall Davina
Reuvid Jennie
Richards Maureen Veronica
Richardson Caroline
Richardson Gillian
Richardson Madeleine J.
Ridley Jane
Rix Sandy
Roy Jane
Ryan Elizabeth
Sandelson Jennifer
Sanders Gill
Scott Liz
Seigal Anthony
Serpell Vivienne
Shaw Sue
Shelley Trevor
Simpson Richard
Snowden Patricia
Sparks Rebecca
Standen Ruth
Stevens Jill
Struthers Morag
Symes Jan
Taylor Jane
Thoburn Marjorie
Thomas Jennifer
Tomlinson Moya
Tunwell Ann
von Bühler José
Vora Valerie
Wallace-Smith Nigel
Wallis Valerie A
Ward Keltie A
Warwick Heather
Watson James P
Webster Lynne
Wells Peter
Wheeley Eleanor
Whelan P W A
Whittaker Ruth
Wilson Llynwen
Wilson Norman
Wylie Kevan R.
Yawetz Christine

BCPC—Bath Centre for Psychotherapy and Counselling

Adams Sue

Barrett Julie
Bruce Sue
Collis Whiz
Crispin Jean
Dewey George
Douglas Sue
Elman Anthony
Feilden Tish
Foster Lesley
Graham Margaret
Hackett Jenny
Hall Kelvin
Hamblin David
Hastings Jon
Hastings Kim
Hawkins Peter
Hoare Ian
Kessel Inge
Labworth Yig
Lacy-Smith Jo
Luthy Barbara
March-Smith Rosie
Maslen Gill
McGowan Fran
Mellett Jane
Mills Christopher
Milton Thelma
Moore Alan
Naydler Nick
Newbery Christopher
Orton Jane
Pirani Alix
Purkiss Jane
Roth Ruth
Ryde Judy
Sawers Martin
Selby Anne
Slattery David
Thomas Penny
Tracy Colin
Valentine Christine
Voelcker Cara
Wheway John Kirti

BPA—British Psychodrama Association

Aguirregabiria Ana
Alexander-Graham Cassy
Bannister Anne
Barton Alan
Batten Francis
Biancardi Jenny
Bould Jane
Bradshaw-Tauvon Kate
Branagan Noelle
Brandwood Pat
Brazier David
Brown Teresa
Casson John
Chesner Anna
Costa Jan
Cramer William
Dale Carole
Daniels Mo
Davenport Hilary
Davis Edna
Eldridge Melanie
Farmer Christopher

FitzGerald Pen
Flynn Stephen
Gill Martin
Hagelthorn Christina
Haworth Peter
Hickmott Barbara
Hodges Barbara
Holmes Paul
Howell Julia
Hutchinson Peter
Jakubska Aggie
Jefferies J.I.
Karp Marcia
Kay Malcolm
Kirk Kate
Kjellstrom Laila
Lambert Louise
Langley Dorothy
Lascelle Hasan
Lea Tan
Leeson Julie
Levens Mary
Littledale Nadine
Lousada Olivia
Luxmoore Nick
MacNeill Enid
Maxwell Hugh
Moggridge Cass
Munsey Jon
Murray Catherine
Potkonjak Dusan
Powell Andrew
Pregnall Sheila
Quin Barbara
Richman Sheila
Ruscombe-King Gillie
Salisbury Jonathan
Scanlan Celia
Searle Yvonne
Simmons Alison
Sprague Ken
Taylor Susie
Thompson Jean Mary
Thomson Simon
Tregear Barbara
Turkie Janine
Walsh Stuart
Watson Roy
Wheadon Sylvia
White Eve
Widlake Bernard C.
Williams Gill
Wooding Sandra
Wright Maureen

BTC—The Gerda Boyesen Centre

Armstrong Caroline
Bardelle-Carrier Rosemary
Barker Elizabeth
Baum Stefanie
Boyesen Ebba
Boyesen Gerda
Boyesen Mona Lisa
Brosskamp Cornelia
Byford Sally
Byring Carola
Cleminson Richard

Crook Didi
Deniflee Ursula
Eisenbarth Heiner
Falkowska Merlyn
Gagnere Maryline
Gandy Rus
Gilbert Gillie
Harris Michele
Hauser Susan
Heinitz Karin
Jones Helen
Korte Achim
Lederman Tsafi
Liebling Lauren
Llewellyn Martha Raquel
McLeod Paula
Mundy Jean
O'Neill Julia
Ohnesorg Johanna
Otto Joachim
Pawson Chris
Pawson Sheila
Quoilin-Lebrun Michelle
Salles Miriam
Samson Andre
Scott Brigitte
Shipton Sunita
Southwell Clover
Sutherland Janet
Tanguay Daniel
Taylor Jill
Van der Wateren Jan-Floris
van Heel Carlien
Webb Deborah

**CAP—The Confederation
of Analytical Psychologists**

Addenbrooke Peter
Alister Ian
Ashley Anne
Ballance Gillian
Beddington Jenny
Bennett Angela
Brieger Johanna
Bruce Ann
Buckley Jane
Burnard John
Carr Jean
Chapman Sandy
Christopher Elphis
Coltart Ingrid
Crowther Catherine
de Haas Curnow Penny
de Hoogh-Rowntree Patricia
Dennis Diana Mary
Diggle Sedwell
Duckham Jennifer
Dunbar Gill
Field Nathan
Fisher Susan
Gardiner Vicki
Godsil Geraldine
Goodman Susan

Hadzanesti Nelly
Hammond Margaret
Harari Michael
Harris Dianne
Hart Robert
Haxell Susan
Herst Edward
Hewison David
Hopwood Ann
Hughes William
Hutchison Eric
Hutton Francoise
Jakobi Sally
Kaplinsky Catherine
Katzman Stewart
Kay David Louis
Kutek Ann
Lee Joan Mary
Lepper Georgia
Loeffler Harriet
Lynch Maria
MacKenna Christopher
Marcus Marietta
Marhsallsay Nicholas
Martin Edward
Masani Peter
McShane Oliver
Menckhoff Beckie
Muffet Ruth
Mulvey Jean
Panetta-Crean Simona
Paton Julia
Perry Christopher
Phillips Virginia
Philo Judith
Pickles Penny
Priestley John
Reed Keith
Richardson Elizabeth
Ross Alistair
Ryde Julia
Samuels Andrew
Schaverien Joy
Schmidt Martin
Sharifi Pury
Sheehan Margaret
Shivakumar H.
Simpson Michael J A
Sladden Anna
Smith Nora
Smith Paola Valerio
Solomon Hester McFarland
Steffens Dorothee
Thackray Dayle
Thomson Jean
Walline Sandra
Wetherell Jean
Williams Averil
Willmott Serena
Wilson Catherine
Wilson Mary
Withers Roberts
Woods Roberts
Wright Susanna

**CAPP—Centre for
Attachment-Based
Psychoanalytic
Psychotherapy**

Adams Janet
Barker Gina
Bucknall Valerie
Callaway Hazel
Charter Anne
Clifford Victoria
Cohen Pat
Cundy Linda
Davies Judy
Davis Emerald
Erskine Judith
Ferid Heidi
Henry John
Hertzmann Leezah
Holland Stevie
Hoskins John
Hughes Hatty
Hurst Hannah
Jolliffe John
Laschinger Bernie
McBride Nigel
McMillan Penny
Michael Jess
Miller Bob
Miller Penny
Odgers Andrew
Parkinson Jane
Pollard James
Preston Kay
Purnell Chris
Raicar Maeja Alexandra
Richardson Sue
Rubie Val
Ryan Jane
Schoenfeld Hilde
Schwartz Joe
Singer Iris
Southgate John
Vas Dias Susan
White Kate
Woodward Joan
Wright Laurie Jo

**CCBP—Chiron Centre for
Body Psychotherapy**

Ablack Joanne
Albrighton Sylvia
Asheri Shoshi
Blair George
Boening Joachim
Boening Michaela
Booth Philip
Browne Maureen
Carroll Roz
Catovsky Mina
Cooper Suzanne
Coxwell-White Jenny
Drewnowska Alicja
Eiden Bernd
Elliott Dena
Gaster Yishai
Hedinger-Farrell Korinna
Heitzler Morit

Henderson Ned
Hills Janet
Holland Ray
Holmes Lynne
Kelly Gillian
Landale Margaret
Law Susan
Lockie Gisela
Lude Jochen
Magriel Nicolas
McCrohan Denise
Millar Wilma
Pervoltz Rainer
Petrie-Kokott Julie
Prall Werner
Prendergast Teresa
Pugh Anna
Schaible Monika
Sell Patrick
Soth Michael
Speyer Josefine
Staunton-Soth Theresa
Stevenson Bruce
Stracey Amarilla
Tristram Sue
Tune David
Weaver Ziva
Westland Gill

**CCPE—Centre for
Counselling &
Psychotherapy Education**

Aldred Sue
Alferoff Tamara
Arbia G. Nicoletta
Attias Sandra
Austrin Chris
Avery Trisha
Basharan Harika
Bilder Tessa
Bond Lesley
Brittain Charlie
Bryant Roger
Buirski Diana
Button Rachel
Cain Dennis
Cantelo Frances
Carlson Theresa
Carrington Linda
Casares Jonathan
Casey Jan
Charley Geoff
Clark Corah
Creamer Mary
Daly John
Dawson Peter
de Nordwall Luci
Desmond Hanora
Donald Philippa
Duffield Ruth
Durban Ann
Economidou Nitsa
Emery Pamela
Emm Susan
Fagan Anthony F.
Fentiman John
Ferguson Joyce
Fitzgerald-Klein Marianne

Flower Charles
Forssander Jennifer
Fox Annie
Franks Julia
Fraser Daphne
Garner Cheryl
Gaunt Pamela
Gibbs Elizabeth
Golten Carole
Gregg Annzella
Griffiths Pamela
Griffiths Thelma
Gruber Angela
Hagenbach Kitty
Hall Linda
Hamilton Nigel
Hamilton Susan
Hanman Elke
Hanna Gilli
Harper Anita
Harris Jonathan
Haskins Nicola
Hay Burns Jean
Hayes Susan
Hiles David
Howell Carolyn
Howell Sylvia
Ingham Nida
Jacobs Paula
Jacques Roma
Jameson Anne
Jones Ros
Kafton Maggie
Keane Agnes
Keane Pamela
Kerry Sue
Kinbacher William
Kingsley Mary
Lamplough Lyn
Lavender Lesley
Lovett-Darby Linda
Lowden Barbara
Martin Brandy
Mason Letizia
Masters Sue
McDermott Cathy
McDermott Paul
McKeown Patricia
Menezes Ray
Meredith Judith
Meza Ann L.
Millward Christopher
Morris Bridget
Murphy Alan
Nappez Sue
Newns David
Nieboer Sarah
O'Connor Maureen
O'Connor Nadia
Parkinson Phil
Patchett Angela
Pegoraro Carla
Petrie Bill
Petrie Clare
Pimentel Allan
Quinn Asha
Reddy William
Reeves Alan
Reilly Nicole

Richardson Ann
Richardson Sacha
Richter Nicola
Rose Wendy
Ross Suzanne
Sagoe Pauline
Salamander Jas Ananda
Sanders Susie
Schimmelschmidt Michael
Shaban Dervishe
Sheridan Dolores
Signora Susanna Jamila
Silver-Leigh Vivienne
Singleton Kryrin
Smith Richard
Smyly Penelope
Stimpson Quentin
Stobezki Yael
Sussman Susan
Swatton Richard
Taylor Jackie
Taylor Sajada Katalin
Taylor-Brook Delia
Thiel Geoffrey
Timmann S.P
Vallely Patricia M.
Waller Charlotte
Ward Hilary
Ward Sharron
Waterman Zak
Wheeler Meredith
Whitaker Christine
Winter Sophia
Young Diana
Young Raymond
Young Sabine
Yusef Dori Fatima

CFAR—Centre for Freudian Analysis and Research

Bar Vivien
Benvenuto Bice
Bull Graham E
Burgoyne Bernard
Campbell Margaret
Conolly J M P
Dachy Vincent
Darcy Gillian
Du Ry Marc
Farquhar Kate
Gessert Astrid
Hill Philip
Hodgkiss Andrew
Kennedy Michael
Leader Darian
Machado Danuza
Pepeli Hara
Reid Liz
Ridley Stella
Rowan Alan
Sullivan Gerry
Watson Lindsay

CPCP—Centre for Personal Construct Psychology

Agnew Joyce
Botella Luis

Botterill Willie
Brennan Damian
Brennan Joady
Bury Dennis R.
Butler Smith Catherine
Button Eric
Catina Ana
Cooper Cassie
Crosby Simon
Cross Malcolm C
Cummins Peter
Dalton Peggy
Dupuy Alan
Epting Franz
Evans Ray
Fogelberg Don
Fransella Fay
Gatti-Doyle Fiorella G.
Goold Peter
Grimshaw Francoise
Harvey Paul
Jackson Sherin
Jones Helen
Kenny Vincent
Morris Clare
Murphy Derry
O'Sullivan Bernadette
Overs Nicola
Peters Anthony
Procter Harry
Rawat Shenaz
Rossotti Nicole
Rowe Dorothy
Selby Gina
Smith Alison
Sparkes Frances
Stein Nathan Bernard
Taylor Helen
Thompson Joan
Thomson Alan
Thorman Chris
Viney Linda
Winter David

CPP— Centre for Psychoanalytical Psychotherapy

Birkett Diana
Boulton John
Bradley Jonathan
Bradley Lorne–Natalie
Darling Liv
Graves Jane
Hadary Orna
Heeran Rita
Kinder Diana
Lambor Florangel
Lippitt Gwenda
Newby Rita
Poledri Patricia
Redish Elisabeth
Romm-Bartfeld Goldie
Smith Patsy

CSP—Cambridge Society for Psychotherapy

Arriens Pamela
Briant Steve

Briggs Margarete
Brown Ulla
Cockett Ann
Corrigall Jenny
Dasgupta Carol
Davies Judy
Farrell Margaret
Gentry Valerie
Goodrick Jean
Gordon Leila
Greaves Sarah
Hargraves Annie
King Lucy
Klug Liebe
Lew Clara
Minaar Doris
Morgan Sian
Paramour Annabelle
Parkinson Dorn
Pepper Marie
Randall Rosemary
Robinson Carole
Seymour Clark Vivienne
Smith Gillian
Wilde Deborah

CSPK—Centre for the Study of Psychotherapy (University of Kent)

Anderson Tony
Andrews Ruth
Bunker Carol
Bunker Nigel
Cairns Mary
Carey Jean
Cartwright Alan
Cartwright Kate
Clift Lynda
Cronin Jeremiah
Cunningham Diane J
Darnley Hazel
Gaffney Mahin
Hirons Ruth
Hughes Jennifer
Jones Deborah
Leiper Rob
Lepper Georgia
Lewis Penny
Lomax Vivien
McLewin Ali
O'Brien Sally
Reading Bill
Reilly Anne
Reynolds Helen
Riding Ann
Riding Nick
Roberts Jane
Schaedel Maggie
Shaw Maureen
Thomason June

CTIS—Centre Training International School of Hypnotherapy and Psychotherapy

Berry Margaret
Birley Paul

Bonnebaight Andre
Brookhouse Shaun
Campbell Caroline
Cooper Patricia
Cutner Adrienne
Doyle Alan
Fairhurst Pat
Gonsalkorale Wendy
Goodson Christina
Hardman Anne
Hayward Marjorie
Howell Judy
Iles David
Isaac Toni-Lee
Jogessar Yashmi
MacPherson David
Martin Susan
McClatchey E.P.(Toni)
McGrath Adrian
McVey Damien
Middleton Margaret
Moon Barbara
Mullins Pat
Mwelwa Edward
Proffitt Dorothea
Redgrave Kenneth
Renwick Fran
Sawyer Ken
Stableford Joyce
Stokes Fergus
Taylor Elizabeth
Tollan John H
Vannen-Hyland Joan
Von Uexkull Maxine
Washington Sue
Watson Dorothy

CTP—Centre for Transpersonal Psychology

Allard Alain
Allen Dorothy
Allsop Pamela
Anthony Monica
Arus Sarajane
Barclay Elizabeth
Bayne Brenda Therese
Bennett Rosanagh
Bishop Beata
Boddaert Michael
Brain Sara
Campbell Janet
Chappell Claire
de Serdici-Parker Simona
Dieffenbacher Jutta
Fieldhouse Pauline
Fletcher Karyn
Fowles Anne
Grant Mary
Guest Hazel
Haywood Carol
Hock Gaby
Holden Maxine
Lindley-Jones Kerstin
Marshall Hazel
McCormick Elizabeth Wilde
McDonald Christina
McGouran Gill
Merriott Peter

Michaelson Sue
Millais Suzy
Muschamp Maureen
O'Hagan Judith
Pearman Cathy
Peet Sandra
Peters Maggie
Pool Nicky
Preece Rob
Proctor Ann
Quinn Susan
Saabor Geraldine
Salmon Cindy
Smith Gerry
Somers Barbara
Swallow Joan
Swallow Reynold
Turner Senga
Tyrrell Susannah
Vaizey Philippa
Vibert Eva
Vick Philippa
Waygood Rob
Wellings Nigel
White Ruth
Whyte Miranda
Williams Diana
Wishart Marian
Young Anne

FAETT—Forum for the Advancement of Educational Therapy & Therapeutic Teaching

Adams Sarah K
Arnesen E
Axson Barbara Astrid
Burridge Ellora Polly
Chappell Claire
Clifford-Poston Andrea
Coles Walter
Daniel Catherine
Dover Jennifer
Geddes Heather
Greenwood Angela
Hannon Sr. Mary Letizia
Haussman Rochelle
High Helen
Holloway Sheila
Jennings Lyn C.
Kee Cynthia
Lyndon Barbara
McWilliam Jill
Morton Gillian
Oromi Irene
Robertson Ruth
Salmon Gillian
Selby Marilyn
Taube Idonea
Tillett Penny

FIC—The Family Institute, Cardiff

Alexander Erica
Benbow Susan
Brett John David
Cartwright Tony

Cox Brenda
Crossling Paddy
Faris Jeff
Foulkes Michael
Gagg Susan
Hardy William
Jones Sue
Marks Helen
Marshall Cherrith A.
Mason Barry
Matthews Shane
Mylan Trish
Osborn James
Ostler Dorothy
Pieczora Marek
Reimers Sigurd
Robinson Gary
Roys Clare
Sayers Jacqui
Speed Bebe
Street Eddy
Weeks Mark
Williams Richard
Wilson Jim

FIP—The Forum for Independent Psychotherapist

Alexander Gail
Alexander Gina M V
Anderson Elizabeth
Aquarone Luc-Remy
Bamber Nicola
Barnett Ruth
Birkett Diana
Bradley Lorne–Natalie
Brewer Madelyn
Buckley Judy
Carr Jean
Chapman Sandy
Christopher Elphis
Corneck Susan
Davies Ann
de Berker Patricia
de Berker Paul
Dianin Gianni
Dickinson Adrian
Dobbs Wendy
Eiles Clive
Ellis Sian
Erskine Archibald
Fanning Alexandra
Farquhar Kate
Ford Susan
Francis Anne M.
Freeman Martin
Froshaug Ann
Gardiner Margaret
Ghiaci Golshad
Godfrey-Issacs Godfrey
Haddington Janet
Hall Guy
Hall Kirsty
Harris Tirril
Hashemi Beth
Hatswell Valerie
Hewitt Philip J.

Hopwood Jean
Hopwood Michael
Irving Susan
Isaacs Joy
Jaques Penny
Kenny Miranda
Leeburn Jennifer
Lethbridge Sue
Lewis Jo-Ann
Lunardon Francesco
Marks Gaby
Masterson Ingrid
McCreanor Teresa
McKenzie-Smith Bryce
Mears Sylvia
Mellows David
Mellows Hilary
Mendoza Steven
Mordecai Kay
Mordicai Aslan
Morgan-Jones Richard
Morley Ann
Morley Elspeth
Morley Robert
Mycroft Jessica
Nesbit Judith
Norton Sheila
O'Connell Victoria
O'Dell Tricia
Parks Val
Phillips Marianne
Piper Robin
Pokorny Michael R
Power Kevin
Pratt Sheila
Randall Lynda
Ratigan Bernard
Reid Liz
Richardson Elizabeth
Rogers Anne
Rose Sally
Samuels Andrew
Scarlett Jean
Seu Irene Bruna
Sinclair Fiona
Stanton Martin
Stephens Lyn
Stokeld Alasdair
Stolte Eva
Stone Miriam
Taylor Mary
Thomas Kerry
Thomson Jean
Turner Diana
Veling Rolf
Vernon Paul
Walker Catriona Jane
West Marcus
Wetherell Jean
Wieland Christina
Wigram Penny
Wilmot Vivienne
Wilson Maureen
Woolf Ralph
Yallop Melanie
Young Robert M.
Zinkin Hindle

FPC—Foundation for Psychotherapy and Counselling

Albrecht Gisela
Allan Kay
Andrew Elizabeth
Archer Ruth
Arundell Jane
Aylward P J
Baker Moke
Bannister Gill
Bartlett Beatrice
Baynes Gay
Beard Dorrie
Beer Margaret
Beguin Agnes
Bielicz Paul
Bingham Jane
Blackwood Renate
Blum Arna
Botha Marie
Brown Elizabeth Ann
Browne Val
Buchan Ann
Buckley Marie-Noël (Billie)
Carr Brede
Cathie Sean
Cazalet Deborah
Channon Michael T
Chapman Maureen R
Clancy Catherine
Clark Christine
Clark Margaret
Clifford Jennifer
Cobden Vivienne
Combes Ann
Cooper Ian
Costello Marie
Crawford Stephen
Crowley Julia
Czubinska Grazyna
Danks Alan
Dare-Bryan Arminal
Dawson Joyce
Day Sally
de Jong Corrie
Dean Sally
Dixon-Nuttall Rosemary
Doktor Ditty
Dooley Patricia
Driver Christine
Duckworth Moira
Errington Meg
Farmer Eddie
Fenton Christopher MT
Flatt Raymond
Freeman Sue
Gibson Melanie
Goodrich Anne
Graff Avril
Gray Dennis
Greally Brid
Green Brian
Groom Nigel A
Gulliver Pamela
Gundry Caroline
Hamilton-Duckett Paule
Harding Celia

Hardman Jacquie
Hartman Wendy
Harvey Natasha
Hashemi Beth
Henny Lindy
Hoang Astrid
Holden John W
Hudson Marjorie
Hudson Rachel
Hughes Jennifer
Jones Janet
Jones Merryn
Kell Midge
Kidd Lee
Kingsnorth Wendy
Knowles Valerie
Lallah Regine
Lamprell Michael
Leeming Gareth
Leon Barbara D.
Levick Barbara
Levy Colette
Linden Roger
Lloyd Roger
Lodrick Michael
Lutyens Marianna
Mander Gertrud
Marsden Patricia
Marshall Vivien
Marx Philippa
Matthews Carol
Maunder Brian Lawrence
McDouall Veronica
McKeon Mary
McLoughlin Brendan
Meaden Rosaleen
Millier Sylvia
Monticelli Wendy
Morrison Lesley
Moses Susan
Murdin Lesley
Neal Lalage
Nowlan Kate
O'Dell Tricia
O'Leary Anne
Parker Rosie
Parkinson Judy
Parks Val
Pawsey Jack
Peters Linda
Pople Sue
Quaine Mary K
Rees-Roberts Diane
Reynolds Hilary
Richards Michael
Rignell John
Roberts Pauline
Rosseter Bill
Russell Gillean
Saville Sue
Sharman Juliet
Sharp Belinda
Skinner Charmian
Snow Randa
Somerville Gwynnedd
Stang Pamela
Steward Jill
Stewart John A
Steyn Angela

Stokes Jean
Stone Miriam
Sutton Bobbie
Taylor-Thomas Caroline
Thorndycraft Bill
Tjepkema Froukje
Tompkins Susan E
Trayling Laurie
Walsh Aine (Anne)
Webster Anne
Wenham Jane
White Lela Ljiljana
Wigram Penny
Williams Sherly
Winders Suzanne
Wood Rob
Wood-Bevan Martyn
Wright James
Yallop Melanie
Yariv Gail
Yates Tony

GCL—The Gestalt Centre, London

Allport Maggie
Ambrose Tony
Becker Amely
Bryan Angus
Coronas Ita
Crombie Clare
Davidge Maggie
de Luchi Martin
Ellis Michael
Gilligan Toni
Hall Jill
Hancock Maureen
Houston Gaie
John-Wilson Deb'bora
Leary-Joyce John
Marsden Veronica
Martin Linda
Morgan Barbara
Powell Helen
Puddy Jane Kahan
Rose Alivia
Sherno Peggy
Siederer Carol
Smith Jonathan
Styles Heather
Veale Maurice
White Jennifer
White Nuala

GCP—Guildford Centre for Psychotherapy

Astor Bronwen
Blackwood Renate
Davies Ann
de Berker Patricia
de Berker Paul
Francis Anne M.
Hashemi Beth
Hatswell Valerie
Holve Harriet
Hopwood Jean
Hopwood Michael
Lynch Valerie

MacKenna Christopher
O'Dell Tricia
Oldman David
Owtram Peter
Pratt Sheila
Reid Rosamund
Scarlett Jean
Seymour E. John
Stanwood Frederick
Stolte Eva
Walker Jim
Wilmot Vivienne
Yallop Melanie

GPTI—Gestalt Psychotherapy Training Institute

Appleby Joy
Aram Eliat
Ashcroft Dinah
Bar-Yoseph Talia Levine
Bate Dolores
Bentley Ros
Bodgener Sue
Brooks Carole
Broughton Vivian
Brown Lesley
Butler Todd
Critchley Bill
Daintry Penelope
Dawson Jenny
Denham Juliet
Denham-Vaughan Sally
Edwards Dagmar
Evans Richard
Finar Ruth
Fish Sue
Fitton Freda
Fry Julie
Gilbert Maria
Glanville Tony
Goodfellow Joanna
Graham Marilyn
Greenway Ian
Gregory Judith
Harris Neil
Hemming Judith
Higgins Judith
Houghton Christine
Hughes Geraldine
Hughes Jacqui
Jackson Elizabeth
Jacques Glenys
Jameson Milner Jane
Joyce Philip
Kearns Anne
Kelly Caro
Kennedy Des
Kennedy Helen
Kennett Christine
Kwei Daniel
Lake Moira
Leiper Elizabeth
Levitsky Patricia D.
Lubbock Philippa
MacKenzie Liz
Mackewn Jennifer
Makin Anne

Mann David
Manning Helen
McGowan Dominica
Mitchell John
Morin Terry
Mukuma Diana
Nathan (Jennifer) Ruth
Opienski Jacek
Orlans Vanja
Osborne Lynda
Parava Anna
Parlett Malcolm
Parmley Alison
Philippson Peter
Retallick Malcolm
Ridgewell Margaret
Rosemary Margaret
Scott Janice
Shearman Christine
Thomas Marcia
Thomas Mark
Turton Mike
Tyson Robert
Vollans Audrey
Voss Tony
Wallstein Richard S
Warburton Geoff
Waterstone Carolyn
Weller Celia
Whines Jonathan
Williams Chris
Williams Guinevere

GUILD—Guild of Psychotherapists

Adams Tessa
Addenbrooke Mary
Amiel Olivia
Armitage Pamela
Armstrong-Perlman Eleanore
Arnold Rosemary
Atkinson Paul
Ayres Anthony
Bacon Roger
Bar Vivien
Barham Peter
Barnett Mary
Barrett Jean
Barwell Peter
Battersby Audrey
Beard Hilary
Beaumont Mia
Berry Peter
Bhatt Vibha
Bickerton Tricia
Blandy Evanthe M
Bosanquet Camilla
Briant Michael
Buckingham Linda
Buckroyd Julia
Campbell Elizabeth
Chancer Anne
Chandler Philip
China Jacques
Clackson Suzanne
Clare Louise
Cohen Sylvia
Cohn Nancy

Coleridge Jane
Collins Natalie
Colver Stephen
Coombs Suzanne
Cooper Sara
Couzyn Jeni
Cronin Jeremiah
Daniel Barbara
Davison Susan
Draney Sue
Dunn Jenny
Dutton Andrew
Easter Judith
Egert Susan
Eisen Susan
Ezekiel Lyn
Farhi Nina
Farrell Margaret
Ficarra Berthe
Field Kate
Fry Caroline
Gal Oshrat
Garlovsky Rita
Gilljam Annika
Goldblatt Phyllis
Good Simon
Goodrich Diana
Gosling Pat
Gow Marion
Gray Anne
Gray Kati
Greaves Sarah
Griffiths Anne
Guy Liana
Hall David
Halpin Jill
Harrison Jacqueline
Harvard-Watts Olivia
Henriques Marika
Hoag Linda M.
Hopkins Jill
Howard Angela
Hudson Marjorie
Hughes Ann
Johansson Birgitta
Jones Margaret
Kane Ros
Karan Alexandra
Kerr Anna
Kerridge Jack
Krzowski Sue
Lawrence Margaret
Lee Jan
Lewis Sheila
Lloyd Elizabeth
Maguire Marie
Marsh Jennifer
Milburn Irene
Miller Michael
Mitcheson Brown Muriel
Moore Rosemary
Morgan Sian
Morris Monique
Morris Shosh
Nabarro Elizabeth
Naylor-Smith Alan
Nicholson Elizabeth
Noble Jane
O'Connor Noreen

Oakley Haya
Payne John
Pearmain Rosalind
Percy David
Phillips Adam
Pratt Sheila
Price Susan
Ransome Helen
Rea Judith
Richards Christopher
Richards Janet
Richards Val
Rickett Marion
Roberts Laurence
Robertson Judith
Robertson Zuleika
Robinson Hazel
Robinson Judy
Robinson Sue
Rumney Boris
Schofield Lynn-Ella
Scott Glenys
Sinclair Alison
Slade Laurie
Smith Anne
Springford Kate
Spurling Laurence
Stokes Jenny
Tait Adrian
Taussig Hanna
Vallins Yvonne
Veasey Helen
Vickers Salley
Voikhanskaya Marina
Wells Lesley
Wells Roger
Westcott Rosemary
Wheeley Shirley
White Jean
Wilce Gillian
Woodhead Louise
Wooster Frances
Worrall Chrysoula
Worthington Anne

HIP—The Hallam Institute of Psychotherapy

Agass Dick
Ashton John
Barker Lily
Beard Hilary
Bennison Judy
Berry Juliet
Blacker Polly
Bolsover G.N.
Bostock Christine
Boysan Zehra
Daines Brian
De Carteret John
Dixon Linda
Donovan Maxine
Drucquer Helen
Edwards David
Ellis Lynda
Fitzgerald Geariod
Garlovsky Rita
Gudjonsson Ingolf
Guiton Anita

Headworth Jean
Hopkins Vera M.
Howlett Stephanie
Hunt Patricia A.
Johnston James
Lidmila Alan
Littlewood Ann
Loftus Patrick A.
MacNeill Enid
Maitlis Marion
Marshall Myra
McAuley John
Meredith Joan
Monach Jane
Oram John E.D.
Peltier Judy
Pethen Susan
Pickvance Deborah
Pittock Frances
Porteous Louise
Rayner Beryl Ann
Read Nicholas W
Robinson Felicity
Shipton Geraldine
Smith Eileen F.
Sudbury John
Thomas Sandra V.M.
Thomson Pat
Todd Margaret C
Vincent Jane
Ward Ruth
Woolfson Myra

IATE—Institute for Arts in Therapy and Education

Blench Graeme
Cruthers Helen
Dawkins Sue
Dean Paul
Edington Jane
Fish Sue
Hall Francesca
Harris Sue
Ingham Rosie
James Jo
Leon Sara
Low James
Mendoza Hilda
Naor Lillie
Plunkett Eileen
Raphael Francesca
Rowan Chris
Savins Charlotte
Smosarski Lizzie
Sunderland Margot
Velarde Dominique
Waterfield Julia
Wilson Ronni

IFT—Institute of Family Therapy

Adams Melissa
Adcock Margaret
Aggett Percy
Anthias Louise
Askin Pauline
Attwood Peter

Avigad Jocelyn
Bagnall Steve
Barratt Sara
Bennett Margaret
Bentovim Arnon
Bianco Vicky
Blackburn Paul
Bor Robert
Boston Paula
Bourne Juliet
Bousfield Anne
Burck Charlotte
Burns Elizabeth
Chimera Kathleen
Collins Lynda
Connolly Cath
Cooklin Alan
Cornish Ursula
Dale Barbara
Daniel Gwyn
Davies Lorraine
Dawson Neil
Dodge Elizabeth
Dowling Emilia
Draper Rosalind
Dutton Jane
Egert Stella
Eisler Ivan
Erskine Ruth
Esposito Claude
Farzim Pari
George Evan
Glasscoe Claire
Graham Nancy
Green Joe
Gross Vivien
Hancock Sarah
Harrison Gillian
Heavey Anne
Henley June
Herington Steve
Hildebrand Judy
Hill Finella
Hooper Christine M.
Howell Simon
Hubbard Leslie
Humphreys David
Hussain Nasima
Inglebright Shanti
Iveson Chris
Iveson Diana
Jacobs Brian W
Jacobs Linda
Jenkins Hugh
Jones Elsa
Kavner Ellie
Kraemer Sebastian
Lafon Robert George
Lask Judith
Lau Annie
Lewington Paul
Lindsey Caroline
Lobatto Wendy
Mandin Philippe
Mason Barry
Mayer Robert
McCann Damian
McCann Linda
McGrath Rita

McHugh Brenda
Messent Philip
Middlecoat Andrew
Miller Ann
Miller Riva
Moorhouse Anni
Morris Allan
O'Brian Charles
O'Brien Pat
Paulson Diana
Pettle Sharon
Pike Margery
Pooley Jane
Ratner Harvey
Reynolds Dorothy
Robinson Margaret
Sheehan Nuala
Smith Gerrilyn
Stevens Ann Penberthy
Stogdon Mark
Summer Jennifer
Tapang Peter
Topliss Nick
Turner Annie
Van-Loo Douglas
Virtanen Helena
Waters Kathleen
Wieselberg Huguette
Woodcock Jeremy

IGA—Institute of Group Analysis

Abbasi Shafika
Allsop Wendy
Anderson Linda
Antao Ivor
Arnott Biddy
Azu-Okeke Okeke
Bacha Claire
Bamber James
Behr Harold
Berman Paul
Berry Eileen
Bhat Radha
Birchmore Terry
Bloch Linda
Boakes Janet
Boronat Dascha
Boswood Bryan
Bozovic Zoran
Brown Dennis
Burgess Jo
Campos Hanne
Canty Josephine
Chilton Maggie
Christie Jim
Clairmonte Tosin
Cohen Vivienne
Cooper Robin
Corbett Martyn
Dalal Farhad
Davies Roger
Daykin Amanda
de Mare Patrick
De Zulueta Felicity
Dean Sally
Deco Sarah
Denton Marika

Duckham Jennifer
Eagles Marjorie
Einhorn Sue
Elliott Barbara
Ernst Sheila
Evans Chris
Fagbadegun Rufus
Farquharson Graeme
Fasht Ruth
Feeney Michael
Festenstein Geraldine
Fischer Michael
Foguel Brenda
Fuller Victoria Graham
Gallagher Eileen
Gallop Margaret
Glenn Liza
Gold Bonnie
Gorman Susan
Gottesmann Ewa
Green Roberta
Greenberg Maurice
Greenland Sue
Haddock Ray
Haigh Rex
Hallard Sharon
Hamrogue Tom
Harrow Anne
Hartley Phil
Hasler-Winter Susan
Hearst Lisbeth E
Heatley John
Helbert Jan
Hobbs Michael
Holden Sarah
Hollis Peter
Holman Christopher
Holmes Anne
Hook Beatrice
Hook John
Hopper Earl
Hudson Inge
Hughes Patrick
Hutchinson Sylvia
Hyde Keith
Ikkos George
James Jessica
Jenkins Hansen Anne
Jones Dan
Jukes Adam
Keggereis Duncan
Kennard David
Kinder Diana
King Desmond
Knowles Jane
Lee John
Lilley Davina
Lintott Bill
Love Derek
Lucas Tina
Lyon Heather
MacAlister Eileen
Mace Chris
MacKenzie Nancy
Maher Michael
Maltby Michael
Mandikate Patrick
Maple Norma Anderson

Maratos Jason
Mark Peter
Marrone Mario
Maxwell Brian
Mayer-Johnson Jessica
McCabe Ruth
McGrath Patrick
McLoughlin Una
McNeilly Gerald
Meinrath Monica
Millard Mackintosh Sheila
Mitchison Sally
Mittwoch Adele
Murphy Denis
Nathan Gill
Nitsun Morris
O'Leary Carmen
Ormay Tom
Panchkowry Marion
Parker Michael
Patalan Anna-Maria
Pennycook-Greaves Wil
Peternel Franc
Powell Andrew
Pullin Andrew
Rance Christopher
Read Tim
Reik Herta
Rheinschmiedt Otto
Roberts Jeff
Roberts Julie
Robinson Rosalyn
Rogers Cynthia
Rosenfeld Angela
Russell Wilson J
Sarra Nicholas
Scanlon Chris
Schneider Evelyne
Scott Michael
Sengun Seda
Sepping Paul
Sevitt Michael
Sharpe John
Sharpe Meg
Simpson Ian
Sipos-Sarhandi Zsuzsa
Skynner Robin
Smith Val
Sproul-Bolton Robin
Stacey Ralph
Stevenson Beaumont
Strich Sabina
Sutton-Smith Deirdre
Tait Mike
Tanna Nick
Tantam Digby
Tough Harry
Vella Norman
Vincent David
Walker David
Westcott Bernard
Wetherill Julie
White Jeremy
Whiteley J. Stuart
Wilke Gerhard
Williams Jane
Willis Sally
Wilson James

Wojciechowska Ewa
Woolmer Tim
Wright W. Harry

IGAP—The Independent Group of Analytical Psychologists

Anderton Michael
Begg Ean
Burritt William
Campbell Nye Aileen
Cantwell Maureen H E
Costello John
David Johanna
David Julian
Davis Joyce
Denman Cara
Evetts-Secker Josephine
Fitzgerald J
Freeman Linda
Ginsborg Robby
Gordon Elizabeth
Harwood Matthew
Hiller Ruth
Hirst Diane Zervas
Jackson Eve
Keating Jacqueline
Kind Gill
Kujawski Pedro
Maguire Anne
Milne Frances
Morris Petrina
Papadopoulos Renos
Rees Myfanwy
Reynal Carmen
Shearer Ann
Shorter Bani
Smalley John
Spencer Janet
Tatham Peter
Tuby Molly
Weinrich Hildegard
Whan Michael

IPSS—Institute of Psychotherapy and Social Studies

Aizenberg Eldad
Allawi Nadia
Bennett Lesley
Bensimon Marlene
Bishop Patricia
Black Sandra
Blackwell Frances
Blair Dana-Jane
Brave-Smith Anna
Broadbent Sara
Buckley Judy
Burns Alex
Burns Paula
Byrne Deidre
Cameron Katherine
Campos Juan
Chandwani Lilian
Chessell Karen
China Giselle
Clare John

Coleman Jane
Cotton Naomi
Coulter Theresa
Courtault Susie
Cullis Andrew
Cussins Anne
Daniels Susan
Daudy Isabelle
Davidoff Leslie
Davidson Steve
Davis Diana
de Souza Joney
Dogmetchi Geri
Dowber Hilary
Duckworth Rosemary
Dunford Kathy
Feldberg Tom
Ferid Heidi
Fiasche Mara
Franklyn Frank
Gauntlett Tim
Gladstone Guy
Gordon Paul
Goslett Kate
Green June
Green Michael
Grey David
Hawkes Bernadette
Horwood Tone
Howard Heather
Howells Megan
Jn-Baptiste Louisa
Joffe Riva
Kerkham Patricia
Law Heather
Lehrer Pam
Lesley Alison
Letts Muriel
Little Marie
Lloyd Patricia
Lovel Mary
Manglani Dona
Marshall Antoinette
Masterson Ingrid
McEldowney Dennis
McGee Colin
Michaud-Lennox Suzanne
Morante Flavia
Mycroft Jessica
Norburn Veronica
O Briain Ciaron
Oakley Madeleine
Patricia Thelma
Rabin Norman
Rapp Hilde
Richards Val
Roberts June
Robertson Judith
Rogers Maggie
Rognerud Tove
Rose Kevin
Shetland Ilrich
Smith Jonathan
Spyer Natalie
Steiner Monika Celebi
Stopher Andy
Stovell Joy
Sucher Ingerborg
S|nkel Sue

Utting Julia
Walker Jim
Whitby Susan
Williams Gwen
Wise Penny
Woodley Ermine
Yazar Jale
Zarbafi Ali

ITA—Institute of Transactional Analysis

Agar James
Allen Patricia M.
Arredondo Beverly
Ayres Alison
Banks Jan
Beazley-Richards Joanna
Beechcroft Diane
Bisgood Bill
Blyth Fiona
Boyd Suzanne
Brauner Rita
Brereton June
Bresloff Valerie
Bridge Jenny
Brunt Mervyn
Bukovics-Heiller Birgit
Bulmer Liz
Cardile Pietro
Clarkson Barbara
Clevely Sarah
Cooke Bob
Cox Mary
Cunningham Valerie
Dates Stephanie
David Ann
Davies Peggy
Davis Jim
Dennis Stephen
Duffy Gerry
Duncan Ursula
Etherington Mary Elizabeth
Felton Mo
Fish Sue
Flatt Debbie
French Jean
Galloway Betsy
Gibson Jenny
Gilbert Maria
Gildebrand Katarina
Goddard Lynne
Gowling David
Green Eliott
Greening Sarah
Gregory Josie M
Hanna Hyams
Hannah Francesca
Hargaden Helena
Harley Ki
Harling Biljana
Heath John
Henshaw Judith
Heppel Valerie
Hewett Rachael
Hewson Julie Ann
Hirst Hazel
Hobbes Robin
Homer Marjorie

Hopping Geoff
Horton Annie
Hostick Kathie
Howard Sister Columba
Howells Kate
Irving Nicholas
Jesson Alison
Johnson Janette
Lapworth Phil
Law Gordon
Lawrence Yvonne
Leach Kathy
Lee Adrienne
Lewin Melanie
Lister-Ford Christine
Little Ray
Lomond Lynne Marsha
Lucas Carol
Luden Maureen
Mardula Jody
McNamara Jennifer
McQuillin Jane
Midgley David
Monk-Steel Barbara
Monk-Steel John
Moodie Alastair
Moore Joan
Morrish Susan
Mountain Anita
Mundy Pamela
Oates Stephanie
Pamphlett Nicholas
Parkinson Jillian
Parr John
Payman Barbara
Phelps Gwyneth
Phillips Susan
Pollitzer Juliette
Porter Barbara
Pyves Gerry
Reddy Michael
Rigney Ann
Rimmer Annie
Robinson Jenny
Rose Sylvia
Salole Roy
Salters Diane
Sanders Peter
Shadbolt Carole
Shearman Christine
Shmukler Diana
Sills Charlotte
Sless Deborah
Spenceley Dave
Stevenson Alice
Stewart Ian
Stuart Lilly H.
Summers Graeme
Swift Sue
Taylor Rosemary E.B.
Thacker Rose
Thomas Jenny
Tilney Anthony
Traynor Barbara
Tudor Keith
Turner Carole
Tweed Mary
Van Halm Corrie
Vernon Olabisi

Walford Jane
Walford Robin
Ward Shona
Warner Kerri
Welford Enid
Wells Martin
Whitley Liz
Wood Christine Jones
Wood Jane
Wyatt Gill

KCC—Kensington Consultation Centre

Abeles Margi (Margaret)
Allen Lesley
Anderson Eleanor
Anson Carol
Aufflick Julia
Ayo Yvonne
Bailey-Smith Yvonne A
Bentley Patrick
Bevan Judith
Blacker Sandra Rosamond
Bolton Jan
Bond Sharon
Bownas Jo
Briner Wendy
Brown Mavis
Buffery Elli Patricia
Burnham John
Cardwell Amynta
Carr Samantha
Charvet Anne
Chataway Carola
Cutteridge Simon
D'Aguilar Yvonne
Dalal Caroline
Davis Gill
de Laszo Alexandra
DeFries Jeanne Margaret
Deres Mebrat
Dighton Rosemary
Docking Raymond Fredrick
Egan Jude
Ekdawi Isabelle
Elder Meldene
Fausset Ann
Fernandez Florence
Flower Michael
Fredman Glenda
Friend Sue
Godinho Bernadette
Goldstein Pam
Goodwillie Gill
Gordon Inger
Gordon Virginia
Gorney Carry
Haddon Jarmaine
Hanks Helga
Hannah Chris
Hannah Clare
Harben Ursula
Hart Azina
Hartley Althea
Harvey Pam
Hedges Fran
Heismann Elisabeth
Hickman Sue

Hoare Elizabeth
Howard Trevor
Hudson Pauline
Jackson Jo
Jarvis Eileen
Jones Amanda
Kavanagh Sister Catherine
Kemmis Betty Sally
King Madeleine
Lang Peter
Lang Susan
Lauchlan Sheila
Lema Juan Carlos
Levitt Olga
Lewis Joan
Lingard Shirley Ruth
Little Martin
Louden Penny
Makatini Zethu
Makgoba Sindi
Manicom Hilary
Manojlovic Jelena
Markovic Desa
Martin Gloria
McCafferty Stewart
McCarry Nicola
McEvoy Patricia Elaine
McKay Barbara
McManus Gaynor
McNair Ann G
Micciarelli Felicia
Middleton-Smith Virginia
Milani Belinda
Mohlala Morris
Mudarikiri Maxwell Magondo
Nafie Omar Ibrahim
Neate Patricia
Noonan Mairead
Nottingham Sue
O'Connor Michael
O'Leary Brid
Ohene Margaret D.
Oliver Christine
Parker Gabrielle
Partridge Karen
Penalosa-Clarke Adriana
Pidgeon Patricia
Poole Carol Lynn
Priest Caroline
Pugh Gabrielle
Quinn John J
Rae Frances
Roberts Alison
Roberts Sylvia M
Roche Sile
Ruismaki Marjo
Rushforth Catherine
Ryburn Murray
Schreiber Kaye
Short Patricia
Simon Gail
Smart Tanya
Smith Maggie
Spence Mary
Stacey-Ong Lesley
Stevenson Kate
Stocks Samantha
Stratton Peter M
Sweet Patricia

Sykes Ann
Tague Jackie
Taylor Mary
Teng Christina
Togher Margaret
Tugendhat Julia
Van Der Eijk Mike
Wainwright Claire
Walby Jane Kathryn
Warnakula Amina Bibi
Way Patsy
Webb Ann
Wheeler Maria
White Anne
Whitfield Gwyn
Wilkinson Mary
Wilson Teresa
Woodward Jan

LAPP—The London Association of Primal Psychotherapists

Coombes Clare
Cowan-Jenssen Susan
Jenssen Einar D.
Kostic Jasna
Lafargue Martine
Nodelman Marsha
O'Connor Aine
Pollack Angela

LCP–London Centre for Psychotherapy

Craib Ian
Johnson-Smith Camilla
Kitson Nicholas
Love Mollie
McCreanor Teresa
Poole Robert
Shuen Dorcas
Spearman Penny
Sprent Sue
Whitwell John

LPDO—Liverpool Psychotherapy Diploma Organisation (University of Liverpool)

Applegarth Janet
Baynes Monica
Bergel Edith
Challis Suzy
Clarke Elaine
Collins Gloria
Cooper Graham
Dickinson Paul
Dorndorf-Turner Rhoda
Doyle Elizabeth
Edwards Jennifer
Egerton Judy
Essex Delia
Farrell Bill
Ferguson Mary
Foster Paul
Gabbay Mark
Geldeard Bryan W.J.

Glynn Julie
Gopfert Michael
Green Barbara A.
Hagan Patricia
Hamilton Angela
Hamilton Sheila L.L.
Haworth Chester Ann
Hester Bridget A
Higgo Robert J.
Kiemle Gundi
Kirkland-Handley Nick V.
Lamb Kirsten
Lindsay Marion
Maguire Claire
Mattison Sheila
McIntee Jeannie
McNab Stuart
Mercer Annie
Nevin Jaqui
O'Reilly Thomas J
Oakley Ian H.
Parker John
Pollet Sheena
Potter Steve
Prothero Peggy
Prussia Celia M.
Ross Julie
Sexton Janette G.
Sharples Geraldine M
Shetty Grish Chander
Simpson Kevin J.
Smith Flo M.F.
Smith Margaret E
Stewart June
Taylor Patsy
Thorley Helen
Wallace Daphne
Wattis Libby
Webb Joan
Wheeler Anne
Woods Angie
Woodward Raie

MC—Minster Centre

Abrahams Elisabeth M
Alder Helena
Alder Roger
Arnold Lynn
Baker Jan
Barnett Madeleine
Bathai Parizad
Beaumont Anne
Borges Sheila
Bowman Heather
Cato Jane
Claxton Brenda
Colverson John
Cook Jane
Coumont Graubart Valerie
Coussens Kay
Davis Helen
Dunn Nicola
Dyson Margaret
Embleton-Tudor Louise
Field Rosalind
Flinspach Elisabeth
Geen Sheryle
Gibson Walter

Gottschalk Margaret S
Granowski Margaret
Gravelle John
Hayhurst Sohani
Humphrey Anna
Hussain Fakhir
Hyde Dennis H
Jefferies Alison
Johnson Patricia Anne
Jordan Ruth
Kane Janine
Kolbuszewski Marianne
Lang Richard
Lester Clare
Lewis Richard
Littlejohn Sarah
Lock Josephine
Mazure David
Moore Julia
Morgan Ruth
Morrison Barbara
Murphy Ger
Music Graham
Nelson Sandy
Newbigin Alison
O'Callaghan Lesley
O'Gorman Mary Pat
Pixner Stefanie
Platt Sue
Presant Fern
Renoux Martine
Robinson Louise
Roth Ruth
Schiemann Margot
Scovell Janet
Sellers Duncan
Shapiro Adella
Sichel David
Simmonds Tina
Slade John
Smith Gill
Soloway Clare
Steel Sandra
Sutters Amabel
Virgo Leslie Canon
Walsh Carys
Wanless Anna
Wanless Peter
Williams Nigel
Williams Pat
Williams Ruth
Winder Joy Ruth
Wiseman Anna
Wood-Bevan Rosemary
Wynn-Parry Charlotte
Wyse Hymie
Young Margot

MET—Metanoia Institute

Anderson Phil
Ashcroft Dinah
Beazley-Richards Joanna
Blyth Fiona
Borsig Su
Brauner Rita
Bridge Jenny
Bukovics-Heiller Birgit
Butler Todd

Casatello Giovanna
Cassidy Mandy
Clevely Sarah
Clifton Elaine
Cottrell Sue
Critchley Bill
Cunningham Valerie
David Ann
Dawson Liz
Day Laurie
Day Lesley
Dean Paul
Dhillon-Stevens Harbrinder
Elton Wilson Jennifer
Fry Julie
Gerlach Lynne
Gilbert Maria
Gildebrand Katarina
Goodfellow Joanna
Graham Marilyn
Hadwin Peter
Hargaden Helena
Harley Ki
Harling Biljana
Heley Mary
Henderson Andrew
Hipps Hilary
Hopping Geoff
Houghton Christine
Hughes Jacqui
Hughes Janet
Isaksson-Hurst Gun I.E.
Jeffries Rosie
Jesson Alison
Jones Sue
Joyce Philip
Kearns Anne
Kelly Caro
Kennedy Des
Kowszun Grazyna
Lapworth Phil
Lawes Ginny
Leigh Elana
Leiper Elizabeth
Leitman Norman
Lubbock Philippa
Macgregor Wynne
Mackewn Jennifer
Magner Valerie
McGlashan Judy
McGowan Dominica
McKeown Andy
Michaels Ruth
Moore Maureen
Mukuma Diana
Murphy Katherine
Murray Christine
Murray Jane
Nathan (Jennifer) Ruth
O'Dwyer Annegret
Opienski Jacek
Orlans Vanja
Osborne Lynda
Parava Anna
Pearce Peter
Perring Michael
Phillips Susan
Porter Barbara
Prentice Hilary

Ransley Cynthia
Rattigan Bridget
Razzaq-Bains Saira
Renwick John
Retallick Malcolm
Rickman Chrisse
Ridgewell Margaret
Rimmer Annie
Rowlands Helen
Scott Janice
Scott Judy
Shearman Christine
Sills Charlotte
Skegg Roz
Tabak Carolyn
Taussig Maggie
Taylor Sheena
Tholstrup Margaret
Thomas Marcia
Tudor Keith
Turner Carole
Turner Mary
Valentine Victoria
Vollans Audrey
Wallace Norma
Watters Tamara
Whines Jonathan
Wood Jane
Woodward Gillian
Wyatt Gill
Yates Helen

NAAP—Northern Association for Analytical Psychotherapy

Aird Eileen
Black Patricia Anne
Cooper Margaret H
Dobson Mary
Firth Sue
Gilbert Barbara
Hellier Mary B.
Kendal Jo Reed
Longford Joan
Lund Charles
MacPherson Malcolm
Mahmood Janet
McGregor-Hepburn Jan
Miles Carolyn
Morgan Shirley P.
Payne Graham
Phoenix Ashleigh
Proctor Susan
Shrubsole Lindsay
Stafford Amanda
Stanbury Christine
Tod Ian
Watson Pauline

NAFSI–Nafsiyat

Al Jarrah Nadina
Alleyne Aileen
Bartels-Ellis Phillida
Bonadie-Arning Sondra
Brauner Rita
Dupont-Joshua Aisha
Eleftheriadou Zack

Güngör Dilek
Hawkes Bernadette
Husain-Shackle Shakrukh
Love Jasminder Kaur
McKenzie- Mavinga Isha
Mordecai Kay
Mordicai Aslan
Nippoda Yuko
Nkumanda Rachel
Richards Diana M
Yazar Jale

NGP—The Northern Guild for Psychotherapy

Andrews Carol
Duncan Ursula
Epstein Melanie Lynn
Galloway Betsy
Greening Sarah
Hamlyn Sarah
Homer Marjorie
Johnson Janette
Kelly Peter
Lawrence Yvonne
Ledward Judi
Lister-Ford Christine
Lough Mark
McNamara Jennifer
Sizikova Tanya
Thacker Rose
Wicks Carole Ann

NRHP—The National Register of Hypnotherapists and Psychotherapists

Ashworth Freda
Ayres Kathleen
Bonner David Calvert
Butler John
Campbell Colin B.G.
Campbell-Beattie John
Cawley Anthony
Challis Raymond Thomas
Chamier Suzanne
Coia Grace
Cox Christine Sarah
Diyaljee Angeli
Edgell Marjory
Faruki Shirley
Fish Deborah M.
Fitzgerald-Butler Albina
Gausden Christopher
Gilkes Pauline
Glasspool Patricia
Golding Pauline
Graham Hilary E.
Greenfield Terence Aubrey
Grew Lesley
Grinonneau Peter
Harris Gerald A.
Hart Mary A.M.
Hazlehurst Jean
Hogg Christine Retson
Hormasji Faridoon
Howie David D.
Iremonger Sue
Johnson Duncan B.
Johnstone Janice Mary

King Christine
Kulyk Michael
Langley Allen
Linn Iris
Luce Peter James
Ludolf Monica
MacDonald Ross
Mahon David
Malcolm Hanne
Mallardo Renee
Marshall Jill
Mattar Gretta
May Adam
McGregor Tony
McIntosh Stuart
Milton Harry
Moreby Patricia Joyce
Mountjoy Lesleen
Munro Carole
Pain Jean
Peace Susan
Penn Joyce
Peters Sheila
Plotel Angela
Plowman John
Prince Tania
Rawson-Jones Elizabeth
Raymond Caroline
Redgrave Kenneth
Richardson Susan
Riley Brenda
Savage Peter J.D.
Scott Catherine
Sever Michael
Shearer Annette
Shewan Alistair
Smith Alica
Smith Susan Diane
Steel Patricia
Steven David B.
Stevens Jean
Stevenson Krystyna
Sutherland Robert I.
Thornley John
Thorpe Terry
Tierney Sue
Timmann S.P
Toyne Joy K.
Trewhella John
Wesson Peter M.J.
Wilkins David
Williams Ann
Wren Pauline

NSAP–North Staffs. Association for Psychotherapy

Barry Anne
Breeze Graham
Donnai Andrew
Ghent Rita
Gregory Kayt
Hassall Alan
Pantall Marlis
Reagan Catherine
Taylor James
Whittam Enid
Wiles Margaret

NSHAP—National School of Hypnosis and Psychotherapy

Adams Ghislaine
Adams Megan
Al Rubaie Talal
Beattie Anya
Bibby Keith
Black Judith
Black Margaret
Boff Roger
Boyden Christina
Braterman Eleanor
Burgess Shanti
Busolini Don
Butcher Barbara
Caird Elizabeth J.
Carder Misha
Clegg Ian
Cole Shanti
Coutts Linda
Dale Anne M.
Duck Dorothy M.
Duncan Fraser
Eaton John
Freeman Susan
Gawler-Wright Pamela
Gould Geraldine
Green-Thompson Cyril
Haynes Eric
Holm Kirsti E.
Howtone Christina
Jones Pamela
Kalitowski Matthew
Kanakam Jonathan
Keedy-Lilley Ray
Keith Charlotte
Kendrick Margaret
Kohler Christiane
Luckcock Ronald Cosmo
Lyon Josephine
Mackinnon Sylvia
McGreevy Edith
McGuinness Mark
Morgan Jo
Morgan Linda
O'Brien Ann
O'Neill Christopher J.
Peacock Anne
Porter Jim
Ridley Elizabeth
Sawyer Albert
Smolira David
Thomas Graham
Tomlinson Andy
Ward Dawn

NWIDP—North West Institute for Dynamic Psychotherapy

Allen Tessa
Arkwright Lynda
Bacha Claire
Barnett Gillian
Berman Linda
Bielicz Paul
Bird John

Black Teresa J.
Brown Philip
Buckley Michael
Churcher John
Coldridge Liz
Conlon Isobel
Cornell Maria
Davenport Sarah
Fischer Michael
Gatrell Jane
Gowrisunkur Jaya
Guthrie Else
Hellin Kate
Horne Alan
Hughes Lynette
Hunt Patricia A
Hyde Keith
Judkins Malcolm
Jukes Rachel
Kaberry Susan
Lancelot Maggie
Layfield Kate
Lendrum Susan
Liddle Helen
Lunt Aidan
Margison Frank
McAllister Susan
McGrath Graeme
Mitchell Lesley
Morris Jane
Nicholson Jane
Osborn Madeline Frances
Prodgers Alan
Rawsthorne Jean
Rhodes Adrian M.
Sheldon Helen
Smith Janet M.
Sutton Adrian
Sykes Kathleen
Tanna Nick
Tantam Digby
Taylor Theresa
Towse Esme
Whitmore Robert

PA—Philadelphia Association

Caviston Paul
Clapham Miles
Cooper Hilary
Cooper Robin
Davenport Marie-Laure
Fielder Michael
Friedman Joe
Gans Steve
Ghiaci Golshad
Gill Douglas
Gordon John Fredrick
Gordon Paul
Green Prudence
Gurney Paul
Hardy Liz
Hurd Joan
Itten Theodor
King Lucy
Lawson Christine
Loewenthal Del
Low James

O'Neill James
Redler Leon
Touton-Victor Patricia
Watson Gordon

RCSPC—Regent's College School of Psychotherapy and Counselling

Adams Martin
Adams-Langley Stephen
Adey John
Aldridge Janet
Arzoumanides Yiannis
Ashwin Mary
Asmall Ismail
Aston John
Austin Lesley
Babarik Anthony
Bailey Catalena
Baker Adrienne
Beasley Rachel
Berger Jocelyn
Bessant Irene
Bland Roger
Blyth Doug
Boa Quint
Bradley Linda
Brown Ian B
Browne Margaret
Buckingham Sarah
Budgell Rosemary
Caleb Ruth
Cameron Angela
Campbell Christine
Campher Rosemary
Carsley Carol
Cedro Karin
Cleminson Dorel
Cohn Hans W.
Coleman Eva
Collins Leila
Cooper Jillian
Cooper Michael
Corbett Gemma
Crouch Carol
Daniels Deborah
David Anna
Davies Rosina
de Botton Susan
Dennison Paul
Dolphin Eve
Dorrian Maeve
Du Plock Simon
Duffy Kathleen
Durlach Stefan
Eglin Patricia
Eisenhauer Gary
Eleftheriadou Zack
Epstein Bunny (F.C)
Farrell Em
Foley Dermot
Fox Almuth-Maria
Fox Delia-Ann
Gallagher Teresa
Gardner Peter
Gatti-Doyle Fiorella G.
Gavin Verity J
George Dorothy

Golden Sylvia
Goldenberg Harriet
Gooding Kim
Goodman Jenny
Gorodensky Arlene
Grace Carole
Green Dror
Gunton Gaye
Guthrie Barbara
Hall Albyn
Hamm Alexandra
Hanaway Monica
Harding Michael
Harlap Nahum
Harman Josephine
Harmel Barbara
Harris Mary
Harvey Sandra
Haskayne Amanda
Haugh Sheila
Hay Jennifer
Hazelton Sally
Henderson Mary
Heralall Ellen
Holmes Carol
Hornby Jackie
Horne David C
Hughes Janet
Isaacson Zelda
Jacobson Rosemary
Johnson Patricia
Jonathan Arthur
Julien Michael
Kahr Brett
Karban Barbara
Keal Susan
Kerr Libby
Kingsley Joan
Kondos Sandra
Kostoris Laura
Lawlor Virginia Katherine
Le Brun Christine
Lemma Alessandra
Leveque Brigitte
Lever Maureen
Lewis Jacqueline
Lipman Amanda
Little Jon
Lowe Julie
Luca-Stolkin Maria
Lumbis Gerald
Lund Leslie Ann
Malkin Marion
Manifold Claire
Mansall Cordelia
Marshall Susan
Massara Catharine
Massil Ros
McAleer Eileen
McKenna Clare
Miles Natalie
Miller Joanna
Milton Martin
Mitchell Diana
Moja-Strasser Lucia
Morgan-Williams Susan
Morrison Philippa
Muldoon Nuala
Murphy Sue

Myers Piers
Nelson Margaret
Ngone Mary
Nuttal Clive
O'Brien John
O'Sullivan Renee
Oaten Gae
Ogilvie Renata
Oldfield Nina
Owen Ian
Owens-Ward Lyn
Pae Linda L S
Palamountain Alan
Parissis Maria
Parkin Gwendolyn
Parr Meriel A
Pearmain Rosalind
Platt Monique
Popple Gillian
Poulopoulos Katerina
Purpura Davide
Rabin Judith
Radlett Marty
Reardon Paula
Redmill-Sorensen Bernice
Riddy Paula
Roland Saskia
Romisch-Clay Liza
Royle Anthony
Ruggieri Gloria
Russell Doug
Russell Tina
Sabayinda Michael
Sachs Adah
Saroff Rahel
Sayyah Shahrzad
Schmitt-Castilla Maria
Shields Ellen Attracta
Sim Camilla
Singer Daniela
Slater Joan
Smallwood Imogen
Spendelow Lyndsay
Spinelli Ernesto
Stadlen Anthony
Steeds Leila
Steel Marion
Stehle Peter
Stein Yvonne
Stockley Rosalind
Strasser Alison
Strasser Freddie
Sullivan E. Mary
Swynnerton Richard
Tarkow-Reinisch Lili
Taylor Marsha
Thompson Christine
Thompson Fiona
Thompson Patricia
Thornton Suzanne
Thorpe Ivan
Ticktin Stephen
Unsworth Gisela
van Deurzen Emmy
Ventham Brian
von Britzke Michaela
Walker Jillian
Walton Michael
Wanja Kirima Ruth

Warburton Kitty
Warren Yvonne
Weaver Carol
Weisensel Karin
Weixel-Dixon Karen
Wicks Alan
Wilks Frances
Williams Claerwen
Williams Jill
Williams Katherine
Wilson Carol
Wilson Shula
Wolf Darren
Woolf Tanya
Worrell Michael
Young Sarah
Zinovieff Nicholas

RE.V—Re.vision

Adams Eve
Bobsin Mica
Brady Kate
Brown Lesley
Butcher Marilyn
Carroll Helen
Crawford Joan
Dennis Suzanne
Duberry Mark
Findlay David Alistair
Freshwater Dawn
Frischer Livia
Holland Nicki
Hutchinson Gary
O'Connor Ann
Plowman Polly
Robertson Chris
Robertson Ewa
Ryall Sue
Towers Cathy
Tutton Catherine
Van Gogh Mark
Vibert Eva
Weinberg Jane
Woodroffe Roe

SIP—Severnside Institute for Psychotherapy

Allan Kay
Ash Robert
Batten Cecilia
Box Sally
Brown Ray
Brown Robin Gordon
Brown Robin Richard
Clacey Robert
Collens Louise
Cottman Barbara
Davies Sheila
de Hoogh-Rowntree Patricia
Dresser Iain
Elliott Lea K.
Forryan Barbara
Frye Helen
Gardner Fiona
Gell Eva
Gosling Pat
Gottlieb Sue

Gracie Jane
Green Sylvia
Grocott Annie
Hahn Herbert
Hancock Patricia
Hanley Marie
Harris Gordon
Hawdon Sheila
Hazell Jeremy
Hill Jenny
Holmes Jeremy
Hopkins Jill
James Glenys
James Pat
Jones Nicole
Matthews Carol
McNamara Barbara
Mitcheson Brown Muriel
Morris Stephen
Palmer Barnes Fiona
Patterson Linda
Pehrsson-Tatham Lena
Pocock Olga
Richards Christopher
Robinson Martin
Rowe Jill
Scovell Michael
Seigal Elizabeth
Shewan Doreen
Skailes Claire
Smith H Judith
Sproston Suzanne
Standish Elizabeth
Stones Christine
Tatham Peter
Telders Martina
Turner Philip
Tute Iris
Watkins Judy
Wedderkopp Abigail
Wilson Alexandra
Yariv Gail
Zeal Paul

SITE—The SITE for contemporary psychoanalysis

Adams Tessa
Armstrong-Perlman Eleanore
Azgad Rachel
Berry Sally
Brewer Madelyn
Cohen Sylvia
Davies Alison
de Leon Heather
Einhorn Sue
Ellis Mary Lynne
Evans Peter L.
Gray Kati
Greally Brid
Guild Liz
Gurney Paul
Hall Kirsty
Hill Penny
Hurd Joan
Kreeger Angela
Lloyd Elizabeth
Molino Anthony

Murdin Lesley
Nevins Peter
O'Connor Noreen
Oakley Haya
Parker Rosie
Pope Alan
Ryan Joanna
Ryan Tom
Sinclair Fiona
Stanwood Frederick
Swift Joanna
Townsend Heather
Voikhanskaya Marina
Zeal Paul

SPEC—Spectrum

Allsop Paul
Bennett Ross
Brennan Stan
Carruthers Dianna
Cooper Terry
Dahle Josephine
Doust Gill
Dryden Jan
Fletcher Joan
Gabriel Jill
Gotto Jane
Greaves Margaret
Hargreaves Judy
Hollings Avril
Lane Jeff
McKenzie Maggie
McNeil Delcia
Methuen Oriel
Naish Julia
Neal Charles
Paterson Stuart
Patterson Anna
Rose-Smith Gillian
Roth Jenner
Russell Marion
Salter Gill
Shreeves Rosa
Stone Anthony
Webster Sarah Craven
Widdicombe Howard
Williams Kate
Willmott Susan
Witt John

SPTI—The Sherwood Psychotherapy Training Institute

Allen Penny
Anderson Naomi
Atkinson Pamela
Avery Anna
Barley Andrew
Bassett George
Belle-Boule Annabell
Brown Kate
Browning Peter
Bryant Pat
Canon Sue
Carrette Timothy
Carton Roy
Catesby Cynthia
Clements Wendy

Cooper Jane
Coward Malcolm
Cullwick Joy
Davies Rae
Derrick Stephen
Drury Gitta
Dunn Michael
Eagle Gillian
Erskine Richard
Evans Kenneth
Evans Mairi M.
Fisher Paul
Fitzgerald Patricia
Fookes Andrew
George Stephen
Gilson Jean
Green Marion
Greville Coral
Hale Sue
Harris Richard
Hawksworth Janet
Hayman Penny
Hope David
Howard Tayler Jacky
Hutchby Rosemary
Jackson Diana
Janks Ann
Jordan Karen
Keen Caroline
Kennett Christine
Kerry Helen
Kitchin Duncan
Lake Dorry
Lavender Peter
Lehain Daniel
Leiper Elizabeth
Levett Ann
Loiseau Kate
Louw Francois
Malcolm Charles
Mann David
Marshall Clare
Marshall Pauline
Maudling Caroline
McFarlane Kay
Mitchell Paul Christoph
Moulding Jacqueline
Orlandi-Fantini Claire
Orlandi-Fantini Peter
Page Jonathan
Paris Jan
Pigott Sheila
Pugsley Stephanie
Quilter Sally
Rosenbaum Linda Ann
Sanders Harmen
Scott Combes Jacqueline
Senior Maggie
Sharpe Rob
Shaw Robert
Shmukler Diana
Short Deborah
Sless Deborah
Smith Cora
Spicer Robert
Spitz Shirley
Stalmeisters Dzintra
Stephens June
Straker Gill

Stratton-Woodward Sally
Tilley Alison
Victory Sian
Waterstone Carolyn
Whitworth Patricia
Wilkinson Heward
Wilkinson Kate

STTDP—South Trent Training in Dynamic Psychotherapy

Bailey James
Bradley Marie
Buckley Nicky
Denness Brian
Fisk Geoff
Headworth Jean
Jones Richard
Lee Helen
Marshall Pam
Norton Sheila
Randall Lynda
Ratigan Bernard
Schrvder Thomas
Smith David
Staines Jill
Stewart Naomi
Walker Catriona Jane
Whyte Chris
Young Raymond

TMSI—Tavistock Marital Studies Institute

Abse Susanna
Binnington Linda
Bollinghaus Elaine
Buss-Twachtmann Christel
Cleavely Evelyn
Clulow Christopher
Colman Warren
Cudmore Lynne
Daniell Diana
Daniels Orpa
Dearnley Barbara K.
Fullerton Peter B.
Hodson Pauline
Hughes Lynette
Judd Dorothy
Koppelman Liora
Millington Malcolm
Morgan Mary
Morley Elspeth
Oldman David
Olney Felicia
Pengelly Paul
Rosenthall Joanna
Tarsh Helen
Vincent Christopher
Wright Kenneth
Yass Marion

ULDPS—University of Leicester Diploma in Psychodynamic Studies

Dent Peter
Duffin Lorna

Dunn Elizabeth
East Patricia
Horrocks Pam
Hurwood Judith
Jacobs Michael
Jane Susan
Janickyj John
Jarrett Betty
Jewson Sue
King Gail
Madden Felicity W.
McFarland Alf
McKay Lynn
Peglar Graham
Strang Jenny
Walker Moira
Williams Sherly

UPA —Universities Psychotherapy Association

Adams Clare E A
Arcari Sallie R
Arzoumanides Yiannis
Bailey Lorna M
Beber Ray
Bennett John
Bhattacharyya Amit
Bibbey Judy
Boronska Teresa .W
Brittain Charlie
Brooks Cynthia M
Browne Chris
Burden Michele A
Burgin Hazel
Butler John
Byers Angela
Charlton Patricia .S.
Clarkson Petruska
Cohn Hans W.
Cole Laurence E
Davis John D
Davis Marcia L
Dixon Linda
Dorey Mary
Dudley Jane M
Duggan Conor
Dunn Mark
Elvin Gill R
Flacke Theresa
Flannery Jean
Gatti-Doyle Fiorella G.
Glover Nicholas
Greenwood Anthony
Griffiths E Anne
Güngör Dilek
Heller Fawkia
Henley Mavis G
Hershkowitz Annie
Hodgkiss Andrew
Huet Valerie
Jefford Adam
Jude Julia
Jupp Elizabeth
Kendall Tim
Keshet-Orr Judi
Knowles Elisabeth A
Lewis Kate A
Leygraf Bernd

Little Jon
Loewenthal Del
Lohman Frans
Low James
Lund Charles
Maloney Chris
McCabe Jennifer
Millar David
Miller Lynda R
Mitchell Diana
Morley Jane
Nolan Michael A
Norman Caroline
O'Neill Christopher J.
Pardoe Kathleen A
Pokorny Michael R
Pover Jane .S.E
Power Kevin
Raimes Peter
Rainsford Helena
Rapp Hilde
Ratigan Bernard
Rejaie Carol
Riding Nick
Rosenthal Hat A
Rowland Catherine
Schaedel Maggie
Schembri Veronica
Sexton Sylvia
Shipton Geraldine
Siret Eiran R
Smith David L.
Stern Julian
Strasser Freddie
Tantam Digby
Tibbetts Coral
Tomlin Minoo
Urquhart Peta A
van Deurzen Emmy
Waller Diane E
Ward Joseph B
Watson James P
Weaver David
White Lauren E
Winship Gary

**VAPP—Vaughan
Association of
Psychodynamic
Psychotherapists**

Dent Peter
Duffin Lorna
Dunn Elizabeth
East Patricia
Ellis Roger
Flanagan Diana
Horrocks Pam

Hurwood Judith
Jacobs Michael
Jane Susan
Janickyj John
Jarrett Betty
Jewson Sue
King Gail
Madden Felicity
McFarland Alf
McKay Lynn
Peglar Graham
Strang Jenny
Walker Moira
Williams Sherly

**WMIP—West Midlands
Institute of Psychotherapy**

Abberley Colette
Anderson Judith
Anees Nabil
Arthur Andrew R.
Barden Nicola
Barker John F.
Barrett James
Beedie Margaret
Birtle Janice
Blakey Angela
Bond Ann R.
Bray Jillyan
Brough Sue
Burke Robina
Burton Mary V.
Calvert Jane
Campbell Duine
Camps Thomas
Carlish Sonia
Cheshire Jane
Cooper Grahame F.
Cox Margaret
Crisp Jennifer
Curran Maureen
Davis Patrick
Elliott Lea K.
Ellis Blythe
Feasey Don
Fox Fiona
Fraser Douglas A.
Gilliver Catherine
Gladwell Stephen
Goodyear P A J
Groom Nigel A
Hamilton Jane
Harrington Leslie
Harvey Tricia A.
Hill Val
Hoag Linda M.
Hogg Rosemary

Holmes Dorothy
James Pat
Johnson Judy
Kahn Ashraf
Kenny Peter
Kingsley L.D
Liebling Angela J.
Lloyd Helen
Lowery I M
Mackenzie Ian D.
Madden Felicity W.
Male David F.
Maté Helen
McCormick Helen
McDonald James T
McFarland Alf
Mills Burton M.
Morley Ann
Myers Marion
Nicholas John
O'Connor Ann
Oakley Ian H.
Owen W Meredith
Pratt Sheila
Ratoff Tammy
Rentoul Robert W.
Reynolds Michael John
Roy Geraldine
Ryan Angella M.J.
Sadgrove Jenny
Samson Anne
Schaverien Joy
Shrimpton David W
Simpson Elizabeth
Skailes Claire
Speed Bebe
Spencer Margaret
Stokes Jenny
Taylor Vivienne
Toms David A.
Truckle Brian
Truckle Shirley
Tucker Joanna
Vallance Fiona
Van Marle Susanna J
Villia-Gosling Athina
Wattis Libby
Way Jean
Wheeler Sue
Wheeley Shirley
White H.
Williams Sherly
Winkley Linda
Woodward Joan
Wright W. Harry
Yates Kathleen

**WTC—The Women's
Therapy Centre**

Aird Eileen
Austin Susan
Berry Sally
Brennan Clare
Charalambous Praxoulla
Einhorn Sue
Gorman Susan
Hudson Inge
Kleinot Pamela
Meleagrou-Dixon Mando
Montero Isabel
Orbach Susie
Powell Angela
Ritchie Sheila
Smith Ruthie

**YAPP—Yorkshire
Association for
Psychodynamic
Psychotherapy**

Aylard Paul
Bolsover G.N.
Bonner Kate
Bostock Christine
Cann Lesley
Conlon Isobel
Courtney Mary
Daines Brian
Douglas Angela
Gilljam Annika
Godsil Susan
Gudjonsson Ingolf
Hanks Helga
Harrow Anne
Heenan Colleen
Hester Bridget A
Kennard David
Lancelot Maggie
Lewis Sheila
Martin Carol
Martin Gill
McCluskey Una
Oakley Ian H.
Page Annabel
Reilly Stephen
Rose Sally
Rowe Celly
Sidey Brian
Stokeld Alasdair
Syme Gabrielle
Tanna Nick
Vincent Jane
Wattis Libby
Webb Joan
Welsh Catherine

Multilingual Practitioners

Afrikaans

Allison Lyn
London South East

Botha Marie
Kent

Clarkson Petruska
London West

Davids Jennifer
London North West

Fowler Barry
Lancashire

Jogessar Yashmi
Sussex East

Law Gordon
Worcestershire

Lown Judy
Nkumanda Rachel
London South East

Poole Carol Lynn
Wiltshire

Salters Diane
Overseas-S.Africa

Sanders Harmen
Overseas-Netherlands

Vallance Fiona
West Midlands

Webster Jeni
Manchester

Akan

Ohene Margaret D.
London North

Amharic

Deres Mebrat
London South East

Arabic

Al Rubaie Talal
London North

Allawi Nadia
London South West

Bishay Nagy R.
Manchester

El-Hadi Ali
Essex

El-Khayat Redwan
Wiltshire

Heller Fawkia
London South West

Issa Soraya
Overseas–Australia

Azarbija

Rouhifar Zhila
Middlesex

Balineese

Hobart Angela
London West

Bengali

Bhattacharyya Amit
Northamptonshire

Hussain Nasima
Middlesex

Bulgarian

Pepper Marie
Cambridgeshire

Petkova Petia
Middlesex

Cantonese

Lau Annie
Essex

Teng Christina
Essex

Catalan

Campos Hanne
Overseas-Spain

Chinese

Chin John C L
Kent

Lau Bernard Wai Kai
Overseas-Hongkong

Tse Claude
Kent

Creole

Sawyerr Alice
London North West

Warnakula Amina Bibi
Essex

Croatia

Nielsen-Cernkovich Rudy
London Central

Peternel Franc
Overseas-Slovenia

Danish

Blow Kirsten
Oxfordshire

Jensen Greta
Johansson Birgitta
London North

Krause Inga-Britt
Bedfordshire

Looms Suzanne
Surrey

Malcolm Hanne
Scotland-Dundee

Patricia Thelma
Overseas-Norway

Veje Margit
Overseas-Denmark

Dutch

Bukovics-Heiller Birgit
Surrey

Burbach Frank
Somerset

Burck Charlotte
London North West

Carton Roy
Overseas-Netherlands

Clarkson Petruska
London West

De Boer Onno
London North West

De Jong Corrie
Hampshire

Doktor Ditty
Cambridgeshire

Draper Pim
County Durham

Du Ry Marc
London Central

Hiestand Rene
Cambridgeshire

Holve Harriet
Surrey

Lockie Gisela
Somerset

Lohman Fran
Lincolnshire

Maas Willem
Overseas

McDonnell Fokkina
Manchester

Mitchell Diana
Surrey

Rappard Marie Chalotte
Overseas

Schopman Els (Elisabeth)

Overseas-Netherlands

Tjepkema Froukje
Overseas-Netherlands

Van Bilsen Henck P.J.G.
Overseas-New Zealand

Van Der Wateren Jan-Floris
London West

Van Deurzen Emmy
Sheffield

Van Halm Corrie
Sussex East

Van Heel Carlien
London North West

Van Wijk Jacqueline
Overseas

Veling Rolf
London North

Wanless Anna
Hertfordshire

Farsi

Bathai Parizad
London North West

Farzim Pari
London North West

Ghiaci Golshad
London North

Rouhifar Zhila
Middlesex

Sharifi Pury
London North

Zarbafi Ali
London West

Finnish

Brown Ulla
Cambridgeshire

Byring Carola
London North

Gordon Leila
Cambridgeshire

Lettington Lisa
Kent

Ruismaki Marjo
Overseas-Finland

French

Adams Ghislaine
Buckinghamshire

Alexander Erica
Warwickshire

Alferoff Tamara
London North

Aquarone Luc-Remy
Norfolk

Asseily Alexandra
London West

Austin Susan
London North West

Ayres Kathleen
Sussex West

Banks Ron
Wiltshire

Barrows Paul
Avon

Basharan Harika
London West

Begg Ean
Scotland-Glasgow

Beguin Agnes
London West

Bensimon Marlene
London North

Bentovim Arnon
London North West

Bibby Keith
London South West

Birkett Diana
London South West

Black Teresa J.
Shropshire

Blackburn Ivy-Marie
Tyne & Wear

Blackburn Paul
Humberside

Boll Antonia
London South West

Bousfield Anne
Kent

Bowman Elizabeth
Sussex East

Boyesen Ebba
London West

Boyesen Gerda
London West

Bradley Jonathan
Browne Maureen
London West

Buckley Marie-Noîl (Billie)
London South West

Burck Charlotte
London North West

Burlington Maggie
London East

Burnet-Smith Tamara
Berkshire

Campos Hanne
Overseas-Spain

Campos Juan
Overseas-Spain

Canobbio Victoria
Overseas-Germany

Carr Brede
Surrey

Chalkley A.J.
Avon

Champion Lynn
Essex

China Giselle
London North West

China Jacques
London North

Christie Jim
Scotland-Glasgow

Clare Louise
Bedfordshire

Clifton Elaine
London South West

Coia Grace
Scotland-Glasgow

Colahan Mireille
London North West

Cole Shanti
Lancashire

Coles Walter
London South West

Conolly J M P
London North

Courtault Susie
London South West

Coxwell-White Jenny
Berkshire

Craddock Jenny
London North West

Crossling Paddy
Lancashire

Dachy Vincent
London Central

Danthois Didier
London North

Daudy Isabelle
Cambridgeshire

Davenport Marie-Laure
London North

Davis Joyce
London West

De Berker Patricia
Surrey

De Zulueta Felicity
London South East

Domb Yair
London North

Dorey Mary
Hertfordshire

Draper Rosalind
Hampshire

Drucquer Helen
Sheffield

Du Ry Marc
London Central

Duck Dorothy M.
Kent

Dupont-Joshua Aisha
Hampshire

Einzig Hetty
London North

Elliott Dena
London West

Farhi Nina
London North West

Ferid Heidi
London North West

Ficarra Berthe
London North West

Foguel Brenda
Overseas–France

Forti Laura
London North

Freeman Catherine
London North

Gagnere Maryline
Cambridgeshire

Gale Derek
Essex

Gauthier Jean-Baptise
Merseyside

Gavin Verity J
Overseas-France

Godsil Susan
Yorkshire West

Gorodensky Arlene
Middlesex

Gowrisunkur Jaya
Manchester

Graham Judith
London North

Green Charlotte H
London West

Grimshaw Francoise
Surrey

Haberlin Jane
London South West

Hadzanesti Nelly
London West

Haine Stephen R
London North West

Hall Guy
London North

Hallett Caroline
Hertfordshire

Hamilton-Duckett Paule
London North

Hanna Gilli
London Central

Hanna Hyams
Overseas-Switzerland

Hannon Sr. Mary Letizia
London North

Harris Tirril
London North

Hartnup Trevor
London South West

Haussman Rochelle
London North West

Henny Lindy
London South West

Hering-Josefowitz Pauline
Overseas-Switzerland

Heuer Gottfried
London West

Hoang Astrid
London East

Hobart Angela
London West

Hodges Jill
London Central

Holmes Jeremy
Devon

Houston Gaie
London North West

Howe Patricia
Somerset

Hussain Fakhir
Surrey

Hutton Francoise
Sussex East

Jackson Eve
London North

Jenkins Hugh
London South East

Jones Nicole
Devon

Julien Michael
Essex

Kelly Anne
Northern Ireland

Kerr Anna
London South East

Kerridge Petra
Overseas-Italy

Kirk Kate
Cheshire

Kohon Valli
Kolbuszewski Marianne
London South West

Korte Achim
London Central

Kutek Ann
London South West

Lafargue Martine
Northern Ireland

Lallah Regine
London North

Lemma Alessandra
London North West

Lendrum Susan
Scotland-Edinburgh

Leveque Brigitte
London West

Liddle Helen
Lancashire

Lloyd Elizabeth
Sussex East

Loiseau Kate
County Durham

Lousada Olivia
London North

Luden Maureen
Surrey

Macdonald Helen F.
Sheffield

Macdonald Laurie
London South East

Mackewn Jennifer
Avon

Maguire Anne
London Central

Maitlis Marion
Sheffield

Mandin Philippe
London North West

Marshall Antoinette
London North

Marshall Myra
Sheffield

Masoliver Chandra
London West

Massara Catharine
Hampshire

McAndrew Brigitte
Kent

McBride Nigel
London North

McEldowney Dennis
London West

Messner Hans Jorg
London North

Millais Suzy
London South West

Miller John Andrew
London North West

Mills Burton M.
Oxfordshire

Milne Frances
Scotland-Aberdeen

Milne Pamela J.E
Northamptonshire

Moja-Strasser Lucia
London North West

Molleson John Ivitsky
Scotland-Glasgow

Morgan Barbara
Hertfordshire

Morgan Sian
Cambridgeshire

Morris Monique
London North West

Morrish Susan
Kent

Mostaeddi Bahman
Middlesex

Nabarro Elizabeth
London North West

Nappez Sue
London South West

Neal Lalage
London South West

Nesbit Judith
London East

Nichols Hamish
Surrey

O'Cleary Susan
London North West

O'Connor Aine
Overseas-Ireland

O'Connor Nadia
Overseas-Ireland

O'Dwyer Annegret
Surrey

Pain Jean
Cambridgeshire

Passey Miranda
Isle Of Wight

Peltier Judy
Yorkshire West

Pepeli Hara
London North

Perriollat Munro Elizabeth
Manchester

Phillips Asha

Pirani Alix
Avon

Pitt Chris
Merseyside

Pocock Olga
Wiltshire

Polden Jane
Norfolk

Pollitzer Juliette
London South West

Porter Barbara
Oxfordshire

Purkiss Jane
Avon

Quoilin-Lebrun Michelle
Berkshire

Reddy Michael
Buckinghamshire

Reid Liz
London North

Reilly Nicole
Sussex West

Renoux Martine
London North

Reynal Carmen
Oxfordshire

Rhode Maria
London North West

Richards Val
London North

Ridgewell Margaret
Leicestershire

Robertson Zuleika
Devon

Robinson Felicity
Sheffield

Roddick Mary
Devon

Rosemary Margaret
Sheffield

Rosenfeld Angela
Sheffield

Rowan Chris
Yorkshire West

Rozenberg Rosette
London North

Ryley Brigitte
London South East

Sandbank Audrey
Surrey

Scarlett Jean
London North West

Shearman Christine
London East

Sheppard Fidler Angela
Surrey

Shipton Geraldine
Sheffield

Sills Charlotte
London West

Sinclair Alison
Cambridgeshire

Sinclair Fiona
Cambridgeshire

Smail Richard
London South West

Smith Gillian
Cambridgeshire

Smith H Judith
London West

Solomon Hester Mcfarland
London North West

Sookdeb S.
London North West

Soutar Sarah
Sussex East

Springford Kate
Sussex East

Stanton Martin
London South East

Stern Erika
Nottinghamshire

Stewart Ian
Nottinghamshire

Stone Martin
London North West

Struthers Cassandra
London South West

Szary Gerard
Cleveland

Tabak Carolyn
Surrey

Taussig Hanna
Cambridgeshire

Taylor Jill
Middlesex

Touton-Victor Patricia
London North West

Tuby Molly
London South West

Tutton Catherine
London North

Upton Jay
Surrey

Van Deurzen Emmy
Sheffield

Van Schoor Linda
London North

Velarde Dominique
Sussex East

Ward Dawn
Shropshire

Warnakula Amina Bibi
Essex

Watson Lindsay
London North West

Watters Tamara
Kent

Whatley Ann
Essex

White H.
London South West

Whittle Lorna
Cambridgeshire

Wieselberg Huguette
London North

Wigram Penny
London West

Wilson Jancis
Devon

Woods Roberts
London North West

Wren Pauline
Warwickshire

Wyse Hymie
Surrey

Young Sabine
London South West

Gaelic

Brankin Maire
Oxfordshire

Caird Elizabeth J.
Overseas-Ireland

German

Al Rubaie Talal
London North

Albrecht Gisela
London North

Albrighton Sylvia
London North West

Alder Roger
Buckinghamshire

Averbeck Marcus
Kent

Ayres Kathleen
Sussex West

Baum Stefanie
Gloucestershire

Bayley Eva
Surrey

Becker Amely
London North

Begg Deike
Scotland-Glasgow

Begg Ean
Scotland-Glasgow

Bierschenk John Henry
London North

Bishop Beata
London West

Bloomfield Irene
London West

Boening Joachim
London West

Boening Michaela
London West

Boyesen Ebba
London West

Boyesen Gerda
London West

Boyesen Mona Lisa
Overseas-Denmark

Brauner Rita
London North

Brieger Johanna
Yorkshire North

Briggs Margarete
Essex

Brosskamp Cornelia
Sussex East

Bukovics-Heiller Birgit
Surrey

Burnet-Smith Tamara
Berkshire

Campos Hanne
Overseas-Spain

Canobbio Victoria
Overseas-Germany

Catina Ana

Chesner Anna
London East

China Giselle
London North West

Christmann Cornelia
London North West

Cohn Hans W.
Surrey

Collard Patrizia C
London South West

Coombes Clare
Surrey

Coronas Ita
London South West

Coxwell-White Jenny
Berkshire

Crick Verena
Middlesex

Daniels Mo
Hampshire

David Anna
London East

De Laszo Alexandra
London North West

Deniflee Ursula
London South East

Dieffenbacher Jutta
Overseas-Germany

Draper Rosalind
Hampshire

Drury Gitta
Overseas-Spain

Durlach Stefan
Overseas-Australia

Ehlers Hella
London Central

Eiden Bernd
London West

Eisenbarth Heiner
Sussex East

Ferid Heidi
London North West

Flinspach Elisabeth
London North

Fox Almuth-Maria
Essex

Gessert Astrid
Dorset

Godsil Susan
Yorkshire West

Hanks Helga

Yorkshire West

Hanman Elke
London West

Harris Gordon
Oxfordshire

Haupts Brigitte
London West

Hauser Susan
London West

Hearst Lisbeth E
London North

Hedinger-Farrell Korinna
Surrey

Hedley Karen
Gloucestershire

Heinitz Karin
Kent

Heismann Elisabeth
London North

Heller Fawkia
London South West

Herbert Claudia
Oxfordshire

Herst Edward
London North West

Heuer Gottfried
London West

Hiller Ruth
London North

Hoang Astrid
London East

Hobart Angela
London West

Hock Gaby
Oxfordshire

Hudson Inge
London North

Jones Nicole
Devon

Karan Alexandra
London West

Karban Barbara
London North West

Kessel Inge
London North

Kohler Christiane

Korte Achim
London Central

Kuettner Enno
West Midlands

Landale Margaret
Oxfordshire

Landesmann Sonya
London North

Lendrum Susan
Scotland-Edinburgh

Leygraf Bernd
London North

Liddle Helen
Lancashire

Lude Jochen
London West

Lutyens Marianna
Oxfordshire

Mac Liam Fionnula
Overseas-Ireland

Mander Gertrud
London North West

Mansall Cordelia
Derbyshire

Marcus Marietta
London South West

Masterson Ingrid
Overseas-Ireland

Messner Hans Jorg
London North

Milne Frances
Scotland-Aberdeen

Netzer-Stein Antje
London South West

Nicholson Jane
Manchester

Niesser Arthur
Wales-North

Noack Miké
Devon

O'Dwyer Annegret
Surrey

Ogilvie Renata
Overseas-Australia

Ohnesorg Johanna
Overseas-Switzerland

Parker Niki
Kent

Pervoltz Rainer
Overseas-Germany

Pollack Angela
Overseas-Germany

Prall Werner
London North West

Preisinger Kristiane
London North West

Rabe Marie-Louise
Surrey

Reid Liz
London North

Reik Herta
London North West

Rheinschmiedt Otto
Wiltshire

Richards Val
London North

Richter Nicola
Hertfordshire

Ridley Wendy
London North

Rosenfeld Angela
Sheffield

Schaible Monika
London West

Schiemann Margot
London North West

Schimmelschmidt Michael
London North

Schoenfeld Hilde
London North West

Schreiber-Kounine Christa
Avon

Shearman Christine
London East

Smith Jonathan
London North

Smith Jonathan
London West

Soth Michael
Oxfordshire

Speyer Josefine
London North West

Steffens Dorothee
London South West

Stehle Peter
Sussex East

Steiner Monika Celebi
Buckinghamshire

Stern Erika
Nottinghamshire

Stewart Ian
Nottinghamshire

Stolte Eva
Hampshire

Strich Sabina
Oxfordshire

Stuart Lilly H.
London South East

Sucher Ingerborg
Essex

S¸Nkel Sue
London North

Syrett Karin
London West

Taussig Hanna
Cambridgeshire

Tute Iris
Avon

Twelvetrees Heidy
Kent

Van Bilsen Henck P.J.G.
Overseas-New Zealand

Wach Karin Marie
London South East

Ward Ruth
Lincolnshire

Weinrich Hildegard
London North West

Weisensel Karin
London North West

Wieland Christina
London North

Wilford Gerti
Surrey

Wilke Gerhard
London North West

Willis Sally
Surrey

Wittenberg Isca
London North West

Wyse Hymie
Surrey

Yallop Melanie
Surrey

Young Sabine
London South West

Ghanaian

Sawyerr Alice
London North West

Greek

Arzoumanides Yiannis
London West

Athanasiadis Loukas
Overseas-Greece

Cameron Anna
London North

Charalambous Praxoulla
London North

Economidou Nitsa
London South West

Eleftheriadou Zack
London North

Forbes Constanze N
Norfolk

Hadzanesti Nelly
London West

Haxell Susan
London North West

Ikkos George
Middlesex

Jackson Eve
London North

Layiou-Lignos Effie
Overseas-Greece

Luca-Stolkin Maria
London North

Luckcock Ronald Cosmo
London North

Mazaraki Angeliki
London East

Meleagrou-Dixon Mando
London West

Metaxa Jennie
London West

Morris Elizabeth
Gloucestershire

Mouratoglou Vassilis
London North West

Moutzoukis Chris
Overseas-Greece

Papadopoulos Renos
London East

Pepeli Hara
London North

Pericleous Christine
London North

Petkova Petia
Middlesex

Shaban Dervishe
London North

Simos Gregoris
Overseas-Greece

Spyropoulos Nick
Hertfordshire

Totman Maria
Kent

Vastardis Gethsimani

Villia-Gosling Athina
West Midlands

Wieland Christina
London North

Worrall Chrysoula
London North

Gujurati

Bhat Radha
London South East

Hormasji Faridoon
Essex

Nadirshaw Zenobia
London West

Parikh Prakash
London South West

Tanna Nick
Yorkshire West

Hebrew

Alferoff Tamara
London North

Altman Michelle
London Central

Aram Eliat
London North

Asheri Shoshi
London North

Azgad Rachel
London North

Baradon Tessa
London North

Berke Joseph
London North

Dana Mira
Overseas-Israel

Foguel Brenda
Overseas–France

Gal Oshrat
London North West

Gaster Yishai
London North West

Gurion Michal
London North

Hadary Gideon

Hanna Hyams
Overseas-Switzerland

Harlap Nahum
London North West

Heitzler Morit
Overseas-Israel

Lederman Tsafi
London North

Levitsky Patricia D.
Buckinghamshire

Marcus-Jedamzik Deena
London North

Naor Lillie
London North

Oakley Haya
London North West

Rabin Judith
London North West

Rozenberg Rosette
London North

Schonfield Tamar
London North

Shapiro Adella
London North

Singer Iris
Middlesex

Spitzer Shayne
London North

Spyer Natalie
London North West

Steiner Monika Celebi
Buckinghamshire

Taussig Hanna
Cambridgeshire

Weaver Ziva
London North

Weider Bilha
London North West

Heldakiew

Teng Christina
Essex

Hindi

Bhat Radha
London South East

Cariapa Illana
Yorkshire South

Dayal Mahendra Singh
West Midlands

Husain-Shackle Shakrukh
London North West

Magriel Nicolas
London North West

O'brian Charles
Overseas-Hong Kong

Sookdeb S.
London North West

Hindustani

Hussain Fakhir
Surrey

Hussain Nasima
Middlesex

Hungarian

Bishop Beata
London West

Lanczi Katalin
Kent

Marcus Marietta
London South West

Moja-Strasser Lucia
London North West

Ormay Tom
London North West

Sipos-Sarhandi Zsusza
London Central

Vibert Eva
London Central

Icelandic

Gudjonsson Ingolf
Sheffield

Sveinsdottir Bjorg
London North

Igbo

Azu-Okeke Okeke
London South West

Iranian

Hussain Fakhir
Surrey

Irish

Alder Helena
Buckinghamshire

Murphy Ger
Overseas-Ireland

Italian

Arbia G. Nicoletta
London West

Benvenuto Bice
Oversea- Italy

Boll Antonia
London South West

Buckley Marie-Noîl (Billie)
London South West

Burnet-Smith Tamara
Berkshire

Canobbio Victoria
Overseas-Germany

Cardile Pietro
London West

Casatello Giovanna
London West

Coia Grace
Scotland-Glasgow

Corlando Annalisa
Overseas-Italy

Coronas Ita
London South West

Curti-Gialdino Francesca
London North

Davies Judy
Cambridgeshire

De Zulueta Felicity
London South East

Deres Mebrat
London South East

Dianin Gianni
London North

Doe Anthony
London West

Forti Laura
London North

Garcia-Llovona Cristina M
London West

Gatti-Doyle Fiorella G.
London South West

Hannon Sr. Mary Letizia
London North

Harris Tirril
London North

Hirst Diane Zervas
London West

Jacques Glenys
London East

Kenny Vincent
Overseas-Italy

Lemma Alessandra
London North West

Lunardon Francesco
London North West

Maitlis Marion
Sheffield

Mallardo Renee
Devon

Marrone Mario
London North West

Masoliver Chandra
London West

Mason Letizia
Buckinghamshire

Mellows David
London North

Mendelsohn Annette
London North West

Messner Hans Jorg
London North

Micciarelli Felicia
London South West

Molino Anthony
Overseas-Italy

Mondadori Roberta
London North West

Morante Flavia
London West

Morrish Susan
Kent

O'Dwyer Annegret
Surrey

Panetta-Crean Simona
London North

Patalan Anna-Maria
London North West

Pavincich Lesley
London South West

Pegoraro Carla
Oxfordshire

Pozzi Maria E.
Hertfordshire

Ruggieri Gloria
Oxfordshire

Sabbadini Andrea
London North

Salole Roy
Overseas-Canada

Seu Irene Bruna
London North West

Sidoli Mara
Overseas-Usa

Smith H Judith
London West

Spinelli Ernesto
London South East

Tabak Carolyn
Surrey

Toole Stuart
West Midlands

Usiskin Judith
London North

Vaciago Smith Marta
Yorkshire West

Wilson Teresa
London South West

Japanese

Nippoda Yuko
London West

Kannada

Shivakumar H.
London North West

Kikuyu

Ngone Mary
Hertfordshire

Luganda

Sabayinda Michael
Essex

Malay

Ngah Zah
London North

Singh Satwant
London North

Maltese

Caruana Charles Victor
London South East

Vella John
Overseas–Malta

Mandarin

Lau Annie
Essex

Mcvey Damien
Merseyside

Marati

Bhat Radha
London South East

Ndebele

Mudarikiri Maxwell Magondo
London South East

Norwegian

Balmbra Steven
Overseas-Norway

Boyesen Ebba
London West

Boyesen Gerda
London West

Boyesen Mona Lisa
Overseas-Denmark

Bukovics-Heiller Birgit
Surrey

Holm Kirsti E.
London North West

Jenssen Einar D.
London North

Patricia Thelma
Overseas-Norway

Tajet-Foxell Britt
London South West

Persian

Collins Leila
Hertfordshire

Polish

Czubinska Grazyna
London South East

Drewnowska Alicja
Middlesex

Gulcz Magdalena
London North West

Hanchen Thomasz
London South East

Kolbuszewski Marianne
London South West

Kowszun Grazyna
London South East

Kutek Ann
London South West

Stevenson Krystyna
London North

Wojciechowska Ewa
Yorkshire North

Portuguese

Bacha Claire
Manchester

Casson Isabel
Hampshire

De Souza Joney
Overseas-Brazil

Elliott Lea K.
Gloucestershire

Kujawski Pedro
London West

Leite Da Costa Mariza
Essex

Love Jasminder Kaur
Hertfordshire

Machado Danuza
London North West

Mazure David
London North

Morante Flavia
London West

Pimentel Edna
London North

Rotenberg Claudio

Salles Miriam
London North

Samson Andre
Overseas-Brazil

Sell Patrick
London West

Punjabi

Dayal Mahendra Singh
West Midlands

Husain-Shackle Shakrukh
London North West

Krause Inga-Britt
Bedfordshire

Romanian

Airey Gabriela
London North West

Catina Ana

Gabriela Airey
London North West

Moja-Strasser Lucia
London North West

Russian

Lowery I M
West Midlands

Petkova Petia
Middlesex

Pocock Olga
Wiltshire

Sizikova Tanya
Overseas-Russia

Voikhanskaya Marina
Cambridgeshire

Serb-Croat

Bozovic Zoran
London West

Harling Biljana
Sussex West

Kostic Jasna
London North

Manojlovic Jelena
London West

Markovic Desa
London Central

Markovic Olivera
Lancashire

Papadopoulos Renos
London East

Peternel Franc
Overseas-Slovenia

Renton Mirjana
London North West

Shona

Mudarikiri Maxwell Magondo
London South East

Slovenian

Nielsen-Cernkovich Rudy
London Central

Peternel Franc
Overseas-Slovenia

Pugh Anna

Shawe-Taylor Metka
Surrey

Sotho

Makgoba Sindi
London North

Spanish

Acquarone Stella
London North West

Aguirregabiria Ana
London South West

Amez Susana
Hampshire

Arredondo Beverly
Gloucestershire

Attias Sandra
London South East

Bacha Claire
Manchester

Baker Jan
London West

Batten Cecilia
Gloucestershire

Begg Ean
Scotland-Glasgow

Blair Dana-Jane
London North

Bowman Elizabeth
Sussex East

Burnet-Smith Tamara
Berkshire

Campos Hanne
Overseas-Spain

Campos Juan
Overseas-Spain

Catovsky Mina
London West

Coronas Ita
London South West

De Souza Janice
Wiltshire

De Zulueta Felicity
London South East

Dianin Gianni
London North

Drury Gitta
Overseas-Spain

Feldberg Tom
London North West

Fiasche Mara
London North West

Garcia-Llovona Cristina M
London West

Gracia Olga
Sussex East

Graham Judith
London North

Green Eliott
Kent

Hanman Elke
London West

Hayward Marjorie
Lancashire

Heuer Gottfried
London West

Ibanez Julian
Overseas-Spain

Lema Juan Carlos
London North West

Lew Clara
Cambridgeshire

Lohman Fran
Lincolnshire

Looms Suzanne
Surrey

Loret De Mola Maria
London North West

Luden Maureen
Surrey

Lunardon Francesco
London North West

Maitlis Marion
Sheffield

Marrone Mario
London North West

Masoliver Chandra
London West

Mendoza Hilda
London West

Millais Suzy
London South West

Montalbetti M.L.
Overseas-Peru

Montero Isabel
London North

Mulhern Alan
London North

Oclander Goldie Silvia
London North West

O'Leary Carmen
London East

Pain Jean
Cambridgeshire

Patalan Anna-Maria
London North West

Penalosa-Clarke Adriana
London North

Rae Frances
Kent

Reddy Michael
Buckinghamshire

Reynal Carmen
Oxfordshire

Robinson Ferga
London South East

Russell Margo
Overseas-Sweden

Ryz Patsy
London North

Sinclair Alison
Cambridgeshire

Smith H Judith
London West

Stone Martin
London North West

Szary Gerard
Cleveland

Testa Rita
London North West

Turner Carole
Overseas-Spain

Valentine Victoria
London North

Wheeler Maria
Hertfordshire

Young Sabine
London South West

Swahili

Ngone Mary
Hertfordshire

Swedish

Bradshaw-Tauvon Kate
Overseas-Sweden

Burns-Lundgren Eva
Surrey

Frischer Livia
Overseas-Sweden

Furst Lena
Surrey

Gildebrand Katarina
London North West

Gilljam Annika
Yorkshire West

Hagelthorn Christina
Overseas-Sweden

Harley Ki
London North

Isaksson-Hurst Gun I.E.
London North West

Johansson Birgitta
London North

Kjellstrom Laila
Scotland-Edinburgh

Krause Inga-Britt
Bedfordshire

Lindley-Jones Kerstin
Oxfordshire

Massara Catharine
Hampshire

Patricia Thelma
Overseas-Norway

Pehrsson-Tatham Lena
Devon

Perera Ajit
Surrey

Ruismaki Marjo
Overseas-Finland

Sandler Topsy
Overseas-Sweden

Seymour Charlotte
London North

Smith Eva
Oxfordshire

Sullivan Anita
London North West

Tajet-Foxell Britt
London South West

Tham Anna
Wiltshire

Swiss Twelvetrees Heidy
Kent

Tamil

Venki Malathi
Dorset

Tigrigna

Deres Mebrat
London South East

Turkish

Basharan Harika
London West

Boysan Zehra
Sheffield

Bray Stephen
Dorset

Güngör Dilek
London North

Shaban Dervishe
London North

Sungur Mehmet Z
Overseas-Turkey

Yazar Jale
London South East

Yusef Dori Fatima
Essex

Urdu

Abbasi Shafika
London North West

Bhat Radha
London South East

Dayal Mahendra Singh
West Midlands

Husain-Shackle Shakrukh
London North West

Hussain Nasima
Middlesex

Magriel Nicolas
London North West

O'Brian Charles
Overseas-Hong Kong

Parikh Prakash
London South West

Welsh

Bisgood Bill
Wales-South

Davies Dilys
Leicestershire

Davies John
Sheffield

Davies Mairlis
Wales-South

Davies Rosina
Wales-South

Ellis Sian
Essex

Howes Kathleen Mary
Wales-South

Hughes Lynette
Wales-North

Kendrick Margaret
Essex

Lloyd Elizabeth
Sussex East

Morgan Sian
Cambridgeshire

Thomas Jenny
Wales-South

Xhoga

Makgoba Sindi
London North

Yiddish

Rozenberg Rosette
London North

Yoruba

Azu-Okeke Okeke
London South West

Zimbabwean

Jiah Hildah
London South East

Zulu

Makgoba Sindi
London North

Contact Information

1 Analytical Psychology Section

Association of Jungian Analysts
Flat 3
7 Eaton Avenue
London NW3 3EL
Tel: 020 7794 8711

Confederation of Analytical Psychologists
148 Mercers Road
London N19 4PX

Independent Group of Analytical Psychologists
PO Box 1175
London W3 6DS
Tel: 020 8993 3996

2 Behavioural and Cognitive Psychotherapy Section

British Association for Behavioural and Cognitive Psychotherapies
PO Box 9
Accrington
Lancashire BB5 2GD
Tel: 01254 875277

3 Experiential Constructivist Therapies Section

Association for Neuro-Linguistic Programming
PO Box 78
Stourbridge
West Midlands DY8 4ZJ
Tel: 01254 875277

Centre for Personal Construct Psychology
The Sail Loft
Mulberry Quay
Falmouth TR11 3HD

Society for Existential Analysis
BM Existential
London WC1N 3XX
Tel. 07000 473337

4 Family, Couple, Sexual, and Systemic Therapy Section

The Association for Family Therapy and Systemic Practice in the UK
Administrator: Sue Kennedy
12 Mabledon Close
Heald Green
Cheadle
Cheshire SK8 3DB
Tel: 01925 26445

British Association of Sexual and Relationship Therapy
PO Box 13686
London SW20 9ZH
Tel: 020 8543 2707

The Family Institute, Cardiff
105 Cathedral Road
Cardiff CF1 9PH
Tel: 029 2022 6532

Institute of Family Therapy
24–32 Stephenson Way
London NW1 2HX
Tel: 020 7391 9150

Kensington Consultation Centre
2 Wyvil Court
Trenchold Street
London SW8 2TG
Tel: 020 7720 7301

5 Humanistic and Integrative Psychotherapy Section

Association of Accredited Psychospiritual Psychotherapists
21 Silverston Way
Stanmore HA7 4HS
Tel: 020 8954 2504

Association of Cognitive Analytic Therapists
4th Floor North Wing
Division of Academic Psychiatry
St. Thomas' Hospital
Lambeth Palace Road, London SE1 7EH
Tel: 020 7928 9292 ext. 3769

Association of Humanistic Psychology Practitioners
BCM AHPP
London WC1N 3XX
Tel: 0345 660326

Bath Centre for Psychotherapy and Counselling
1 Walcot Terrace
London Road
Bath BA1 6AB
Tel: 01225 466635

British Psychodrama Association
Heather Cottage
Rosneath
Helensburgh
Argyll Bute G84 0RF

Centre for Counselling & Psychotherapy Education
Beauchamp Lodge
2 Warwick Crescent
London W2 6NE
Tel: 020 7266 3006

Centre for Transpersonal Psychology
86a Marylebone High Street
London W1M 3DE
Tel: 020 7935 7350

Chiron Centre for Body Psychotherapy
26 Eaton Rise
London W5 2ER
Tel: 020 8997 5219

The Gerda Boyesen Centre
170 Goldhawk Road
London W12 8ER
Tel: 020 8743 2437

The Gestalt Centre, London
First Floor, 62 Paul Street
London EC2A 4NA
Tel: 020 7613 4480

Gestalt Psychotherapy Training Institute
PO Box 2555
Bath BA1 6XR
Tel: 01225 482135

The Institute of Psychosynthesis
65a Watford Way
Hendon
London NW4 3AQ
Tel: 020 8202 4525

Institute of Transactional Analysis
6 Princes Street
Oxford OX4 1DD
Tel: 01865 728012

The Institute for Arts in Therapy and Education
The Windsor Centre
Windsor Street
London N1 8QL
Tel: 020 7704 2534

Karuna
Natworthy Manor
Widecombe in the Moor
Newton Abbot
Devon TQ13 7TR
Tel: 01647 221457

London Association of Primal
Psychotherapists

West Hill House
6 Swains Lane
London N6 6QU
Tel: 020 7267 9616

The Metanoia Institute

13 North Common Road
London W5 2QB
Tel: 020 8579 2505

The Minster Centre

Unit 1/2 Drakes Court Yard
291 Kilburn High Road
London NW6 7JR
Tel: 020 7372 4940

Northern Guild for Psychotherapy

77 Acklam Road
Stockton on Tees
Cleveland TS17 7BD
Tel. 01642 649004

North Staffs. Association for Psychotherapy

87 Basford Bridge Road
Cheddleton
Staffordshire ST13 7EQ
Tel: 01538 361193

Psychosynthesis and Education Trust

92/94 Tooley Street
London SE1 2TH
Tel: 020 7403 2100

Regent's College School of Psychotherapy
and Counselling

Regent's College
Inner Circle
London NW1 4NS
Tel: 020 7487 7406

Re.Vision

97 Brondesbury Road
London NW6 6RY
Tel: 020 8357 8881

The Sherwood Psychotherapy Training
Institute

Thiskney House
2 St James Terrace
Nottingham NG1 6FW
Tel: 020 8340 0426

Spectrum

7 Endymion Road
London N4 1EE
Tel: 0181 341 227/
0181 340 0426

6 Hypno-Psychotherapy Section

British Autogenic Society

c/o Royal London Homeopathic Hospital
Great Ormond Street
London WC1M 3HR
Tel: 020 7713 6336

Centre Training School for Hypnotherapy
and Psychotherapy

145 Chapel Lane, Longton
Preston PR4 5NA
Tel: 01772 617663

The National College of Hypnosis and
Psychotherapy

12 Cross Street
Nelson
Lancs BB9 7EN
Tel: 01282 699378

The National Register of Hypnotherapists
and Psychotherapists

12 Cross Street
Nelson
Lancs BB9 7EN
Tel: 01282 699378

National School of Hypnosis and
Psychotherapy

28 Finsbury Park Road
London N4 2JX
Tel: 020 7354 9938 (referrals)
020 7359 6991 (training)

**7 Psychoanalytic and
Psychodynamic Section**

Arbours Association

6 Church Lane
London N8 7BU
Tel: 020 8340 7646

Association for Group and Individual
Psychotherapy

1 Fairbridge Road
London N19 3EW
Tel: 020 7272 7013

The Association of Independent
Psychotherapists

PO Box 1194
London N6 5PW
Tel: 020 7700 1911

British Association of Psychoanalytic and
Psychodynamic Psychotherapy Supervisors

PO Box 275
Dorking RH4 1YR

Cambridge Society for Psychotherapy

41 Beaulands Close
Cambridge CB3 1JL
Tel: 01223 510229

Centre for Attachment Based
Psychoanalytic Psychotherapy

CAPP Admin., 58a High Street
Heathfield
East Sussex TN21 8JB
Tel: 020 7794 4306

Centre for Freudian Analysis and Research

76 Haverstock Hill
London NW3 2BE
Tel: 020 7267 3003

Centre for Psychoanalytical Psychotherapy

538 Finchley Road
London NW11 8DD
Tel: 020 8922 8551

Centre for the Study of Psychotherapy

Kent Research and Development Centre
University of Kent
Canterbury CT2 7PD
Tel: 01227 764000 x3691

Forum for Independent Psychotherapists

167 Sumatra Road
London NW6 1PN
Tel: 020 8806 3655

Foundation for Psychotherapy and
Counselling (WPF)

607 The Chandlery
50 Westminster Bridge Road
London SE1 7QY
Tel: 020 7721 7660

Guild of Psychotherapists

149 Faraday Road
London SW19 8PA
Tel: 020 7540 4454

Guildford Centre for Psychotherapy

PO Box 63
Guildford
Surrey GU1 2UZ
Tel: 01483 560607

Hallam Institute of Psychotherapy

PO Box 1098
S20 7YQ

Institute of Group Analysis

1 Daleham Gardens
London NW3 5BY
Tel: 020 7431 2693

Institute of Psychotherapy and Social
Studies

West Hill House
6 Swains Lane
London N6 6QU
Tel: 020 7284 4762

Liverpool Psychotherapy Diploma
Organisation

Treasurer & Membership Secretary
Denton House
Mental Health Resource Centre
Denton Drive, Northwich CW9 7LU
Tel: 01606 353800

London Centre for Psychotherapy

32 Leighton Road
London NW5 2QE
Tel: 020 7482 2002/2882

NAFSIYAT

278 Seven Sisters Road
London N4 2HY
Tel: 020 7263 4130

Northern Association for Analytical
Psychotherapy

Consulting Room
Post Office Cottage
Mickley
Stocksfield
Northumberland NE43
Tel: 01661 842727

North West Institute for Dynamic
Psychotherapy

c/o Dr Graeme McGrath
Gaskell House Psychotherapy Service
Swinton Grove
Manchester M13 0EU
Tel: 0161 273 2762

Philadelphia Association

4 Marty's Yard
17 Hampstead High Street
London NW3 1PX
Tel: 020 7794 2652

Severnside Institute for Psychotherapy

Administration Secretary:
Vivien Hagen
11 Orchard Street
Bristol BS1 5EH
Tel: 01275 333266

South Trent Training in Dynamic
Psychotherapy

c/o The Department of Psychology,
1 St Ann's Road,
Lincoln LN2 5RA
Tel: 01552 512000

Tavistock Marital Studies Institute

Tavistock Centre
120 Belsize Lane
London NW3 5BA
Tel: 020 7263 6200

The Site for Contemporary Analysis

37c Cromwell Avenue
London N6 5HN
Tel: 020 8374 5934

Vaughan Association of Psychodynamic
Psychotherapists

Department of Adult Education
Vaughan College, St. Nicholas Circle
Leicester LE1 4LB
Tel: 0116 251 7368

West Midlands Institute of Psychotherapy

Rooms 123/124, First Floor Gazette
Building
168 Corporation Street
Birmingham B4 6TF
Tel: 0121 248 4450

Westminster Pastoral Foundation
23 Kensington Square

23 Kensington Square
London W8 5HN
Tel: 020 7937 6956

Women's Therapy Centre

6–9 Manor Gardens
London N7 6LA
Tel: 020 7263 6200

Yorkshire Association for Psychodynamic
Psychotherapy

5a Westgate
Otley
West Yorkshire LS21 3AT
Tel: 01943 851110

**8 Psychoanalytically-based Therapy
with Children**

Association of Child Psychotherapists

120 West Heath Road
London NW3 7TU
Tel: 020 8458 1609

Forum for the Advancement of Educational
Therapy and Therapeutic Teaching

13 Highbury Terrace
London N5 1UP
Tel: 020 8226 8103

Institutional Members

Tavistock Clinic

120 Belsize Lane
London NW3 5BA
Tel: 020 7435 7111

Universities Psychotherapy Association
(UPA)

35 Linden Walk
Louth LE1 7DR
Tel: 01507 610746

Special Members

British Psychological Society

St Andrews House
48 Princess Road East
Leicester LE1 7DR
Tel: 0116 254 9568

Royal College of Psychiatrists

17 Belgrave Square
London SW1X 8PG
Tel: 020 7235 2351

Friend of the Council

British Association for Counselling

1 Regent's Place
Rugby
Coventry
CV21 2PJ
Tel: 01788 578328

Multi-affiliated Members

List of psychotherapists with more than one membership affiliation

A

Adams Tessa, *GUILD, SITE*
Aird Eileen, *NAAP, WTC*
Allan Kay, *FPC, SIP*
Anderson Elizabeth, *AGIP, FIP*
Armstrong-Perlman Eleanore, *GUILD, SITE*
Arzoumanides Yiannis, *RCSPC, UPA*
Ashcroft Dinah, *GPTI, MET*
Astor Bronwen, *AGIP, GCP*
Austin Susan, *ARBS, WTC*

B

Bacha Claire, *IGA, NWIDP*
Bamber James, *AJA, IGA*
Bar Vivien, *CFAR, GUILD*
Barry Anne, *NSAP, AGIP*
Beard Hilary, *ACAT, GUILD*
Beazley-Richards Joanna, *MET, ITA*
Becker Amely, *AHPP, GCL*
Beecher-Moore Naona, *AAPP, AHPP*
Berry Sally, *ARBS, SITE, WTC*
Birkett Diana, *CPP, FIP*
Blackwood Renate, *FPC, GCP*
Blandy Evanthe M, *ACP, GUILD*
Blum Anita, *BASRT, FPC*
Blyth Fiona, *MET, ITA*
Bolsover G.N., *HIP, YAPP*
Bostock Christine, *HIP, YAPP*
Boyden Christina, *ANLP, NSHAP*
Bradley Jonathan, *ACP, CPP*
Bradley Lorne–Natalie, *CPP, FIP*
Brauner Rita, *MET, NAFSI, ITA*
Brewer Madelyn, *FIP, SITE*
Bridge Jenny, *MET, ITA*
Brittain Charlie, *CCPE, UPA*
Brock Sue, *AHPP, ANLP*
Brown Lesley, *GPTI, RE.V.*
Buckingham Linda, *ACP, GUILD*
Buckley Judy, *FIP, IPSS*
Buckley Nicky, *ARBS, STTDP*
Bukovics-Heiller Birgit, *AHPP, MET, ITA*
Burnet-Smith Tamara, *AHPP, BAS*
Bury Dennis R., *BABCP, CPCP*
Butler John, *NRHP, UPA*
Butler Todd, *GPTI, MET*

C

Campbell Margaret, *AAPP, CFAR*
Chandler Philip, *GUILD, UPA*
Chapman Sandy, *CAP, FIP*
Chappell Claire, *CTP, FAETT*
Christopher Elphis, *CAP, FIP*

Clarke Susan Elizabeth, *ACAT, BABCP*
Clarkson Petruska, *AHPP, UPA*
Claxton Brenda, *AHPP, MC*
Clevely Sarah, *MET, ITA*
Cohen Sylvia, *GUILD, SITE*
Cohn Hans W., *RCSPC, UPA*
Collis Whiz, *AHPP, BCPC*
Conlon Isobel, *NWIDP, YAPP*
Cooper Cassie, *AIP, CPCP*
Cooper Grahame F., *BASRT, WMIP*
Cooper Robin, *IGA, PA*
Corneck Susan, *AGIP, FIP*
Coronas Ita, *AHPP, GCL*
Critchley Bill, *GPTI, MET*
Cronin Jeremiah, *CSPK, GUILD*
Cunningham Diane J, *AGIP, CSPK*
Cunningham Valerie, *MET, ITA*

D

Daines Brian, *BASRT, HIP, YAPP*
David Ann, *MET, ITA*
Davies Ann, *AGIP, FIP, GCP*
de Berker Patricia, *FIP, GCP*
de Berker Paul, *FIP, GCP*
de Hoogh-Rowntree Patricia, *CAP, SIP*
Dean Paul, *IATE, MET*
Dean Sally, *FPC, IGA*
Dent Peter, *ULDPS, VAPP*
Dianin Gianni, *ARBS, FIP*
Dighton Rosemary, *BASRT, KCC*
Dixon Linda, *HIP, UPA*
Dixon-Nuttall Rosemary, *AGIP, FPC*
Dobbs Wendy, *AGIP, FIP*
Dorey Mary, *AIP, UPA*
Duckham Jennifer, *CAP, IGA*
Duckworth Moira, *AJA, FPC*
Duncan Ursula, *NGP, ITA*
Dunn Mark, *ACAT, UPA*

E

Eaton John, *ANLP, NSHAP*
Eiden Bernd, *AHPP, CCBP*
Eiles Clive, *ARBS, FIP*
Einhorn Sue, *IGA, SITE, WTC*
Eleftheriadou Zack, *NAFSI, RCSPC*
Elliott Lea K., *SIP, WMIP*
Ellis Michael, *AHPP, GCL*
Ellis Sian, *AGIP, FIP*
Evans Peter L., *ACP, SITE*

F

Farquhar Kate, *CFAR, FIP*
Farrell Margaret, *CSP, GUILD*
Ferid Heidi, *CAPP, IPSS*
Fischer Michael, *IGA, NWIDP*
Fish Sue, *GPTI, IATE, ITA*
Flannery Jean, *AGIP, UPA*

Francis Anne M., *AGIP, FIP, GCP*
Fry Julie, *GPTI, MET*

G

Galloway Betsy, *NGP, ITA*
Gardiner Margaret, *AGIP, FIP*
Gardner Damian, *BABCP, SPTI*
Garlovsky Rita, *GUILD, HIP*
Gatti-Doyle Fiorella G., *CPCP, RCSPC, UPA*
Gawler-Wright Pamela, *ANLP, NSHAP*
Ghiaci Golshad, *FIP, PA*
Gilbert Maria, *GPTI, MET, ITA*
Gildebrand Katarina, *MET, ITA*
Gilljam Annika, *GUILD, YAPP*
Gladstone Guy, *AHPP, IPSS*
Goodfellow Joanna, *GPTI, MET*
Gordon Paul, *IPSS, PA*
Gorman Susan, *IGA, WTC*
Gosling Pat, *GUILD, SIP*
Graham Marilyn, *GPTI, MET*
Gray Kati, *GUILD, SITE*
Greally Brid, *FPC, SITE*
Greaves Sarah, *CSP, GUILD*
Greenfield Terence Aubrey, *BABCP, NRHP*
Greening Sarah, *NGP, ITA*
Groom Nigel A, *FPC, WMIP*
Gudjonsson Ingolf, *HIP, YAPP*
Guest Hazel, *AHPP, CTP*
Güngör Dilek, *NAFSI, UPA*

H

Hall Kirsty, *ARBS, FIP, SITE*
Hamblin David, *AAPP, BCPC*
Hanks Helga, *KCC, YAPP*
Harari Michael, *ACP, CAP*
Hargaden Helena, *MET, ITA*
Harley Ki, *MET, ITA*
Harling Biljana, *MET, ITA*
Harrow Anne, *IGA, YAPP*
Harvey Tricia A., *ACP, WMIP*
Harward Matthew, *ARBS, IGAP*
Hashemi Beth, *FIP, FPC, GCP*
Hatswell Valerie, *FIP, GCP*
Hawkes Bernadette, *IPSS, NAFSI*
Hawkins Peter, *AHPP, BCPC*
Headworth Jean, *HIP, STTDP*
Heath Christine, *ACP, AFT*
Henriques Marika, *AHPP, GUILD*
Hester Bridget A, *LPDO, YAPP*
High Helen, *ACP, FAETT*
Hoag Linda M., *GUILD, WMIP*
Hodgkiss Andrew, *CFAR, UPA*
Homer Marjorie, *NGP, ITA*
Hopkins Jill, *GUILD, SIP*
Hopping Geoff, *MET, ITA*
Hopwood Jean, *FIP, GCP*

Hopwood Michael, *FIP, GCP*
Houghton Christine, *GPTI, MET*
Hudson Inge, *IGA, WTC*
Hughes Jacqui, *GPTI, MET*
Hughes Jennifer, *CSPK, FPC*
Hughes Lynette, *NWIDP, TMSI*
Hunt Patricia A, *BASRT, NWIDP*
Hurd Joan, *PA, SITE*
Hyde Keith, *IGA, NWIDP*

I

Ingham Nida, *BAS, CCP*

J

Jacques Glenys, *AHPP, GPTI*
James Pat, *SIP, WMIP*
Jesson Alison, *MET, ITA*
Johnson Janette, *NGP, ITA*
Johnson-Smith Camilla, *AHPP, LCP*
Joyce Philip, *GPTI, MET*
Judd Dorothy, *ACP, TMSI*

K

Kalisch David, *AAPP, AHPP*
Kearns Anne, *GPTI, MET*
Kelly Caro, *GPTI, MET*
Kennard David, *IGA, YAPP*
Kennedy Des, *GPTI, MET*
Kennett Christine, *GPTI, SPTI*
Keshet-Orr Judi, *AHPP, BASRT, UPA*
Kinder Diana, *CPP, IGA*
King Lucy, *CSP, PA*
Kleinot Pamela, *ARBS, WTC*
Kowszun Grazyna, *AHPP, MET*

L

Labworth Yig, *AAPP, BCPC*
Lancelot Maggie, *NWIDP, YAPP*
Lapworth Phil, *MET, ITA*
Lawrence Yvonne, *NGP, ITA*
Leiper Elizabeth, *GPTI, MET, SPTI*
Leon Sara, *AHPP, IATE*
Lepper Georgia, *CAP, CSPK*
Lethbridge Sue, *AGIP, FIP*
Lewis Jo-Ann, *AGIP, FIP*
Lewis Sheila, *GUILD, YAPP*
Leygraf Bernd, *AHPP, BASRT, UPA*
Linden Roger, *ANLP, FPC*
Linnell Maxine, *AAPP, AHPP*
Lister-Ford Christine, *NGP, ITA*
Little Jon, *RCSPC, UPA*
Lloyd Elizabeth, *GUILD, SITE*
Loewenthal Del, *PA, UPA*
Love Mollie, *AGIP, LCP*
Low James, *ACAT, BASRT, IATE, PA, UPA*
Lubbock Philippa, *GPTI, MET*
Lude Jochen, *AHPP, CCBP*
Lunardon Francesco, *ARBS, FIP*

Lund Charles, *NAAP, UPA*
Luthy Barbara, *AHPP, BCPC*

M

MacKenna Christopher, *CAP, GCP*
Mackewn Jennifer, *GPTI, MET*
MacNeill Enid, *BPA, HIP*
Madden Felicity W., *WMIP, VAPP*
Mann David, *GPTI, SPTI*
Maple Norma Anderson, *ACAT, IGA*
March-Smith Rosie, *AHPP, BCPC*
Mason Barry, *FIC, IFT*
Masterson Ingrid, *FIP, IPSS*
Matthews Carol, *FPC, SIP*
May Adam, *BABCP, NRHP*
McCluskey Una, *AFT, YAPP*
McCormick Elizabeth Wilde, *ACAT, CTP*
McCreanor Teresa, *FIP, LCP*
McFarland Alf, *VAPP, WMIP*
McGowan Dominica, *GPTI, MET*
McGroary-Meehan Maureen, *BABCP, BASRT*
McKenzie-Smith Bryce, *AGIP, AIP, FIP*
McNamara Jennifer, *NGP, ITA*
Meleagrou-Dixon Mando, *ACP, WTC*
Mellett Jane, *AHPP, BCPC*
Millar David, *ACP, UPA*
Miller Lynda R, *AGIP, UPA*
Mitchell Diana, *RCSPC, UPA*
Mitcheson Brown Muriel, *GUILD, SIP*
Montero Isabel, *ARBS, WTC*
Mordicai Aslan, *FIP, NAFSI*
Morgan Sian, *CSP, GUILD*
Morley Ann, *FIP, WMIP*
Morley Elspeth, *FIP, TMSI*
Mukuma Diana, *GPTI, MET*
Murdin Lesley, *FPC, SITE*
Mycroft Jessica, *FIP, IPSS*

N

Nathan (Jennifer) Ruth, *GPTI, MET*
Nesbit Judith, *AGIP, FIP*
Newbery Christopher, *AHPP, BCPC*
Nippoda Yuko, *AHPP, NAFSI*
Norton Sheila, *FIP, STTDP*

O

O'Connor Noreen, *GUILD, SITE*
O'Dell Tricia, *FIP, FPC, GCP*

O'Neill Christopher J., *NSHAP, UPA*
Oakley Haya, *GUILD, SITE*
Oakley Ian H., *LPDO, WMIP, YAPP*
Oakley Madeleine, *IPSS, AFT*
Oldman David, *GCP, TMSI*
Opienski Jacek, *GPTI, MET*
Orlans Vanja, *AHPP, GPTI, MET*
Osborne Lynda, *GPTI, MET*

P

Pain Jean, *ANLP, NRHP*
Palmer Barnes Fiona, *AJA, SIP*
Panetta-Crean Simona, *AIP, CAP*
Papadopoulos Renos, *AFT, IGAP*
Parava Anna, *GPTI, MET*
Parker Rosie, *FPC, SITE*
Parks Val, *FIP, FPC*
Pearmain Rosalind, *GUILD, RCSPC*
Pearman Cathy, *AAPP, CTP*
Perring Michael, *BASRT, MET*
Phillips Adam, *ACP, GUILD*
Phillips Marianne, *ARBS, FIP*
Phillips Susan, *MET, ITA*
Pirani Alix, *AHPP, BCPC*
Pittock Frances, *HIP, UPA*
Pokorny Michael R, *AGIP, FIP, UPA*
Porter Barbara, *MET, ITA*
Powell Andrew, *BPA, IGA*
Powell Angela, *ARBS, WTC*
Power Kevin, *FIP, UPA*
Pratt Sheila, *FIP, GCP, GUILD, WMIP*
Procter Harry, *AFT, CPCP*

Q

Quin Barbara, *AFT, BPA*

R

Randall Lynda, *FIP, STTDP*
Raphael Francesca, *IATE, AGIP*
Rapp Hilde, *IPSS, UPA*
Ratigan Bernard, *FIP, STTDP, UPA*
Redgrave Kenneth, *CTIS, NRHP*
Reid Liz, *CFAR, FIP*
Retallick Malcolm, *GPTI, MET*
Reuvid Jennie, *BAS, BASRT*
Richards Christopher, *GUILD, SIP*
Richards Val, *GUILD, IPSS*
Richardson Elizabeth, *CAP, FIP*
Ridgewell Margaret, *GPTI, MET*
Riding Nick, *CSPK, UPA*
Rimmer Annie, *MET, ITA*
Ritchie Sheila, *AGIP, WTC*
Robinson Martin, *AJA, SIP*
Robinson Sue, *AFT, GUILD*

Rogers Anne, *AGIP, FIP*
Rose Sally, *ARBS, FIP, YAPP*
Roth Ruth, *BCPC, MC*
Ryan Tom, *ARBS, SITE*
Ryde Judy, *AHPP, BCPC*

S

Samuels Andrew, *CAP, FIP*
Scarlett Jean, *FIP, GCP*
Schaedel Maggie, *ARBS, CSPK, UPA*
Schaverien Joy, *CAP, WMIP*
Schembri Veronica, *AHPP, UPA*
Scott Janice, *GPTI, MET*
Scott Tricia, *AHPP, UPA*
Shearer Ann, *AIP, IGAP*
Shearman Christine, *GPTI, MET, ITA*
Shipton Geraldine, *HIP, UPA*
Shivakumar H., *AIP CAP*
Shmukler Diana, *SPTI, ITA*
Sills Charlotte, *MET, ITA*
Singer Daniela, *AHPP, RCSPC*
Skailes Claire, *SIP, WMIP*
Sless Deborah, *SPTI, ITA*
Smith Jonathan, *AHPP, GCL*
Smolira David, *AFT, NSHAP*
Soloway Clare, *AHPP, MC*
Somers Barbara, *AAPP, CTP*
Speed Bebe, *WMIP, FIC*
Speyer Josefine, *AHPP, CCBP*
Stadlen Anthony, *AIP, RCSPC*
Stanwood Frederick, *AGIP, GCP, SITE*
Stein Yvonne, *AFT, RCSPC*
Stephens Lyn, *AGIP, FIP*
Stokeld Alasdair, *ARBS, FIP, YAPP*
Stokes Jean, *AJA, FPC*
Stokes Jenny, *GUILD, WMIP*
Stolte Eva, *AGIP, FIP, GCP*
Stone Miriam, *FIP, FPC*
Strasser Freddie, *RCSPC, UPA*

T

Tanna Nick, *IGA, NWIDP, YAPP*
Tantam Digby, *IGA, NWIDP, UPA*
Tatham Peter, *IGAP, SIP*
Thacker Rose, *NGP, ITA*
Tham Anna, *AAPP, BAS*
Thomas Marcia, *GPTI, MET*
Thompson Joan, *ANLP, CPCP*
Thomson Jean, *CAP, FIP*
Timmann S.P, *BABCP, CCPE, NRHP*
Truckle Brian, *ACP, WMIP*
Truckle Shirley, *ACP, WMIP*

Tudor Keith, *AHPP, MET, ITA*
Tune David, *AHPP, CCBP*
Turner Carole, *MET, ITA*
Turner Diana, *ARBS, FIP*

V

van Deurzen Emmy, *RCSPC, UPA*
Vas Dias Susan, *ACP, CAPP*
Verduyn Christine M., *AFT, BABCP*
Vibert Eva, *CTP, RE.V.*
Vincent Jane, *HIP, YAPP*
Voikhanskaya Marina, *GUILD, SITE*
Vollans Audrey, *GPTI, MET*

W

Walker Catriona Jane, *FIP, STTDP*
Walker Jim, *GCP, IPSS*
Walsh Stuart, *AFT, BPA*
Waterstone Carolyn, *GPTI, SPTI*
Watson James P, *BASRT, UPA*
Wattis Libby, *LPDO, WMIP, YAPP*
Webb Joan, *LPDO, YAPP*
Wellings Nigel, *AGIP, AIP, CTP*
Wells Lindsay James, *AGIP, AIP*
Westland Gill, *AHPP, CCBP*
Wetherell Jean, *CAP, FIP*
Wheeley Shirley, *GUILD, WMIP*
Whelan P W A, *BASRT, UPA*
Whines Jonathan, *GPTI, MET*
White Lauren E, *UPA, GUILD*
Wieland Christina, *AGIP, FIP*
Wigram Penny, *FIP, FPC*
Williams Sherly, *FPC, VAPP, WMIP*
Wilmot Vivienne, *FIP, GCP*
Wilson Maureen, *AGIP, FIP*
Wilson Ronni, *AHPP, IATE*
Winkley Linda, *ACP, WMIP*
Wood Jane, *MET, ITA*
Woodward Joan, *CAPP, WMIP*
Wright W. Harry, *IGA, WMIP*
Wyatt Gill, *MET, ITA*

Y

Yallop Melanie, *FIP, FPC, GCP*
Yariv Gail, *FPC, SIP*
Yazar Jale, *IPSS, NAFSI*

Z

Zeal Paul, *SIP, SITE*

Confederation of Analytical Psychologists

**The following members of the Confederation of Analytical Psychologists belong to either the Society of Analytical Psychology (SAP) or the British Association of Psychotherapists (BAP) or both. The BAP and the SAP were founding Member Organisations of the UKCP. Since 1999 they are no longer members.

Peter Addenbrooke (p.179)
Ian Alister (p.12)
Anne Ashley (p.165)
Gillian Ballance (p.41)
Jenny Beddington (p.68)
Angela Bennett (p.68)
Johanna Brieger (p.191)
Ann Bruce (p.103)
Jane Buckley (p.12)
John Burnard (p.112)
Jean Carr (p.149)
Sandy Chapman (p.62)
Elphis Christopher (p.70)
Ingrid Coltart (p.123)
Catherine Crowther (p.71)
Diana Mary Dennis (p.59)
Sedwell Diggle (p.13)
Jennifer Duckham (p.167)
Gill Dunbar (p.89)
Sarah Farmer (p.72)
Nathan Field (p.72)
Susan Fisher (p.124)
Vicki Gardiner (p.13)
Geraldine Godsil (p.73)

Susan Goodman (p.105)
Penny de Haas Curnow (p.88)
Nelly Hadzanesti (p.125)
Margaret Hammond (p.138)
Michael Harari (p.138)
Dianne Harris (p.43)
Robert Hart (p.168)
Christopher Hauke (p.49)
Susan Haxell (p.92)
Edward Herst (p.92)
David Hewison (p.92)
Patricia de Hoogh-Rowentree (p.34)
Ann Hopwood (p.115)
William Hughes (p.142)
Eric Hutchison (p.14)
Francoise Hutton (p.176)
Sally Jakobi (p.169)
Catherine Kaplinsky (p.176)
Stewart Katzman (p.76)
David Louis Kay (p.76)
Ann Kutek (p.116)
Joan Mary Lee (p.107)
Georgia Lepper (p.77)

Harriet Loeffler (p.126)
Maria Lynch (p.139)
Christopher MacKenna (p.170)
Marietta Marcus (p.117)
Nicholas Marhsallsay (p.77)
Edward Martin (p.107)
Peter Masani (p.177)
Carola Mathers (p.117)
Oliver McShane (p.127)
Beckie Menckhoff (p.139)
Ruth Muffet (p.96)
Jean Mulvey (p.177)
Simona Panetta-Crean (p.80)
Julia Paton (p.80)
Christopher Perry (p.140)
Virginia Phillips (p.108)
Judith Philo (p.80)
Penny Pickles (p.118)
John Priestly (p.118)
Keith Reed (p.128)
Elizabeth Richardson (p.45)
Alistair Ross (p.81)
Julia Ryde (p.82)
Andrew Samuels (p.82)

Joy Schaverien (p.57)
Martin Schmidt (p.109)
Pury Sharifi (p.82)
Margaret Sheehan (p.109)
H. Shivakumar (p.99)
Michael J A Simpson (p.15)
Anna Sladden (p.45)
Nora Smith (p.155)
Paola Valerio Smith (p.109)
Hester McFarland Solomon (p.100)
Dorothee Steffens (p.119)
Dayle Thackray (p.129)
Jean Thomson (p.101)
Sandra Walline (p.120)
Jean Wetherell (p.101)
Averil Williams (p.121)
Serena Willmott (p.85)
Catherine Wilson (p.121)
Mary Wilson (p.110)
Robert Withers (p.178)
Susanna Wright (p.102)